The Private Collection of
EDGAR DEGAS

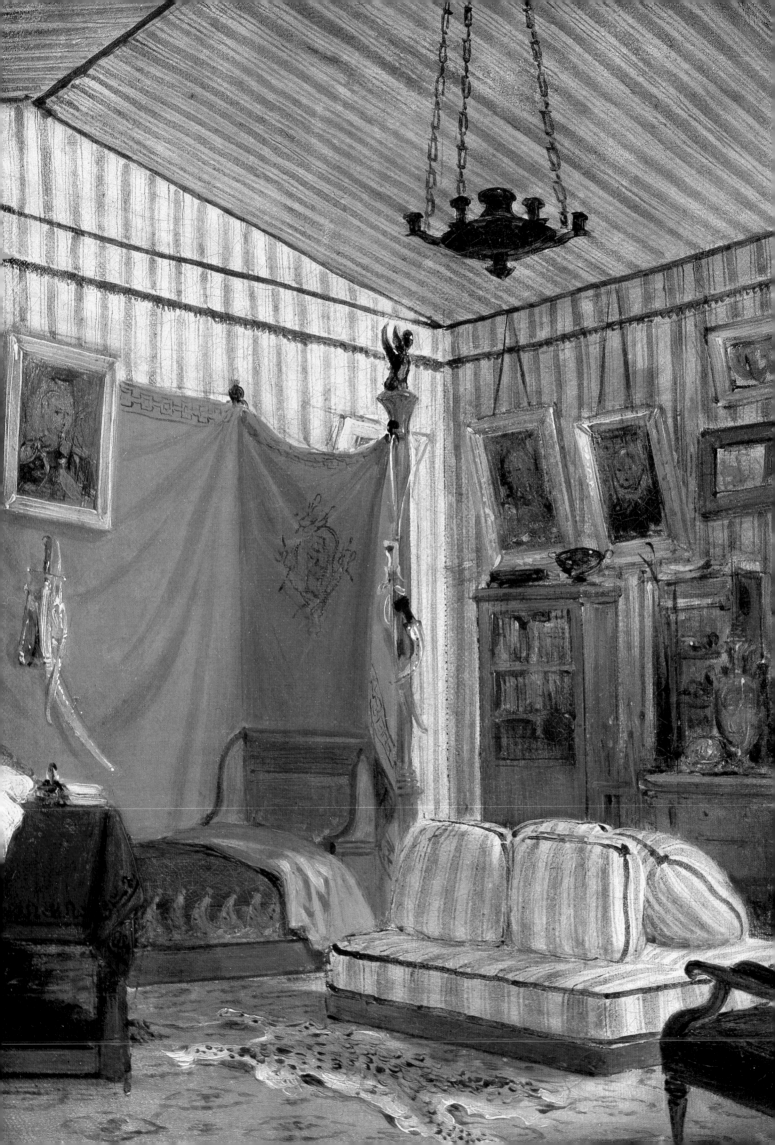

The Private Collection of
EDGAR DEGAS

ANN DUMAS

COLTA IVES

SUSAN ALYSON STEIN

GARY TINTEROW

With contributions by Françoise Cachin, Caroline Durand-Ruel Godfroy,

Richard Kendall, Mari Kálmán Meller and Juliet Wilson-Bareau,

Rebecca A. Rabinow, Theodore Reff, and Barbara Stern Shapiro

THE METROPOLITAN MUSEUM OF ART, NEW YORK

Distributed by Harry N. Abrams, Inc., New York

This catalogue is published in conjunction with the exhibition "The Private Collection of Edgar Degas," held at
The Metropolitan Museum of Art, New York, from October 1, 1997, to January 11, 1998.

The exhibition is made possible by **TEXACO INC.**

An indemnity has been granted by the Federal Council on the Arts and the Humanities.

The publication is made possible, in part, by Janice H. Levin.

Published by The Metropolitan Museum of Art, New York

John P. O'Neill, Editor in Chief
Ruth Lurie Kozodoy, Editor
Bruce Campbell, Designer
Gwen Roginsky, Production, with the assistance of Tracy George
Robert Weisberg, Computer Specialist

New photography at The Metropolitan Museum of Art principally by Juan Trujillo, the Photograph Studio,
The Metropolitan Museum of Art, New York

Translations from the French by Mark Polizzotti

Typeset in Adobe Garamond
Color separations made by Professional Graphics Inc., Rockford, Illinois
Printed and bound by Arnoldo Mondadori Editore, S.p.A., Verona, Italy

Library of Congress Cataloging-in-Publication Data
Dumas, Ann.
The private collection of Edgar Degas / Ann Dumas and Gary Tinterow et al.
p. cm.
Catalog of an exhibition held at The Metropolitan Museum of Art, Oct. 1, 1997–Jan. 11, 1998.
Includes bibliographical references and index.
ISBN 0-87099-797-1 — ISBN 0-87099-799-8 (pbk.) — ISBN 0-8109-6512-7 (Abrams)
1. Art, French—Exhibitions. 2. Art, Modern—19th century—France—
Exhibitions. 3. Art—Exhibitions. 4. Degas, Edgar, 1834–1917—Art
collections—Exhibitions. 5. Art—Private collections—France—Exhibitions.
I. Tinterow, Gary. II. Metropolitan Museum of Art (New York, N.Y.) III. Title.
N6847.D86 1997 97-17882
760'.0944'0747471—dc21 CIP

Jacket/cover illustration: Detail, Edgar Degas, *Family Portrait (The Bellelli Family),* 1858–67; fig. 90
Frontispiece: Detail, Eugène Delacroix, *Count de Mornay's Apartment,* 1832–33; fig. 4

Contents

Sponsor's Statement

The Private Collection of Edgar Degas surprises and delights us because it reveals another dimension of an artist we imagine we know so well. Here, side by side with Degas's graceful studies of dancers and bathers, powerful portraits, and evocative history paintings, are richly varied works by artists such as Ingres, Delacroix, Daumier, Manet, Cézanne, and Gauguin—all from Degas's private collection. It is this hidden dimension of Degas, the connoisseur—blending the unexpected with the familiar—that helps to distinguish this exhibition.

Degas's range as a collector reflects his own cosmopolitan roots: he was a Parisian, with a mother born in New Orleans and a grandmother from Genoa.

As a global energy company that has been operating for more than ninety-five years, Texaco is proud to sponsor this expression of one artist's broad and impeccable taste. In our business, as in our long-standing support of the arts, we have sought to go beyond the expected—and to find the extra dimension that marks truly inventive work.

Peter I. Bijur
Chairman and Chief Executive Officer
TEXACO INC.

Director's Foreword

Only a privileged coterie of friends knew the extent of Edgar Degas's passion for collecting. Even fewer were invited to enter the private museum that he set up in the late 1890s in his apartment in Paris, where he hoarded a staggering array of masterpieces by the artists he regarded as his forebears, J.-A.-D. Ingres, Eugène Delacroix, and Honoré Daumier, and by a select group of contemporaries, principally Édouard Manet, Paul Cézanne, and Paul Gauguin. One visitor, Arsène Alexandre, a journalist and a collector himself, wrote in 1901 that "Degas is possessed by the devil of collecting, rarer than one would think among artists," but warned his readers that the collection was "closed, defended, shut away, and it is not recommended that you ring at the door unless you are carrying under your arm an unknown Ingres."

For the last five years of his life, Degas, old and infirm, was himself closed, defended, and shut away. Following his death in September 1917, the revelation of his collection as well as of the contents of his studio—hundreds of paintings and thousands of drawings and prints—astounded an art world that was otherwise preoccupied with the war advancing across Europe. Upon the announcement that Degas's holdings would be sold, collectors, curators, and dealers mobilized their resources, while a group of experts prepared the first of eight sales that would be held in Paris over the course of two years to disperse the nearly eight thousand items Degas had owned. The press was soon stunned by the prices being paid at the auctions, conducted while, on the outskirts of the French capital, German cannons boomed. The Metropolitan Museum of Art managed to secure two magnificent portraits by Ingres and ten drawings by Degas at the sales; the Louvre bought a number of works by Degas, including the magnificent *Family Portrait (The Bellelli Family),* as well as paintings and drawings by Ingres, Delacroix, and Manet; and the National Gallery of London was able to acquire works by Ingres, Delacroix, Manet, Cézanne, Gauguin, and Degas, effectively creating a collection of nineteenth-century French painting where there had been none. Another consequence of the sales was to make early and late works by Degas visible en masse for the first time, allowing connoisseurs and historians to embark upon an assessment of this remarkable man's extraordinary fifty-year career. One writer suggested that an exhibition of all the paintings sold should be organized "in three or five years, to know where they ended up."

It now has been almost eighty years since the collection of Edgar Degas was dispersed, and this exhibition fulfills that hope, at least in large part. Thanks to the exceptionally generous collaboration of present-day collectors and museums around the world—in particular, our colleagues at the Museum of Fine Arts, Boston, The Art Institute of Chicago, the Ordrupgaardsamlingen, Copenhagen, the National Gallery and the British Museum, London, the Musée du Louvre and the Musée d'Orsay, Paris, the Nationalmuseum, Stockholm, and the National Gallery, Washington, D.C.—our curators have been able to assemble a remarkable number of fine paintings, pastels, drawings, watercolors, and prints by some forty artists, all works of art that were in Degas's home or studio.

An exhibition of this scope would not have been possible without the important financial support received from Texaco Inc. In particular, we would like to acknowledge the company's Chairman and Chief Executive Officer, Peter I. Bijur. We are also extremely grateful to Janice H. Levin for her support of this publication.

Identifying the works formerly in Degas's possession and finding their current owners was no easy task. Gary Tinterow, Colta Ives, Susan Alyson Stein, and guest curator Ann Dumas have spent countless hours tracking works known only through a brief mention or an enigmatic reference, with the goal of learning as completely as possible what Degas collected and when, and of understanding why. Aided by Rebecca A. Rabinow and Julie A. Steiner, they have set forth the results of their research in this fascinating book, which is also enriched by contributions from leading specialists in France, England, and the United States who explore the relationships between Degas's own art and the art he collected. A *Summary Catalogue* of the entire collection is published in a supplementary volume. The result is an extraordinary glimpse into fin-de-siècle Paris and the private world of one of the greatest artists of all time, Edgar Degas.

Philippe de Montebello
Director, The Metropolitan Museum of Art

Lenders to the Exhibition

Public Institutions

AUSTRIA
Vienna, Graphische Sammlung Albertina

CANADA
Ottawa, National Gallery of Canada

DENMARK
Copenhagen, Ny Carlsberg Glyptotek
Copenhagen, Ordrupgaardsamlingen

FRANCE
Dijon, Musée des Beaux-Arts
Montauban, Musée Ingres
Paris, Musée des Arts Décoratifs
Paris, Musée du Louvre
Paris, Musée d'Orsay
Tours, Musée des Beaux-Arts

GERMANY
Munich, Neue Pinakothek, Bayerische
 Staatsgemäldesammlungen

GREAT BRITAIN
Cambridge, The Provost and Fellows of King's
 College
Cardiff, National Museum of Wales
Charleston, The Charleston Trust
London, Trustees of the British Museum
London, Courtauld Institute Galleries

London, Trustees of the National Gallery
London, Tate Gallery
Manchester, The Whitworth Art Gallery,
 The University of Manchester
Oxford, Visitors of the Ashmolean Museum

JAPAN
Tokyo, The National Museum of Western Art

NETHERLANDS
Rotterdam, Museum Boijmans Van Beuningen

NORWAY
Oslo, Nasjonalgalleriet

SWEDEN
Göteborg, Göteborgs Kunstmuseum
Stockholm, Nationalmuseum

SWITZERLAND
Basel, Oeffentliche Kunstsammlung, Kunstmuseum
 Basel
Bern, Kunstmuseum Bern
Lausanne, Musée Cantonal des Beaux-Arts

UNITED STATES
Baltimore, The Baltimore Museum of Art
Boston, Museum of Fine Arts
Cambridge, Fogg Art Museum, Harvard University
 Art Museums
Chicago, The Art Institute of Chicago

Cleveland, The Cleveland Museum of Art

Detroit, The Detroit Institute of Arts

Glens Falls, New York, The Hyde Collection

Los Angeles, Los Angeles County Museum of Art

New Brunswick, The Jane Voorhees Zimmerli Art
Museum, Rutgers, The State University of
New Jersey

New York, Brooklyn Museum of Art

New York, The Metropolitan Museum of Art

New York, The Museum of Modern Art

New York, The New York Public Library, Astor, Lenox,
and Tilden Foundations

Philadelphia, Philadelphia Museum of Art

Princeton, The Art Museum, Princeton University

Providence, Museum of Art, Rhode Island School
of Design

Richmond, Virginia Museum of Fine Arts

San Diego, San Diego Museum of Art

San Francisco, The Fine Arts Museums of San
Francisco, Achenbach Foundation for Graphic Arts

Washington, D.C., Dumbarton Oaks Research Library
and Collections

Washington, D.C., The Library of Congress

Washington, D.C., National Gallery of Art

Washington, D.C., The Phillips Collection

Williamstown, Massachusetts, Sterling and Francine
Clark Art Institute

Worcester, Massachusetts, Worcester Art Museum

Other Collections

Association des Amis d'Honoré Daumier

Marc Blondeau, S.A., Paris

André Bollag-Bloch, Switzerland

Eric G. Carlson

Arturo Cuéllar and Johannes Nathan

Durand-Ruel et Cie

Dr. and Mrs. Martin L. Gecht, Chicago

Collection Jasper Johns

Ursula and Stanley Johnson

Josefowitz Collection

Jan and Marie Anne Krugier-Poniatowski

Gianna and Thomas Le Claire

Paolo Marzotto from the Gaetano Marzotto Collection

Fundação Medeiros e Almeida

Thomas Parr

The Henry and Rose Pearlman Foundation, Inc.

Dr. and Mrs. Meyer Potamkin

Mr. and Mrs. Louis-Antoine Prat

Charles Ryskamp, New York

Mrs. Ulla Toll

Galerie Yoshii

and other private collectors who choose to remain
anonymous

Acknowledgments

It is little more than a year since Ann Dumas wrote Gary Tinterow to inquire whether the Metropolitan Museum would be interested in mounting an exhibition similar to "Degas as a Collector," which she had organized for the National Gallery, London, in the summer of 1996. Happily, Philippe de Montebello immediately recognized the value of such a project and made available the space and funds necessary to realize a large and comprehensive exhibition based on the very beautiful show in London. Colta Ives and Susan Alyson Stein joined the curatorial team. With the generous cooperation of our friends at the National Gallery, Neil MacGregor and John Leighton, and also those at the British Museum, Robert Anderson and Antony Griffiths, the exhibition was under way with a key group of important works that had been purchased by those museums directly from the Degas sales in 1918.

To reveal the full range and quality of Degas's astounding collection, it remained to identify, locate, and borrow some two hundred fifty works. This difficult, at times seemingly insurmountable task was made enjoyable by the extraordinary cooperation of colleagues throughout the world—museum directors, curators, art historians, dealers, collectors, researchers, librarians, and archivists—all of whom appreciated the importance of a project to reassemble much of Degas's private collection. Their names are given below. Thanks to their enthusiasm, the present exhibition became possible. Thanks to the information they shared, we know vastly more about Degas's activities as a collector, the relationship of his collection to his own art, and the conditions of art collecting in Paris at the turn of the century.

We are especially grateful to Henri Loyrette, who, as Degas's most thorough biographer and the director of the Musée d'Orsay, made exceptional contributions to this project. We thank him above all for the loan of Degas's greatest painting, *Family Portrait (The Bellelli Family)*, the work in the artist's collection most keenly sought by the French state. Among many additional kindnesses, he made available to us the art in the *fonds* Fevre—works by Degas, and others, that were retained by Degas's niece Jeanne Fevre and her descendants and are now at the Musée d'Orsay and the Musée du Louvre. We also warmly thank Arlette Sérullaz for responding to our numerous queries regarding the *fonds* Fevre as well as the Delacroix works owned by Degas.

Many other museums were equally generous. The Museum of Fine Arts, Boston; The Art Institute of Chicago; the Ordrupgaardsamlingen, Copenhagen; the British Museum, London; the Musée du Louvre, Paris; the Nationalmuseum, Stockholm; the National Gallery of Art, Washington, D.C.; and the Francine and Sterling Clark Art Institute, Williamstown, each contributed an unusually large group of works, in many cases at very short notice. At these institutions we wish to thank in particular David Brown, Görel Cavalli-Björkman, Michael Conforti, Philip Conisbee, Jean-Pierre Cuzin, Douglas Druick, Anne Brigitte Fonsmark, Margaret Morgan Grasselli, Sidsel Helliesen, Vincent Pomarède, Earl A. Powell III, Andrew Robison, Malcolm Rogers, Pierre Rosenberg, Georges Shackelford, Françoise Viatte, Mikael Wivel, and James Wood.

A number of other museums made exceptional loans that we wish to acknowledge: The Baltimore Museum of Art, Kunstmuseum Basel, Kunstmuseum Bern, the Neue Pinakothek, Munich, the Philadelphia Museum of Art, the Worcester Art Museum; and we would like to express our gratitude to Christoph Heilmann, Brenda Richardson, Joseph Rishel, Katharina Schmidt, Toni Stooss, and James Welu at those institutions.

The generosity of lenders was matched by that of colleagues who, going beyond professional courtesy, generously gave their time and expertise to this project. Lee Johnson, Anne Roquebert, Jayne Warman, and Peter Zegers were exceedingly helpful in answering queries and providing information about works in Degas's collection. Other scholars graciously shared their insights and knowledge: Sylvain Bellenger, Jean Sutherland Boggs, Guy Boyer, Jean-Loup Champion, Elizabeth Childs, Timothy Clarke, Guy Cogeval, David Daniels, Roland Dorn, Walter Feilchenfeldt, Richard S. Field, Jacques Fischer, Suzanne Folds-McCullough, Barbara B. Ford, Simonetta Fraquelli, Claire Frèches-Thory, Romy Golan, Tim Higgins, Roger Keyes, Ger Luijten, Jenny Malkin, Kaspar Monrad, Sasha Newman, Joy Newton, Michael Pantazzi, Ursula Perucchi-Petri, Vincent Pomarède, Louis-Antoine Prat, Julie Saul, Richard Thomson, Georges Vigne, and Gerrard White.

For their assistance in helping to locate and secure loans of interest to the exhibition, we extend our warmest thanks to Alex Apsis, Luc Bellier, Anisabelle Berès, Pierre Berès,

W. M. Brady, Libby and Gordon Cooke, Christopher Drake, Adrian Eeles, Ruth Fine, Marie-Cécile and Dominique Forest, Kate Garmeson, Margrit Hahnloser, Katharina Maeyer Haunton, John Herring, Paul Herring, Waring Hopkins, Ay-Whang Hsia, Katherine Lochnan, Joachim Pissarro, Jonathan Pratt, Maria-Christina zu Sayn-Wittgenstein, Robert Schmit, David Scrase, Laurence Smith, Nesta Spink, Guy Stair-Sainty, and Anna Swinbourne.

For granting us exceptional access to unpublished documents, we gratefully acknowledge: at the Archives de la Ville de Paris, Béatrice Betoulaud, Philippe Grand, Alain Grassel, and Brigitte Lainé; at the Archives Bernheim-Jeune, Guy-Patrice and Michel Dauberville; at the Archives Durand-Ruel, Caroline Durand-Ruel Godfroy; at the Archives of M. Knoedler and Co., Melissa de Medeiros; at the Musée d'Orsay, Laure de Margerie and Marie-Pierre Salé; and at the Petit Palais, Mourad Langry. We are indebted to Phillip Brame for allowing us to consult precious documents in his possession.

All of the authors of the catalogue deserve our special thanks, not only for their individual contributions to the present anthology but for the suggestions and information they generously provided about works of art formerly owned by Degas. We thank Françoise Cachin, Caroline Durand-Ruel Godfroy, Richard Kendall, Mari Kálmán Meller, Rebecca A. Rabinow, Theodore Reff, Barbara Stern Shapiro, and Juliet Wilson-Bareau. John P. O'Neill, Editor in Chief, oversaw the entire publication and gave support throughout. The catalogue was sensitively and skillfully edited by Ruth Lurie Kozodoy, Senior Editor, who managed to shepherd an enormous and complicated endeavor with patience, good humor, and grace. Gwen Roginsky, Chief Production Manager, expertly guided the book into print, ably assisted by Tracy George; Bruce Campbell produced the fine design. We also thank Elizabeth Powers, for valuable editorial assistance; Penny Jones, who edited bibliographic references and captions; Mark Polizzotti, the translator; and Peter Rooney, who compiled the index.

We would like as well to express our appreciation to the United States Government Indemnity panel, and especially to Alice M. Whelihan, Indemnity Administrator at the National Endowment for the Arts, for invaluable support of the project. We are grateful too to Polly Sartori and David Tunick, who generously devoted time and effort to reviewing the indemnity application.

For their cooperation on this project, we would like to thank our colleagues at the Metropolitan Museum: Everett Fahy, Dorothy Kellett, and Samantha Sizemore, Department of European Paintings; Calvin D. Brown and David del Gaizo, Department of Drawings and Prints; Aileen K. Chuk, Registrar; Linda M. Sylling, Operations; Jeanie M. James, Archives; Diana H. Kaplan, Deanna D. Cross, and Carol E. Lekarew, Photograph and Slide Library; Barbara Bridgers and Juan Trujillo, Photograph Studio. The handsome design of the exhibition and its graphics are the work of Daniel Kershaw and Constance M. Norkin, both of the Design Department.

The realization of "The Private Collection of Edgar Degas" was above all a collaborative effort among the four of us and other key people whose talents and dedication we gratefully acknowledge. Rebecca A. Rabinow worked closely with the curators on all aspects—both scholarly and practical—of the exhibition and catalogue. Her keen intellect, meticulous attention to detail, and superb research and organizational skills proved indispensable. It was at her initiative that the thousands of works formerly owned by Degas were entered into a database program that became the basis for the *Summary Catalogue* of Degas's collection. The enormous challenge of manning this database was assumed by Julie A. Steiner, who, with remarkable discernment and intelligence, brought order and clarity to a massive amount of documentation, in the process contributing many new discoveries about the works in Degas's collection. Gretchen Wold assembled all the photographic material for the catalogue with her usual efficiency and care, making a daunting task seem effortless. Robert McDonald Parker combed libraries and archives in Paris, diligently tracking down information from sale catalogues, auction records, and all manner of unpublished documents that proved crucial to the identification and location of hundreds of works owned by Degas. Mary C. Weaver made significant contributions to our study of drawings and prints in the artist's collection, and Melinda Farneth provided helpful research assistance.

Ann Dumas　　　　　　　*Colta Ives*
Susan Alyson Stein　　　 *Gary Tinterow*

CURATORS OF THE EXHIBITION

ANN DUMAS, *Guest curator*

COLTA IVES, *Curator, Department of Drawings and Prints, The Metropolitan Museum of Art*

SUSAN ALYSON STEIN, *Associate Curator, Department of European Paintings, The Metropolitan Museum of Art*

GARY TINTEROW, *Engelhard Curator, Department of European Paintings, The Metropolitan Museum of Art*

with the assistance of

REBECCA A. RABINOW, *Research Associate, Department of European Paintings, The Metropolitan Museum of Art*

JULIE A. STEINER, *Research Assistant, Department of European Paintings, The Metropolitan Museum of Art*

NOTE TO THE READER

Edgar Degas's collection of art was sold in 1918 in three sales, referred to in this book as Collection Sale I, Collection Sale II, and Collection Print Sale. The artist's own works that he had kept in his studio until his death were sold in 1918 and 1919 in five sales, referred to here as Atelier Sales I–IV and Atelier Print Sale. Full citations for the catalogues of the sales appear at the head of the Bibliography.

Works illustrated in this book that were sold at any of the Degas sales carry caption information naming the sale, followed by the lot number. Works that were retained by Degas's heirs are so identified.

Catalogue raisonné numbers are cited in abbreviated form (e.g., L 136); full citations for the catalogues raisonnés will be found in the Bibliography.

Degas's partial inventory of his collection, contained in unpublished notes, is abbreviated "Degas inv." in references and is included in the Bibliography.

An illustrated companion volume to this publication, *Summary Catalogue of the Collection of Edgar Degas,* contains information on every item listed in the collection sale catalogues.

THE
ARTIST-COLLECTOR

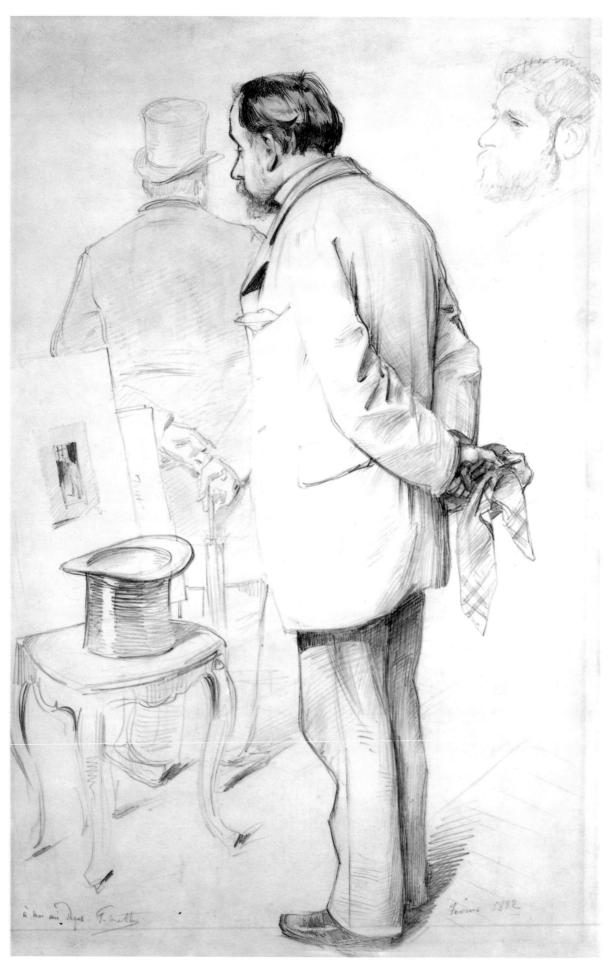

Fig. 1. Paul Mathey (1844–1929), *Portrait of Edgar Degas,* February 1882. Graphite, 18⅞ × 12⅜ in. (48 × 31.5 cm). National Gallery of Art, Washington, D.C., Collection of Mr. and Mrs. Paul Mellon (1995.47.57). Dedicated "to my friend Degas." Collection Sale II: 223

Degas and His Collection

ANN DUMAS

To be both "illustrious and unknown": this was his desire, Hilaire-Germain-Edgar Degas (1834–1917) once asserted.[1] The artist became illustrious well before his death and is still among the most widely acclaimed and thoroughly studied of all French painters. Yet one significant aspect of Degas's career does remain largely unknown—his activity as a collector.[2] The magnificent assemblage of paintings, drawings, and prints that he brought together in the latter part of his life was so substantial and of such distinction that for a while he thought, quite reasonably, of establishing a museum.

Degas's collection was dispersed after his death, yet it remains of the greatest interest both for its intrinsic quality and, especially, for its significance for comprehending his own art. Like any great artist, Degas remains "unknown" —the inner workings of his genius can be only imperfectly understood—but through an examination of his passions as a collector we may perhaps catch glimpses of his motives as an artist.

In exploring the links between Degas's collecting and his art, the historian is forced to indulge in a speculative exercise. Degas left no conveniently illuminating exposition of the impulses behind his collecting. He made notes on some of the works he owned, but they are mostly confined to practical information; and his expressions of his views on art, which can be found here and there in the memoirs of friends, are invariably brief and enigmatic. Anecdotes told by his contemporaries offer only occasional and partial clues.

After Degas's death in Paris on September 27, 1917, the discovery of his full artistic legacy came as a revelation. Although his own work had of course appeared in exhibitions and dealers' galleries, much more had remained hidden in his studio. And certainly his collection of art was not widely known: outside his circle of friends, dealers, and collectors, few knew of its existence. A rare reference to the collection made during Degas's lifetime was the critic Arsène Alexandre's remark on its inaccessibility, an observation that was repeated in newspaper articles in 1918 when the collection was put up for sale.[3]

For the last five years of his life, Degas lived more or less as a recluse in rented rooms at 6, boulevard de Clichy in Montmartre, opposite the Cirque Medrano, in a district that by the early years of the century was becoming dilapidated. He had never married, and his longtime housekeeper, Zoé Closier, had retired because of illness. Degas's anti-Semitic stance with regard to the Dreyfus affair had cost him a number of important friendships; several other close friends and relatives had died. When in 1912 he was forced to leave his previous apartment on the rue Victor Massé because the building was to be demolished by developers, the move destroyed the life Degas had known. The routines and associations built up over fifteen years were wrenched apart. Aided by a few friends, he watched his possessions and his precious collection being packed up and moved on carts twenty yards or so up the hill to his new address. Degas was now seventy-eight, frail, and almost blind; after the shock of this move he was never able to reestablish his life. The vast body of his own work, hoarded over a lifetime, including even the masterpieces of his early years that he had never been able to part with, remained piled against the walls and heaped on temporary tables. Only the collection was partly unpacked and displayed.[4]

The collection was devoted mostly to French art of the nineteenth century and was dominated by works by Jean-Auguste-Dominique Ingres and Eugène Delacroix, the two idols of Degas's youth, both of whom had the most profound influence on him throughout his career. He owned twenty paintings and eighty-eight drawings by Ingres. Among the outstanding portraits were *Jacques-Louis Leblanc* and *Madame Jacques-Louis Leblanc* (figs. 22, 21), *Marquis de Pastoret* (fig. 20), and *Monsieur de Norvins* (fig. 186). The thirteen paintings by Delacroix included *Louis-Auguste Schwiter* (fig. 44) and *Count de Mornay's Apartment* (fig. 4), in addition to well over two hundred works on paper. Despite Degas's lifelong veneration of old master painting and its importance to his own art, he owned few old masters: two El Grecos, *Saint Ildefonso* (fig. 2) and *Saint Dominic* (fig. 383); a painting of a horse by a follower of Aelbert Cuyp; a work by the eighteenth-

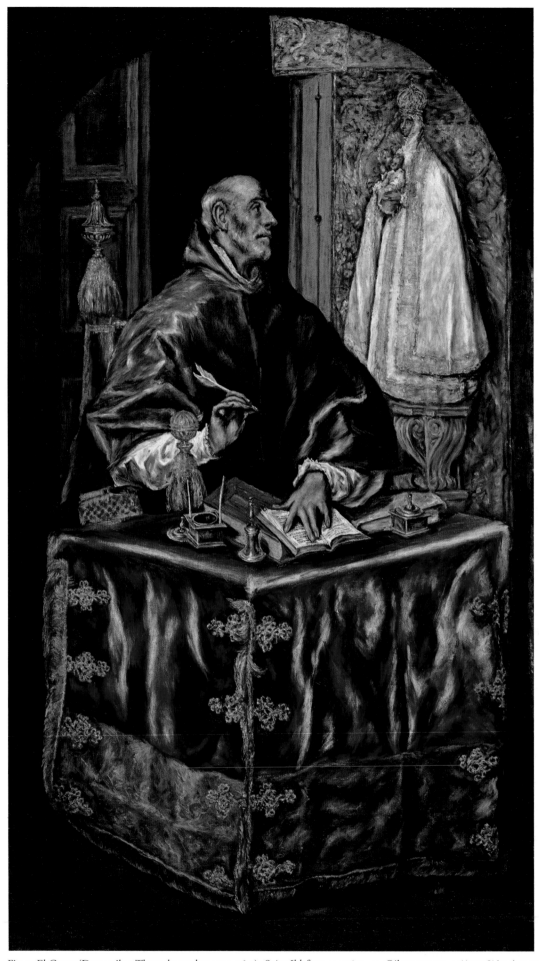

Fig. 2. El Greco (Domenikos Theotokopoulos; 1541–1614), *Saint Ildefonso,* ca. 1603–14. Oil on canvas, 44⅛ × 25⅞ in. (112 × 65.8 cm). National Gallery of Art, Washington, D.C., Andrew W. Mellon Collection (1937.1.83). Collection Sale I: 2

century French portrait painter Jean-Baptiste Perronneau (fig. 164); and a few drawings by Giovanni Domenico Tiepolo.[5] Camille Corot was represented by a group of seven oils that included the splendid *Limay Bridge* (fig. 378).[6] Among the paintings by Degas's contemporaries, it is no surprise to find work by his friend Édouard Manet, including the fragments of *The Execution of Maximilian, Emperor of Mexico* (fig. 60). Yet, rather less predictably, Degas also admired Vincent van Gogh, Paul Cézanne, and Paul Gauguin. Graphic art was a particular enthusiasm of Degas's: he acquired a vast collection of lithographs by Honoré Daumier and Paul Gavarni, as well as almost the complete graphic work of Manet and groups of experimental prints by Camille Pissarro, Mary Cassatt, Gauguin, and James Abbott McNeill Whistler, together with a number of Japanese prints. Degas's most significant "non-acquisition" is also worth mentioning—Gustave Courbet's twenty-foot-wide manifesto of his artistic aims, *The Painter's Studio*, 1855 (Musée d'Orsay, Paris), for which he had bid unsuccessfully in 1897.[7]

On the whole, there are few specific correspondences between the subjects of the works Degas collected and those of his own art. There were no representations of ballet dancers, Degas's best-known subject. And while Degas acquired a large number of images of horses,[8] they are not very significant proportionally compared to his own extensive exploration of equestrian subjects. More generally, however, the large number of portraits in the collection (by Ingres, Delacroix, Manet, and Cézanne) and the many representations of nudes (especially by Ingres but also by Manet, Gauguin, and Cézanne) reflect the important place that these subjects occupied in Degas's work. Many of the Daumier and Gavarni prints that he owned confirm his interest in themes from modern life. Still, overall, the connections between Degas's collection and his art relate to deeper and more complex concerns than subject matter.

The Dispersal

The hundreds of his own paintings, drawings, and pastels found in Degas's studio after his death were sold at five sales in 1918 and 1919. His collection was sold at three further sales held in Paris in 1918. All the sales were organized by the firms of Bernheim-Jeune and Durand-Ruel together with the dealer Ambroise Vollard, assisted by members of Degas's family.[9] Degas's friend Étienne Moreau-Nélaton, who acted as an adviser to Durand-Ruel for the sale, visited the dealer's premises just before the first collection sale and subsequently conveyed in his journal the excitement of the impending event: "The collections filled three rooms. Masterpieces were piled up pell-mell; an unbelievable heap of riches. The Ingres, the Delacroix, the Degas, all mixed together. The drawings and watercolors by Delacroix that I examined were magnificent."[10] The first sale of the collection contained all the major paintings and works on paper, the second was devoted to Degas's extensive collection of prints, and the third, apart from substantial groups of drawings by Ingres and Delacroix and a few by Théodore Géricault, was largely composed of minor works by little-known artists such as Adolphe Midy, Prosper Marilhat, and Fernand du Puigaudeau, and of unattributed paintings ascribed simply to Japanese, Persian, Italian, or French schools. Of those listed under "Modern School," a number have since been identified as copies of old master paintings made by Degas himself.[11]

The catalogues of the three sales of Degas's collection are the basic documents for its contents, but they can be supplemented by other documents: some unpublished inventory notes that Degas himself made on a number of works he acquired, the inventories drawn up after his death by Durand-Ruel and Vollard, references in Degas's letters and those of his friends, and the descriptions of the collection by his friend Paul Lafond and later by the art historian Paul-André Lemoisne.[12] Not everything in the collection appeared in the sales catalogues, presumably because Degas parted with some things before his death, because they were retained by his friends or family, or because of misidentification.[13] Degas refers in his notes to a portrait of a huntsman by Courbet, perhaps the *Portrait of a Hunter* listed under "Modern School" in the sale catalogue,[14] and Lafond mentions a portrait of a man by Thomas Couture, which was not included in any of the sales.[15]

While the third sale was, on the whole, a commercial failure, with many lots failing to reach their estimates, the first sale was a spectacular success, fetching prices that were much higher than expected and described in *Les Arts* as "the event of the season."[16] The exceptional quality of the works offered and the added cachet that the works had belonged to Degas attracted distinguished collectors, dealers, and museum representatives. These included David David-Weill; the dealer Joseph Durand-Ruel, acting for himself and for the American millionairess Mrs. H. O. Havemeyer and The Metropolitan Museum of Art in New York; the dealer Trotti acting for the collector Wilhelm Hansen of Copenhagen; the Musée du Luxembourg; Paul Leprieur for the Louvre; and Charles Holmes, director of the National Gallery, London.

For Louisine Havemeyer, Durand-Ruel acquired Cassatt's *Girl Arranging Her Hair*, 1886, now in the National Gallery of Art, Washington, D.C. (fig. 3). For the Metropolitan Museum he purchased Ingres's splendid pendant portraits

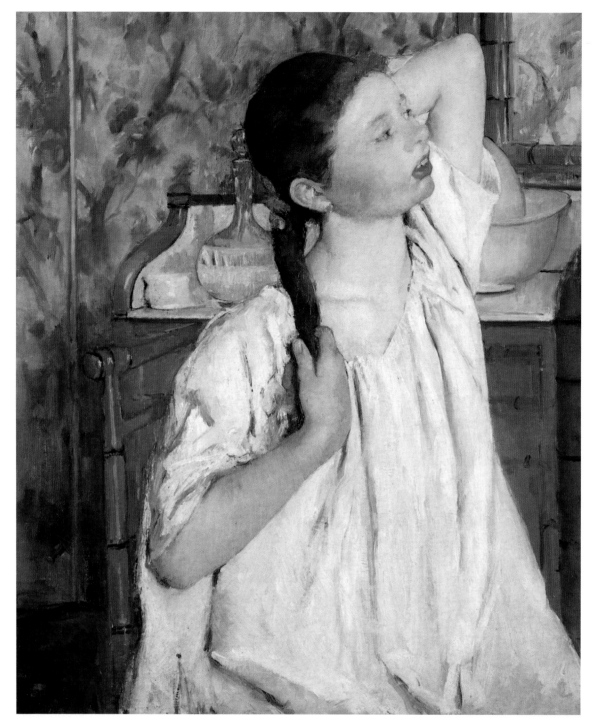

Fig. 3. Mary
Stevenson Cassatt
(1844–1926),
*Girl Arranging Her
Hair,* 1886. Oil on
canvas, 29½ × 24½ in.
(75 × 62.3 cm).
National Gallery of
Art, Washington,
D.C., Chester Dale
Collection
(1963.10.97).
Collection Sale I: 8

Jacques-Louis Leblanc and *Madame Jacques-Louis Leblanc,* both 1823, the two paintings that Degas himself thought of as the high point of his collection (figs. 22, 21).

Financial restrictions at the height of World War I meant that the French museums had only limited funds to spend at the sale. Léonce Bénédite, curator of the Musée du Luxembourg, requested 5,000 francs to buy works by Alphonse Legros: a painting, *Young Women in a Garden,* and three drawings of hands (figs. 409, 40). Although he acquired the drawings,[17] the price of the painting exceeded his budget. However, by a quirk of fate it was bequeathed to the Louvre in 1953 and then deposited with the Musée des Beaux-Arts in Dijon.[18]

The Louvre succeeded in raising 260,000 francs to bid at the sale and purchased Delacroix's *Count de Mornay's Apartment,* 1832–33 (fig. 4) and sixteen of his watercolors and drawings;[19] two painted studies by Ingres, *The Feet of Homer* and *Profile of Raphael and Hands,* and a drawing of *The Odyssey,* all studies of 1826–27 for *The Apotheosis of Homer* (figs. 38, 39, 31); Manet's pastel portrait of his wife, *Madame Manet on a Blue Sofa,* circa 1874 (fig. 242); and a study in black chalk of two nudes by Jean-François Millet (fig. 150).[19]

By far the most substantial group of acquisitions was, however, owing to an unusual set of circumstances, made by the National Gallery, London. The critic Roger Fry,

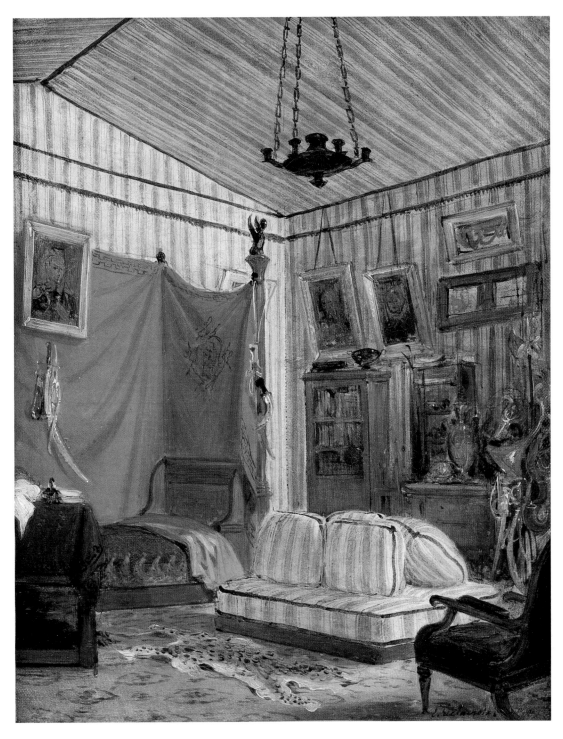

Fig. 4. Ferdinand-Victor-Eugène Delacroix (1798–1863), *Count de Mornay's Apartment*, 1832–33. Oil on canvas, 16⅛ × 12¾ in. (41 × 32.5 cm). Musée du Louvre, Paris (R.F. 2206). Collection Sale I: 31

recognizing that the sale represented an exceptional opportunity for the Gallery to acquire the modern paintings that were conspicuously lacking from its holdings, persuaded his friend John Maynard Keynes, the renowned economist, to exert his influence with the Treasury. Even though the National Gallery's acquisitions budget had been suspended because of the war, Keynes's intervention resulted in the British government awarding the Gallery a special grant of £20,000 with which to bid at the sale.[20]

Charles Holmes left a vivid account in his autobiography of his journey to Paris with Keynes (as part of an international financial mission) under wartime conditions and of the bidding in the salesroom, interrupted by explosions outside:

Matters had droned on thus for a full hour, when, at three o'clock, a dull "Boom" sounded outside, as if a smallish bomb had dropped. "C'est le canon" was heard on all sides, and people began to leave the room. Still the paintings did not appear. At 3:15 a second "Boom" showed that what we afterwards knew as Big Bertha had again got going. There was quite a considerable rush to the door, at least one prominent Paris dealer being among the fugitives.[21]

As a result, the best pictures came up for sale before a much-depleted audience. Holmes secured Ingres's *Monsieur de Norvins* (fig. 186) for about a third of what he had

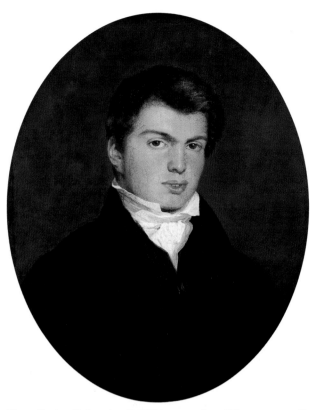

Fig. 5. Eugène Delacroix, *Abel Widmer,* ca. 1824. Oil on canvas, 23½ × 19 in., oval (59.7 × 48.3 cm, oval). By courtesy of the Trustees, the National Gallery, London (NG 3287). Collection Sale I: 33

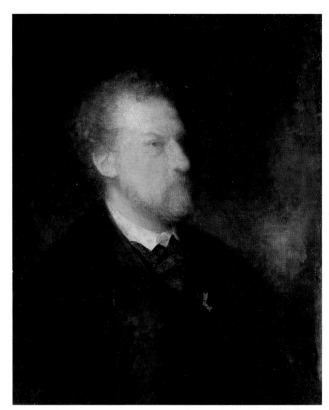

Fig. 6. Gustave Ricard (1823–1873), *Portrait of a Man (Alexandre Bida),* 1866. Oil on canvas, 25⅝ × 21⅝ in. (65 × 55 cm). By courtesy of the Trustees, the National Gallery, London (NG 3297). Collection Sale I: 91

expected, but his bidding for Delacroix's *Louis-Auguste Schwiter* (fig. 44) provoked a frisson of indignation: "That is for the Louvre, Monsieur. You are bidding against the Louvre, Monsieur," he was informed. Unperturbed, Holmes persisted and eventually won the painting but lost another Delacroix, *Count de Mornay's Apartment* (fig. 4), to the Louvre. On the second day Holmes was outbid on everything he tried for: El Greco's *Saint Ildefonso* (fig. 2), Perronneau's *Bust of a Woman (Madame Miron)* (fig. 164), and "the best examples of Gauguin."[22]

Holmes returned home with some considerable prizes— thirteen paintings in all for the National Gallery. In addition to the Ingres and Delacroix paintings, he acquired: Corot, *Ruins in the Roman Campagna, with Claudian Aqueduct* (fig. 153); Delacroix, *Abel Widmer* (fig. 5); Jean-Louis Forain, *The Tribunal,* 1902–3 (fig. 57); Gauguin, *A Vase of Flowers* (fig. 306); Ingres, *Roger Freeing Angelica, Oedipus and the Sphinx, Pindar Offering His Lyre to Homer* (figs. 17, 26, 37); Manet, *The Execution of Maximilian* and *Woman with a Cat (Madame Manet)* (figs. 60, 243); Théodore Rousseau, *The Valley of Saint Vincent* (fig. 56); and Gustave Ricard, *Portrait of a Man* (fig. 6). (The Forain and Manet's *Woman with a Cat* now belong to the Tate Gallery, London, but are on loan to the National Gallery.) Holmes also bought fifteen drawings: ten by Delacroix, one then

attributed to Jacques-Louis David (fig. 393),[23] and four by Ingres, all of which were transferred to the British Museum. Keynes failed to persuade Holmes to purchase Cézanne's *Apples* (fig. 289), so he bought it himself, together with an Ingres drawing and two works by Delacroix.[24]

These acquisitions were transported from Paris to London under conditions that would horrify the modern museum conservator. The Channel crossing, in a convoy that included two camouflaged hospital ships, was enlivened not only by rough weather but also by the threat of German mines. The two very large pictures, Manet's *The Execution of Maximilian* and Delacroix's *Louis-Auguste Schwiter,* were packed together in a crate so large that it would not fit into the train Holmes took from Folkestone and had to follow unattended in a freight train. Arriving at Charing Cross in the dead of night, the crate made the final stage of its precarious journey to Trafalgar Square trundled on a handcart lit by two lanterns.[25]

THE COMPULSIVE COLLECTOR

The most intensive period of Degas's collecting was the decade beginning in 1890, when successful sales of his own work allowed him to indulge his passion to the full. The

widely held idea that after 1890 Degas became a curmudgeonly recluse immured in his studio is, as Richard Kendall has demonstrated, largely a myth.[26] Although in the latter part of his career Degas encouraged an image of himself as an artist who did not exhibit, in fact his work was regularly shown in Paris and abroad.[27] It is true that after his move from the rue Victor Massé in 1912 he was increasingly isolated by poor health and weakened morale, but until that time he continued to participate actively in the social and artistic life of Paris. His life followed patterns that were by then well established: among his many friends were artists, writers, critics, and musicians, and the activities that absorbed his time were his art, the opera, and, increasingly, the unrelenting pursuit of paintings, drawings, and prints for his collection. Often in the company of a friend such as his fellow collector Henri Rouart or the sculptor Albert Bartholomé he would haunt dealers' offices, galleries, and auction rooms, especially those at the Hôtel Drouot, where he frequently bid anonymously.

By 1890 Degas's reputation was well established and his income from his art substantial. In 1899 his friend Bartholomé remarked, "Only Degas continues to sell at ever more formidable prices . . . which he hardly notices. . . . He is dumbfounded by all these stockmarket games, he watches it all with seeming indifference."[28] Degas commented worriedly to Vollard that if the market pushed up the prices of his work, the consequences would be undesirable: "And if my 'articles' start to sell at these prices, what does that mean for Ingres and Delacroix? I'll no longer be able to afford them."[29] Degas lived modestly, even frugally, keeping his housekeeper on a tight budget. The poet Paul Valéry, who knew Degas quite well, complained about the "faultless insipidity" of his dinners, with their "all-too-innocent veal and the macaroni cooked in plain water."[30] Degas spent little on personal comfort, reserving all his money for his collecting. In 1901 he confided to the dealer Hector Brame, "I knew how to amass beautiful paintings, but not money."[31]

Compared to the fortunes of some of the collectors of his work—the banker Isaac de Camondo or the industrialist Auguste Pellerin, for instance—Degas's means were relatively modest. How, then, did he succeed in putting together such a distinguished collection? First, several of his acquisitions were gifts from artist friends or exchanges with other artists for his own work. After the eighth Impressionist exhibition in 1886, Degas gave Mary Cassatt his pastel *Woman Bathing in a Shallow Tub,* 1886 (The Metropolitan Museum of Art, New York), in exchange for her painting *Girl Arranging Her Hair* (fig. 3);[32] both works had been shown in the exhibition. Gauguin gave Degas his

little painting *The Mandolin (On a Chair),* 1880 (fig. 297), to Degas in exchange for a pastel of dancers.[33] Furthermore, the works of some of Degas's contemporaries—especially Gauguin and Cézanne, who had still received little recognition by the 1890s—were available for very low prices. Degas paid 400 francs for Cézanne's *Glass and Apples* and only 150 francs for his *Victor Chocquet,* both bought from Vollard in 1896 (figs. 63, 62);[34] and for one of Gauguin's most important paintings, *Day of the God (Mahana no atua)* (fig. 66), which he bought directly from the artist in 1894, he paid 500 francs.[35] By contrast, Delacroix's *Louis-Auguste Schwiter* (fig. 44) was priced at 12,000 francs in 1895, giving an idea of the price that a major Delacroix commanded at the time (although this was still low compared to, say, the 900,000 francs that Millet's *Angelus,* a small painting, had fetched in 1890) and also of the value of Degas's own work, since he acquired the portrait in exchange for three of his pastels.[36]

In order to facilitate his purchases, Degas came to an arrangement with certain dealers. Durand-Ruel, in particular, more or less acted as Degas's banker, accepting his own works in exchange for those by other artists he wanted. The notes Degas made on his collection show that a great many of his acquisitions were secured in this way. On occasion he would beg Durand-Ruel to release money for a work he desperately wanted to buy: "Do not deprive me of the little copy after Ingres," he wrote in 1898; "do not insult and hurt me like this. I really have need of it."[37]

Precisely when Degas began to collect is not known. Although he acquired most of the works he owned during the 1890s, there is evidence of an earlier collection, but little is known about what it contained. Collecting seems to have run in the Degas family. Degas's father was a collector. His grandfather Hilaire De Gas, who became a successful banker in Naples after arriving there as a refugee from the French Revolution, formed an impressive collection of pictures—we can glimpse the edge of a frame in Degas's portrait of him painted in 1857 (Musée d'Orsay, Paris)—as well as of books, Empire furniture, and gilt silver; but what happened to his collection is not known.[38] According to Lemoisne, Degas began collecting early but by 1875 was forced to sell this first collection to the dealer Brame in order to meet financial obligations: his father's death the previous year had left the family banking business with considerable debts that Degas felt obliged to assume.[39] Lemoisne's claim that Degas owned some pastels by the eighteenth-century master of pastel Maurice-Quentin de La Tour, which he had to sell in 1875, is confirmed by Theodore Reff, who has identified two of the La Tour pastels Degas once owned.[40] Degas had probably

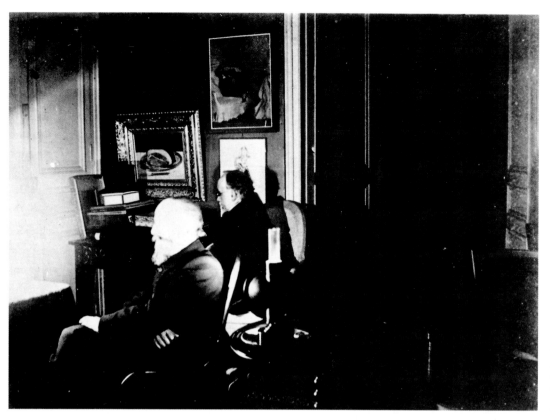

Fig. 7. Edgar Degas (1834–1917), *Degas and Paul-Albert Bartholomé,* photograph, ca. 1895–97. Modern print from a glass negative. Bibliothèque Nationale, Paris. The room is probably in Degas's apartment on the rue Ballu, where he lived from April 1890 to November 1897. On the wall are Manet's *The Ham* (fig. 8), Degas's portrait of Édouard Manet and his wife (fig. 248), and Manet's lithograph *Polichinelle* (fig. 275).

Fig. 8. Édouard Manet (1832–1883), *The Ham,* ca. 1875–78. Oil on canvas, 12¾ × 16⅝ in. (32.4 × 41.2 cm). Glasgow Museums, The Burrell Collection. Collection Sale I: 75

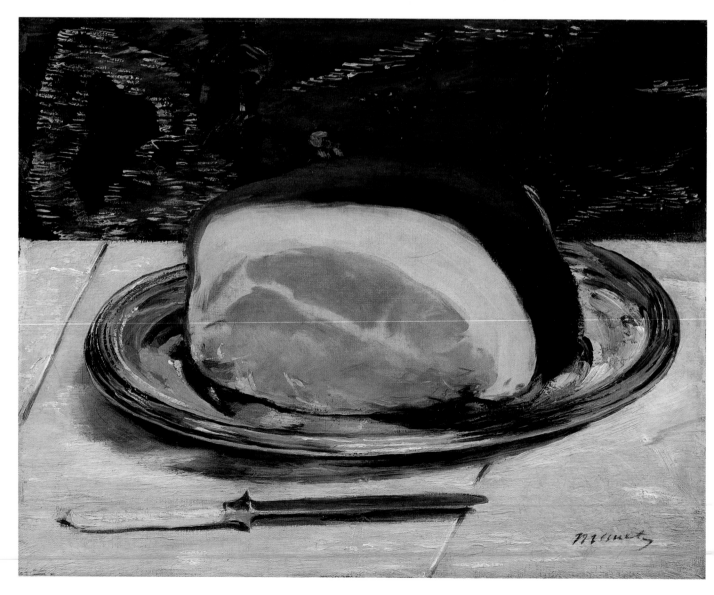

inherited these from his father, along with the group of Tiepolo drawings in his collection. We know for certain that Degas kept at least one work from his father's collection, Perronneau's *Bust of a Woman (Madame Miron)* (fig. 164), since it appears on the wall in Degas's pastel portrait of his sister Thérèse, painted about 1869 in the family apartment at 4, rue de Mondovi, Paris (fig. 124).[41] Although the Perronneau and the La Tour pastels perhaps reflect Degas's father's taste more than his own, Degas nevertheless had a taste for the Rococo, especially in portraiture.[42] In his youth he had painted an excellent copy of La Tour's *Portrait of a Man* (fig. 162), and later he often visited the museum in Saint-Quentin to see the fine collection of portraits by that artist.[43]

The financial disaster that engulfed the family business in the 1870s severely reduced Degas's income. Yet despite limited resources he managed to buy a few paintings during the period, mostly from his even poorer Impressionist friends. It was at that time, of course, that he was actively engaged in organizing and showing in the Impressionists' group exhibitions. Pissarro was delighted when Degas bought his *Ploughed Fields near Osny,* 1873 (fig. 388), from Durand-Ruel on December 16, 1873, for 400 francs,[44] enthusing in a letter to Théodore Duret, "I couldn't be more flattered that Degas likes this painting."[45] Around this time Degas also acquired two other landscapes by Pissarro, *Riverbanks,* 1871 (private collection)[46] and *Landscape at Pontoise* (fig. 384),[47] as well as, probably, Alfred Sisley's *The Factory during the Flood,* 1873 (fig. 160), and Auguste Renoir's *Mademoiselle Henriette Henriot,* 1874 (fig. 159).[48] Another Renoir, described by Degas as a "Painted study. Woman seated, in a chemise with blue and black striped stockings, putting on a boot," is not listed in the sale catalogue but is recorded as a gift from Renoir in 1874.[49] Lemoisne recounts that Degas and Renoir frequently quarreled and that Degas, who was particularly furious when Renoir sold a pastel of his acquired from the sale of the Gustave Caillebotte collection in 1894, returned to Renoir paintings and drawings he had previously received from him.[50] Conceivably this study was among those works, which would explain its absence from the sale catalogue.

Other purchases made during the 1870s and early 1880s include prints and drawings, which were generally more affordable than paintings, such as the sixty-two drawings by Delacroix's cousin Léon Riesener.[51] It was probably in the 1870s that Degas began collecting what became enormous holdings of Daumier lithographs; at that time he was closely associated with the Naturalist writer Edmond Duranty, who shared his enthusiasm for Daumier.[52] An entry in one of Degas's notebooks for 1881 reveals a sub-

stantial gift from his friend Alexis Rouart of ninety-three superb lithographs by Gavarni.[53] At least some of the Japanese prints in the collection were acquired in the 1870s. Degas belonged to the circle of Japanophiles that included James Tissot, Whistler, Philippe Burty, Félix Bracquemond, and the Goncourt brothers, who began collecting Japanese prints at such shops as La Porte Chinoise in the 1860s,[54] and he was listed as one of the lenders of Japanese prints in a review of the Paris World's Fair of 1878.[55]

About this time Degas also began to acquire the work of his great contemporary Manet. In January 1881 he bought an impression of Manet's only color lithograph, *Polichinelle,* 1874, in addition to Adolph von Menzel's vigorous drawing of a workman (fig. 9), from the sale of Duranty's collection.[56] At the sale of Manet's studio contents following his death in 1883, Degas bought two drawings, *Leaving the Bath,* 1860–61, and *Henri Vigneau,* circa 1874 (figs. 61, 58), and a lithograph, *The Barricade*—modest purchases in comparison to the celebrated paintings on offer, which included *Olympia,* 1863, and *Bar at the Folies-Bergère,* 1881–82.[57] However, soon afterward Manet's brother Eugène made Degas

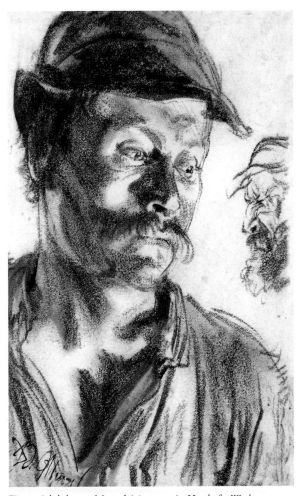

Fig. 9. Adolph von Menzel (1815–1905), *Head of a Workman, Lit from Below,* ca. 1870–75. Graphite and ink, 8 × 5 in. (20.2 × 12.7 cm). Private collection. Collection Sale I: 230

a gift of *Departure of the Folkestone Boat*, 1869 (fig. 262), and this became the first of several major paintings by Manet to enter his collection.[58]

From his quip in a letter to Bartholomé in April 1890—"The Hôtel Ingres is moving and will be transferred to 23, rue Ballu"—it is clear that Degas already possessed a substantial group of Ingres works by that date.[59] During the following decade he was to direct most of his resources to collecting art by Ingres and Delacroix. At the sale of Millet's collection in April 1894, Degas bought a number of drawings by Delacroix as well as El Greco's *Saint Ildefonso* (fig. 2).[60] The major purchase of 1895 was Delacroix's *Louis-Auguste Schwiter* (fig. 44). Toward the end of the following year, Degas's friends were becoming alarmed at the pace of his collecting. Bartholomé wrote to Lafond, "Degas keeps it up, buying, buying. In the evening he asks himself how he will pay for what he bought that day, and the next morning he starts in again: more Ingres, some Delacroix, an El Greco this week. And then he takes a certain pride in announcing that he can no longer afford to clothe himself."[61]

In 1896, in addition to a number of works by Delacroix, notably his copy of Rubens's *Henri IV Entrusts the Regency to Marie de Médicis* (fig. 211)[62] and El Greco's *Saint Domi-*

nic (fig. 383),[63] Degas purchased Ingres's magnificent paired portraits of M. and Mme Leblanc (figs. 22, 21). In 1897 he bought Ingres's fine portrait *Marquis de Pastoret* (fig. 20),[64] and the following year his *Monsieur de Norvins* (fig. 186)[65] and Pierre Andrieu's *Still Life with Fruit and Flowers* (fig. 10). Degas bought the Andrieu as a Delacroix, noting that despite his initial doubts about it he was pleased that he had allowed Rouart to persuade him to buy it because it was an admirable work and a good bargain at 1,600 francs.[66] The painting was later acquired by Renoir.

Alongside these acquisitions, Degas was intensively collecting works by his contemporaries: two still lifes by Van Gogh acquired from Vollard, *Two Sunflowers*, in exchange for two little sketches of dancers, and *Still Life with Fruit* (figs. 11, 12);[67] a group of works by Cézanne, nearly all bought from Vollard between November 1895 and June 1897;[68] and a number of works by Gauguin, some acquired from the sales of his work that Gauguin organized. Several friends, including Daniel Halévy, recorded the almost frenzied compulsiveness with which Degas continued to buy:

Here is my new Van Gogh, and my Cézanne; I buy! I buy! I can't stop myself. The trouble is that people are beginning to know about it and are bidding

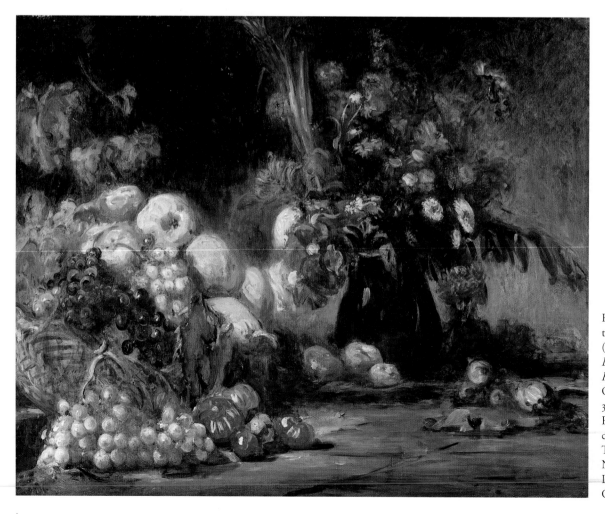

Fig. 10. Attributed to Pierre Andrieu (1821–1892), *Still Life with Fruit and Flowers*, ca. 1850–64. Oil on canvas, 25⅞ × 31⅞ in. (65.8 × 81 cm). Reproduced by courtesy of the Trustees, the National Gallery, London (NG 6349). Collection Sale II: 55

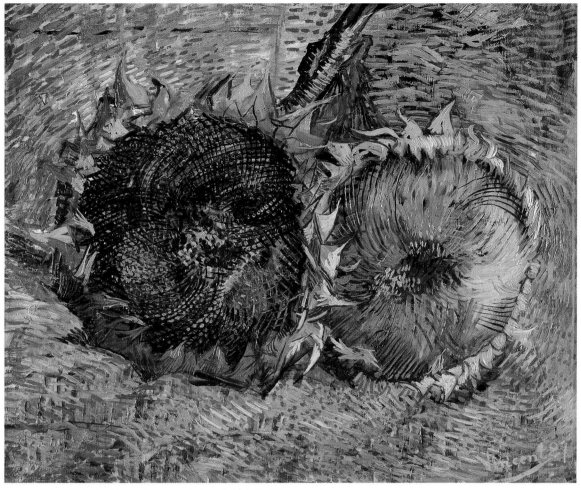

Fig. 11. Vincent van Gogh (1853–1890), *Two Sunflowers,* 1887. Oil on canvas, 19¾ × 23⅝ in. (50 × 60 cm). Kunstmuseum Bern, Gift of Professor Dr. Hans R. Hahnloser, Bern. Collection Sale I: 93

Fig. 12. Vincent van Gogh, *Still Life with Fruit,* 1887. Oil on canvas, 18¼ × 21¾ in. (46.5 × 55.2 cm). The Art Institute of Chicago, Gift of Kate L. Brewster (1949.215). Collection Sale I: 92

against me: they know that when I want something, I absolutely must have it.[69]

To his holdings of works by Manet he added *Woman with a Cat* (fig. 243),[70] acquired from Vollard in 1895 in exchange for a pastel of his own worth 500 francs; *Monsieur Armand Brun* (fig. 382);[71] the pastel of *Madame Manet on a Blue Sofa* (fig. 242);[72] fragments of the monumental *Execution of Maximilian* (fig. 60);[73] and *Berthe Morisot* (fig. 253).[74] By 1900, however, the pace of Degas's collecting was beginning to slow. His last recorded purchase appears to have been Ingres's *The Duke of Alba at Saint-Gudule's in Brussels, 1815–19* (fig. 188), which he bought in December 1904.[75]

ARRANGEMENT OF THE COLLECTION

For Degas, works of art could carry an emotional significance almost like that of living beings, as the painter Jacques-Émile Blanche movingly conveyed. He described Degas, who was by then almost blind, at the sale of his friend Henri Rouart's collection in 1912, taking his leave of the works he had known for so long:

> Degas bent over the much-loved paintings, the companions of his life, the Daumiers, the Prud'hons, the Delacroix, and the Corots; he touched them as if to recognize them, as if to seize with his hands those colors, those lines, that pictorial beauty he craved; he came back every day; a group of collectors, friends, young people, came with him, gathering around him so as not to leave him alone with his grief.[76]

The way Degas's collection was installed in his home makes it clear that the works formed part of the fabric of his daily life. In November 1897 he moved into an enormous apartment—big enough to accommodate his rapidly expanding collection—in the building at 37, rue Victor Massé, where he had had his studio for the last seven years (see fig. 13). Spread over three floors, the apartment was in an old provincial-style house overlooking a secluded garden in the ninth arrondissement, the quarter on the edge of Montmartre, filled with artists' studios and cafés, that Degas had always inhabited.

From contemporary accounts by friends who visited Degas during these years it is possible to form a fairly complete picture of how he displayed his collection. The most comprehensive description is a firsthand personal record made by Degas's friend Paul Lafond and published in 1918, only a year after the artist's death.[77] Most of the informa-

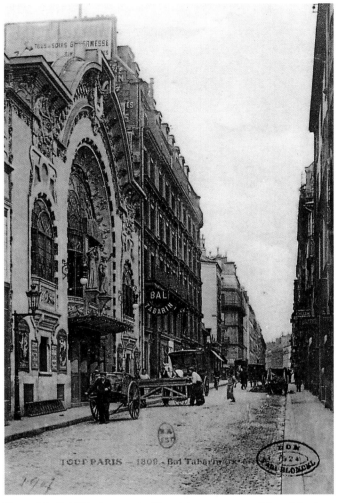

Fig. 13. The Bal Tabarin opposite Degas's house at 37, rue Victor Massé, ca. 1907. Modern print from a glass negative. Bibliothèque Nationale, Paris

tion in this account was repeated, with some additions, by Paul-André Lemoisne, the author of the catalogue raisonné of Degas's work that appeared between 1946 and 1949.[78] Several other reminiscences provide extra details.[79] Differences among these descriptions can surely be explained by the fact that during the fifteen years Degas lived on the rue Victor Massé, he naturally moved things around as the collection grew. A few photographs that Degas took of his apartment provide tantalizing glimpses of some of the works (figs. 14, 15).

Several visitors remarked on the contrast between the chaotic muddle in the studio on the top floor—easels piled with paintings and drawings in progress, other pictures stacked against the walls, and tables covered with the clutter of an artist's paraphernalia—and the orderly arrangement of the living quarters on the floors below. Degas's apartment exuded an air of bourgeois respectability that reminded Lafond of the home of a retired magistrate. Unlike the opulent interiors occupied by many contemporary wealthy Salon painters of the fin de siècle, Degas's

home was comfortable but modest. Furnished with faded Louis-Philippe furniture inherited from his parents and with the oriental rugs he liked to buy, these discreetly appointed rooms served as a background to the extraordinarily rich and varied array of works installed in them.

That Degas should have thought carefully about the arrangement of his collection is not surprising, since on more than one occasion he had demonstrated a deep concern for the effective display of art. As early as 1870 he had addressed a letter to the Salon jury, published in the newspaper *Paris-Journal,* outlining radical proposals to eliminate the crowded hanging of pictures floor to ceiling at the Salon. Paintings should be hung in two rows only, he proposed, and drawings and paintings should be displayed together on screens.[80] These suggestions were pursued later at the exhibitions of the Impressionist group, in which Degas played an active organizational role. His interest in how works were presented at these exhibitions is evident from plans in his notebooks showing lights or windows and partition screens.[81] Degas is known to have paid attention to the mats and frames for works he sold, and sketches in the notebooks show him working out ideas for frame moldings.[82]

The most striking feature to emerge from contemporary accounts of the arrangement of his collection is the distinction Degas made between major, large-scale paintings and smaller, more intimate works. In a huge bare room on the first floor that was always kept locked he established a

sort of grand gallery that he referred to as his museum. Here, as Lafond described it, the masterpieces of the collection—the two El Grecos, the Ingres portraits and his *Roger Freeing Angelica,* Delacroix's *Entombment, Count de Mornay's Apartment,* and *Louis-Auguste Schwiter*—were displayed on easels placed in a semicircle. However, Walter Sickert recalled a less orderly arrangement, "a forest of easels standing so close to each other that we could hardly pass between them, each one groaning under a life-sized portrait by Ingres, or holding early Corots and other things I cannot remember."[83] On the walls could be seen the portraits by Courbet and Couture, the fragments of Manet's *Execution of Maximilian,* Renoir's *Mademoiselle Henriette Henriot,* and Daumier's *Don Quixote Reading* (fig. 154), together with other works by Manet, Cézanne, Gauguin, and Van Gogh.

In contrast to the "museum," with its spare grandeur, the more intimate rooms of the apartment contained smaller works—paintings, drawings, and prints—hung together, sometimes interspersed with works by Degas himself. Lafond's detailed tour from room to room relates that on first entering the apartment through an anteroom one would encounter Gauguin's *Copy after Manet's "Olympia"* (fig. 67). Passing from there to the dining room one could admire drawings and sketches by Ingres; drawings, pastels, and watercolors by Degas's friends Bartholomé, Forain, Pierre-Georges Jeanniot, Ludovic-Napoléon Lepic, and Henri Rouart; lithographs by Daumier and Gavarni; and

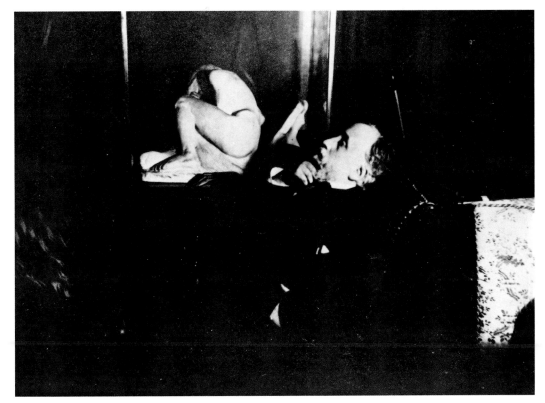

Fig. 14. Edgar Degas or Albert Bartholomé (1848–1928), *Degas Looking at the Statue "Crouching Girl" by Albert Bartholomé,* photograph, ca. 1895–1900. Modern print from a glass negative. Bibliothèque Nationale, Paris

engravings by Jeanniot. A glass case contained a bizarre miscellany of objects—albums of prints by Utamaro and other Japanese artists displayed with casts of the hands of Javanese women, a plaster cast of Ingres's hand holding a pencil, and some Neapolitan dolls. Although no sculpture was listed in the sales catalogues, Lafond mentions that Degas owned bronzes by Bartholomé and Antoine-Louis Barye as well as a bust of himself by the amateur sculptor Paul Paulin.[84] A photograph of Degas in his apartment shows him contemplating Bartholomé's plaster cast of *Crouching Girl, Study for the "Monument to the Dead,"* which was displayed in a vitrine (fig. 14).[85] At one time, it seems, plaster and wax statuettes that Degas had modeled himself and the fragments of his famous wax sculpture *The Little Fourteen-Year-Old Dancer,* of about 1880 (fig. 84) could also be seen in his apartment.[86] On top of a bookcase were boxes containing most of Manet's graphic work and lithographs by Daumier and Gavarni. Other boxes were filled with drawings by Ingres and Delacroix. In a small service room off the dining room was a fine drawing by Ingres of a woman in a turban, no doubt the *Head of a Young Woman* (fig. 390).

In the salon were drawings and small paintings by Ingres including two heads of Jupiter, Corot's *Mountains in the Auvergne,* and Manet's *Madame Manet on a Blue Sofa.* As we can see from a photograph taken by Degas (fig. 15), Cassatt's *Girl Arranging Her Hair* also hung in this room. A table in the center of the room was piled with copies of *Le Figaro* containing drawings by Forain, whose acerbic caricatures Degas admired.

From his bed Degas could contemplate Delacroix's sketch for *The Battle of Nancy,* 1828–29 (fig. 210), and his own *Lorenzo Pagans and Auguste De Gas* (fig. 92), a work to which he had a particular attachment, keeping it with him all his life.[87] Also in his bedroom were Ingres's preparatory drawing of the figure of the Odyssey for *The Apotheosis of Homer* (fig. 31), watercolors by Delacroix, a drawing of a nude by Pierre Puvis de Chavannes, Manet's *The Ham* (fig. 8), two small Italian scenes by Corot, one of which was probably *Ruins in the Roman Campagna, with Claudian Aqueduct* (fig. 153), and two early portraits by Degas, of his brother Achille and of his sister Thérèse (figs 83, 124).[88] Degas seems to have positioned certain works with their visual relationships in mind: Manet's little still life *Pear* of circa 1880 (fig. 245) was hung next to an Ingres drawing, perhaps to juxtapose their painterly and linear qualities;[89] a Legros drawing of hands was placed between two Ingres drawings, possibly to emphasize their similarities.[90] Over the bed hung Torii Kiyonaga's diptych print *The Bath House* (fig. 331) next to some equally linear interpretations of the female nude, Ingres's drawings for *The Golden Age.*[91]

THE "MUSÉE DEGAS"

Degas's own sense of the high quality of his collection and of its importance as a coherent whole is confirmed by the fact that from about 1895 to 1900 he was preoccupied with a scheme to preserve it intact as a museum.[92] This scheme may also have directed the patterns of his collecting,

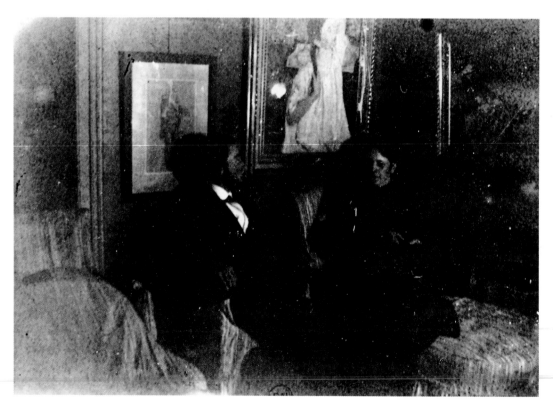

Fig. 15. Edgar Degas, *Élie Halévy and Madame Ludovic Halévy in Degas's Apartment,* photograph, ca. 1895–97. Modern print from a glass negative. Bibliothèque Nationale, Paris. On the wall behind Mme Halévy is Mary Cassatt's *Girl Arranging Her Hair* (fig. 3), and to the right is Édouard Manet's *Madame Manet on a Blue Sofa* (fig. 242)

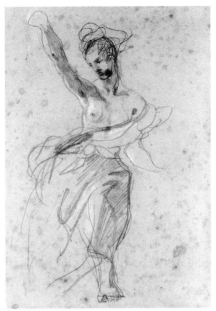

Fig. 16. Eugène Delacroix, *Three Studies for "Liberty, July 28, 1830."* Musée du Louvre, Paris, Département des Arts Graphiques. *a:* Graphite heightened with white, 12¾ × 9 in. (32.4 × 22.8 cm); R.F. 4522. *b:* Graphite heightened with white, 11¾ × 8⅛ in. (29.9 × 20.5 cm); R.F. 4523. *c:* Graphite and black chalk, 11½ × 7⅞ in. (29 × 20 cm); R.F. 4524. Collection Sale II: 106. 1,2,3

encouraging him, at least with the artists he admired most, to make his collection as comprehensive as possible. Of course, as is clear from contemporary accounts of Degas's activity in the salesrooms, many of his acquisitions were made on the spur of the moment when he was inspired by what he saw; but he also would search many years for a particular work. Vollard related that when the print expert Loys Delteil asked if he could photograph a Delacroix lithograph in the collection, Degas retorted, "I've waited twenty years for that Delacroix. Let others do the same."[93]

The question of whether Degas collected in a systematic way is worth considering. Did he acquire representative groups of certain artists' work for his own satisfaction as a collector or, possibly, because he hoped to give coherence and value to a permanent collection? Manet, for example, is represented by a group of paintings that include every genre he worked in—there are portraits, still lifes, and his modern history painting *The Execution of Maximilian*—as well as by drawings in a variety of styles and almost all the prints. When Degas bought a substantial group of Manet's prints from the Burty sale in 1891, he made a note to himself: "Try to complete."[94] He once asked Alexis Rouart for his opinion of a group of Gavarni prints that he thought would make a significant addition to his collection. On another occasion he turned down a gift of Gavarni prints that he thought would add nothing.[95] In the case of Delacroix, Degas acquired not only a remarkable group of paintings that present Delacroix the portraitist as well as the history painter but also a comprehensive selection of the graphic work, including detailed studies of armor (figs.

45–48), more expressive drawings rendered in the artist's typical energetic line such as the studies for *Liberty, July 28, 1830* (fig. 16), and watercolors and pastels that display his skill as a colorist. Similarly, Ingres is represented by all aspects of his work. In addition to the portraits and paintings of historical and mythological subjects, Degas amassed a remarkably diverse collection of drawings ranging from such precisely drawn, complete compositional studies as *Roger Freeing Angelica* (fig. 192) to more rudimentary sketches of details. For *The Apotheosis of Homer,* clearly a work that held a particular fascination for him, Degas put together an encyclopedic body of preparatory studies, both painted and drawn (figs. 31–39).

In the late 1890s Degas embarked on a busy campaign of recording and documenting his collection, acting almost as a museum curator. In a letter of 1896 to the restorer Henri Haro, Degas asked him to wait until he could photograph a small Ingres before Haro began work on it.[96] Where Degas lacked certain drawings that related to Ingres paintings that he owned, he made up the deficit with photographs. In the summer of 1897 he visited the Musée Ingres at Montauban in order to examine the large collection of Ingres's drawings there. "The museum owns drawings that relate to paintings by Ingres that I am fortunate enough to possess," he informed the mayor of Montauban. "I will have photographs made in Paris of what I have, and the museum will let me photograph what is relevant. I would add that the reproductions I am offering have not been published."[97] Shortly afterward he applied to the

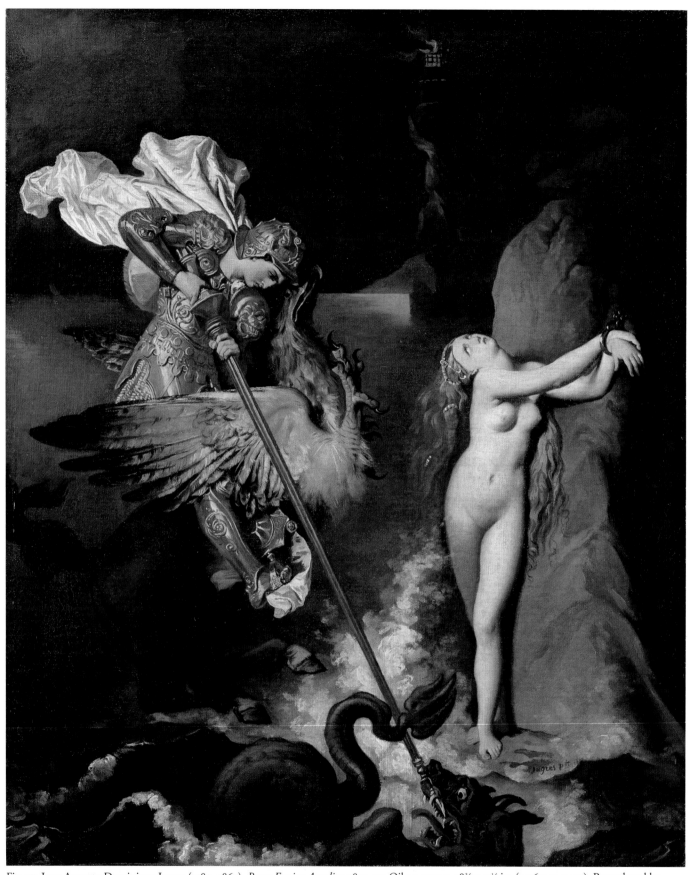

Fig. 17. Jean-Auguste-Dominique Ingres (1780–1867), *Roger Freeing Angelica,* 1819–39. Oil on canvas, 18¾ × 15½ in. (47.6 × 39.4 cm). Reproduced by courtesy of the Trustees, the National Gallery, London (NG 3292). Collection Sale I: 56

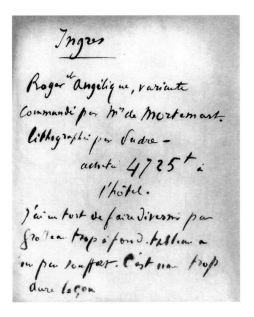

Fig. 18. Page from Degas's inventory on Ingres's *Roger Freeing Angelica* (fig. 17); see note 109. Private Collection

Musée Fabre at Montpellier, asking for "permission to photograph certain paintings in the museum and especially Ingres's *Stratonice,* for which I have expressly made this journey to Montpellier."[98] Degas also owned an album of photographs of works by Ingres that were bought at the sale of his collection by the artist Paul Helleu.[99] It is known that Degas assembled a collection of sales catalogues and other documentary material relating to works he owned.[100]

The inventory notes that Degas made on part of the collection may have been compiled with a catalogue in mind. The consistency of the information recorded (dimensions, medium, price, provenance, sometimes condition or related works) and the uniform way it is presented suggest that this was something more than a private memoir. Degas's vagueness about some of the facts, his frequent use of "I remember" ("Je me souviens"), the fact that the paper used, a separate sheet for each work, was more or less uniform throughout—together these indicate that the notes were compiled retrospectively, in a concentrated effort, either from memory or from jottings made when the works were acquired.

The previous histories of works of art in his collection intrigued Degas. He was especially pleased to acquire works that had belonged to other artists. On buying El Greco's *Saint Ildefonso* (fig. 2), he noted, "This picture hung for a long time over Millet's bed."[101] On another occasion he recorded that a drawing by Ingres of Mlle Leblanc (the daughter of M. and Mme Leblanc, whose portraits by Ingres Degas owned) bore a stamp of the collection of the artist Léon Bonnat.[102] It is amusing to note how often Degas was sidetracked from recording routine facts about a work into personal, anecdotal digressions concerning the previous owners of his pictures. In his notes on a Delacroix

sketch, he recalled: "Came from Jenny Le Guillou, died in Franche Comté, through the nephew employed on the railway."[103] And of an Ingres drawing, a study for *The Apotheosis of Homer,* he observed: "This drawing of a nude of the Iliad was done from a model called Josephine the German, whom I saw as an old woman when I was young, and who was selling paintbrushes in the studio. You can even recognize her in the painting."[104] Degas's notes show his interest in the identities of the sitters and the histories of the paintings he collected, mixed with personal reminiscences, as well as attention to related drawings and to the works' physical condition. His most detailed notes pertained to his most treasured possessions, the Ingres portraits of M. and Mme Leblanc (fig. 22, 21), and here it is worth quoting Degas at length:

Ingres. Portraits of M. and Mme Leblanc, painted in Florence in 1823, bought at the Hôtel [Drouot, Paris], the man for 3,500 [francs], the woman for 7,500 [total], with the charges 11,550, January 23, 1896, in a sale after the death of Mme Place, their daughter.

I remember having seen these portraits in 1854 in the home of M. Leblanc, their son, in the rue de la Vieille Estrapade, a house with an iron fence that still exists, on the ground floor. M. Poisson-Séguin, a lawyer and friend of Father's, took us there with his wife. The younger M. Leblanc was an assistant teacher at the École Polytechnique. I saw these portraits again in 1855, at the World's Fair, on the avenue Montaigne. Mme Place obtained these portraits from her brother, a bachelor, who came to live with her after the death of her husband and who died before her.

There were [also] portraits in pencil: Mme and M. Leblanc standing, which entered Bonnat's collection; the young Leblanc, which was once owned by Albert Goupil and which Gérôme, his heir, sold to Mme de Scey-Montbeliard; two others, a man and a young woman with headbands [and] leg-of-mutton sleeves who could well have been the young Mme Place. These two drawings were sold together at the same sale to Morgand, of the passage des Panoramas, and sold by him to Bonnat (at the sale, sold for 2,160 francs). I also have the two photographic reproductions of the two full-length portraits in pencil that Bonnat gave to the family.

The family, whence the two large portraits had never emerged, had had the background of the man repainted, in order to make it identical to that of the woman. I was able to have it removed in my presence, easily enough to prove that this revision could not

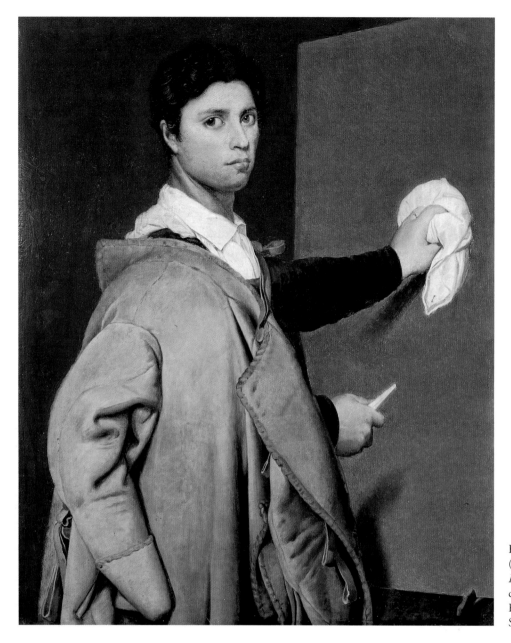

Fig. 19. Marie-Anne-Julie Forestier (b. 1789), *Copy after a Self-Portrait by Ingres,* 1804 [compare fig. 172]. Oil on canvas, 25⅝ × 20⅞ in. (65 × 53 cm). European private collection. Collection Sale I: 39

have been more than ten years old. The [original] red background was found intact. There are fools among the aristocrats as well as elsewhere.[105]

Degas cared passionately about the conservation of works of art. Vollard recalled how he often came across Degas with his latest acquisition at the studio of the picture liner Chapuis, the only "picture doctor" Degas trusted.[106] He was outraged by what he considered the insensitive and excessive restorations of paintings in the Louvre, notably of Rembrandt's *Pilgrims at Emmaus.*[107] And it was at Degas's instigation that Arsène Alexandre wrote to *Le Figaro* objecting to the crude retouching in Delacroix's *Women of Algiers* and the abrasive cleaning of Rubens's *Henriette of France.*[108] Yet this concern did not always prevent Degas from making mistakes with pictures in his own collection; in his inventory he bitterly regretted "the too-hard lesson"

("trop dure leçon") of having too much varnish removed from one of his favorite Ingres paintings, *Roger Freeing Angelica* (fig. 17).[109]

Degas's concern for the physical integrity of paintings is evident from the trouble he took to reassemble the fragments of Manet's *Execution of Maximilian* (fig. 60), which had been cut up, probably by Léon Leenhoff, Mme Manet's "brother,"[110] in the hope of selling the separate pieces. An entry in the diary of Julie Manet, the painter's niece, indicates that Degas had acquired two sections of the picture by November 1894 and mentions his intention "to try to put the painting back as it was."[111] Degas first acquired the detail of the sergeant loading his rifle, from the dealer Alphonse Portier. He subsequently obtained the central section with the firing squad from Vollard, who had obtained it from Leenhoff. Vollard's account of the transaction conveys Degas's sense of urgency about reassembling

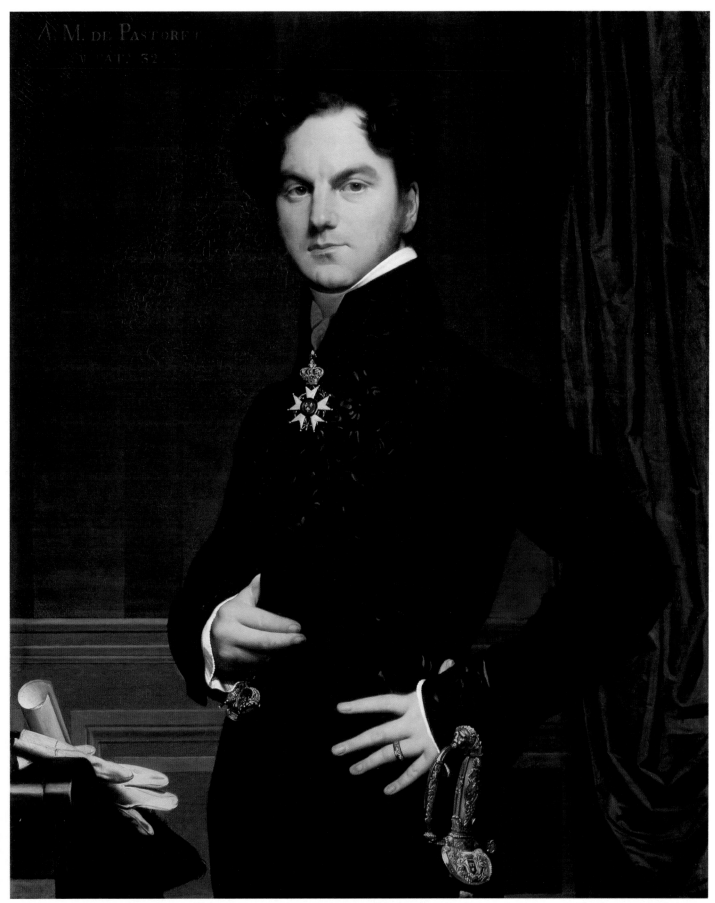

Fig. 20. J.-A.-D. Ingres, *Amédéé-David, the Marquis de Pastoret (1791–1857)*, 1826. Oil on canvas, 40⅝ × 32⅞ in. (103 × 83.5 cm). The Art Institute of Chicago, Bequest of Dorothy Eckhart Williams; Robert Allerton Purchase, Bertha E. Brown, and Major Aquisitions Funds (1971.452). Collection Sale I: 52

Fig. 21. J.-A.-D. Ingres, *Madame Jacques-Louis Leblanc, née Françoise Poncelle (1788–1839)*, 1823. Oil on canvas, 47 × 36½ in. (119.4 × 92.7 cm). The Metropolitan Museum of Art, New York, Catharine Lorillard Wolfe Collection, Wolfe Fund, 1918 (19.77.2). Collection Sale I: 55

Fig. 22. J.-A.-D. Ingres, *Jacques-Louis Leblanc (1774–1846)*, 1823. Oil on canvas, 47⅝ × 37⅝ in. (121 × 95.6 cm). The Metropolitan Museum of Art, New York, Catharine Lorillard Wolfe Collection, Wolfe Fund, 1918 (19.77.1). Collection Sale I: 54

the composition: "He put his hand on the Maximilian as if he owned it. You're going to sell me this, Vollard. And you will tell Mme Manet that I want the sergeant's legs and the emperor's head that are missing from your piece."[112] A photograph of the painting as assembled by Degas, though in quite a damaged state, was published in the sale catalogue of the collection.

Clearly, his idea of founding a museum was talked about in Degas's circles around 1895, for in the brief, touching letter that Berthe Morisot wrote the day before she died, she urged her daughter Julie, "Tell Monsieur Degas that if he founds a museum, he must choose a Manet."[113] There are other indications, too, that Degas thought of leaving his collection to posterity. When he acquired Ingres's portraits of M. and Mme Leblanc in 1896, he assured Daniel Halévy, not without a hint of irony, "Yes, I want to give them to my country: and then I'll go and sit down in front of them and look at them, thinking about the noble act I have just committed."[114]

Exactly what Degas had in mind for the museum is not clear. A man who loathed the state and officialdom in general, he wanted the museum, not surprisingly, to be privately run. When in 1906 Degas's friend Étienne Moreau-Nélaton left his collection to the state, he provoked a severe reprimand from Degas: "One doesn't involve the state in an affair like that. Once we had found the location we could have formed a private company; we would have nominated our own director, who would have chosen his successor."[115] And since he believed that great art should not be too accessible, he wanted the museum to be located outside Paris in a suburban area, something like the location near London of the Dulwich Picture Gallery.[116]

Degas is known to have remarked that he hoped other collectors would follow his example, but whether he meant that other collectors should also form public collections or that other collections should be contributed to his museum is not clear.[117] A more intriguing question that remains unanswered is whether Degas intended to have his museum include his own work as well as his collection.[118] His notorious reluctance to part with his creations meant that by the 1890s Degas's studio was filled with paintings, pastels, and drawings from all periods of his career, and there is evidence to suggest that he was preparing his own work for eventual display in a museum. For instance, at about that time he restored some of the major works of his early years that were still in his possession—*Family Portrait*, 1858–67 (fig. 90), and *Interior*, circa 1868–69 (fig. 94), for example—possibly with public display in mind.[119] He began to sort and order his drawings, perhaps for his

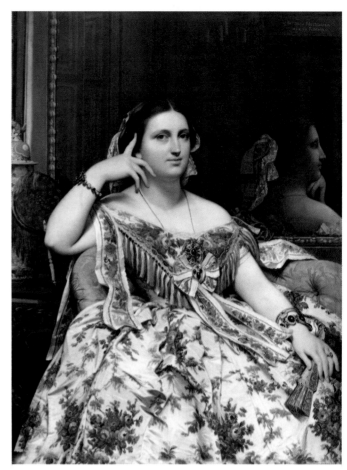

Fig. 23. J.-A.-D. Ingres, *Madame Moitessier*, 1856. Oil on canvas, 47¼ × 36¼ in. (120 × 92.1 cm). Reproduced by courtesy of the Trustees, the National Gallery, London (NG 4821)

personal satisfaction but possibly also with the intention of presenting them more publicly. One visitor to his studio noted, "The disorder that reigned in the studio was only an illusion. The dusty boxes contained series of studies and drawings that formed a homogeneous and harmonious ensemble. He liked to put his early drawings with those he had done much later, and he would complete the series with the one he considered the definitive expression of one of these visions."[120]

The "Musée Degas" would have been a remarkable place; but, sadly, the scheme was never realized. According to Lafond, Degas was put off by the burdensome administrative activities involved in setting up a museum. Those fears were no doubt confirmed by the bureaucratic inefficiency that surrounded the bequest of Gustave Caillebotte's collection to the Musée du Luxembourg in 1897. Furthermore, Degas was furious because seven of his works that had belonged to Caillebotte were, probably without his own consent, to be housed in the Luxembourg, an establishment he despised as a vehicle of the state.[121] Degas rejected Moreau-Nélaton's suggestion that he leave his col-

lection to the Musée des Arts Décoratifs, an institution not under state control, because he found that Moreau-Nélaton's paintings, on exhibition there, had been poorly hung where they reflected the light.[122] But what seems finally to have killed Degas's interest in forming a museum was a visit in 1903 to the newly opened Gustave Moreau museum. "'How truly sinister,' he remarked on leaving. 'You would think you were in a mausoleum. . . . All those paintings jammed together made me think of a thesaurus, a *Gradus ad Parnassum* [textbook of classical prosody].' "[123]

Although these factors contributed to Degas's loss of interest in founding a museum, they do not tell the whole story. For example, he could have found a more positive model in the museum successfully set up by Léon Bonnat in his native Bayonne in southwest France. The real reasons surely lie deeper within Degas's character. Probably, as Henri Loyrette suggests, at some level the museum idea was never more than a fantasy, like other desires stated but unfulfilled: to enter a monastery, for example, or to marry and have children.[124] There was a contrariness in Degas's character that led him to contemplate leaving his collection to the nation but at the same time to pull back from making the idea a reality. For Degas, the overriding inter-est lay in extending the collection rather than in planning a permanent home for it, a situation analogous to his well-known difficulty in ever reaching the point of considering a work finished. What excited Degas was the thrill of the search and the beauty of the objects he found.

DEGAS AND TRADITION

Degas's feeling for modern life was rooted in a strong sense of artistic tradition. An earlier era's oversimplified view of Degas as an Impressionist underestimated his continued reliance on the academic methods learned in his youth; in the last two decades, studies have made clear the extent to which preparation, documentation, and a knowledge of the art of the past underlie all of his work.[125] Degas expressed this in his often-quoted remark to the Irish writer George Moore: "I assure you that no art was ever less spontaneous than mine. What I do is the result of reflection and the study of the Great Masters."[126] From Ingres and Delacroix, his two great mentors, Degas derived not only continuing inspiration for his art but also a confirmation of his experience of the old masters that he had studied in his youth.

Fig. 24. J.-A.-D. Ingres, *Study for "Madame Moitessier,"* 1847. Black chalk over graphite, squared in graphite (recto), 7⅜ × 7⅞ in. (18.7 × 20 cm). Courtesy of the Fogg Art Museum, Harvard University Art Museums, Cambridge, Bequest of Charles A. Loeser (1932.178). Collection Sale I: 183

Fig. 25. J.-A.-D. Ingres, *Head of a Woman, Study of Madame Moitessier,* ca. 1851. Graphite and white chalk, 18 × 13¼ in. (45.8 × 33.6 cm). The J. Paul Getty Museum, Los Angeles (89.GD.50). Collection Sale I: 210

Ingres: Drawing and Design

To Degas, Jean-Auguste-Dominique Ingres (1780–1867) represented an ideal of draftsmanship and classical design, principles that were fundamental to his own art throughout his career. Degas's admiration for every aspect of Ingres's achievement is reflected in the works he acquired. In addition to the magnificent group of twenty paintings, including portraits and historical subjects, he amassed a remarkable range of drawings by Ingres—"those marvels of the human spirit," as he called them.[127] Degas's veneration of Ingres was almost cultlike. In later life he delighted in recalling his visits to Ingres as a young man, which, although brief, came to assume an almost mythic significance for him. On one occasion Ingres told him, "Study line, draw lots of lines, either from memory or from nature," advice that Degas remembered all his life.[128] When an exhibition of Ingres's work was held at the Galerie Georges Petit in May 1911, Degas, by then an old man, went every day. So profound a knowledge of Ingres's art had he absorbed over the years that, although he was too blind to see the paintings, he could still recognize the contours and surfaces of those he knew by touch, according to Daniel Halévy.[129]

Ingres's work provided the most consistent model for Degas's early portraits. His pastel of his sister Thérèse in the salon of the family apartment on the rue de Mondovi, in which she is shown leaning against the fireplace and reflected in the mirror above it,[130] is clearly indebted to Ingres's *Comtesse d'Haussonville* of 1845 (figs. 124, 356). One of Degas's earliest self-portraits, painted in 1855,[131] is often compared to Ingres's youthful self-portrait of 1804 (figs. 171, 172). Interestingly, Degas acquired another, very similar portrait of the youthful Ingres that had been painted by his sometime fiancée Julie Forestier (fig. 19), the young woman at the center of Ingres's traced drawing of the Forestier family, which Degas owned (fig. 29).[132]

As Degas developed a more informal portrait style, the influence of Ingres became less direct. Nevertheless, Ingres's gift for conveying the individual character of his sitter through pose, the surrounding objects, and a carefully observed setting continued to be relevant to Degas's modern concept of portraiture. The assured hand-on-hip pose adopted by the Marquis de Pastoret in Ingres's portrait of him (fig. 20) perfectly captures the young aristocrat's bravura, and in the probing gaze and nonchalant stance of M. de Norvins (fig. 186) Ingres seizes the essence of the blunt, perhaps ruthless, character of this chief of police in occupied Rome. The opulent setting of red damask that contrasts with the sitter's black coat and crisply folded white stock seems to reinforce his aura of authority. The bust of Athena on a pedestal inscribed "Rom . . ." (presumably for Rome) must be a reference to de Norvins's residence in that city.

As noted, the two paintings that Degas considered the masterpieces of his collection, the acquisition of which he had described as "the event of my life as a collector," were the portraits of M. and Mme Leblanc (figs. 22, 21). Degas must have responded above all to their magnificent formal design. Ingres's flowing arabesque plays over the surfaces of mahogany, marble, silk, and flesh, drawing these variegated textures into a rhythmically balanced arrangement. With great subtlety he establishes complementary and contrasting relationships between the pendant images of husband and wife. Mme Leblanc's gold necklace echoes the dipping contour of her husband's watch chain, while the intricate pink-and-yellow pattern of her paisley shawl is complemented by the bolder design and deeper, more masculine hues of orange and blue in the Turkish carpet on his table. These rich fabrics provide a visual foil to the poised and somberly clad figures who occupy their space with such benign composure.

Degas never forgot the paintings he had seen in Ingres's atelier as a young man. "There were paintings in that studio that are fixed in my memory as if on a photographic plate," he was later to recall.[133] One of the works he had admired at a small exhibition that Ingres organized in his studio in 1864 was the seated portrait of Mme Moitessier (fig. 23), which he referred to as "in the pose of the Cybele of Naples."[134] Later he acquired a number of preparatory drawings for this portrait (fig. 24), some of which he described in his notes—a drawing of the nude figure, one of the left arm with a double hand on tracing paper, and one of the skirt—together with a fine study of the head (fig. 25) for another portrait of the same sitter that shows her standing in a black gown with flowers in her hair (National Gallery of Art, Washington, D.C.). When in 1898 he visited the sitter's two daughters to study the paintings, he recorded his observations of the London version (fig. 23): "flowered dress, fine composition, less finished than the other, but more modern."[135] Degas was fascinated by this icon of Second Empire bourgeois opulence and, like Pablo Picasso, by the undulating contours that enclosed her luxuriant form. On a visit to the Museo Nazionale in Naples in 1856, Degas had made a drawing of a figure of Arcadia from the Roman wall painting that had been Ingres's original source for Mme Moitessier's pose—her head on her hand—a pose that often occurs in Degas's portraits, where it usually suggests a tentative or introspective quality, in contrast to the self-assurance it lends Mme Moitessier.

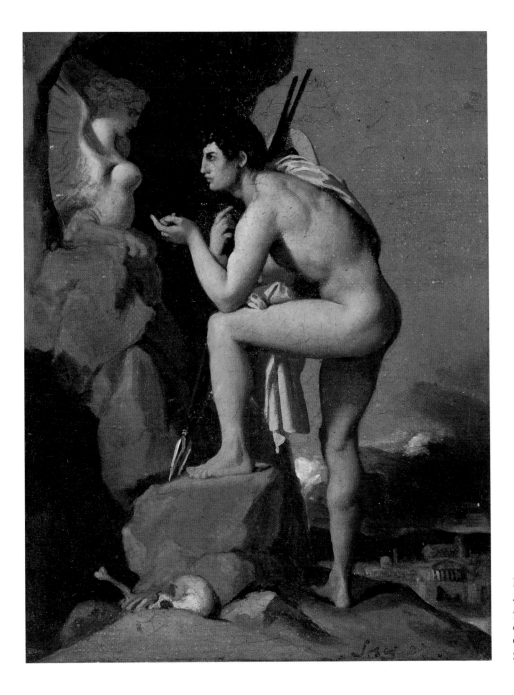

Fig. 26. J.-A.-D. Ingres, *Oedipus and the Sphinx,* ca. 1826–28. Oil on canvas, 6⅞ × 5⅜ in. (17.5 × 13.7 cm). Reproduced by courtesy of the Trustees, the National Gallery, London (NG 3290). Collection Sale I: 51

Often Degas acquired works related to those he had admired in his youth. He had copied Ingres's *Roger Freeing Angelica* of 1819 (Musée du Louvre, Paris) at the 1855 exhibition and again in 1859 when it was shown at the Musée du Luxembourg, exploring the composition's two contrasting elements, Angelica's pliant, idealized form (fig. 178) and Roger's violently fluttering cloak.[136] Later he acquired both a smaller painted version, now in the National Gallery, London (fig. 17), and a drawing of the entire composition rendered in Ingres's refined and precise line (fig. 192).[137] Similarly, he acquired a small, later version (fig. 26) of the *Oedipus and the Sphinx* of 1808, which had entered the Louvre in 1878.[138] He also owned drawings for *The Martyrdom of Saint Symphorian,* which had been installed in Autun

Cathedral in 1834 and which Degas had copied when it was exhibited in Paris in 1855.[139]

During his brief stint as a student at the École des Beaux-Arts, Degas had admired *Achilles Receiving the Envoys of Agamemnon,* 1801 (École des Beaux-Arts, Paris), a model of Neoclassical composition that had won Ingres the Prix de Rome. By 1898, when Degas acquired the oil sketch for the work (fig. 27), the painting had clearly lost none of its appeal.[140] Its influence is perhaps seen in the choreographed, friezelike grouping of the figures in his *Young Spartans,* circa 1860–61 (National Gallery, London). But even when Degas moved away from such historical subjects, Ingres's deeply pondered arrangements of forms kept their meaning for him and resurface in the calculated, asymmetrical

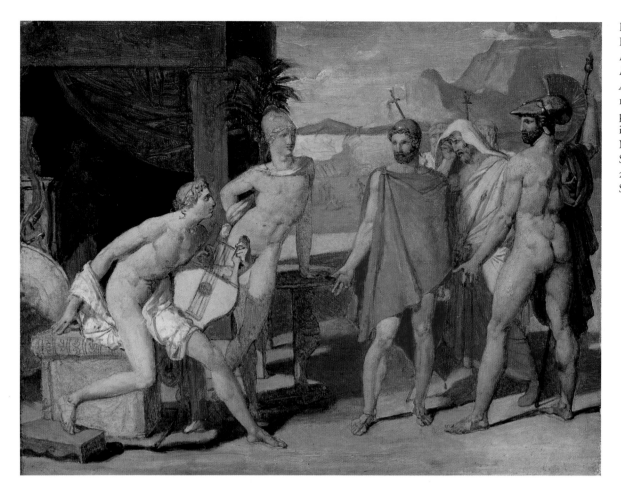

Fig. 27. J.-A.-D. Ingres, *Achilles Receiving the Envoys of Agamemnon,* 1801. Oil on panel, 9⅞ × 12¾ in. (25 × 32.5 cm). Nationalmuseum, Stockholm (NM 2161). Collection Sale I: 50

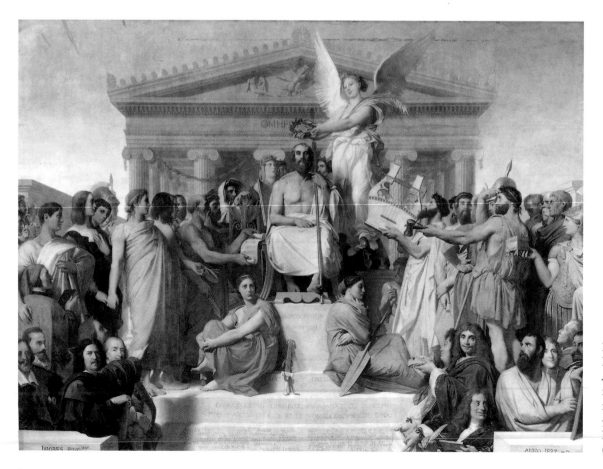

Fig. 28. J.-A.-D. Ingres, *The Apotheosis of Homer,* 1827. Oil on canvas, 152 × 202¾ in. (386 × 515 cm). Musée du Louvre, Paris (INV. 5417)

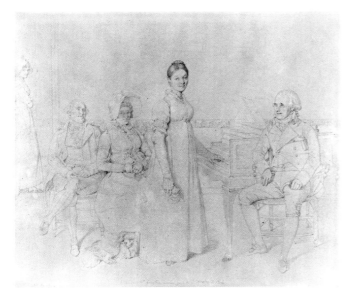

Fig. 29. J.-A.-D. Ingres, *The Forestier Family,* ca. 1828. Graphite with white chalk accents on tracing paper, 11⅞ × 14⅝ in. (30 × 37.2 cm). Courtesy of the Fogg Art Museum, Harvard University Art Museums, Cambridge, Bequest of Grenville L. Winthrop (1943.842). Collection Sale I: 208

geometry of the more radical compositions of the 1870s and 1880s.

Ingres's drawing was a no less enduring model. The reverence it could inspire in Degas comes across in a conversation with Moore that took place about 1898, when the two were examining a red-chalk drawing of a hand by Ingres:

> Ah! look at it, I bought it only a few days ago; it is a drawing of a female hand by Ingres; look at those fingernails, see how they are rendered. That is my ideal of genius, a man who finds a hand so lovely, so wonderful, so difficult to render that he will shut himself in all his life, content to do nothing but indicate fingernails.[141]

Indeed, the example of Ingres's draftsmanship is apparent in Degas's work, from the delicate precision of such early pencil drawings as the exquisite drapery studies he made for *Semiramis Building Babylon,* circa 1860–62 (Musée du Louvre, Paris; see figs. 104, 106), to the heavy, simplified charcoal contours that define his very last figures of bathers and dancers.

The drawings by Ingres that Degas collected vary from the most private and informal working-out of an idea to such carefully composed and delicately executed complete drawings as the group portrait *The Forestier Family* (fig. 29), a work in which Degas might well have seen a connection with his own *Family Portrait,* also called *The Bellelli Family* (fig. 90). But most of all it was Ingres's line itself and its power to render form with the utmost economy that in-

spired Degas, just as it was to inspire Gauguin, Henri Matisse, and Picasso. Degas was fond of quoting Ingres's maxim, "Drawing is not outside the line, but within it."[142] His sense of this relationship between line and form must have motivated his early copy of the *Valpinçon Bather* at the Paris World's Fair in 1855 and his purchase in 1889 of one of the most elegantly spare of all of Ingres's drawings, the *Study for "La Grande Odalisque"* (fig. 359).

Draftsmanship had been the basis of Degas's early training. When his artistic identity began to form, in the 1850s, he followed the traditional and expected path for a young artist embarking on a career in France in the mid-nineteenth century. Ingres, who stood for an ideal of impeccable draftsmanship, was held up as the model that aspiring artists should strive to emulate. Degas at first studied briefly under the academic painter Félix Barrias and then with Louis Lamothe, a sometime pupil of Ingres. He was schooled by these teachers in the academic discipline that stressed drawing, the study of the human figure, and the need to build up a composition from numerous preparatory studies of its different parts, and this discipline would be fundamental to Degas's art for the rest of his life. Drawing from the model was supplemented by copying from the old masters, an essential aspect of academic training. From the mid-1850s until the late 1860s Degas filled his notebooks with copies made in the Louvre and in churches and museums all across France and, like countless students before him, in Italy, where he concentrated on Italian artists of the fifteenth and sixteenth centuries, the great Renaissance masters of line. So extensive was this independent program of copying that Theodore Reff has described the first phase of Degas's career, before 1860, as essentially that of a copyist.[143]

Fig. 30. Edgar Degas, *"The Apotheosis of Degas,"* photograph, 1885. Modern print from a glass negative. Bibliothèque Nationale, Paris

Fig. 31. J.-A.-D. Ingres, *Seated Woman, Study for the Odyssey in "The Apotheosis of Homer,"* 1826–27. Graphite and white chalk, 11⅞ × 10¼ in. (30 × 26 cm). Musée du Louvre, Paris, Département des Arts Graphiques (R.F. 4512). Collection Sale I: 189

Fig. 32. J.-A.-D. Ingres, *Phidias, Study for "The Apotheosis of Homer,"* ca. 1827. Oil on canvas, mounted on panel, 12⅝ × 13⅞ in. (32 × 35 cm). San Diego Museum of Art, Museum purchase with Earle W. Grant Endowment Funds (1974.007). Collection Sale I: 65

Fig. 33. J.-A.-D. Ingres, *Two Studies of Pindar, One Nude, the Other Draped, for "The Apotheosis of Homer,"* 1826–27. Graphite and white chalk on brown paper, *a:* 18¾ × 7¾ in. (47.6 × 19.7 cm), *b:* 18¼ × 8¾ in. (46.5 × 22 cm). British Museum, London (1975.3.1.49, 50). Collection Sale I: 191.

Fig. 34. J.-A.-D. Ingres, *Head of Victory, Study for "The Apotheosis of Homer,"* ca. 1826–27. Oil on canvas mounted on panel, 9⅜ × 7⅜ in. (23.7 × 18.7 cm). The Hyde Collection, Glens Falls, New York (1971.23). Collection Sale I: 62

Fig. 35. J.-A.-D. Ingres, *The Odyssey, Study for "The Apotheosis of Homer,"* ca. 1826–27. Oil on canvas, mounted on panel, 9⅜ × 7⅜ in. (23.7 × 18.7 cm). The Hyde Collection, Glens Falls, New York (1771.25). Collection Sale I: 67

Fig. 36. J.-A.-D. Ingres, *Dante Offering His Works to Homer, Study for "The Apotheosis of Homer,"* ca. 1827. Oil on canvas, mounted on panel, 15 × 13⅞ in. (38 × 35 cm). Ordrupgaard, Copenhagen. Collection Sale I: 60

Fig. 37. J.-A.-D. Ingres, *Pindar Offering His Lyre to Homer,* ca. 1828. Oil on canvas, mounted on panel, 13¾ × 11 in. (35 × 28.5 cm). By courtesy of the Trustees, the National Gallery, London (NG 3293). Collection Sale I: 66

Fig. 38. J.-A.-D. Ingres, *The Feet of Homer, Study for "The Apotheosis of Homer,"* ca. 1827. Oil on canvas, 6¾ × 8¾ in. (17 × 22 cm). Musée du Louvre, Paris, Département des Peintures (R.F. 3773). Collection Sale I: 58

Fig. 39. J.-A.-D. Ingres, *Profile of Raphael, Hands of Raphael, Racine, and Poussin, Study for "The Apotheosis of Homer,"* ca. 1827. Oil on canvas, mounted on panel, 14¾ × 10⅝ in. (37.5 × 27 cm). Musée du Louvre, Paris, Département des Peintures (R.F. 2746). Collection Sale I: 59

In many ways Degas's collection can be connected with this academic approach. A number of Ingres drawings in the collection are preparatory studies for paintings, suggesting that Degas wanted to explore Ingres's method, which parallels his own tireless investigation through drawing. By this means Degas sought to arrive at a sort of truthfulness that was ultimately conferred on a figure or pose through his continued working and reworking. One of the paradoxes of his art is that even his most apparently spontaneous compositions, vignettes snatched from the continuum of everyday life, are in fact the result of careful preparation. Despite his modernity, Degas never abandoned the academic approach and always worked out his composition through a series of drawings and sketches, some from the model, some of individual details. "For Degas," Paul Valéry observed in his memoir on the artist, "a painting was the result of a limitless number of sketches—and of a whole series of operations."[144] When utilized for the historical subjects Degas painted in the 1860s, this documentary approach is no surprise, but when we discover that he produced an equally large number of sketches to ensure accuracy of costume and setting for so modern a subject as that of *Mademoiselle La La at the Cirque Fernando,* 1879

(National Gallery, London), which shows a popular trapeze artist of the day hanging by her teeth from the roof of a circus tent, we understand the extent to which the academic method underlies every aspect of his art.

No group of works in the collection is more revealing of the fascination that Ingres's working process held for Degas than the studies for *The Apotheosis of Homer.* Although Degas also owned groups of studies for other major compositions by Ingres—*King Midas, The Martyrdom of Saint Symphorian,* and *The Age of Gold*—these are not as comprehensive as the fifteen drawings and six oil studies for the *Apotheosis* (see figs. 31–39).[145] This enormous Neoclassical "machine" was clearly a key work for Degas. While on vacation in Dieppe in 1885, he made fun of its rigid symmetry and its solemnity by posing a group of friends in a mock-heroic photographic tableau in which he himself took the central part of Homer (fig. 30). What intrigued Degas in this work was the inexhaustible repertory of poses and gestures provided by its enormous cast of figures, poses he had explored in numerous copies of the work made in his early notebooks. It is significant, perhaps, that he seems never to have copied the whole composition, instead concentrating on individual figures. As

Fig. 40. Alphonse Legros (1837–1911), *Studies of Hands*. Black chalk, 5⅛ × 7½ in. (13 × 19 cm). Musée du Louvre, Paris, Département des Arts Graphiques (R.F. 15888). Collection Sale I: 216

Reff points out, this preference anticipates the practice that Degas developed in his later work of turning an "elegant fragment" into the entire composition.[146]

In this respect Degas's collection invites comparison with earlier old master collections—that of Rubens, for example. It was not uncommon for an artist to gather a body of drawings that functioned as a sort of reference library of poses and motifs. Degas's collection is different, of course, in that it was mostly acquired toward the end of his career and thus did not serve his art in so direct a way. Nevertheless his collecting of drawings of details can be seen as a continuation of his early practice of copying, which provided him with ideas for poses throughout his career.

Apart from one drawing of the entire composition, dedicated by Ingres to his friend Frédéric Reiset,[147] all the studies for *The Apotheosis of Homer* in Degas's collection were of individual figures or parts of bodies or of other details. They range from the eloquent seated figure of the Odyssey (fig. 31), in which the wonderfully subtle chalk highlighting of the drapery folds rounds out and softens the volume of the figure, to simple sketches of a roll of parchment, a fold of drapery, a hand, or a foot.[148] The splendid pair of drawings for the figure of Pindar, one nude and one draped (fig. 33),[149] exemplifies the standard academic practice of making preparatory drawings of a figure both nude and clothed. (Degas followed this procedure even with his most modern subjects, for instance the dancers in his paintings of the ballet.) Other studies of Pindar include one in oil, *Pindar Offering His Lyre to Homer* (fig. 37), although this was not made preparatory to *The Apotheosis of Homer* but later and is related to a scheme for a modified version of the work that was never carried out.[150]

Degas's admiration for the linear tradition exemplified by Ingres also accounts for his acquisition of works by a remarkably diverse range of artists that, broadly speaking, share an emphasis on line. There was, for example, a surprisingly large group of drawings by Charles-Emmanuel Serret, a now-forgotten figure who, like Degas, had been trained in the academic tradition by Ingres's pupil Lamothe and who had tailored a traditional style to suit his contemporary figures (fig. 394).[151] Other Degas acquisitions were the Ingresque portrait drawings by François-Joseph Heim;[152] two drawings of nudes by Puvis de Chavannes;[153] Legros's finely drawn studies of hands (fig. 40);[154] minutely descriptive drawings by Denis-Auguste-Marie Raffet, a specialist in military uniforms (fig. 404);[155] and a group of drawings of nudes by Suzanne Valadon (fig. 415). The "terrible Maria," as Degas called Valadon, was a former Montmartre model turned artist whom he pestered in a long series of letters to sell him the drawings he so admired for their "great, supple lines."[156]

The linear arabesque displayed in Japanese prints, though springing from a quite different tradition, must have offered Degas a fresh confrontation with Ingres's flowing line, as in the Kiyonaga color woodcut diptych *The Bath House* (fig. 331) and Japanese-inspired prints such as Manet's *The Cats' Rendezvous* (fig. 75) that were in his collection.

DELACROIX: COLOR AND MOVEMENT

If Degas admired Ingres above all for his line, in Eugène Delacroix (1798–1863) he found the most complete expression of the value of color. Ingres stood for the linear tradition epitomized by such artists as Mantegna, Bronzino, and Holbein, whose works Degas had copied; in Delacroix, Ingres's historic rival, Degas saw a summing up of his own long-standing enthusiasm for the more painterly and

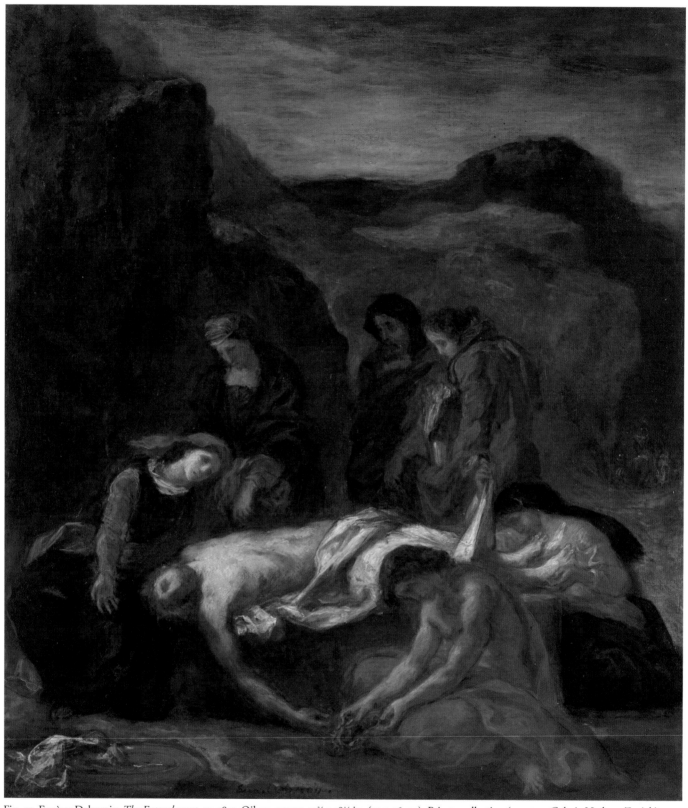

Fig. 41. Eugène Delacroix, *The Entombment*, ca. 1853. Oil on canvas, 21¾ × 18⅛ in. (55 × 46 cm). Private collection (courtesy Galerie Nathan, Zurich). Collection Sale I: 27

coloristic work of Rubens and the Venetians Veronese, Titian, and Tintoretto.[157] Degas had demonstrated his taste for Rubens by making a large copy, circa 1858–59, of *Henri IV at the Battle of Ivry* (location unknown),[158] which was still in his possession when he died. He must have been de-

lighted to acquire Delacroix's copy after Rubens of *Henri IV Entrusts the Regency to Marie de Médicis,* done before 1835 (Los Angeles County Museum of Art).

Degas had probably been introduced to the work of Delacroix by Gustave Moreau, whom he had met when they

Fig. 42. Edgar Degas, *Copy after Delacroix's "Ovid among the Scythians,"* Notebook 18, p. 127, 1859. Brown ink with brown and gray wash, 7½ × 10 in. (19.2 × 25.4 cm). Bibliothèque Nationale, Paris

were both students at the French Academy in Rome. On returning to Paris in 1859, Degas had plunged into an extensive study of Delacroix no less intense than his exploration of Ingres a few years earlier. He began copying a number of major works by Delacroix, including *The Entry of the Crusaders into Constantinople,* 1840 (Musée du Louvre, Paris),[159] *The Massacre at Chios,* 1824 (Musée du Louvre, Paris),[160] and *Ovid in Exile among the Scythians,* 1859 (National Gallery, London)[161]—partly in connection with his biblical painting *The Daughter of Jephthah,* 1859–61 (Smith College Museum of Art, Northampton, Mass.), whose rich color and dramatic composition were obviously inspired by these models. What had interested Degas in Ingres's paintings was the individual figure or a striking pose or gesture; but from Delacroix he wanted to learn about the dynamics of composition and the emotive power of color. Therefore his copies tend to focus on the whole composition or on the principal figures, although, curiously, nearly all the copies are drawings, with notes added to indicate the colors and tonal arrangements.[162]

Again, Degas's enthusiasm for works he had copied as a student is also confirmed by purchases for his collection. At the Salon of 1859 he had made a heavily shaded, loosely drawn sketch of Delacroix's *The Entombment,* a version of which he was able to buy in 1899 (fig. 41).[163] When Delacroix's *Journal* began to appear in print in 1893, Degas had

his housekeeper read it aloud to him and was thrilled to discover notes on the color and technique of *The Entombment.*[164] Degas also acquired two drawings that relate to another painting he had copied at the 1859 Salon, *Ovid in Exile among the Scythians* (National Gallery, London); one is called *Arab Camp* and the other, a hexagonal drawing, *Study for "Ovid in Exile among the Scythians."*[165] In his copy of the painting, which was probably done from memory, since it is not exact in every detail, Degas achieved a remarkably pictorial effect even though he was working only in ink and wash (fig. 42). Through subtle variations in shading he succeeds in suggesting the moody landscape background that in the painting is evoked with a sonorous palette of orange and green.[166]

Ovid in Exile among the Scythians, like *The Apotheosis of Homer,* is a work that seems to have had a special resonance for Degas, and one can sense its influence in the romantic landscape settings of a number of his equestrian scenes.[167] Oddly enough, Degas did not seize the chance to buy an important oil sketch of the painting when it was included in the sale of Victor Chocquet's collection in July 1899, where it was much admired by Julie Manet, who afterward commented on the low price it had fetched.[168] Instead he bought the sketch for *The Death of Charles the Bold at the Battle of Nancy,* 1828–29 (fig. 210),[169] a work filled with vivid color and energetic movement of the kind

he must also have admired in the sketch for another, similar battle scene, *The Battle of Poitiers*, 1829–30 (fig. 204), which he had copied in oil during a period of renewed interest in Delacroix in the late 1880s.[170]

One of Degas's favorite paintings by Delacroix was *Count de Mornay's Apartment* (fig. 4),[171] a work that, like his own painting of an uninhabited interior, *The Billiard Room at Ménil-Hubert*, 1892, painted at the country house of his friends the Valpinçons (fig. 129), effectively evokes the presence of its absent occupants. He also owned a Delacroix landscape, *Landscape with River (Champrosay)*, 1850(?) (fig. 387);[172] a study for a ceiling decoration for the Hôtel de Ville, *Hercules Rescuing Hesione*, 1852 (Ordrupgaard, Copenhagen);[173] two early portraits, *Abel Widmer* (fig. 5) and *Amédée Berny d'Ouville*, 1830 (fig. 423); *Greek Officer*, circa 1822 (fig. 136);[174] and *Louis-Auguste Schwiter* (fig. 44).

For Degas, the painting of Schwiter must have represented an ideal of Romantic portraiture. The sitter's aristocratic ease, tempered by a hint of introspective melancholy, is conveyed both by the setting—the stone terrace leading to a landscaped park stretching into a sunset sky (supposedly partly painted by Paul Huet)—and by Delacroix's distinctive, pliant brushwork, which enlivens every surface in the painting. The coloring is sober, yet it glows with the subdued opulence of the Venetian painters Delacroix admired. The black garb of Schwiter's tall figure provides a foil for the metallic blue glaze of the Chinese vase and contrasts with the vivid red lining of the hat and the ocher-cream gloves. It is even possible that Degas identified with the sitter, who like himself was a painter, a dandy, a man of taste, and a collector. Something of the flavor of all this is felt in Degas's early *Self-Portrait: Degas Lifting His Hat*, circa 1863 (fig. 82),[175] where he sets himself, in a silk top hat and holding a pair of tan kid gloves, against a distant, brooding sky.

In addition to these paintings, Degas owned over two hundred of Delacroix's drawings. Like those by Ingres, many are studies of the human figure or details of accessories, revealing Degas's interest in the ways Delacroix worked out his ideas, often in preparation for a painting.[176] Many of the drawings related to Delacroix's historical paintings are studies of costume or medieval armor. The watercolor study of a caparisoned saddle and the armored leg of a knight, enlivened by a touch of brilliant red (fig. 45), suggests a connection with Degas's studies of horses and riders, such as the 1866 group of drawings done in essence (diluted oil) in which he systematically explored different positions of jockeys in the saddle.

While Degas admired the purity of Ingres's line, he saw in Delacroix's vigorous and expressive draftsmanship a powerful means of conveying movement. This is particularly apparent in the studies of the figure of Liberty for *Liberty, July 28, 1830* (fig. 16), in which the reiteration of rough, urgent lines captures the energy of the figure as she charges forward into the viewer's space.[177] For Degas, the repetition of the figure in these three related studies probably affirmed his own working methods. Repetition was fundamental to his approach: in order to understand movement he studied sequential views and then executed them.[178] This impulse was responsible for his works in series, such as the group of pastels that exhaustively examine aspects of a woman's toilette. From his earliest student days, Degas had used tracing paper to transfer an image from a printed source to his own notebooks. Later, in the 1890s, he began to use tracing paper extensively to draw and redraw his own images. "Make a drawing, begin it again, trace it; begin it again and trace it again," he would say,[179] as if by repeatedly drawing lines he could finally seize the very essence of a form.

Degas acquired a large group of Delacroix's pastels and watercolors. While in his oil paintings Delacroix often

Fig. 43. Eugène Delacroix, *Gentleman in Seventeenth-Century Costume*. Graphite and watercolor, 9½ × 6⅞ in. (24.2 × 17.4 cm). Trustees of the British Museum, London (1975.3.1.37). Collection Sale I: 128

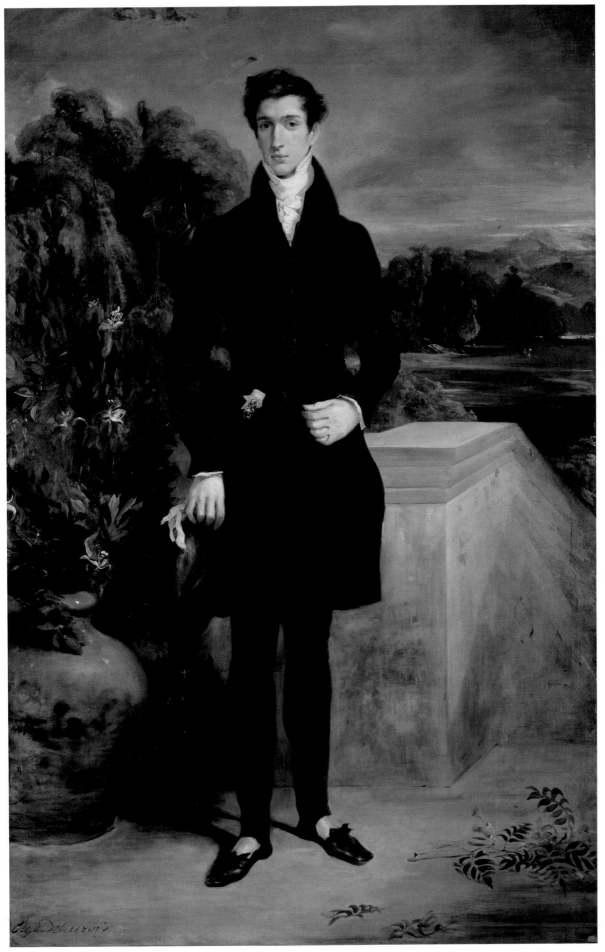

Fig. 44. Eugène Delacroix, *Louis-Auguste Schwiter,* 1826–30. Oil on canvas, 85¾ × 56½ in. (217.8 × 143.5 cm). Reproduced by courtesy of the Trustees, the National Gallery, London (NG 3286). Collection Sale I: 24

Fig. 45. Eugène Delacroix, *Study of a Saddle,* 1825. Graphite and watercolor, 10⅜ × 7⅜ in. (26.6 × 18.6 cm). Trustees of the British Museum, London (1975.3.1.35). Collection Sale I: 117

Fig. 46. Eugène Delacroix, *Four Studies of Saddles,* ca. 1825. Graphite and watercolor, 7¼ × 10¼ in. (18.3 × 26 cm). Musée des Arts Décoratifs, Paris (20951). Collection Sale I: 119

Fig. 47. Eugène Delacroix, *Study of Armor from the Time of François I,* 1825. Pen and ink, wash, and watercolor, 10⅝ × 6⅞ in. (27 × 17.5 cm). Musée du Louvre, Paris, Département des Arts Graphiques (R.F. 30029). Collection Sale I: 142

Fig. 48. Eugène Delacroix, *Studies of Medieval Armor and Costumes,* 1825. Graphite, ink, brown and gray wash, 9⅞ × 8 in. (25.5 × 20.2 cm). Musée du Louvre, Paris, Département des Arts Graphiques (R.F. 30030). Collection Sale I: 139

theories discussed in Delacroix's *Journal,* and, according to Denis Rouart in his study on Degas's technique, he went so far as to acquire some of Delacroix's original paper palettes in order to analyze their color combinations.[185] He returned to his student practice of copying, producing a freely painted rendering of Delacroix's sketch for *The Battle of Poitiers* in the late 1880s[186] and an oil copy of the late version of *The Fanatics of Tangier* (see figs. 204, 205, 208, 209) several years later.[187] It is surely no accident that during this period, when Degas was intensively acquiring Delacroix's work and saw before him every day the glowing color schemes of *Louis-Auguste Schwiter* and *The Entombment,* he also conducted the most daring experiments with color in his own work.

While color became more intense in Degas's late work, that transformation was matched by an increasing insistence on line—in the vigorous charcoal drawings and in the pastels, where the artist could literally draw with color. The examples of both Ingres and Delacroix had shaped Degas's art in his formative years; by late in his career, especially in such work as his pastels of nudes, in which he achieved a complete fusion of line and color, he had completely absorbed the lessons of their art. In collecting the work of these two masters, he confirmed, and paid homage to, their guidance and inspiration.

COROT AND LANDSCAPE

Degas often expressed his dislike of the countryside, yet landscapes constitute a significant category within his collection. The image of himself as the Parisian par excellence, who hated nature and thought that landscape painters should be shot, was largely an affectation.[188] In fact, he spent long summers away from Paris, with such friends as the Valpinçons at their estate at Ménil-Hubert in Normandy and later with Jeanniot at Diénay in Burgundy, and he was far from insensitive to scenic beauty. In his earliest notebooks, alongside the numerous drawings made in museums, we find sketches of landscapes ranging from panoramic Italian views to verdant country lanes in Normandy.

Although it is true that Degas's primary subject was the human figure, landscape is a much more important and consistent theme in his work than has generally been acknowledged.[189] His taste in landscape painting was shaped by his early admiration for the classical tradition. His notebook entries for the years he spent in Italy, 1856 to 1859, show a consistent enthusiasm for the work of Claude Lorrain, whose *Landscape with the Nymph Egeria Mourning over Numa,* 1669 (Museo e Gallerie Nazionali di Capodimonte,

Naples), had particularly impressed him. While in Rome he read the letters of Poussin, and later he copied his works.

Like many of his contemporaries, Degas had always had the greatest admiration for Jean-Baptiste-Camille Corot (1796–1875), who by the time of his death was generally acknowledged to have kept alive the tradition of his great seventeenth-century forebears. Degas's career overlapped Corot's for about twenty years: he is reputed to have met the older artist on more than one occasion, although he never knew him well.[190] Degas often asserted that Corot's genius lay in his figure paintings, but six of the seven Corots that he acquired are landscapes.[191] The seventh, *Seated Italian Woman,* is a minor work.[192] Degas seems to have ignored the later sylvan scenes bathed in Corot's famous silvery light, which is curious, perhaps, given Degas's belief in working from memory and the dreamlike mood of his own late monotype landscapes. Possibly he found these late landscapes of Corot too formless or too sentimental, for he seems to have been drawn to those based more on direct observation: the finely structured *Limay Bridge,* 1855–60 (fig. 378),[193] with its monumental stone bridge arching through a spare landscape; and the more complex *Rocky Chestnut Wood* (fig. 53), in which the sense of a powerful nature dwarfs the tiny figures.[194] Two smaller landscapes date from the 1820s, when Corot was working in the countryside around Rome: a study of some trees made at the Villa d'Este, Tivoli, and a view of the Roman Campagna that stands out for its pristine freshness (fig. 153).

This last work probably appealed to Degas for its clarity and pictorial structure, but it must also have touched on memories of the years he himself had spent as a young man, in the 1850s, sketching in Italy. Indeed, many of Degas's luminous oil sketches from that period recall Corot's early Italian landscape sketches.[195] In a letter written from Rome in the 1850s, Degas had described the aura of antiquity that he sensed in the Roman Campagna: "A feeling of antiquity survives in the countryside, which is wild, empty, cursed like the desert, with its great mountains carrying aqueducts and its herds of cattle spread far and wide. This is really beautiful, with the kind of beauty that is like a dream of antiquity."[196]

Degas's preference for Corot's early work was unusual at the time. It was shared by only a few artists and by sophisticated collectors such as Henri Rouart, who had pioneered the taste for early Corot landscapes and had assembled an outstanding collection of fifty-three of his paintings.[197] Degas acknowledged this shared enthusiasm in his portrait of Hélène Rouart, Henri's daughter (fig. 130), by including in the background an early Corot from Rouart's collection, *The Castel dell'Ovo in Naples* of 1828.

Fig. 53. Jean-Baptiste-Camille Corot (1796–1875), *Rocky Chestnut Wood (Morvan or Auvergne)*, 1830–35. Oil on canvas, 21¾ × 33⅛ in. (55 × 84 cm). Oskar Reinhart Collection "Am Römerholz," Winterthur, Switzerland. Collection Sale I: 18

Degas's family on his mother's side was Neapolitan, and he had visited Naples frequently, especially in his youth. He himself had made several sketches of the Castel dell'Ovo in the early 1860s, accompanied by notes that reveal his response to the colors of the Bay of Naples and the silhouette of the fortress: "The Castel dell'Ovo produced a curious effect, greenish and black as in winter, outlined against the roseate slopes of Vesuvius."[198] (One of these views was listed in the sale of Degas's collection as an unattributed work but has now been identified by Reff as a painting by Degas.)[199]

Perhaps prompted by nostalgia for these visits, Degas collected a number of views of Naples and especially of Mount Vesuvius: a watercolor by his friend the painter and engraver Lepic and two oils by another painter friend, the Italian Giuseppe de Nittis, whom, like Lepic, Degas had invited to exhibit with the Impressionists.[200] The two paintings by de Nittis (figs. 54, 55) are described vaguely in the sale catalogue as *Mountainous Site, Italy* and *Site in Italy, Mountainous Landscape*,[201] but in his inventory Degas identified them more precisely as views of Vesuvius.[202] Another work in the collection, entitled *Vesuvius Erupting*, is listed in the sale catalogue under "Modern School" but was

bought by Degas as a Corot and described in his inventory notes as "Vesuvius, plume of smoke, sun setting, blue sea."[203] We do not know when Degas acquired this work, but doing so may have prompted him to return to the theme of Vesuvius in a monotype he made of the volcano erupting in 1892, though Richard Kendall has suggested that Hokusai's views of Mount Fuji were also an inspiration.[204] At any rate, Degas did not produce his monotype in response to the site itself, since he had last visited Naples in 1886.

Both Degas's collection and his work reveal a highly developed taste for lyrical landscape, with an emphasis on sky studies (fig. 52), sunsets, seascapes, and mountains. Unlike the Impressionists, he was most moved by dramatic, untamed landscapes, remarking to Moreau-Nélaton that he was "bowled over by the black mountains" in Corot's *Monte Casso*.[205] A lyrical mood pervades the four Eugène Boudin "sky studies" *(études de ciel)* that Degas acquired in 1899, in which we see Boudin capturing in pastel the pearly light of the Normandy coast—the "studies of nothing" that Charles Baudelaire had so admired at the Salon of 1859 and that probably reminded Degas of the pastels he himself had made along the same coast in 1869.[206] A beau-

Fig. 54. Giuseppe de Nittis (1846–1884), *Mountainous Site, Italy*, Oil on panel, 5½ × 9⅞ in. (14 × 25 cm). Property of Paolo Marzotto from the Gaetano Marzotto's Collection. Collection Sale II: 72

Fig. 55. Giuseppe de Nittis, *Mountainous Site, Italy (Torre Annunziata)*, 1872. Oil on panel, 7¼ × 12¼ in. (18.5 × 31 cm). Property of Paolo Marzotto from the Gaetano Marzotto's Collection. Collection Sale II: 73

tiful pastel study of a sunset over the sea, probably also in Normandy, in which the elements of air and water are reduced to abstract streaks of yellow, violet, and magenta (fig. 391), is one of the many landscapes by Delacroix in Degas's collection.[207] Among these was one of Delacroix's few landscapes in oil, *Landscape with River (Champrosay)* (fig. 387), and several in watercolor and pastel, some displaying the Romantic sensibility expressed in the sunset study but others showing a more objective topographical approach, as in the view of the rocky coast of Gibraltar made when Delacroix traveled to North Africa in 1832 (fig. 400).

Degas did not share the widespread taste of his day for the Barbizon painters, led by Théodore Rousseau, Charles Daubigny, and Jean-François Millet, who, with Corot, had evolved a new, naturalistic style of landscape beginning in the 1830s. Possibly he felt their views of nature were too prosaic. Millet is represented in the collection only by a painting of his first wife, *Madame J.-F. Millet* (fig. 151), 1841, and a drawing of a nude (fig. 150) and four prints, all of figure subjects.[208] Degas's one landscape by Rousseau, the preeminent Barbizon painter—a barren, mountainous view, *The Valley of Saint Vincent* (fig. 56)—was bought by mistake; seeing it from the back of the salesroom, Degas thought it was a Corot.[209]

Even more conspicuous is the absence in Degas's collection of landscapes by his contemporaries in the Impressionist group. He owned nothing at all by Monet, whose works he found formless and whom he once described as "a mere decorator,"[210] and only a few landscapes by Pissarro and Sisley. He bought Berthe Morisot's beautiful view of a woman on a terrace overlooking a landscape, *In a Villa at the Seaside*, 1874, and her watercolor *A Woman and a Child Sitting in a Meadow* (figs. 157, 158), 1871,[211] but showed no interest in adding other Impressionist landscapes to his collection later on. One can only assume that these few

works had been acquired in a spirit of solidarity during the early years of the Impressionists' group enterprise.

A more surprising omission, perhaps, is that of any of Cézanne's firmly articulated landscapes. Degas could have acquired them easily and inexpensively—several were included in the 1895 Vollard exhibition, at which Degas did make some purchases—and there is no obvious explanation for his apparent lack of interest in this area of activity of an artist for whom in every other respect he had the greatest admiration.

DEGAS AND HIS CONTEMPORARIES

Although Ingres and Delacroix dominated Degas's collection, he also acquired an impressive array of works by some of his contemporaries. His choices in this domain are no less revealing about his taste and artistic concerns than those regarding his predecessors. Among his contemporaries the artists most fully represented were Manet, Cézanne, and

Fig. 56. Théodore Rousseau (1812–1867), *The Valley of Saint Vincent*, ca. 1830. Oil on canvas, 7⅛ × 13¾ in. (18 × 34.9 cm). Reproduced by courtesy of the Trustees, the National Gallery, London (NG 3296). Collection Sale I: 89

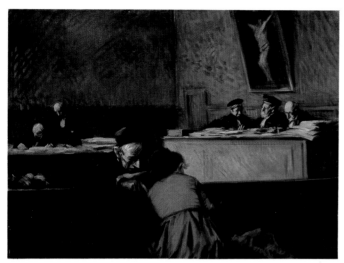

Fig. 57. Jean-Louis Forain (1852–1931), *The Tribunal*, ca. 1902–3. Oil on canvas, 23⅝ × 28¾ in. (60 × 73 cm). Tate Gallery, London (11.96). Collection Sale I: 38

Gauguin, all of whom, although in different ways and to varying degrees, shared his beliefs in the importance of tradition and formal structure. Color too was a primary incentive in Degas's acquisition of modern works. His own experiments with bold color in his late work must have been reinforced by the brilliant canvases of Cézanne, Gauguin, and Van Gogh—all artists who, like himself, were deeply indebted to Delacroix—that had joined his collection. The two Van Gogh still lifes in particular (figs. 11, 12), with their vigorous hatchings of vivid color, seem paralleled by Degas's late pastel technique.

Degas had no disciples as such, but his example influenced a number of artists, especially Gauguin, Georges Seurat, Cassatt, Henri de Toulouse-Lautrec, Forain, and Valadon. His recorded statements suggest that he resented being imitated too closely. He is known to have told William Rothenstein that he admired Toulouse-Lautrec's draftsmanship,[212] but he did not collect that artist's work and seems to have felt that it derived too much from his own. To Valadon's comment, "He dresses in your clothes," Degas responded dryly, "But adjusting them to his size."[213] Of Forain, whose subject matter and style most conspicuously derived from Degas, he remarked, "He paints with his hands in my pocket."[214] He owned only one painting by Forain, *Le Tribunal*, circa 1902–3 (fig. 57), but he did have a number of drawings that indicate he admired Forain's caricatural drawing style (fig. 389).

Often Degas's omissions as a collector are as striking as his acquisitions. We have noted that some of the principal Impressionists were only sparsely represented in the collection; nor were there many works by the minor artists in the Impressionist group who were his friends and protégés, such as Federico Zandomeneghi (fig. 403) and Henri

Rouart, and none by Jean-François Raffaëlli; the fact is surprising because Degas's persistent championship of these artists had caused considerable dissension in the Impressionist ranks.

Degas's seeming indifference to other contemporary movements is also intriguing. He owned no works by Seurat or his Pointillist followers—"very big" was his only recorded comment on *Sunday Afternoon on La Grande Jatte* when it was shown with his own work at the last Impressionist exhibition, in 1886—yet the speckled application of color in his pastels of the late 1880s suggests a response to Seurat.[215] Symbolism too seems to have left him cold, with the exception of the work of Eugène Carrière, whom he apparently appreciated.[216] He admired Édouard Vuillard, of whom he once said that he could "turn an old wine bottle into a bunch of sweet peas,"[217] but on the whole he disliked the Nabis and owned none of their work.[218] He did not respond to Fauvism, although he was friendly with Georges Rouault. He seems to have been impressed but puzzled by the Cubists: "They're very strong, those young people, and they could do something much more difficult than painting,"[219] he is said to have remarked after an early Cubist exhibition.

Although selective in his acquisitions of their work, Degas was in general very encouraging to younger artists. The myth that he was a misanthropic recluse in the latter part of his life is much exaggerated. It is true that after his move from the rue Victor Massé in 1912 Degas became very isolated, but before that time he received a constant stream of visitors, as is clear from numerous contemporary accounts.[220] Suzanne Valadon claimed to have visited him every day for a time; Maurice Denis painted his portrait twice; Rouault transcribed his brief conversations with Degas in his *Soliloques;* and many other artists, including Gauguin, Cassatt, and lesser-known figures, had regular access to Degas's studio and apartment. In an era before art publications were issued in abundance, all of these artists must have found Degas's collection a remarkable resource. There were few places in Paris where one could see paintings and also little-known drawings by Ingres and Delacroix hung alongside works by Manet or the most recent accomplishments of Cézanne and Gauguin.

DEGAS AND MANET

Among Degas's friends, it was Édouard Manet (1832–1883) with whom he was the most overtly competitive. From similar haut-bourgeois backgrounds, Degas and Manet also shared much common ground as artists. Their friendship

was at its most intimate in the late 1860s and early 1870s,[221] the period when Degas drew and etched a number of portraits of Manet that capture his debonair style and painted the double portrait of Manet and his wife (fig. 248) that led to the famous rift between the two artists. (Manet cut off part of the painting that included his wife, Suzanne, supposedly because he did not like the way Degas had depicted her; Degas, according to Vollard, responded by returning a small still-life painting of plums that Manet had given him.) Although they grew apart, Degas never lost his admiration for Manet's work, eventually acquiring a remarkable selection of his still lifes, portraits, and modern-life subjects in several media—paintings, drawings, and prints.

Both artists were known for their wit and urbanity, and in their art they were linked by a commitment to contemporary life, which both observed with detachment and irony. And for each the underpinning of his modernity lay in his study of the old masters. Indeed, the two are reputed to have met as students when both were copying Velázquez's *Infanta Margarita* in the Louvre and Manet, to his astonishment, discovered Degas etching his copy directly onto a copper plate. Degas was later to acquire Manet's etching after the same work (fig. 241).[222]

Degas and Manet were also both involved in Naturalist circles, groups mainly of artists and writers, among them Edmond Duranty, who sought to render ordinary, everyday subjects in seemingly natural ways. During the 1870s Degas moved away from the conventions of portraiture epitomized by Ingres and developed a more informal style in which he sought to capture the essence of personality through facial expression and above all through gesture and pose. As Duranty explained in his pamphlet *The New Painting,* published in 1876 and often taken to be a vehicle for Degas's ideas, "The form of a back should reveal a whole temperament, an age, a social condition"; "A gesture should express a whole range of feelings."[223]

Two portraits by Manet that were in Degas's collection particularly exemplify this radical new approach. The pastel portrait *Madame Manet on a Blue Sofa* (fig. 242) shows the sitter dressed in street attire but casually reclining on a sofa, as if she had just returned, exhausted, from a shopping expedition. The portrait of the Impressionist painter Berthe Morisot (fig. 253), to whom both Manet and Degas were very attached, was painted shortly after the death of her father in January 1874 and is unique in Manet's oeuvre for its unrestrained expression of strong feeling. Demonstrating extraordinary empathy for his subject's grief, Manet conveys her anguish in the facial expression and by the wild, expressionistic brushwork.

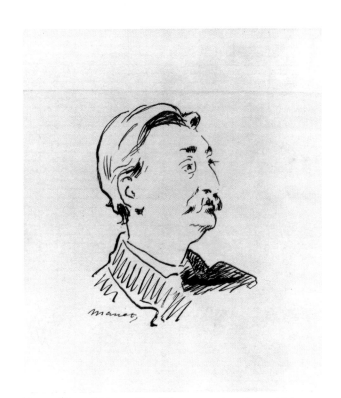

Fig. 58. Édouard Manet, *Henri Vigneau,* ca. 1874. Pen and ink, 7¾ × 5⅝ in. (19.9 × 14.3 cm). The Baltimore Museum of Art: The Cone Collection, formed by Dr. Claribel and Miss Etta Cone of Baltimore, Maryland (50.12.654). Collection Sale I: 220

Fig. 59. Édouard Manet, *Seated Woman Wearing a Soft Hat,* ca. 1875. Graphite and ink wash, 7⅜ × 4¾ in. (18.6 × 12 cm). The Fine Arts Museums of San Francisco, Achenbach Foundation for Graphic Arts, Bequest of Ruth Haas Lilienthal (1975.2.6). Collection Sale I: 224

Fig. 60. Édouard Manet, *The
Execution of Maximilian, Emperor of
Mexico,* ca. 1867–68. Oil on canvas,
four fragments mounted on a single
support, 76 × 111⅞ in. (193 × 284 cm).
Reproduced by courtesy of the
Trustees, the National Gallery,
London (NG 3294). Collection
Sale I: 74

Fig. 61. Édouard Manet, *Leaving the Bath,* 1860–61. Ink and wash, 10⅜ × 8 in. (26.6 × 20.3 cm). Private collection. Collection Sale II: 220

Both the detached air of modern reportage and the references to earlier art, especially to Goya's *Executions of May 3, 1808,* must have contributed to the appeal for Degas of *The Execution of Maximilian* (fig. 60), Manet's great modern-life history painting and the most important work by him that Degas owned. The depiction of the incident—the execution of the emperor Maximilian and his two generals Mejía and Miramón—is utterly stripped of the rhetoric one would expect in conventional history painting. The accidental, casual grouping of the soldiers and their victims has all the immediacy of a modern newspaper photograph. The physical impact of the scene is further reinforced by the stark black-white contrast of the soldiers' uniforms and the tactile quality of Manet's paint surfaces. The value the painting held for Degas is clear from the pains he took to track down and assemble the fragments into which it had been cut. It is especially interesting that the first fragment Degas acquired was the one that shows the sergeant loading his rifle, a choice that accords with his taste for random, unedited details and his fascination with the gestures of an individual absorbed in a particular task—the recurring pose of a ballet dancer tying her slipper, for instance.

For both Manet and Degas, the theme of a bather held an interest that can be linked to admiration for the art of the past. It was perhaps in recognition of this mutual interest that Degas acquired Manet's fluent ink drawing *Leaving the Bath,* 1860–61 (fig. 61), in which light and dark areas are deployed to exceptionally painterly effect. The drawing is a sketch for *The Surprised Nymph,* a painting in which Manet deliberately attempted to rival the outdoor nudes of Raphael or Rubens.[224] Degas's comment in his notes, "probably for a Susanna," acknowledges Manet's allusion to the traditional biblical subject of Susanna and the Elders. Among other drawings by Manet in the collection was a sketch, dashed off like a caricature, of the famous *Olympia,* a gift from the artist. It is probably a drawing for the etching of the same subject, an impression of which Degas owned (fig. 271).[225] Degas was clearly attached to this emblem of nineteenth-century painting; he also owned a copy of the painting by Gauguin (fig. 67).

Manet has often been called an artist's artist. Degas, who had the greatest respect for the artist's craft, must have appreciated the sheer painterly bravura of *Gypsy with Cigarette* (fig. 255), an exceptionally bold and colorful painting for its early date of 1862. And he must have admired the loose, open brushwork of *Woman with a Cat* (fig. 243), not to mention the virtuoso painting displayed in the two still lifes he owned, *The Ham* (fig. 8) and *Pear* (fig. 245), both of which admirably display Manet's rapid, fluent touch. *Pear* is typical of the little painterly still lifes, often depicting only a single or a very few objects, that Manet painted in the 1880s as gifts for friends.[226]

DEGAS AND CÉZANNE

Degas's friends were at first surprised by his enthusiasm for the work of Paul Cézanne (1839–1906). "Degas so passionate over Cézanne's studies, what do you think?" exclaimed Pissarro in a letter to his son Lucien, after a one-man exhibition of Cézanne's work had opened at Vollard's gallery in December 1895.[227] It is true that on the face of it Degas, an urbane Parisian, had little in common with Cézanne, who was known for his gruff, churlish manner. Nevertheless, during the 1860s and 1870s they both belonged to the circle of artists that congregated at the Café Guerbois in Paris. Both were outside the mainstream of Impressionism, although each exhibited with the group, Cézanne in 1874 and 1876 and Degas in seven of the eight exhibitions. During these years they formed an awkward association, engaging in lively discussions about art that would sometimes explode into outright conflict, but they were never friends.[228]

During the 1880s they saw little of each other, partly because Cézanne withdrew increasingly to the solitude of his family estate near Aix-en-Provence in the south of France.

Yet Degas clearly felt a profound affinity with Cézanne as an artist. Julie Manet, who visited the Vollard exhibition with Renoir and Degas, recorded in her journal how the two had drawn lots for "a magnificent still-life watercolor of pears" (*Three Pears,* circa 1888–90; fig. 278).[229] In the next few years Degas acquired from Vollard no fewer than seven paintings by Cézanne: *Bather with Outstretched Arms* (fig. 283); *Victor Chocquet* (fig. 62); *Glass and Apples* (fig. 63); *Apples* (fig. 289); *Two Fruits,* circa 1885 (fig. 280); *Venus and Cupid,* 1873–75 (fig. 284); *Self-Portrait* (fig. 276); and possibly a drawing, *Sleeping Hermaphrodite,* circa 1895–98 (private collection, Switzerland). All were modest in scale and acquired for very low prices; 400 francs, for *Glass and Apples,* was the highest price Degas paid for a work by Cézanne.

The two portraits by Cézanne, *Self-Portrait* and *Victor Chocquet,* display a concentrated energy contained in a web of characteristically densely interlocking brushstrokes. The self-portrait is one of Cézanne's most authoritative images of himself. In the portrait of the collector Chocquet, Cézanne builds up a craggy surface with thick, pastelike touches of paint that endow this mild-looking man with unexpected vigor. Degas was so taken with this portrait that three years later, at the Chocquet sale, he tried to buy another portrait of him by Cézanne. Julie Manet, who was present at the sale, recorded in her diary: "M. Degas was very sorry not to have gotten the Chocquet portrait—'the portrait of one madman by another,' as he said. He liked it

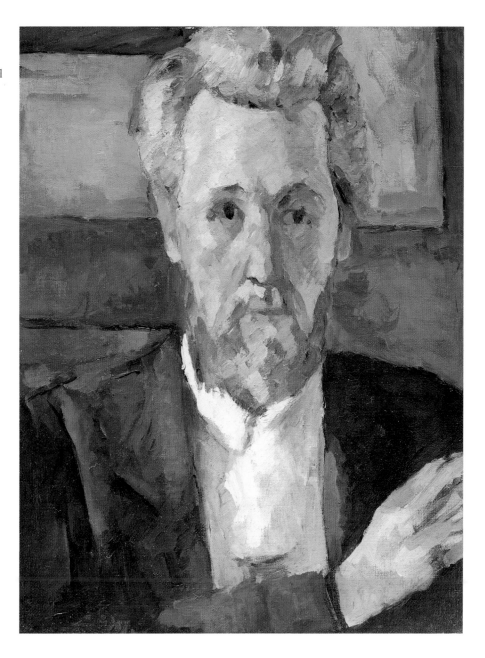

Fig. 62. Paul Cézanne (1839–1906), *Victor Chocquet,* ca. 1877. Oil on canvas, 13⅞ × 10¾ in. (35.2 × 27.3 cm). Virginia Museum of Fine Arts, Richmond, Va., Collection of Mr. and Mrs. Paul Mellon (83.14). Collection Sale I: 15

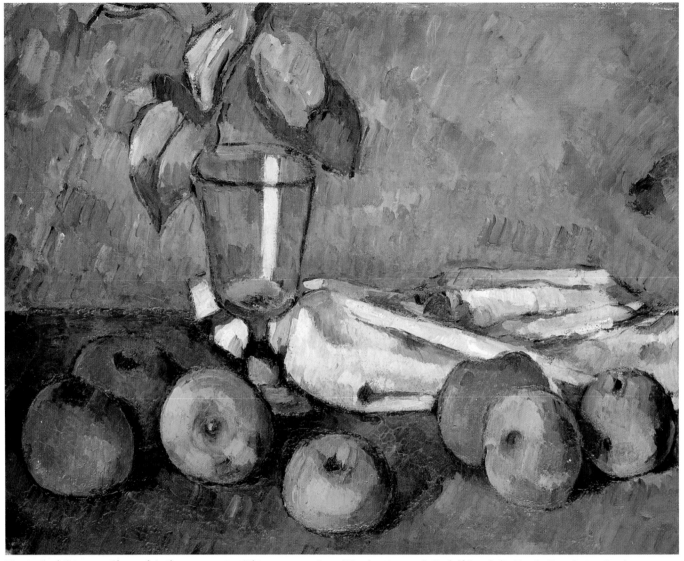

Fig. 63. Paul Cézanne, *Glass and Apples,* ca. 1879–82. Oil on canvas, 12⅜ × 15¾ in. (31.5 × 40 cm). Rudolf Staechelin Family Foundation, Basel. Collection Sale I: 14

enormously. Durand-Ruel bought it for only 3,500, but M. Degas had been afraid that Camondo would get it."[230]

Degas seems to have been drawn to two sides of Cézanne that reflect a polar opposition within his own work between the contained and the expressive. The still lifes Degas chose display wholeness, serenity, and pictorial harmony, while in the figures of bathers the turbulent energy and even the violence of Cézanne's youthful work are only barely contained.

Since Degas virtually ignored still life in his own work, his acquisition of four examples by Cézanne is significant. Except for the tiny *Two Fruits,* a fragment of a larger work, the still lifes all reveal the side of Cézanne that seeks equilibrium and pictorial resolution. *Apples* (fig. 289), probably painted in the mid-1870s, eschews traditional notions of still-life arrangement—seven apples are simply placed on a tabletop—but in the balance between cool yellow-greens and warm orange-reds, and in the tension generated by the

fruits' spherical density and the contours that contain them, Cézanne makes good on the conviction, shared by Degas, that "everything in a painting is about relationships."[231] *Glass and Apples,* one of Cézanne's most beautiful still lifes, achieves its equanimity through the relationships of form and above all color. Like Degas, Cézanne was profoundly influenced by Delacroix's mastery of the interaction between warm and cool tones. In this highly resolved work we see Cézanne at his most poised, with no hint of the unease that sometimes threatens to disrupt the apparent serenity of his more complex works in the genre.

An intriguing entry in a stockbook of Vollard's gallery transactions indicates that Degas may have considered buying one of the most difficult and disquieting paintings from Cézanne's early period, *Luncheon on the Grass,* circa 1870–71 (private collection), in which Manet's famous arcadian scene is recast in terms of a morbid nightmare.[232]

The stockbook entry is struck out, however, which may simply indicate that it was an error on Vollard's part but also suggests the more tantalizing possibility that Degas intended to buy the work and then changed his mind.

Both Degas and Cézanne were obsessed with the venerable theme of bathing figures in a landscape, particularly in the latter part of their careers. For both, the fascination with this classical subject arose from long study of the old masters, with their vast heritage of interpretations of the nude. This passion for the art of the past discloses a surprisingly rich area of common ground between the two. As Richard Kendall has shown, not only did they share a taste for the same artists—including Titian, Veronese, Raphael, Michelangelo, and, among more recent artists, Delacroix—but they copied at least fifteen identical works.[233]

Degas owned two of Cézanne's paintings of bathers, *Venus and Cupid* and *Bather with Outstretched Arms,* and perhaps the drawing *Sleeping Hermaphrodite.*[234] He had much earlier displayed an interest in Cézanne's bathers when in 1877, at the third Impressionist exhibition, he had sketched the central figure of Cézanne's *Bathers: Project for a Painting, Bathers at Rest,* circa 1876–78.[235] But Degas's exploration of the theme of a nude bather in an idealized landscape setting, undertaken in the last decade of his working life, from 1895 to 1905, reveals a late involvement with the work of Cézanne that may well have been prompted in part by the paintings of bathers he acquired for his collection. Venus's pose in *Venus and Cupid* (fig. 284), a rather tumultuous interpretation of this classical theme, has been linked specifically to the central figure in one of Degas's late bather compositions, *Bathers* of circa 1896 (The Art Institute of Chicago),[236] although in fact Degas had already explored this motif in the 1880s.[237]

For Degas, individual actions, poses, and gestures were charged with a high degree of expressive and formal meaning. Clearly, the pose of a figure with a raised arm held a particular fascination for him: it appears in his many variations of dancers leaping with outstretched arms in the celebrated *étoile* (star) pose, and in later pastels of groups of dancers with arms raised. An intriguing example of the links that exist between the art Degas collected and his own art can be seen in a sequence of works with this pose.

The sequence begins with a number of early notebook drawings Degas made at some point in the 1850s after a

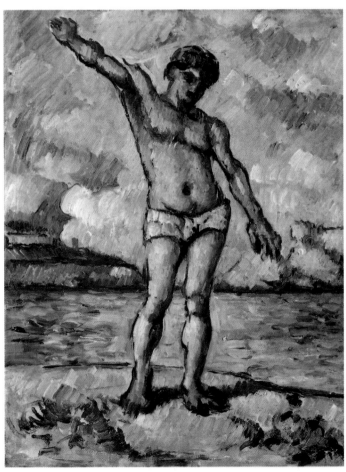

Fig. 64. Paul Cézanne, *Bather with Outstretched Arms,* ca. 1883. Oil on canvas, 13 × 9½ in. (33 × 24 cm). Collection Jasper Johns. Collection Sale I: 12

Fig. 65. Edgar Degas, *Nude Man Standing with Left Hand Raised,* ca. 1900. Charcoal, 26¼ × 17⅞ in. (66.6 × 44.9 cm). The Cleveland Museum of Art. Atelier Sale IV: 182b

small painting of an *écorché* (that is, a flayed figure display-
ing the muscles, often used by artists in studying anatomy)
by the eighteenth-century artist Edme Bouchardon, which
Degas had in his studio. The pose is found again in Degas's
work more than forty years later, when he returned to the
subject, making several charcoal drawings, defining the
figure with the repeated bold contours that characterize his
late style (fig. 65).²³⁸ About the time he was making these
drawings he also acquired no fewer than five works that in
different ways explore the same pose: a drawing of a female
nude by Millet (fig. 150); Delacroix's suite of three dy-
namic drawings of the charging figure of Liberty, studies
for his painting *Liberty, July 28, 1830;* and, most compelling
of all, Cézanne's small, tautly energetic canvas of a stand-
ing man with an arm raised, *Bather with Outstretched Arms*
(fig. 64),²³⁹ one of a number of Cézanne's explorations of
this strange subject.²⁴⁰ In the willed awkwardness of the
pose we can sense the same impulse, almost a desire to dis-
tort the conventional grace of this classical theme, that
underlies many of Degas's late bathers.

The Cézanne entered Degas's collection in 1895, and
perhaps this powerful little painting reactivated an idea
that had lain dormant in Degas's memory, challenging him
to return once again to drawing the *écorché* figure. Whether
Degas deliberately chose those images for his collection be-
cause they related to an idea he was exploring in his work,
or whether he was responding unconsciously to the corre-
spondences between them, is something we can only guess
at. Nonetheless, this glimpse of the way Degas's mind
obsessively reworked a motif surely relates to the concen-
trated and extended studies of a single pose so characteris-
tic of his late work.

DEGAS AND GAUGUIN

Fifteen years younger than Degas, Paul Gauguin (1848–
1903) was in many ways his protégé. As a young artist try-
ing to make his way within the Impressionist circle in the
1870s, Gauguin had looked to Degas for inspiration and
guidance, and to the end of his life Degas remained a
primary influence on his work. Degas offered sustained
support at a time when Gauguin's work attracted mostly
derision and few buyers. By 1881 he had acquired Gauguin's
little still life of a mandolin in exchange for a pastel of
his own.²⁴¹ When Degas bought *La Belle Angèle* (fig. 303)
from the sale Gauguin organized at the Hôtel Drouot
in 1891, Pissarro noted his generosity: "Degas, who deep
down is a kind soul and very sensitive to others' misfortune,
has offered to help Gauguin, and he bought a painting at

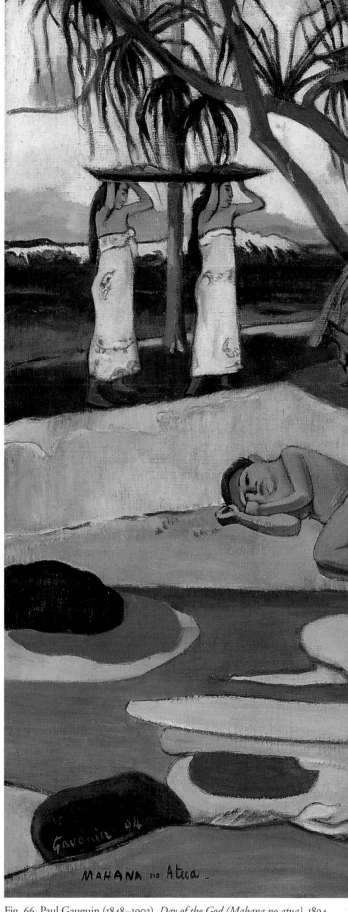

Fig. 66. Paul Gauguin (1848–1903), *Day of the God (Mahana no atua),* 1894.
Oil on canvas, 26⅜ × 35½ in. (67 × 90 cm). The Art Institute of Chicago,
Helen Birch Bartlett Memorial Collection (1926.198). Collection Sale I: 43

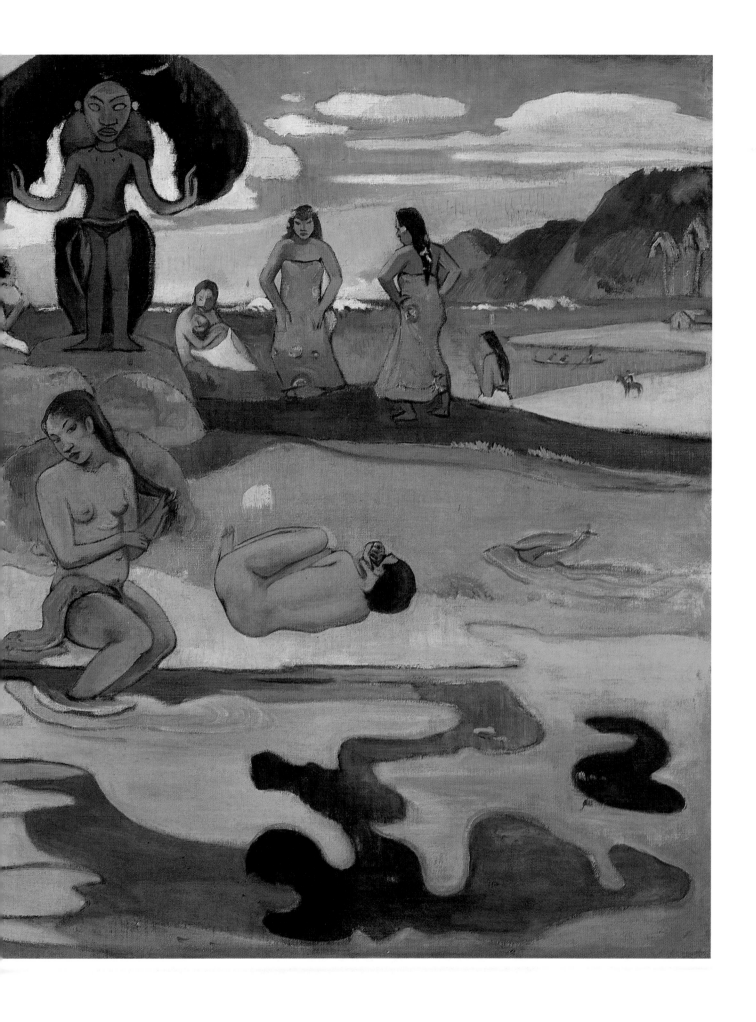

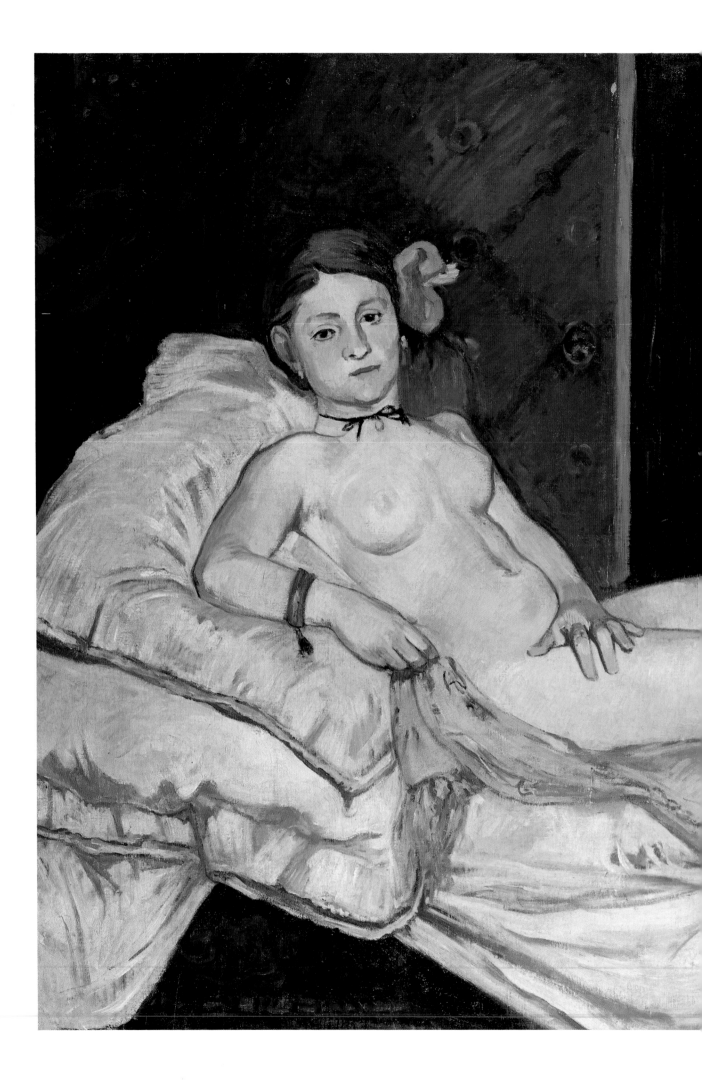

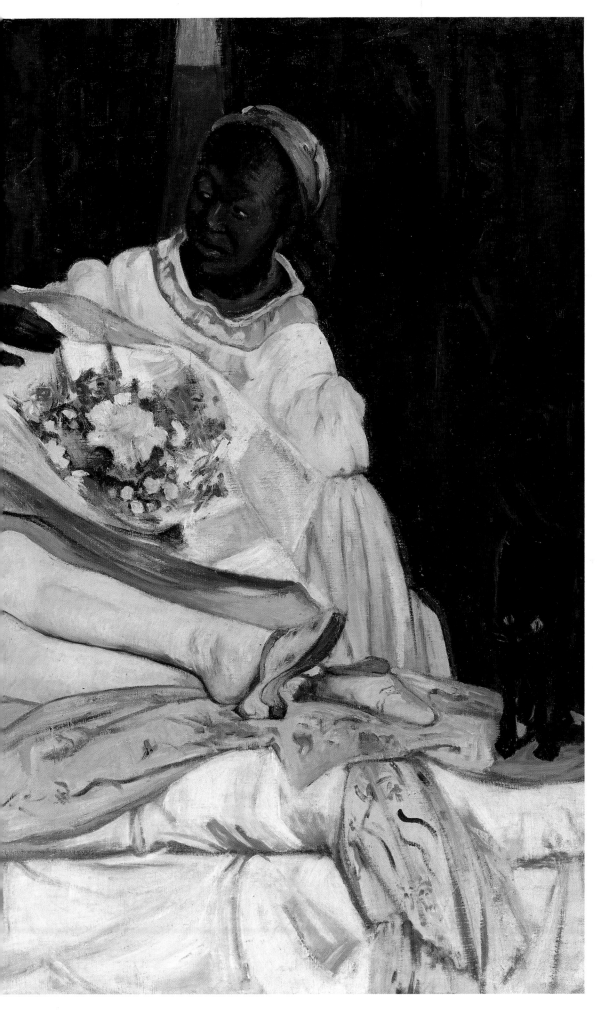

Fig. 67. Paul Gauguin, *Copy after Manet's "Olympia,"* 1891. Oil on canvas, 50⅜ × 35⅛ in. (128 × 89 cm). Private collection. Collection Sale I: 46

his sale."[242] Shortly afterward Degas acquired *Martinique Landscape,* 1887 (fig. 311).[243]

On Gauguin's return from Tahiti in 1893, it was Degas who persuaded Durand-Ruel to give him an exhibition. The sale was a failure, but Gauguin showed his appreciation for Degas's support[244] by later presenting Degas with one of his finest paintings, one that had attracted some of the most hostile criticism at the exhibition, the spectacular *The Moon and the Earth,* now in the Museum of Modern Art, New York (fig. 304).[245] Two years later Degas acquired *Woman of the Mango* (fig. 305) and Gauguin's copy of Manet's *Olympia* (fig. 67) at the sale Gauguin organized to raise money for his last trip to Tahiti. Again the sale was a failure, as Pissarro informed his son Lucien: "The Symbolists here are lost. Gauguin, who is their leader, has just suffered a disastrous failure. His sale was very bad. Without Degas, who bought some paintings, it would have been even worse."[246]

But paternalism is not an adequate explanation for Degas's acquisition of ten of Gauguin's paintings, among them some of his most challenging and now most celebrated works, as well as one pastel, six monotypes, and ten woodcuts. The affinity that Degas felt for Gauguin's work at first seems difficult to comprehend. Certainly in terms of character and temperament the two men could not have been more different: Degas, the Parisian bourgeois whose life was regulated by domestic and social routine; Gauguin, the restless adventurer who sought an escape from civilization in the exotic and the unfamiliar. Degas was baffled by Gauguin's flight to the South Seas, remarking on one occasion, "I advised him to go to New Orleans, but he considered it too civilized. He needs people with flowers on their heads and rings through their noses."[247] And he had little taste for Gauguin's mythical subjects or his Symbolist aims. To understand Degas's response to Gauguin's work, one has to look more deeply into Degas's artistic concerns. It is clear from the paintings he acquired that in their formal qualities and vivid color he found an affinity relevant to many of the issues that challenged him, especially in his late work.

Although Degas never shared Gauguin's pursuit of flatness and uninflected surfaces—texture was always important to Degas, especially in his late pastels—he must nevertheless have regarded Gauguin's brilliant zones of color enclosed in strong contours as a development parallel to the high-key, antinaturalistic palette and bold, abstracting line that he himself had been evolving since the late 1880s. Like Degas, Gauguin admired both Ingres and Delacroix, and like (and perhaps inspired by) Degas, he too sought to create a visual language from the fusion of color and line, although in an entirely different and more decorative manner. Gauguin's description of the disparate images that he assembled in a scrapbook, linked by a common emphasis on line, strikingly corresponds to a number of the works in Degas's collection: "Japanese sketches, Hokusai prints, Daumier lithographs; Forain's cruel observations grouped together in an album, not by chance but quite intentionally. I add to them a photograph of a painting by Giotto—because even though they look different, I want to demonstrate the similarities between them."[248]

Degas responded to Gauguin's sense of pictorial structure. Perhaps it is not far-fetched to suggest that he sensed in Gauguin's magnificent *Day of the God* (fig. 66) a reminder of the symmetry and formal design of Ingres's *Apotheosis of Homer* (fig. 28). The central figure of Homer is here replaced by a Tahitian deity; the echoing forms in the Ingres—the two seated figures of the Iliad and the Odyssey—resurface in the Gauguin in the mirror images of the two reclining nudes. The rhythm established by this compositional device corresponds to the point and counterpoint that Degas himself often exploited most effectively by combining different views of a single figure, as, for instance, in *Laundresses Carrying Their Linen,* circa 1878–79 (private collection), or *Dancers at the Barre,* 1876–77 (The Metropolitan Museum of Art, New York).[249]

Like Degas and many other artists of the time, Gauguin studied Delacroix's *Journal* closely. His debt to the great Romantic is acknowledged in a long passage in his unpublished manuscript "Diverses Choses" in which Gauguin boasts of going beyond Delacroix's discoveries: "Color! This profound, mysterious language, a language of the dream. I enjoy imagining Delacroix having arrived in the world thirty years later and undertaking the struggle that I dared to undertake."[250] The legacy of Delacroix's glowing palette is clear in such works as Gauguin's *A Vase of Flowers* (fig. 306), while *Woman of the Mango* (fig. 305) offers one of the most striking examples of Gauguin's audacious use of color and powerfully linear composition. The deep purple of the dress seems to vibrate against the strong chrome-yellow background, and the impact is made even more immediate by the bold contours that outline the figure in a shallow space, pulling her right up to the picture plane.

In one of his most original paintings, *La Belle Angèle* (fig. 303), Gauguin achieves a compelling iconlike effect by isolating the figure in a circle that suggests a halo; the device is borrowed from the well-known prints of Hiroshige and Hokusai, which both he and Degas admired.[251] The impact of Japanese art is felt, too, in *Te faaturuma,* also known as *Sulking,* 1891 (fig. 296), both in the use of a high

viewpoint and in the figure silhouetted against an empty space. Gauguin often developed in his paintings ideas that had originated with Degas; the image in this work of a weary woman sitting head-in-hand recalls some of Degas's figures of dancers seated in empty rehearsal rooms. When Degas acquired the painting from Durand-Ruel in 1898, Gauguin seems to have been particularly proud and had a publicity photograph of himself taken in front of it.[252]

Degas appreciated Gauguin's sheer technical virtuosity, noting admiringly that his copy of Manet's *Olympia* had been "done in three days,"[253] though this claim smacks of Gauguin's notorious bragging—in fact, he took more than eight days to complete his copy.[254] But Degas probably enjoyed Gauguin's response to Manet's famous image, an image that he himself valued highly. Here it is worth noting another connection between Manet and Gauguin: Gauguin's *The Ham,* 1889 (Phillips Collection, Washington, D.C.), was inspired by Manet's painting of the same subject, which he would have seen in Degas's apartment.[255]

THE PRINTS

Degas once remarked, "If I had to live my life again, I would work only in black and white."[256] Throughout his long career he was a tireless experimenter with all kinds of techniques and media; he worked in oil, charcoal, pencil, pastel, wax modeling, and even photography. But his con-suming fascination with invention and process is reflected above all in his prints. Degas was an outstanding print-maker whose experiments in etching and monotype extended the creative possibilities of these techniques in entirely new ways. His large collection of prints was exceptional both for the exceedingly high quality of nearly every piece he acquired and for the inventiveness of the ones produced by his contemporaries. Yet the prints remain the least explored area of his collection.

Degas owned virtually no old master prints.[257] His collection consisted mainly of French nineteenth-century prints that encompassed nearly all the major developments of that enormously innovative period in the history of printmaking. Ingres made only a few prints, but Degas owned, in addition to three lithographs, a very fine impression and a counterproof of the only etching he ever made, *Gabriel Cortois de Pressigny.*[258] Delacroix was represented by lithographs after antique medals (an enthusiasm shared by Pissarro) as well as by lithographs of animals (fig. 223) and historical scenes,[259] and Théodore Géricault by a small group of the equestrian lithographs that, as Reff has pointed out, may have influenced Degas's early studies of racehorses.[260]

By far the largest groups were Degas's vast holdings of prints by Honoré Daumier and Paul Gavarni, the two great nineteenth-century illustrators who, working in the relatively new medium of lithography, had from the 1830s on reached a wide public by way of such satirical periodicals

Fig. 68. Honoré Daumier (1808–1879), *Rue Transnonain, April 15, 1834,* July 1834. Lithograph, 11⅜ × 17½ in. (29 × 44.5 cm). The Metropolitan Museum of Art, New York, Rogers Fund, 1920 (20.23). Surrogate for Degas's unlocated impression, Collection Print Sale: 69

Fig. 69. Honoré Daumier, from The Middle Class (Les Bons Bourgeois), *a:* "What the middle class has agreed to call a little recreation" ("Ce que le bourgeois est convenu de nommer une petite distraction"), August 1846; *b:* "The trouble with leaving . . . a train . . ." ("Inconvénient de quitter . . . un convoi de chemin de fer . . ."), January 1847. Lithographs, image 10⅛ × 8⅞ in. (25.5 × 22 cm). The Metropolitan Museum of Art, New York, Rogers Fund, 1922 (22.61.14, 22.61.17). Surrogates for Degas's unlocated impressions, Collection Print Sale: 77, 99bis

as *La Caricature* and *Le Charivari*. The 750 or so Daumier prints included outstanding examples of his most important early lithographs, such as *Rue Transnonain, April 15, 1834* (fig. 68) and *The Legislative Belly* (fig. 226), as well as groups of impressions from most of his major suites, including The Happy Days in Life, The Middle Class, Parisian Boaters, and The Human Comedy. While many of the lithographs in the collection sale were of exceptional quality, as annotations in the catalogue indicate, Degas also collected ordinary, mass-produced impressions that he simply cut out of the pages of *Le Charivari.*[261] (Degas did not have a collector's stamp, but the prints, or at least the good impressions, were stamped "Atelier Ed. Degas" in red or black in December 1917, three months after his death. The lithographs he cut out of *Le Charivari* probably do not have the stamp.)

Degas was unusual among contemporary print collectors in his appreciation of both Daumier and Gavarni.[262] Gavarni was represented in his collection by about two thousand lithographs, including groups from most of his major suites, such as The *Lorettes*, Paris by Night, The Enfants Terribles, and The Students of Paris, in distin-

guished as well as in ordinary impressions. Thanking his friend the print collector Alexis Rouart for a gift of about ninety very fine lithographs by Gavarni, Degas wrote: "Wednesday morning I'll drop everything to have a long look with a magnifying glass and in good daylight at the magnificent Gavarnis you have given me. I'll make a separate box for the items of that quality and I'll put an ordinary impression next to each one, and that will double my enjoyment of the exceptional one."[263]

Although Degas appreciated Daumier's and Gavarni's prints as fine examples of lithography, it was their imagery that had the greatest impact on his art.[264] At the end of the 1860s Degas's quest for greater naturalism was accompanied by a turning away from historical subjects and toward the contemporary themes that were to dominate his art for at least the next fifteen years. In developing a new imagery for these subjects, Degas derived many lessons from art of a lower status—caricature.

The poet (and art critic) Charles Baudelaire had already praised Daumier and Gavarni for expressing what he called "the epic and heroic quality" of modern life in his essay *The Painter of Modern Life* (1859).[265] Baudelaire's ideal

was most completely fulfilled, however, by the minor illustrator Constantin Guys, whose ephemeral cameos of social scenes do not seem to have interested Degas, probably because they do not sufficiently transcend the fashion that inspired them. But in the penetrating vision and daring compositions of Gavarni and especially of Daumier, Degas found new ways of exploring modern-life subjects that had meaning for him.

When Degas commented in a notebook in about 1868, "Ah! Giotto, let me see Paris, and you, Paris, let me see Giotto,"[266] he was summing up epigrammatically his need to address modern subject matter without sacrificing the form and draftsmanship of classical art. For Degas, and for many of his contemporaries as well, no artist achieved this synthesis more effectively than Daumier. Both Baudelaire and Degas explicitly ranked Daumier's draftsmanship with that of Ingres and Delacroix.[267] "What distinguishes Daumier is his certainty," Baudelaire had observed: "he draws like the great masters."[268]

Degas admired Daumier for the vigor of his line and his sense of plastic form. It is significant, perhaps, that both artists shared a need to take the expression of form beyond the flat surface by modeling in wax. In his paintings Daumier's line develops into the heavy, articulated contour that we see defining the shadowy bulk of the figure in *Don Quixote Reading* (fig. 154), the only painting by Daumier that Degas owned.[269] But it was above all the incisive line of Daumier's caricatures that confirmed for Degas his

belief in the power of drawing to capture the essence of a subject. This is clear from a rapid notebook sketch Degas made of one of Daumier's most famous lithographs, *The Legislative Belly*, at the time of an important exhibition of Daumier's work that Durand-Ruel mounted in 1878 (fig. 225). In his sketch we can see Degas emulating Daumier in a few swift lines that pinpoint the heart of the caricaturist's mordant attack but do not attempt to duplicate the image. Later Degas acquired a fine impression of this print (fig. 226).

In Daumier's lithographs Degas found a whole range of subjects that corresponded to the material he was investigating for his portrayal of life in modern Paris, while Daumier's bold compositions inspired the cropping of figures, unusual viewpoints, and strongly contrasted lighting that Degas utilized in shaping his snapshot vignettes of modern urban life. The relationship is especially apparent in Degas's works on theatrical and café-concert subjects. For instance, Daumier's *Bring Down the Curtain, the Comedy Is Over* (fig. 70), with the clown's raised arm silhouetted against the light, anticipates similar theatrical gestures in Degas's many depictions of entertainers; for example, the black-gloved hand in his painting *Café Singer*, circa 1878 (fig. 71).

Degas's ability to seize the telling gesture or pose was crucial to his modernity. He found a kindred impulse in Daumier's talent for "reducing figures or things to a few traits which capture their particularity," which Duranty

Fig. 70. Honoré Daumier, *Bring Down the Curtain, the Comedy is Over*, 1834. Lithograph, 7⅞ × 11 in. (20 × 27.8 cm). The Metropolitan Museum of Art, New York, Gift of Mrs. Edwin De T. Bechtel, 1958 (58.580.38). Surrogate for Degas's unlocated impression, Collection Print Sale: 63

Fig. 71. Edgar Degas, *Café Singer*, ca. 1878. Oil on canvas, 21⅛ × 16⅜ in. (53.5 × 41.8 cm). The Art Institute of Chicago, Bequest of Clara Margaret Lynch in Memory of John A. Lynch (1955.738)

Fig. 72. Paul Gavarni (1804–1866), *Man and Woman Talking,* from The *Lorettes,* 1842. Lithograph, 7¾ × 6⅛ in. (19.8 × 15.8 cm). Trustees of the British Museum, London (1980.5.10.164). Collection Print Sale: 144

Fig. 73. Paul Gavarni, *La Coiffure,* from The *Lorettes,* 1842. Lithograph, 7¾ × 6¼ in. (19.8 × 15.8 cm). Trustees of the British Museum, London (1980.5.10.163). Collection Print Sale: 144

had singled out for praise in an article on the 1878 exhibition.[270] A listener and a performer at a café-concert, pictured in Daumier's lithograph *At the Champs-Élysées* from his series The Good Days in Life (fig. 233), find echoes in the figures of world-weary café habitués we see in works by Degas such as *In a Café (The Absinthe Drinker),* circa 1875–76 (Musée d'Orsay, Paris); but they seem more specifically related in their poses to the figures in his portrait *Lorenzo Pagans and Auguste De Gas* (fig. 92), a painting that hung in Degas's apartment all his life. The lithograph's contrast between the slumped figure of the inebriated man and the taut energy of the performer is paralleled by the vigorous pose of the celebrated Spanish guitarist and the absorbed receptivity of Degas's father as he listens to the music.

"Gavarni was a great philosopher," Degas told his friend Jeanniot. "He knew about women."[271] In The *Lorettes,* published in 1842, in which Gavarni chronicled the lives of the demimondaines, quasi-prostitutes who earned their living on the borderline of Parisian society (figs. 72, 73), we find an important precedent for Degas's scenes of women at their toilette. Some scenes that show the *lorettes* conversing with each other or with their protectors anticipate Degas's own venture into illustration—the monotypes he

produced to accompany Ludovic Halévy's *La Famille Cardinal,* 1876–77, a tale of two dancers and their adventures behind the scenes at the Paris Opéra.

Gavarni's numerous compositions that revolve around the interaction of two figures may have encouraged Degas's penchant for painting double portraits. And Gavarni's device of implying a narrative subtext but leaving it intriguingly unresolved, as he does in the scene of a man and a woman conversing with their backs turned to the viewer (fig. 72), is reflected in paintings by Degas that hint at a narrative content: for instance, *Sulking,* 1869–71 (The Metropolitan Museum of Art, New York), and *Interior,* circa 1868–69 (fig. 94), in both of which the atmosphere is tense with some unexplained narrative dynamic between the male and female protagonists.

Degas's collection included works by artists who were pioneers in the revival of etching in the 1850s and 1860s: Bracquemond, Whistler, Legros, Fantin-Latour, and above all Manet. They were all members of the Société des Aquafortistes, founded in 1862 by the printer Auguste Delâtre and the print dealer and publisher Alfred Cadart. Although Degas was never a member of the society, his close involvement with it is revealed by etchings and drypoints by

Delâtre that were dedicated to him.[272] Bracquemond's etching after Holbein's *Erasmus,* a tribute to an artist whom Degas also admired and whose work he too had copied,[273] was a key work in the etching revival: a state commission, it had provoked a scandal when it appeared in 1863, since Bracquemond had violated accepted norms by reproducing an old master work in an etching instead of in the traditional medium, engraving.[274]

Whistler was represented in Degas's collection by sixteen early etchings documenting life along the Thames—the "Thames Set," as they came to be called—produced soon after the artist's return to London from Paris in 1859. In *The Lime Burner* (fig. 74) Whistler evokes a complex and mysterious space with a web of lightly and more heavily etched lines. "The profound and complicated poetry of a vast capital" is what Baudelaire observed in these prints when they were exhibited at the Galerie Martinet in Paris in 1862.[275] This impression is particularly fresh, suggesting that it is from an early set printed by Whistler and Delâtre about 1861 rather than from the edition of one hundred printed a decade later in London.[276]

Nearly all the graphic work of Manet, most of it acquired from the sale of Philippe Burty's collection in 1891, was represented in Degas's collection.[277] Included were outstanding impressions of etchings after Manet's own paintings, among them *Lola de Valence, Olympia,* and *The Dead Toreador,* as well as some based on old master works, such as *The Infanta Margarita* and *Philip IV* after Velázquez, in which the artist achieved remarkably painterly effects in the black-and-white medium. One of the finest etchings was intended as a cover design for a portfolio of fourteen prints to be published by Cadart about 1862–63 (fig. 76). The motif of a hat and a guitar lying on a pile of Spanish costumes was taken from one of Manet's paintings.[278] The etching, of exceptional quality, is of particular interest because of its dedication of friendship: "à mon ami, Charles Baudelaire" (and see fig. 77).[279]

In addition to the etchings, Degas possessed some of Manet's most innovative lithographs, such as *Balloon* and *The Races*—which were distinguished from conventional lithographs of the time by their exceptionally free and spontaneous drawing style—as well as a fine impression of *The Execution of Maximilian* that was based largely on the London version of the painting (figs. 274, 258, 247).[280] Degas also acquired an impression of Manet's only known experiment in color lithography, *Polichinelle,* 1874, from the sale of Edmond Duranty's collection in 1881, and owned an impression of the unique first state in black and white (fig. 275).[281] But perhaps the most delightful of Degas's lithographs by Manet was *The Cats' Rendezvous*

(fig. 75),[282] a design for a poster intended to advertise a little book of anecdotes about cats, *Les Chats,* written by Jules Champfleury, who was famous as the great champion of Realism and defender of Courbet. The design's elegant silhouettes, so suited to its feline forms, are an obvious response to Japanese prints, which provided an impetus to both Manet and Degas in their painting and their printmaking.[283]

Some of the most complex and fascinating prints in the collection were those by Camille Pissarro and the strong-minded American artist Mary Cassatt, who were Degas's principal collaborators in 1879 in a short-lived venture to produce a journal containing original prints, to be known as *Le Jour et la nuit* (Day and Night). Although the scheme was never realized, the experiments in unconventional methods carried out in Degas's studio stimulated him and his friends to produce prints of outstanding originality.[284] As Barbara Stern Shapiro has explained: "For the first time in the nineteenth century, the etching medium, with all its most creative ramifications, was explored artistically for

Fig. 74. James Abbott McNeill Whistler (1834–1903); *The Lime Burner,* 1859. Etching and drypoint, 10 × 7 in. (25.3 × 17.8 cm). Dr. and Mrs. Meyer P. Potamkin. Collection Print Sale: 321

Fig. 75. Édouard Manet, *The Cats' Rendezvous*, 1868. Lithograph, first state, 25⅝ × 19¾ in. (65 × 50 cm). Nationalmuseum, Stockholm (NM G 325.1924). Collection Print Sale: 272

its own sake. Its role as a means of reproducing paintings was completely rejected; instead, the intention to fashion impressionistic, painterly images without obvious contours or noticeable etched lines was brilliantly achieved."[285]

More than thirty impressions by Pissarro, among them multiple proofs of some prints, were included in the sale of Degas's collection.[286] They are some of Pissarro's most original prints, and Degas's active involvement in their making—both giving advice and actually printing at least a dozen of the impressions—is of great interest. The extent of Degas's participation is clear from his detailed technical instructions in a letter to Pissarro advising him to use a copper rather than a zinc plate. Degas was probably referring to the unique first state of *Wooded Landscape at l'Hermitage, Pontoise* (fig. 323), which Pissarro intended to be his contribution to *Le Jour et la nuit* and which was still in Degas's possession at the time of his death.[287]

Among the most beautiful of the prints on which the two artists collaborated are those in the *Twilight with Haystacks* series, particularly the second and third states, where Degas's inventiveness is displayed in the unusual colors—red, brown, red-brown, and green, and ultramarine and

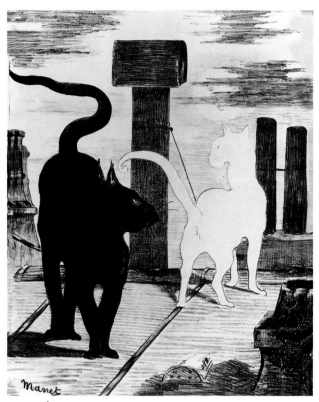

Fig. 76. Édouard Manet, *Hat and Guitar*, "*Eaux-fortes par Édouard Manet*," 1862. Etching, drypoint, and aquatint, first state, 17⅜ × 11¾ in. (44 × 29.6 cm). Nationalmuseum, Stockholm (NM G 303.1924). Collection Print Sale: 224

Fig. 77. Édouard Manet, *Baudelaire*, 1868. Etching with pen and brown ink, second state, 6⅞ × 4⅛ in. (17.5 × 10.6 cm). Nationalmuseum, Stockholm (NM G 313.1924). Collection Print Sale: 248

Fig. 78. Mary Cassatt (1844–1926),
Maternal Caress, 1891. Drypoint, aquatint,
and softground etching, printed in color,
14⅜ × 10⅝ in. (36.7 × 26.9 cm). The
Metropolitan Museum of Art, New York,
Gift of Paul J. Sachs, 1916 (16.2.5). Surrogate
for Degas's unlocated impression, Collection
Print Sale: 50

crimson—in which he printed different impressions.[288] By capturing a single motif in different light effects, these differently colored print impressions embody the essence of Impressionism and anticipate Monet's *Haystacks* by about ten years. Degas also owned two states and eight proofs of *Woman Emptying a Wheelbarrow,* another print on which he collaborated with Pissarro in the printing process (figs. 326–328).[289] Here too Pissarro conceived of the various proofs as a series, this time recording a progression of seasonal effects.[290] That Degas was himself interested in pursuing the notion of a series is apparent from notes he made for a series of modern-life subjects for *Le Jour et la nuit.*[291] Of course in a broader sense a serial approach to the making of prints corresponds to Degas's repeated explorations of a single theme—women bathing, for

instance—and to his open-ended approach to the creating of images.

After Degas's death more than ninety impressions of Cassatt's prints—her "delicious efforts in engraving," as he called them—were found in his studio. These were mostly working proofs and varying states that she had executed and printed years before, when she had worked closely with Degas on prints for the proposed *Le Jour et la nuit.*[292] Among them were a first state, four other states, and a trial proof of her intended etching for this project, *In the Opera Box,* no. 3 (figs. 316, 317),[293] based on *Woman in a Loge,* a painting of 1879 (Philadelphia Museum of Art), which shows her sister Lydia, a fan in her hand, in a box at the theater. (Cassatt used a related motif, a young woman in profile in a theater box, for a pastel that Degas also

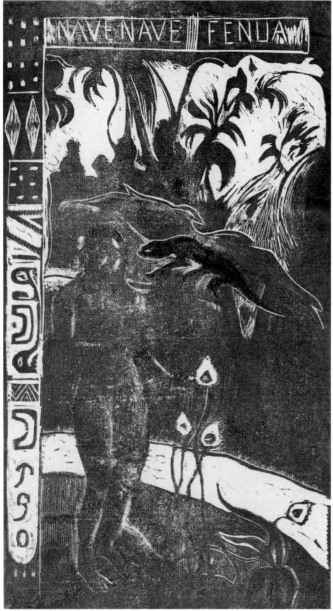

Fig. 79. Paul Gauguin, *Nave nave fenua*, 1893–94. Woodcut printed in black and grayish brown, touches of watercolor; mounted on heavy blue paper, 14 × 8 in. (35.6 × 20.3 cm). The Metropolitan Museum of Art, New York, Rogers Fund, 1922 (22.26.11). Probably Collection Print Sale: 128.2

owned.)[294] Cassatt's prints of this period reflect her experiments in the unconventional techniques of soft-ground etching and aquatint, which she had learned from Degas, both used here with great effect to suggest the contrast between shadowy darkness and bright artificial light in the theater. Degas's fascination with the evolution of these experimental prints is confirmed by the fact that he owned all thirteen states of one of Cassatt's most ambitious prints, *The Visitor* (figs. 320–322).[295] As Shapiro has observed, it is this print that reveals most clearly Cassatt's response to Degas's innovations. In its composition, diagonal perspective, and contre-jour (placement of forms against the

light), and in the highly experimental mix of media combining soft ground, aquatint, etching, and drypoint, the print is linked to Degas's own contributions to *Le Jour et la nuit: Mary Cassatt at the Louvre: The Etruscan Gallery* and especially *Mary Cassatt at the Louvre: The Paintings Gallery*, both 1879–80 (figs. 312, 337), in which the mélange of media was so complicated that Degas had to pull more than twenty trial proofs.[296]

In addition to Cassatt's early experimental prints, Degas acquired a number of the drypoints she produced about 1889, which in their clean contours and concise draftsmanship reflect her study of Holbein and of Japanese prints.[297] In 1891 Degas purchased three of Cassatt's color etchings when they were exhibited at the Durand-Ruel gallery.[298] The year before, both he and Cassatt had visited the great exhibition of Japanese art held at the École des Beaux-Arts, which included more than seven hundred prints.[299] The exhibition spurred Cassatt to produce her remarkable suite of ten color etchings (see fig. 78) in which she adopted the simplified outlines, subtle color, and patterning of Japanese woodblock prints (especially those by Utamaro), a number of which she had bought from the exhibition. Of the three etchings by Cassatt that Degas acquired, *Woman Bathing* seems particularly to have impressed him and directly inspired a set of lithographs of 1891–92 that focus on the back view of a nude woman bathing and drying herself.[300]

Degas's admiration for Japanese prints is well documented. He made frequent use of Japanese compositional devices—high viewpoints, steep perspective, objects cut off by the picture's edge—to enhance the experience of informality and modernity in his work of the 1870s and 1880s. The Cassatt prints are not the only ones he collected that show a Japanese inflection. Pissarro's *The Valley*, described in the sale catalogue as a "piece in the shape of a frieze,"[301] was probably inspired by the wide format of certain Japanese prints, a format that Degas himself had experimented with in some of his paintings, such as *The Dance Lesson*, 1880–85. In one of the most beautiful prints by Pissarro that Degas owned, *Rainfall* of 1879,[302] diagonal strokes create the effect of rain in a manner highly reminiscent of ukiyo-e prints; a similar effect is repeated in Degas's pastel *Jockeys in the Rain* of 1886 (Glasgow Art Gallery, Burrell Collection)—the only work by Degas in which rain appears.

The sale catalogue provides such scant, vague information about Degas's Japanese prints that hardly any of them can be identified with certainty. He owned numerous loose sheets by Hokusai, Utamaro, Shunsho, and others; over fifteen drawings by Hiroshige; two triptychs by

Utamaro; and sixteen albums of prints, including two by Nishikawa Sukenobu (fig. 338). Images of ritualized bathing and grooming that recur in the woodcut illustrations in Sukenobu's two albums, *One Hundred Qualities of Women,* are particularly relevant to Degas's obsession with the theme of women who perform their toilette unaware of the spectator's gaze. Torii Kiyonaga's *The Bath House* (fig. 331) shows a frieze of courtesans, mostly naked, performing their ablutions. *The Bath House* was, in fact, a celebrated and sought-after print at the time and was considered highly unusual among Japanese prints in showing the nude figure.[303] Indeed, the Japanese art dealer Hayashi Tadamasa , who gave the print to Degas, noted its similarity to Degas's nudes.[304] Hayashi, who had arrived in Paris in 1878, was well known to Degas. He exchanged a number of Japanese prints for works by him, and an entry in Degas's unpublished notes records a painting demonstration given by the Japanese artist Watanabe Seitei for which Hayashi acted as interpreter. Seitei painted watercolors of birds for Degas, Burty, de Nittis, and Manet. Later Bartholomé gave Degas a plaster cast of his bronze mask of Hayashi, made in 1892 (Musée d'Orsay, Paris).

Among the prints by Gauguin that Degas owned were some of the artist's most experimental, such as the ten woodcuts that constituted his Noa Noa suite, produced on his return to Paris from Tahiti in 1893 (fig. 79). It seems likely that Degas would have been especially interested in Gauguin's revival of woodcut technique and experiments in color, since he himself had thought about, although not pursued, a similar technique of making color prints using woodblocks and watercolor, something he had described in a letter to Pissarro over a decade earlier.[305] Gauguin's experiments in woodcut prints may have been directly influenced by Degas's monotypes, especially those versions in which a lightly printed image was subsequently reinforced with watercolor, echoing Degas's habit of reworking his monotypes with pastel.[306] The description of them in the sale catalogue indicates that they were remounted on blue paper.[307]

Gauguin's experiments in monotype must have been of particular interest to Degas, since he had extensively explored this medium over the previous twenty years or so. He acquired five of the watercolor monotypes that Gauguin made in Brittany in the summer and autumn of 1894,[308] and his comments in his inventory on one of them, *The Hut*—"Water impression, by means of a plate of glass and a paper pressed with a roller, by hand"[309]— show that he took a close interest in Gauguin's technical methods and probably discussed them with him. It is generally thought that Gauguin's color transfers, made by the

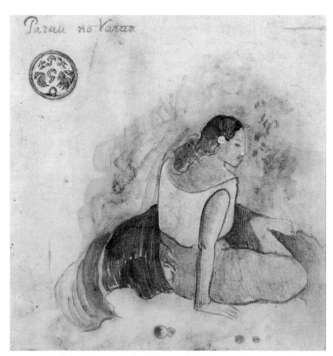

Fig. 80. Paul Gauguin, *Words of the Devil (Parau no varua),* 1894. Monotype heightened with color, 9½ × 9¼ in. (24.1 × 23.5 cm). Dr. and Mrs. Martin L. Gecht, Chicago. Collection Print Sale: 127

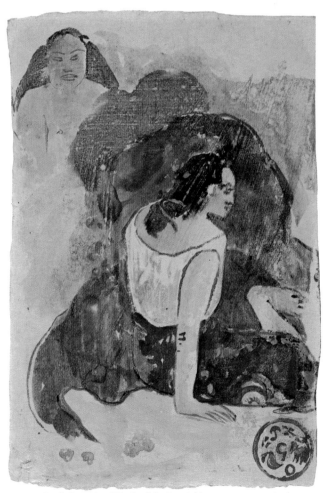

Fig. 81. Paul Gauguin, *Words of the Devil (Arearea no varua ino),* 1894. Monotype heightened with color, 9⅝ × 6⅛ in. (24.5 × 16.5 cm). National Gallery of Art, Washington, D.C., Rosenwald Collection (1943.3.9078). Collection Print Sale: 127

simple method of pressing a dampened sheet of paper on a drawing done in a water-soluble medium such as pastel, owe little to the example of Degas's monotypes.[310] But Degas's note suggests that, at least on this occasion, the method Gauguin used was the more traditional one, closer to his own, in which pigment was transferred onto the paper from a resistant surface, generally a metal plate, although in this case Gauguin used glass.

Two of the watercolor transfers by Gauguin that Degas acquired were from the same matrix, the second transfer paler and less complete than the first (figs. 80, 81). In the same way that Degas often elaborated the surfaces of his monotype impressions with other media, such as pastel, here Gauguin made significant changes to the transfers in watercolor, thus creating two different images from a single source.[311] The evocative images in these transfers produced by the pale residue of pigment left on the paper recall the dreamlike landscapes that Degas had made in monotype only a few years before, in 1891. Although in subject and mood the landscapes are remote from Gauguin's Tahitian scenes, both groups of works show how their makers could manipulate the fluid and insubstantial effects of the monotype medium to distill from an image its poetic essence.

Degas's collection gave tangible form to the enthusiasms and influences that had shaped his work over a lifetime. In the last phase of his career the works by other artists with which he surrounded himself continued to play a part in the complex and reflective process through which he made his art. The works in his collection were remarkably diverse, reflecting the many aspects of Degas's long, exploratory career. He acquired examples of the most radical achievements of his contemporaries as well as extensive holdings of the two artists he revered the most, Ingres and Delacroix, not only for their own outstanding qualities but for the sake of the earlier traditions they represented.

Like other artists of his generation—Cézanne, for example, who wanted to make paintings that had the weight and timelessness of the masterpieces in the Louvre—Degas, in his later years, profoundly wished to reinvent himself as a modern old master. His youthful obsession with the art of the past resurfaced during these years, when he was most intensively collecting the works of Ingres and Delacroix. Had Degas actually managed to establish his museum, it is not hard to believe that he would have displayed his own works alongside those of his two great mentors, taking his place as the third in a triumvirate of nineteenth-century French artists.

1. Lemoisne 1946–49, vol. 1, p. 1. Degas's statement to Alexis Rouart.
2. The earliest detailed accounts of Degas's collection are Lafond 1918, pp. 118–22, and Lemoisne 1946–49, vol. 1, pp. 173–82. More recently, two unpublished academic studies, Wagner 1974 and Dumas 1981, and a published one, London 1996, have treated the subject. Reff 1976a, "Three Great Draftsmen," pp. 37–89 (reprinted in this catalogue), discusses some works in the collection. Jean Sutherland Boggs refers to the chronology of Degas's collecting in Paris, Ottawa, New York 1988–89a, pp. 486–98. Anne Roquebert gives an account of the collection, with much hitherto-unpublished material on the chronology and prices of a number of Degas's acquisitions, in Roquebert 1989. Degas's collecting is also discussed in Loyrette 1991, pp. 615–23.
3. Alexandre 1901; Armand Dayot, "L'Atelier de Degas," *L'Illustration*, March 16, 1918, pp. 256–59 (reprinted in this volume: see "Contemporary Accounts of the Degas Collection Sales.")
4. For accounts of Degas's last years see Dayot, "L'Atelier de Degas"; Lafond 1918, pp. 122–25; Lemoisne 1946–49, vol. 1, pp. 100–101; Fevre 1949, pp. 141–49; Halévy 1960, pp. 150–53.
5. The collection also included reproductions of the whole of Rembrandt's graphic oeuvre, except for twenty-five plates; see Collection Print Sale: 4.
6. This work has often been known as *The Bridge at Mantes* but was entitled *Le Pont de Limay et le Château des Célestins* in the sale catalogue, Collection Sale I: 16.
7. *The Painter's Studio* was no. 108 in the sale of the Haro père collection at the Hôtel Drouot, Paris, on April 2–3, 1897. It was sold to Victor Desfossés for 26,500 francs. See E. Rouart 1937, p. 13.
8. By the English sporting painter John-Lewis Brown; some drawings and a group of etchings by Géricault; one painting and a number of drawings and pastels by Delacroix.
9. Sales of the studio: Atelier Sale I, Atelier Sale II, Atelier Sale III, Atelier Sale IV, Atelier Print Sale. Sales of the collection: Collection Sale I, Collection Sale II, Collection Print Sale.
 Ambroise Vollard, who had begun as a dynamic young art dealer from a French colony in the Indian Ocean, became the most important dealer of his generation.
10. Moreau-Nélaton, journal entry, January 11, 1918, cited in Patricia Pomarède and Vincent Pomarède, "Étienne Moreau-Nélaton (1859–1927), un Journal," *Revue du Louvre et des Musées de France*, no. 1 (1992), p. 84.
11. See the list of such works in the Summary Catalogue, volume 2 of this publication.
12. Degas inv., and inventories in Musée du Louvre, Bibliothèque Centrale et Archives des Musées Nationaux, Archives Vollard, and Archives Durand-Ruel, Paris. For letters, see *Lettres de Degas* 1945 and Sutton and Adhémar 1987.
13. Degas left two wills. In the first, dated August 10, 1914, he left everything to his brother René. In the second, dated February 1916, he left everything to his "natural heirs" (see letter from Paulin to Lafond, December 14, 1917, in Sutton and Adhémar 1987, p. 178), i.e., his brother René and the four children of his sister Marguerite Fevre (his brother Achille and his sister Thérèse had died without issue). After Degas's death René threatened to contest the claim of the Fevre children.
14. Collection Sale II: 9. Degas listed in his notes a bust-length portrait of a hunter by Courbet: "Bust-length, a hunter, gray felt hat, beard, green cloth coat, strap of the ammunition holder" ("en buste, un chasseur, chapeau de feutre gris, barbe, jaquette drap vert, corde de la poudrière"), noting that the work seemed to have been cut down from a larger painting and relined; Degas inv., in Dumas 1981, no. 28. He added that he acquired it in 1896 for 500 francs from Montagnan. A portrait of a hunter in Fernier 1977–78, no. 71, seems to correspond to Degas's description, although Fernier cites the work as having been with a Dr. Potel in Lille in 1899. It seems unlikely that Degas would have gotten rid of the work after only three years.
15. Other works not listed in the sale catalogues but mentioned in Degas's inventory notes include Renoir's *Étude peinte*, not identified in Daulte

1971; a portrait by Couture, see Lafond 1918, p. 117; a portrait of Degas as a child by Destouches, ibid.; and five plaster casts by Bartholomé. Lafond refers to bronzes by Bartholomé and Barye that were not in the sale. I have not been able to identify the sculptures by Barye that belonged to Degas. Rothenstein 1931–39, vol. 1, p. 104, mentions some casts of an Indian dancing figure, a *nataraja* or an *apsara*.

16. Frits Lugt, *Les Marques des collections de dessins & d'estampes, supplément* (The Hague, 1956), p. 118, nos. 657, 658; total profit 137,941 francs. A. Frappart, "Chroniques des Ventes," *Les Arts* 14, no. 168 (1918), p. 26.

17. Now in the Musée du Louvre, R.F. 15886, 15887, 15888.

18. See Roquebert 1989, pp. 79–80, 85 n. 77. The painting is no longer attributed to Legros.

19. Ibid. The works acquired by the Louvre are: Ingres: *The Feet of Homer*, R.F. 3773; *Profile of Raphael and Hands*, R.F. 2746; *Seated Woman, Study for the Odyssey*, R.F. 4512, all studies for *The Apotheosis of Homer*; Delacroix: *Count de Mornay's Apartment*, R.F. 2206; *Young Arab*, R.F. 4874; *Bay Windows in an Arab Interior*, R.F. 4526; *Interior of a Moorish Courtyard*, R.F. 4525; *Female Nude Brandishing a Staff, Studies for Liberty July 28, 1830*, R.F. 4522, 4523; *Cloud Study*, R.F. 4511; *The African Coast Seen from the Straits of Gibraltar*, R.F. 4510; *Studies of Drapery*, R.F. 4524; *Four Studies of Feet*, R.F. 4529; *Border of Flowers*, R.F. 4508; *Study of a Right Arm and Two Feet*, R.F. 4530; *Moroccan Interior: Green Door*, R.F. 4528; *Arab Interior, Said to Be Delacroix's Room in Meknes*, R.F. 4521; *Interior in Algeria*, R.F. 4527; *Study of a Woman's Left Arm*, R.F. 4531; *Study of a Kneeling Man, after the Antique*, R.F. 4532; *Studies of a Saddle* (now Musée des Arts Décoratifs, Paris, 20951); *Two Sheets of Sketches of a Burnoose* (now Musée des Arts Décoratifs, 21153 A/B); Dehodencq (formerly thought by Delacroix): *Arab Musician Seated*, R.F. 4509; Manet: *Madame Manet on a Blue Sofa*, R.F. 4507 (now Musée d'Orsay, Paris); Millet: *Two Studies of a Female Nude*, R.F. 4513.

20. Keynes ingeniously argued that the cost to the Exchequer would be nonexistent because the bidding would be financed by the French government in partial repayment of a colossal war debt. These payments were in lieu of issuing bills to the British government in exchange for loans—bills that the British did not expect to be repaid either as principal or possibly even as interest. Correspondence in Archives, The National Gallery, London. See also Emberton 1996.

21. Holmes 1936, p. 337.

22. Ibid., p. 339. Vanessa Bell, in a letter to Roger Fry, was critical of Holmes: "Holmes's purchases are idiotic considering his chances. He wouldn't hear of Cézanne and in the end didn't spend all the money, but came back with 5,000 unspent and no El Greco which he might easily have had." Richard Shone and Duncan Grant, "The Picture Collector," in Milo Keynes, ed., *Essays on John Maynard Keynes* (London, 1975), p. 283.

23. Collection Sale I: 109, *Étude de jeune fille (famille Sedaine)*. The drawing is now in the British Museum, London (C.110 Roy), but is no longer attributed to David.

24. Cézanne, *Apples*, 1879–81, Collection Sale I: 10; Delacroix, *Horse Standing in a Meadow*, 1819, Collection Sale I: 29 (J 42); and a drawing by Delacroix for the Palais Bourbon frieze, subsequently given to Duncan Grant. See David Scrase and Peter Croft, *Maynard Keynes: Collector of Pictures, Books and Manuscripts*, exh. cat., Cambridge, Fitzwilliam Museum (Cambridge, 1983), p. 10; in ibid., p. 53, it is suggested that the Ingres drawing may be a copy by Degas.

25. Holmes 1936, pp. 341–42.

26. See London, Chicago 1996–97, pp. 13–14.

27. Ibid., pp. 41–51.

28. Letter from Bartholomé to Lafond, May 22, 1899. See Sutton and Adhémar 1987, p. 174.

29. Vollard 1924, p. 67.

30. Valéry 1960, p. 21.

31. Lemoisne 1946–49, vol. 1, pp. 173–74.

32. See Paris, Ottawa, New York 1988–89a, p. 385. See also the Appendix to "Degas's Degases" in this catalogue.

33. This work, entitled *Sur une chaise*, was listed in the fifth Impressionist exhibition, of 1881, as belonging to Degas. See Bodelsen 1970, p. 593. Bodelsen's supposition that the painting was given to Degas as an exchange, since Gauguin noted in a Brittany-Arles sketchbook, "Degas still-life exchange" ("Degas nature morte échange"), is confirmed by Degas's own comment in his notes: "given by him in exchange for a pastel of a dancer" ("donné par lui en échange d'un pastel de danseuse"). Degas inv., in Dumas 1981, no. 75.

34. Archives Vollard, pp. 27, 32, Musée du Louvre, Bibliothèque Centrale et Archives des Musées Nationaux, Paris; and Degas inv.

35. Degas bought this work from Gauguin in December 1894 at his studio at 6, rue Vercingétorix. Degas inv.

36. Through the dealer Montaignac. Degas inv.

37. *Lettres de Degas* 1945, no. 217, p. 220. No date, postmarked 1898.

38. L 27. See Boggs 1963, p. 273.

39. Lemoisne 1946–49, vol. 1, p. 173. Pool 1963, p. 31, claims that "by 1875 Degas had already made a considerable collection of Old Masters," but does not elaborate.

40. See Lemoisne 1946–49, vol. 1, p. 31; Reff 1971, p. 539 n. 27. Reff notes that Paul Brame confirmed the sale of three La Tour pastels at this time, recorded in the archives of his gallery. He adds that the two that Degas owned were probably no. 390 in Alfred Besnard, *La Tour: La Vie et l'oeuvre de l'artiste* (Paris [1928]), listed as "ancienne collection de Gast[sic]," and no. 326, lent to an exhibition in 1874 by "M. de Gas."

41. L 255, private collection, New York. Reff 1976a, "Pictures within Pictures," pp. 113–14.

42. However, Degas did not participate in the widespread revival of interest in the Rococo in the 1890s, exemplified by such collectors as Camille Groult and Jacques Doucet.

43. Degas's copy was sold at Collection Sale I: 37 as "École française, XVIIIe siècle." It was probably done between 1865 and 1870 and is in the Musée Cantonal des Beaux-Arts, Lausanne. La Tour's *Portrait of a Man* is in the Musée Jacquemart-André, Paris. See Reff 1971, p. 539. For Degas's visits to Saint-Quentin, see Havemeyer 1993, p. 256.

44. Collection Sale I: 86. PV 220. Archives Durand-Ruel, Paris, stock no. 3150. Cited in Roquebert 1989, pp. 66, 82 n. 6. Degas described the work as "plowed field and plot of cabbages/in the front, lively sky" ("plaine labourée et carré de choux/sur le devant, ciel mouvementé"); Degas inv., in Dumas 1981, no. 162.

45. Letter from Pissarro to Théodore Duret, December 8, 1873, quoted in PV 1939, no. 220.

46. Collection Sale I: 87. PV 1939, no. 124. *Riverbanks* is probably the work that Degas describes in his inventory as "On the Seine, at the edge of Bougival" ("Sur la Seine, à l'entrée de Bougival"). He adds, "bought at the sale of 1874" ("acheté à la vente de 1874"), though it is not clear which sale he is referring to; Degas inv., in Dumas 1981, no. 163. No title that corresponds to this appears in the catalogue of the first Impressionist exhibition, in 1874. Perhaps Degas made a mistake in identifying the river and the painting is *Bords de l'Oise*, listed in the official record of the Hoschedé sale; see Bodelsen 1968, p. 333. The work does not appear in the 1875 sale of Impressionist works at the Hôtel Drouot; ibid., pp. 335–36.

47. Collection Sale I: 85. PV 1939, no. 163. Degas describes *Landscape at Pontoise* as "countryside with green wheat" ("campagne avec des blés verts") and adds that it was acquired from Martin for an exchange. Degas inv., in Dumas 1981, no. 164.

48. *Mademoiselle Henriette Henriot*: Daulte 1971, no. 108, private collection. Degas records that she was "later an actress at the Odéon; bought at a sale of Monet, [Renoir], Mme Morisot, and Sisley, about 1874" ("actrice plus tard à l'Odéon, acheté à une vente de Monet, lui, Mme Morisot et Sisley vers 1874"). Degas inv., in Dumas 1981, no.

166. This is most probably the *Tête de Femme* by Renoir listed as no. 39 in the March 1875 sale; see Bodelsen 1968, p. 336 n. 63, since the dimensions given, 41 × 32 cm, correspond closely to those of Degas's painting, 41 × 33 cm. No. 39 was listed in the 1875 exhibition catalogue as having been purchased by Henri Rouart for 80 francs; he must have subsequently given the picture to Degas.

49. "Étude peinte. Femme assise, en chemise avec des bas rayés bleu et noir, mettant une bottine." Degas inv., in Dumas 1981, no. 165.

50. Lemoisne 1946–49, vol. 1, p. 178.

51. Raymond Escholier et al., *Léon Riesener: From Romanticism to Impressionism*, exh. cat., London, Couper Gallery (London, 1965), n.p.

52. Duranty wrote an important two-part review of the exhibition of Daumier's work held at the Galerie Durand-Ruel in 1878: "Daumier," *Gazette des Beaux-Arts* 17 (May 1878), pp. 429–43, and (June 1878), pp. 528–44.

53. See Reff 1976b, vol. 1, p. 143, Notebook 35, p. 108. Reff has established a date of February 1881 for Degas's letters to Rouart concerning the gift, pointing out that they were wrongly placed in a sequence suggesting a date of 1894 by Marcel Guérin in his edition of the letters, *Lettres de Degas* 1945, pp. 202–4.

54. See Colta Ives, *The Great Wave: The Influence of Japanese Woodcuts on French Prints*, exh. cat., New York, The Metropolitan Museum of Art (New York, 1974), p. 34 (a revised version of the essay appears in the present catalogue); and Gabriel P. Weisberg, *Japonisme: Japanese Influence on French Art 1854–1910*, exh. cat., The Cleveland Museum of Art (Cleveland, 1975), p. 4.

55. Ernest Chesneau, "Exposition Universelle: Le Japon à Paris," *Gazette des Beaux-Arts* 10 (September 1874), p. 387. Other lenders of prints included Monet, Manet, Tissot, Fantin-Latour, and Zola.

56. Degas inv. See also Roquebert 1989, pp. 66 and 82 n. 9. Menzel's study is for his famous *Steel Rolling Mill*, 1872–75 (Nationalgalerie, Berlin), which had been exhibited in Paris at the World's Fair in 1878. Duranty had received the drawing as a gift from Menzel in gratitude for his articles in the *Gazette des Beaux-Arts*.

57. Vente Édouard Manet, Paris, Galeries Durand-Ruel, February 4–5, 1884. *Leaving the Bath*, Collection Sale II: 220, RW 362; *Henri Vignaux*, Collection Sale I: 220, RW 472; *The Barricade*, Collection Print Sale: 276, "superb proof of first state, before lettering" ("superbe épreuve du 1er état avant la lettre"), Paris 1978, no. 80. Degas paid 147 francs for the three works.

58. Collection Sale I: 72, RW 146. The painting had first been bought by Berthe Morisot as a gift for her brother-in-law, Commander Pontillon, a naval officer, but the commander objected to Manet's disregard for naval procedure (showing the commander of the ship on the bridge during maneuvers) and declined the gift. See Morisot 1950, p. 121.

59. Sutton and Adhémar 1987, p. 168. Letter dated "around 1890."

60. Sale following the death of Millet's widow, Hôtel Drouot, Paris, April 24–25, 1894. Degas paid 2,322 francs for the El Greco.

61. Letter from Bartholomé to Lafond, October 4, 1896. Sutton and Adhémar 1987, p. 173.

62. In exchange for two of his own pastels, worth 6,000 and 2,000 francs *(Dancer with Arms Raised in a Decor of Rocks and Dancer in the Wings)*. Degas inv.

63. From the critic Zacharie Astruc. Degas inv.

64. For 8,715 francs. See Roquebert 1989, p. 68 and p. 83 n. 32.

65. Bought from the dealer Haro for 7,700 francs. Degas inv.

66. Collection Sale II: 55, as "Modern School." See Degas inv. Bought from Brame. The presence of the wax seal of the posthumous Delacroix sale of 1864 on the back has led to confusion about its attribution. However, Andrieu was in possession of this seal, and most authorities now agree that the work is by Andrieu. See Davies 1970, no. 6349.

67. Collection Sale I: 92, 93. *Two Sunflowers*, on October 29, 1895, for 400 francs. Degas notes, "bought from Vollard for two little sketches of dancers," and "black and white muscat grapes and lemons, bought

from Vollard" ("acheté à Vollard pour deux petits croquis danseurs"; "raisins muscats noirs et blancs et citrons, acheté à Vollard"), but does not record a date of acquisition. Degas inv., in Dumas 1981, nos. 172, 173.

68. Degas inv. Archives Vollard, Musée du Louvre, Bibliothèque Centrale et Archives des Musées Nationaux, Paris.

69. Halévy 1960, p. 86.

70. Archives Vollard. See Degas inv.

71. *Monsieur Armand Brun*, RW 326 (Bridgestone Gallery, Tokyo), titled *Portrait of Monsieur X* in the sale catalogue, Collection Sale I: 73. Acquired in exchange for a small pastel, "night scene, nude woman on a small low armchair, fidgeting before the fire while the maid, kneeling, combs her hair" ("effet de nuit, femme nue sur un petit fauteuil bas, gigotant devant le feu pendant que la bonne à genoux la peigne"), and four monotypes: "4 drawings done on plate, highlighted, brothel scenes" ("4 dessins sur plaque, rehaussée, scènes de bordel"). Degas inv., in Dumas 1981, no. 147.

72. Through the dealer Portier; Degas inv. Degas does not give a date for the purchase, but as Vollard suggests in his comments on the sale of Degas's collection, it must have been after 1894: "At this same sale could also be seen, among other works by Manet, *The Ham* [RW 35] and *Madame Manet on a Blue Sofa* [RW 3]; these are two exceptional works that in 1894, that is, more than ten years after the painter's death, were still in the hands of his widow awaiting a purchaser." Vollard 1937a, p. 71.

73. See p. 48 and nn. 111, 112.

74. Acquired from Vollard on May 22, 1897, for 1,000 francs. Archives Vollard.

75. Degas inv. Acquired from a Monsieur Le Veau in exchange for a pastel of dancers.

76. Jacques-Émile Blanche, "Notes sur la peinture moderne (À propos de la Collection Rouart)," *Revue de Paris* 20, no. 1 (January–February 1913), p. 27.

77. Lafond 1918, pp. 117–22.

78. Lemoisne 1946–49, vol. 1, pp. 175–82.

79. Michel 1919, p. 628; Moreau-Nélaton 1931, in Lemoisne 1946–49, vol. 1, pp. 259–60; Rothenstein 1931–39, vol. 1, p. 318; Valéry 1960, p. 20; Sickert 1917, p. 186.

80. Reff 1968a, pp. 87–88. Letter originally printed in *Paris-Journal*, April 12, 1870.

81. For the apartment at 28, avenue de l'Opéra, for example, which was the venue for the fourth Impressionist exhibition, in 1879. See Reff 1976b, vol. 1, Notebook 31, pp. 35, 54, 64, 65.

82. See Reff 1976b, p. 133, Notebook 30, pp. 19, 25–26; Vollard 1924, pp. 72–74; and Havemeyer 1993, p. 250, for Degas's careful framing of *Répétition de Ballet* in a soft gray-green frame that harmonized with the colors in the painting. See also Isabelle Cahn, "Degas's Frames," *Burlington Magazine* 131, no. 1033 (April 1989), pp. 289–92.

83. Sickert 1917, p. 186.

84. Lafond 1918, p. 118.

85. None of these sculptures are in the sale catalogues. Degas mentions gifts of plaster casts by Bartholomé, but no bronzes. Degas inv. I have not been able to identify any bronzes by Barye that belonged to Degas.

86. See Richard Kendall, "'Who Said Anything about Rodin?' The Visibility and Contemporary Renown of Degas' Late Sculpture," *Apollo* 142, no. 402 (August 1995), pp. 73–74, 77 nn. 9–14, citing accounts by Paul Valéry, Mme Jeanniot, Walter Sickert, Louisine Havemeyer, William Rothenstein, and Alice Michel.

87. Accounts differ as to whether this painting was beside the fireplace or whether it was one of several candidates for the place over Degas's bed. Probably it occupied both positions, at different times.

88. *Achille De Gas as a Naval Ensign*, ca. 1859–62, oil on canvas (National Gallery of Art, Washington, D.C., Chester Dale Collection), L 30. *Madame Edmondo Morbilli, née Thérèse De Gas*, 1869, pastel (private collection, New York), L 255.

89. Jeanniot 1933, p. 284.

90. Rothenstein 1931–39, vol. 1, p. 26.

91. Lemoisne 1946–49, vol. 1, p. 176.

92. See Lafond 1918, p. 182; Lemoisne 1946–49, vol. 1, p. 154; Moreau-Nélaton 1931, in Lemoisne 1946–49, vol. 1, p. 259.

93. Vollard 1924, p. 101.

94. "Chercher à completer." Degas inv., in Dumas 1981, no. 151.

95. See Lemoisne 1946–49, vol. 1, p. 181.

96. Reff 1968a, p. 91. Letter dated April 9, 1896; Bibliothèque Doucet, Paris, MS 237. Henri Haro (1855–1911) was a painter, restorer, and dealer and the son of Étienne Haro, who owned an important collection of Ingres's work.

97. *Lettres de Degas* 1945, no. 206, p. 218, dated August 25, 1897.

98. Unpublished letter dated September 2, 1897. Musée Fabre, Montpellier, quoted in Loyrette 1991, pp. 621, 799 n. 472.

99. Collection Print Sale: 212, listed under Ingres as "Diverse subjects. Portraits, figure studies. An album put together containing approximately 140 photographs of paintings and drawings by the master." ("Sujets divers. Portraits, études de figures. Un album factice contenant environ 140 photographies d'après les peintures et dessins du maître.") Now in a private collection, New York. See Loyrette 1991, p. 799 n. 472.

100. See Loyrette 1991, p. 620. None of these was included in the sales of the collection, and I have not been able to discover what happened to them.

101. "Ce tableau a été au dessus du lit de Millet pendant longtemps." Degas inv., in Dumas 1981, no. 2.

102. Degas inv.

103. ". . . viendrait de chez Jenny Le Guillou, morte en Franche Comté, par le neveu employé au chemin de fer." Degas inv., in Dumas 1981, no. 35.

104. "Ce dessin du nu de l'Iliade a été fait d'après un modèle nommé Joséphine l'Allemande, que j'ai vue vieille dans ma jeunesse, et qui vendait des pinceaux dans l'atelier. Elle est même reconnaissable dans le tableau." Degas inv., in Dumas 1981, no. 128.

105. Degas inv. The passage was first published by Theodore Reff in Reff 1976a, pp. 88–89, the source of this translation.

106. Vollard 1924, p. 81. Degas apparently insisted that Chapuis reline pictures by means of the Italian method, "le rentoilage à l'italien," since this did not involve the use of a hot iron.

107. Halévy 1960, pp. 83–84.

108. An article in two parts by Alexandre, "Les Microbes du Louvre," appeared in *Le Figaro* on December 17 and 22, 1896. See Degas inédit 1989, p. 412.

109. "Ingres. Roger and Angelica, variant, commissioned by M. de Mortemart. Lithographed by Sudré—bought for 4,725 francs at the hotel [Drouot]. I was wrong to have too much varnish removed by Grolleau. The picture has suffered a bit. It's a too-hard lesson." ("Ingres. Roger et Angélique, variante/ commandé par Mr de Mortemart. Lithographié par Sudré—acheté 4725 F à l'hotel. J'ai eu tort de faire trop dévestir par Grolleau trop à fond. Tableau a un peu souffert. C'est une trop dure leçon.") Degas inv., in Dumas 1981, no. 100.

110. It is now generally accepted that Leenhoff was Mme Manet's son, fathered by Édouard Manet's father.

111. Manet 1987, p. 54, entry dated November 7, 1894. See also John Leighton and Juliet Wilson Bareau, "The Maximilian Paintings: Provenance and Exhibition History," in *Manet: The Execution of Maximilian*, exh. cat., London, The National Gallery (London, 1992), pp. 112–13.

112. Vollard 1936, p. 55. Degas noted: "1. Group of soldiers. 2. Head of General Miramón. 3. His leg (blue pants). No. 1 was relined by Chapuis's nephew. This picture, which had remained rolled up for a long time at Mme Manet's in Gennevilliers, was cut up and sold, in all probability by his brother, Leenhoff. The picture lopped off on the left was at first kept on the rue Rodier with Mme Martin and Camentron. Then carved up. The sergeant loading his rifle, behind the group who are firing, was peddled about and finally sold for 500 francs to Portier, who let me have it" ("1. groupe de soldats. 2. tête de général Miramon. 3. jambe [pantalon bleu] de celui-ci. Le no. 1 a été rentoilé par Chapuis neveu. Ce tableau resté [*sic*] longtemps roulé à Gennevilliers chez Mme Manet, a été coupé et débité, selon toute probabilité par Leenhoff son frère. D'abord le tableau rogné à gauche avait été longtemps déposé rue Rodier chez Mme Martin et Camentron. Puis dépecé. Le sergent armant son fusil, derrière le group qui fusille a été colporté et vendu enfin 500 francs à Portier qui me le cède"). Degas inv., in Dumas 1981, no. 148. See also the Vollard stockbook entry for November 29, 1894: "Peloton, *The Execution of Maximilian,* for works by Degas worth 2000 francs" ("Peloton l'Exécution de Maximilien pour oeuvres de 2000 francs par Degas"). Archives Vollard.

113. Morisot 1950, p. 185; letter dated March 1, 1895.

114. Halévy 1960, pp. 97–98.

115. Moreau-Nélaton 1931, in Lemoisne 1946–49, vol. 1, p. 259.

116. Rothenstein 1931–39, vol. 1, p. 319.

117. "The idea of a museum is splendid! But will it catch on with other collectors, as he believes?" ("L'idée du musée est belle! Mais sera-t-il suivi par d'autres amateurs comme il le pense?") Letter from Bartholomé to Lafond, private collection; quoted in Paris, Ottawa, New York 1988–89a and b, p. 491.

118. See Valéry 1960, p. 33: "A visit he paid to the Musée Moreau in the rue de la Rochefoucauld made him abandon the idea he had formed of creating his own museum, which would have included his private collection (and perhaps part of his studio)."

119. See Jeanniot 1933, p. 167. See also D. Rouart 1988, pp. 16–19. For *Family Portrait,* see Paris, Ottawa, New York 1988–89a, p. 81.

120. P. Romanelli, "Comment j'ai connu Degas," *Le Figaro littéraire*, March 13, 1937, p. 6.

121. Letter from Bartholomé to Lafond, March 15, 1899 (or 1897?), mentioning his "rage de se voir au Luxembourg." Sutton and Adhémar 1987, p. 174.

122. Moreau-Nélaton 1931, in Lemoisne 1946–49, vol. 1, p. 259.

123. Paul Valéry, *Degas, danse, dessin* (Paris, 1946), first published 1938, p. 53. Degas would have been well acquainted with the plans for the Moreau museum because its first curator, Georges Rouault, was a frequent visitor to his studio.

124. Loyrette 1991, p. 622.

125. See particularly Theodore Reff's articles on Degas and older art, Reff 1963, 1964a, 1965, 1971, his edition of Degas's notebooks, Reff 1976b, and his essay "Three Great Draftsmen," reprinted in this catalogue. More recently, important work on Degas's knowledge and use of the old masters has been done by Richard Thomson, R. Thomson 1987 and 1988.

126. Moore 1890, p. 423.

127. Letter to Bartholomé, undated, but grouped by Guérin with other letters of 1888, *Lettres de Degas* 1945, no. 101, p. 127.

128. Degas told the story of his youthful visits to Ingres on a number of occasions late in his life. The accounts of how Degas persuaded Valpinçon, the father of his school friend, to lend his famous Ingres *Bather* to the World's Fair of 1855 although he had initially refused, and later on returned to collect the work, vary somewhat. Degas visited Ingres's studio again, in 1864, to see a small exhibition of the master's work. See Valéry 1960, pp. 34–36; Halévy 1960, pp. 57, 147; Moreau-Nélaton 1931, in Lemoisne 1946–49, vol. 1, pp. 260–61. See also Loyrette 1991, pp. 55–56, for a review of these anecdotes.

129. Halévy 1960, pp. 138–39.

130. *Madame Edmondo Morbilli, née Thérèse De Gas,* 1869 (private collection, New York), L 255.

131. L 5.

132. Collection Sale I: 39.

133. Halévy 1960, p. 57.

134. Moreau-Nélaton 1931, in Lemoisne 1946–49, vol. 1, p. 261, and for the quotation, Degas inv., in Dumas 1981, no. 104: "dans la pose de la

Cybèle de Naples." See Philippe Burty, "Six tableaux nouveaux de M. Ingres," *La Chronique des arts et de la curiosité*, July 10, 1864, pp. 204–5, for a review of this exhibition, cited in Loyrette 1991, p. 687 n. 70.

135. Degas inv., in Dumas 1981, and Paris, Ottawa, New York 1988–89a, p. 493. The nude is Atelier Sale I: 183. The study of the arm and hand has not been identified. Degas mentions that he acquired the drawing for the skirt (which appears in his inventory but not in the sale catalogue) from the sale of the Reiset collection at the Hôtel Drouot (June 25, 1895). The study of the head for the Washington version is Collection Sale I: 210. Its date of acquisition is not recorded.

136. See Reff 1976b, p. 38, Notebook 2, pp. 48, 53; pp. 88, 89, Notebook 15, pp. 16, 38.

137. Collection Sale I: 56, 213. The drawing is in the Fogg Art Museum, Harvard University Art Museums, Cambridge.

138. Collection Sale I: 51.

139. Collection Sale I: 63, 184, 202; Collection Sale II: 193. For Degas's 1855 oil copy of the entire work, see Reff 1964a, p. 255 and fig. 6; for other copies, Reff 1976b, Notebook 2, pp. 79, 82–83.

140. Collection Sale I: 50 (Nationalmuseum, Stockholm). The work was included in the sale of the Haro collection in 1897, where it was acquired by Bernheim-Jeune, from whom Degas obtained it in exchange for one of his own small drawings. Degas noted that, according to Monsieur Delaborde, Ingres had made the copy to send to his father in Montauban. Degas inv.

141. Moore 1913, p. 79.

142. Valéry 1960, p. 33.

143. Reff 1964a, p. 250.

144. Valéry 1960, p. 50.

145. Collection Sale I: 58, 60, 62, 65, 66, 67, 185, 189, 191, 196, 199, 206; Collection Sale II: 202 (4 drawings).

146. Reff 1963, p. 247.

147. Collection Sale I: 199.

148. For example, Collection Sale I: 58, 196; Collection Sale II: 202.

149. Collection Sale I: 191.

150. Collection Sale I: 66. The modified design exists in the form of a drawing begun about 1843 and completed in 1865 or soon thereafter, sometimes known as *The Deification of Homer* (Musée du Louvre, Paris). See Davies 1970, p. 120 n. 83, no. 3293. Davies suggests that the *Pindar and Ictinus* is more likely to have been a small, separate painting than a study for *The Deification of Homer*.

151. Collection Sale II: 240–48. Degas's early interest in Charles Serret (1822–1900) is evident from a notebook copy, see Reff 1976b, vol. 1, p. 49, Notebook 5, p. 49, a sketch of a young man inscribed: "d'après M. Serret, jeudi, 24 jan. 1856." Gauguin also collected works by Serret. See Bodelsen 1970, p. 593, for his purchase of a series of Serret etchings in January 1882.

152. Collection Sale I: 179–81.

153. Collection Sale I: 236, 237.

154. Collection Sale I: 216, 217. Degas also owned a silverpoint portrait of himself by Legros, Collection Sale II: 215.

155. Collection Sale I: 238–42.

156. Collection Sale II: 254–63. Letter from Degas to Valadon, *Lettres de Degas* 1945, no. 129, vol. 189, p. 206, dated ca. 1895. Other letters from Degas to Valadon, ibid., 1945, nos. 195–96, 202–5, 212, 215, 222, 224, 229, 242, 251, 253.

157. Sketches of paintings by Veronese and Delacroix appeared together in a notebook of 1860–62, see Reff 1976b, p. 103, Notebook 19, pp. 8, 15.

158. BR 33.

159. Degas's copy, ca. 1859–60, oil on paper mounted on canvas, is on loan from a private collection to the Kunsthaus, Zurich. BR 35.

160. Sketch with color notes made in a notebook dated 1859–60. Reff 1976b, p. 91, Notebook 16, p. 36.

161. Reff 1976b, p. 97, Notebook 18, p. 127.

162. See Reff 1976a, "Three Great Draftsmen," pp. 57–58.

163. Reff 1976b, vol. 1, p. 80, Notebook 13, p. 53. The work exhibited at the 1859 Salon is *The Entombment* of 1859, ibid., vol. 3, no. 470 (National Museum of Western Art, Tokyo). The work Degas acquired is based on *The Lamentation* of 1848, ibid., no. 434 (Museum of Fine Arts, Boston); it is a smaller variant, probably of 1853, also titled *The Lamentation*, in ibid., vol. 3, no. 459 (Nathan Collection, Zurich). Degas probably acquired his version at the Desfossés sale on April 26, 1899, lot 280, via Bernheim-Jeune.

164. D. Rouart 1945, p. 46.

165. *Campement Arabe*, Collection Sale I: 162 (location unknown); see Johnson 1981–89, vol. 3, p. 151. It was reproduced in the sale catalogue, and a photograph is at the Bernheim-Jeune gallery, Paris. *Étude pour Ovide chez les Scythes*, Collection Sale I: 141, possibly a study for one of the pendentives in the Poetry cupola in the library of the Palais Bourbon, where Delacroix first used the subject; see Johnson 1981–89, vol. 3, p. 151.

166. Johnson 1981–89, vol. 3, p. 152, suggests that Degas's copy was made from the drawing he owned, but the copy's highly tonal quality makes it more likely that it was done after the National Gallery's painting, from memory.

167. See Kendall 1993, pp. 72, 101.

168. Manet 1987, p. 177. The painting was sold for 1,800 francs. In 1908 it entered the Hatvany collection in Budapest. The fate of this collection during and after World War II is not known. See Johnson 1981–89, vol. 3, p. 139.

169. Collection Sale I: 26; J 142. It is a sketch for *The Death of Charles the Bold at the Battle of Nancy* (Musée des Beaux-Arts, Nancy), J 143.

170. Degas's copy, Collection of Barbara and Peter Nathan, Zurich; see Paris, Ottawa, New York 1988–89a, pp. 457–58, for a discussion of this copy and its dating to ca. 1885–89.

171. Collection Sale I: 31. See Paul Poujaud's letter to Marcel Guérin, January 15, 1933, *Lettres de Degas* 1945, p. 253.

172. Sold as *Paysage à Champrosay*, Collection Sale I: 32, J 482.

173. Collection Sale I: 34, J 591; acquired from the Chocquet sale, July 1, 1899.

174. Collection Sale I: 30, J 29.

175. L 105.

176. Examples are: drawings for the Palais Bourbon frieze, Collection Sale I: 134–36 (British Museum, London) and 143; drawing for *Ovid among the Scythians*, Collection Sale I: 141, see note 165 above; studies for *The Barque of Dante*, Collection Sale II: 96, 97; *The Massacre of Chios*, Collection Sale II: 99, 100; *Jacob Wrestling with the Angel* and *Heliodorus Driven from the Temple* (Saint-Sulpice murals), Collection Sale II: 137, 138.

177. Collection Sale II: 106.1, 106.2, 106.3.

178. For example, Eadweard Muybridge's photographs of horses and humans in rapid movement. See Reff 1976a, "The Artist as Technician," pp. 293–94, 338 nn. 61, 62. Reff 1976b, vol. 1, p. 137, Notebook 31, p. 81.

179. Lafond 1918, p. 20.

180. For example, Collection Sale I: 116 (Musée du Louvre, Paris, R.F. 4508) and Collection Print Sale: 130.

181. Collection Sale I: 113, 118, 120, 122; Collection Sale II: 89, 93, 129, 131 (Musée du Louvre, Paris, R.F. 4525, 4526, 4528), 132, 136, 140, 144–48, 152. For the facsimile of the album see Moreau-Nélaton 1931, in Lemoisne 1946–49, vol. 1, p. 257 n. 218.

182. Jeanniot 1933, p. 161.

183. D. Rouart 1945, p. 32.

184. Huysmans 1883, pp. 119–20.

185. D. Rouart 1945, p. 46.

186. The Delacroix, now in the Walters Art Gallery, Baltimore, was bought by Hector Brame, one of Degas's dealers, at the Baron de Beurnouville sale, April 29, 1890. Degas presumably saw it in Brame's gallery and made his free copy from memory, altering some features of the composition. See Brame and Reff 1984, p. 90, no. 83.

187. Delacroix's late version of *The Fanatics of Tangier*, 1857, J 403 (Art Gallery of Ontario, Toronto). Degas's copy, private collection. Degas

probably copied this work when it was exhibited at the École des Beaux-Arts, Paris, in 1885, or in 1891 when it was sold at the Hôtel Drouot; see BR 143.

188. See Jeanniot 1933, p. 280; Kendall 1993, pp. vii, viii.

189. See especially Kendall 1993.

190. Halévy 1960, p. 110; Clarke 1991a, pp. 15, 16, 20 n. 2.

191. Collection Sale I: 16–22. Degas recorded that he paid 6,500 francs for the painting now titled *Rocky Chestnut Wood*, Collection Sale I: 18, which was acquired for him from Bernheim-Jeune by Durand-Ruel in December 1899. Degas inv. The prices paid for the other paintings by Corot were more modest.

192. Robaut and Moreau-Nélaton 1905, vol. 2, no. 113. Present location unknown.

193. Collection Sale I: 16, titled *Le Pont de Limay et le Château des Célestins*. Robaut and Moreau-Nélaton 1905, vol. 2, no. 822.

194. Collection Sale I: 18. Ibid., no. 294.

195. "Landscapes, but Degas made many of them and very beautiful ones! There are views of Italy that recall, as much by their purity of line as by their light and poetry, the best Italian Corots." Fevre 1949, p. 60. See also Clarke 1991a, p. 128; Kendall 1993, p. 2.

196. Cited in Coquiot 1924, p. 13.

197. See Reff 1976b, pp. 138, 318 nn. 146, 147; Galassi 1991, p. 229 n. 9; Clarke 1991a, p. 128.

198. Reff 1976b, vol. 1, p. 103, Notebook 19 (dated 1860–62), p. 6.

199. Collection Sale II: 42, as "École moderne." Sale of Degas's niece's collection, *Catalogue des tableaux . . . collection Mlle J. Fevre*, Galerie Charpentier, Paris, June 12, 1934, no. 142. Reff 1976a, "Pictures within Pictures," pp. 140, 318 n. 152. Brame and Reff 1984, p. 20 n. 19, *Le Château de l'Oeuf*, 1856–57, oil on cardboard. Private collection, Switzerland.

200. Lepic, *Vue de Naples*, Collection Sale II: 218.

201. Collection Sale II: 72, 73.

202. The first of these entries is accompanied by a sentimental musing that seems to reflect Degas's own nostalgia for the place: "He said that he had been so happy at Portici during this period. He made a painting there, *Walkers at Vesuvius*, for which this must have been a study." ("Il disait qu'il avait été si heureux à cette époque à Portici. Il fit là un tableau, *Promeneurs au Vésuve*, pour lequel cette étude a pu devenir.") Degas recorded that he bought both works at the Hôtel Drouot sometime after de Nittis's death. Degas inv., in Dumas 1981, no. 158.

203. "Corot, Vésuve, panache de fumée, soleil couchant, mer bleu." Degas further noted, "Semble peint sur papier, rentoilé. 28 × 20. acheté à Portier, 350 francs." ("Seems painted on paper, mounted on canvas. 28 × 20. Bought at Portier, 350 francs.") Degas inv., in Dumas 1981, no. 23. Collection Sale II: 11.

204. Degas, *Vesuvius*, 1892, monotype and pastel (private collection). See Janis 1968, no. 310; Kendall 1993, p. 201.

205. Moreau-Nélaton 1931, in Lemoisne 1946–49, vol. 1, p. 258, in the course of complaining about the high prices of works at the Robaut sale, December 18, 1907.

206. Charles Baudelaire, "Salon de 1859," in Baudelaire 1965, vol. 2, p. 360.

207. Collection Sale I: 111. British Museum, London.

208. Collection Sale I: 82. Collection Sale I: 231, Musée du Louvre, Paris. Collection Print Sale: 292.

209. Degas recorded: "Th. Rousseau. Studies of Mountains, Cantal valley. No. 221 Doria sale, May [18]99, 1000 francs. Bought by mistake, I thought, from a bit of a distance, that they were selling a Corot. Durand-Ruel didn't want to take it back from me and assured me that it was an excellent picture, which is true. I remember Moreau-Nélaton, laughing at my blindness, when they knocked it down to me." ("Th. Rousseau. Études de Montagnes, vallée cantal. No. 221 Vente Doria, mai 99, 1000F. acheté par erreur, ai cru, d'un peu loin, qu'on vendait un Corot. Durand-Ruel n'a pas voulu me le reprendre tout en m'assurant que c'était un excellent tableau, ce qui est vrai. Je me souviendrai de Moreau-Nélaton, riant de l'aveugle, quand on me l'adjugea.") Degas

inv., in Dumas 1981, no. 168. See also Archives, The National Gallery, London.

210. Letter from Camille Pissarro to his son Lucien, July 8, 1888; Bailly-Herzberg 1980–91, vol. 2, p. 239.

211. Collection Sale I: 83, 232.

212. See also Degas's comment, "This lad has a genius for drawing," quoted in E. Rouart 1937, p. 7.

213. Coquiot 1924, p. 127.

214. Sévin 1975, p. 28.

215. See London, Chicago 1996–97, pp. 102–3.

216. Ibid., p. 162.

217. F. Fosca, "Portraits de Degas de 1860 à 1915," *L'Amour de l'art* 12, no. 7 (July 1931), p. 266.

218. London, Chicago 1996–97, p. 164.

219. Gimpel, 1966, p. 416.

220. See London, Chicago 1996–97, pp. 15–19, for the debunking of this myth and an account of a number of visits to Degas's apartment and studio.

221. As many references in letters of that period make clear; Morisot 1950.

222. Étienne Moreau-Nélaton, *Manet raconté par lui-même*, 2 vols. (Paris, 1926), vol. 1, p. 36, cited in Paris, Ottawa, New York 1988–89a, pp. 140, 142 n. 2.

223. Duranty 1876, p. 42.

224. For a discussion of the sources for this work see Paris, New York 1983, pp. 83–86.

225. The sketch, RW 378; the etching, Collection Print Sale: 250.

226. *The Ham*, 1880, RW 351; Collection Sale I: 75. *Pear*, ca. 1880, RW 355: Collection Sale I: 79, bought at the Pertuiset sale, June 6, 1886.

227. Letter from Pissarro to his son Lucien, December 4, 1895 (Ashmolean Museum, Oxford); see Bailly-Herzberg 1980–91, vol. 4, p. 128.

228. Georges Rivière, *Mr. Degas, Bourgeois de Paris* (Paris, 1935), p. 76, cited in Richard Kendall, "Degas et Cézanne," in *Degas inédit* 1989, p. 103.

229. Manet 1987, entry for November 29, 1895, p. 76.

230. Manet 1987, p. 177. The portrait in question, of about 1877, is now in the Columbus Museum of Art, Columbus, Ohio. The portrait of Chocquet that Degas owned was probably either a study for the Columbus portrait or of the same format originally but cut down to its present size. See John Rewald, "Chocquet and Cézanne," *Gazette des Beaux-Arts* 74 (July–August 1969), p. 53.

231. Halévy 1960, p. 63.

232. V 107. Entry in the Vollard stockbook for November 29, 1895: "1 tableau de Cézanne, Déjeuner sur l'herbe 80½ × 59½ (manière noire), 600 francs." I am grateful to Richard Kendall for drawing this notation to my attention.

233. Among them Donatello, *Saint George*, Giorgione, *Concert Champêtre*, Delacroix, *The Entry of the Crusaders into Constantinople*, Michelangelo, *The Battle of Cascina*. See Kendall in Paris, Ottawa, New York 1988–89a, pp. 104–5.

234. The drawing, V 1456, Chappuis 1973, no. 1129, did not appear in the sale catalogues. See Kendall, "Degas et Cézanne," in *Degas inédit* 1989, p. 113 n. 13, for the suggestion from the Bollag family, Zurich (who bought three Cézannes from the Degas sale, Collection Sale I: 11, 12, 105), that the drawing belonged to Degas.

235. For Degas's sketch see Reff 1976b, p. 129, Notebook 28, p. 3. It has been generally accepted that *Les Baigneurs: Étude, projet de tableau*, no. 26 in the 1877 exhibition, is the work now in the Barnes Foundation, Merion, Pa., V 276. However, Richard Brettell has proposed that it is more likely to have been the smaller version, ex-Springold Collection, New York, V 273. See Washington, San Francisco 1986 p. 196.

236. Chicago 1984, p. 189.

237. See Kendall, "Degas et Cézanne," in *Degas inédit* 1989, pp. 109, 113 n. 19.

238. For a discussion of Degas's early and late interest in the *écorché* see R. Thomson 1988, pp. 195–97. The *écorché* is seen in the early paint-

ing, *Coin d'atelier*, ca. 1855–60, L 9, and in notebook drawings, see Reff 1976b, Notebook 8, pp. 2v, 3, 32v, 43; Notebook 9, p. 18. Reff 1971, p. 539. For other late drawings of the figure, see Atelier Sale IV: 123b,c.

239. Collection Sale I: 231; Collection Sale II: 106; Collection Sale I: 12.

240. Five paintings and a number of drawings. See Theodore Reff, "Cézanne's Bather with Outstretched Arms," *Gazette des Beaux-Arts* 59 (March 1962), pp. 173–90, for an investigation of all the variants and an analysis of the psychological implications of the subject.

241. See note 33 above.

242. Letter to his son Lucien dated May 13, 1891, in Bailly-Herzberg 1980–91, vol. 3, pp. 81–82.

243. Collection Sale I: 45; not in Wildenstein 1964. Degas described this painting: "93 × 72 cm. Landscape of Martinique, cabins of Blacks under the trees—at left, at the horizon, windmill" ("93 × 72 cm. Paysage de la Martinique, cases nègres sous les arbres—à gauche, à l'horizon moulin à vent"), noting that this was an exchange with Manzi after "the first Hôtel sale" ("la première vente de l'hôtel"). Degas inv., in Dumas 1981, no. 73. See also Douglas Cooper, "An Important Gauguin Discovery," *Burlington Magazine* 123, no. 937 (April 1981), pp. 195–97.

244. See the anecdote about a walking stick Gauguin gave Degas in Charles Morice, *Paul Gauguin* (Paris, 1920), p. 32. It was not included in any of the collection sales.

245. Collection Sale I: 40; W 499.

246. Letter dated February 28, 1895, in Bailly-Herzberg 1980–91, vol. 4, p. 40.

247. See Sévin 1975, p. 29.

248. Gauguin 1923, p. 61.

249. L 410, 408.

250. "Diverses Choses," in *Noa Noa*, Louvre MS.220-1, cited in Richard Brettell, "The Final Years: Tahiti and Hivaoa," in Washington, Chicago, Paris 1988–89, p. 393 and n. 14.

251. See Claire Frèches-Thory on this painting in Washington, Chicago, Paris 1988–89, p. 159.

252. First published in Claude Roger-Marx, "Revue artistique: Exposition Paul Gauguin," *Revue encyclopédique*, no. 76 (February 1, 1894), p. 33. See Charles F. Stuckey in Washington, Chicago, Paris 1988–89, p. 231 and n. 6. It is generally thought that Degas acquired this work at the 1893 exhibition at Durand-Ruel, see Stuckey, ibid., p. 231 and n. 5, but Degas notes that he bought it from Vollard in December 1898 for 300 francs, Degas inv. This is more or less confirmed by the Vollard stockbook, where it is recorded that Degas paid 350 francs for the painting on November 11, 1898; Archives Vollard.

253. Degas inv., in Dumas 1981, no. 77.

254. See Françoise Cachin in Washington, Chicago, Paris 1988–89, pp. 202–3.

255. Ibid., pp. 124–25.

256. Adhémar and Cachin 1973.

257. With the exception of a portrait by J. Tardieu after Jean-Marc Nattier; a Robert Nanteuil after Philippe de Champaigne; a Gérard Edelinck after Jacques Rigaud; one print by Thomas Rowlandson; and 353 reproductions of Rembrandt's etchings. Collection Print Sale: 1–5.

258. Collection Print Sale: 200–204. See Loys Delteil, *Le Peintre-graveur illustré*, vol. 3, *Ingres et Delacroix* (Paris, 1908), no. 1.

259. Collection Print Sale: 110 or 111. Degas, letter dated January 22, 1884, in C. Pissarro 1950, pp. 74–75: ". . . a Delacroix lithograph done after antique medals. These copies are very rare today, and I am very much attached to them." (". . . une lithographie de Delacroix d'après des médailles antiques. Ce sont des exemplaires fort rares aujourd'hui et auxquels je tiens beaucoup.")

260. Reff 1971, p. 537, for Géricault's influence on Degas's racehorse drawings in his notebooks of 1859–60.

261. Lemoisne 1946–49, vol. 1, pp. 180–81, but with an unsupported figure of 1,800 lithographs.

262. Conversations with Michel Melot and Barbara Stern Shapiro.

263. *Lettres de Degas* 1945, no. 186, p. 204. Guérin groups the letter with oth-

ers of 1894, but Reff has connected it with a gift of Gavarni prints from Alexis Rouart in 1881 recorded in a notebook, see Reff 1976b, vol. 1, p. 143, Notebook 35, pp. 108, 109–11.

264. See Reff 1976a, "Three Great Draftsmen," pp. 76–80.

265. Charles Baudelaire, "Le Peintre de la vie moderne," in Baudelaire 1965, vol. 2, p. 442.

266. Reff 1976b, vol. 1, p. 23, Notebook 22, p. 5.

267. Charles Baudelaire, "Salon de 1845," in Baudelaire 1975–76, vol. 2, p. 356. Jeanniot 1933, p. 171, recording a conversation between Degas and Gérôme.

268. Charles Baudelaire, "Quelques caricaturistes français," 1857, in Baudelaire 1975–76, vol. 2, p. 556.

269. Collection Sale I: 23.

270. Duranty 1878, p. 429.

271. Jeanniot 1933, p. 171.

272. Collection Print Sale: 119.

273. For Degas's copies of portraits by Holbein in a notebook of circa 1858–61, see Reff 1963, p. 245. For Degas's notebook copy of Holbein's *Anne of Cleves* in the Louvre, see Reff 1976b, Notebook 18, p. 115; oil copy L 80.

274. Passeron 1974, p. 11.

275. Charles Baudelaire, "Peintres et Aquafortistes," 1862, in Baudelaire 1975–76, vol. 2, p. 740.

276. See Ruth Fine in London, Paris, Washington 1995, p. 101. Whistler completed the Thames Set by 1861 and impressions were printed by Auguste Delâtre and Whistler. However, the Thames plates were not formally published until 1871, when an edition of one hundred was produced; see ibid. I have not been able to discover when Degas acquired his Whistler etchings. Since he was a friend of both Whistler and Delâtre and the impressions he owned were of very high quality, as is indicated in the sale catalogue, it is possible that his are among the first impressions that were produced prior to 1871.

277. Two boxes of prints were acquired at the sale by Manzi but then obtained by Degas in exchange for his own work. Degas inv.

278. *Hat and Guitar*, 1862. Musée Calvet, Avignon; RW 60.

279. For a discussion of this and related prints see Juliet Wilson Bareau in Paris, New York 1983, pp. 139–42.

280. Ibid., pp. 277–79.

281. Collection Print Sale: 283, 282; Guérin 1944, no. 79. Degas mentions his acquisition of the color lithograph from the Duranty sale, Degas inv. I have not been able to locate the color lithograph owned by Degas, but it seems likely that it would have been an impression from the first printing of a dozen or so proofs or the second printing of twenty-five, rather than the third, much larger printing; see Wilson Bareau 1978, no. 83, for a discussion of these editions. Degas owned the only known impression in black and white of this print, inscribed "Épreuve unique E.M.," ibid. It was probably included in the two boxes of etchings and lithographs by Manet that Degas recorded acquiring from the Burty sale (March 4–5, 1891) via Manzi; Degas inv. The impression is now in a private collection on loan in the United States. According to Guérin 1944, no. 79, another impression in black and white was colored in watercolor by Manet in preparation for the color printing. Guérin also surmised that there was probably at least one other impression, which would have been used as a transfer by the printer; see Paris 1978.

282. Collection Print Sale: 272: "Very fine proof, before lettering, on China paper." ("Très belle épreuve, *avant la lettre*, sur chine.")

283. See Juliet Wilson Bareau in Paris, New York 1983, pp. 299–301, for a discussion of this lithograph. The images of cats by Hiroshige and Hokusai probably were models for Manet.

284. In addition to drypoint and etched lines, those methods included aquatint, the little-known soft-ground etching technique, the dusting of resin grains, and salt grain; there were also interesting accidental effects produced by printing imperfections. See Barbara Stern Shapiro, "Pissarro the Print-Maker," in London, Paris, Boston 1980–81, p. 92.

285. Ibid.

286. Collection Print Sale: 300–311.
287. Collection Print Sale: 310. See *Lettres de Degas* 1945, no. 25 [1880], p. 53. Degas suggests that the overall grayish tone is the result of Pissarro using a greasy zinc plate that retained too much of the printer's black ink. He would achieve a better effect, Degas suggested, with a copper plate. In the same letter Degas gave detailed instructions on how to achieve a finely uniform gray sky by using grains.
288. Most of the color impressions annotated by Pissarro bear the inscription "imp. par Degas" in Pissarro's hand: for example, those in the National Gallery of Canada, Ottawa, and in a private collection, printed in red-brown; and the one in the Museum of Fine Arts, Boston, in Prussian blue. See Shapiro 1992, pp. 297–98.
289. Collection Print Sale: 304. See Shapiro, "Pissarro the Print-Maker," in London, Paris, Boston 1980–81, p. 209. Degas also had a maculature of the tenth state.
290. Ibid.
291. See Reff 1976b, vol. 1, p. 134, Notebook 30, pp. 202, 205, 207; dated 1879.
292. Collection Print Sale: 16–58 include eighty-seven impressions plus thirteen working proofs from plates, for the most part "unfinished." See Washington, Boston, Williamstown, Mass. 1989–90, pp. 58, 86 n. 2.
293. Collection Print Sale: 21, 22, 23.
294. Collection Sale I: 102. *In the Loge,* 1879, pastel (Philadelphia Museum of Art). Breeskin 1970, no. 61.
295. Collection Print Sale: 54. *La Visite,* with the indication "unique series of thirteen states" ("série unique de treize états").
296. See Boston, Philadelphia, London 1984–85, pp. 184–97, no. 52, for a discussion of this print, in which Degas combined aquatint, drypoint, etching, and *crayon électrique,* and for reproductions of all twenty states.
297. These were shown at the two exhibitions of the Société des Peintres-Graveurs that Durand-Ruel put on in January–February 1889 and March 1890. The twelve prints shown at the second of these exhibitions were issued in editions of twenty-five by Durand-Ruel. It is likely that Degas owned impressions of most of these drypoints, but this is hard to establish with certainty since the titles given to Cassatt's prints have varied over time and it is not possible to correlate them directly with the often vague information given in the sale catalogue of Degas's print collection.
298. Only one color etching is specified in the sale catalogue of Degas's prints, lot no. 50, *Maternal Caress (Tendresse maternelle)* ("Très belle épreuve; *imp. en couleurs*"), but according to the Durand-Ruel stock-books Degas purchased three prints, including *Woman Bathing (La Toilette),* on December 18, 1893 (Book of "Reçu en dépôt," Maison Durand-Ruel, Paris); see Barbara Stern Shapiro, "Mary Cassatt's Color Prints and Contemporary French Printmaking," in Washington, Boston, Williamstown, Mass. 1989–90, p. 87 n. 63.

299. Degas refers to this in a letter to Bartholomé. See *Letters de Degas* 1945, no. 120, p. 151, n.d., received April 29, 1890.
300. See Boston, Philadelphia, London 1984–85, nos. 61.IV, 66.III, 66.V.
301. Collection Print Sale: 309. The two states Degas owned ("deux états, trois épreuves, une signée") may be the two zinc and copper plates mentioned by Shapiro in London, Paris, Boston 1980–81, p. 203, the second made from the first by an electroplating technique.
302. Collection Print Sale: 307.
303. Conversation with Timothy Clark, Assistant Keeper of Japanese Antiquities, British Museum.
304. See Roquebert 1989, p. 84 n. 58.
305. Letter to Pissarro, ca. 1880, *Lettres de Degas* 1945, no. 25, p. 54. "This sort of pattern might be placed on a line or soft-ground etching and the uncovered parts then printed by means of porous woodblocks saturated with watercolor. Some pretty trial prints in color, original and curious, might thus be produced." ("On pourrait appliquer ces sortes de patrons, sur une épreuve au trait et un peu à l'effet, à l'eau-forte ou au vernis mou et imprimé alors avec du bois poreux chargé de couleur à l'eau les parties mises à découvert. Il y aurait là à faire de jolis essais d'impressions originales et curieuses en couleur.")
306. For the influence of Degas's monotypes on Gauguin's wood-block technique see Field 1968, pp. 504, 507.
307. Collection Print Sale: 128. "Series of ten woodcuts. Very fine proofs, most printed in many colors, and remounted on blue paper." ("Série de dix gravures sur bois. Très belles épreuves, la plupart tirées en plusieurs tons, et remontées sur papier bleu.") The blue mounts were almost certainly the work of Gauguin.
308. Collection Print Sale: 123–27.
309. "Impression à l'eau, au moyen d'une plaque de verre et d'un papier pressé par un rouleau à la main." Degas inv., in Dumas 1981, no. 66.
310. See Field in Philadelphia 1973, p. 15, and Barbara Stern Shapiro, "Nineteenth-Century French Monotypes," in *The Painterly Print: Monotypes from the Seventeenth to the Twentieth Century,* exh. cat., New York, The Metropolitan Museum of Art (New York, 1980), p. 132. See also discoveries made by Peter Zegers about Gauguin's method of making watercolor transfers in Richard Brettell, "Watercolor and Gouache Transfers on Tahitian Themes," in Washington, Chicago, Paris 1988–89, p. 352. For a discussion of Degas's monotype technique, see Janis 1968.
311. Collection Print Sale: 127, *Words of the Devil (Parau no varua).* "Two color monotypes, variants of the same composition. Passe-partout [mounted under glass]." ("Deux monotypes en couleurs, variantes de la même composition. Sous-verre.") The first transfer has since been identified as *Arearea no varua ino* (The National Gallery of Art, Washington, D.C.). They were pasted onto the same mount by Gauguin and then separated at a later date. See Brettell in Washington, Chicago, Paris 1988–89, pp. 352–53, n. 326.

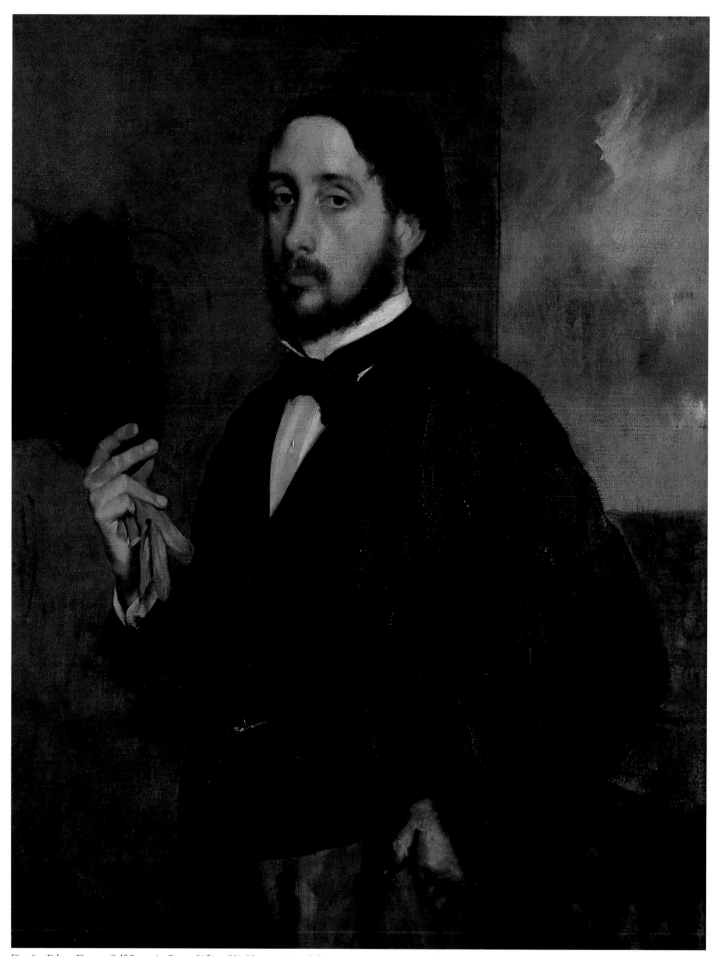

Fig. 82. Edgar Degas, *Self-Portrait: Degas Lifting His Hat,* ca. 1863. Oil on canvas, 36⅜ × 26⅛ in. (92.5 × 66.5 cm). L 105. Fundação Calouste Gulbenkian–Museu, Lisbon (2307). Retained by Degas's heirs

Degas's Degases

GARY TINTEROW

Tell Monsieur Degas that if he founds a museum, he must choose a Manet."[1] Given his boundless admiration for Manet's works, it is not difficult to imagine Degas availing himself of the offer made by Berthe Morisot in her last, testamentary letter to her daughter Julie Manet, whose uncle was the painter Édouard Manet. Morisot was a close friend and colleague of Manet as well as the wife of his brother Eugène, and she owned a number of highly covetable works by the artist. At the time of her death in March 1895, Degas himself possessed some five canvases by Manet and innumerable drawings and prints. To choose from among Morisot's Manets would have been a painful but exquisite task. Degas never proceeded with his museum, however, and thus could not in good faith accept Morisot's offer. Instead, two years later, he bought from the dealer Ambroise Vollard Manet's moving portrait of Berthe Morisot in mourning for her father (fig. 253). The purchase of that picture was unquestionably bound up with Degas's own grief over the loss of his friends Morisot and Manet.

If Degas *had* founded his museum, which of his own works would he have chosen to display? Or, putting the question another way, what did he value most in his oeuvre, and how did he regard his own work in the context of the art he collected? The answer to the question is ultimately unknowable, but a trail of clues as fluid and indirect, yet as logical, as the complexities of his relations with Manet and Morisot can be used to conjure up his imaginary museum. There is no doubt that he made plans for it,[2] but since they were never set down, it is not absolutely certain that he intended to include his own work in the museum he envisioned.[3] While his notions must have changed over time before the project was definitely abandoned, they would have been framed largely by the precedents at hand. The Musée Granet in Aix-en-Provence, the Musée Fabre in Montpellier, and the Musée Ingres in Montauban had all been endowed in the middle of the nineteenth century with both the private collections of the eponymous artists and the contents of their studios at

death.[4] Indeed, the Musée Ingres and the Musée Fabre were the objects of a pilgrimage Degas made in the summer of 1897, during which he drafted a pious letter to the mayor of Montauban proposing to exchange photographs of works by J.-A.-D. Ingres in his own collection for photographs of works in the Musée Ingres.[5] Without question, Degas's own collection was on his mind as he visited these prototypical museums, and he was probably also aware of the plans of his old friend Léon Bonnat to establish a similar museum in Bayonne. (Bonnat commissioned a new building for his museum;[6] Ingres and François-Xavier Fabre had given their collections to previously existing provincial museums.)

Much closer to home was the Musée Gustave Moreau in Paris, which opened to the public in 1903, in the building in which Moreau had lived, worked, and taught. According to Daniel Halévy, then a friend of more than twenty years, it was a visit to this museum that dealt a death blow to the idea of a Musée Degas: "It dissuaded him from following through with his project to found a museum where his collection (and also part of his studio) could be included." Leaving the museum, Degas said, "How truly sinister . . . you would think you were in a mausoleum. All of those paintings jammed together make me think of a thesaurus, a *Gradus ad Parnassum* [textbook of classical prosody]."[7] Since the Moreau museum houses the majority of the artist's extant work and very little by other artists, what provoked Degas's recoil must have been the sight of Moreau's paintings, drawings, and watercolors en masse. Although Degas had been Moreau's devoted acolyte when the two young students were in Rome together in the late 1850s, ten years later they had grown apart, and by the mid-1870s Degas was disdainful of Moreau's art.[8] Presumably it was not just Moreau's work, heavily encrusted with dense detail, that so repelled Degas at the museum on the rue de La Rochefoucauld, but also the revelation of an unedited accumulation of an obsessive life. The Musée Gustave Moreau exhibits hundreds of canvases and holds thousands of drawings, orderly in their arrangement but

overwhelming in their extent and in the singularity of Moreau's preoccupations.

Degas was also a packrat, but, in contrast to Moreau, he carefully edited anything he planned to reveal to his friends, not to mention to the public at large. In his unofficial and very private museum established in late 1897 on the bottom floor of the three-story apartment at 37, rue Victor Massé,[9] he gave pride of place to his masterpieces by Eugène Delacroix and Ingres. Visitors to that room, inevitably astounded by the portraits of Baron Schwiter, M. and Mme Leblanc, and the Marquis de Pastoret (figs. 44, 22, 21, 20), did not mention seeing Degas's own work there. In his dimly lit and dusty studio on the top floor of

the building, with its forest of easels and beat-up props for his pictures—tubs, screens, benches, and a chaise longue—the only work visible was work in progress, which was more likely to be a wax figure of a bather or dancer on a sculptor's tripod than a painting or a pastel. One of Degas's models at the turn of the century, Pauline, described the place: "There was nothing, not the slightest ornament or drapery, to brighten this somber interior. The doors and high brown walls were bare, without a single drawing or painting. Degas put all his work away in boxes or cupboards, or piled them up in the little room at the end of the studio."[10]

But in his living quarters, Degas intermingled some works of his own with those he had acquired. Paul Lafond,

who knew the artist well, published reminiscences immediately after Degas's death that included a detailed description of the arrangement of his rooms in the rue Victor Massé, where Degas lived from 1897 to 1912. In the sanctum sanctorum, Degas's bedroom, some early portraits of his siblings—the pastel of his sister Thérèse Degas shown in their father's sitting room (fig. 124) and the portrait in oil of his brother Achille as a naval officer (fig. 83)—hung alongside works by Delacroix, Ingres, Camille Corot, the Manets, and Torii Kiyonaga. Photographs of Degas's salon, probably the one in the rue Ballu apartment that he occupied from 1890 to 1897 (figs. 7, 14),[11] show Degas's portrait of Manet (fig. 248) hung with Manet's *Ham* (fig. 8). It was probably in this room as well as later in the salon in the rue Victor Massé that visitors saw in a vitrine the fragile wax and gauze *Little Fourteen-Year-Old Dancer* (fig. 84), the

only sculpture that Degas exhibited during his lifetime. Louisine Havemeyer, who tried several times over a twenty-year period to acquire the original wax, remembered from a 1903 visit to Degas's apartment "how faded the gauze was and how wooly the dark hair appeared, but nevertheless I had a great desire to possess the statue."[12] Some of his small wax sculptures, as well as the few plaster casts that he had had made from his waxes about 1900, were also displayed here (fig. 85).[13]

Degas died on September 27, 1917, in a small, unloved flat on the boulevard de Clichy which he had moved to in 1912 but had never properly arranged. When the contents of his studio were placed on view prior to their sale in May 1918, it came to light that Degas had kept an enormous quantity of his own work, far more than his friends had ever seen in any of his apartments. It took five auctions held

Fig. 84. Edgar Degas, *The Little Fourteen-Year-Old Dancer,* 1879–81. Wax, cotton skirt, satin hair ribbon, H. 37½ in. (95.2 cm). Collection of Mr. and Mrs. Paul Mellon, Upperville, Virginia. Photograph taken by Gauthier in 1918. Retained by Degas's heirs

Fig. 85. Edgar Degas, *Dancer Looking at the Sole of Her Right Foot,* ca. 1900. Plaster, H. 18⅞ in. (48 cm). Private collection, Paris

Fig. 86. Edgar Degas, *The Crucifixion, after Mantegna*, 1861. Oil on canvas, 27⅛ × 36⅜ in. (69 × 92.5 cm). L 194. Musée des Beaux-Arts de Tours (France, Indre-et-Loire) (934-6-1). Atelier Sale I: 103

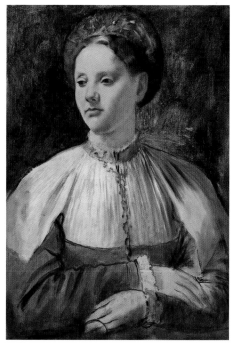

Fig. 87. Edgar Degas, *Portrait of a Young Woman*, after a drawing then attributed to Leonardo da Vinci, 1858–59. Oil on canvas, 26 × 17½ in. (63.5 × 44.5 cm). L 53. National Gallery of Canada, Ottawa (15222). Retained by Degas's heirs

over two years to disperse the nearly three thousand individual items.[14] Although most of the important canvases were known to his intimates, who over the years had been given special viewings of particular works, few friends had realized the enormous size and variety of the ensemble. Mary Cassatt knew more than most through her close friendship with Jeanne Fevre, Degas's niece, who had come to Paris about 1915 at Cassatt's request to care for the old and

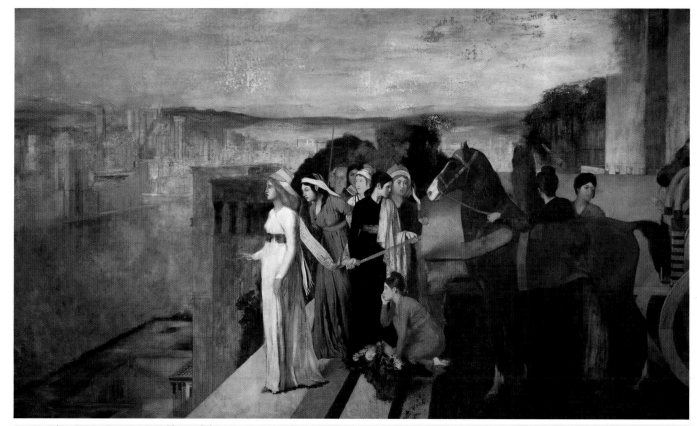

Fig. 88. Edgar Degas, *Semiramis Building Babylon*, ca. 1860–62. Oil on canvas, 59 × 101⅝ in. (150 × 258 cm). L 82. Musée d'Orsay, Paris (R.F. 2207). Atelier Sale I: 7a

ailing artist. Cassatt announced to her friend Louisine Havemeyer just months after Degas's death, "One thing is sure, the interest in Art remains, the Degas sale will be a sensation. . . ."[15] Seeing the material in 1918, Paul Jamot, a curator at the Louvre, discovered that "the most complete collector of Degas's works was Degas himself."[16]

Daniel Halévy vividly summed up the character of Degas's Degases as they were being arranged prior to auction: "Monday [April 29, 1918] at Durand-Ruel. All the movable pictures from Degas's studio are there. We shifted them around and compared them: all the early paintings that he had held on to; all the unfinished ones from the last few years. Everything in between is missing. But what is in between is not the most precious. Degas's studies are superb, and especially admirable are the forms he discov-

ered in his despair, the colors he ground out, crushing the pastel into the canvas [sic] to find relief from what had become the exhausting labor of capturing forms. . . ."[17] Halévy understood that Degas had kept the work of his youth and the work of his old age, all of his unfinished work, all of his copies after old masters, and most of his drawings and prints.

The finished canvases and pastels that Degas kept fall neatly into several categories. The first are copies after other masters, from Mantegna to Leonardo to Quentin de La Tour to Delacroix (see figs. 86, 87, 162, 205), which form a kind of collection within a collection.[18] Next are the ambitious compositions created in the 1860s, some to be shown at the Salon, including *Semiramis Building Babylon, Mademoiselle Fiocre in the Ballet "La Source," Family Portrait*

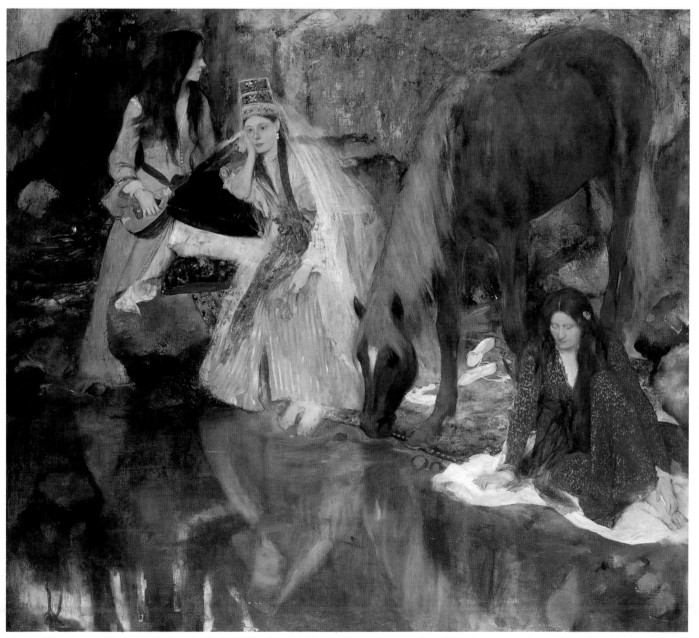

Fig. 89. Edgar Degas, *Mademoiselle Fiocre in the Ballet "La Source,"* 1867–68. Oil on canvas, 51⅛ × 57⅛ in. (130 × 145 cm). L 146. The Brooklyn Museum, New York, Gift of A. Augustus Healy, James H. Post, and John T. Underwood (21.111). Atelier Sale I: 8

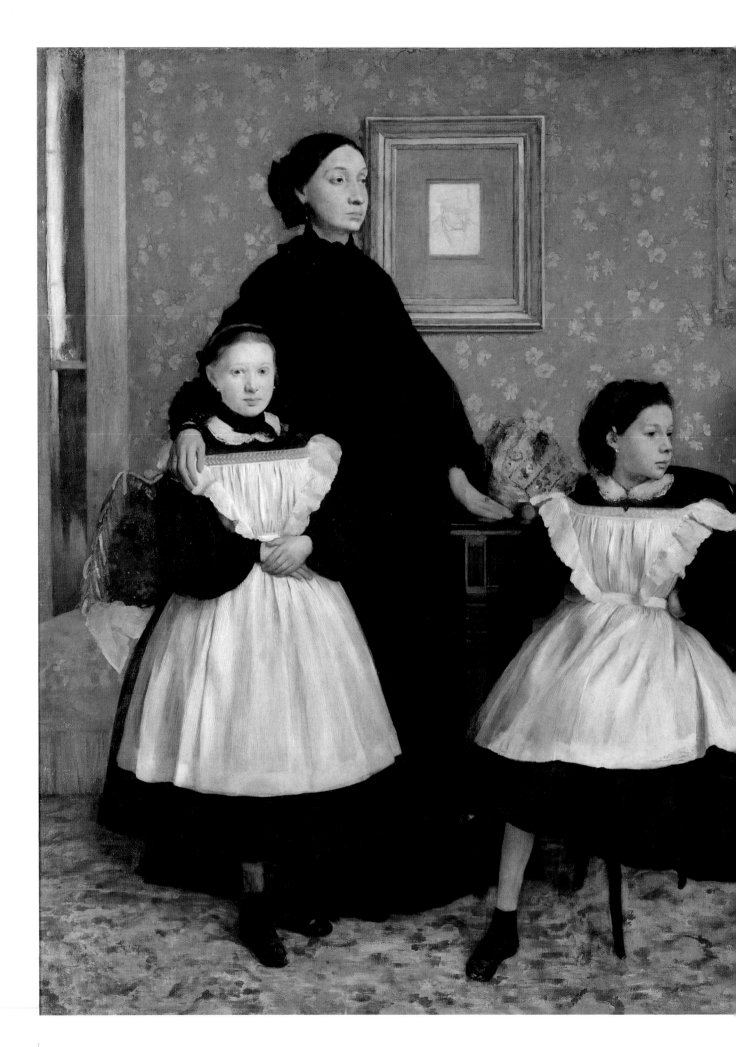

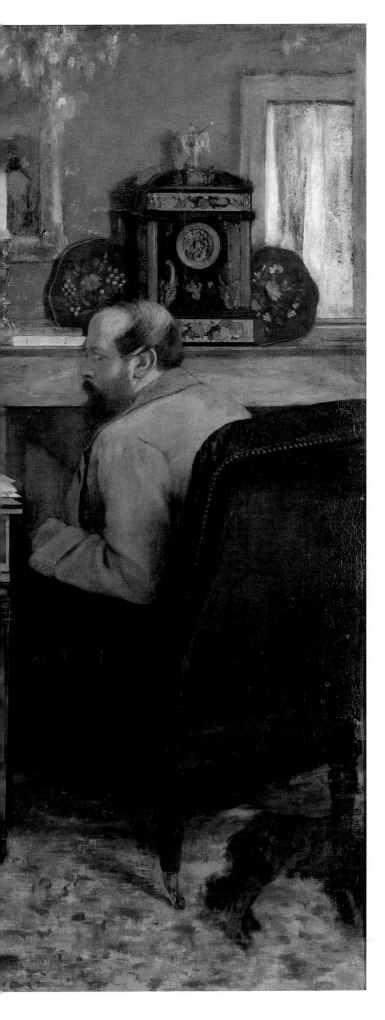

Fig. 90. Edgar Degas, *Family Portrait,* also called *The Bellelli Family,* 1858–67. Oil on canvas, 78¾ × 98⅜ in. (200 × 250 cm). L 79. Musée d'Orsay, Paris (R.F. 2210). Atelier Sale I: 4

Begun in Florence in 1858 and completed in Paris about 1859, this painting was slightly revised before its exhibition at the 1867 Salon in Paris. It was not often visible thereafter. One acquaintance, the critic François Thiébault-Sisson, saw it in Degas's studio about 1879; the artist Jean-Jacques Henner saw it in 1881. Cumbersome and neglected, the huge canvas was deposited with Durand-Ruel for safekeeping in 1912, when Degas had to leave his large apartment at 37, rue Victor Massé. The picture's reappearance prior to the Degas sale created a sensation.

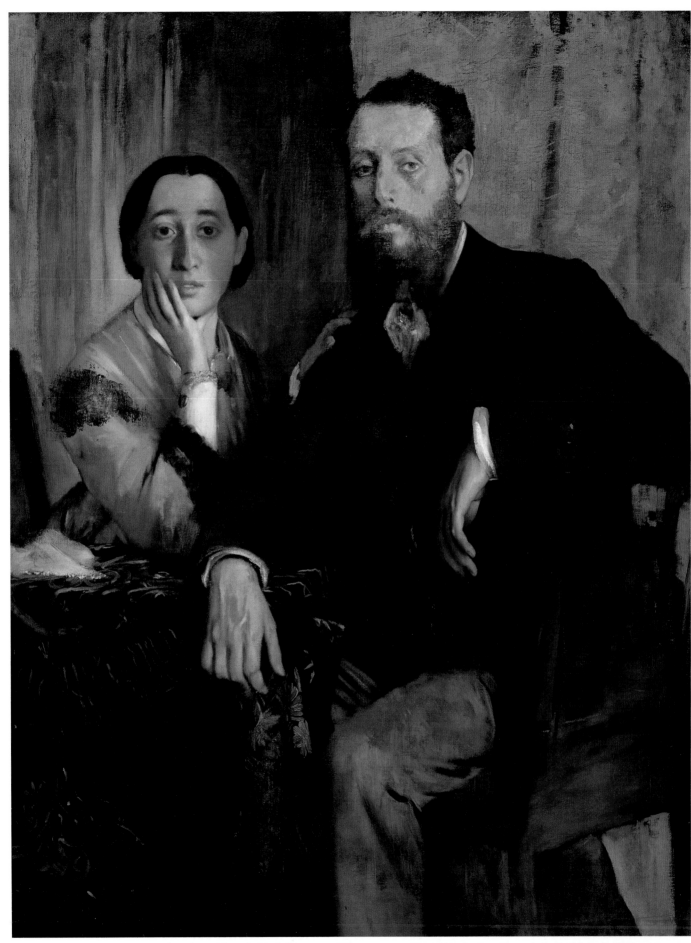

Fig. 91. Edgar Degas, *Monsieur and Madame Edmondo Morbilli,* ca. 1865. Oil on canvas, 45⅞ × 34¾ in. (116.5 × 88.3 cm). L 164. Museum of Fine Arts, Boston, Gift of Robert Treat Paine II (31.33). Retained by Degas's heirs

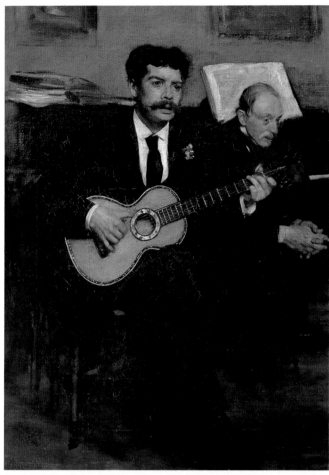

Fig. 92. Edgar Degas, *Lorenzo Pagans and Auguste De Gas,* ca. 1871. Oil on canvas, 21¼ × 15¾ in. (54 × 40 cm). L 256. Musée d'Orsay, Paris (R.F. 3736). Retained by Degas's heirs

(also called *The Bellelli Family*), and *The Steeplechase* (see figs. 88–90, 361). The group of portraits of himself, family, and friends, such as *Self-Portrait: Degas Lifting His Hat, Monsieur and Madame Edmondo Morbilli, Lorenzo Pagans and Auguste De Gas, Violinist and Young Woman Holding Sheet Music,* and *James Tissot* (figs. 82, 91–93, 333), date from as early as the 1850s until as late as 1905.[19] A small number of singular compositions date from the late 1860s to mid-1880s, among them *Interior, The Song Rehearsal,* and *The Millinery Shop* (figs. 94–96). The final group is of large canvases executed in the second half of the 1890s, such as *The Coiffure, After the Bath,* and *Fallen Jockey* (figs. 99–101), which may or may not be finished.[20] These same categories also apply to the works that Degas sold rather than kept: he sold very few of the finished pictures from his youth, the 1850s and 1860s; he sold almost all the finished pictures of his maturity, the 1870s and 1880s, except for portraits and a few isolated compositions; and he sold only selected pieces from his old age, the 1890s and the first years of the twentieth century, works that Halévy called "sad in their violence."[21] If portraiture is defined in the narrowest sense, one may say that Degas very rarely sold portraits during his lifetime.[22]

This pattern conforms with the crude facts of Degas's economic life. Supported by his affluent family, he had little

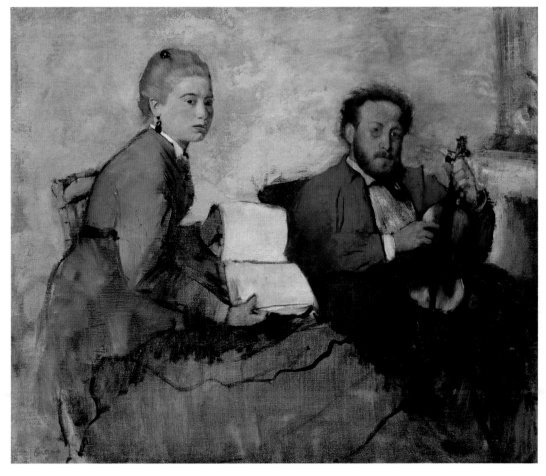

Fig. 93. Edgar Degas, *Violinist and Young Woman Holding Sheet Music,* ca. 1872. Oil on canvas, 18¼ × 22 in. (46.4 × 55.9 cm). L 274. The Detroit Institute of Arts, Bequest of Robert H. Tannahill (70.167). Atelier Sale I: 49

Fig. 94. Edgar Degas, *Interior*, also called *The Rape*, ca. 1868–69. Oil on canvas, 31⅞ × 45⅝ in. (81 × 116 cm). L 348. Philadelphia Museum of Art, The Henry P. McIlhenny Collection in memory of Frances P. McIlhenny (1986-26-10). Retained by Degas's heirs

When Degas showed this painting to his friend Paul Poujaud in 1897, he called it simply "my genre painting," although it was probably inspired by Zola's novel *Thérèse Racquin*. Degas kept the painting until 1905, well after he had abandoned plans to establish a museum, then deposited it with the dealer Durand-Ruel. It was not sold until 1909, when an American bought it from the New York branch of the gallery.

Fig. 95. Edgar Degas, *The Song Rehearsal*, 1872–73. Oil on canvas, 31⅞ × 25⅝ in. (81 × 65 cm). L 331. Dumbarton Oaks Research Library and Collections, Washington, D.C. (18.2). Atelier Sale I: 106

Fig. 96. Edgar Degas, *The Millinery Shop,* ca. 1882–86. Oil on canvas, 39⅛ × 43½ in. (100 × 110.7 cm). L 832. The Art Institute of Chicago, Mr. and Mrs. Lewis Larned Coburn Memorial Collection (1933.428)

need to sell his early work. The death of his father, a private banker, in February 1874 revealed that the family firm was bankrupt, and thus in the 1870s and 1880s Degas had a dramatic need for money to support himself and to repay, with his brother Achille, the debts left by their father's business. By the end of the 1880s the debt had been paid, and the high prices obtained from the sale of the few works he chose to release provided ample income for himself and supported his newly felt need to build a collection of works of art. Toward the end of Degas's career there was such a demand for his work that he could readily have sold almost anything. Dealers a generation younger than Paul Durand-Ruel, the principal promoter of the Impressionist artists—such as Michel Manzi, Ambroise Vollard, René

Gimpel, and the Bernheims—paid court, hoping to obtain paintings and pastels; so did museum curators from Paris and New York.[23] Gimpel recorded being told by Durand-Ruel, "When [Degas] parted with a picture, his dearest wish was that it shouldn't be sold, and given the chance, he wouldn't fail to speak disparagingly of it. For thirty years he wanted nothing to go out of his studio; occasionally we'd be allowed a study."[24] Degas's friend the amateur sculptor (and dentist) Paul Paulin confirmed that Degas "only allowed the pictures he regarded as finished to leave his studio."[25]

Degas's collection of Degases was formed deliberately: its makeup was neither accidental nor the result of indifference.[26] More than anything else, this assemblage

Fig. 97. Edgar Degas, *Four Dancers,* ca. 1896–98. Oil on canvas, 59 × 71 in. (150 × 180 cm). L 1267. National Gallery of Art, Washington D.C., Chester Dale Collection. Atelier Sale I: 10

constituted a working archive from which new works could be generated. For example, his portfolios of drawings, which he traced, retraced, and redrew, provided the point of departure for much of his late output. So did early works such as *Scene of War in the Middle Ages,* 1865 (L 124; fig. 358), which he mined for inspiration later in life. But he was not a meticulous curator of his own work. Writing in 1918 of his own excitement at seeing *Family Portrait (The Bellelli Family)* properly stretched after it had long lain rolled in an obscure corner, Paul Jamot wrote that Degas was the "most secret" but not the "most careful" collector of his own art.

It was necessary to wait for the death of the author not only for this work to be admired and put in its proper place by historians and critics but also, a more elemen-

tary matter, for the very existence of the canvas to be made known. [*Family Portrait*] is unique because of its large size and the importance of its composition. But how many other pictures of even greater interest, finished or only sketched in, particularly the seductive work of his youth, were also hidden—buried under the dust of the studio! It is a practically unknown Degas that has been revealed to us.[27]

If Degas had endowed a museum with the contents of his studio at death, the best-known work of his career—the ballet scenes, the racetracks, and the laundresses created during the years in which he participated in the eight Impressionist exhibitions, 1874–86—would scarcely be represented. Instead, portraiture, which seems to have been fundamentally a private matter for him, would assume

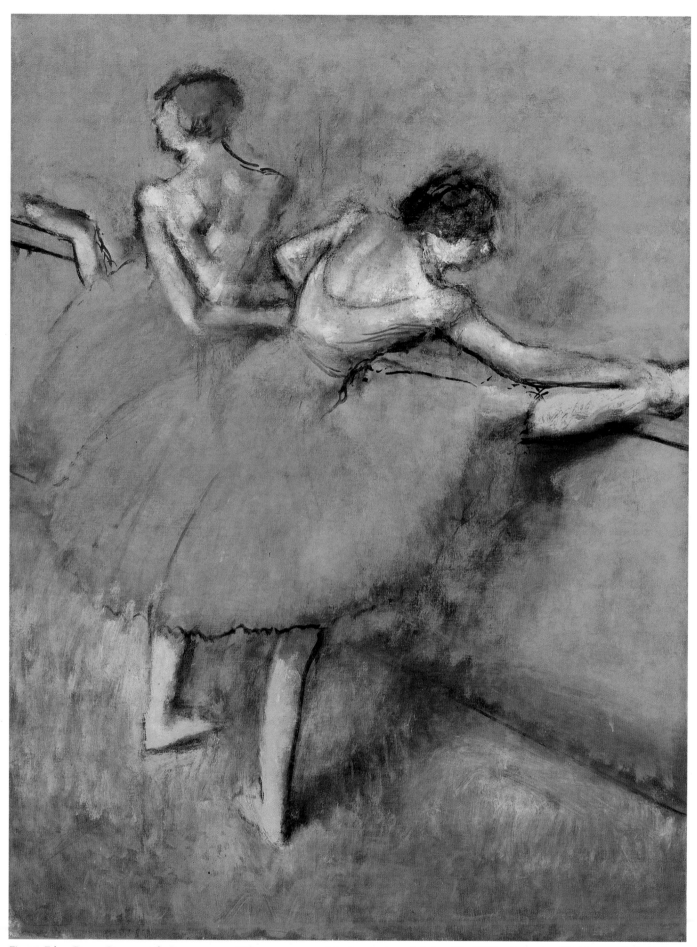

Fig. 98. Edgar Degas, *Dancers at the Barre*, ca. 1900. Oil on canvas, 51 × 38 in. (130 × 96.5 cm). L 807. The Phillips Collection, Washington, D.C. Atelier Sale I: 93

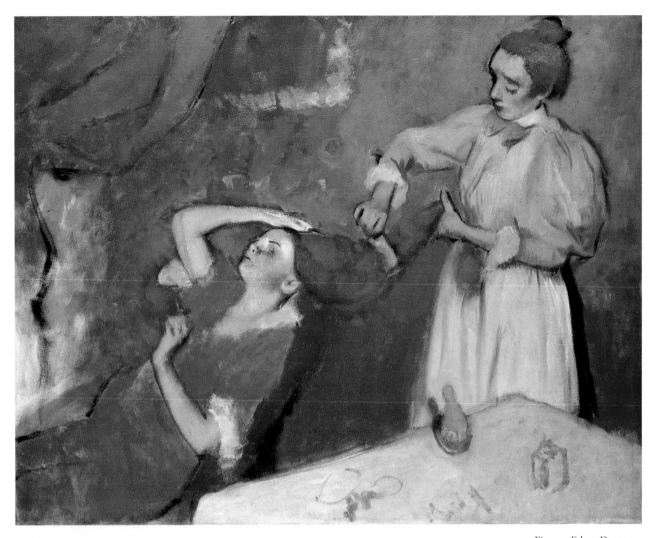

Fig. 99. Edgar Degas, *The Coiffure,* ca. 1896. Oil on canvas, 48⅞ × 59 in. (124 × 150 cm). L 1128. Reproduced by courtesy of the Trustees, the National Gallery, London (NG 4865). Atelier Sale I: 44

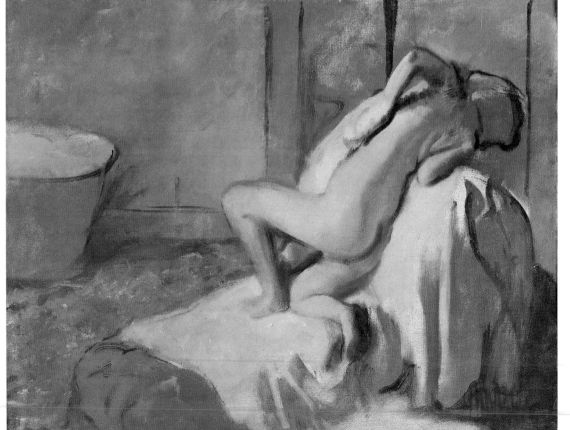

Fig. 100. Edgar Degas, *After the Bath,* ca. 1896. Oil on canvas, 35 × 45¾ in. (89 × 116 cm). L 1231. Philadelphia Museum of Art, Purchased with funds from the estate of George D. Widener (1980-6-1). Atelier Sale II: 17

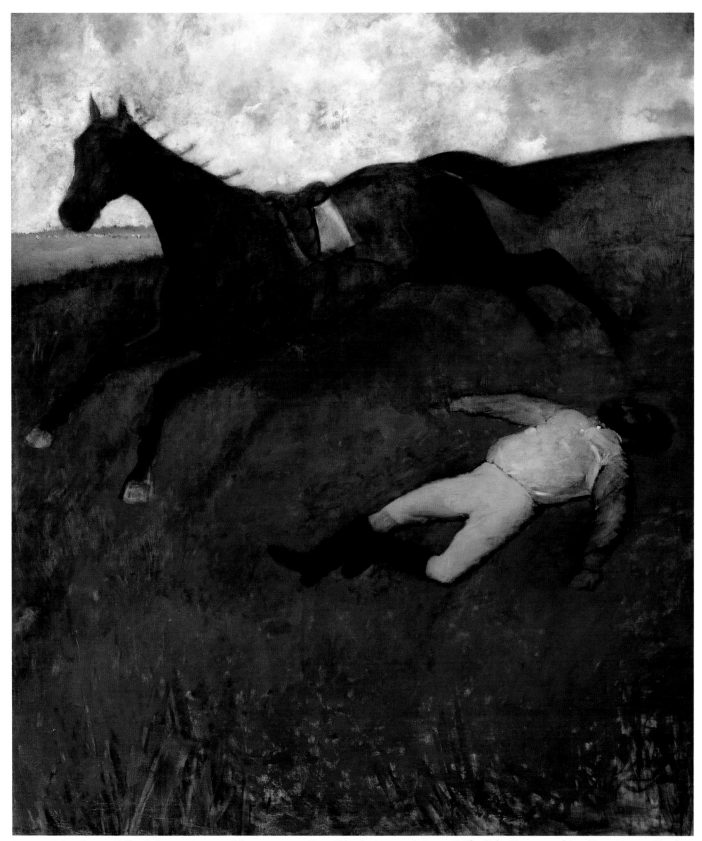

Fig. 101. Edgar Degas, *Fallen Jockey,* ca. 1896–98. Oil on canvas, 70¾ × 59½ in. (181 × 151 cm). L 141. Oeffentliche Kunstsammlung, Kunstmuseum Basel (G 1963.29). Atelier Sale I: 56

a prominent role.[28] It was perhaps to redress this imbalance in his holdings that Degas embarked upon a series of large canvases in the second half of the 1890s. These paintings, each a "museum work" in scale and ambition, take up one by one the central themes in his oeuvre: dancers on the stage (fig. 97), dancers in the rehearsal room (fig. 98), a woman having her hair combed (fig. 99), a woman drying herself after a bath (fig. 100), a racing scene (fig. 101). Much like the great canvases painted at the end of Moreau's career, these paintings epitomize Degas's lifelong preoccupations,

Fig. 102. Edgar Degas, *Kneeling Nude, Study for "Semiramis,"* 1861. Black chalk heightened with pastel, 13⅜ × 8⅞ in. (34.1 × 22.4 cm). Musée du Louvre, Paris, Département des Arts Graphiques, Fonds Orsay (R.F. 15488). Atelier Sale I: 7b

Fig. 103. Edgar Degas, *Nude, Seen from Behind, Climbing into a Chariot,* 1861. Graphite, 11¼ × 6⅛ in. (28.5 × 15.5 cm). Musée du Louvre, Paris, Département des Arts Graphiques, Fonds Orsay (R.F. 15486). Atelier Sale I: 7b

Fig. 104. Edgar Degas, *Drapery Study for "Semiramis,"* ca. 1860–62. Graphite, watercolor, and touches of gouache, 9⅝ × 12¼ in. (24.4 × 31.1 cm). Musée du Louvre, Paris, Département des Arts Graphiques, Fonds Orsay (R.F. 22615). Atelier Sale I: 7b

To demonstrate his affiliation to the practice of his revered Ingres, Degas chose to reproduce figure studies both nude and draped.

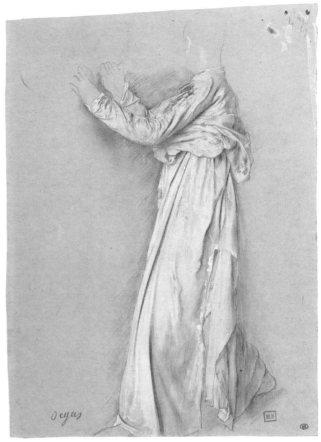

Fig. 105. Edgar Degas, *Drapery Study for a Figure Climbing into a Chariot,* 1861. Graphite, 12 × 8⅞ in. (30.4 × 22.6 cm). Musée du Louvre, Paris, Département des Arts Graphiques, Fonds Orsay (R.F. 15515). Atelier Sale I: 7b

Fig. 106. Edgar Degas, *Standing Figure, Clothed, Study for "Semiramis,"* ca. 1860–62. Graphite heightened with watercolor and goauche on blue-green paper, 11½ × 8⅝ in. (29.1 × 21.9 cm). Musée du Louvre, Paris, Département des Arts Graphiques, Fonds Orsay (R.F. 15502). Atelier Sale I: 7b

developed in his final, passionate, sometimes savage, often theatrical, style. As the Degas scholar Jean Sutherland Boggs has observed, these late canvases possess "the artificiality as well as the scale and carrying power of the theater. His colors became stronger and harsher, his handling richer, and his line more brutal."[29] It is impossible to imagine Degas selling these paintings; they were too large for the collectors who sought his work and too daring for any public museum. He can only have made them to satisfy a personal need.

Of the art in Degas's studio, it was the graphic work—the drawings, pastel studies, etchings, lithographs, and monotypes—that provided a continuum from the beginning of his career until the end. If Degas had followed the precedents of the Musée Ingres, the Musée Fabre, the Musée Granet, or the Musée Gustave Moreau, he would have bequeathed the portfolios of graphic art to his museum. Degas's appreciation of graphic art is legendary. (He insisted, for example, that drawings be accorded the same prestige as paintings when he helped to arrange the memorial exhibition for Berthe Morisot.) Yet it is known that at the end of his life, long after he had abandoned plans for the museum, Degas entered into a pact with a few young

disciples, whom he asked to destroy a large portion of his studio, presumably working drawings and unfinished canvases and pastels. Letters between Paul Valéry and André Gide reveal that Ernest Rouart, who was the son of Degas's old friend Henri Rouart as well as the husband of Julie Manet and a painter himself, had been entrusted with the responsibility of editing the contents of the atelier; but he failed to do so.[30] Whether this was because of lack of courage on his part or because of pride or greed on the part of Degas's heirs—his younger brother René, his niece Jeanne Fevre, and her brothers and sisters—one will never know.[31] Valéry wrote to Gide after the first day of the sale of the contents of Degas's studio: "Disaster. The Degas exhibition. It's treason. When one thinks that he planned to commit to Ernest [Rouart] the task of filtering things out in his atelier, of burning a lot . . . then he became senile. All the promises that he wanted were made to him, and now that he is dead he has been submitted to everything he detested: his collection sold; the B[ernheims] placed in charge of his sale; his sketches exhibited and placed on auction. The exhibition was painful to me, and the sale yesterday was exasperating."[32]

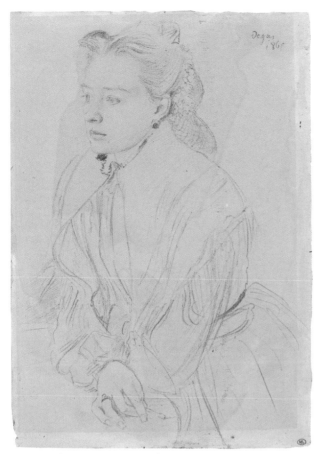

Fig. 107. Edgar Degas, *Portrait of a Young Person (Hélène Hertel)*, 1865. Graphite, 10⅞ × 7¾ in. (27.6 × 19.7 cm). Musée du Louvre, Paris, Département des Arts Graphiques, Fonds Orsay (R.F. 5604). Atelier Sale I: 313

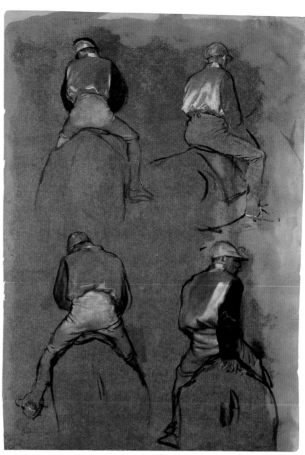

Fig. 108. Edgar Degas, *Four Studies of a Jockey for "Racehorses before the Stands,"* 1866. Essence heightened with white gouache on brown paper, 17¾ × 12⅜ in. (45 × 31.5 cm). L 158. The Art Institute of Chicago, Mr. and Mrs. Lewis Larned Coburn Memorial Collection (1933.469). Atelier Sale III: 114.1

Knowing that Degas intended his portfolios to be edited, how can one identify the graphic work that the artist might have allowed to be displayed in his museum? Happily there is a sure guide in the album *20 Reproductions d'après des dessins de M. Degas*, which the dealer Michel Manzi published in the spring of 1898.[33] Using an expensive and complicated process of color heliography that has not since been surpassed, Manzi reproduced in color twenty works chosen by Degas, some in full size. Several of the reproductions seem to have been heightened with pastel by hand. Each of the one hundred albums in the edition was signed by Degas, a reliable sign that he had given his imprimatur to the selection and the final result. With only a few exceptions, he retained until his death the original drawings and pastels, which were then sold in the atelier sales. These drawings have been located today, and many are reunited in the present exhibition (see figs. 102–121).

Manzi exhibited the album upon publication, and, as with any appearance of a work by Degas in the 1890s, the exhibition became an event. The drawings Degas had selected for reproduction spanned his entire career; for the first time, early work by Degas was visible (in some form)

outside the context of a privileged visit to the artist's studio. Reviewing the album, André Mellerio noted how impossible it was to know Degas's work through public museums. The Gustave Caillebotte collection, that subject of controversy ("collection de combat"), had been displayed since 1896 at the Musée du Luxembourg, but Mellerio found that, despite the presence of certain choice works, Degas was not represented there "as he surely will one day be represented at the Louvre." In order to understand Degas, he wrote, it was necessary to view the remarkable collections formed by Isaac de Camondo, Henri Rouart, Henri Lerolle, and Georges Viau. More important, "for all collectors and critics, as for all artists, the present publication contains not only material worth admiring but also a lesson on which to reflect profoundly. What strikes one, with Degas, is his certainty, that mark of a master; his absolute control, consisting simultaneously of precision and ease." Mellerio noted that the entire story of Degas's development as an artist was contained in the album. "The beginnings are to be found in these dry draperies, a little in the style of Albrecht Dürer; then he frees himself successively in the studies of jockeys and dancers, to reach a final

Fig. 109. Edgar Degas, *Dancer in Position,* 1872. Essence on pink paper, 11 × 8⅝ in. (28 × 22 cm). L 300. Private collection. Atelier Sale II: 231a

Fig. 110. Edgar Degas, *Laundress,* 1869. Pastel, charcoal, and white chalk, 29⅛ × 24 in. (74 × 61 cm). Musée du Louvre, Paris, Département des Arts Graphiques, Fonds Orsay (R.F. 28829)

Fig. 111. Edgar Degas, *Young Woman in Street Dress,* 1872. Essence on pink paper, 17¾ × 11¼ in. (32 × 25 cm). L 296. Fogg Art Museum, Harvard University Art Museums, Cambridge

Fig. 112. Edgar Degas, *Dancer in Position, Three-quarter View,* 1872. Graphite and crayon heightened with white chalk on pink wove paper, 16⅛ × 11¼ in. (41 × 28.5 cm). Fogg Art Museum, Harvard University Art Museums, Cambridge, Bequest of Meta and Paul J. Sachs. Atelier Sale I: 328

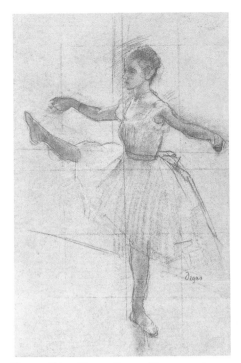

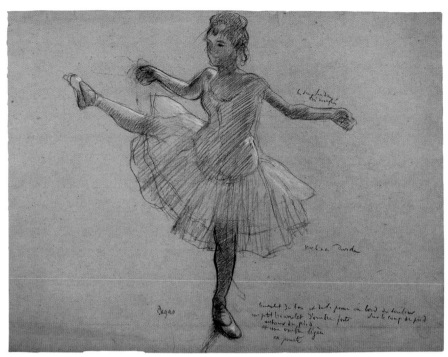

Fig. 113. Edgar Degas, *Dancer (Battements in Second Position)*, 1874. Charcoal heightened with white, 17¾ × 11¾ in. (45 × 30 cm). Private collection. Atelier Sale II: 247

Fig. 114. Edgar Degas, *Dancer (Battements in Second Position)*, 1880. Charcoal heightened with white on tan paper, 12¼ × 22⅞ in. (31.1 × 58.1 cm). Private collection. Atelier Sale III: 359

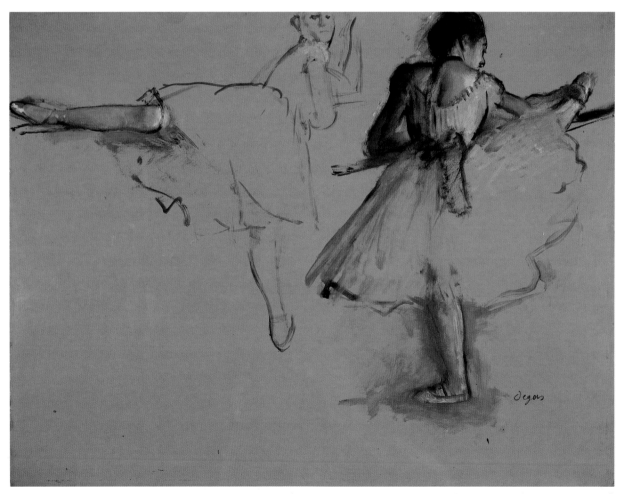

Fig. 115. Edgar Degas, *Dancers at the Barre*, ca. 1873. Essence and sepia on green paper, 18⅞ × 24⅝ in. (47.4 × 62.7 cm). L 409. Trustees of the British Museum, London (1968.2.10.25). Atelier Sale II: 338

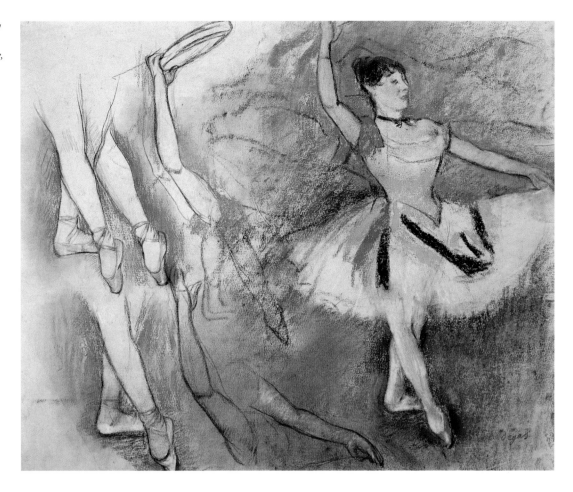

Fig. 116. Edgar Degas, *Study of Legs and Arm Movements for a Dancer with Tambourine,* 1882. Pastel heightened with black, 18⅛ × 22⅞ in. (46 × 58 cm). Musée du Louvre, Paris, Département des Arts Graphiques, Fonds Orsay (R.F. 4534). Atelier Sale I: 161

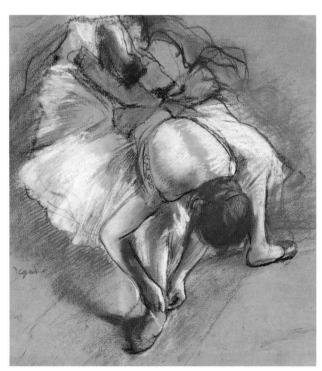

Fig. 117. Edgar Degas, *Dancer Tying Her Shoe,* 1887. Pastel and black chalk on buff paper, mounted at the edges on board, 18⅝ × 16⅞ in. (47.2 × 43 cm). L 913. Private collection

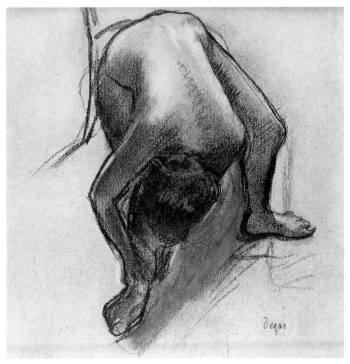

Fig. 118. Edgar Degas, *Study of a Nude for the Previous Drawing,* 1887. Graphite and charcoal heightened with pastel, 11¾ × 11¾ in. (30 × 30 cm). L 906. Private collection. Atelier Sale I: 324

triumph in the female nudes."[34] Thadée Natanson noted in *La Revue blanche*, "Leafing through the book, one comes to appreciate the genius of the painter-draftsman and simultaneously to realize how many of the best contemporary artists owe to him practically everything they know or dare to do."[35]

When the contents of his studio were viewed posthumously, the reactions, as Degas himself might have anticipated, differed widely. Halévy and Valéry, both of whom had been his friends, spoke of the harshness and crudeness of much of his late work. The dealer Gimpel adopted a purely commercial point of view.

> Seeing these paintings destroyed one of my illusions. A legend has grown up over the years that he kept his most beautiful pictures, that he showed them to no one, that his sale would reveal unsuspected aspects of his genius. This was an exaggeration. There are some pretty pastels, some very fine paintings, but very many elementary studies that tell us nothing, mere notes for the artist alone; numerous pastels which are quite incomplete or partially effaced—evidence of shocking carelessness and neglect. Some pastels are covered in thirty years' accumulation of dust, so much so that Durand-Ruel, in an effort to prevent forgers if possible from

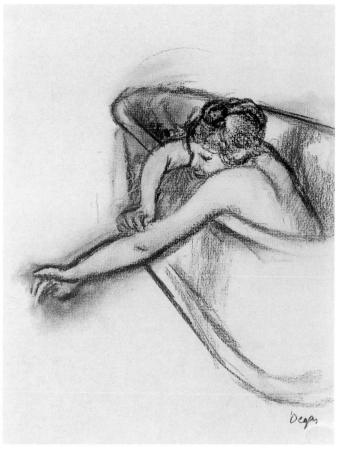

Fig. 119. Edgar Degas, *Woman in a Bath, Scrubbing Her Arm,* 1896. Charcoal on paper. Narodni Muzej, Belgrade

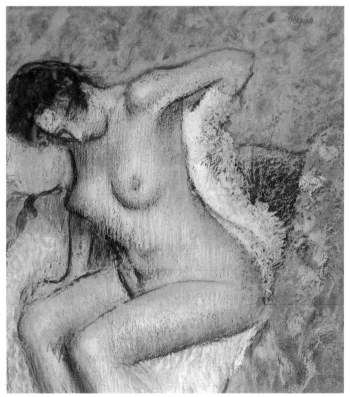

Fig. 120. Edgar Degas, *Woman Drying Her Back with a Towel,* 1895. Pastel, gouache, tempera, and charcoal on gray paper, mounted on cardboard, 32¼ × 28 in. (82 × 71 cm). L 1179. The Hermitage Museum, Saint Petersburg

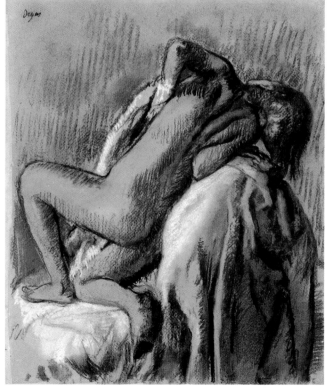

Fig. 121. Edgar Degas, *Woman on a Chaise Longue, Wiping Her Back with a Rolled Towel,* 1896. Pastel and charcoal, 15⅜ × 13¾ in. (39 × 35 cm). Private collection. Atelier Sale I: 237

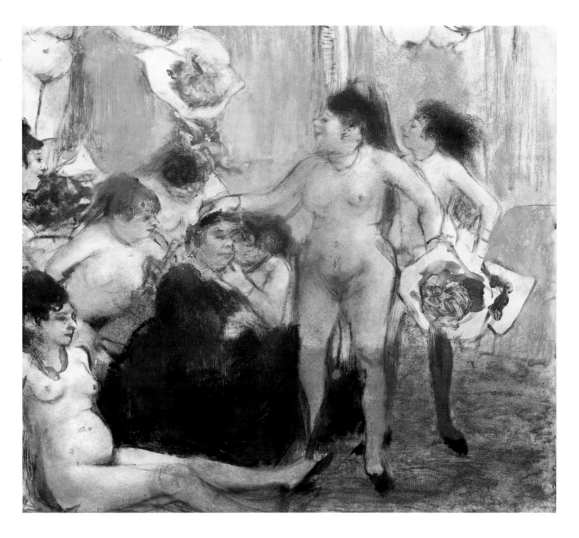

Fig. 122. Edgar Degas, *The Name Day of the Madam*, 1876–77. Pastel over monotype, 10½ × 11⅞ in. (26.6 × 29.6 cm). L 549. Musée Picasso, Paris (R.F. 35791). Atelier Print Sale: 212

finishing these pastels and even the paintings, has had very detailed photographs taken of all the Degas which are going up for sale and will distribute prints to all art institutions and libraries in France and abroad.[36]

Mary Cassatt asked me if I had seen the etchings. I told her that I had, and told her, too, that the family destroyed the erotic works for fear of seeing a *Degas Erotica* published someday.[37] Durand-Ruel showed me *The Fête of the Mistress*, an etching that he saved [fig. 122]. They're very much in the raw, those women!"[38]

On the other hand, such connoisseurs as Paul Jamot, quoted above, were captivated by the revelation of Degas's studio. An anonymous writer for *La Chronique des arts et de la curiosité* wrote: "It's a Degas *Ingriste* and classicist who continues to be unveiled, much to the surprise of the collectors faithful to innumerable sketches produced by the sly old confidant of wild intimacies, vulgar dancers, and skinny jockeys; he is the greatest draftsman of the last century, since Ingres, and the most knowing naturalist, from the most finished study to the most casual impression."[39]

"Would Degas have been happy with all this?" a friend mused. "I doubt it."[40] After Degas's death, events spun out

of control in a manner that surely would have enraged the artist. He had always resented any display of his work without his prior permission; his wrath at the various posthumous exhibitions that occurred on short notice and with little forethought is easy to imagine. Immediately following his death in September 1917, the Galerie Durand-Ruel showed some of the large canvases that Degas had stored there when he moved to smaller quarters in 1912: *Family Portrait, Semiramis Building Babylon*, and *Fallen Jockey*. After the inventory was made, many of the atelier contents were exhibited at Durand-Ruel prior to the pre-sale viewing at Galerie Georges Petit (see Paul Valéry's account quoted above). Paul Paulin wrote to Lafond describing the "enormous crowd" of visitors who waited in line to see Degas's work at the Galerie Petit (in fact, more than six thousand visitors passed through the gallery over the weekend):

One could hardly turn around there, and you had to queue up before the display. The canvases had been hung in the large gallery (with my bust [fig. 123] at the back, center) and in the two adjoining galleries. They reached to the ceiling and were unbelievably

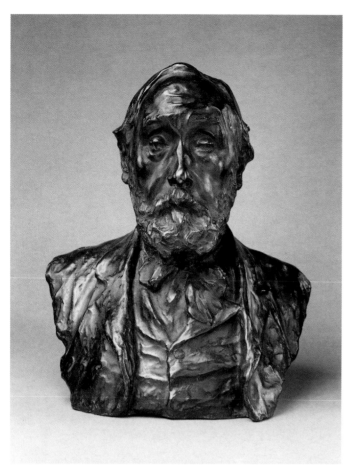

Fig. 123. Paul Paulin (b. 1852), *Bust: Edgar Degas at the Age of Seventy-Two,* 1907. Bronze, H. 18¼ in. (46.4 cm). The Metropolitan Museum of Art, New York, Edith Perry Chapman Fund, 1996 (1996.92)

beautiful to see. The colors of the pastels, which dominated, added a note of gaiety to the whole. They had brought back the five canvases lent to the Salon du Petit Palais. . . .[41]

The sculptor Albert Bartholomé instigated a small, brief exhibition of paintings by Degas held prior to the sale at the Musée du Petit Palais in Paris.[42] He made the necessary arrangements with René De Gas. René's niece, Jeanne Fevre, was barely on speaking terms with her uncle; counseled by Mary Cassatt, Fevre refused to see Bartholomé. Degas had disapproved of Bartholomé's second marriage to a model and had dropped him for some time as a result.[43] Fevre and Cassatt carried on the grudge; they conspired to entrust the casting of Degas's wax sculpture to the founder Renoir employed rather than see it go to Bartholomé, who had allied himself with René.[44] René seems to have requested a burial for his brother in the Pantheon and may have dangled the possible gift of *Family Portrait* to the state as an inducement.[45] Prevailing over attempts to buy the painting made by Louisine Havemeyer and The Metropolitan Museum of Art, both advised by

Mary Cassatt,[46] the Louvre was able to purchase this masterpiece from Degas's heirs for 300,000 francs ($60,000), considerably less than its appraised value and 100,000 francs less than the agreed-upon price of 400,000 francs. The acquisition was considered an event of national importance.

Bitter that her clients had lost the portrait of the Bellellis, Cassatt redoubled her efforts to secure the wax *Little Fourteen-Year-Old Dancer* for her friend Louisine Havemeyer.[47] But the family, well aware of the money that could be made from bronzes of it if cast in a large edition, was reluctant to release the sculpture. When they finally agreed to sell, their asking price, 500,000 francs—more than the Louvre had paid for *Family Portrait*—was considered insulting by Cassatt and excessive by Havemeyer.[48] She finally contented herself with buying the first bronze cast of the dancer as well as the first full set of bronze replicas of the other, smaller wax sculptures left in Degas's studio (seventy-two were in good enough condition to be cast). It was in connection with the casting of the bronzes, a huge commercial and manufacturing undertaking (since bronze was both scarce and expensive in Europe after the war), that a final proposal for a Musée Degas was mooted. The bronze founder, A.-A. Hébrard, feared that unauthorized casts might be made once his bronzes were released.

He therefore sought to have the original waxes and the set of master bronzes installed in a museum where collectors might compare fakes against the original. To this end he wrote to Jeanne Fevre on June 14, 1921, not long after the death of René De Gas: "I would like to see realized a project that has haunted me for a long time and for which your assistance is indispensable: a Musée Degas, to be established in Paris (at either the Louvre or the Petit Palais). All your uncle's sculpture would be reunited in this museum, along with the drawings and paintings donated by your family and friends and admirers of Degas, either in their lifetime or by bequest. . . ." Hébrard concluded, "If we succeed, it will be to the glory of your uncle, your family, and our country."[49]

Jeanne Fevre did not consent. Perhaps she could still hear her uncle railing against the French art establishment. Perhaps she understood how vehemently he had resisted anything that smacked of permanence and perpetuity.[50] But, in the end, Hébrard's wish was fulfilled. Thanks to the dispersion of Degas's Degases through the sale of the contents of his studio, many Musées Degas have been established over the last sixty years, at museums in Boston, Chicago, Copenhagen, London, New York, Paris, São Paolo, Washington—indeed, almost anywhere the friends and admirers of Degas have been found.

Appendix: Mary Cassatt on the Degas Sales and the Casting of the Sculpture

The following letters are taken from the extensive correspondence between Mary Cassatt and Louisine Havemeyer. Mrs. Havemeyer, the most important collector of modern French painting in America at the turn of the century, was Mary Cassatt's closest friend. During World War I, Cassatt, who was in France, kept Havemeyer abreast of current affairs there with these remarkably vivid, heartfelt letters. Besides relating fascinating gossip from the Parisian art market and remarks made by others in Degas's world, among them the Durand-Ruels, Ambroise Vollard, and Auguste Renoir, Cassatt's letters paint a picture of both the immense suffering the war imposed on France and the personal difficulties the artist endured as she lost her friends, her eyesight, and her physical strength.

The excerpts printed here present nearly everything that survives of what Cassatt wrote to Havemeyer about the sale of Degas's collection and atelier and the casting of his original wax sculptures, in particular *The Little Fourteen-Year-Old Dancer*. Anne Pingeot has published much of the correspondence between Cassatt and the Durand-Ruel gallery regarding the casting of Degas's sculptures;[51] these letters from Cassatt to Havemeyer provide the missing links. Although the letters are quoted in the catalogues of the 1988–89 Degas retrospective and the 1992 exhibition of the Havemeyer collection, *Splendid Legacy*, all but three are here reproduced *in extenso* for the first time.[52]

Cassatt's letters to Havemeyer, written in English, are transcribed here without revision of spelling or punctuation. One letter from Jeanne Fevre to Mary Cassatt, also included in the following selection, was written in French and appears here in translation. All of these letters are kept in the Archives of The Metropolitan Museum of Art.

Tuesday Oct 2nd [1917]
10, Rue de Marignan

Dearest Louie

Of course you have seen that Degas is no more. We buried him on Saturday a beautiful sunshine, a little crowd of friends and admirers, all very quiet and peaceful in the midst of this dreadful upheaval of which he was barely conscious. You can well understand what a satisfaction it was to me to know that he had been well cared for and even tenderly nursed by his niece [Jeanne Fevre] in his last days. When five years ago I went to see them in the South, and told them what the situation was, his unmarried niece hesitated about going to see him, afraid he might not like her to come, but I told her she would not be there a week before he would not be willing to part with her, of course she found this true, and now for two years and a half she has never left him. She was at the hospital at Nice and had training enough to know just how to nurse her Uncle. I put her in the hands of my neighbor Monsieur Theret one of the well known Paris notaries and thanks to his advice everything is as it should be, for Degas's brother [René] had meant to have everything and rob his sister's children of their share. One sometimes can help a little in this World, not often. There [will] of course be a sale. The statue of the "danseuse" if in a good state you ought to have. Renoir spoke of it enthusiastically to me. It is a very fine and original work. . . . Paris is full of Americans and English. Sat [Cassatt's nephew, Gardner Cassatt] has been here for a day but as he has not signed for the war he will soon be released, and will come here to see if he can find anything to do, or if he had better go home and find something there. The situation is not at all clear. If the Russians are treated as the Belgians are it may revive them.

The sanitary situation is *very* bad, in the country my Doctor told me he had whole families, *all the children* infected by syphilis by the Father when he returns on permission. An Army doctor told Sat that such a state of affairs had never been heard of. And I was told yesterday that it leads to leprosy! The Indian and African troops have spread the disease. This when men feel that they are going to be killed they are reckless. Oh my dear Louie humanity is always the same. . . .

. . . . Heaps of love how I want to see you.

always affectionately yours
Mary Cassatt

Dec 12th [1917]
10, Rue de Marignan

Dearest Louie

Here I am still but shall I hope be South in a few days. . . . I shall be very lonely, and as my sight gets dimmer every day, the operated eye will not help my sight much even tho' the secondary cataract is absorbed altogether which is very doubtful if not quite sure. I think you must have written to Grasse, as I have no letter for two weeks. There are many things I should like to tell you, one thing we all agree on that at home you none of you understand the conditions here. One thing is sure, the interest in Art remains, the Degas sale will be a sensation. I am glad that in the collection of pictures of other painters he owned I will figure honorably, in fact they thought the two, a painting, & a pastel were his at first [Mary Cassatt, *Girl Arranging Her Hair* (fig. 3); *Young Woman in a Loge* (fig. 392)]. The painting is of the same date as the portrait you are keeping for me [possibly *Lady at the Tea Table (Mrs. R. M. Riddle)*, The Metropolitan Museum of Art, New York (23.101)], the year after, as it is not a maternal subject. I said to J.D.R. [Joseph Durand-Ruel] it would not sell so well, but he said otherwise. It was the one he asked me for and gave me the nude [Degas's pastel of 1885, *Woman Bathing in a Shallow Tub*[53]] in exchange. There will be no nude like mine in the sale. The statue is in perfect condition. Joseph says it will be a more sensational sale than Rouarts. J. will send you through his Mother letters of Degas Renoir Monet, & I enclose some of my precious signatures. I cannot say how much I should like to see you once more, will it ever be? Heaps of love to you, and to Addie [Adaline Havemeyer Frelinghuysen] & all

most affectionately yours
Mary Cassatt

Dec 28th [1917]
Villa Angeletto
Grasse

Dearest Louie

I am here at last. . . .

I send you a letter Degas wrote to me 30 years and more ago, and which his niece found amongst his papers it was never sent, but I remember the time.

I told Sat [Gardner Cassatt] to offer you my Degas if I die before I can see you. I fixed the price for the three[54] at $20,000, now dearest Louie if you don't want them don't take them, of course they will be sold as no one in the family can understand them or would care in the least for them. The nude is considered by everyone as one of his best, better than Marx's. There is nothing so complete in what he has left of nudes. Joseph is enthusiastic over the picture I gave in exchange.[55] I would like a Museum to buy it but none of ours would dream of such a thing. In looking back over my life, how elated I would have been if in my youth I had been told I would have the place in the world of Art I have acquired and now at the end of life how little it seems, what difference does it all make.

I am nearer despair than I ever was, operating on my right eye before the cataract was ripe, is the last drop. I asked Borsch if it was ripe and he assured me *it was*! The sight of that eye is inferior but still I saw a good deal in spite of the cataract now I see scarcely at all. Oh Louie what a world we live in. I feel more and more that this is the end of civilization.

May this year see an end to some of the suffering. As to the millenium after the war I don't believe in it.

Heaps of love to you all. I can not see to read letters and soon won't be able to write.

always affectionately yours
Mary Cassatt

May 9th 1918
Villa Angeletto
route de Nice
Grasse (A.-M.)

Dearest Louie

I send you with this the account of the first days sale of Degas['s] atelier. The prices were high for there was nothing of his best. When one thinks of how nobody would buy when you first began! but that is the way with everything. . . . I wish I could write enough to tell you but I must not tire my eyes now that the cataract is ripening. . . . I have a letter from Mlle Fevre Degas niece, with the account of how their hands were forced by the press, under the instigation of a sculptor friend of Degas [Albert Bartholomé] who needs to wrap himself in Degas genius, not having any of his own. Oh the world Louie! As for us does one think of the diminution of the white races? Is it possible that France can recover her losses? That is the thing no one talks about, the diminution of ours and the increase of the yellow races. Well it is the end of a civilization.

Heaps of love dear and to you all from

your always affectionately
Mary Cassatt

June 25th 1918
Villa Angeletto
route de Nice
Grasse (A.-M.)

Dearest Louie

. . . I am writing this while I am waiting for Jeanne Fevre who is coming to stay with me for a day, it is the first time I have seen her since the sale she will tell me about the wax statues. She is so grateful to me, for what I was able to do but I am especially so to her for the care of her uncle for two years and a half before his death. We are living in suspense, it may be that the Italian victory may retard the German offensive. We Americans have the defense of Paris in our hands, the French say we are as good soldiers as they are, better than their nearest allies. I wonder if there could be any doubt about that we have had many wounded at the last battle not so many killed some missing. Heaven help those who are prisoners. What a breakdown of civilization, when women votes begin to tell will it be better? It will take long long years for France to recover, if ever she does, and the slaughter still goes on. . . .

June 26 I saw Jeanne Fevre Degas niece yesterday, & I also have your letter of the 1st this morning. Yours of the 9th with the check came yesterday morning. As to the Degas sale it was perfectly genuine, and not one single touch has been added to the pictures or the pastels. Even pictures with half the painting scratched out, sold for high prices! The explanation is in part speculation by dealers some neutrals most French and also amateurs, & the revelation of Degas as an artist of not only great talent but great variety. Now as to the statue George D.R. [Durand-Ruel] took it on himself to write me that the heirs would not sell, but it is not the case they are perfectly willing to sell it to you as a *unique* piece, there has been objection as to not having it reproduced so that France may keep a copy but the beauty of the statue would lose much if put into bronze as the dress could not be reproduced, the statues are in a place of safety and will not be cast until after the war. The founder [Hébrard] advised Mlle Fevre to accept an offer of 100,000 fcs I think 80,000 might be accepted. You will have to think it over, I only wish I could see it again & especially that you could. The sculpture has made a great sensation. It is more like egyptian sculpture. Of course we are in a very nervous and depressed state here, the Italian victory is a slight lifting of the cloud but not enough to reassure us. We shall know what to expect in two or three months.

My love to you dear Louie and all, poor Electra I feel for her,[56] we have had not so many killed but the wounded! Sat is in the transport service his General very pleased with him

affectionately
Mary Cassatt

August 4th 1918
Villa Angeletto
route de Nice
Grasse (A.-M.)

Dearest Louie

I am waiting for my papers to leave here, and go to Beaufresne, only passing thru Paris, and probably seeing my oculist. You cannot imagine how I feel, after the way he treated me, assuring me that the cataract was ripe & only telling me of the failure when I had paid him! Of course I am only an old woman & near the end of life, but only my eyes have noted some things no one had noted before, but this American is incapable of caring for that. . . . Dearest Louie life is too much of a struggle now & I oh! so wish I was at the end. My letters from friends are sad, the young in constant danger. When will it end? This defeat I am afraid will not end it. I wont be able to write you soon I will have to get my maid to write in French.

Vollard is at Renoirs and has sent word he will come here tomorrow. If he does and has anything to say I will write it to you. Degas niece writes that he was at La Colle to see her, she also is leaving, going to Marseilles to see her brother, before he returns to the Army. The journey to Paris is a very tiresome one, I am taking the servants to Beaufresne. One has trouble with ones trunks, many are lost now. . . .

August 5th Vollard has just gone. He thinks that you ought to get the statue cheaper. Degas has said to him that he was finishing it for you & you were to pay 40,000 fcs it would be dearer now, suppose you say 60,000? Perhaps 70,000. Vollard thinks that the Armies will begin again over Paris when the retreat stops, but we will be there. The heat in Paris is great. I dont see how I am to get there. Life is hard at present. What is humanity after all? Heaps of love dear to you and all

always affectionately
Mary Cassatt

Vollard will try & get the note of thanks for the jam[57] & the signature.

August 24th [1918]
Villa Angeletto
route de Nice
Grasse (A.-M.)

Dearest Louie

. . . War is a great demoralization. It is very difficult to make a democracy like ours out of an old monarchy. Renoir says that Nature is opposed to Chastity. That the women succumb to, or rather that they throw themselves at the herd of allied troops is I suppose natural. In England it is just the same as here only they havent the excuse of being an invaded country.

As to buying the Degas statue here, that is absolutely impossible and when could I get eyes to see it. My sight is getting dimmer every day. I find writing tires my eyes. I look forward with horror to utter darkness & then an operation which may end in as great a failure as the last one. Renoir says the finest death is a soldiers, why dont they send all of us who are old and useless to the front. Death is a release, you would miss me [but] you have so many. Heaps of love dear Louie to you and all

ever yours affectionately
Mary Cassatt

Sept 22 [1918]
Villa Angeletto
route de Nice
Grasse (A.-M.)

Dearest Louie

Melle [Mlle] Fevre was here on Thursday. She told me many interesting things about the sales already made & those to come. There are to be 4 sales beginning in November one of things Degas left of other painters without great interest & which will be sold at the Hotel Drouot. One of etchings, she says there are many of these. You have two, Jenny's portrait which I gave you & one of Degas himself which you bought at Marx sale.[58] Of course you will want others so I write in time. There are many fine monotypes & drawings touched with pastel, but you have many of those. Joseph bought for 9000 fcs the splendid picture of the steeple chase [*The Steeplechase* (fig. 361), Mellon Collection]. Degas you know wanted to retouch it & drew black lines over the horses heads & wanted to change the movement. I thought these could be effaced but it was not possible. Well now Joseph has had the lines filled in, no doubt he will sell it for $40,000 or more. I wanted the pic-

ture for my brother Aleck & Degas declared it was my fault that he spoiled it! I begged him so to give it as it was, it was very finished, but he was determined to change it. . . .

always affectionately yours
Mary Cassatt

Dec 1st 1918
Villa Angeletto
route de Nice
Grasse (A.-M.)

Dearest Louie

. . . . I have no news from Paris and no catalogues! I think the D.R's [Durand-Ruel's] ought to have sent me all of them. As many of my dry points were sold & I hear at good prices, this from Mademoiselle Fevre. I have nothing from Demotte, he does not keep his word, he promised to see the skeleton[59] which is so fine, & Vollard promised to send the photos of the Degas danseuse, which he has not done. I think George [Durand-Ruel] wanted to buy my Degas, when he came up to see me, but I told him I had offered them to you. . . .

Heaps of love

always affectionately
Mary Cassatt

Jeanne Fevre to Mary Cassatt

December 4, 1918

My dear Miss

Receiving your letter, I was very surprised and very annoyed to learn that you have not received any of the catalogues of the auctions.

I must tell you that when I arrived in Paris the catalogues were distributed and I had only a small quantity at my disposal. Persuaded that Durand-Ruel had sent them to you, I did not have any forwarded to you.

I, thus, went yesterday to Durand-Ruel and told him to send some to you immediately. As for photographs of the wax, I reclaimed them from M. Vollard. He has finally sent them to me.

I must tell you that there are a few good photos but that, unfortunately, the one of the grande danseuse did not come out at all. I will show them to you as soon as I return to La Colle. Your friend Mrs. Havemeyer has always wanted to trouble herself about this business. M. Hébrard has as yet begun nothing. He does not have

the right man to cast [Albino Palazzolo], he is still mobilized; moreover Hébrard has to build a special studio for casting. He believes he will need one year for the molding and another for the casting.

I was glad to hear of your news. I ask you again to excuse me and I send you affectionate regards.

Jeanne Fevre

Dec 7th [1918]
Villa Angeletto
route de Nice
Grasse (A.-M.)

Dearest Louie

I send you Melle Fevre's letter, it tells of the nine sculptures. It seems to me that the skeleton [offered to Havemeyer by the dealer Demotte] might be in a private collection if the museums wont have it. When one thinks of that chef d'ouvre [sic] at Bar le Duc! . . . I have the Degas catalogues I posed for the woman at the Louvre leaning on an umbrella.[60] It seems my things sold well. I am going to be more helpless than ever. Hilda my Swiss maid is going to Switzerland for a month. She reads me my letters in English without understanding a word now I must appeal to English nursery maids, oh what it is to be helpless if only we could leave the World when one's work is over. Heaps of love dear I hope Electra has news of her husband and that he will soon go home. Plenty to do there. Heaps of love to you and all from yours ever affectionately

Mary Cassatt

Dec 8th [1919]
10, Rue de Marignan

Dearest Louie,

. . . . As to the Degas "danseuse" Hebrard who is to cast it says it is in perfect condition & only needs cleaning & a new skirt. As to the price it has not yet been fixed but every time the sale is mentioned it gets dearer. I think casting it will be difficult because the bodice is glued to the statue & this may make it difficult. Melle Fevre is in town & is to keep me informed as soon as I know anything I will write.

Dec 10th M[lle Fevre] was here yesterday evening, they have finally decided on the price for the danseuse, 500,000 fcs! When I expressed surprise she told me that that was only $50,000 & that her uncles works were rising in price everyday. Now they give you a month to get an answer to me, & then if you do not accept the statue will be cast not in bronze but in something as much like the original wax as possible. As a unique thing and in the original it is most interesting, but 25 copies in [illegible] wax takes away the artistic value in my opinion, they don't think of that. What would Degas have thought of this? . . . I hope to be in Grasse when you get this

ever yours
Mary Cassatt

Dec 31st [1919]
Villa Angeletto
route de Nice
Grasse (A.-M.)

Dearest Louie

Your cable refusing the "danseuse" has just come. Of course I knew you would not accept such a preposterous price I am much disappointed at the Fevres asking it the brother of course is capable of anything. One must not be surprised at anything when there is a question of money, but here is a woman intelligent & fretting under full dependence on a brother who comes into an inheritance of 900,000 fcs & feels badly at not having a million altho she had pictures representing a value according to Joseph D.R. [Durand-Ruel] of half a million, & now she and the others are counting on a great sum for the sculptures! Before I forget I must tell you that Duveen was prepared to pay 200,000 fcs for the bust at the Manzi sale,[61] considering that Demotte knew this it seems rather hard on the Manzis that he let it go at the price he did, but Manzi was disliked & the two women were not able to cope with the dealers. The daughter is to be married & I am very glad for her. . . .

yours ever affectionately
Mary Cassatt

January 16th [1920]
Villa Angeletto
Grasse A M

Your dear kind letter dearest Louie gave me real pleasure. It is a great consolation to think that I have been of some use in the World. Just think what it has been for me to have known you and Mr Havemeyer! As to the statue we feel exactly alike. I would not want one of those 25 chromo's. I have written to Melle Fevre to beg her to put off casting the danseuse. I have told her that

her uncle is known only to a *very* few people as a sculptor. Let the other statues be cast. There are 60 in all, but Joseph D.R [Durand-Ruel] says 30 only are complete, then when Degas reputation as a sculptor is established they can sell the danseuse as a unique piece, (provided it is in a good state which Joseph says it is not. They would not allow [Dikran] Kelekian to see it). I shall also write to Joseph to speak to the brother, who is beyond anything. The Fevres, niece & nephews consider that they owe me a great deal, what I say may have an effect. . . . At home every one is dancing & amusing themselves & the young may bring their whiskey flasks in their pockets! Well when are we to meet, if only I could see & get Mathilde I would go home, for the moment I see less than ever.

<div style="text-align: right">from yours ever
Mary Cassatt</div>

April 10th [1920]
Villa Angeletto
Grasse A M

Dearest Louie

Kelekian wires from Paris this morning "Viens de voir la cire de Degas exposé chez Hébard c'est une chose admirable aussi belle que l'Art [illegible] recommande chaudement Mme Havemeyer acheter." ["Just saw the wax by Degas shown at Hébrard's. It's an admirable thing, as beautiful as the art [illegible]. Warmly recommended that Mrs. Havemeyer buy it."] He must have found it in a good state we know of course that it is a fine thing & have known it for many years. I don't cable because I dont think there is any hurry & for you the delay may mean a great economy. The way things are going now the exchange may be greatly more in your favor. I am writing to Jeanne Fevre & she will want an offer from you. We are going through a very anxious time, why was not Germany, that is Prussia[,] disarmed? . . .

<div style="text-align: right">ever affectionately
Mary Cassatt</div>

You will of course not offer asking price.

April 18th 1920
Villa Angeletto
Grasse A M

Dearest Louie

It is raining in torrents & I am wondering if Melle Fevre will come & see me as she wrote that she would having much to talk about regarding the statue. As it is on business I think she may brave the rains, her brother has never been to see me & she only twice this winter & then only about this business. I am also wondering if she is going once more to raise the price! I have had a letter from Rob [Robert Kelso Cassatt] telling me of the distribution of the pictures [belonging to Cassatt's sister-in-law, Mrs. Alexander J. Cassatt] he talks of 4 Manets & the same number of Degas. If they sell they will undoubtedly be offered by the D.R's [Durand-Ruel] about ¼ of what the pictures are worth

3 P.M. It is pouring pitchforks & I fancy she is not coming, so I will go on with this. Many thanks for the cuttings about my exhibition at Keppels when I think the D.R's refused me ten thousand francs for the sketches & etchings 96 I think or 98! How can I hope to get the $3000 from them for the picture? I shall have them send it to Sat. Rob speaks in his letter of there being 4 Degas or rather 3, each niece to get a Degas! Do they think the pastels of which there are two not of his best, a horse & another, being of the same value as the picture. It is a girl reading seated on a bench the same model as the one who posed for the statue & bust of her a very fine classic group of dancers, one of Degas best[62] I am curious to know what the D.R's would offer for it.

Monday April 18th. Jeanne has just been here Degas brother [René De Gas] refuses to sell the statue for less than one million francs, they have had an offer of 700,000. You will know what to do. When I think that for years you were the only buyer. Well the World is a fine place, just think what his life was. The broker's [René De Gas's] illegitimate children will get all the others nothing. The brother is what he ought to be for this fraud. It seems that the eldest nephew has a very sick wife & isnt happy yet he is a good fellow. Heaps of love dear. I hope when the World is governed by women it will be better.

<div style="text-align: right">always affectionately yours
Mary Cassatt</div>

1. Letter from Berthe Morisot to Julie Manet, March 1, 1895; Morisot 1950, p. 185.

2. Degas mentioned his plans to friends including Morisot, Daniel Halévy, Albert Bartholomé, and Henri Rouart; he also seems to have discussed the subject with several individuals outside his immediate circle, such as Étienne Moreau-Nélaton, a wealthy amateur artist and serious historian of art who wrote admirable catalogues raisonnés of the work of Delacroix and Corot and was a collector on a scale even greater than Degas. Although Moreau-Nélaton had ties to the administrations of various museums run by the state, and Degas regarded administrators of the modern French state with suspicion and abhorrence, he appears to have respected Moreau-Nélaton. But when he learned that Moreau-Nélaton had arranged to leave his collection to the state in 1906, Degas was disappointed. See Moreau-Nélaton 1931. François Fosca noted after a visit with Degas on June 26, 1911, that Degas had intended to leave his collection to the city of Paris, but that the plan was not carried out because of his insistence on designating his own curator. François Fosca, "Portrait de Degas," L'Amour de l'art (July 1931), p. 219.

3. For the "musée Degas," see the summary of the known facts in Ann Dumas's essay "Degas and His Collection" in this volume.

4. François-Marius Granet (1775–1849), born near Aix-en-Provence, left nearly 200 drawings to the Louvre and the remainder of his atelier, some 500 works, to the museum in Aix, which was renamed the Musée Granet after his bequest. François-Xavier Fabre (1766–1837) donated his extensive collection of works by old masters to his native Montpellier in 1825, following the death of his companion, the countess of Albany, whose wealth had supported his collecting. The city founded the Musée Fabre, a library, and an art school at his initiative, and Fabre left the museum the remainder of his atelier at his death. Jean-Auguste-Dominique Ingres (1780–1867), born in Montauban, sold some works to provide a cash inheritance for his wife so that the remainder of his atelier and collection could be left to his native town, which renamed the museum the Musée Ingres.

5. Letter from Degas to the mayor of Montauban; Lettres de Degas 1945, no. 206, p. 218. Degas also wrote a letter to the curator of the Musée Fabre proposing a similar exchange, first published in Loyrette 1991, p. 799 n. 472. According to Georges Vigne, curator of the Musée Ingres, the exchange Degas had in mind was probably not made, since no record of Degas's photographs has been found in Montauban. The original of Degas's letter to the mayor of Montauban could not be located in the town archives (conversation, Montauban, March 12, 1997). Nevertheless, Degas's album of photographs of works by Ingres (in a private collection) does contain photographs from Montauban.

6. Bonnat announced the architectural competition in 1891 and endowed the Musée Bonnat in 1896.

7. Paul Valéry, Degas, danse, dessin (Paris, 1946), p. 53, quoted in Loyrette 1991, p. 620.

8. Edmond Duranty's attack on Moreau in his seminal article of 1876, "La Nouvelle Peinture," is indicative of Degas's change of heart, since Duranty's opinions in this article are known to reflect Degas's. See Loyrette 1991, p. 161. See also Loyrette in Paris, Ottawa, New York 1988–89a, p. 91.

9. Despite extensive research, the dates of Degas's changes of address are still disputed. He leased the studio at 37, rue Victor Massé on January 9, 1890. Daniel Halévy indicates that Degas did not establish his apartment on the two lower floors of that building until November 1897 (Halévy 1960, p. 120). However, Theodore Reff (cited by Richard Kendall in London, Chicago 1996–97, p. 305 n. 72) has found that Degas's voter registration for 1890 gives the 37, rue Victor Massé address as his residence rather than that of his apartment at 23, rue Ballu (formerly called rue de Boulogne). Yet this suggestion that Degas was both living and working on the rue Victor Massé is contradicted by at least two letters, one of April 1890 in which Degas wrote his friend Paul Lafond, "The Hôtel Ingres is moving and will be transferred to 23, rue Ballu" (Sutton and Adhémar 1987, p. 168), and one dated April 28, 1890, in which Degas announces to Bartholomé that he has just spent his first night in his new apartment, presumably on the rue Ballu (Lettres de Degas

1945, no. 120, pp. 151–52; Letters of Degas 1947, no. 132, pp. 145–46). In an entry of July 16, 1895, in Vollard's stockbook, Degas's address is given as "rue Ballu" (Archives du Musée d'Orsay, Paris). And Henri Loyrette has pointed out that Degas gave his address on the rue Ballu as late as July 1896 (Loyrette 1991, p. 757 n. 50; see also Degas inédit 1989, pp. 463, 469). Thus it seems that Halévy was correct and that Degas continued to live on the rue Ballu for most of the 1890s.

10. Michel 1919, p. 459. Other visitors to Degas's studio in the 1890s sometimes remembered seeing the corner of a picture through the jumble of easels and furniture, but no one has suggested that Degas made any attempt to display much of his work there. More may have been visible in earlier times. George Moore described a visit of the 1880s to the studio at 21, rue Pigalle, where he noted "in perennial gloom and dust the vast canvases of his youth are piled up in formidable barricades." Moore 1918, p. 27.

11. These photographs are often dated by scholars to ca. 1895–97. Some feature Ludovic and Louise Bréguet Halévy, who would not have visited Degas after their friendship with him ended when Degas broke with them on the pretext of the Dreyfus Affair, precisely on December 23, 1897 (see the lettre de rupture published by Henri Loyrette in Loyrette 1991, p. 640). Since Degas moved into the apartment on the rue Victor Massé only in November 1897 and no longer saw the senior Halévys after December 1897 (although he did on occasion see their son Daniel), there is only a short period during which these photographs could have been taken at the rue Victor Massé. Thus it is more likely that they show his rooms on the rue Ballu.

12. Havemeyer 1993, p. 255.

13. On the visibility of Degas's sculptures in his studio and apartment, see Richard Kendall, "Striking a Blow for Sculpture: Degas' Waxes and Bronzes," Apollo 141 (August 1995), pp. 3–4. When Joseph Durand-Ruel made the posthumous inventory of Degas's possessions, he found "about 150 pieces scattered over his three floors in every possible place. [He must be referring to the building on the boulevard de Clichy.] Most of them were in pieces, some almost reduced to dust. We put apart those that we thought might be seen, which was about one hundred, and we made an inventory of them. Out of these, thirty are about valueless, thirty badly broken up and very sketchy; the remaining thirty are quite fine. They can be cast in bronze." Letter from Durand-Ruel to Royal Cortissoz, June 7, 1919, published by Charles Millard in Millard 1976, pp. 25–26. In the end, Degas's friend Albert Bartholomé was given the task of repairing the sculptures and supervising the casting of seventy-five works. See Pingeot 1991 for the most complete account of this enterprise.

14. Catalogue des tableaux, pastels et dessins par Edgar Degas et provenant de son atelier . . . , four sales at Galerie Georges Petit, Paris: Sale I, May 6–8, 1918, about 450 items in 366 lots; Sale II, December 11–13, 1918, 408 items in 386 lots; Sale III, April 7–9, 1919, about 637 items in 410 lots; Sale IV, July 2–4, 1919, about 754 items in 391 lots; Print sale, Catalogue des eaux-fortes, vernis-mous, aqua-tintes, lithographies et monotypes par Edgar Degas et provenant de son atelier . . . , Galerie Manzi-Joyant, Paris, November 22–23, 1918, 570 items in 317 lots. Abbreviated in this catalogue as Atelier Sales I, II, III, IV, and Atelier Print Sale. There were a total of about 2,820 items, which sold for 8,350,053 francs, almost four times the total for Degas's collection: 2,178,253 francs. The sale of Family Portrait (The Bellelli Family) to the Louvre contributed an additional 300,000 francs to the total of the atelier sales.

15. Unpublished letter from Mary Cassatt to Louisine Havemeyer, December 12, 1917. MMA Archives.

16. Jamot 1918, pp. 127–28.

17. Halévy 1960, pp. 179–80.

18. The majority of Degas's copies were made after Italian works of the fifteenth and sixteenth centuries; he also copied many seventeenth-century works, most notably those of Poussin, and a surprising number of eighteenth- and nineteenth-century pictures, including some by Thomas Lawrence and Horace Vernet. See Theodore Reff's many excellent studies of Degas as a copyist: Reff 1963, Reff 1964a, Reff

1964b, Reff 1965, Reff 1971, Reff 1985. With the important exception of Delacroix, there is little overlap between the artists Degas collected and the artists he copied. As Ann Dumas notes in this volume (see "Degas and the Collecting Milieu"), Degas had ample opportunity to buy Italian paintings and drawings but chose not to, even though as a youth he had admired works of the Italian school sufficiently to make many copies of them.

19. Jean Sutherland Boggs dates *Madame Alexis Rouart and Her Children* to 1905 (L 1450; Musée du Petit Palais, Paris).

20. As with Cézanne, the question of completion is a thorny issue with Degas. Normally the presence of a signature on a work indicates completion, but many works by Degas bear multiple signatures, which means they were completed several times over, revision being one of the artist's favorite activities. On the other hand, there are a number of works that seem to be completed—that is to say, their surfaces are entirely covered with pigment and the level of finish is consistent throughout—but the works remain unsigned, presumably because Degas never intended them to leave his studio. It appears that he signed works only when he parted with them or allowed them to be reproduced.

21. Halévy 1960, p. 180.

22. The major exception is *Portraits in an Office (New Orleans)*, 1873 (L 331), which Degas sold to the Musée des Beaux-Arts in Pau, where it remains, for 5,000 francs in 1878. This picture, much more a genre painting than a portrait, was the only work Degas ever sold directly to a museum. As he wrote to the curator in Pau, Charles Le Coeur, the uncle of Renoir's patron Jules Le Coeur, "I must also confess that this is the first time I have been singled out by a museum, and that this official [recognition] surprises and deeply flatters me." (Letter from Degas to Charles Le Coeur, March 31, 1878, in *Degas inédit* 1989, pp. 428–29.) Some portraits were given by Degas to their sitters, and occasionally these changed hands during Degas's lifetime. The most prominent examples are *Vicomte Lepic and His Daughters* (L 368, on deposit at The Hermitage, Saint Petersburg) and *Henri Rouart Standing before His Factory*, ca. 1875 (L 373, The Carnegie Museum of Art, Pittsburgh). Some more or less conventional portraits sold by Degas include *A Woman Seated beside a Vase of Flowers*, 1865 (L 125, The Metropolitan Museum of Art, New York), sold to Theo van Gogh on July 22, 1887; *Madame Gaujelin*, 1867 (L 165, Isabella Stewart Gardner Museum, Boston), which Degas announced his intention to sell in 1877 (in a letter to Giuseppe de Nittis of May 21, 1877, reprinted in Mary Pittaluga and Enrico Piceni, *De Nittis* [Milan, 1963], p. 344) but in fact only sold in the 1890s, to Michel Manzi; *Madame Théodore Gobillard, née Yves Morisot*, 1869 (L 213, The Metropolitan Museum of Art, New York), sold to Manzi, probably in the 1890s; *Woman with a Vase of Flowers*, 1872 (L 305, Musée d'Orsay, Paris), sold to Manzi before June 1894; *The Invalid*, 1872–73 (L 316, private collection, New York), sold to Durand-Ruel on January 31, 1887. Although this may seem a lengthy list of exceptions, Degas retained the overwhelming majority of his portraits throughout his life.

23. See Susan A. Stein's essay in this volume.

24. Gimpel 1966, p. 77.

25. Letter from Paul Paulin to Paul Lafond, May 6, 1918, in Sutton and Adhémar 1987, p. 180.

26. In only a few instances is Degas known to have bought back a work of his own in order to keep it. The most important examples are six paintings all made before 1870 that Jean-Baptiste Faure bought from Durand-Ruel in 1873 and 1874 and then returned to Degas. The artist sold one of these in 1885 but kept the remaining five until the mid-1890s (for a full account see Michael Pantazzi, "Degas and Faure," in Paris, Ottawa, New York 1988–89a, pp. 221ff.). Perhaps as an act of charity, Degas bought the portrait *Évariste de Valernes* (L 177, Musée d'Orsay, Paris) from the impoverished sitter in 1893 (*Letters of Degas* 1947, p. 93). On June 22, 1897, Degas paid Vollard 2,000 francs for "une peinture de lui-même" that Vollard had bought at the Lepic sale. This is almost certainly the copy after Thomas Lawrence's *Miss*

Murray, sold at Atelier Sale I: 94 (this identification was made by Susan A. Stein). On the few occasions that Degas was able to borrow back a work belonging to someone he knew, it was in order to correct or revise something that bothered him.

27. Jamot 1918, p. 128.

28. Jamot underlined this point. Reviewing Degas's collection, he wrote: "There are, however, some pictures that cannot be categorized in any of the famous series, that do not present claims to modernity or novelty of subject, that passed almost unnoticed for a very long time but today are prominent among our preferences. These are the portraits." Jamot 1918, p. 129. As Jean Sutherland Boggs has noted, about one-fifth of Degas's work is portraiture; see her overview of Degas's portraits in Zurich, Tübingen 1994–95.

29. Jean Sutherland Boggs in Paris, Ottawa, New York 1988–89a, p. 484.

30. Édouard Manet had made arrangements for the same kind of culling to take place after his death. In his will he directed the art critic and dealer Théodore Duret "to undertake this task, for I rely entirely on his taste, and on the friendship he has shown me, to know what should be put up for auction or destroyed." Quoted in Distel 1990, p. 61. Duret did orchestrate the auction but does not appear to have destroyed anything. Manet's widow retained the unsold contents of the studio and quietly sold them over the years.

31. Degas's two wills were laconic. The first, dated August 20, 1914, left everything to his sole surviving sibling, his brother René De Gas. The second, dated February 1916, left everything to his "natural heirs"; that is, in addition to his brother René, his four Fevre nieces and nephews, who were the children of his sister Marguerite (letter from Paul Paulin to Paul Lafond, December 4, 1917, in Sutton and Adhémar 1987, p. 178). See the résumé of the last years of the Degas family and the relations between the artist's brother René and Jeanne Fevre in Loyrette 1991, pp. 666ff.

32. Letter of May 6, 1918, André Gide and Paul Valéry, *Correspondance 1890–1942* (Paris, 1955), p. 470. Gide responded (p. 471) without surprise: "One could have predicted it. But that doesn't make it any less painful. . . . But then why did Degas keep his sketches? Ernest's mission could not have been more delicate. I am happy for him, though pained for Degas, that he didn't have to take it on." I thank Michael Pantazzi for bringing these letters to my attention.

33. Although it is known that Manzi produced the book, it was published by the partnership of Jean Boussod, Manzi and Joyant & Cie, successors to the old house of Goupil & Cie. The same appraisal cannot be given to the book published by Ambroise Vollard in 1914, *Quatre-vingt-dix-huit reproductions signées par Degas*. This album of murky black-and-white reproductions is of works that Vollard had managed to buy from Degas over the years. Degas allowed their reproduction but did not participate in the production, nor did he select the works reproduced.

34. André Mellerio, "Un Album de 20 reproductions d'après des dessins de M. Degas," in *L'Estampe et l'affiche*, no. 4 (April 15, 1898), p. 81. The monogrammist A. D. noted in *Le Journal des arts*, no. 25 (April 6, 1898), p. 2, that the selection of drawings was made by "some collectors, friends of the painter and draftsman E. Degas, who wish to save and transmit to an elite public an experience of this artist's talent." It seems quite unlikely, however, that the selection was made by anyone but Degas, in conjunction with Manzi. It was probably during the selection that Degas organized his portfolios, signing the drawings and inscribing sheets with dates that are occasionally incorrect—the result, no doubt, of the lapse of time, sometimes as great as forty years, between the creation of the drawing and its inscription.

35. Thadée Natanson, "Petite Gazette d'art," in *La Revue blanche* (April 15, 1898), p. 619.

36. In fact, almost every work by Degas offered in the four atelier sales was illustrated in the catalogues that Durand-Ruel prepared. On the other hand, the catalogue of the print sale was not well illustrated.

37. It seems unlikely that many or even any of Degas's brothel monotypes were destroyed, since a large number were included in the atelier print sale of November 1918.

38. Diary entry of March 20, 1918, in Gimpel 1966, pp. 9–11.

39. "Mouvement des arts: Les Grandes Ventes prochaines, Atelier Edgar Degas," *La Chronique des arts et de la curiosité* (July 1919), pp. 216–17.

40. Letter from Paulin to Lafond, May 6, 1918, in Sutton and Adhémar 1987, p. 180.

41. Ibid.

42. There is uncertainty as to what was shown at the "Exposition organisée sous le Patronage de la Ville de Paris au Profit des Oeuvres de Guerre de la Société des Artistes Français et de la Société Nationale des Beaux Arts" at the Petit Palais, May 1–June 30, 1918. Under the rubric "Expositions Exceptionelles: Hommage de la 'Nationale' à cinq de ses présidents décédes," one catalogue lists four works by Degas: (8) *Portrait de Famille*, (9) *Mlle Fiocre dans le ballet de la Source*, (10) *Les Malheurs de la Ville d'Orléans*, (11) *Répétition de musique*. Another catalogue lists four canvases and some drawings: *Portrait de Famille, Sémiramis, Les Malheurs de la Ville d'Orléans, Portrait de Marcellin Desboutin,* Cadres des dessins pour le tableau de *Sémiramis,* Cadres des dessins pour le tableau *Les Malheurs de la Ville d'Orléans.* I thank Robert McDonald Parker for locating these catalogues at the Musée du Petit Palais.

43. Recounted in a letter from Paulin to Lafond, December 14, 1917, in Sutton and Adhémar 1987, pp. 178–79.

44. See the excellent account of the negotiations over the casting of Degas's sculpture in Pingeot 1991, pp. 23–31.

45. According to Sutton and Adhémar 1987, p. 180 n. 1.

46. See Susan A. Stein's essay in this volume.

47. See the account by Michael Pantazzi in Paris, Ottawa, New York 1989–90a, pp. 342–52, and by Anne Pingeot in Pingeot 1991, pp. 188–90.

48. Cassatt, exasperated, exclaimed to Havemeyer, "What would Degas have thought of this?" Letter from Mary Cassatt to Louisine Havemeyer, December 8, 1919. MMA Archives.

49. In the remainder of the letter, Hébrard indicated that he had previously discussed the matter with one of Jeanne Fevre's brothers: "I already broached the matter with your brother, who must have spoken to you. Perhaps you have already reached a decision? I have been given to understand that my idea is not displeasing to him, that he would be a little sad to give up his portion of the series of sculptures I am committed to make for your family, but he is not opposed to the project. I didn't hide from him that I was prepared to make the first sacrifice. If, as I do not doubt, you are willing to take part in my project, please be so kind as to tell me what you think of it. Perhaps, when the edition of bronzes has been completed, I would be quite happy to preserve several of the small waxes (an avowal that moderates Palazzolo's declarations!). [The caster Albino Palazzolo came from Italy to cast the seventy-two waxes at Hébrard's foundry.] Waxes with good armatures will last for years if they are placed in vitrines, entirely protected from contact. Don't you think that they too should go in the Musée Degas? Please consult with your brothers; when you have replied, I will approach the heirs of René De Gas. . . ." In Pingeot 1991, p. 30.

50. For example, when Vollard suggested to Degas that he have his sculptures cast, he scoffed: "Too much responsibility lies behind anything in bronze, that substance [is] for eternity." Vollard 1924, p. 112.

51. Pingeot 1991.

52. Paris, Ottawa, New York 1988–89a, and New York 1993. The three previously published letters (of October 2, December 12, and December 28, 1917) appear in Mathews 1984.

53. L 816; The Metropolitan Museum of Art, New York (29.100.41).

54. All three are now at The Metropolitan Museum of Art, New York: L 816, *Woman Bathing in a Shallow Tub* (29.100.41); L 861, *Portrait of a Young Woman* (29.100.183); L 223, *Fan Mount: Ballet Girls* (29.100.555).

55. Cassatt's *Girl Arranging Her Hair* (fig. 3).

56. Electra Havemeyer Webb suffered a miscarriage.

57. Louisine Havemeyer was involved with a project to send jam to troops in Europe.

58. Mary Cassatt, *Edgar Degas*, Collection Print Sale: 16.

59. Not identified; perhaps a medieval sculpture on the French art market.

60. Edgar Degas, *At the Louvre*, ca. 1879: L 581; private collection.

61. A thirteenth-century head of a king, sold at Galerie Manzi, Joyant et Cie, Paris, December 15, 16, 1919.

62. *The Dance Class*, 1881: L 479; Philadelphia Museum of Art, W.37.2.1.

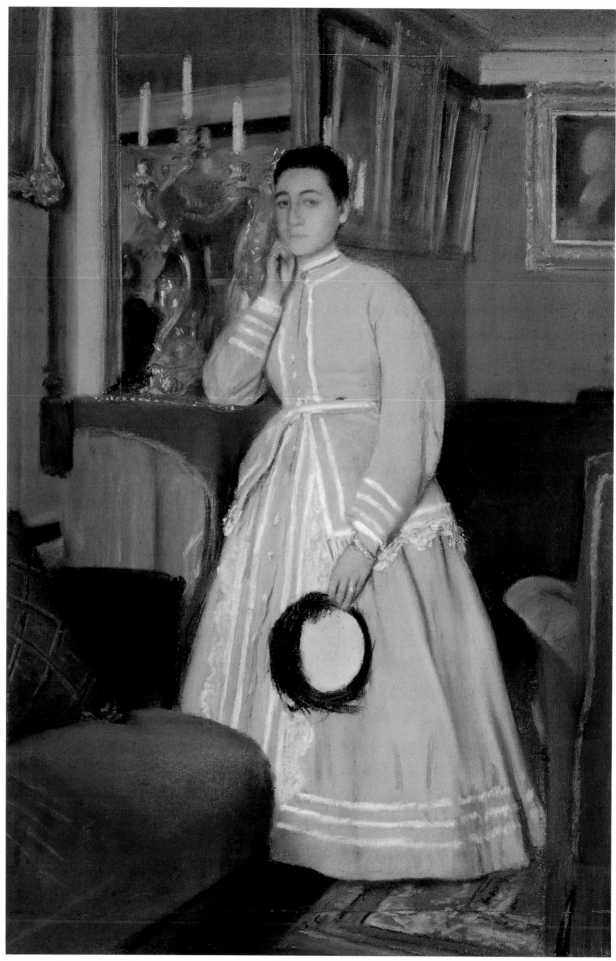

Fig. 124. Edgar Degas, *Madame Edmondo Morbilli, née Thérèse De Gas,* 1869. Pastel, strips of paper added at top and bottom, 20⅛ × 13⅜ in. (51 × 34 cm). L 255. Private collection. Retained by Degas's heirs

Degas and the Collecting Milieu

ANN DUMAS

A new feeling, an almost human tenderness for *things,* which in our times makes nearly everyone a collector" is how Edmond de Goncourt, writing in 1880, summed up an obsession that he felt had engulfed his age.[1] A common subject of French fiction in the second half of the nineteenth century—from Balzac's *Cousin Pons* to Huysman's *Des Esseintes*—the collector is also ubiquitous in visual imagery from Honoré Daumier to Edgar Degas (fig. 125). There were collectors in many social strata: those of modest means hunted after bric-a-brac, while millionaires amassed spectacular assemblages of paintings.

The flood of publications devoted to collectors and collections makes clear how eclectic tastes were: passions ran high for everything from Chinese bronzes to Renaissance drawings. However, a few consistent patterns emerge. First, the enthusiasm for eighteenth-century French art proved remarkably persistent throughout the period. Second, a love of the exotic found expression in the immense popularity of Japanese prints and other oriental artifacts once Japan opened up to the outside world in the late 1860s. Third, the predominant taste was, unquestionably, for French nineteenth-century art. Camille Corot, Jean-François Millet, Charles Daubigny, and other painters of the Barbizon school who had attracted attention in the 1830s and 1840s partly because of an increasing sense of national identity,[2] became particularly popular with the nouveau-riche collectors of the Second Empire; but by the last two decades of the century, the Impressionists were the artists most sought after by a new generation of wealthy collectors.

A growing number of dealers had begun to flourish in the climate of vigorous consumerism that prevailed during the third quarter of the century. Preeminent among these was Paul Durand-Ruel, a brilliant entrepreneurial strategist who promoted first the Barbizon school and then the Impressionists and whose expertise lay behind many prominent collections formed in the latter part of the century. Other dealers, notably Ambroise Vollard, found new markets for the avant-garde art of Paul Cézanne, Paul Gauguin, and Vincent van Gogh. That art was a speculative investment seemed confirmed when in 1853 the auction house

Hôtel Drouot opened not far from the Stock Exchange.[3] Since there was no established museum of contemporary art in Paris, the Hôtel Drouot became the main setting in which large displays of modern works could be seen,[4] supplementing the smaller displays in the dealers' shops—many of which clustered along the rue Laffitte, not far from Degas's home. Together these venues provided a fertile hunting ground. For a decade or so after 1890, when he had begun to collect in earnest, Degas could be seen here almost daily, often in the company of one of his collector friends (fig. 126).

The escalating prices that modern art could command toward the end of the century from not only French but

LES BONS BOURGEOIS.

Votre tableau me plairait assez mais décidément il a une demi canne de moins que ce qu'il me faut !

Fig. 125. Honoré Daumier, "I rather like your picture. . . . but it's definitely an inch or two smaller than I need!" ("Votre tableau me plairait assez . . . mais décidement il a une demi canne moins de ce qu'il me faut!" From The Middle Class (Les Bons Bourgeois), 1846. Lithograph, 9¾ × 8¼ in. (24.8 × 21 cm). The Metropolitan Museum of Art, New York, Elisha Wittelsey Collection, The Elisha Wittelsey Fund, 1979 (1979.542). Surrogate for Degas's unlocated impression, Collection Print Sale: 77

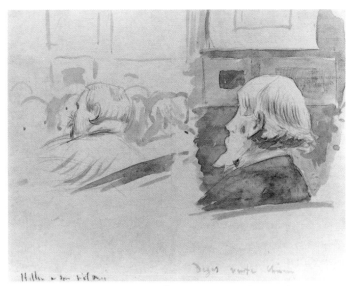

Fig. 126. Paul Helleu (1859–1927), *Étienne Moreau-Nélaton and Degas at the Cheramy Sale*, 1908. Wash, 3½ × 4 in. (8.9 × 10.2 cm). Private collection

a model of the *amateur,* was, as the critic Arsène Alexandre explained, an aristocrat ("un grand seigneur") by birth but also in spirit. Like his close friend Henri Rouart, he was "a true *amateur* of art, the man who loves beautiful things not for speculation or vanity but for the cultivation and, one could almost say, for the health of his soul."[6]

The true collector was a fanatic. His mania for a work of art was fired by its intrinsic qualities, not by its value or the reputation of the artist. In a revealing anecdote, Ernest Rouart, Henri's son, recalled Degas's uncontrollable passion for buying pictures, not just masterpieces but anything with true aesthetic value that caught his eye:

Walking one day with Degas in the streets of Avignon, father and I watched him stop suddenly in front of the window of a bric-a-brac shop. An old frame had caught his eye, and from a few skillfully placed strokes of the brush on the canvas one could make out the

also international, and particularly American, buyers provoked a reaction among intellectuals, critics, writers, and old-guard collectors. Alarmed by what they saw as the rampant materialism and spiritual impoverishment of their age, they regretted the genteel practices of the old days, when art could be bought for modest prices by the discerning collector. The *amateur*—art lover, or gentleman collector—was seen as belonging to a disappearing breed overtaken by a new, vulgar species of modern speculator who acquired art for status or financial gain but without any understanding or love of his acquisitions. This view was encapsulated in a memoir of the distinguished collector Henri Rouart (1833–1911), Degas's friend, written by the painter Jacques-Émile Blanche (see fig. 127) in 1919, eight years after Rouart's death: "With these collectors of the old school the last of a great generation is disappearing, and only later will we understand the importance of the role they have played in our country. Soon that appealing figure, the modest picture collector, will be crushed by the stampede of irresponsible American millionaires or the new industrial aristocracy from Germany and Russia."[5]

The disappearance of the *amateur* is a theme that cropped up repeatedly: in a series of articles on collectors published in the 1890s in the *Gazette des Beaux-Arts,* for example, or in introductory essays for the lavish catalogues of collections sales written by well-known critics. Indeed, in these years the earlier generation who epitomized this ideal type were quite literally a disappearing breed, and as they died off their holdings were being put up for auction. The great collector of Barbizon and Impressionist pictures Count Armand Doria (1824–1896), who was venerated as

Fig. 127. Jacques-Émile Blanche (1861–1942), *Francis Poictevin*, 1887. Oil on canvas, 10⅜ × 6½ in. (26.5 × 16.5 cm). Tate Gallery, London, Presented by Miss Hilda Trevelyan, 1939 (NO 4995). Owned by Degas ca. 1887–1904

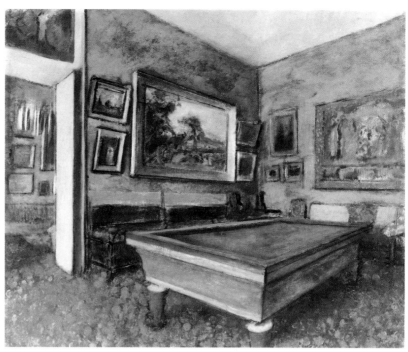

Fig. 128. Edgar Degas, *The Collector of Prints*, 1866. Oil on canvas, 20⅞ × 5¾ in. (53 × 40 cm). L 138. The Metropolitan Museum of Art, New York, H. O. Havemeyer Collection, Bequest of Mrs. H. O. Havemeyer, 1929 (29.100.44)

Fig. 129. Edgar Degas, *The Billiard Room at Ménil-Hubert*, 1892. Oil on canvas, 25⅝ × 31⅞ in. (65 × 81 cm). L 1115. Staatsgalerie Stuttgart (2792). Atelier Sale II:37

tomb of Napoleon on Saint-Helena. The willow tree was admirable! Indeed, everything in this little picture struck him as sublime. The purchase was immediately concluded and the object brought back triumphantly to Paris. What happened to it afterward, I don't know![7]

A modest collector leafing through his portfolio of prints is the subject of Degas's sympathetic portrayal of an unknown sitter, *The Collector of Prints* (fig. 128), and there is no doubt that he himself identified quite consciously with this sort of person. "I have only known how to accumulate beautiful pictures, not money," he complained to the dealer Hector Brame in 1901.[8] He frequently expressed contempt for the speculator who pushed prices up beyond the reach of the true art lover. "There are no more disinterested buyers like you and me," he confided to Étienne Moreau-Nélaton after attending a sale at which Alfred Robaut, the Delacroix expert, had bid up the prices of drawings by Eugène Delacroix that Degas wanted to buy.[9] In later life he often spoke of a childhood visit with his father to the famous collector of eighteenth-century French art François Marcille (1790–1856), with his old cloak, his battered hat, and his priceless pictures by Chardin, Fragonard, and Watteau piled at random in the corner of a room.[10]

Degas had grown up in a cultured, haut-bourgeois milieu where collecting and living with art were part of a way of life. Sometimes this world is conveyed in his art, as in *The Billiard Room at Ménil-Hubert* (fig. 129), which

Degas painted on one of his frequent visits to the Normandy country house of his friend Paul Valpinçon, the son of a famous collector of works by J.-A.-D. Ingres. Two years after making this painting Degas purchased Delacroix's delightful study of the tented apartment of the Count de Mornay, Delacroix's patron (fig. 4), the subject of which is also an empty room whose furnishings and paintings express the taste of its occupant.

"LE GÉNIE FRANÇAIS"

Degas's enormous collection was assembled with great concentration of purpose over a relatively short period, about 1890 to 1904. In its range it reflected the eclectic patterns of contemporary collecting, although the surprising juxtapositions—of El Greco with Van Gogh and Gauguin, for instance—reveal the idiosyncrasies of Degas's taste. Édouard Manet and Corot were well represented, and there was a large group of Japanese prints as well as prints by Daumier and Paul Gavarni and by Degas's contemporaries. However, the collection's overwhelming strength, its extensive and magnificent holdings of paintings and drawings by Ingres and Delacroix, the two giants of the earlier part of the century, shows Degas placing himself in a particular nineteenth-century French tradition.

In forming a substantial historic collection Degas was unique among his avant-garde artist peers. Those who

Fig. 130. Edgar Degas, *Hélène Rouart,* 1886. Oil on canvas, 63⅜ × 47¼ in. (161 × 120 cm). L 869. Reproduced by courtesy of the Trustees, the National Gallery, London (NG 6469). Atelier Sale II: 170

bought art tended to buy each other's work. The most outstanding example is of course Gustave Caillebotte, who used his personal fortune to acquire his friends' work (he bequeathed his impressive collection of Impressionist works to the Musée du Luxembourg, which finally accepted the bequest in 1897 after much controversy). Claude Monet owned a few paintings by Cézanne and Auguste Renoir and had purchased a work by Degas. Even those of Degas's contemporaries whom he had the most in common with and admired the most and whose art, like his, was rooted in tradition—Manet, Cézanne, and Gauguin— did not buy earlier art in any serious way. It is true that Gauguin had formed a collection of about fifty works before he lost his job on the Paris stock exchange in 1883

and was forced to sell it, but that had been composed largely of Impressionist pictures.[11]

Unlike those other artists, Degas resembled the mainstream collectors of mid-nineteenth-century France whose collections demonstrated the notion of a modern French painting tradition. One of the most distinguished and representative assemblages of this type was formed between about 1870 and the end of the century by Degas's friend Henri Rouart.

Like Degas's, Rouart's collecting was in ways a manifestation of the conservatism and deep-rooted nationalism of the Parisian *grande bourgeoisie* to which he belonged. Educated at the prestigious École Polytechnique, Rouart was a wealthy engineer and industrialist who invented a

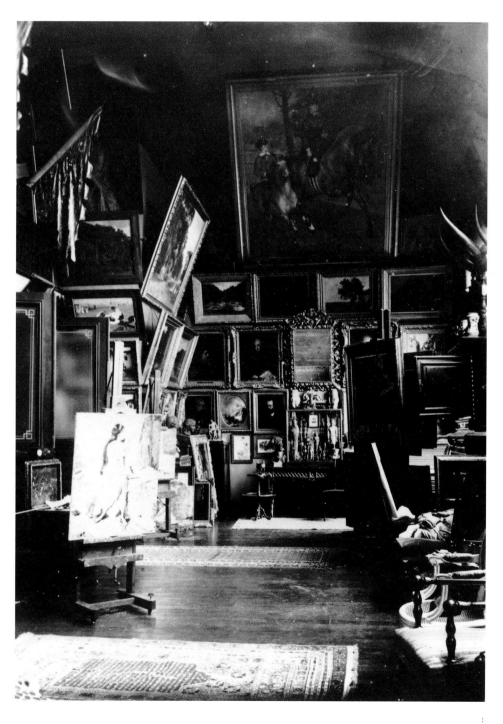

Fig. 131. Interior of Henri Rouart's atelier at 34, rue de Lisbonne, Paris, ca. 1900. Private collection

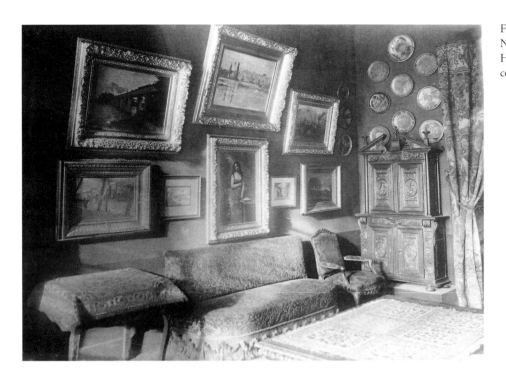

Fig. 132. Interior of Étienne Moreau-Nélaton's townhouse at 73, Faubourg Saint-Honoré, Paris, February 1907. Private collection

machine for making ice and another for sending telegrams. In his spare time he was a keen amateur painter who exhibited with the Impressionists. He and Degas had been boyhood friends at the venerable Lycée Louis-le-Grand and had met again in 1870 when they fought together on the barricades during the siege of Paris. That youthful, idealistic nationalism hardened later, in the wake of the Dreyfus affair that began in 1894, into a xenophobic anti-Semitism that was particularly virulent in Degas's case.[12] A more benign conservatism, however, fueled their lifelong adherence to attachments established in youth, whether old friendships formed within their social milieu or artists whose impact had been felt early on.

In the portrait he painted of Rouart's daughter Hélène in 1886 (fig. 130)—which in a sense is a surrogate portrait of Rouart himself, his presence palpably conveyed in the imposing but empty chair—Degas pays tribute to the range of Rouart's tastes, especially his love of Millet and Corot, whose works appear on the wall behind Hélène.[13] The friendship of Rouart and his family—"my only family in France,"[14] he once called them—meant a great deal to Degas; and there is no doubt that Degas played an equally important role in Rouart's life. Their affectionate correspondence reveals them often seeking each other's advice about acquisitions and visiting salerooms and dealers' shops together. Degas was a regular guest at Rouart's Friday evening dinners, where his brilliant repartee and incisive intelligence impressed the young Paul Valéry.[15] Valéry described how Rouart's house at 34, rue de Lisbonne was hung from top to bottom with his magnificent collection of pictures by Delacroix, Corot, Manet, Monet, and oth-ers, jostling for space on the walls in the typical nineteenth-century manner also employed at the Salon (fig. 131).[16]

Henri Rouart had set out to form a collection that would express "le génie français" ("the French spirit"), in the words of Blanche.[17] Indeed, in 1901 Alexandre described Rouart's collection as "one of the most characteristic in Paris: it is complete and definitive."[18] It represented Rouart's view of a modern, that is, nineteenth-century, French tradition—essentially a line that extended from Delacroix to Impressionism in the realm of color and light while also encompassing the development of Realism. The key figures were Delacroix, Corot, Daumier, Millet, Gustave Courbet, Daubigny, Théodore Rousseau, Manet, Monet, Degas, Renoir, and Camille Pissarro.

In acquiring along these lines, Rouart was following in the footsteps of such collectors as Count Doria, of the previous generation, and also setting a pattern that would be followed at the end of the century by Étienne Moreau-Nélaton (1859–1927), who amassed his collection in comparatively few years, between 1897 and 1906. Moreau-Nélaton, a profoundly patriotic man, bought more programmatically than Rouart: building on a great collection of Delacroix, Corot, and Barbizon paintings inherited from his grandfather, he sought not only to represent French painting from Delacroix to Monet but also to assemble a collection that he expressly intended to donate to the preeminent national institution, the Louvre. With this purpose in mind, he acquired works that he knew would fill gaps in the museum's holdings (fig. 132).[19]

Collections like those of Rouart and Moreau-Nélaton, who followed a more systematic agenda than Degas, pro-

vide a barometer of the taste of the time. While a strong notion of tradition also informed Degas's approach, his choices were inspired primarily, of course, by his motives as an artist. A comparison of Degas's collection with these others—especially with that of Rouart, because the two were so close and Rouart influenced his collecting—provides fascinating insights into the ways Degas's taste coincided with, and diverged from, the principal contemporary trends.

For all three, Delacroix was a keystone of the modern French tradition. Moreau-Nélaton had announced his admiration for Delacroix with one of his first acquisitions, Henri Fantin-Latour's group portrait *Homage to Delacroix* of 1864 (fig. 133). Later he extolled Delacroix as "the incarnation of the France that we love" in his *Delacroix raconté par lui-même*, a book written in a spirit of fervent patriotism during World War I.[20] While Degas's hundreds of works by Delacroix—drawings, watercolors, and pastels (see figs. 134–148) and thirteen paintings, including such masterpieces as *Louis-Auguste Schwiter* (fig. 44) and *The Entombment* (fig. 41)—were more substantial than the nine paintings and sixty-five works on paper in Rouart's collection, the character of the works the two men owned is in some ways similar, doubtless partly because they often compared notes about their potential acquisitions: "Try to find a moment, my dear friend, to go to Bernheim to examine three sketches of flowers by Delacroix, so that we can discuss them tomorrow at your place," Degas wrote to Rouart in 1898.[21] Both owned a number of studies for decorative schemes, including the Apollo ceiling for the library of the Palais Bourbon. The drawings Degas bought tend to be more summary, perhaps reflecting his particular interest in exploring the way Delacroix worked as revealed in his most informal sketches. But their acquisitions of watercolors of horses, tigers, flowers, landscapes, and Moroccan subjects are evidence of their mutual enthusiasm for these beautiful works.

A striking difference between Degas's collection and those of Rouart and Moreau-Nélaton was the major presence of Degas's other great passion, Ingres. Ingres did not interest the other two men. As the epitome of a linear, academic tradition, he had no place in their view of modern art based on color, light, and painterliness. Indeed, it seems that Degas's equal enthusiasm for the two historic rivals Ingres and Delacroix was highly unusual and set him apart from other contemporary collectors. Whereas Degas owned twenty paintings by Ingres, including such superlative works as the portraits of M. and Mme. Leblanc and the Marquis de Pastoret (figs. 22, 21, 20), as well as eighty-eight drawings, Rouart had one tiny painting and only three drawings. "Despite the remonstrances of M. Degas," explained Alexandre, "[Rouart] could not bring himself to recognize the originality of Ingres; but with Delacroix he sought out the most lively examples he could find."[22] Nonetheless, Degas would still on occasion seek Rouart's advice on an Ingres drawing: "Dear friend," he wrote on January 7, 1897, "If you add your report as an expert on quality and price, you would help me a lot. You understand it!"[23]

Corot, like Delacroix, was central to Rouart's concept of nineteenth-century French painting, and the landscapist was the most fully represented artist in his collection: his holdings of fifty-three paintings and fifteen drawings far surpassed Degas's. By the time of Corot's death in 1875 he

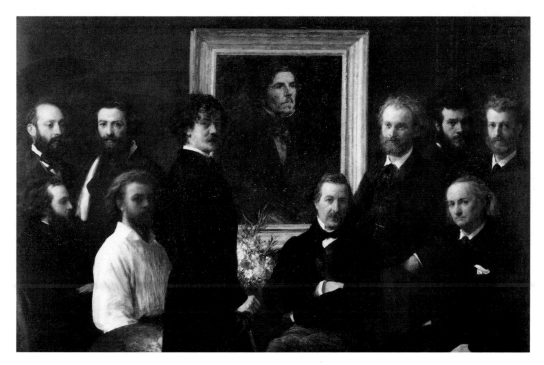

Fig. 133. Henri Fantin-Latour (1836–1904), *Homage to Delacroix*, 1864. Oil on canvas, 63 × 98½ in. (160 × 250 cm). Musée d'Orsay, Paris (R.F. 1664)

Fig. 134. Eugène Delacroix, *Heads of Arabs and Blacks.* Graphite, 8⅞ × 11¼ in. (22.5 × 28.5 cm). Arturo Cuéllar and Johannes Nathan. Collection Sale I: 163

Fig. 135. Eugène Delacroix, *Study for the Portrait of Count Palatiano,* 1826. Watercolor and ink, 7½ × 4½ in. (19 × 11.5 cm). Jane Voorhees Zimmerli Art Museum, Rutgers, The State University of New Jersey, New Brunswick, N.J., Stern Collection, Philadelphia Museum of Art, Transfer (64.017.005). Collection Sale II: 139.4

Fig. 136. Eugène Delacroix, *Greek Officer,* 1822. Oil on canvas, 16⅛ × 12¼ in. (41 × 31 cm). Göteborgs Konstmuseum, Gift of W. Lundqvist, 1918 (WL17). Collection Sale I: 30

Fig. 137. Eugène Delacroix, *Studies of the Head of an Oriental Man in a Burnoose,* ca. 1823–24. Graphite, 9 × 11⅜ in. (23 × 28.8 cm). Musée du Louvre, Paris, Département des Arts Graphiques (R.F. 10028). Collection Sale II (hors catalogue)

Fig. 138. Eugène Delacroix, *Seated Moroccan in an Interior,* 1832. Watercolor and graphite, 7½ × 11¾ in. (19 × 29.8 cm). Musée du Louvre, Paris, Département des Arts Graphiques (R.F. 4874). Collection Sale I: 113

Fig. 139. Eugène Delacroix, *Study of Mechla: Figure Wearing a Burnoose; Black and Yellow Burnoose,* 1832. Graphite, watercolor, and wash, 8⅞ × 13 in. (22.5 × 33 cm). Musée des Arts Décoratifs, Paris (21153B). Collection Sale II: 129.2

Fig. 140. Eugène Delacroix, *Four Studies of Moroccan Costumes.* Watercolor, 10 × 12¼ in. (25.5 × 31 cm). Private collection. Collection Sale I: 123

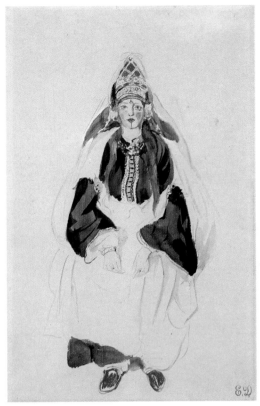

Fig. 141. Eugène Delacroix, *Jewish Woman of Tangier in Festive Costume*, 1832. Watercolor over graphite, 8¾ × 5¾ in. (22 × 14.5 cm). Gianna and Thomas Le Claire. Collection Sale II: 146

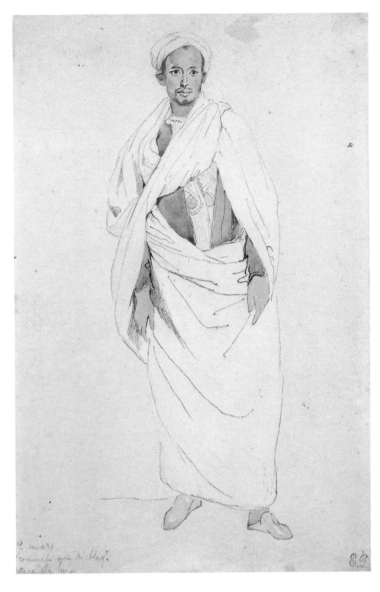

Fig. 142. Eugène Delacroix, *Standing Moroccan,* 1832. Watercolor, 10⅝ × 7⅛ in. (27 × 18 cm). Private collection, New York. Collection Sale II: 152

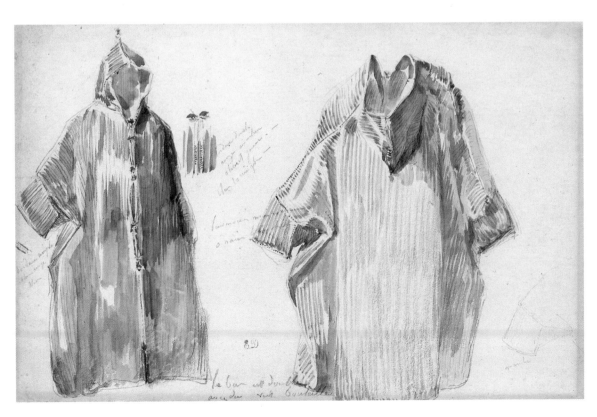

Fig. 143. Eugène Delacroix, *Study of Mechla: The Front and Back of a Moroccan Burnoose,* 1832. Graphite, watercolor, and wash, 9½ × 14¾ in. (24 × 37.5 cm). Musée des Arts Décoratifs, Paris (21153A). Collection Sale II: 129.1

Fig. 144. Eugène Delacroix, *Moroccan Interior: Green Door*, 1832. Watercolor and graphite, 9⅝ × 8¾ in. (24.4 × 22 cm). Musée du Louvre, Paris, Département des Arts Graphiques (R.F. 4528). Collection Sale II: 131.4

Fig. 145. Eugène Delacroix, *Moroccan Bed*, 1832. Watercolor, 3¾ × 5⅞ in. (9.5 × 15 cm). Private Collection. Collection Sale II: 93.2

Fig. 146. Eugène Delacroix, *Interior of a Moorish Courtyard*, 1832. Graphite and watercolor, 4 × 5¼ in. (10 × 13.2 cm). Musée du Louvre, Paris, Département des Arts Graphiques (R.F. 4525). Collection Sale I: 131.1

Fig. 147. Eugène Delacroix, *Bay Windows in an Arab Interior,* 1832. Watercolor and graphite, 8⅜ × 10½ in. (21.2 × 26.8 cm). Musée du Louvre, Paris, Département des Arts Graphiques (R.F. 4526). Collection Sale II: 131.3

Fig. 148. Eugène Delacroix, *Arab Interior, Said to Be Delacroix's Room at Meknes,* 1832. Watercolor, 5¾ × 8⅛ in. (13.5 × 20.5 cm). Musée du Louvre, Paris, Département des Arts Graphiques (R.F. 4521). Collection Sale II: 132

Fig. 149. Jean-Baptiste-Camille Corot, *Lady in Blue,* 1874. Oil on canvas, 31½ × 19⅞ in. (80 × 50.5 cm). Musée du Louvre, Paris, (R.F. 2056)

Fig. 150. Jean-François Millet (1814–1875), *Two Studies of a Female Nude Raising Her Arms.* Black chalk, 9½ × 6⅛ in. (24 × 15.5 cm). Musée du Louvre, Paris, Département des Arts Graphiques (R.F. 4513). Collection Sale I: 231

Fig. 151. Jean-François Millet, *Madame J.-F. Millet, née Pauline Virginie Ono,* 1841. Oil on canvas, 16½ × 12¾ in. (41.8 × 32.3 cm). Courtesy Museum of Fine Arts, Boston, Tompkins Collection (44.73). Collection Sale I: 82

was generally regarded as one of the pillars of the French tradition, although his figure subjects and early landscapes were not widely appreciated; most collectors preferred the late silvery works. Degas used to assert that Corot's genius lay in his figures, but he owned only one slight figure composition, of an Italian woman,[24] while Rouart had a number of outstanding figure paintings, including the famous *Lady in Blue* of 1874 (fig. 149). However, Degas shared Rouart's (and Moreau-Nélaton's) prescient admiration for the early landscapes, especially the Italian studies. Rouart owned a number of the small, luminous Italian views painted in the 1820s comparable to *Ruins in the Roman Campagna, with Claudian Aqueduct* of 1826 in Degas's collection (fig. 153), among them the view of the bay of Naples that Degas included in his portrait of Hélène Rouart as a discreet acknowledgement of this shared and unconventional taste.

Rouart's assemblage of paintings by Millet, whom he had known and often painted with in the Forest of Fontainebleau, was second only to his collection of works by Corot. Given Degas's often-avowed distaste for nature and landscape painting—a standing joke between him

Fig. 152. Jean-François Millet, *The Gust of Wind*, 1873. Oil on canvas, 35½ × 44½ in. (90.2 × 113 cm). National Museum and Gallery, Cardiff (NMW A 2745)

and Rouart[25]—it is no surprise that he did not share the widespread contemporary enthusiasm for the landscapes of Millet and the other Barbizon painters that Rouart admired: Daubigny, Rousseau, and Diaz de La Peña. The fourteen paintings by Millet that Rouart acquired covered

every phase of the artist's career, from the early Romantic pastorales to his most majestic scenes of barren heath and brooding forest, such as *The Gust of Wind* of ca. 1871–73 (fig. 152). Degas owned hardly any works by Millet: an early portrait and (although he is known to have admired Millet's draftsmanship)[26] apparently only two quite slight drawings of the female nude (figs. 151, 150),[27] in contrast to Rouart's outstanding collection of fifty-four drawings, with many fine examples of peasant figures rendered in the artist's powerful charcoal line.

Courbet and Daumier, key figures in the development of Realism, were both well represented in Rouart's collection, which included some eight pictures by Courbet, including the portrait of the philosopher Tapadoux, and, installed in a special cabinet room, a substantial twelve paintings by Daumier, an unusual concentration at the time.[28] Whereas Degas was certainly interested in Courbet —he bid frenetically for one of Courbet's greatest works, *The Painter's Studio*, when it came up for auction in 1897[29]—the only work he seems to have owned is a small portrait of a hunter that was listed in his personal inventory but not included in the sales of his collection.[30] And one

Fig. 153. Jean-Baptiste-Camille Corot, *Ruins in the Roman Campagna, with Claudian Aqueduct*, ca. 1826–28. Oil on canvas, 8⅝ × 12⅝ in. (22 × 32 cm). Reproduced by courtesy of the Trustees, the National Gallery, London (NG 3285). Collection Sale I: 19

Fig. 154. Honoré Daumier, *Don Quixote Reading (Man Seated in an Armchair)*, 1865–67. Oil on canvas, 32⅜ × 25⅝ in. (82.2 × 65.1 cm). National Museum and Gallery, Cardiff (NMW A 2454). Collection Sale I: 23

wonders if the sole Daumier painting he owned, the unfinished *Don Quixote Reading* (fig. 154), may not have been bought at Rouart's instigation.

With Manet, Degas's group of eight paintings, including the magnificent *The Execution of Maximilian, Emperor of Mexico,* 1867 (fig. 60), surpassed Rouart's holdings of three high-quality paintings: *The Music Lesson* (Museum of Fine Arts, Boston), *On the Beach* (Musée d'Orsay, Paris), and *Female Nude* (private collection). Moreau-Nélaton's acquisition in 1900 of Manet's celebrated *Luncheon on the Grass,* 1862 (Musée d'Orsay, Paris), provided the pivot between the earlier works in his collection, centered around Corot, and the later group of Impressionist pictures.

An almost complete lack of interest in Impressionism differentiated Degas from Rouart, Moreau-Nélaton, and other collectors of the day. He had acquired a few works in the pioneer days of the Impressionist group in the early 1870s—two Pissarro landscapes (figs. 384, 388) and one by Alfred Sisley (fig. 160), two Renoirs and a painting by Berthe Morisot (figs. 159, 158), but nothing by Monet. In the long run, he had no taste for mainstream Impressionism. While early Impressionist landscape could be easily accommodated within Rouart's or Moreau-Nélaton's concept of tradition, it had no place in Degas's, which was based on his fundamental beliefs in draftsmanship, structure, and a

Fig. 155. Honoré Daumier, *Bust of a Man.* Ink and graphite, 4⅜ × 3¾ in. (11 × 9.5 cm). Private collection. Collection Sale I: 106

Fig. 156. Honoré Daumier, *Two Male Heads,* Ink and graphite, 4⅛ × 3¾ in. (10.5 × 9.5 cm). Private collection. Collection Sale I: 106

Fig. 157. Berthe Morisot (1841–1895), *A Woman and a Child Sitting in a Meadow,* 1871. Watercolor, 8¼ × 9½ in. (21 × 24 cm). Private collection, Courtesy Galerie Hopkins-Thomas. Collection Sale I: 232

Fig. 158. Berthe Morisot, *In a Villa at the Seaside,* 1874. Oil on canvas, 19¾ × 24⅛ in. (50.2 × 61.3 cm). Norton Simon Art Foundation, Pasadena (M.1979.21.P). Collection Sale I: 83

Fig. 159. Auguste Renoir (1841–1919), *Mademoiselle Henriette Henriot,* 1874. Oil on canvas, 16⅛ × 13 in. (41 × 33 cm). Private collection. Collection Sale I: 88

Fig. 160. Alfred Sisley (1839–1899), *The Factory during the Flood,* 1873. Oil on canvas, 19¾ × 25⅝ in. (50 × 65 cm). Ordrupgaard, Copenhagen. Collection Sale I: 90

meditative approach to art. Rouart, on the other hand, put together an important group of early Impressionist works: five landscapes by Monet, five by Pissarro, a Morisot, and three figure compositions by Renoir. Several of these were bought at the early Impressionist sales in the 1870s,[31] making Rouart one of the pioneer collectors of early Impressionism, a group that included, among others, Victor Chocquet, Armand Doria, the famous baritone Jean-Baptiste Faure, and the brilliant critic Théodore Duret.[32] Rouart also acquired a few outstanding works by his friend Degas—eight pastels and five oils, including *Beach Scene,* circa 1876–77 (National Gallery, London), and *Dancers Practicing at the Barre,* 1876–77 (fig. 396)— although not as many as he would have liked, because Degas was reluctant to take money from his friend, and Rouart was uneasy about accepting gifts.[33]

Moreau-Nélaton's substantial collection of Impressionist works also dated mostly from the 1870s. By the time he was collecting, in the late 1890s and the early years of the twentieth century, early Impressionism had already joined the accepted canon for private collectors if not for state institutions (the Caillebotte bequest of Impressionist works to the Musée du Luxembourg still caused a furor in

Fig. 161. Paul Cézanne, *Five Bathers*, 1877–78. Oil on canvas, 15½ × 16½ in. (39.4 × 42 cm). Barnes Foundation, Merion, Pa.

1897). It was Americans, for instance the Havemeyers and Mrs. Potter Palmer from Chicago, who were the first to acquire—starting in the late 1880s—later Impressionist works of the 1880s and 1890s. Moreau-Nélaton purchased outstanding examples by Monet, including his *Poppies near Argenteuil*, 1873 (Musée d'Orsay, Paris), as well as several Pissarros and a large group of Sisleys, nearly all landscapes of the 1870s. However, with the exception of some retardataire classicizing figure compositions by his friend Maurice Denis, Moreau-Nélaton's acquisitions stopped with Impressionism, which he considered the end of a tradition rather than the beginning of something new.[34]

On the other hand, Rouart rather surprisingly acquired avant-garde art: his purchases of five Cézannes, including *Five Bathers*, now in the Barnes Collection (fig. 161), and his one spectacular Gauguin, *Delightful Days (Nave, nave mahana)*, 1896 (Musée des Beaux-Arts, Lyons), were surely made with Degas's encouragement. No doubt Rouart felt these works were necessary as a final chapter in his comprehensive story of French nineteenth-century painting, but one suspects that he was not entirely at ease with them. According to his son, Rouart liked the color of his Cézannes but admitted that otherwise he cared little for them.[35]

COLLECTING THE OLD MASTERS

As a coda to this comparison of Degas's collection with Henri Rouart's, it is worth mentioning an unexpected

departure into the realm of old master collecting,[36] their mutual enthusiasm for the work of the Spanish seventeenth-century painter El Greco. A taste for El Greco was rare at the time and was shared by only a handful of advanced collectors, including Degas's friend the printer Michel Manzi, Doria, and the Americans the Havemeyers and Henry Clay Frick. Rouart owned four,[37] and very likely it was he who encouraged Degas to buy his two paintings by El Greco, *Saint Dominic* (fig. 383) and *Saint Ildefonso* (fig. 2), writing him an ecstatic letter after the purchase of one of them, probably the *Saint Dominic*, which had belonged to Millet.[38] Degas's taste for El Greco was very likely also encouraged by his friend Paul Lafond, director of the Musée des Beaux-Arts in Pau, who was a pioneer in making El Greco known in France in the late nineteenth century and collaborated with Maurice Barrès on a widely read book on the painter that was published in 1911.[39]

Whereas in England the celebrated sale of the collection of the Duke of Orleans in 1798 had established a pattern of old master collecting that lasted throughout the nineteenth century, in France old master painting was not being extensively collected in the late nineteenth century.[40] Although the paintings may generally have been inaccessible or expensive, it is curious that Degas was not tempted to buy old master drawings, especially Italian drawings of the fifteenth and sixteenth centuries, given that he had admired and copied them so extensively in his youth. A fascinating comparison on this point is provided by a contemporary, the portrait painter Léon Bonnat, one of a circle of collectors of old master drawings that included Gustave Dreyfus, a curator at the Louvre, Philippe de Chennevières, former minister of fine arts, and Charles Ephrussi, the director of the *Gazette des Beaux-Arts*. Degas had gotten to know Bonnat when they were students together in Rome in the 1850s. He painted Bonnat's portrait in 1863 (fig. 169), but later on, differences in art, outlook, and way of life caused them to drift apart. Bonnat's immense success as a portrait painter producing likenesses of French and American grandees enabled him to build an opulent mansion in Paris (fig. 163) (for which Puvis de Chavannes painted a mural, *Doux Pays*, 1882) and to fill it with paintings and objects, above all a magnificent collection of Italian, Flemish, and Dutch old master and French nineteenth-century drawings. The majority of Bonnat's old master drawings seem to have come from London sales, many acquired though Thibaudeau, a French dealer living in London who used to bring drawings to Paris to show him. Bonnat was also in touch with Sir John Robinson, described by Francis Haskell as "probably the

Fig. 162. Edgar Degas, *Portrait of a Man, Copy after Quentin de La Tour,* ca. 1868–70. Oil on canvas, 29⅜ × 24⅝ in. (75 × 62.5 cm). BR 48. Musée Cantonal des Beaux-Arts, Lausanne. Sold as "Eighteenth-Century French School," Collection Sale I: 37

Fig. 163. Ricardo de los Rios (1846–1929), *Léon Bonnat in His Studio,* ca. 1896. Oil on canvas, 14⅜ × 18⅛ in. (37 × 46 cm). Musée Bonnat, Bayonne (2652)

Fig. 164. Jean-Baptiste Perronneau (1715–1783), *Bust of a Woman (Madame Miron de Porthioux)*, 1771. Oil on canvas, 25⅜ × 21 in. (64.5 × 53.5 cm). Private collection. Collection Sale I: 4

greatest expert of the nineteenth century on Italian Renaissance drawings and sculpture."[41] According to Jacob Bean, Bonnat was paying what for that time were extremely high prices for some of the drawings; in 1880 he had paid 15,000 francs for a Michelangelo drawing, *Adam and Eve*.[42] In 1896 he paid 3,500 francs for a Ghirlandaio drawing, *The Coronation of the Virgin*, that came from the celebrated sale of Lord Warwick's collection, while in the same year Degas paid 3,500 francs for Ingres's *Jacques-Louis Leblanc*. The year before, in June 1895, Degas had paid 12,000 francs for Delacroix's *Louis-Auguste Schwiter*. One might conclude that Degas could have afforded to acquire a collection of old master drawings but preferred to buy nineteenth-century French art.

Apart from the two paintings by El Greco and one painting of a horse after Aelbert Cuyp,[43] the only examples of earlier art in Degas's collection were the portrait of Mme Miron de Porthioux (fig. 164) by the fine eighteenth-century pastelist Jean-Baptiste Perronneau and a few drawings by Giovanni Domenico Tiepolo. The portrait, which appears in the background of Degas's 1869 portrait of his sister Thérèse in the family apartment (fig. 124), was undoubtedly inherited from Degas's father, a cultivated banker who cared more for the arts than he did for busi-

ness. And it is likely that the Tiepolo drawings also came from his father, as did some pastels by Maurice-Quentin de La Tour that Degas was obliged to sell following the collapse of the family business in 1875.[44]

Nostalgia for the Rococo proved surprisingly tenacious throughout the nineteenth century. For Degas's father's generation, the paintings of Fragonard, Chardin, and especially Watteau represented the more gracious age of the ancien régime, and this escapist appeal lost none of its force as the nineteenth century progressed. In the 1890s that nostalgia enjoyed a final flowering in the form of Art Nouveau.[45] Although Degas had a liking for the Rococo, especially the portraits of La Tour (see his copy of *Portrait of a Man*, fig. 162),[46] as a collector he does not seem to have been involved in the revival of Rococo taste, unless one considers the numerous lithographs by Gavarni he acquired to be a nineteenth-century manifestation of the previous century's comedy of manners, as the Goncourts proposed in their monograph on the artist.[47]

By the end of the nineteenth century high prices had put eighteenth-century paintings beyond the range of most collectors. One exception was a friend of Degas's, the wealthy minor Impressionist painter Michel Henri-Lévy, who assembled a number of significant paintings and

Fig. 165. Paul Helleu, *Alexis Rouart,* 1898. Drypoint, 21¼ × 16⅜ in. (54 × 41.5 cm). Sterling and Francine Clark Art Institute, Williamstown, Mass. (1985.34). Collection Print Sale: 198

drawings by Watteau, Fragonard, Chardin, and Boucher. Degas painted his portrait in 1878 (now, Calouste Gulbenkian Museum, Lisbon) surrounded by his own paintings, which seem to have been Impressionist interpretations of the Rococo *fête-galante*.[48] Eighteenth-century drawings were more affordable than paintings, however, and were eagerly sought by a whole group of collectors, including Camille Groult (1837–1908), the couturier Jacques Doucet (1853–1929), and above all those well-known popularizers of eighteenth-century taste, the Goncourt brothers.[49]

PRINT COLLECTING

The Goncourts were also preeminent collectors of contemporary and Japanese prints, the appreciation of which constituted two major trends in late-nineteenth-century French taste. Degas shared the interest, and although both these aspects of his collection are fully discussed in the essays by Colta Ives and Barbara Stern Shapiro in this catalogue, their significance in the context of contemporary collecting deserves a brief mention here.

Degas had vast holdings of lithographs by Gavarni and

Fig. 166. Paul Gavarni, *Two Women Talking,* from The *Lorettes,* 1842. Lithograph, 7¾ × 6¼ in. (19.8 × 15.8 cm). Trustees of the British Museum, London (1980.5.10.164). Collection Print Sale 144

Fig. 167. Honoré Daumier, *"Do I need eloquence?"* (*"Ai-je besoin d'éloquence?"*), from The Human Comedy, 1843. Lithograph, 8⅝ × 7⅜ in. (22 × 18.8 cm). Josefowitz Collection. Collection Print Sale: 81

Fig. 168. Camille Pissarro (1830–1903), *The Old Cottage,* 1879. Etching and aquatint, with printed color, 6⅝ × 6¾ in. (16.8 × 17 cm). Josefowitz Collection. Collection Print Sale: 311

Daumier, those two brilliant social commentators of the previous generation (figs. 166, 167). His taste for Gavarni was shared by many, including the Goncourts and Alexis Rouart, Henri's brother (fig. 165), whom Degas sometimes used as a sounding board for projected purchases: "Try and look at them," he wrote to Rouart in 1894. "Examine them well, to see if they really are all proofs before [lettering]."[50] In feeling equal enthusiasm for both Gavarni and Daumier, however, Degas seems to have been unusual.[51]

As a collector and an artist, Degas was involved in the revival of original printmaking that was pioneered in France in the second half of the nineteenth century by Félix Bracquemond, Fantin-Latour, Alphonse Legros, Manet, James Tissot, James Abbott McNeill Whistler, and of course Degas himself. Among the many collectors of these prints were Théodore Duret and Philippe Burty (a foremost spokesman of the etching revival); Degas bought many of his prints by Manet from Burty's sale in 1891. The fact that Degas was so experimental in his own prints is reflected in his collection, especially in his interest in owning, for example, different states of a single impression by Manet or of the prints Pissarro and Mary Cassatt made in collaboration with Degas for the projected *Le Jour et la nuit* venture. To a degree, this orientation distinguished Degas's from other print collections. For example, Moreau-Nélaton's collection of Manet prints, although filled with fine impressions, did not show the fascination that Degas's did with the subtleties of technique.[52]

Like many of his contemporaries—both writers (Émile Zola, Duret, Burty, and the Goncourts) and the numerous artists who were influenced by and collected Japanese prints—Degas was caught up in the fashion for *japonisme* that mushroomed in the later nineteenth century, especially after the 1870s. His collection of Japanese prints, although large, is difficult to define because the information given on it in the sale catalogue is extremely vague. Certainly he had at least one piece of rarity and quality, Torii Kiyonaga's *The Bath House,* 1787 (fig. 331), but in general his holdings did not compare with the truly outstanding collections of oriental artifacts, comprising not only prints but fabrics, lacquerware, weapons, and ancient Chinese bronzes, that were assembled by his contemporaries, notably the Goncourts, Burty, Duret, Alexis Rouart, and Henri Cernuschi.

COLLECTORS AND THE FUTURE

The "secret anguish of the collector"[53]—the ultimate fate of his collection—was a preoccupation expressed in print frequently toward the end of the nineteenth century. Some collectors, determined to keep their collections intact, donated or bequeathed them to the nation, taking action on an issue that was particularly topical in the late 1890s. Partly they were motivated by alarm at the increasing numbers of paintings leaving France because they had been purchased by foreign, especially American, collectors; and partly these powerful and wealthy individuals were seeking a permanent monument to their taste and generosity. But there were altruistic motives as well. One of the values bound up with the concept of the gentleman collector was a strong sense of public duty. Such collectors saw themselves as guardians of the French patrimony; in their role as upholders of culture in a bourgeois society, they had, they believed, replaced the aristocratic patrons of the ancien régime. A prominent example was Moreau-Nélaton, who, as we have seen, felt it was his responsibility as a man of taste and wealth to preserve his collection for the nation. He donated the major part of his collected art to the Louvre in 1906, twenty-one years before his death. And there were other examples: Henri Cernuschi systematically put together a comprehensive collection of oriental art, with the aim of creating a museum for the city of Paris, which was established in 1896 and today bears his name; Caillebotte's collection of Impressionist works finally confirmed Impressionism as art worthy of the museums when it entered the Musée du Luxembourg in 1897; and in 1911 the Louvre was considerably enriched by

Fig. 169. Edgar Degas. *Léon Bonnat*, 1863. Oil on canvas, 16⅞ × 14⅛ in. (43 × 36 cm). L III. Musée Bonnat, Bayonne

the bequest of Count Isaac de Camondo's major collection of Impressionist and Postimpressionist paintings.

At the provincial level, there was an established tradition of French collectors forming collections with the intention of bequeathing them to their native towns. Henry Vasnier (1832–1907) left his Impressionist collection to the museum at Reims, and a Rouen merchant, François Depeaux (1853–1920), enriched his city's museum with a large donation of Impressionist pictures in 1909.[54] But the most striking practitioner of this civic generosity was Léon Bonnat, who amassed his remarkable collection expressly intending to endow his native town of Bayonne with a splendid museum (the Musée Bonnat) in gratitude for a scholarship that had enabled him to study in Paris and Rome in his youth.

A completely opposite view, one stressing private and personal enjoyment rather than public responsibility, was held by Edmond de Goncourt. Despite the great care with which he had arranged his acquisitions into aesthetic ensembles in his house in Auteuil, Goncourt did not

intend his collection to survive intact. On the contrary: as he explained in a statement to be published at the head of the sale catalogue when his collection was sold after his death, his hope was that each object he had owned could live on by enriching the individual life of its new collector:

> My wish is that my drawings, my prints, my curios, my books, the things that have been the happiness of my life, not suffer the cold tomb of the museum and the stupid gaze of the indifferent passerby: I ask that they all be dispersed under the auctioneer's hammer and that the pleasure each one of them afforded me be given again to those who inherit my tastes.[55]

To ensure the immortality of his collection at least in writing, Goncourt published in *La Maison d'un artiste* (The Artist's House, 1881), and a few years later in his *Journal*, an extraordinarily detailed inventory and description of his possessions.[56]

Degas occupied an ambivalent position somewhere between the public-spirited and the private views. There is evidence that during the mid-1890s he was thinking of preserving his collection in the form of a museum and that the most intense phase of his collecting, from about 1895 to 1900, was done with this in mind.[57] Certainly he shared the widely held conviction that French art should not leave France.[58] No doubt his idea for a museum was partly influenced by Moreau-Nélaton; at one point he seems to have been contemplating a joint venture together with him and other collectors. But Degas was put off by what he regarded as the poor installation of Moreau-Nélaton's collection when it was temporarily housed in the Musée des Arts Décoratifs, as well as by his general mistrust of anything to do with the state. "One doesn't involve the state in an affair like that," he told Moreau-Nélaton at the time of the donation, and added, "I thought we were going to do our little venture together."[59] Degas's motives for creating a museum differed from those of Moreau-Nélaton or Bonnat, because the public good was not his primary motivation. "Yes, I want to give them to my country: and then I'll go and sit down in front of them and look at them, thinking about the noble act I've just performed," was his wry comment when he acquired the Leblanc portraits by Ingres.[60]

For Degas, privacy was of great importance. One of the rare accounts of his collection published in his lifetime commented on its inaccessibility: "But this collection, you can't expect to see it. It is closed, a citadel behind walls. You are not advised to ring the bell unless you are carrying under your arm an unknown Ingres."[61] Although Degas's reclusiveness in his later years has been exaggerated,[62] it is

apparent that few people were privileged to see the art installed in his apartment and his "museum" room. While Henri and Alexis Rouart and a number of others were conscious of the importance of their collections for the public and were known to welcome visitors on a regular, often weekly, basis, Degas's collection was not readily accessible.

The thought of his collection's ultimate dispersal must have concerned Degas. Blanche's touching account of the aged artist at the sale of Henri Rouart's collection in 1912, looking for the last time at the paintings that had for so long been part of his own life, conveys the image of a man profoundly saddened not only by the loss of a friend but by the dispersal of a great collection. It was in the same year that Degas's own collection was dismantled when he had to move from the rue Victor Massé, and also around this time that he effectively stopped working.

Degas's collecting was the product of a complex interaction with his work, and his failure to make a museum was connected to his deeply ambiguous attitude in his later years toward exhibiting his own work. In may ways Degas had a horror of publicity. He was greatly displeased, for example, when the Caillebotte bequest, which included some of his own works, was exhibited at the Musée du Luxembourg in 1897 and attracted considerable public attention.[63]

If Degas had actually founded a museum, he intended, it has been convincingly proposed,[64] to display his own work along with his collection. Doing so would have meant expressing in a tangible way his sense of his own role within the modern French tradition. But in the end, Degas was interested neither in that kind of statement nor in making his collection public.

1. Edmond de Goncourt, *La Maison d'un artiste*, 2 vols. (Paris, 1881), vol. 1, p. 3.

2. See Nicholas Green, *The Spectacle of Nature: Landscape and Bourgeois Culture in Nineteenth-Century France* (Manchester, 1990), p. 102.

3. See Green 1989, pp. 29–32.

4. See Distel 1990, p. 53.

5. Blanche 1919 (1927), pp. 253–54.

6. Arsène Alexandre, *Collection de M. le comte Armand Doria*, vol. 1, *Tableaux modernes* (Paris, 1899), p. xxxiv.

7. E. Rouart 1937, p. 13.

8. Quoted in Lemoisne 1946–49, vol. 1, pp. 173–74.

9. Moreau-Nélaton in Lemoisne 1946–49, vol. 1, p. 258.

10. Ibid.

11. See Bodelsen 1970.

12. See Degas's letter to Rouart, 1900, *Letters of Degas* 1947, no. 249, p. 217. On the Dreyfus affair, see "The Degas Collection Sales and the Press," n. 4, in this volume.

13. Jean-François Millet, *Peasant Girl Seated by a Haystack*, ca. 1851–52 (Musée du Louvre, Paris, Départment des Arts Graphiques); Camille

14. Letter to Alexis Rouart, December 27, 1904. *Letters of Degas* 1947, no. 262, p. 223.

15. Paul Valéry, *Degas, danse, dessin* (Paris, 1938), p. 16.

16. The paintings Valéry saw there had a determining influence on his taste in art, which found expression later in books he wrote on Daumier and Corot. Jean-Dominique Rey, "Paul Valéry et Henri Rouart," in *Paul Valéry et les arts*, exh. cat., Paris, Musée Paul Valéry de Sète (Paris, 1995), pp. 15–24.

17. Blanche 1919 (1927), p. 259.

18. Alexandre 1901.

19. His first major donation was made in 1906, followed by two others in 1907 and 1919. For a thorough discussion of Moreau-Nélaton and his collecting see Paris 1991.

20. Étienne Moreau-Nélaton, *Delacroix raconté par lui-même*, 2 vols. (Paris, 1916).

21. Letter dated June 30, 1898, *Letters of Degas* 1947, no. 235, p. 209.

22. Arsène Alexandre, Preface to *Catalogue des tableaux anciens . . . tableaux modernes . . . composant la collection de feu M. Henri Rouart . . .* (Paris, 1912), p. xiii.

23. January 7, 1897, *Letters of Degas* 1947, no. 228, p. 206.

24. Collection Sale I: 21; location unknown.

25. E. Rouart 1937, p. 12. Degas's letter to Rouart, August 22, 1884, *Letters of Degas* 1947, no. 66, p. 83.

26. Sickert 1917, p. 186.

27. According to Henri Bénézit, Degas owned some early Millet drawings that were wrongly attributed to Degas himself in the catalogue of his atelier sale. I am grateful to Robert Herbert for telling me about these.

28. Rey, "Paul Valéry et Henri Rouart," p. 21.

29. E. Rouart 1937, p. 134.

30. See "Degas and His Collection," n. 14, in this volume.

31. See Bodelsen 1968.

32. See Distel 1990 for a comprehensive study of these collectors.

33. E. Rouart 1937, p. 6.

34. See Vincent Pomarède, "La Collection de peintures," in Paris 1991, p. 42.

35. Blanche 1919 (1927), p. 261.

36. Rouart had a small group of not very distinguished old master paintings, including works by Bruegel, Philippe de Champaigne, Chardin, Fragonard, and Goya.

37. *An Apostle, The Apparition of the Virgin, Saint Francis of Assisi, Saint Francis of Assisi Praying.*

38. Letter from Rouart to Degas dated September 30, 1896, cited in Degas inv. in Dumas 1981, no. 3. "Oh Greco . . . the most beautiful of all . . . and how happy I am to know that it belongs to you!" The reference is probably to *Saint Dominic*, bought in November 1896 (perhaps Degas's purchase was negotiated before the sale, or Degas made a mistake in dating the letter in his inventory), since *Saint Ildefonso* was bought on April 25, 1894, at the sale of Mme Veuve Millet.

39. Maurice Barrès, *Greco, ou le secret de Tolède* (Paris, 1911).

40. See Hippolyte Mireur, *Dictionnaire des ventes d'art faites en France et à l'étranger pendant les XVIIIe et XIXe siècles*, 7 vols. (Paris, 1901–12).

41. Haskell 1976, p. 146.

42. Jacob Bean, *Les Dessins italiens de la Collection Bonnat.* Inventaire Général des Dessins des Musées de Provence, 4, Bayonne, Musée Bonnat (Paris, 1960), p. 8.

43. Collection Sale I: 1.

44. See "Degas and His Collection," n. 40, in this volume.

45. See Debora L. Silverman, *Art Nouveau in fin-de-siècle France: Politics, Psychology, and Style* (Berkeley and Los Angeles, 1989), pp. 19ff.

46. Collection Sale I: 37 as "Ecole française, *Portrait d'homme.*"

47. Edmond de Goncourt and Jules de Goncourt, *Gavarni, l'homme et l'oeuvre* (Paris, 1879).

48. Reff, "Pictures within Pictures," in Reff 1976a, pp. 128–29.

49. Edmond de Goncourt and Jules de Goncourt, *L'Art du XVIIIme siècle*, 12 vols. (Paris, 1859–75).

50. *Letters of Degas* 1947, no. 199, p. 191.

51. In conversation with Michel Melot.

52. See François Fossier, "La Collection d'estampes," in Paris 1991, p. 246.

53. A. J. du Pays, *L'Illustration*, September 11, 1852, cited in Vincent Pomarède, "Étienne Moreau-Nélaton, traditionaliste et précurseur," in Paris 1991, p. 23.

54. See Anne Distel, "Étienne Moreau-Nélaton, historien d'art," in Paris 1991, p. 5.

55. *Collection des Goncourt: Dessins, aquarelles et pastels du XVIIIe siècle*, Hôtel Drouot, Paris, February 15, 16, 17, 1897.

56. Edmond de Goncourt, *La Maison d'un artiste; Journal des Goncourt: Mémoires de la vie littéraire,* vol. 9, *1892–1895* (Paris, 1896), Friday, December 14, 1894, pp. 268–89.

57. Loyrette 1991, pp. 618–19.

58. Rothenstein 1931–39, vol. 1, p. 102.

59. Moreau-Nélaton 1931, p. 259.

60. Halévy 1960, pp. 97–98.

61. Alexandre 1901.

62. See Richard Kendall in London, Chicago 1996–97, pp. 15–19, for a re-examination of the myth that Degas was a recluse.

63. Letter from Albert Bartholomé to Paul Lafond, March 15, 1897, in Sutton and Adhémar 1987, p. 174.

64. See Loyrette 1991, p. 619; Gary Tinterow, "Degas's Degases," in this volume.

ARTIST TO ARTIST

Fig. 170. Detail, J.-A.-D. Ingres, *The Forestier Family*, ca. 1828. Graphite with white chalk accents on tracing paper, 11⅞ × 14⅝ in. (30 × 37.2 cm). Fogg Art Museum, Harvard University Art Museums, Cambridge, Bequest of Grenville L. Winthrop (1943.842). Collection Sale I: 208

"Three Great Draftsmen": Ingres, Delacroix, and Daumier

THEODORE REFF

Given his conviction that all art was essentially artifice and that his own, despite its appearance of informality, was entirely "the result of reflection and study of the great masters,"[1] Edgar Degas was inevitably drawn into close and fruitful contact with many types of contemporary and recent art. The range of interests and independence of judgment that enabled him in the last years of his life to form one of the finest collections of nineteenth-century art assembled by anyone of his generation—a collection almost equally strong in J.-A.-D. Ingres and Eugène Delacroix, Honoré Daumier and Camille Corot, Édouard Manet and Paul Cézanne—had already led him in his early and middle years to copy and study intensively works representing all the major tendencies of the first half of the century and to assimilate important elements of them into his own work.[2]

As a student of Ingres's pupil Louis Lamothe about 1855, and thus imbued with the master's Neoclassical taste, Degas drew repeatedly after Ingres's mythological and religious compositions and occasionally his portraits, which served as models for his own early portrait style (figs. 171, 172). And, returning to Ingres's sources, he reproduced in both pencil and oil some of the vigorously rendered figures in Jacques-Louis David's paintings of historical subjects and traced some of John Flaxman's illustrations of the *Iliad* and the *Odyssey*, episodes of which he himself planned to illustrate.[3] He also copied after works by Hippolyte Flandrin, one of Ingres's chief disciples, and spent a summer studying ancient and Renaissance art in Lyons, the center of these disciples' activity.[4] In reacting against this doctrinaire classicism four years later, Degas turned with equal enthusiasm to Delacroix and other artists of a dramatic or coloristic tendency. In museums and exhibitions, in public buildings and churches, he sketched and took extensive notes on the Romantic master's works, and he referred to them often in planning his own ambitious paintings of literary subjects.[5] In addition, both the monumental religious compositions of Théodore Chassériau and the intimate genre scenes of Eugène Fromentin appealed to him then, their exotic imagery stirring his imagination, though he also painted copies of aristocratic portraits by Thomas Lawrence that reflect another aspect of Romantic colorism.[6]

In the same years, Degas began to work in still another tradition, drawing repeatedly after equestrian paintings and prints by Théodore Géricault and Alfred de Dreux in preparation for his own realistically rendered pictures of racetracks.[7] A decade later he continued to incorporate into them images of horses that he had encountered in the work of specialists such as Ernest Meissonier and the English sporting artist John Frederick Herring.[8] By then he had also become acquainted with Manet, whose more sophisticated notion of Realism strongly influenced his own and was in turn influenced by Degas's; there are similarities between several of their portraits and domestic interiors of the late 1860s, as there are a decade later between their representations of cafés and café-concerts.[9] These, however, are clearly indebted for their compositions and their satirical vision to the lithographs of Paul Gavarni and especially of Daumier; and the latter's political caricatures, which Degas admired and occasionally copied, are an important source for his own.[10] He was no less aware of developments outside France, having known and admired Victorian artists such as James Tissot and John Everett Millais, whose meticulously painted, psychologically disturbing scenes of modern life seem to have influenced him, and having also met the German artist Adolph von Menzel, whose brilliant study in artificial illumination, *The Supper at the Ball,* impressed him so much that in 1879 he reproduced it in oil from memory (fig. 173).[11]

In each of these three major movements of nineteenth-century art, one figure was of particular and even exemplary importance for Degas, not only in his early, formative

Fig. 171. Edgar Degas, *Self-Portrait*, 1855. Oil on canvas, 31⅞ × 25¼ in. (81 × 64 cm). L 5. Musée d'Orsay, Paris (R.F. 2649). Retained by Degas's heirs

years but also in his maturity; the three are Jean-Auguste-Dominique Ingres (1780–1867), Eugène Delacroix (1798–1863), and Honoré Daumier (1808–1879). His admiration for the first two, amounting in his later years virtually to veneration, is evident enough in his letters, in the memoirs of those who knew him, and in his collection, which was stronger in works by these masters—twenty paintings and ninety drawings by Ingres, thirteen paintings and 190 drawings by Delacroix—than any others.[12] More surprising is the importance ascribed to Daumier, about whom Degas wrote and said little; even the presence in his collection of a painting, five drawings, and some 750 lithographs by the great Realist, almost one-fifth of his graphic production, may strike the student of Degas's taste as something inexplicable.[13] Yet he himself was quite explicit in ranking Daumier with the other two, as the incident he reported to Pierre-Georges Jeanniot around 1885 demonstrates: "I was speaking of him the other day with [Jean-Léon] Gérôme at the Café de la Rochefoucauld. I was praising Daumier. 'What,' said Gérôme, 'you admire this

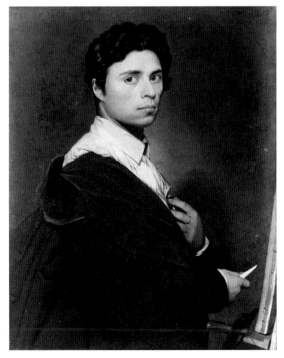

Fig. 172. J.-A.-D. Ingres, *Self-Portrait*, 1804. Oil on canvas, 30⅜ × 24 in. (77 × 61 cm). Musée Condé, Chantilly

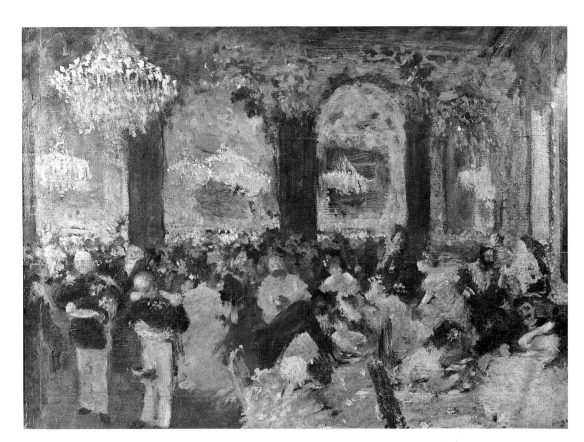

Prudhomme?' 'But I am of the opinion,' I told him, 'that there have been three great draftsmen in the nineteenth century: Ingres, Delacroix, and Daumier!'"[14] This flaunting of the popular cartoonist in the face of the distinguished academician was no doubt a gesture of defiance, but not a betrayal of Degas's convictions. Seven or eight years earlier he had expressed the same thought in the privacy of his notebook, spontaneously choosing the same three names while examining the forms of artists' signatures.

A fascinating document of Degas's consciousness of the smallest elements of his art, even one so peripheral and traditionally personal as the signature, this notebook page (fig. 174) contains his own name at the lower right, Delacroix's in the center, Ingres's above it, and Daumier's initials at the upper right; it also contains Gustave Doré's name, repeated five times, and the composer Ernest Reyer's at the lower left.[15] Reyer, a friend of Degas's, had recently been elected to the Institut de France; hence, no doubt, his presence here and the extravagant flourish, ending in a sexual image, around his name. It was no such satirical impulse that led Degas to imitate the other signatures—more accurately than Reyer's, although still from memory[16]—but rather a desire to compare them with his own. Significantly, in three of the four the final initial is a "D" and in one the first initial is an "E," which he repeats directly above his name. There are also formal similarities between the "D" in Daumier's signature, the "e," "g," and

"a" in Delacroix's, the final "s" in Ingres's, and the corresponding letters in his own. It is tempting to see in these analogies Degas's search for a distinctive professional signature, but that was already established by the time he used this notebook. Only its initial "D" seems to have changed about then,[17] and this may explain the successive transformations of the same letter in Doré's signature to approximate its rounded form in his own. For Doré was of minor significance for Degas as an artist whereas his choice of the other three, precisely because he made it so unprogrammatically, in such private circum-

Fig. 174. Edgar Degas, Imitations of signatures, Notebook 27, p. 43, ca. 1877. Graphite, 3⅜ × 5⅜ in. (8.5 × 13.8 cm). Bibliothèque Nationale, Paris

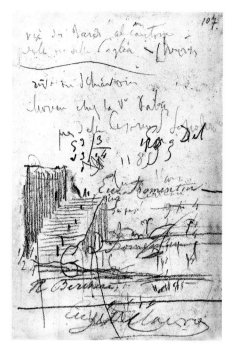

Fig. 175. Edgar Degas, Notes and imitations of signatures, Notebook 12, pp. 106–7, 1859. Graphite, each page 5¾ × 3⅞ in. (14.5 × 9.8 cm). Bibliothèque Nationale, Paris

Fig. 176. Edgar Degas, Quotation from the *Iliad* and signature, Notebook 11, p. 104, 1858. Graphite, 5 × 3¼ in. (12.6 × 8.3 cm). Bibliothèque Nationale, Paris

stances, confirms their central place in his thinking about nineteenth-century art.

It was not the first occasion on which Degas imitated a favorite artist's signature or compared it with his own. On adjacent pages of a notebook he used almost twenty years earlier (fig. 175), at the very moment of his "conversion" to Romanticism, he signed his own name in several ways, this time really searching for a distinctive form, and surrounded it with imitations or specimens of the signatures of those who were influential in effecting that conversion: Gustave Moreau, who had evidently communicated his admiration for Delacroix and the Venetians while he and Degas were traveling in Italy; Fromentin, who was a close friend of Moreau's and, in his more subtle, realistic way, a follower of Delacroix's exoticism; and of course Delacroix himself, whose work Degas studied closely at this time and took as a model for the expressive, coloristic qualities in his own.[18] Only one year earlier, however, in a notebook used in Italy (fig. 176), he had written Ingres's name in Greek capital letters, as if imagining it incised in stone, like the long inscriptions in Ingres's *Apotheosis of Homer* (fig. 28); and as if to reinforce its classical connotation, he had copied on the same page the first two lines of the *Iliad,* also in Greek, and had noted on the facing page an edition of Poussin's correspondence.[19]

THE ADMIRATION that had led Degas to picture J.-A.-D. Ingres's name printed in Greek and later to imitate it written in script eventually became a kind of veneration, of which Georges Rouault could justly maintain, "He imposed on his time his worship of Dominique Ingres."[20]

Half a century later, Degas still cherished the memory of a youthful meeting with the old master, whose famous *Bather*[21] he had succeeded in persuading its owner, Édouard Valpinçon, to lend to a retrospective exhibition of Ingres's work. Recounting that meeting for friends, he dwelled on the advice he had received when he confessed his own artistic ambition, advice that in retrospect seemed remarkably prophetic: "Study line . . . draw lots of lines, either from memory or from nature."[22] In another version, however, he was supposedly told: "Young man, never work from nature. Always from memory, or from the engravings of the masters,"[23] and indeed Degas's early work was dominated by drawings after older art, above all after Raphael and the antique, which were Ingres's models, and after the latter's works. These Degas had a unique opportunity to study at the retrospective exhibition, organized as part of the Paris World's Fair of 1855, for which he had helped to obtain the *Valpinçon Bather.*

The many copies Degas made on that occasion were in fact almost entirely after Ingres, despite the presence of equally comprehensive exhibitions of Delacroix and Gustave Courbet either at the World's Fair or outside it. Attracted primarily by the plastic perfection of the older master's forms, Degas concentrated on the mythological and religious subjects rather than the portraits, often isolating a particularly graceful figure—the naked Angelica in one version of *Roger Freeing Angelica,* the archangel Raphael in one of the cartoons for stained-glass windows—and rendering it in delicate detail (figs. 177, 178).[24] Apart from a small, unfinished oil sketch of *The Martyrdom of Saint Symphorian* and a careful, almost dutiful drawing of the *Valpinçon Bather,* none of these early copies is of an entire

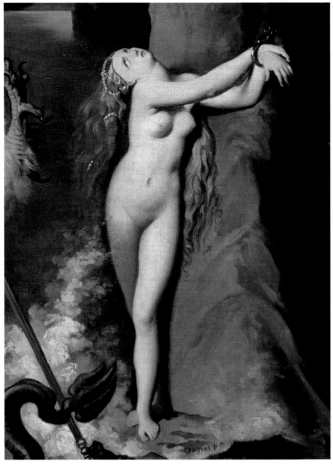

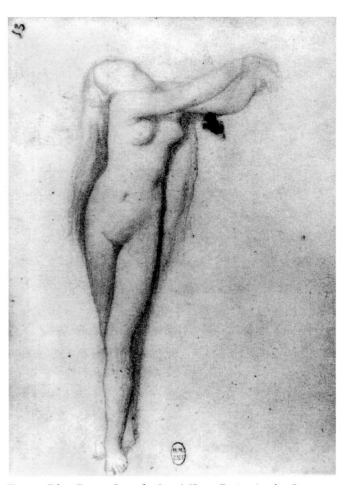

Fig. 177. Detail, J.-A.-D. Ingres, *Roger Freeing Angelica,* 1819–39. Oil on canvas, 18¾ × 15½ in. (47.6 × 39.4 cm). Reproduced by courtesy of the Trustees, the National Gallery, London (NG 3292). Collection Sale I: 56

Fig. 178. Edgar Degas, *Copy after Ingres's "Roger Freeing Angelica,"* Notebook 18, p. 53, 1855. Graphite, 6 × 4⅛ in. (15.2 × 10.4 cm). Bibliothèque Nationale, Paris

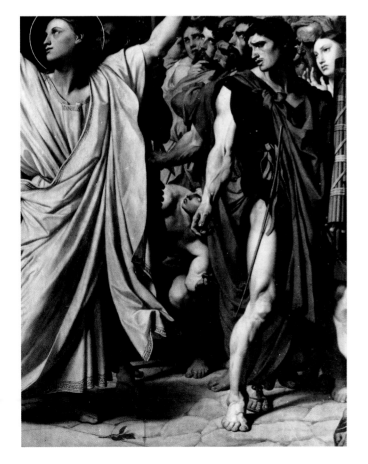

Fig. 180. Edgar Degas, *Copy after Ingres's "The Martyrdom of Saint Symphorian,"* Notebook 2, p. 83, 1855. Graphite, 6 × 4⅛ in. (15.2 × 10.4 cm). Bibliothèque Nationale, Paris

Fig. 179 (left). Detail, J.-A.-D. Ingres, *The Martyrdom of Saint Symphorian,* 1834. Oil on canvas, 160¼ × 133½ in. (407 × 339.1 cm). Cathedral Saint-Lalaie, Autun

Fig. 181. Edgar Degas, *Copy after Ingres's "Apotheosis of Homer,"* ca. 1860. Graphite. Location unknown

composition, whereas Ingres's own copies after Raphael and Poussin were generally just that.[25] On the contrary, some of Degas's studies are of marginal, thematically insignificant elements that must have had a special appeal, like the group of painters and lyric poets at the left side of *The Apotheosis of Homer,* or that exhibited a striking movement or expression, like the animated figure of Saint Symphorian's mother in the upper left corner of the *Martyrdom* and that of the stooping soldier half-hidden in the throng at the lower right side (figs. 179, 180).[26] In this concentration on a subordinate yet visually arresting detail there is a hint of that taste for the eloquent fragment that is so characteristic of Degas's mature vision.

The emergence of such a taste is more apparent in drawings Degas made after some of the same pictures four or five years later, when he had come into contact, in Italy and through French artists he met there, with a greater range of styles than he had known previously and had already begun to develop his own style. These later copies are exclusively of single figures or parts of their costume, often chosen with a potential use in mind, and are rendered with new freedom and confidence. From the group of painters and poets in *The Apotheosis of Homer* (fig. 28), which he had once drawn in pale, delicate tints, he now extracted only the nobly poised figure of Apelles and part of the seated "Iliad" figure beside it, reproducing the clas-

Fig. 182. Edgar Degas, *Study for "The Daughter of Jephthah,"* ca. 1859. Graphite, 9 × 11⅝ in. (23 × 29.5 cm). Location unknown. Atelier Sale IV: 120c

sical drapery in tones of strongly contrasted light and dark (fig. 181); from the group of sculptors and philosophers at the far right, only the graceful figure of Alexander, intercepted by the frame in a way that foreshadows Degas's more radical use of this device a decade or more later.[27] Ingres's image of Alexander, however, is also that of a famous hero, who is shown in ancient armor and standing in strict profile as in an ancient relief; this, too, would have interested Degas, who was at just that time planning to paint a picture of Alexander taming Bucephalus.[28] In the same way he now isolated from *Roger Freeing Angelica* (fig. 17) not the suave female form in the center but a peripheral detail of potential use, the mounted knight's wind-blown cloak, whose intricate folds he drew repeatedly in a notebook containing studies for *The Daughter of Jephthah,* where it would easily have been incorporated.[29] This habit of assimilating admired elements of older art, perfectly familiar to Ingres himself, had already led Degas to base the figure of the queen in his first historical composition, *King Candaules' Wife,* on the *Valpinçon Bather* and to mold its classical setting on that in Ingres's *Stratonice and Antiochus,* which he had likewise copied.[30]

It was about 1860 that Degas also began to imitate more extensively than he had before the brilliant style of Ingres's drawings. One reason was undoubtedly their greater accessibility, beginning with the important exhibition at the Salon des Arts-Unis in 1861;[31] another was his growing reaction, within his own art, against the exuberant Romantic style he had explored previously, a reaction that led quite naturally from Delacroix to Ingres. Increasingly in this period he employed the latter's favorite medium, a finely pointed pencil on a smooth surface, to create his favorite effect, an incisive, strongly accented line, which he allowed to stand alone in defining form or supplemented by subtle, almost transparent shading. A particularly striking example of this Ingresque style is the study of a stooping soldier for an early version of *The Daughter of Jephthah* (fig. 182), since the figure's action too was evidently based on one invented by the older artist (fig. 183), in fact the very one that had attracted Degas earlier in *The Martyrdom of Saint Symphorian.*[32] Despite this clear filiation, however, there are revealing differences: just as the attitude of Degas's figure seems more gentle and inward, and its members lack the energetic thrust of Ingres's, so the modeling of its forms is more nuanced and suggestive of mystery. In these studies in general, it has been observed, "there is a difference not unlike that between Greek refinement and Roman fullness, or between Leonardo's precious early drapery designs and those of Raphael."[33] The same may be said of the sensitive drawings of nudes that Degas made in preparation for *Scene of War in the Middle Ages* (fig. 358), some of which are reminiscent of Ingres's drawings for *Stratonice and Antiochus* and *Romulus Victorious over Acron.*[34]

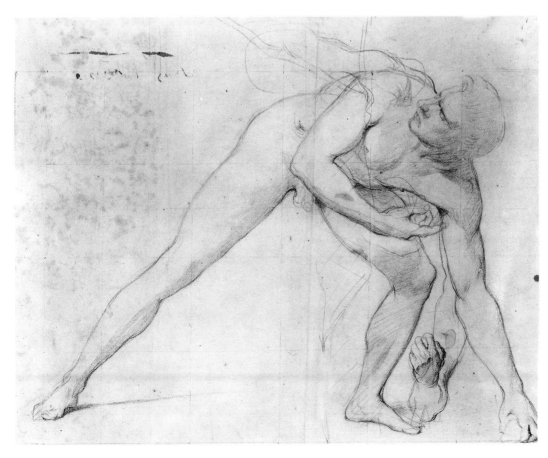

Fig. 183. J.-A.-D. Ingres, *Study for "The Martyrdom of Saint Symphorian,"* 1834. Graphite, 15⅜ × 19⅝ in. (39.1 × 49.8 cm). Fogg Art Museum, Harvard University Art Museums, Cambridge, Bequest of Meta and Paul J. Sachs (1965.296)

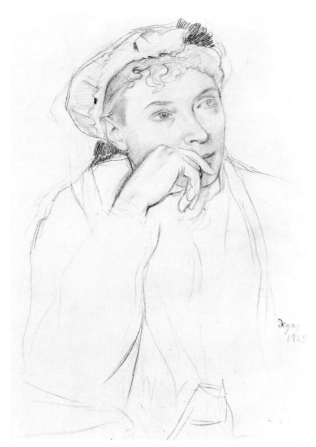

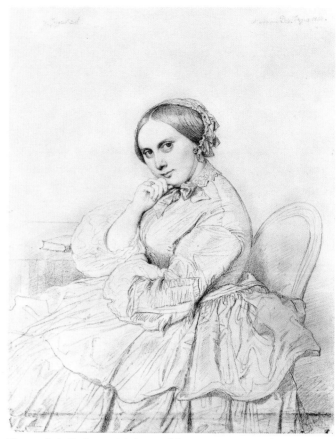

Fig. 184. Edgar Degas, *Study for "A Woman Seated beside a Vase of Flowers,"* 1865. Graphite, 14 × 9⅛ in. (35.6 × 23.2 cm). Fogg Art Museum, Harvard University Art Museums, Cambridge, Bequest of Meta and Paul J. Sachs (1965.253). Atelier Sale I: 312

Fig. 185. J.-A.-D. Ingres, *Madame Delphine Ingres,* 1855. Graphite, 14 × 11 in. (35.6 × 27.9 cm). Fogg Art Museum, Harvard University Art Museums, Cambridge, Gift of Charles E. Dunlap (1954.110)

In portraiture, too, Ingres was by far the most important influence on the young Degas. The finest of his early self-portraits, painted at the age of twenty-one, is a kind of homage to the well-known one depicting Ingres at about the same age, in virtually the same format and position, which Degas undoubtedly saw at the Paris World's Fair that year (figs. 171, 172).[35] But Degas's image lacks the energy and determination of the earlier one, created shortly after the Revolution, and instead projects a mood of lethargy and doubt more characteristic of his own time and personality. That he continued to admire those opposite qualities in Ingres is evident in his sketch of him in full academic dress, in proud profile, some five years later.[36] That he also continued to follow the older artist's example is clear from the portraits he made of relatives in Italy in the late 1850s and above all from the ambitious *Family Portrait,* also called *The Bellelli Family* (fig. 90), painted on his return. Its resemblance compositionally to Ingres's *Gatteaux Family* and *Forestier Family* (figs. 170, 29) has been noted more than once,[37] though the differences in content between these complacent images of domestic harmony and Degas's searching analysis of domestic tension are equally telling. In the following decade such differences became more pronounced, even though Degas had by then mas-

tered the elements of Ingres's draftsmanship as well. His portrait drawing of the younger Valpinçons, dated 1861, may still be Ingresque in its formality and refined linear style;[38] but that of Mme Valpinçon (fig. 184), made four years later in preparation for *A Woman Seated beside a Vase of Flowers* (fig. 202), is more fully personal in both respects. Compared with the type of female portrait, such as that of Mme Ingres (fig. 185), from which it ultimately derives, it exhibits a more complex style, no less precisely linear, but swifter and more strongly accented, responsive to nuances of local color and expression.[39] The direction of the glance, the gesture of the hand, are no longer conventional and flattering but idiosyncratic, expressive of a tense, intelligent personality in a moment of distraction.

Long after Degas had abandoned historical subjects for modern ones, he continued to follow Ingres's example in portraiture, the least dated aspect of his oeuvre. The influence is not always as obvious as that of the *Comtesse d'Haussonville* (fig. 356), shown at the Ingres memorial exhibition of 1867, on his own *Madame Edmondo Morbilli, née Thérèse De Gas* (fig. 124), painted two years later, where the aloofness and studied gesture, the elegant costume and mirrored salon, and the smooth precision of style all recur.[40] Yet it continues to be felt even later in such works

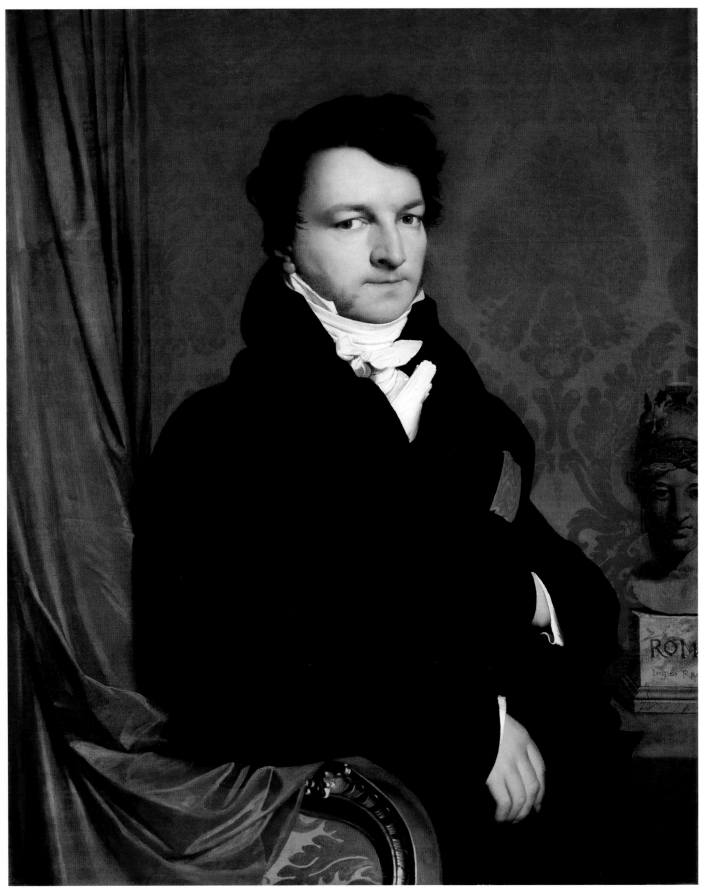

Fig. 186. J.-A.-D. Ingres, *Jacques Marquet, Baron de Montbreton de Norvins (1769–1854)*, 1811–12. Oil on canvas, mounted on panel, 38¼ × 31 in. (97.2 × 78.7 cm).
Reproduced by courtesy of the Trustees, the National Gallery, London (NG 3291). Collection Sale I: 53

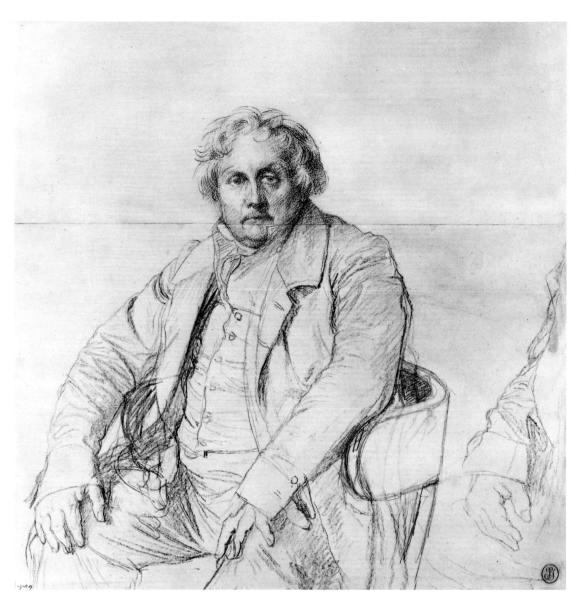

Fig. 187. J.-A.-D. Ingres, *Study for "Louis-François Bertin,"* 1832. Graphite and black chalk, 13¾ × 13½ in. (34.9 × 34.3 cm). The Metropolitan Museum of Art, New York, Bequest of Grace Rainey Rogers, 1943 (43.85.4)

as *The Savoisienne*, both in the sober frontality and symmetry of the figure's design and in the breadth and definition of its forms.[41] The same is true of male portraits, such as the unidentified one in Boston, where the subject's formal dress and the neutral background, unusual in Degas's mature work, are also reminiscent of Ingres, for example of *Monsieur de Norvins*, which Degas subsequently acquired (fig. 186).[42] And, to take two well-known drawings in the Metropolitan Museum, a study (fig. 369) for one of the most thoroughly naturalistic of Degas's later portraits, that of Edmond Duranty seated at a desk piled with books and papers, is surprisingly similar to a study for Ingres's famous portrait of Louis-François Bertin (fig. 187) in its penetrating analysis of gesture and expression and its combination of delicate modeling and swift, emphatic lines, although Degas's lines are in places still more summary. Indeed, when he exhibited a number of drawings, along with the portrait of Duranty (fig. 287), at the Impressionist show in 1880, the critic Charles Ephrussi recognized in him "not only a draftsman of more

than estimable ability, but a pupil of the great Florentines, . . . and above all of a great Frenchman, M. Ingres."[43]

Duranty himself had long been aware that, despite Ingres's reactionary views and outmoded subjects, his pictures and especially his portraits revealed a vigor, a simplicity, and a fidelity to nature that made them important forerunners of Naturalism. In reviewing the Salon of 1872, he opposed to the facile colorism of Henri Regnault the probing draftsmanship of Ingres, "who raised drawing to a great elegance and keenness . . . marked by a strength of character that one rarely encounters."[44] And, in tracing the origins of the "new painting" four years later, he found them in Courbet and Corot, in Jean-François Millet and Ingres, "those simple, reverent souls, those men of powerful instinct," and insisted that Ingres, having "brought back from Greece only a respect for nature, . . . never hesitates or deceives when confronting modern forms."[45] These remarks are doubly important because they were undoubtedly influenced by Degas; indeed, he too contrasted the

authenticity and probity of Ingres's art with the frequently contrived art of the École des Beaux-Arts, even hesitating to visit a major exhibition of photographs of the master's drawings because it was being held too close to the École.[46]

Like Duranty, the mature Degas could still find the personal and naturalistic aspects of Ingres's oeuvre, above all the drawings and portraits, relevant to his own; but he could only parody the public and stiffly formal aspects seen in the historical compositions. This he did in an amusing photograph that he arranged and had taken in front of a summer house at Dieppe in 1885 (fig. 30), showing himself as the solemn Homer of Ingres's *Apotheosis* (fig. 28) and some young friends as muses and reverent choirboys.[47] Many years earlier, we recall, he had taken that work seriously enough to copy several of its figures, though his choice of such details perhaps implied a reservation about the rigidity of the whole. Even now he was prompt to defend it when his friend Henri Rouart observed that "the gods in it, frozen as they were into lofty attitudes, breathed an icy atmosphere. 'What!' Degas burst out. 'But what could be more admirable? The whole canvas is filled with the air of the empyrean.'"[48] In fact, so deeply ingrained in him was Ingres's conception of form that he judged the parody itself in terms of it, regretting the looseness of design

Fig. 188. J.-A.-D. Ingres, *The Duke of Alba at Saint Gudule's in Brussels,* 1815–19. Oil on canvas, 41⅜ × 32¼ in. (105 × 82 cm). Musée Ingres de Montauban, Dépôt du Musée du Louvre, 1951 (MI.D.51.3.1). Collection Sale I: 68

and loss of definition: "My three muses and my two choir children ought to have been grouped against a white or light background. The forms of the women in particular are lost. The figures ought also to have been compressed more."[49]

After this date, the contrast between Degas's admiration for Ingres and his own un-Ingresque practice became increasingly pronounced. Paradoxically, the more his art differed from the older master's in its freedom and intensity of expression, the more enthusiastically he acclaimed that coolly classical art and exalted the personality that had created it. In 1890 George Moore made public what was already known privately when he wrote that "Degas was a pupil of Ingres, and any mention of this always pleases him, for he looks upon Ingres as the first star in the firmament of French art."[50] The year before, in planning to visit an exhibition of the latter's drawings, Degas had referred to them as "those marvels of the human spirit."[51] What he admired in them, their conciseness and wit, their savor of a strong personality, he also found in Ingres's aphorisms on art, which he enjoyed citing. "You can't quote a remark of Ingres's that isn't a masterpiece," he declared, contrasting them with the far longer, more literary essays of Delacroix.[52] Indeed, the trenchant style of his own axiom, "Drawing is not the same as form, it is a way of seeing form," is reminiscent of one by Ingres that he used to repeat, "Form is not in the contour, it lies within the contour."[53] Perhaps the most touching expression of his veneration of the great draftsman was Degas's long-cherished plan to classify and eventually publish all the studies by Ingres in the Montauban Museum, a plan he proposed to that city in 1897 with an offer, surprisingly art-historical in tenor, to exchange photographs of the paintings in his own collection for those of the related drawings in the museum.[54]

By this time he had already formed an important collection of Ingres's works, though he was to continue adding to it for another decade. How passionately Degas pursued the latest acquisition is clear from a letter to his dealer Durand-Ruel, at once imperious and imploring: "Do not deprive me of the little copy after Ingres, do not insult and hurt me like this. I really have need of it."[55] Eventually he possessed four major portraits, including those of M. and Mme Jacques-Louis Leblanc (figs. 22, 21) and sixteen additional paintings or painted sketches, as well as ninety drawings (see figs. 188–195).[56] Many of the latter were studies for, and some of the paintings replicas of, the famous compositions he had copied as a student half a century earlier, among them *The Martyrdom of Saint Symphorian, Roger Freeing Angelica,* and especially *The Apotheosis of Homer,* for which he owned almost twenty sketches in all

Fig. 190. J.-A.-D. Ingres, *Standing Female Nude.* Black chalk, 9½ × 3⅛ in. (24 × 8 cm). Ashmolean Museum, Oxford. Collection Sale I: 211

Fig. 191. J.-A.-D. Ingres, *Study of Arms and Legs.* Graphite, 8⅛ ×
11 in. (20.5 × 28 cm). Trustees of the British Museum, London
(1975.3.1.52). Collection Sale I: 200

Fig. 192. J.-A.-D. Ingres, *Roger Freeing Angelica,*
1818. Graphite, 6¾ × 7¾ in. (17.1 × 19.7 cm). Fogg
Art Museum, Harvard University Art Museums,
Cambridge, Bequest of Grenville L. Winthrop
(1943.859). Collection Sale I: 213

Fig. 193 (left). J.-A.-D. Ingres, *Head of a Bearded Man,* ca. 1808. Oil on canvas, 13¾ × 10¼ in. (35 × 26 cm). Private collection, Switzerland. Collection Sale I: 64

Fig. 194 (above). J.-A.-D. Ingres, *Study of the Right Hand of Jupiter,* 1811. Red chalk, 8¼ × 4½ in. (21.1 × 11.5 cm). Collection Jan and Marie-Anne Krugier-Poniatowski. Collection Sale I: 188

Fig. 195 (below) J.-A.-D. Ingres, *Head of a Woman,* ca. 1821. Oil on canvas, mounted on panel, 8¼ × 6¼ in. (21 × 16 cm). Private collection. Collection Sale I: 57

media (figs. 31–39). The poignancy of these echoes of the past also struck Paul Valéry, who, in reporting Degas's account of his visit to Ingres's studio in 1855, stated that "while they were talking, [Degas] cast an eye around the walls." Valéry added, "At the time he was telling me this [fifty years later], he owned some of the studies he remembered seeing on them."[57]

Long after Degas had ceased collecting and even painting, Ingres remained an object of veneration for him. One of the last vivid images we have of him is of his visits to the retrospective exhibition of the older master's works in 1911, visits made daily with a touching fidelity, though he could no longer see and instead had to touch the pictures he had known so well.[58] Among them, of course, was *The Apotheosis of Homer,* to whose central figure, old and blind and noble, he now bore a striking resemblance, as several of his friends noted. Thus his placement of himself in that role when parodying the picture a quarter of a century earlier (fig. 30) took on in retrospect a strangely prophetic significance.

Fig. 196. Eugène Delacroix, *Mirabeau Protesting to Dreux-Brézé*, 1831. Oil on canvas, 30⅜ × 39¾ in. (77 × 101 cm). Ny Carlsberg Glyptotek, Copenhagen

Fig. 197. Edgar Degas, *Copy after Delacroix's "Mirabeau Protesting to Dreux-Brézé,"* Notebook 18, p. 53, 1860. Graphite, 7½ × 10 in. (19.2 × 25.4 cm). Bibliothèque Nationale, Paris

IT IS NOT SURPRISING that Eugène Delacroix's name, like Ingres's, figured prominently among the imitations of artists' signatures in the notebooks of Degas's youth as well as his maturity: throughout his life these two remained for him the brightest stars in "the firmament of French art." They were already recognized as such, at least among living artists, at the beginning of his career, when both were given retrospective exhibitions at the World's Fair of 1855 and, as the Goncourt brothers later wrote in *Manette Salomon,* a novel of artistic life, "all the young painters were turned, at that moment, toward these two men, whose two names were the two war-cries of art."[59] At that time, of course, Degas's allegiance was entirely to Ingres, and he seems neither to have copied after nor to have imitated any of the works Delacroix exhibited, though he was deeply impressed by the sight of him swiftly and intently crossing a street and remembered it to the end of his life: "Every time I pass that place," he remarked fifty years later, "I see Delacroix again, pressed for time, and hurrying."[60]

It was on his return to Paris in the spring of 1859, after spending nearly three years in Italy, that Degas began to study Delacroix's art intensively. That his interest had been aroused while he was abroad, despite the absence of original examples, is indicated by his father's remark some months earlier, "You know that I am far from sharing your opinion of Delacroix."[61] That this in turn was due to the influence of Moreau has already been suggested apropos the presence of Moreau's name, together with those of Delacroix, Fromentin, and Degas himself, in a notebook he used in Italy and France in that moment of transition (fig. 175). Moreau himself, whom Degas respected highly and was closely acquainted with at the time, had abandoned the academic Neoclassicism of his teacher François-

Édouard Picot for the Romanticism of Chassériau and Delacroix a decade earlier.[62] But the movement toward colorism, freedom of expression, and originality of conception, inspired by the great Romantic's example, went beyond the circle around Moreau; it was part of a larger reaction, as seen, for example, in Charles Baudelaire's review of the Salon of 1859 and even in that of Duranty, who had spurned Delacroix previously but now declared him the only authentic artist in the exhibition and a model for younger ones, "not in order to copy him, but to follow his example and learn to detach oneself from the common herd."[63] Five years later, Duranty and Baudelaire were to figure, along with Manet, James Abbott McNeill Whistler, Henri Fantin-Latour, and other artists of Degas's generation, in Fantin's famous *Homage to Delacroix* (fig. 133).[64]

The depth of Degas's own admiration remained unknown, hidden in his studies and notes. We now know of some twenty copies, both painted and drawn, in notebooks and on larger sheets, after pictures and murals representing almost every aspect of Delacroix's oeuvre, above all the great compositions with religious, historical, and literary subjects. Collectively these copies suggest a remarkably intense assimilation, as if Degas were actively seeking that master's works everywhere in Paris: at the Salon, where he sketched *The Entombment* and *Ovid in Exile among the Scythians,* the latter in pen and wash in a very pictorial style (fig. 42);[65] at the Chamber of Deputies, where he drew and took extensive notes on the mural of *Attila Scourging Italy* and two of the pendentive decorations;[66] at the church of Saint-Denis-du-Saint-Sacrement, where he made a rapid study in pencil of the *Pietà;* at the Hall of Battles at Versailles, where he made a more careful copy in oil (fig. 198) of *The Entry of the Crusaders into Constantinople;*[67] at the

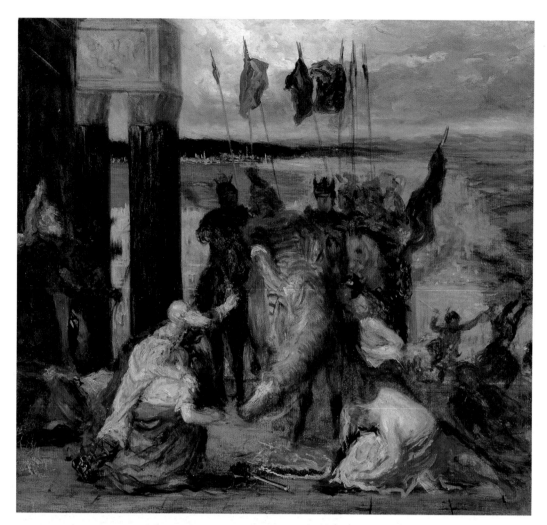

Fig. 198. Edgar Degas, *Copy after Delacroix's "Entry of the Crusaders into Constantinople,"* ca. 1860. Oil on paper, mounted on canvas, 13¾ × 15 in. (35 × 38 cm). BR 35. Private collection, on loan to the Kunsthaus, Zurich

Fig. 199. Edgar Degas, *The Daughter of Jephthah,* 1859–61. Oil on canvas, 77 × 115½ in. (195 × 293.5 cm). L 94. Smith College Museum of Art, Northampton, Mass. (1933-9). Atelier Sale I: 6a

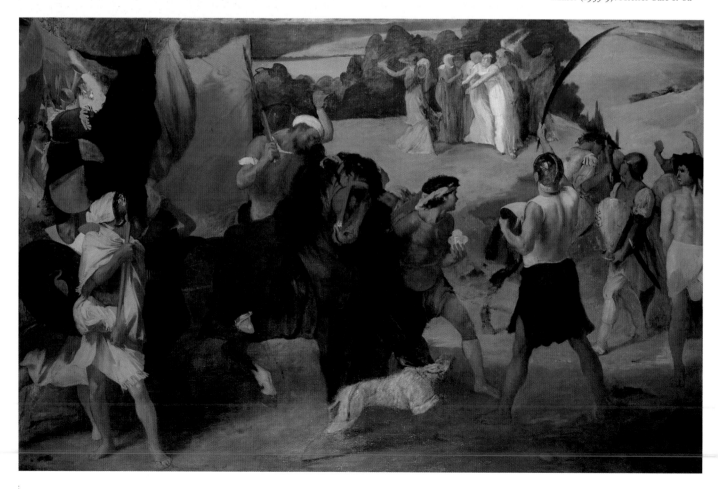

Louvre, where he surveyed the Gallery of Apollo ceiling mural almost topographically, section by section, with many color indications, in his notebook;[68] and at an exhibition in the Galerie Martinet, where he reproduced three dissimilar pictures, *Christ on the Sea of Galilee, The Combat of the Giaour and the Pasha,* and *Mirabeau Protesting to Dreux-Brézé,* the last apparently from memory, in the swift, expressive style characteristic of the group as a whole (figs. 196, 197).[69] Unlike his copies after Ingres, studies of an admired or potentially useful detail, these were usually of the entire composition or its principal figures and were often accompanied by color notations or comments on the conception of the subject. After analyzing Dreux-Brézé's expression and the deputies' symbolic role, for example, Degas wrote: "As for the tonality, sober, dramatic in its ceremonial appearance. A masterpiece! Composition and harmony. Never has this subject been interpreted in this way."[70]

The focus of this concentrated study of Delacroix's use of color and composition in depicting dramatic events was Degas's involvement in creating convincing images of such subjects himself. At the same time, and even in the same notebooks, that he copied after *The Entombment, The Pietà,* and *Christ on the Sea of Galilee,* he made countless sketches for his own picture of religious pathos and resignation, *The Daughter of Jephthah* (fig. 199). It was probably with that work in mind that he reproduced in paint *The Entry of the Crusaders into Constantinople* (fig. 198), an image of military triumph and defeat like the picture he was planning, and in doing so stressed the dramatic effect of the bright banners fluttering against the ominous sky. Indeed, in conceiving the color harmony of *The Daughter of Jephthah* he referred repeatedly to the older master's example. "Almost no green," he wrote of its landscape background, "the hills in a half light as in Delacroix, with a gray sky,"[71] alluding to the latter's luminous grays. For the color of Jephthah's robe, now dark brown but once vermilion, he noted, "Remember the orange-red tones of the old man in Delacroix's picture," probably a reference to the *Pietà* he had copied previously.[72] And though he did not mention it, the principal figure in *Attila Scourging Italy,* which he had also sketched, evidently inspired Jephthah's pose and striking gesture. Beyond such specific forms and colors, the exuberant style of the picture as a whole and the turbulent, impassioned character of the drawings for it likewise reveal the Romantic artist's influence. This "vibrant and vigorous style" derived from Delacroix is, in fact, precisely what characterizes Degas's draftsmanship at this moment in his development.[73]

But as we have seen, he also drew on Ingres for inspiration, specifically on the use of drapery in *Roger Freeing*

Fig. 200. Edgar Degas, *Study for "The Daughter of Jephthah,"* ca. 1859. Oil on cardboard, 3½ × 5½ in. (9 × 14 cm). L 96. Formerly collection of Marcel Guérin, Paris

Fig. 201. Detail, Edgar Degas, *The Daughter of Jephthah,* 1859–61 (see fig. 199)

Angelica and on the posture of a figure in *The Martyrdom of Saint Symphorian.* Indeed, when he worked directly from the model in studying the related figure for *The Daughter of Jephthah* (fig. 182), his drawing style too was much closer to that of Ingres in its precision and subtlety. But when he worked from imagination in visualizing this figure in its pictorial context (fig. 200) he reverted to Delacroix, adopting the broad, painterly manner of the latter's oil sketches (e.g., fig. 204) and even going beyond them in freedom of execution.[74] To achieve this expressive unity of color and touch, he was forced to sacrifice the clear definition of form he had attained in the drawing. In the final painting, the conflict remained unresolved: after moving the stooping soldier closer to the center and transforming him into a leaping dog with the same silhouette (fig. 201), he half obliterated this form too, as though he had planned to revise it once again before he finally abandoned the project.[75] Thus Degas's choice of Ingres and Delacroix revealed,

Fig. 202. Edgar Degas, *A Woman Seated beside a Vase of Flowers,* 1865. Oil on canvas, 29 × 36½ in. (73.7 × 92.7 cm). L 125. The Metropolitan Museum of Art, New York, H. O. Havemeyer Collection, Bequest of Mrs. H. O. Havemeyer, 1929 (29.100.128)

Fig. 203. Eugène Delacroix, *A Bouquet of Flowers in a Stone Vase,* 1843. Oil on canvas, 29⅛ × 36⅜ in. (74 × 93 cm). Kunsthistorisches Museum, Vienna

for perhaps the first time in his career, that ambition to reconcile opposed yet equally attractive modes of vision with which he would never cease to struggle. It was one of the sources of his perpetual dissatisfaction with his work and of his irresistible need to revise it, a need whose fulfillment often brought disastrous results.[76] Yet he was hardly alone in attempting to combine the styles of Ingres and Delacroix, the acknowledged masters of the kind of traditional painting he still sought to produce: Moreau, who had led him from one to the other, and Chassériau, who had led Moreau, had done this earlier. In fact, Degas later spoke warmly of his acquaintance with Chassériau, whose refined and subtle Romanticism was much like his own—"half Indian, half Greek," as he said—and of the influence the latter had exerted on young artists of his generation.[77]

Characterizing the milieu in which Chassériau had played so symbolic a role, the Goncourt brothers wrote in 1867 in *Manette Salomon* that "brilliant personalities, ardent, full of promise, . . . moved, like Chassériau, from the shadow of one master [Ingres] to the shadow of another [Delacroix]."[78] But that milieu, preoccupied with traditional themes and styles, had existed two decades earlier; whereas Degas seems still to have been oscillating stylistically between these masters as late as 1865, as is evident in *Scene of War in the Middle Ages* (fig. 358), the last of his historical compositions, and above all in *A Woman Seated beside a Vase of Flowers* (fig. 202), one of the first with a distinctly modern look.[79] If the image of the woman in this picture is reminiscent, in its linear definition and subtle modeling, of Ingres's late female portraits, the painting of the bouquet is equally indebted, in its brighter coloring and freer execution, to Delacroix's still lifes of flowers, several of which figured in exhibitions and sales held in Paris in 1864 (fig. 203).[80] There are, of course, differences in pictorial conception between the dramatic radiance of the Romantic artist's bouquet and the delicate restraint of the young Realist's, just as there are differences in psychological content between Degas's treatment of the figure and Ingres's. But the derivation from Delacroix seems no less evident than the dependence on Ingres.

Unlike the influence of Ingres, which continued to be felt in Degas's work, at least in portraiture, that of Delacroix seems to have declined in the later sixties and seventies, probably because Degas's work was then at its most soberly realistic and subtly refined, and artists such as Velázquez and Mantegna came more readily to mind.[81] But when toward the end of this period it began to change stylistically, becoming bolder in execution and brighter and more complex in coloring, Delacroix's art once again seemed rel-

evant. It was his signature, the largest and most centrally placed, that Degas must have written first on the notebook page of 1877 (fig. 174), his name that occurred most often in Degas's correspondence in the following decade. Indeed, Degas found the name itself symbolic of the artist's alienated condition, remarking to a colleague in a letter written in a particularly bleak mood in 1882, "De la Croix has a painter's name."[82] Sending greetings to the same colleague from Tangier seven years later, he recalled that "Delacroix passed here," adding with barely concealed emotion, "One loves in nature those people who have not been unworthy to touch it."[83] And in 1880, when pastel had begun to replace paint as his preferred medium, he described for another colleague "a tiger [by Delacroix] which under glass looks like a watercolor. It is pastel applied very lightly on a somewhat smooth paper. It is very vibrant, it is a lovely method."[84]

The effect on Degas's own art of this renewed interest in the great colorist's technique was apparent at once to Joris-Karl Huysmans, who, in reviewing the Impressionist exhibition of 1880, asserted that "no other painter, after Delacroix, whom he has studied closely and who is his true master, has understood as M. Degas has the marriage and adultery of colors."[85] As evidence Huysmans cited the portrait of Duranty (fig. 287), where he observed the use of an "optical mixture" reminiscent of Delacroix's in the forehead streaked with rose, the beard flecked with green, and the yellow fingers outlined in violet. But his statement that this reflected a prolonged study of Delacroix's work probably originated with Degas himself, since no example of such a study had left his studio.

What the studies looked like we learn from his copy (fig. 205) after Delacroix's oil sketch for *The Battle of Poitiers* (fig. 204) that very likely also dates from 1880, when the Delacroix was temporarily accessible to Degas at a dealer's in Paris.[86] Working, perhaps from memory again, from this brilliantly executed sketch, itself greatly simplified in relation to the larger, more conventional picture at Versailles, Degas carried the process further, reducing the representational aspects so drastically that they form an almost abstract pattern of loosely brushed spots of color. If the same degree of freedom is not found in Degas's other works in these years, they do exhibit the same tendencies in color and touch and similarities in composition at times, especially in scenes showing horsemen in an open landscape like Delacroix's. The most striking example is *Gentlemen's Race: Before the Start* (fig. 206), which was painted in 1862 but largely reworked about 1880,[87] perhaps with the *Battle of Poitiers* sketch in mind, since it bears the closest resemblance to the sketch not only in its placement

Fig. 204. Eugène Delacroix, *Sketch for "The Battle of Poitiers,"* ca. 1829–30. Oil on canvas, 20¾ × 25½ in. (52.8 × 64.8 cm). Walters Art Gallery, Baltimore

Fig. 205. Edgar Degas, *Copy after Delacroix's "Sketch for The Battle of Poitiers,"* ca. 1880. Oil on canvas, 21½ × 25⅝ in. (54.5 × 65 cm). Private collection (Courtesy Gallery Nathan, Zurich). Retained by Degas's heirs

of the horsemen below the horizon but also in its summary treatment of the distant forms and its color harmony dominated by vivid spots of red and white against a tan and green ground.

As Huysmans recognized, it was above all in their new approach to color, their intense, vibrant hues juxtaposed in complementary pairs or fused in optical mixtures, that Degas's works were most clearly indebted to Delacroix's in this period. A retrospective exhibition of the latter, held at the École des Beaux-Arts in 1885, was undoubtedly a fresh stimulus;[88] and the pastel *Singer in Green* (fig. 207), with its brilliant alternation of turquoise and vermilion flecked with yellow in the skirt, its subtle repetition of turquoise and vermilion over yellow in the bodice, is one measure of the response.[89] At that exhibition Degas would also have seen the late version of *The Fanatics of Tangier* (fig. 208), of which he made an unusual copy in oil (fig. 209) that has been dated to the time of the exhibition[90] but seems stylis-

Fig. 206. Edgar Degas, *Gentlemen's Race: Before the Start,* 1862–80. Oil on canvas, 18⅞ × 24 in. (48 × 61 cm). L 101. Musée d'Orsay, Paris (R.F. 1982)

Fig. 208 (right). Eugène Delacroix, *The Fanatics of Tangier,* 1857. Oil on canvas, 18½ × 22 in. (47 × 55.9 cm). Art Gallery of Ontario, Toronto

Fig. 207. Edgar Degas, *The Singer in Green,* 1884–85. Pastel on light blue laid paper, 23¾ × 18¼ in. (60.3 × 46.3 cm). L 772. The Metropolitan Museum of Art, New York, Bequest of Stephen C. Clark, 1960 (61.101.7)

Fig. 209. Edgar Degas, *Copy after Delacroix's "The Fanatics of Tangier,"* 1897. Oil on canvas, 18⅛ × 22 in. (46 × 56 cm). Private collection, Paris. Collection Sale II: 54

tically to be much later. Its heavily simplified contours and broadly painted areas of color, partly independent of the contours, link it most closely to Degas's last known copy, made in 1897 from a Mantegna in the Louvre,[91] just as its composition and color harmony, dominated by bluish greens, yellowish whites, and a vivid orange, recur in his ballet pictures of that period.[92]

Pursuing his investigation of Delacroix's color, as he pursued that of Ingres's line, virtually as an art historian, Degas read and discussed with colleagues the many passages on color phenomena in the great Romantic's *Journal* when it began to appear in 1893 and even managed to obtain some of the palettes found in his studio, in which small doses of mixed color, labeled to indicate their components, were arranged in various sequences, depending on the harmony to be created.[93] In fact, Degas supposedly used such a prepared palette himself at this time, finding it analogous to a box of pastels, and advised young artists to do the same. But he also admired the effect of color that Delacroix obtained in his black-and-white lithographs and the ease with which he evoked a vivid personality in his portraits, praising two of those he had just acquired as "cleverly, freely done. . . . [He] did them like a great man who enjoys everything."[94] And if Degas preferred the wit and brevity of Ingres's statements on art, he was fond nevertheless of quoting Delacroix's advice on the advantages of working from memory.[95] Even the appearance of his great predecessor, as fierce and aloof as he himself wished to appear, interested him, and he often repeated Odilon Redon's description: "the head of a tiger, with a cold, imperious air and black, squinting eyes of an unbearable brilliance."[96]

In addition to the two early portraits just mentioned, Degas's impressive collection of works by Delacroix, largely formed in the decade after 1895, contained a more important portrait, the one of Louis-Auguste Schwiter now in the National Gallery, London (fig. 44), along with paintings representing every major aspect of his achievement: religious and mythological scenes, including a large, very dramatic version of *The Entombment* (fig. 41); exotic and historical subjects, among them a sketch for *The Battle of Nancy* (fig. 210) that resembles the *Battle of Poitiers* sketch Degas had once copied; a spirited copy by Delacroix himself after one of Rubens's Marie de Médicis pictures in the Louvre (fig. 211); studies of landscape and animals; even an interior, *Count de Mornay's Apartment* (fig. 4), which Degas later considered one of the three finest pictures in his possession.[97] His excitement in bidding for such works, his eagerness to install them in his collection, are reported by a number of his friends. What is more surprising, in view of his primary interest in Delacroix's color, is that he also acquired some 190 of the latter's drawings (see figs. 212–222);[98] and if many were painted in watercolor or pastel, many others were drawn in pencil with rapid, broken, pulsating strokes, which, in contrast to the contours in Degas's own drawings, locate rather than define forms in space. Like some of the paintings he bought, some of the drawings were studies for pictures Degas had copied forty years earlier and must also have had a sentimental appeal. In examples such as these, we discover once again that remarkable continuity of taste, that unswerving loyalty of attachment, which were so characteristic of Degas's relation to Delacroix as well as to Ingres.

THE SAME CONTINUITY did not exist in Degas's relation to Honoré Daumier; and, appropriately, the great Realist's name, unlike those of Ingres and Delacroix, appears only in the later page of artists' signatures in his notebooks (fig. 174), written after Degas had turned from historical subjects to scenes of modern life. Equally significant are the other differences between this page and the earlier ones (fig. 175): the absence now of Moreau's name and Fromentin's, the presence of Gustave Doré's. For if Doré's tenebrous, visionary art does not seem to have interested Degas—there were no examples of it in his collection, no references to it in his letters and reported conversations— it did resemble and even anticipate his own at times in depicting such familiar urban subjects as the stock exchange, the café-concert, and the music hall.[99] And if Degas maintained his friendship with Moreau, it was no longer based on shared artistic ideals; on the contrary, his contempt for both the esoteric imagery and the excessive detail of his colleague's work prompted some of his most sarcastic sayings: "He would like us to believe that the gods wore watch chains"[100] is but one example. Similarly, Fromentin's failure to develop beyond the refined exoticism of the pictures Degas had admired at the Salon of 1859, indeed his refusal to accept the vitality and modernity of Impressionism, inevitably alienated him from Degas, whose views did develop and were now expressed in Duranty's pamphlet *The New Painting*, written in response to Fromentin's attack on the new tendencies in 1876.[101]

To this antagonism between two artistic ideals, each one realistic in its way, belongs also the controversy between Degas and Gérôme over the importance of Daumier, quoted earlier; for Gérôme too believed he was upholding the dignity of traditional art in choosing exotic or historical subjects and in rejecting as banal the modern urban ones treated by the Impressionists and by Daumier. Hence

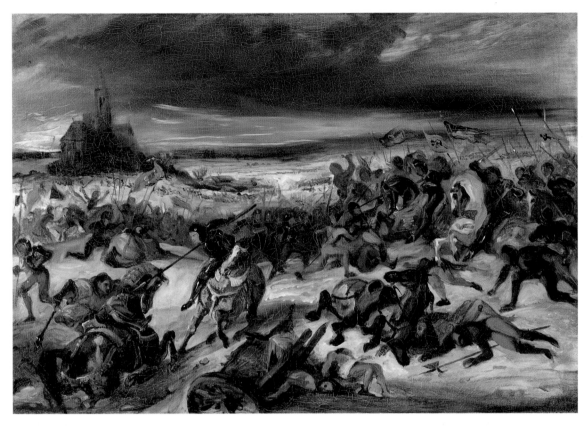

Fig. 210. Eugène Delacroix, *The Death of Charles the Bold at the Battle of Nancy,* 1828–29. Oil on canvas, 19⅛ × 27⅜ in. (48.5 × 69.5 cm). Ny Carlsberg Glyptotek, Copenhagen (I.N. 1905). Collection Sale I: 26

Fig. 211. Eugène Delacroix, *Copy after Rubens's "Henri IV Entrusts the Regency to Marie de Médicis,"* before 1834. Oil on canvas, 35 × 45¼ in. (89 × 115 cm). Los Angeles County Museum of Art (58.12). Collection Sale I: 25

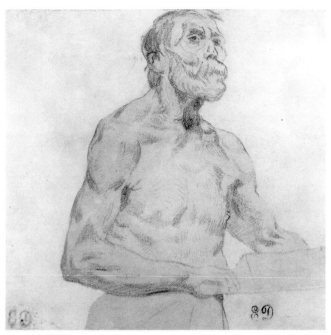

Fig. 212. Eugène Delacroix, *Bust of a Bearded Man, Nude*. Graphite, 5¼ × 4⅜ in. (13.5 × 11 cm). Private collection. Collection Sale I: 145

Fig. 213. Eugène Delacroix, *Female Nude*. Pen and brown ink, 6¾ × 4⅜ in. (17 × 11 cm). Sterling and Francine Clark Art Institute, Williamstown, Mass. (1420). Collection Sale II: 94.1

Fig. 214. Eugène Delacroix, *Two Studies of a Male Nude Torso*. Graphite, 4⅛ × 6⅝ in. (10.6 × 16.8 cm). Private collection. Possibly Collection Sale II: 110.1 or 126.2

Fig. 215. Eugène Delacroix, *Male Nude from the Back, Study for "The Barque of Dante,"* ca. 1820–22. Pen and brown ink, 5⅞ × 8¼ in. (15 × 21 cm). Musée du Louvre, Paris, Département des Arts Graphiques (R.F. 31218). Collection Sale II: 96.1

Fig. 216. Eugène Delacroix, *Study of a Right Arm and Two Feet,* ca 1820–22. Graphite heightened with pastel, 7⅜ × 9⅝ in. (18.6 × 24.5 cm). Musée du Louvre, Paris, Département des Arts Graphiques (R.F. 4530). Collection Sale II: 116.4

Fig. 217. Eugène Delacroix, *Studies of Heads, after Goya,* ca. 1824. Pen and brown ink, 4¾ × 7⅞ in. (12 × 20 cm). Musée du Louvre, Paris, Département des Arts Graphiques (R.F. 31217). Collection Sale II: 124.2

Fig. 218. Eugène Delacroix, *Study of Feet,* ca. 1822–29. Graphite, 10⅛ × 7½ in. (25.7 × 19 cm). Musée du Louvre, Paris, Département des Arts Graphiques (R.F. 4529). Collection Sale II: 116.2

Fig. 219. Eugène Delacroix, *Condemned Man, Study for "The Barque of Dante,"* 1820–22. Pen and brown ink over black chalk and graphite, 10½ × 13 in. (27 × 33.5 cm). The Metropolitan Museum of Art, New York, Rogers Fund, 1961 (61.23). Collection Sale II: 97.2

Fig. 220. Eugène Delacroix, *Dante among Panderers and Seducers ("Inferno," canto 18),* ca. 1822. Black chalk and ink, 8⅝ × 9 in. (22 × 23 cm). Graphische Sammlung Albertina, Vienna (24097). Collection Sale I: 133

Fig. 221. Eugène Delacroix, *Lion and Lioness*. Graphite, 7⅛ × 10¾ in. (18 × 27.4 cm). Trustees of the British Museum, London (1975.3.1.42). Collection Sale I: 137

Fig. 222. Eugène Delacroix, *Two Studies of a Lioness,* ca. 1850–60. Pen and brown ink, 5⅛ × 7½ in. (13 × 19 cm). Sterling and Francine Clark Art Institute, Williamstown, Mass. (1417). Collection Sale II: 109.1

Fig. 223. Eugène Delacroix, *The Atlas Lion,* 1829–30. Lithograph, 16⅜ × 21⅛ in. (41.7 × 53.7 cm). The Baltimore Museum of Art, Gift of Knoedler Galleries (1959.135.9). Collection Print Sale: 114

Degas's insistence in that dispute on ranking the latter with Ingres and Delacroix as one of the "three great draftsmen" of the nineteenth century. Hence too his response to Gérôme, who on learning of his admiration for Daumier had sent him several lithographs: "These precious proofs were lacking in my collection. I thank you warmly for them, and hope that these sublime hooligans will occupy your mind a little"[102]—in other words, that they will teach him a more authentic, vigorous form of Realism.

For Degas himself, however, they were also models of a convincing, vital form of classicism. "Daumier had a feeling for the antique," he remarked to Jeanniot. "He understood it to such an extent that when he drew Nestor [*sic*] pushing Telemachus, it was shown as it would have been at Tanagra."[103] Thus, quite apart from its mythological subject, one of fifty in the famous series entitled *Ancient History*, Daumier's lithograph of Telemachus and Mentor (fig. 224) possessed for Degas a classical strength and simplicity in its style. Its harmonious forms, perfectly legible despite their small size, can indeed be compared with those of the Hellenistic figurines from Tanagra, though its imagery of sadistic pleasure is foreign to them, suggesting a deeper reason for the lithograph's appeal. Long before the Tanagra figures were discovered in the early 1870s, Degas had drawn in the Louvre after similar figures from Cyrenaica;[104] but those found at Tanagra came more naturally to mind when he compared Daumier's print to them around 1885, because he had recently planned a picture centered on a Tanagra figurine. It was a portrait of Henri Rouart's wife and daughter, in which just such a figurine is shown standing on a table before the two living figures, and the daughter's costume and pose are clearly based on that type of Hellenistic work.[105] And in this witty, highly personal, yet ultimately respectful interpretation of the antique, Degas's portrait indeed resembled Daumier's print. Clearly the same could not be said of the stiffly posed, impersonally realistic statue of a seated nude holding a pseudo-antique statuette, entitled *Tanagra*, that Gérôme exhibited at the Salon of 1890, though his slightly later picture *The Roman Pottery Painter* revealed greater historical wit.[106] Indeed, when Degas and Daumier turned to sculpture—and their deep interest in it, their preference for vigorous modeling, and their treatment of subjects taken from their paintings are all further links between them—they achieved a simple grandeur of form and a veracity of movement that were authentically classical.

The distinction was important and already recognized at the time, at least among artists. According to Duranty, the Barbizon painter Charles Daubigny expressed his admiration for Raphael's frescoes in Rome by exclaiming, "It's like

Fig. 224. Honoré Daumier, *Telemachus and Mentor*, 1842. Lithograph, 9⅞ × 7¾ in. (25.1 × 19.8 cm). The Metropolitan Museum of Art, New York, Harris Brisbane Dick Fund, 1936 (36.12.22)

Daumier!"[107] And after admitting that such a comparison "seems at first very surprising," Duranty himself claimed that the heads in the well-known print *The Legislative Belly* (fig. 226) "are modeled as broadly as those in a picture by Poussin," and that the faces and figures in other prints reveal as profound an understanding of expression as those in Holbein's portraits,[108] thus identifying Daumier with other artists of a classical tendency whom Degas too admired. Degas may in fact have inspired these comparisons, since the article in which they occur, a review of the retrospective exhibition of Daumier's work in 1878, dates from the period when he was closest to Duranty; witness his contribution to *The New Painting* two years earlier and his portrait of the writer one year later. Moreover, the only work in the exhibition that Duranty discussed at length, *The Legislative Belly*, was the one that Degas chose to copy in a notebook at this time (fig. 225), perhaps during a discussion with him.[109]

If so, however, it was to illustrate a very different interpretation of the print; for what impressed Duranty was the work's coloristic style—"a marvel of coloring, of vivid tones, harmonized and balanced"—and its realistic content—"the profound, the intense feeling of life and of

truth"¹¹⁰—whereas Degas ignored both aspects, reducing the print's tonal harmony to a stark contrast of black and white and its imagery to a pattern of scribbled shapes and lines. In drastically simplifying the original—in effect, caricaturing a caricature—he expressed literally, in purely graphic terms, that energy of aggression which Duranty described figuratively in calling Daumier "the caricaturist who is bent on disparaging and destroying the ideal," one whose crayon "is almost always full of impulsiveness, of violence."¹¹¹ It is clear from Degas's portraits and caricatures that, more than any of his Impressionist colleagues, he shared Daumier's deep interest in physiognomic expression; he must have examined *The Legislative Belly* in those terms as well.

In fact, when Degas began experimenting with caricature in the later 1860s—he had made a few attempts previously and had copied satirical prints by Hogarth¹¹²—his starting point was Charles Philipon's image of the reactionary King Louis-Philippe as "the pear," which Daumier's lithographs had made famous thirty-five years earlier. On succeeding pages in one of Degas's notebooks we find variations on the "pear" motif (fig. 227), based on such prints

Fig. 225. Edgar Degas, *Copy after Daumier's "The Legislative Belly,"* Notebook 31, p. 6, 1878. Graphite, 4⅜ × 6⅝ in. (11.1 × 16.7 cm). Bibliothèque Nationale, Paris

as *The Past, The Present, The Future* (fig. 228), and primitive versions of his own satirical images of contemporary political leaders, Napoleon III and Bismarck.¹¹³ Degas's progressive simplification of the graphic elements constituting each image, that "boiling down to an easily remembered formula" which is the essence of caricature and the lesson

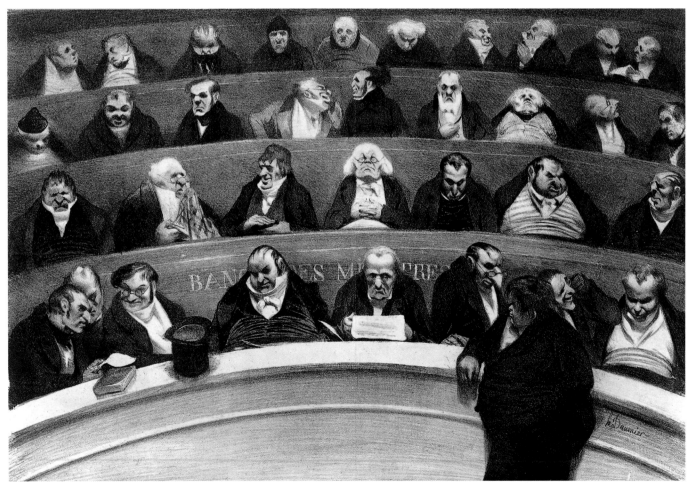

Fig. 226. Honoré Daumier, *The Legislative Belly,* 1834. Lithograph, 11 × 17 in. (28 × 43 cm). Association des Amis de Daumier, Valmondois. Collection Print Sale 64

Fig. 227. Edgar Degas, *Caricature Studies*, Notebook 21, p. 18, ca. 1868. Graphite, 3⅞ × 2¼ in. (9.7 × 5.6 cm). L 175. Bibliothèque Nationale, Paris

Fig. 228. Honoré Daumier, *The Past, The Present, The Future*, 1834. Lithograph, 8⅜ × 7¾ in. (21.4 × 19.6 cm). The Metropolitan Museum of Art, New York, Harris Brisbane Dick Fund, 1941 (41.16.1)

Fig. 229. Edgar Degas, *Caricatures and Other Studies*, Notebook 23, p. 153, ca. 1870. Graphite, 4⅛ × 2⅝ in. (10.6 × 6.8 cm). L 337. Bibliothèque Nationale, Paris

he had learned from Daumier, we find next in the pages of another notebook of this period, where the weaknesses of each personality—the French emperor's shallowness and effeminacy, the Prussian chancellor's bristling arrogance (fig. 229)—emerge with increasing clarity.[114] Unlike his predecessor, however, Degas eventually found the inherent expressiveness of his graphic formulas more important than their topical significance, for he applied one of them with equal effectiveness to a quite different personality: several caricatures in a notebook of the late 1870s, while continuing to resemble Napoleon III, look remarkably like Edmond de Goncourt, an acquaintance whose signature and address appear above one of them.[115]

Surprisingly, in view of his closeness to Degas, Duranty hardly touched on an aspect of Daumier's art that now seems important in defining its influence on later Realist art: his frequent choice of scenes of urban entertainment and diversion—the café, the café-concert, the ballet, the theater, the art exhibition, the boulevard with strollers— and his invention of designs which, in their striking viewpoints and juxtapositions, their daringly cut and brilliantly lit forms, convey a corresponding sense of the movement,

Fig. 230. Edgar Degas, *The Orchestra of the Opéra,* ca. 1869. Oil on canvas, 22¼ × 18¼ in. (56.5 × 46.2 cm). L 186. Musée d'Orsay, Paris (R.F. 2417)

Fig. 231. Honoré Daumier, *The Orchestra during the Performance of a Tragedy,* 1852. Lithograph, 10¼ × 8½ in. (26.1 × 21.6 cm). The Metropolitan Museum of Art, New York, Rogers Fund, 1922 (22.61.304)

vitality, and social contrast inherent in urban life. Although more aware of this side of Daumier's achievement, later writers have either denied that specific examples of its influence can be found in Degas's work or have tended to cite the same one each time, so that the full extent of its significance for him has never been appreciated.[116] In fact, one writer has maintained that Gavarni's prints, which Degas admired and collected in even greater numbers, were equally significant for him as sources of inspiration.[117] But perhaps because he recognized the artistic limitations of Gavarni's prints—"It is a manner of expressing oneself in drawings," he told Jeanniot, "but it is only a manner; it is not a truly artistic expression"[118]—he seems to have borrowed far less from them.

Daumier's influence is most apparent in those pictures of theatrical performance in which Degas could indulge his own delight at juxtaposing the artificial and the natural while drawing on his great predecessor's innovations. The example generally cited, *The Orchestra of the Opéra* of about 1869 (fig. 230), is indeed reminiscent of Daumier's *Orchestra during the Performance of a Tragedy* (fig. 231), where the animated, brightly lit performers onstage are contrasted to the tired, somberly dressed musicians below it, the horizontal footlights acting as a strong divider; though Degas characteristically portrays the musicians as

individuals rather than as members of a class or profession.[119] In *Orchestra Musicians* (fig. 353),[120] painted three years later, he transformed this relatively static opposition of the two groups into a visually more dramatic one, viewed as if from a position directly behind the three musicians, whose heads and instruments loom large in the foreground, overlapping the small, luminous figure of the dancer above them; yet this situation too can be found earlier, in a more clearly contrived, symmetrical form, in Daumier's *Dancer Who Prides Herself on Having Conserved the Noble Traditions.*[121] Even more dynamic in composition than the corresponding work by Daumier, but still closely related to it in conception, is Degas's *Duet* of about 1877, an image of performers onstage, seen from behind as if from the wings, with the prompter peering out of his box at one side and the audience faintly indicated in the background, very much as in Daumier's print *The Evening of a First Performance,* though again the latter is more formal and frontal in design.[122]

In Daumier's treatment of the café-concert, a more specifically popular form of entertainment that allowed for a shrewder psychological analysis of the performers and spectators, Degas seems to have found inspiration for both the somewhat satirical content and the striking pictorial form that characterize his own treatment of the subject.

Unlike the sensitive faces in *The Orchestra of the Opéra*, those of the lower-class audience and musicians in the *Café-Concert at Les Ambassadeurs* (fig. 232) display a coarseness reminiscent of the beer-drinking workers and clerks in Daumier's print *At the Champs-Élysées* (fig. 233), just as the bold division of the surface into two zones—one dominated by heavy, somber shapes, the other by light, delicate ones, with a sharply silhouetted hat linking the two—resembles the print's composition.[123] When Degas turned his satirical attention to the singer rather than the spectators, as he did in *At the Café-Concert: The Song of the Dog*—subtly underlining the vulgarity of her expression, her miming of the animal's gesture—he seems to have drawn once again on Daumier's prints, particularly *The Leading Singer of a Café-Concert*, whose subject is shown in virtually the same position and illuminated from below in the same unflattering manner, though the effect here is rather of haggardness and straining to continue the performance.[124]

This fascination with the mundane reality behind the theatrical illusion naturally led both artists to dwell on scenes set behind the scenes, with the result that here too the older one could provide the younger one with some useful hints. Thus, Degas's monotype *Ludovic Halévy Meeting Madame Cardinal Backstage* (fig. 234) evidently

had, in addition to its literary source in Halévy's *Cardinal Family*, a visual source in Daumier's print *The Mother of the Singer* (fig. 235), a composition that is likewise divided by the wavy edge of a stage flat into two domains—one dominated by a sullen mother standing in its shadow, the other by a graceful daughter performing under the lights.[125] As in the previous examples, however, the earlier Realist stresses the social significance of the contrast, whereas the later one is content merely to record its charm for a subtle observer's eye.

If Daumier's lithographs were readily available to Degas, who eventually owned some 750 of them (see figs. 68–70, 167, 420), many supposedly clipped from the pages of *Le Charivari* each week, his paintings and drawings were much more difficult of access.[126] Rarely shown at the Salon or in dealers' galleries, entirely absent from public collections, they were first displayed in large numbers at the retrospective exhibition of Daumier's works in 1878 and again at the École des Beaux-Arts a decade later, although by then Degas's art was too completely formed for them to affect it. Earlier he may also have seen works that passed through the hands of Hector Brame and Paul Durand-Ruel, dealers with whom he was friendly, or that belonged to the Rouarts and other collectors in his circle, but it is often impossible to specify which ones and when.[127] Hence

Fig. 232. Edgar Degas, *Café-Concert at Les Ambassadeurs,* ca. 1877. Pastel over monotype, 14⅝ × 10⅝ in. (37 × 27 cm). L 405. Musée des Beaux-Arts, Lyons

Fig. 233. Honoré Daumier, *At the Champs-Élysées,* 1846. Lithograph, 9½ × 9 in. (24 × 22 cm). Bibliothèque Nationale, Paris

Fig. 234. Edgar Degas, *Ludovic Halévy Meeting Madame Cardinal Backstage,* 1876–77. Monotype, 10¾ × 12⅛ in. (27.3 × 30.7 cm). Private collection, Paris

Fig. 235. Honoré Daumier, *The Mother of the Singer,* 1857. Lithograph, 9¼ × 8¼ in. (23.5 × 20.5 cm). The Metropolitan Museum of Art, New York, Gift of Edwin De T. Bechtel, 1952 (52.633.1[17])

the retrospective show of 1878 was for Degas, as it was for Duranty and others, his most important encounter with Daumier's paintings, and the works he produced after that date are those in which their influence can be sought.

This is why a contemporary critic's observation that Degas's *Laundresses Carrying Linen,* shown at the Impressionist exhibition of 1879, "looks from afar like a Daumier" is mis-leading.[128] While one of Daumier's pictures of laundresses (fig. 236) had figured in the retrospective of 1878, Degas's had been completed some years before that; and while another of Daumier's pictures had been shown at the Salon of 1861, Degas would hardly have recalled it very clearly after fifteen years.[129] Much more likely to have been inspired by the *Laundress* exhibited in 1878 is the picture of

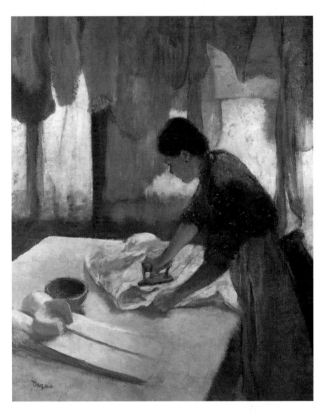

Fig. 236. Honoré Daumier, *The Laundress*, ca. 1863. Oil on wood, 19½ × 13 in. (49.5 × 33 cm). The Metropolitan Museum of Art, New York, Bequest of Lillie P. Bliss, 1931 (47.122)

Fig. 237. Edgar Degas, *Woman Ironing*, ca. 1882. Oil on canvas, 32 × 26 in. (81.3 × 66 cm). L 685. National Gallery of Art, Washington, D.C., Collection of Mr. and Mrs. Paul Mellon (1972.74.1)

a woman ironing that Degas painted four years later (fig. 237).[130] Although an image of skilled labor rather than human hardship, and set in the laundress's shop rather than on a deserted quay, it is remarkably similar in design: here, too, the woman is depicted *à contre-jour*, as a dark, curved form silhouetted against light, generally rectangular ones in the background, and she appears bending far to the left, concentrating on her task, so that her face becomes an anonymous, shadowy profile; and here, too, a small, round form, a bowl instead of a child's head, becomes a focus of the composition. In other laundress paintings of the 1880s Degas again explored the *contre-jour* effect reminiscent of Daumier, but never with such strikingly similar results.[131]

Among the other paintings shown in 1878 that must have impressed Degas was *The Collectors* (fig. 239), for he clearly had it in mind in painting his own version of this subject some three years later (fig. 238).[132] Although his picture is a portrait of two friends devoted to art, the collector Alphonse Cherfils and the scholar Paul Lafond, whereas Daumier's is of unidentified figures interesting only as

types, its dependence on the latter seems evident enough both compositionally and in its presentation of the two men as true *amateurs*, absorbed in the silent contemplation of a small canvas one of them holds. It is likely too that in the various versions of Daumier's *Crispin and Scapin*, also shown in 1878, Degas was struck by the distortions caused by footlights illuminating the actors' faces from below, for in his *Café-Concert Singer Wearing a Glove*, executed in that year, he depicted with equally dramatic effect a performer seen in a glaring footlight from an unusually low and proximate viewpoint.[133]

Whatever the influence of Daumier's paintings may have been at that time, Degas made little effort to collect them later, when he had the means; instead he chose to concentrate on Ingres and Delacroix, Corot and Manet, and other masters. The one canvas he owned, the *Don Quixote Reading* (fig. 154), reveals nothing precise about the nature of his interest in Daumier; nor do the five drawings (see figs. 155, 156, 360), though one of them, a study of *amateurs* admiring a picture (fig. 377), probably appealed for the same reasons as *The Collectors*, whose influence he

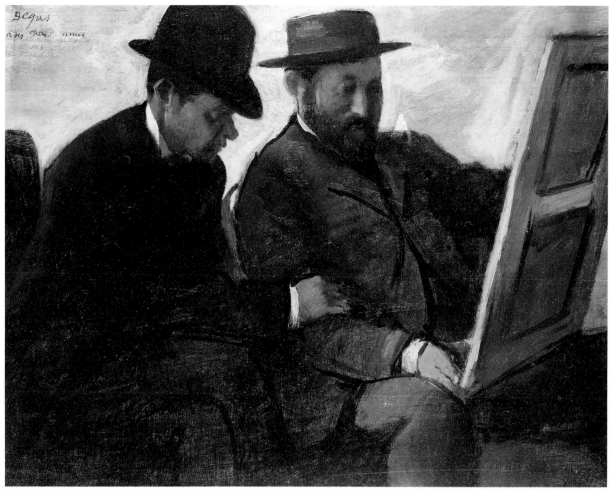

Fig. 238. Edgar Degas, *The Collectors,* ca. 1881. Oil on wood, 10¾ × 13⅞ in. (27.3 × 35.2 cm). L 647. The Cleveland Museum of Art, Bequest of Leonard C. Hanna, Jr.

had felt earlier.[134] Far more important was Degas's collection of Daumier lithographs, many of them rare proofs obviously not taken from *Le Charivari* but purchased individually and valued as fine prints. Here his admiration for Daumier's draftsmanship, which he had once declared equal to that of Ingres and Delacroix, expressed itself in a characteristically expansive form.

THAT DEGAS ADMIRED and collected the works of Ingres, Delacroix, and Daumier, that he often copied after and drew inspiration from them, is not in itself surprising; along with the works of Corot, Courbet, and Millet, they were models of an authentic art, independent of the academy, for many advanced artists of the later nineteenth century.[135] What is remarkable is the extent to which he was able to appreciate the distinctive and in many ways mutually exclusive styles of all three simultaneously and, without any hint of eclecticism, to assimilate important elements of them into his own style. As we have seen, Ingres's art epitomized for Degas from the beginning a Neoclassical

ideal of harmonious form and incisive drawing, just as Delacroix's embodied a Romantic ideal of poetic conception and vibrant coloring, and Daumier's later represented a Realist ideal of trenchant observation and unconventional design. All of these were essential features of his own art. In addition, each of the three artists was preeminent in a genre or type of subject matter in which Degas himself specialized at some time in his career: Ingres in portraiture and nude female figures, Delacroix in narrative composition and horses in motion, Daumier in caricature and scenes of urban life. Thus the achievements of these three not only represent the principal sources of Degas's art—its major links with the artistic culture of his time—but also correspond to important aspects of his own achievement and together symbolize that complexity of style and content which is perhaps the most impressive characteristic of his work.

Certainly the synthesis Degas achieved is unequaled even in the most ambitious art of his generation, that of his Impressionist colleagues. This is not simply because the landscape painters among them rejected the example of

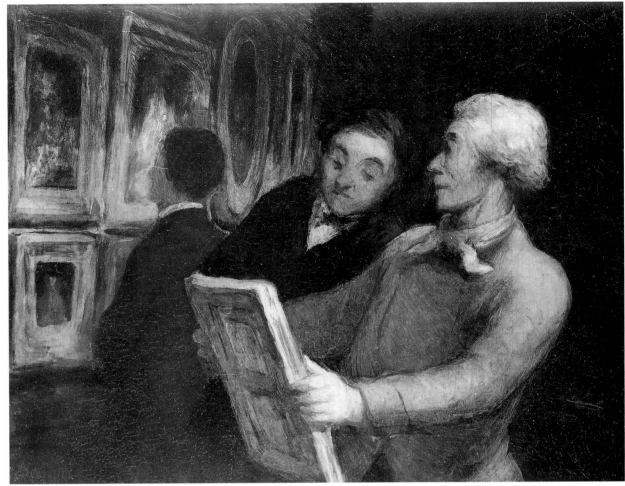

Fig. 239. Honoré Daumier, *The Collectors*, 1860–63. Oil on canvas, 9¼ × 12¼ in. (23.5 × 31 cm). Museum Boijmans Van Beuningen, Rotterdam

earlier art altogether, so that already in the 1860s, while Degas was in the Louvre studying his chosen masters, pencil or brush in hand, Claude Monet was outside on its balcony, painting views of Paris, and Camille Pissarro was in the café opposite, demanding that such "necropolises of art" be burned down.[136] It is because even the figure painters, who were conscious of the lessons to be learned from earlier nineteenth-century art, never struggled as Degas did to reconcile such fundamentally dissimilar styles. On the contrary, when Auguste Renoir turned to the linear precision and bland bather subjects of Ingres in the 1880s, he did so in reaction against the vivid colorism and exotic themes he had learned from Delacroix in the previous decade; as for the emphatic, popular art of Daumier, it seems rarely to have interested him.[137] If Cézanne was influenced by Daumier in his early, expressionist phase, and throughout his career made studies of and drew inspiration from the art of Delacroix, whose homage he planned to paint, he had little but contempt for Ingres, whom he identified with the academy.[138] Only Manet, in many ways the closest in this group to Degas artistically

and socially, seems to have appreciated all three masters and to have borrowed from them at times, but he did so with greater confidence and powers of assimilation, rarely experiencing the tension or frustration that Degas felt in striving for so ambitious a synthesis.[139] As Valéry reports, "he admired and envied the assurance of Manet, whose eye and hand were certainty itself," whereas for him, "who missed nothing, who enjoyed—and suffered from—everything," the mere existence of several diverging styles "constituted the great problem."[140]

However, the problem must have been more acute at certain times than at others. While Ingres commanded Degas's admiration from beginning to end, his actual influence was confined to the period 1855–80 and especially to its first fifteen years, those of Degas's greatest interest in historical subjects and family portraits and of his most classical draftsmanship. Although Delacroix too was an idol throughout, his impact stylistically was most apparent in the early 1860s, when Degas reacted against his conservative early training, and again in the period 1880–1900, when color increasingly became the dominant element in

his art. As for Daumier, whom he began to appreciate later than the other two, his work was evidently a source of inspiration only in the years 1870–85, those of Degas's most active involvement with themes of urban work and entertainment and problems of physiognomic expression. Consequently, the periods of greatest tension between conflicting artistic ideals were those of the sixties, when he sought to combine the opposed stylistic qualities of Ingres and Delacroix, and the seventies, when he attempted to unite with these the imagery and vision of Daumier. But so schematic a summary hardly does justice to the complexity of Degas's art, the product of a subtle interaction of all three tendencies during much of his maturity. Nor does it acknowledge that sense of challenge, almost of exhilaration, that he seems to have felt in responding to all three simultaneously.

Appendix, 1997: Some New and Neglected Texts

1. BAUDELAIRE'S PRIORITY

The conviction that Ingres, Delacroix, and Daumier were the greatest draftsmen of the nineteenth century did not originate with Degas; it had already been expressed by Baudelaire, and evidently for the first time,[141] in his audacious review of the Salon of 1845. Opposing the dominant academic view that there is a single standard of perfect drawing, Baudelaire argued that "there are two kinds of draftsmanship—the draftsmanship of the colorists and that of the draftsmen,"[142] and as evidence he cited the dissimilar yet equally high achievements of those three artists. Degas, who had read the great writer's art criticism shortly after it was collected and published in 1868,[143] may well have found confirmation of his own strongly held opinion in the following passage, written some forty years earlier:

> We only know of two men in Paris who draw as well as M. Delacroix—one in an analogous and the other in a contrary manner. The first is M. Daumier, the caricaturist; the second M. Ingres, the great painter, the artful adorer of Raphael. This is certainly something calculated to astound both friends and enemies, both partisans and antagonists of each one of them; but anyone who examines the matter slowly and carefully will see that these three kinds of drawing have this in common, that they perfectly and completely render the aspect of nature that they mean to render, and that

they say just what they mean to say. Daumier draws better, perhaps, than Delacroix, if you would prefer healthy, robust qualities to the weird and amazing powers of a great genius sick with genius; M. Ingres, who is so much in love with detail, draws better, perhaps, than either of them, if you prefer laborious niceties to a total harmony, and the nature of the fragment to the nature of the composition, but . . . [*sic*] let us love them all three.[144]

2. INGRES'S PORTRAITS

Passages in two letters from close friends of Degas's, one recently published, the other unpublished, shed further light on what was undoubtedly the greatest event in his career as a collector, his acquisition of Ingres's portraits of M. and Mme Leblanc.

The first letter, from the writer Ludovic Halévy to the dilettante Albert Boulanger-Cavé,[145] is dated January 26, 1896, three days after the sale at which Degas bought the two pictures:

> Degas wants you to be among the first to learn that he has just bought two portraits by Ingres, the portraits of M. and Mme Leblanc, dated Florence, 1823. He is literally mad with joy. He paid 12,000 francs for the portraits at the Hôtel Drouot last Thursday. . . . He had learned by chance two weeks ago that these portraits, which he already knew, were going to be sold at the auction house in an unpublicized way, buried in a sale of middle-class furniture. There was nothing [of value] in the sale but these two family portraits. The Louvre had not noticed that the pictures were to be sold. Bonnat,[146] who runs after works by Ingres and pays high prices for them, was in Monaco. For two weeks Degas did not sleep. And [now] he has the pictures. They are destined for his museum, which will afterward become a public museum. Write to congratulate him. His address: 23, rue Ballu. I have not yet seen the pictures. Élie and Daniel[147] saw them yesterday. It seems that the portrait of Mme Leblanc is first rate.

The second letter, from the sculptor Albert Bartholomé to the painter Alfred Roll,[148] written on March 28, 1918, shortly after the Ingres portraits had been sold in the first of several sales of Degas's collection, reveals that Degas had been prepared to buy them jointly with Bartholomé, with the intention of separating them, and, what is more surprising, that he would in that case have chosen the male rather than the female portrait:

Madame Leblanc came to mind since, on leaving the Hôtel Drouot, where Degas and I had just bought the couple by Ingres, knocked down to us for 12,000 francs, my old friend had declared, "I prefer the man." I accepted the woman, who had an arm that was infinitely pleasing to me; and then I gave in when I heard these words: "Look here, Bartholomé, you would not want to separate this couple." The couple has gone from 12,000 to 270,000 francs, the happy couple.

1. Moore 1890, p. 423.
2. This essay, published in 1976 in Theodore Reff, *Degas: The Artist's Mind* (New York), is reprinted here with only minor corrections and two new appendices.
3. For Flaxman, see Reff 1963, p. 248; for David, Reff 1963, pp. 247–48, and L 8, dated 1854–55.
4. Reff 1963, pp. 245, 248; and Reff 1964, p. 247.
5. See below; also Phoebe Pool, "The History Pictures of Edgar Degas and Their Background," *Apollo* 80 (October 1964), pp. 306–11.
6. For Fromentin, see Reff 1964, p. 257; for Chassériau, Reff 1976b, Notebook 14A, p. 9. For Lawrence, see L 81, 189, both dated 1868–70, but more likely of 1860–62.
7. For Géricault, see Reff 1971, pp. 537–38; for de Dreux, Reff 1976b, Notebook 13, pp. 60, 61, 65–66, 68, etc., used in 1858–60.
8. For Meissonier, see Reff 1971, pp. 537–38; for Herring, Reff 1976a, p. 117.
9. See Boggs 1962, pp. 32–33, and Theodore Reff, "Manet's Portrait of Zola," *Burlington Magazine* 117, no. 862 (January 1975), p. 39. Compare, among others, Degas's *At the Café-Concert*, L 380, with Manet's *Café-Concert Singer*, JW 333; and Degas's *Absinthe*, L 393, with Manet's *In the Café*, JW 314. There are also similarities between their pictures of nudes ca. 1880: compare Degas's *Crouching Nude Seen from Behind*, L 547, with Manet's *Woman in a Tub*, JW 424; and Degas's *Leaving the Bath*, L 554, with Manet's *The Toilette*, JW 421.
10. For Daumier, see below; for Gavarni, Reff 1976a, p. 311 nn. 115, 116.
11. For Victorian art, see Reff 1976a, chap. 5, pp. 227–36. For Menzel, see Reff 1964a, p. 255, and L 190, incorrectly dated 1868–70; also Reff 1976a, chap. 5, nn. 88–97. Menzel's *The Supper at the Ball*: Nationalgalerie, Berlin.
12. Compare the collection of his close friend Henri Rouart, which was strong in Delacroix, as well as Corot and Daumier, but weak in Ingres: *Catalogue des tableaux . . . collection de feu M. Henri Rouart*, and *Catalogue des dessins et pastels . . . collection de feu M. Henri Rouart*, Galerie Manzi-Joyant, Paris, December 9–11 and 16–18, 1912.
13. See, e.g., Wagner 1974, p. 187.
14. Jeanniot 1933, p. 171. According to Lemoisne 1946–49, vol. 1, p. 141, Degas began frequenting the Café de la Rochefoucauld about 1883.
15. Reff 1976b, Notebook 27, p. 43, used in 1875–78. See Theodore Reff, "A Page of Degas Signatures," *Gazette des Beaux-Arts* 55 (March 1960), pp. 183–84, on which the following is partly based.
16. For samples of their signatures, see Adolphe Jullien, *Ernest Reyer, sa vie et ses oeuvres* (Paris, 1909), opposite pp. 12, 36, 78; and Emmanuel Bénézit, *Dictionnaire critique et documentaire des peintres, sculpteurs, dessinateurs et graveurs*, 8 vols. (Paris, 1960), vol. 3, p. 56 (Daumier), p. 126 (Delacroix), p. 311 (Doré), and vol. 5, p. 65 (Ingres).
17. Compare the signatures on L 339, 363, 380, with those on L 393, 409, 444; the former group is dated 1874–75, the latter group 1876–77.
18. Reff 1976b, Notebook 12, pp. 106–7; used in 1858–59.
19. Reff 1976b, Notebook 11, pp. 104–5; used in 1857–58.
20. Rouault 1927, p. 94.
21. *Valpinçon Bather*: Musée du Louvre, Paris.
22. Valéry 1960, pp. 34–35.
23. Ibid., p. 35. See also Halévy 1964, pp. 49–50, and Moreau-Nélaton 1931, pp. 269–70.
24. *Roger Freeing Angelica* and *Archangel Gabriel*: Musée du Louvre, Paris. Reff 1976b, Notebook 2, pp. 48, 68; see also the copies on pp. 9, 54; used in 1855.
25. For the *Martyrdom*, see Reff 1964a, p. 255, fig. 6; for the *Bather*, Reff 1976b, Notebook 2, p. 59. For Ingres's copies, see Wildenstein 1954, nos. 29–32, 66–68, 149–51, etc.
26. Reff 1976b, Notebook 2, pp. 30, 79, 82, 83.
27. Drawing in the planned fifth atelier sale; Durand-Ruel photograph no. 15408. Reff 1976b, Notebook 19, p. 50; see also p. 49; used in 1860–62.
28. L 91, 92, 93, dated 1861–62, but more likely of 1859–60.
29. Reff 1976b, Notebook 15, pp. 2, 8, 16, 38, used in 1859–60. The painting is L 94, dated 1861–64, but more likely of 1859–60.
30. *King Candaules' Wife*: private collection, Paris. *Stratonice and Antiochus*: Musée Condé, Chantilly. See Reff 1961, pp. 534, 537, and Reff 1976a, chap. 4, pp. 150–52.
31. See Émile Galichon, "Description des dessins de M. Ingres exposés au Salon des Arts-Unis," *Gazette des Beaux-Arts* 9 (March 15, 1861), pp. 343–62, and 11 (July 1, 1861), pp. 38–48.
32. The study is Atelier Sale IV: 120c. The early version is L 95, dated 1861–64, but more likely of 1859–60.
33. Jakob Rosenberg, *Great Draughtsmen from Pisanello to Picasso* (Cambridge, 1959), pp. 106–7.
34. Studies for *Scene of War in the Middle Ages*: Musée d'Orsay, Paris. Studies for *Stratonice and Antiochus*: Musée Ingres, Montauban. Studies for *Romulus Victorious over Acron*: The Metropolitan Museum of Art, New York; Musée du Louvre, Paris; Musée Bonnat, Bayonne.
35. See Boggs 1962, p. 9, pls. 11, 12; and L 5. There are studies for the latter, together with copies after Ingres, in Reff 1976b, Notebook 2, pp. 58B, 84–85; used in 1854–55.
36. Reff 1976b, Notebook 17, p. 5, probably drawn ca. 1860.
37. For example, in Lemoisne 1946–49, vol. 1, p. 34, and Boggs 1962, p. 13. The portrait is L 79, dated 1860–62, but more likely of 1859–60. *The Gatteaux Family*: private collection, Baltimore.
38. Pierpont Morgan Library, New York. See Suzanne Barazzetti, "Degas et ses amis Valpinçon," *Beaux-Arts*, no. 190, August 21, 1936, p. 3.
39. See Rosenberg, *Great Draughtsmen*, p. 109. However, Degas could not have known the portrait of Mme Ingres; on its provenance, see Cambridge, Mass. 1967, no. 104.
40. *Madame Edmondo Morbilli*: L 255; private collection, New York. *Comtesse d'Haussonville*: Wildenstein 1964, no. 248; The Frick Collection, New York.
41. L 333, dated ca. 1873; Museum of Art, Rhode Island School of Design, Providence. Compare the *Portrait of a Young Woman* that was later in Degas's collection, Cambridge, Mass. 1967, no. 4.
42. L 389, dated 1875–80; Museum of Fine Arts, Boston.
43. Charles Ephrussi, "Exposition des Artistes Indépendants," *Gazette des Beaux-Arts* 21 (May 1, 1880), p. 486.
44. Edmond Duranty, "Salon de 1872," *Paris-Journal*, May 11–June 15, 1872, quoted in Marcel Crouzet, *Un Méconnu du Réalisme: Duranty (1833–1880): L'Homme, le critique, le romancier* (Paris, 1964), p. 310.
45. Edmond Duranty, *La Nouvelle Peinture*, 1876, ed. Marcel Guérin (Paris, 1946), pp. 32–33.
46. See Lapauze 1918, p. 9.
47. See Luce Hoctin, "Degas photographe," *L'Oeil*, no. 65 (May 1960), pp. 36–38. The photographer was a young Englishman named Barnes, whom Degas befriended.
48. Valéry 1960, pp. 32–33.
49. Letter to Ludovic Halévy, September 1885, *Lettres de Degas* 1945, p. 112.
50. Moore 1890, p. 422.
51. Letter to Albert Bartholomé; undated, but probably written in the spring of 1889, when many of Ingres's drawings were shown at the Palais du Champ de Mars as part of the Paris World's Fair; *Lettres de Degas* 1945, p. 127.
52. Halévy 1964, p. 50.
53. Valéry 1960, p. 82; Halévy 1964, p. 50.

54. Letters to the mayor of Montauban, August 25, 1897, and to Alexis Rouart, July 28, 1897, *Lettres de Degas* 1945, pp. 217–18, 211–12. Degas also offered to cooperate in publishing a catalogue of the Montauban drawings; see Lapauze 1918, p. 9.

55. Letter of November 30, 1898, *Lettres de Degas* 1945, p. 220. The copy in question is most likely the one by Ingres's pupil Julie Forestier of his self-portrait as a young man (fig. 19).

56. Collection Sale I: 50–69, 182–214; Collection Sale II: 182–212. On the Leblanc portraits, see Appendix 2 and Ann Dumas's essay "Degas and His Collection" in this volume.

57. Valéry 1960, p. 34, dated October 22, 1905.

58. See Lapauze 1918, pp. 9–10.

59. Edmond de Goncourt and Jules de Goncourt, *Manette Salomon*, 1867 (Paris, 1894), p. 16. See Frank Anderson Trapp, "The Universal Exhibition of 1855," *Burlington Magazine* 107, no. 747 (June 1965), pp. 300–305.

60. Moreau-Nélaton 1931, p. 268, dated December 26, 1907.

61. Letter of January 4, 1859, quoted in Lemoisne 1946–49, vol. 1, p. 229 n. 35.

62. See this essay, below; and Pool 1963, pp. 251–56. See also Degas's letters to Moreau of 1858–59, Reff 1969, pp. 281–86.

63. Edmond Duranty, "Salon de 1859," *Courrier de Paris*, April 19 and 26, and May 3, 1859; quoted in Crouzet, *Un Méconnu du Réalisme*, pp. 89–90, 199–200.

64. Musée d'Orsay, Paris. See Adolphe Jullien, *Fantin-Latour, sa vie et ses amitiés* (Paris, 1909), pp. 62–65, with illustration.

65. Reff 1976b, Notebook 13, p. 53, used in 1858–60. Notebook 18, p. 127, used in 1859–64. *The Entombment:* formerly Santamarina collection, Buenos Aires. *Ovid in Exile among the Scythians:* National Gallery, London.

66. Drawings formerly in the collections of Jeanne Fevre and Maurice Exsteens; see Fries 1964, pp. 354, 355 nn. 36, 37.

67. Reff 1976b, Notebook 16, p. 35, used in 1859–60. Reff 1964a, p. 252.

68. Reff 1976b, Notebook 14, pp. 59, 63–65, 70, 72–74, used in 1859–60.

69. For the *Christ,* see Reff 1976b, Notebook 16, p. 20A; for the *Combat,* Fries 1964, pp. 353, 355; for the *Mirabeau,* Reff 1976b, Notebook 18, p. 53. Other copies after Delacroix made in this period are in Notebook 14, p. 44 *(Hamlet and the Two Gravediggers),* and Notebook 16, p. 36 *(Massacre at Scio). Christ on the Sea of Galilee:* E. G. Bührle Collection, Zurich. *Combat of the Giaour and the Pasha:* Musée du Petit Palais, Paris.

70. Reff 1976b, Notebook 18, p. 53A. See Fries 1964, p. 354.

71. Reff 1976b, Notebook 14, p. 1. In Naples the following year he was reminded of the similar tonality of the seascape in Delacroix's *Demosthenes Addressing the Waves of the Sea;* Notebook 19, p. 15, used in 1860–62.

72. Reff 1976b, Notebook 15, p. 6, used in 1859–60. The original coloring of Jephthah's costume appears in the cracks that have developed in the present paint surface.

73. See Fries 1964, pp. 354–55.

74. L 96, dated 1861–64, but more likely of 1859–60. On the influence of Delacroix, see also Eleanor Mitchell, "La Fille de Jephté par Degas, genèse et évolution," *Gazette des Beaux-Arts* 18 (October 1937), pp. 181–82.

75. A leaping dog had already appeared in some of the studies: Reff 1976b, Notebook 18, pp. 5, 15, 17; and L 97.

76. See Valéry 1960, pp. 91–93; Reff 1976a, chap. 7, pp. 299–302.

77. See Charles Sterling, "Chassériau et Degas," *Beaux-Arts,* no. 21, May 26, 1933, p. 2.

78. Goncourt, *Manette Salomon,* p. 13. See Léon Rosenthal, *Du Romantisme au réalisme: Essai sur l'évolution de la peinture en France de 1830 à 1848* (Paris, 1914), pp. 157–67.

79. L 124, 125; both are signed and dated 1865. L 125, formerly entitled *A Woman with Chrysanthemums* and thought to portray Mme Hertel, has been shown to represent other blossoms and to portray Mme Paul Valpinçon; see Henri Loyrette in Paris, Ottawa, New York 1988–89a, pp. 114–16.

80. Robaut 1885, nos. 557, 1012, 1041, 1071, 1072. On the possible influence of Courbet and Millet, see Boggs 1962, p. 32.

81. See the remarks reported in Edmond de Goncourt and Jules de Goncourt, *Journal, Mémoires de la vie littéraire,* ed. Robert Ricatte, 22 vols. (Paris, 1956), vol. 10, pp. 164–65, dated February 13, 1874.

82. Letter to Albert Bartholomé, September 9, 1882, *Lettres de Degas* 1945, p. 69.

83. Letter to the same, September 18, 1889, ibid., p. 145.

84. Letter to Henri Rouart, October 26, 1880, ibid., p. 60. The pastel in question is probably Robaut 1885, no. 329 or 1057.

85. Joris-Karl Huysmans, "L'Exposition des Indépendants en 1880," *L'Art moderne* (Paris, 1883), pp. 119–20.

86. See the provenance in Maurice Sérullaz, *Mémorial de l'Exposition Eugène Delacroix,* exh. cat., Paris, Musée du Louvre (Paris, 1963), no. 123; both earlier and later, the picture was in private collections.

87. L 101, dated 1862–80.

88. See André Michel, "L'Exposition d'Eugène Delacroix à l'École des Beaux-Arts," *Gazette des Beaux-Arts* 31 (April 1885), pp. 289–308.

89. L 772, dated 1884, but first exhibited in 1886, hence possibly of ca. 1885. The use of cross-hatched, complementary colors in *The Toilette,* another pastel of this period, also shows Delacroix's influence; see L 847, dated ca. 1885.

90. Fries 1964, pp. 355–56. I am indebted to Mr. Fries for the photograph of this copy. If the picture framer on the rue Fontaine whose stamp appears on the back of Degas's copy (ibid., p. 356 n. 59) was Tasset et Lhote, this would support a date in the mid-1890s rather than earlier; see Fevre 1949, p. 140.

91. See Reff 1964a, p. 256, fig. 5. The Delacroix figured in a sale in 1897 for which Durand-Ruel, Degas's dealer, was the expert; see Sérullaz, *Mémorial de l'Exposition Eugène Delacroix,* no. 490.

92. For example, in *Four Dancers Waiting in the Wings,* L 1267, dated 1896–99.

93. See D. Rouart 1945, p. 46, for this and what follows.

94. Halévy 1964, pp. 72–73; on the lithographs, see p. 57. According to Valéry 1960, p. 71, Degas already "greatly admired" *The Battle of Taillebourg.*

95. See Jeanniot 1933, p. 158.

96. Ibid., pp. 284–85.

97. See Paul Poujaud's letter to Marcel Guérin, January 15, 1933, *Lettres de Degas* 1945, p. 253; and Collection Sale I: 24–36.

98. Collection Sale I: 110–65; Collection Sale II: 86–153.

99. See, for example, Doré's *Ménagerie parisienne* (Paris, 1854), pls. 10, 12, etc.; and his illustrations for Blanchard Jerrold, *London, A Pilgrimage* (London, 1872), pp. 161, 167, etc. The Dante illustration in Reff 1976b, Notebook 18, p. 116, ca. 1861, is clearly based on those by Doré in the Paris, 1861, edition of *The Inferno.*

100. Daniel Halévy, *Pays parisiens* (Paris, 1929), p. 60.

101. See Crouzet, *Un Méconnu du Réalisme,* pp. 332–44.

102. Jeanniot 1933, p. 171. The proofs were of *Rue Transnonain* and *Liberty of the Press;* Delteil 1925–26, nos. 135, 133, respectively, both dated 1834.

103. Jeanniot 1933, p. 171.

104. Reff 1976b, Notebook 6, pp. 15–18, used in 1856.

105. L 766*bis,* private collection. See also the drawings, Atelier Sale IV: 264b, 272b, 276b, and Boggs 1962, pp. 67–68.

106. *Tanagra:* Musée d'Orsay, Paris. *Roman Pottery Painter:* Art Gallery of Ontario, Toronto. Richard Ettinghausen et al., *Jean-Léon Gérôme,* exh. cat., Dayton Art Institute; Minneapolis Institute of Arts; Baltimore, Walters Art Gallery (Dayton, 1972), nos. 41, 42.

107. Duranty 1878, p. 429.

108. Ibid., pp. 432, 439.

109. Reff 1976b, Notebook 31, p. 6, used in 1878–79. Significantly, the 1878 article was the only one Duranty wrote on Daumier, other than a partial repetition of it in 1879; see Crouzet, *Un Méconnu du Réalisme,* p. 374 n. 119.

110. Duranty 1878, pp. 438–40.

111. Ibid., pp. 429–30.

112. See Reff 1976b, vol. 1, pp. 25–28, on which the following is based.

113. Reff 1976b, Notebook 21, pp. 18, 20, 20 verso, used in 1865–68. See also Daumier's *1830 and 1833*, Delteil 1925–26, no. 66, dated 1834.

114. Reff 1976b, Notebook 23, pp. 32, 33, 84, 148–51, 153, used in 1868–72. The quotation is from Ernst Kris, *Psychoanalytic Explorations in Art* (New York, 1952), pp. 191–92.

115. Reff 1976b, Notebook 31, pp. 84, 85, 92, 96, used in 1878–79. See the photographs reproduced in Léon Deffoux, *Chronique de l'Académie Goncourt* (Paris, 1909), opposite pp. 40, 112.

116. See Lemoisne 1946–49, vol. 1, pp. 95–97; Boggs 1962, pp. 29, 53–54; and Philippe Jones, "Daumier et l'Impressionnisme," *Gazette des Beaux-Arts* 55 (April 1960), pp. 247–50. The one exception is Mary Evelyn Fahs, "Daumier's Influence on Degas, Cézanne, and Seurat," M.A. thesis, Columbia University, 1961, on which the following is partly based.

117. Lemoisne 1946–49, vol. 1, pp. 181–82. It may be significant that Lemoisne is also the author of the standard monograph on Gavarni.

118. Jeanniot 1933, p. 171. However, see Reff 1976a, chap. 5, n. 155, for one instance of the type of influence Gavarni may have exerted on Degas.

119. L 186, dated 1868–69.

120. L 295; Städtische Galerie im Städelschen Kunstinstitut, Frankfurt.

121. Delteil 1925–26, no. 2908, dated 1857.

122. L 433. Delteil 1925–26, no. 3277, dated 1864.

123. L 405, dated 1876–77. Delteil 1925–26, no. 2231, dated 1852.

124. L 380, private collection.

125. Adhémar and Cachin 1973, no. 56, dated ca. 1880, but more likely of ca. 1878. I owe this comparison to Barbara Mathes. For the influence of a Daumier print on *Portraits at the Bourse*, L 499, dated 1878–79, see Boggs 1962, p. 54.

126. See Lemoisne 1946–49, vol. 1, pp. 180–81. Lemoisne gives a figure of 1800 Daumier prints, but only 746 are listed in the sale catalogue, Collection Print Sale: 61–103.

127. See Lemoisne 1946–49, vol. 1, pp. 146–48; and Maison 1968, vol. 1, pp. 31–33, 46.

128. Armand Silvestre, "Le Monde des arts," *La Vie moderne* 1, no. 3 (April 24, 1879), p. 38, quoted in Lemoisne 1946–49, vol. 1, pp. 245–46 n. 131. The painting, in a private collection, is L 410, dated 1876–78, but possibly as early as 1874: see Reff 1976b, Notebook 22, p. 186, used in 1867–74.

129. Maison 1968, nos. I-159 and I-84, respectively. However, Duranty recalled the latter clearly enough in 1878; see Duranty 1878, p. 538.

130. L 685, dated 1882.

131. For example, L 846, dated 1885. See also the etching *The Laundress*: Adhémar and Cachin 1974, no. 32, dated ca. 1879.

132. L 647, dated ca. 1881.

133. *Cafe-Concert Singer Wearing a Glove*: L 478; private collection, Zurich. *Crispin and Scapin*: Musée d'Orsay, Paris (two versions).

134. The Daumier drawings are Collection Sale I: 23, 106–8, and Collection Sale II: 85.

135. Corot, Courbet, Millet, and Ingres are also the ones Duranty singles out as important predecessors in *La Nouvelle Peinture*, pp. 32–33.

136. See Reff 1964, pp. 552–53; and Kermit Swiler Champa, *Studies in Early Impressionism* (New Haven, 1973), pp. 15–16.

137. See François Daulte, "Renoir's 'Ingres' Crisis," *Paintings by Renoir*, exh. cat., Art Institute of Chicago (Chicago, 1973), pp. 13–17; and Michel Drucker, *Renoir* (Paris, 1944), pp. 24–25, 35–36, 195, 198, etc., on Delacroix.

138. See Gerstle Mack, *Paul Cézanne* (New York, 1942), pp. 146–49, 380, on Ingres, and pp. 143, 201, on Daumier; also Sara Lichtenstein, "Cézanne and Delacroix," *Art Bulletin* 46, no. 1 (March 1964), pp. 55–67.

139. See Alain de Leiris, *The Drawings of Édouard Manet* (Berkeley and Los Angeles, 1969), pp. 59–63, on Ingres, and pp. 18, 62–63, on Delacroix; also John Richardson, *Manet* (London, 1969), pp. 10, 14, 89, on Daumier.

140. Valéry 1960, p. 25.

141. See André Ferran, *L'Esthétique de Baudelaire* (Paris, 1933), pp. 229–30. It was evidently also the last time, at least in published art criticism. The only comparable statement I have found, Champfleury's remark in 1848 that Daumier had "proven to the unbelieving that [he] can walk with Delacroix, Ingres, and Corot, the only three masters of the modern French school," refers to Daumier's paintings, not his drawings: Champfleury [Jules Husson, *dit* Jules Fleury], "Concours de Républiques," *Oeuvres posthumes de Champfleury, Salons 1846–1851* (Paris, 1894), p. 99; first published in *Le Pamphlet,* August 6, 1848.

142. Charles Baudelaire, "Salon de 1845," in Baudelaire 1975–76, vol. 2, pp. 355–56. The translation is from Charles Baudelaire, *Art in Paris 1845–1862: Salons and Other Exhibitions Reviewed by Charles Baudelaire,* trans. and ed. Jonathan Mayne (London, 1965), p. 5.

143. In an unpublished letter, datable to July 1869 (formerly collection Jean Nepveu-Degas, Paris), Manet asks Degas to return "the two volumes of Baudelaire" that he had borrowed. These were undoubtedly *Curiosités esthétiques* and *L'Art romantique,* published in 1868 as volumes 2 and 3 of Baudelaire's *Oeuvres complètes*.

144. See n. 142.

145. Private collection, Paris; partly published in Daniel Halévy, *Degas parle . . .*, ed. Jean-Pierre Halévy, rev. ed. (Paris, 1995), p. 255. This edition corrects the date of Daniel Halévy's journal entry in the 1960 edition, which I had questioned (in Reff 1976a, n. 139); it is January 27.

146. The painter Léon Bonnat, whose important collection is now in the Musée Bonnat at Bayonne.

147. Ludovic Halévy's sons.

148. Institut Néerlandais, Paris, Fondation Custodia, Ms. 1977–A632, unpublished.

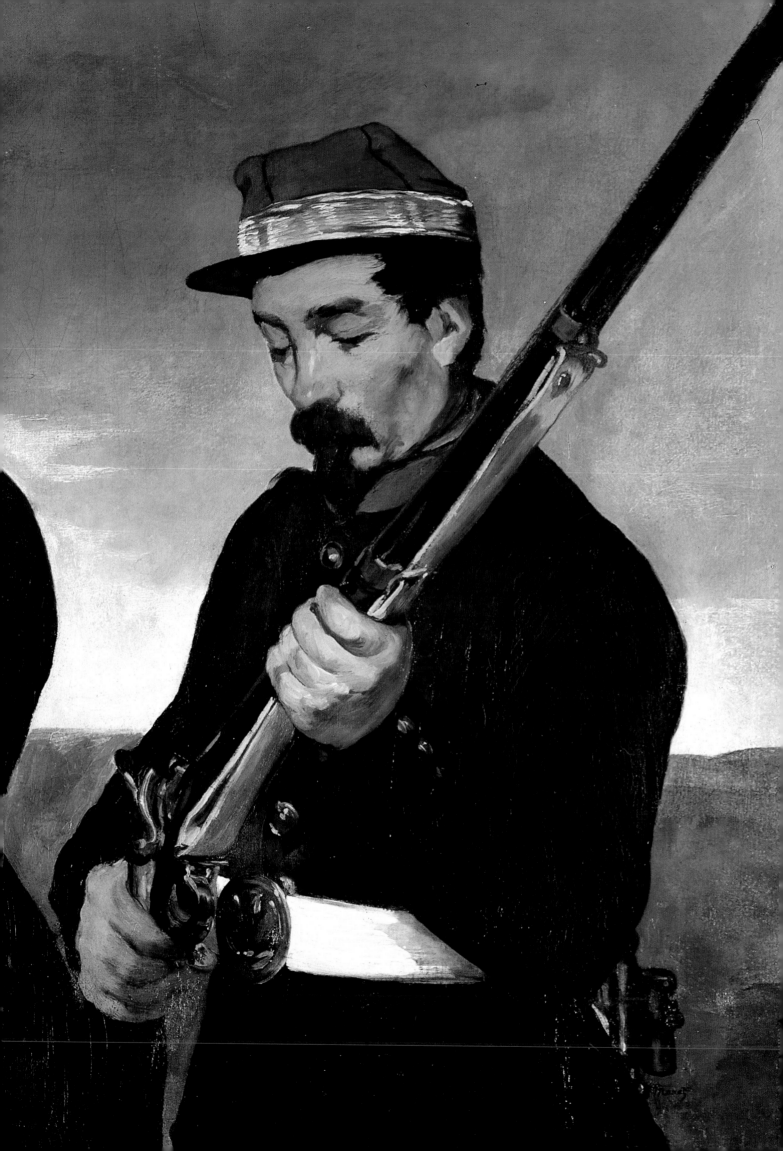

Manet and Degas: A Never-Ending Dialogue

MARI KÁLMÁN MELLER AND JULIET WILSON-BAREAU

L'art n'est pas un amour légitime; on ne l'épouse pas, on le viole." ("Art is not a legitimate love; one does not marry it, one rapes it.")[1] Edgar Degas's almost untranslatable epigram reflects the passions and conflicts behind his own work, which carries a pervasive aura of transgression. As a collector, however, his passion was legitimate; the inveterate bachelor artist cherished a tender, if also contentious, attachment to the pieces he gathered under his roof like an adopted family.

Degas's collection has always been admired for "the great critical power in its selectiveness" noted by Roger Fry[2] and for its exemplary "texture," closely woven from the threads of nineteenth-century artistic practice. At the same time, the record shows how Degas's taste interacted with chance and opportunity. Among his works by Édouard Manet (1832–1883), for example, some were gifts, some were exchanges with Degas's own "articles," as he called them, and some were purchased at public sales or from Manet's widow. In this essay an attempt is made to interpret, from the pictures and prints by Manet that Degas owned, the savor of Manet's incomparably bold address to the artistic aims that preoccupied them both. Each of the Manets in his household was a participant in a dialogue that, in Degas's mind, never came to an end.

In addition to the works he actually acquired over many years, which were dispersed in the collection sale, Degas's interest in the art of certain friends amounted to a "virtual possession" and provides an intimate glimpse into his personal relationships. With the artist's future plans for his collection in mind, Berthe Morisot wrote a few hours before her death to her daughter Julie, "Tell Monsieur Degas that if he founds a museum, he must choose a Manet."[3]

MUSICAL SOIREES, CAFÉ DEBATES

Artistic, political, and social factors that stand behind the Manet-Degas relationship and, more broadly, behind the

development of the "New Painting" are crucial to an understanding of both artists and of their work.[4] Even the story—perhaps a legend?—of the first meeting of the two has its symbolic value. The setting is the Louvre, where Degas is copying from the portrait of the Infanta Margarita by Velázquez. Manet expresses his delight and astonishment at Degas's daring in rendering the work directly onto a copperplate.[5] The supreme artist of the Spanish painting tradition was Manet's ultimate ideal and was more important for Degas than has generally been believed. Manet too made an etched copy of the *Infanta* (fig. 241), markedly different from the print by Degas; each work reveals the individual traits of its maker. Besides Velázquez and the Spanish school, the Flemish and Italian old masters nourished the development of both Manet and Degas. The art of Degas is profoundly italianate, while echoes of Raphael, Titian, and Veronese resound in Manet's early work. In addition, the indelible influence of the French tradition—from the Le Nains to J.-A.-D. Ingres, Eugène Delacroix, and Honoré Daumier—constituted common ground between Manet and Degas.[6]

It was in the salon of the Morisot family and at the musical soirees organized by Degas's father and by the Manets that the two artists' acquaintance developed into friendship. There the Spanish musicians Lorenzo Pagans and Jaime Bosch brought the traditional genre figure of the popular entertainer to life, singing and accompanying themselves on the guitar. Manet's early Salon success, *The Spanish Singer*, his cover design for the sheet music of "A Moorish Lament" by Bosch, and Degas's repeatedly painted double portraits of Pagans and Auguste De Gas (fig. 92) were new renditions of this theme.[7] The atmosphere of these soirees was quite different from that of the exhilarating afternoons spent at the Café Guerbois and later at the Nouvelle-Athènes, where ideas for a "New Painting" were debated. Manet's striking presence and "cutting, punching way of arguing," Degas's scornfully sarcastic observations and incessant "inventions," have been richly recorded.[8] Among the habitués, an assemblage that included artists,

Fig. 241. Édouard Manet, *Infanta Margarita, after Velázquez*, 1860. Etching, 9 × 7½ in. (23 × 19 cm). Nationalmuseum, Stockholm (NM G 310/1924). Collection Print Sale: 246

printmakers, critics, and writers, was Claude Monet, who late in life still remembered these animated discussions: "You always left the café feeling hardened for the struggle, with a stronger will, a sharpened purpose, and a clearer head."[9] These fertile years were abruptly interrupted in 1870 by the Prussian invasion of France. In the war that ensued, Manet and Degas were both "ready to die to save the country," and when Degas was disqualified from the infantry because of poor eyesight, he enrolled, with Manet, in the artillery.[10] In the 1870s, after the war, the two artists chose divergent paths. Manet was determined to try to make his career by way of the official Salon; Degas, with the scornful motto "The Salon does not exist," devoted his efforts to bringing the Impressionist exhibitions into being and was never to change his anti-conformist defense of artistic independence.

Fig. 242. Édouard Manet, *Madame Manet on a Blue Sofa*, ca. 1874. Pastel, 19¼ × 23⅜ in. (49 × 60 cm). Musée du Louvre, Paris, Département des Arts Graphiques, Fonds Orsay (R.F. 4507). Collection Sale I: 221

Fig. 244. Édouard Manet,
Woman in a Tub, 1878–79.
Pastel on board, 21¾ × 17¾ in.
(55 × 45 cm). Musée d'Orsay,
Paris, Département des Arts
Graphiques (R.F. 35.739)

WHAT THE PICTURES SAY

Unrelentingly critical and self-critical, Degas, the bad-tempered "grump" *(grincheux),* never ceased his dialogue with his execrated yet venerated rival: "Damned Manet," he lamented to the English painter Walter Sickert. "Everything he does he always hits off straight away, while I take endless pains and never get it right."[11] Clearly, the admirable assurance of Manet, "whose eye and hand are certainty itself," his ease, and the disarming immediacy with which he brought his subjects to life made a great impact on Degas—Degas who, with his keenly different nature, constantly "postpones pleasure, cultivates difficulty," in the words of Paul Valéry, who knew him intimately.[12]

Manet's pastel portrait *Madame Manet on a Blue Sofa* (fig. 242) exemplified for Degas all the virtues of this porous,

Fig. 245. Édouard Manet, *Pear,* ca. 1880. Oil on canvas, 8⅝ × 6¼ in. (22 × 16 cm). Location unknown. Collection Sale I: 79

volatile medium, which was mastered by his friend and which he himself adopted early on as an integral part of his craft. In this sumptuous piece of work—for one observer a portrait, for another a still life—the bluer-than-blue couch supports the sitter's cloudy whites and grays before a golden backdrop. The pastel was one of Degas's three best-loved pictures, according to his friend Paul Poujaud.[13]

The two oils of about 1880, *Woman with a Cat (Madame Manet)* (fig. 243) and a minimalist still life, *Pear* (fig. 245), are further examples of Manet's pictorial boldness. In the unfinished portrait of his wife with Zizi the cat, Manet's impetuous brushwork aims far beyond description, anticipating abstract action painting. By sensualizing both support and medium, the artist transforms his "motif"—a woman, a pear, a ham (fig. 8)—into a lush, immediate presence to be devoured by the viewer.

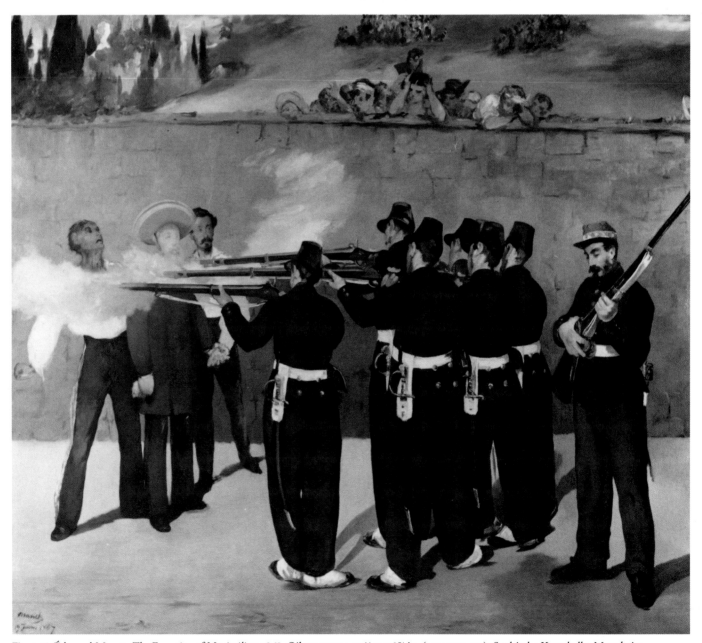

Fig. 246. Édouard Manet, *The Execution of Maximilian,* 1868. Oil on canvas, 99¼ × 118⅞ in. (252 × 302 cm). Städtische Kunsthalle, Mannheim

Fig. 247. Édouard Manet, *The Execution of Maximilian*, 1868. Lithograph, first state, 13⅛ × 17 in. (33.3 × 43.3 cm). Private collection. Collection Print Sale: 271

paintings remains the same, but the visual language changes radically from one version to another. The first (Museum of Fine Arts, Boston), recalling Goya's *Executions of May 3, 1808* (Museo del Prado, Madrid), conveys a sense of chaos and darkness, of guns, smoke, and death. The second version, which survived thanks to Degas's intervention, played a transitional role, leading from the overwhelming tumult of the first picture toward the objective reportage that culminates in the third with "killing" precision (fig. 246). In this final version a high wall, reminiscent of a prison, runs from side to side across the canvas, flattening the scene and emphasizing its highly articulated, decorative quality. In a narrow strip of canvas above the wall, with the cemetery on the left, small-scale, unidentifiable figures watch the drama as they would a bullfight and comment, like the chorus in a Greek tragedy, on the scene enacted below.

DEGAS PORTRAYS MANET

Degas's healing instinct showed itself again in his intention to restore the damage done to his own double portrait *Monsieur and Madame Édouard Manet* (fig. 248). The painting had been attacked by Manet, who, unhappy with Degas's portrayal of his wife's features, sliced through the canvas. Julie Manet described the incident after a visit to Degas's home in 1895: "I admired the portrait of my Uncle Édouard, which I had never seen. The portrait was the cause of a quarrel. M. Degas had done Aunt Suzanne at the piano and my Uncle Édouard lying on a sofa listening to her. Finding his wife's portrait highly unflattering, [Manet] cut it off. M. Degas was rightly angered by this action and took away the canvas, which is now in his sitting room."[17] The painting appears in a photograph of the 1890s as Julie must have seen it, hanging next to Manet's still life *The Ham* and above a framed proof of *Polichinelle* (fig. 7). Although years later Degas added a blank piece of canvas on the right, in the end he failed to reconstruct the pianist's likeness.[18]

Even mutilated, the work reflects conjugal serenity. While Suzanne plays the piano, Édouard is sunk in the upholstered comfort of a sofa, behind his wife rather than facing her. His utterly informal posture is a landmark in the history of painting. George Moore wrote of it, "This picture is something more than a likeness: it is as if you saw the man's ghost"[19]—a *fin-de-siècle* variant on the Renaissance opinion that a portrait by Filippino Lippi was "more like the sitter than he is himself."[20] Something of Manet's particular appearance is perhaps captured by Degas's observation in one of his notebooks: "Il y a des gens *bien mal mis;*

While Degas's absorption of Manet's manner entailed an organic transformation, the same cannot be said of Manet's borrowings from Degas. His pastel *Woman in a Tub* (fig. 244) of circa 1879, inspired by Degas's updated Susannas with their modern accessories of tin tub, sponge, and towel, does not attempt to match his colleague's intricate engineering. Moreover, the young woman dares to respond serenely to our gaze. (Who has ever seen a serenely responding bather by Degas?)

THE STORY OF MANET'S "MAXIMILIAN"

Referring to the imminent Degas sales in 1918, Roger Fry commented, "It seems a pity that the French nation is not able to keep this magnificent collection together in the Louvre."[14] The English critic could not foresee that Manet's *Execution of Maximilian, Emperor of Mexico* (figs. 60, 240) and twenty-six other works would shortly join British public collections and there serve to represent modern French art. This work, damaged and cut into pieces, was saved by Degas in the 1890s when he retrieved several fragments from different locations and reunited them.[15] He already owned an impression of Manet's lithograph of the subject, acquired in 1891 (fig. 247).

Manet's triple staging of the *Execution* breaks through the tired idioms of conventional history painting, uniting the apparently incompatible: on the one hand, unceremonial reportage of the political subject (with its implicit criticism of Emperor Napoleon III) and, on the other, a monumental presentation of the tragic scene.[16] The subject of his three

Fig. 248. Edgar Degas, *Monsieur and Madame Édouard Manet,* ca. 1868–69. Oil on canvas, 25⅝ × 28 ⅜. (65 × 71 cm). L 127. Kitakyushu Municipal Museum of Art (0-119). Atelier Sale I: 2

plus encore, je crois, de *mal bien mis.*" ("There are some people who are badly turned out well; and some who are well turned out badly.") Degas set down in the same notebook an amplification of the statement by the writer Jules Barbey d'Aurevilly: "There is sometimes a certain ease in awkwardness which, if I am not mistaken, is more graceful than grace itself."[21] This attitude is illustrated by Nadar's well-known photograph of Charles Baudelaire in which the poet (a professional dandy and admirer of Manet) sports a carelessly tied cravat. In a self-portrait drawing he wears a cravat with even more ostentatious negligence. Another example is provided by Stendhal, who, writing in the 1840s about England in his book *On Love,* refers to what he terms, in English, the "carefully careless" manner invented in Bond Street. He is quick to add: "A Frenchman . . . knows that without ease there can be no grace." The current meanings of the words "debonair" and "nonchalant" touch only lightly on the attitudes thus

analyzed. In the double portrait by Degas, Manet's body language expresses the particular state of mind of one who is physically present but psychically absent. Degas's por-

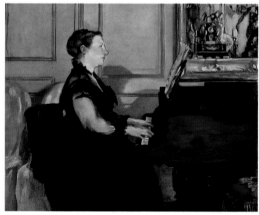

Fig. 249. Édouard Manet, *Madame Manet at the Piano,* 1867–68. Oil on canvas, 15 × 18 in. (38 × 46 cm). Musée d'Orsay, Paris (R.F. 1994)

Fig. 250. Edgar Degas, *Head of Manet*. Lithograph, ex coll. Marcel Guérin. Location unknown

trayals of the moods and tensions in human relationships are psychoanalytic essays in visual form.

The room itself, with the piano, is no doubt the one at 49, rue de Saint-Pétersbourg in which the Manets held their musical soirees from 1866 through the 1870s. Degas's double portrait is very close to Manet's own painting of his wife at the piano (fig. 249), and both works are usually dated to the late 1860s.[22] They show the same white dust covers on the furniture, one of the distinctive "new accessories" repeatedly painted by Degas—"the most inventive mind, in the modern sense of the word"—in his up-to-date interior scenes.[23] Lines of paneling, suggested behind Manet in Degas's portrait and strongly defined behind Suzanne in Manet's, reappear in Degas's *Song Rehearsal* of 1872–73 (fig. 95), once again behind the pianist's head, in a striking demonstration of the grid system essential to Degas's compositions at this time.[24]

Degas made several drawings and etched portraits of Manet.[25] One of these, the etching *Édouard Manet Seated, Turned to the Right* (fig. 363), shows a stretched canvas behind Manet, indicating a studio setting. The unpreten-

Fig. 251. Edgar Degas, *Manet Seated*, ca. 1862–64. Black chalk. Private collection, Paris

Fig. 252. Edgar Degas, *Manet Leaning on a Table*, 1864–68. Pencil and India ink wash, 13⅞ × 9 in. (35.2 × 22.9 cm). Musée du Louvre, Paris, Département des Arts Graphiques, Fonds Orsay

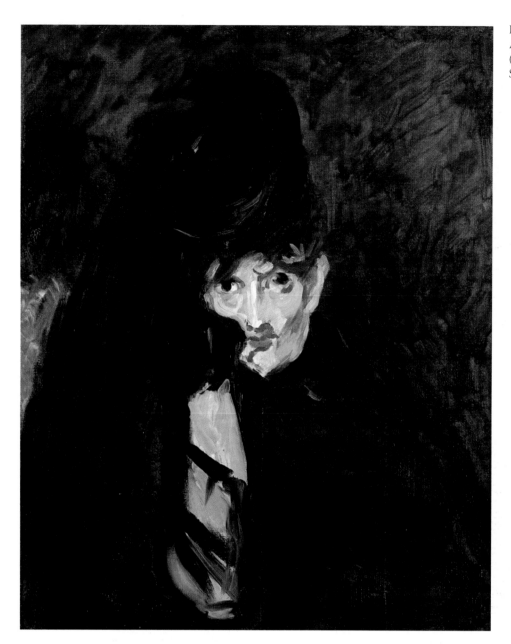

Fig. 253. Édouard Manet, *Berthe Morisot in Mourning,* 1874. Oil on canvas, 24 × 19¾ in. (61 × 50 cm). Private collection. Collection Sale I: 76

tious posture, with the artist sitting sideways on his chair, is again of the "carefully careless" kind, and, as so often, Degas is playing with opposed angles against the picture plane. Is this the informality of the sitter or perhaps of Degas himself, or simply a way to enliven the surface? The group of drawings of Manet was presumably made over a brief period of time: at the top of the sheet with preparatory drawings for the etching (fig. 251) is a small study of Manet's head as it appears in a washed drawing of the artist seen leaning against a table (fig. 252).

Degas's penetrating insight and his particular realism, even where most obviously stylized, bring the appearance of Manet extraordinarily close to the present-day viewer. This is the supreme merit of all Degas's portraits of Manet, in whatever medium. Although the portrait etchings are somewhat dry—not veiled and shaded, like his earlier prints—there is a small lithograph, known only from the

Fig. 254. Edgar Degas, *Melancholy,* ca. 1867–70. Oil on canvas, mounted on panel, 7½ × 9½ in. (19 × 24 cm). L 357. The Phillips Collection, Washington, D.C.

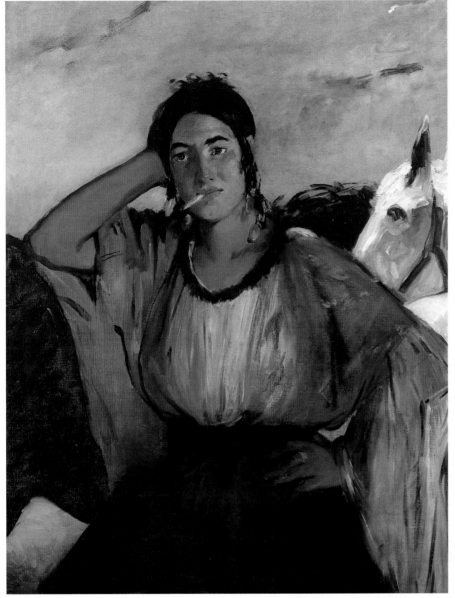

Fig. 255. Édouard Manet, *Gypsy with Cigarette*. Oil on canvas, 36¼ × 28⅞ in. (92 × 73.5 cm). The Art Museum, Princeton University, Bequest of Archibald S. Alexander, Class of 1928 (y1979-55). Collection Sale I: 78

Fig. 256. Édouard Manet, *Nana,* 1877. Oil on canvas, 60¾ × 45¼ in. (154 × 115 cm). Hamburger Kunsthalle, Hamburg

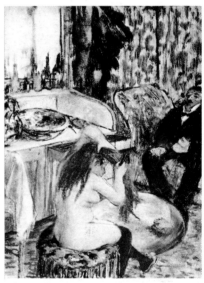

Fig. 257. Edgar Degas, *Brothel Scene,* 1876–77. Pastel over monotype, 8½ × 6⅜ in. (21.5 × 16.2 cm). L 456. Ex coll. Ittelson Collection

frontispiece illustration to Marcel Guérin's catalogue of Manet's prints (fig. 250), in which Manet's well-shaped, leonine head is softly rounded like a relief or some finely worked antique gem.[26]

FEMALE IMAGES

Two men, two artists: Manet and Degas project two inherently different worlds of women. Yet two female images by Manet in Degas's collection are a far cry from the artist's better-known society beauties, with their fairy-tale dresses and hats or appealingly naked busts. The *Gypsy with Cigarette* (fig. 255), of undetermined date, suggests the interest of both painter and collector in a freer type of woman who existed outside the social hierarchy.[27] The

portrait of Berthe Morisot in mourning, painted in 1874 (fig. 253), speaks of human anguish in the face of death, a lifelong trauma for Degas. In this commanding work of art, the drama of the subject is masterfully synchronized with Manet's cruel, oily blacks and eloquent brushstrokes.

Tragic expression takes on varied forms in Degas's own imagery. *Melancholy* of circa 1867–70 (fig. 254) is self-tormenting in its fiery chromaticism and represents, like the double portrait of the Manets discussed above, a particular state of mind. More elegiac is Degas's evocation of his relatives in *The Duchessa di Montejasi with Her Daughters Elena and Camilla*, painted in 1876.[28] And other states of mind find nuanced expression: on the rare occasions when Degas's visual translation of mood catches a fleeting smile on female lips, as in *Woman on a Sofa* of about 1868–72,[29]

Fig. 258. Édouard Manet, *The Races*. Lithograph, first state, 14½ × 20¼ in. (36.8 × 51.4 cm). Nasjonalgalleriet, Oslo (16509). Collection Print Sale: 279

Fig. 259. Edgar Degas, *Jockey on a Galloping Horse,* 1875–76. Black chalk, 12⅜ × 8⅞ in. (31.5 × 22.5 cm). Private collection. Atelier Sale IV: 230

Fig. 260. Édouard Manet, *Greyhound,* 1871. Oil on canvas, 7⅝ × 9¾ in. (19.4 × 24.7 cm). Private collection

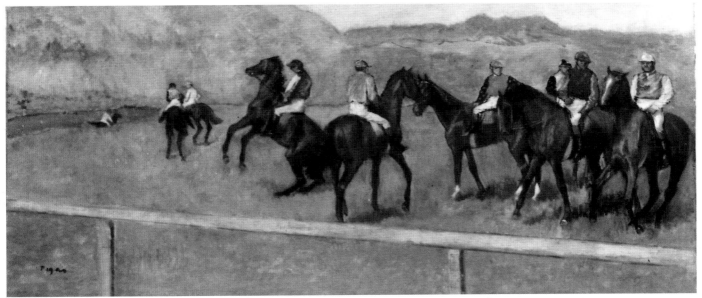

Fig. 261. Edgar Degas, *Behind the Rails,* ca. 1880. Oil on canvas, 15⅜ × 35 in. (39 × 89 cm). E. G. Bührle Collection, Zurich

the viewer searches outside the picture frame for the person whom she addresses.

Known above all as the painter of the dancer, Degas represents all his female sitters, whether laundresses and milliners or of his own social class, with the same impartial observation. In images that place the sexes intimately side by side, the divergence between Manet and Degas is sharply revealed. Manet's generously curvilinear *Nana* (fig. 256), paralleling the demimondaine heroine of Zola's contemporaneous novel, and Degas's ungainly naked prostitute combing her hair in *Brothel Scene* (fig. 257) are both watched by their admirers. But while Manet's raillery verges on complicity, Degas nails the marketed pleasure as miserable, comic, and absurd.

TIME AND MOTION — PUBLIC SPACES

The suggestion of movement is a sine qua non of Degas's imagery. Addicted as he was to indirect, sophisticated manipulations, he must have been struck by Manet's impressively straightforward representation of speed in his view of a horse race in the Bois de Boulogne painted in 1864 (subsequently dismembered and reworked).[30] Degas owned a splendid first state of the undated lithograph of this subject, *The Races* (fig. 258). In all three known versions of this composition Manet focused on the group of five horses thundering out of the distance, but in this print the enormous expanses of sky and foreground, far greater than in the other two works, accelerate the exploding energy of the animals' headlong gallop.

Although Degas did not share Manet's interest in the representation of speed as the central subject of racing

scenes, sculptures[31] and drawings of a horse at full gallop (fig. 259)[32] are among his highest achievements. Degas abstracts from the sporting event the elements he needs to represent not speed but time. His system is based on relativity, measuring the tempo of one horse or group of horses against another, as can be observed in *Behind the Rails* (fig. 261). These racing scenes, based on detailed studies made in situ and meticulously composed in the studio, can be read as a thesis on the relationship of time and space.

In the elongated fields of the races, just as in the similarly multifocused, friezelike ballet scenes, varying tempi and melodic cadences move within and beyond the picture frame.[33] Degas's compositional devices take account of the viewer's perceptual processes: "He makes visible some of the paradoxes in vision itself, the things we must sort out before we can make sense of them," as Theodore Reff has observed.[34] Manet does the same, not only in the ambitious racecourse composition discussed above but also in his daring depiction of a "galloping" greyhound (fig. 260) in which the dog's forelegs are elongated, which is how they would be perceived, while the blurring of the hind legs mocks the slowness of the viewer's eye.[35]

Degas began painting racecourses earlier than Manet, for once anticipating his friend in the choice of a contemporary subject. In his earliest known racing scene, *At the Racetrack* of 1861 (Kunstmuseum, Basel), the gallop, a luminous, miniaturized vision, speeds out of sight like a miracle vanishing before the eyes of distracted "believers" — in this case, the spectators at a sporting event. Though the nominal subject is a racing scene, its real theme is the act of looking. In the later 1860s, Degas assembled drafts and

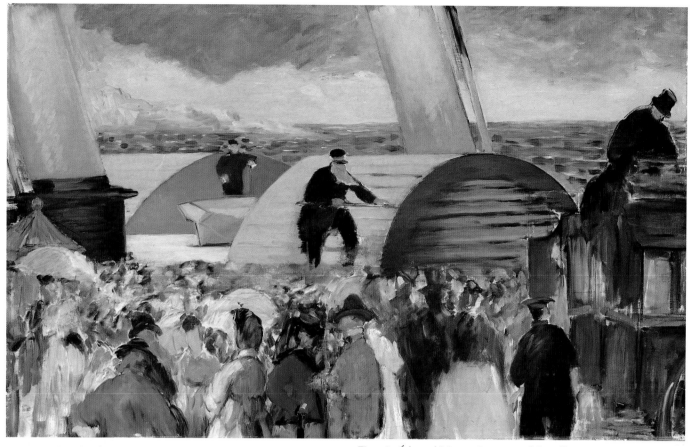

Fig. 262. Édouard Manet, *Departure of the Folkestone Boat*, 1869. Oil on canvas, 24⅜ × 39⅜ in. (62 × 100 cm). Oskar Reinhart Collection "Am Römerholz," Winterthur, Switzerland. Collection Sale I: 72

Fig. 263. Édouard Manet, *Bazaine before the War Council*, 1873. Graphite, 7¼ × 9⅜ in. (18.5 × 23.8 cm). Museum Boijmans Van Beuningen, Rotterdam (F-II-107). Collection Sale I: 219

Fig. 264 (lower left). Édouard Manet, *At the Theater*, ca. 1880. Black chalk, 7¼ × 10¾ in. (18.5 × 27.2 cm). André Bollag-Bloch, Switzerland. Collection Sale I: 229

Fig. 265. Édouard Manet, *At the Folies-Bergère*, ca. 1880. Pen and brown ink over graphite, 5⅞ × 8⅝ in. (15 × 21.8 cm). Private collection. Collection Sale I: 218

studies for an unrealized painting with the figure of Manet in the foreground watching a race (or perhaps looking instead at the woman next to him, as has been suggested) (fig. 367).[36] Manet knew how to respond to such *plaisanteries*, turning Degas's little joke against him. Glimpsed in the foreground of his own racing scene of 1872, *The Races in the Bois de Boulogne*, are the figures of Degas and a woman, evidently determined to avoid each other's gaze.[37]

"One paints a crowd not with fifty but with five," said Degas.[38] This principle is exemplified in Manet's *Departure of the Folkestone Boat* of 1869 (fig. 262) and in his early lithograph *Balloon* (fig. 274). Degas owned a number of drawings by Manet that focus on political and public events involving crowds of figures: *Bazaine before the War Council* of 1873, *At the Theater* and *At the Folies-Bergère*, both of circa 1880 (figs. 263–265). These graphite sketches, sometimes with hints of caricature, show Manet's own notational formulae for representational problems posed by another eminently Parisian master, Honoré Daumier, whose prints Degas amassed in vast quantities.[39]

"La Belle Peinture" and Its Ever-Changing Artifices

Manet's monochrome prints and drawings, works of extraordinary painterly richness, inevitably had a great impact on Degas, who repeatedly expressed his enthusiasm for the black-and-white image. Such diverse prints as the early etching *La Toilette,* with its mysterious chiaroscuro (fig. 270), and the lithograph of *The Races* mentioned above (fig. 258) powerfully suggest color where there is none. Degas undoubtedly also knew *Le Corbeau (The Raven)*, the bilingual edition of Poe's poem published in 1875 with Stéphane

Fig. 266. Édouard Manet, *Head of a Raven, with Duret's Dog, Tama,* 1875. Transfer lithograph, 9⅞ × 12⅞ in. (25 × 32 cm). Nationalmuseum, Stockholm (NM G 326 1924). Collection Print Sale: 285

Fig. 267. Édouard Manet, *The Raven: "Perched upon a bust of Pallas . . . ,"* 1875. Transfer lithograph, 18¾ × 12½ in. (47.5 × 31.6 cm). The Metropolitan Museum of Art, New York, Harris Brisbane Dick Fund, 1924 (24.30.27 [3])

Fig. 268. Édouard Manet, *The Raven: "That shadow that lies floating on the floor . . . ,"* 1875. Transfer lithograph, 11⅜ × 10⅞ in. (29 × 27.6 cm). The Metropolitan Museum of Art, New York, Harris Brisbane Dick Fund, 1924 (24.30.27 [5])

Fig. 269. Edgar Degas, *Madame Camus in Red,* 1870. Oil on canvas, 28¾ × 36¼ in. (73 × 92 cm). L 271. National Gallery of Art, Washington, D.C. Atelier Sale I: 96

Mallarmé's translation and Manet's orientalizing illustrations that echo the poem's subject and style. Degas owned two proofs of the *Head of a Raven, with Duret's Dog, Tama* (fig. 266), a precious rarity.[40] This bizarre print shows the "grim, ungainly, ghastly, gaunt and ominous bird of yore," which reappears on a page of the publication sitting on the bust of Pallas and croaking "Nevermore" (fig. 267). Its doom-laden figure casts a pale shadow on the wall, while random brush strokes suggest the horror of the night. On the final page an overwhelmingly "corporeal" shadow pours into the room, reshaping itself on the floor into the raven (fig. 268). It evokes, as Japanese prints do, "a presence by its shadow, the whole by a fragment."[41] Surrealistic overtones like these are also cunningly woven into Degas's imagery, for instance in his mocking gaslight Impressionism of the late 1870s and early 1880s. In monotypes and etchings, the globes of lamps in public places provoke associations with the moon or with both comically and mysteriously multiplied moons. In the 1890s Degas was chasing effects of darkness and night with his camera, commenting to the Halévys: "It is hard what I am trying to capture, the atmosphere of lamplight, or the moon."[42]

In an article on *japonisme* in Paris, Ernest Chesneau claimed that in his Poe illustrations Manet owed to Japan "the clarity of his shapes and his taste for bizarre forms."[43] Degas had been attacked by Edmond Duranty for a similar trait. Faithful to his own credo of Realism, the critic disparaged Degas's *Madame Camus in Red* (fig. 269), painted five years before Manet's lithograph designs for *The Raven,* and castigated her painter's "systematic interest in the peculiar."[44] Duranty, who hated poetry, compared

the painting with the futilities of the "sonnet-mongers," divining Degas's later experiments with the sonnet form.[45] In Mme Camus's portrait, a decorative sculpture of a "blackamoor" (by Charles Cordier) projects its large shadow on the wall. Here, a concatenation of pseudo-realities rises to a crescendo of artificiality: the illusionistic painted space itself, the sculpture within the picture, the shadow of the sculpture, and the all-pervasive, unnatural redness of the light.[46]

Degas, the painter-poet, and Manet, friend of Baudelaire and the Symbolist poet Stéphane Mallarmé, were both working on a poetic-symbolic plane. In the 1870s and 1880s, the representation of common experience was being enriched by a shift into a visually ambiguous domain layered with impalpable substances, such as cloudy masses of smoke or steam, and complex optical realities like shadows, reflections, and mirrored images. (Of the four exercising dancers in Degas's classroom, one is only a reflection; Manet's barmaid is addressed by a man whose existence we surmise with the help of a mirror.)[47] This visual language itself mirrored a certain perception of life. Styles come and go, ways of sensing life and making it visible are constantly changing, recalling both the inexhaustible example of the old masters and the commitment to express lived experiences, to be modern. Ultimately, the painter is engaged with his cherished, tirelessly exercised *métier* and with the

Fig. 270. Édouard Manet, *La Toilette,* 1861. Etching, second state, 11¼ × 8⅞ in. (28.7 × 22.5 cm). The Metropolitan Museum of Art, New York, Harris Brisbane Dick Fund, 1929 (29.56). Surrogate for Degas's unlocated impression, Collection Print Sale: 240

unfading ideal of art's highest achievements, "la belle peinture." This is the faith that these enthusiastic and prodigiously inventive artists nurtured all their lives.

Degas's well-known comment after Manet's death in 1883, "Il était plus grand que nous ne pensions" ("He was greater than we thought"), is ambiguous. Degas attempts to define Manet's extraordinary talent in a deceptively simple phrase that combines reserve with high praise and carries a note of self-criticism. In his view Manet was "bien plus gentil, bien plus simple" ("much nicer, much simpler") than one-sided memoirs suggested.[48] Significantly, the success of Manet's pictures is bound up with his natural charisma: like Baudelaire's newborn baby blessed by the fairy, he had the gift of pleasing.[49] Some approach to this rare quality is provided by Degas's recollections of his friend's engaging observations, which were noted by Sickert: "He said that Manet had a charming expression. In speaking of a hunchback, for instance, he would say, 'Ça a son chic' ['That has its own chic']."[50] Illuminating, if extreme, this remark reveals Manet's inherent understanding that the life-enhancing, creative instinct for stylization is active even in the deformed.

Degas, Manet's junior by two years, survived him by more than two productive decades, remembering his friend and collecting his work. In the 1890s and later, the congenitally dissatisfied, inveterately puritanical Degas still loved Manet for *Olympia* and loved *Olympia* because she had been created by Manet. He had presented Degas with a crayon tracing of his demimondaine (Collection Sale I: 227), and Degas also owned rare proofs of the two etched versions of *Olympia* (figs. 271, 272). That this "beneficent misanthrope"[51] even kept in the spacious vestibule of his Montmartre apartment a copy by Paul Gauguin of Manet's epoch-making female image (fig. 67) offers a revealing hint of what lies down the emotional corridors of memory and artistic influence.

Appendix: Degas, Connoisseur of Manet's Prints

On Manet's death, his private collection contained not one work by Degas, according to the inventory, although it did include a number of paintings by Claude Monet and works by old friends and colleagues such as Henri Fantin-Latour, Théodule Ribot, and Count Albert de Balleroy as well as Berthe Morisot, Eva Gonzalès, and Giuseppe de Nittis.[52] And Degas had not only taken back his own portrait of Édouard and Suzanne Manet, but had returned to Manet in a fit of pique the still life given him by the artist. Yet Manet's work formed a prized and major part of his collection: Degas owned eight paintings and fourteen drawings by Manet.

One spectacular aspect of Degas's print collection is the quality of the Manet prints. Indeed, reproduced at the head of the section of the catalogue devoted to "Modern Prints" is the extremely rare, possibly unique first state of the larger *Olympia* plate (fig. 272). The catalogue lists a total of sixty-nine separate proofs by Manet under fifty lot numbers (Collection Print Sale: 224–89), the set of nine etchings on Japan paper issued by the publisher and print seller Alfred Cadart in 1874 (lot 290), and a final lot that included a relief print reproduction by Michelet of the *Polichinelle* lithograph and what was described as a "facsimile" of a pen-and-ink drawing of Courbet (fig. 273). The many exceptional items are described in the sale catalogue in laudatory terms: "Very fine and rare," "Superb . . . the only known impression," "Extremely rare." However, the discriminating choices that underlie such a collection had in fact been made not by Degas but by the art critic

Fig. 272. Édouard Manet, *Olympia*, 1867. Etching, first state, 6⅜ × 9½ in. (16.1 × 24.2 cm). New York Public Library, Avery Collection. Surrogate for Degas's unlocated impression, Collection Print Sale: 256

Philippe Burty, an enthusiastic supporter of the etching revival in the 1860s. When his collection of modern prints was sold in 1891 after his death, the outstanding examples by Manet were grouped under one lot number with fifty-five sub-lots. The entire group was purchased by Michel Manzi, from whom Degas then acquired it by exchange.[53]

Burty had had privileged access to the studios of the painter-printmakers and the workshops of their printers, and had a connoisseur's eye for the rare proof, preferably

Fig. 273. Édouard Manet, *Portrait of Gustave Courbet*. Transfer lithograph, 3⅞ × 4¼ in. (9.7 × 10.8 cm). Nasjonalgalleriet, Oslo (16729). Collection Print Sale: 291

hand-touched or lettered. How he came by such exceptional items as Manet's *bon à tirer* proof (the artist's authorized proof) of the frontispiece etching *Hat and Guitar*, dedicated "To my friend Charles Baudelaire" (fig. 76), or one of only three known proofs of the earlier trial plate for a frontispiece with *Polichinelle* (Collection Print Sale: 260), is unknown. The collection included proofs of all fourteen prints listed on the frontispiece etching as well as the two trial versions of *Boy with a Sword* (Collection Print Sale: 263, 264), possibly Manet's earliest prints made with the help of Alphonse Legros, in which he set out to master the art of etching by copying his own oil painting of 1861 (in The Metropolitan Museum of Art, New York). Further rarities connected with Baudelaire include proofs of the etchings made for Charles Asselineau's biography of the poet published in 1869 (fig. 77), one of them with a chalk-drawn banderole added (Collection Print Sale: 247–49). All Manet's lithographs were present, except for the earliest (known only in a unique proof since it was reproduced mechanically in a periodical) and the ephemeral song sheet *Lola de Valence*.[54] For most of the lithographs, either the print is altogether of exceptional rarity, like the proof of *Balloon*, or the artist's proof state, before letters, is unique or rare. This is the case for the lithographs that were published by Manet's widow in 1884 and of which the proofs in Burty's collection were very possibly made during the artist's lifetime (Collection Print Sale: 271, 276–79). Also of the greatest rarity is the proof from Manet's original chalk

drawing on stone of *Polichinelle*, annotated by him "Épreuve unique" (fig. 275); although there is in fact a second "original" proof that Manet colored with gouache and watercolor (private collection, New York) to serve as the model from which the printer Lemercier's technicians could prepare the color stones after transfer of Manet's original lithograph "drawing." The "unique" proof of *Polichinelle*, printed in black, is almost certainly identifiable hanging on the wall in Degas's apartment, next to the Manet *Ham* and below the double portrait of Édouard and Suzanne Manet (fig. 7).[55]

The only prints by Manet that Degas is known to have acquired before the Burty group are a framed impression of the final "chromolithograph" of *Polichinelle* (Collection Print Sale: 283), published in 1874, which he purchased at the Duranty sale in 1881, and an impression of the lithograph *Civil War* from the posthumous sale of Manet's works in 1884, where it was catalogued under lot 167 with the incorrect title *Derrière la barricade*, suggesting that it was probably a proof before lettering and the same as the one now in Oslo (Collection Print Sale: 274).

Degas apparently neither purchased nor received as gifts any prints published by Manet in the 1860s and 1870s, although the artist was generous with proofs, which he inscribed to his friends. And although Degas owned Cadart's 1874 publication of nine of Manet's etchings of the 1860s (Collection Print Sale: 290), which did not come from Burty, the Degas sale included no copy of *Le Corbeau*, published the following year. Burty's collection had, however, provided him with three of the four recorded impres-

sions of the related *Head of a Raven, with Duret's Dog, Tama* (fig. 266), and he evidently disposed of one of these before his death (Collection Print Sale: 285, 286). It is curious that Degas may not have owned *Le Corbeau*, since not only are the graphic qualities of the illustrations outstanding, but also his own interest in transfer processes and his work with professional relief plate makers would have made him aware of the technical importance of Manet's remarkable transfer lithographs.[56]

Burty's collection gave Degas almost an *oeuvre complet* of Manet's prints (he noted on its acquisition his intention to try to fill in the gaps). Some of the finest items must have given him particular pleasure, foremost among them an outstanding rarity, Manet's hand-lettered lithographic cover design for "A Moorish Lament" (Collection Print Sale: 270) by Jaime Bosch, the guitarist whose relationship with both Manet and Degas has been noted above. The design was printed from the original stone and is a proof in pristine condition, before the image was transferred for the commercial printing with added lettering that follows Manet's lively brush-drawn design. The solo guitar version of Bosch's composition was dedicated to Manet on the finished music sheet published in 1866 and must have been played in both the Manet and Degas family salons.

Although relatively few of Manet's lithographs were published in his lifetime, Degas must have known and admired the freedom and richness of his technique long before he acquired *Civil War* at Manet's posthumous sale in 1884. It is more difficult to know what appealed to him in his very first acquisition, the *Polichinelle* from Duranty's posthu-

Fig. 274. Édouard Manet, *Balloon*, 1862. Lithograph, 15⅞ × 20¼ in. (40.3 × 51.5 cm). New York Public Library, Avery Collection. Surrogate for Degas's unlocated impression, Collection Print Sale: 269

Fig. 275. Édouard Manet, *Polichinelle*, 1874. Lithograph, first state in black ink, 21⅜ × 14 in. (54.2 × 35.6 cm). Private collection. Collection Print Sale: 282

mous sale: was it bought as simply a souvenir of a very close friend, or as an example of a technical exploit—the use of commercial "chromolithography" in the service of art? (However, this was art with a distinctly polemical, satirical flavor; the image was initially banned because it was suspected of being a caricature of Marshal MacMahon, the general who became president of France.)

Since most of Manet's prints were published by Cadart and exhibited from time to time at the Salon as well as in Cadart's windows, and since both Félix Bracquemond and Burty actively collected them, Degas had plenty of opportunity to see what his rival was doing in the field of printmaking. He also owned an impression of a beautiful etching by Bracquemond after Manet's *Young Woman in Spanish Costume* (Yale University Art Gallery, New Haven) that was included in the first of the Impressionist exhibitions in 1874 (Collection Print Sale: 12). Degas probably hoped that Manet himself would agree to contribute at least prints and drawings, if not paintings, to these exhibitions with which he was so deeply involved, but the only group show in which Manet's works appeared in the 1870s was Durand-Ruel's 1876 exhibition in the gallery's "Noir et Blanc" series, where he showed mainly etchings from the 1860s, as well as his recent lithograph *Civil War*.[57]

From that year, printmaking again became a major part of Degas's artistic activity, a renewal that took up the thread of the group of etched portraits of Manet he had made some ten years earlier (fig. 363). But while Degas moved toward ever more complex and painterly effects in his etchings with aquatint and his late lithographs, often reworking his proofs with pastel, Manet gradually abandoned the "cuisine" of etching for the spontaneous calligraphy that he could achieve through crayon lithography on stone, as in *Civil War* and *The Barricade*, or through brush-and-ink transfer lithography, as in the magnificent illustrations for *Le Corbeau*, his café and theater scenes (Collection Print Sale: 284), and the *Portrait of Courbet* (fig. 273). The last was correctly listed in the Burty sale as a lithograph but was described in the Degas sale catalogue as a "facsimile of a pen drawing" and has been omitted from all the oeuvre catalogues of Manet's prints.[58] Manet did indeed turn increasingly to *gillotage*, and he was as unembarrassed as Degas at using modern technology to reproduce and publicize his work, making many pen or brush drawings specifically for reproduction in exhibition catalogues and art journals. The inventive spontaneity and liveliness of all Manet's prints, whether direct or indirect, fully "original" or semimechanical, were undoubtedly of the greatest interest to Degas, who was fortunate in being able to acquire one of the most outstanding collections of

them ever formed. The common interests of both artists in the old master tradition as well as the modernity of the world about them, together with their understanding of print media, produced the two most original print corpuses of the 1860s and 1870s. After Manet's tragically early death in 1883, Degas continued over the following decade to pursue the possibilities of printmaking in all its forms.

J W - B

1. Lemoisne 1946–49, vol. 1, p. 119.
2. Fry 1918.
3. Denis Rouart, ed., *The Correspondence of Berthe Morisot with Her Family and Friends, Manet, Puvis de Chavannes, Degas, Monet, Renoir and Mallarmé*, trans. B. W. Hubbard, ed. K. Adler and T. Garb (London, 1986), p. 212; also p. 185, cited in Roquebert 1989, p. 77. On Degas's museum project, see "Degas and His Collection" in this volume.
4. For the development of the "New Painting," see T. J. Clark, *The Painting of Modern Life: Paris in the Art of Manet and His Followers* (New York, 1985); Reff 1976a; Washington, San Francisco 1986; Gary Tinterow and Henri Loyrette, *Origins of Impressionism*, exh. cat., New York, The Metropolitan Museum of Art (New York, 1994).
5. Sue Welsh Reed and Barbara Stern Shapiro in Boston, Philadelphia, London 1984–85, p. 43, do not exclude the authenticity of the story.
6. Theodore Reff has written extensively on the role of tradition in Degas. On Degas's affinity with Velázquez, see Mari Kálmán Meller, "Exercises in and around Degas's Classrooms: Part II," *Burlington Magazine* 132, no. 1045 (April 1990), pp. 260–61, and her exhibition review, "Zurich and Tübingen: Degas Portraits," *Burlington Magazine* 137, no. 1105 (April 1995), p. 270. On Manet, see Michael Fried, "Manet's Sources: Aspects of His Art, 1859–1865," *Artforum* 7 (March 1969), pp. 28–82, but also Theodore Reff in the same journal, pp. 40–48; Juliet Wilson-Bareau, *The Hidden Face of Manet: An Investigation of the Artist's Working Processes*, exh. cat., London, Courtauld Institute Galleries (London, 1986), also in *Burlington Magazine* 128, no. 997 (April 1986), suppl. following p. 314.
7. The *Spanish Singer*: painting, The Metropolitan Museum of Art, New York; etching, Collection Print Sale: 230–32. Design for "A Moorish Lament": Collection Print Sale: 270. On the soirees and the two artists' friendship, see Jean Sutherland Boggs, "Degas as a Portraitist," in Zurich, Tübingen 1994–95, pp. 24–26.
8. See McMullen 1984, pp. 154–55, citing Armand Silvestre, *Au pays des souvenirs* (Paris, 1892), pp. 176–77, and Jacques-Émile Blanche, *Manet* (London, 1925), p. 49. Blanche writes of ". . . the Pigalle Quarter where men retailed Degas's remarks, where his theories had seen the light, and where they passed from studio to studio, from restaurant to restaurant."
9. Monet interview with Thiébault-Sisson, cited in McMullen 1984, p. 155.
10. See *The Correspondence of Berthe Morisot*, p. 56, and Loyrette 1991, p. 251. The social, political, and patriotic views of Degas and Manet are discussed in depth in McMullen 1984, pp. 186–90, and Loyrette 1991, pp. 249–60.
11. "Sacré Manet! Tout ce qu'il fait est toujours tout de suite d'aplomb, tandis que je me donne tant de mal, et ce n'est pas ça!" In Sickert 1917, p. 186; cited by Éric Darragon, "Degas sans Manet," in *Degas inédit* 1989, pp. 97–98.
12. Paul Valéry, *Degas danse dessin* (Paris, 1938): Manet, "de qui l'œil et la main sont des certitudes," p. 44; Degas "diffère la jouissance, crée la difficulté," p. 9.
13. The others were Delacroix's painting *Count de Mornay's Apartment* (fig. 4) and his own double portrait *Lorenzo Pagans and Auguste De Gas*, already mentioned (fig. 92). See Paul Poujaud in *Lettres de Degas* 1945, p. 253.
14. Fry 1918, p. 118.
15. Ambroise Vollard acquired from Manet's widow the central portion of the *Execution* and took it to Degas, who already owned another fragment; Loyrette 1991, p. 617, citing Vollard. See "Degas and His Collection" in this volume.

16. For a full discussion of Manet's three paintings, see *Edouard Manet and the Execution of Maximilian: Painting, Politics, and Censorship*, exh. cat., Providence, Brown University, Department of Art (Providence, R.I., 1981); Juliet Wilson-Bareau in *Manet: The Execution of Maximilian*, exh. cat., London, the National Gallery (London, 1992).

17. Julie Manet, *Journal (1893–1899): Sa jeunesse parmi les peintres impressionnistes et les hommes de lettres* (Paris, 1979), entry for November 20, 1895, p. 72; quoted in Loyrette 1991, p. 220.

18. For a full discussion of the incident, including Vollard's later account of it, see Henri Loyrette in Paris, Ottawa, New York 1988–89a, no. 82.

19. Moore 1918, p. 65.

20. See E. H. Gombrich, "The Mask and the Face: The Perception of Physiognomic Likeness in Life and Art," in *Style International Encyclopedia* (New York, 1968), p. 2.

21. "Il y a parfois une certaine aisance dans la maladresse, qui, si je ne me trompe, est plus gracieuse que la grâce même." See Reff 1976b, Notebook no. 22, ca. 1867–74, pp. 3, 6.

22. On the relationship between Manet and Degas and the dating of Degas's portrait, see Jean Sutherland Boggs in Zurich, Tübingen 1994–95, pp. 24–26. The portraits by Degas and Manet with Suzanne at the piano are generally dated 1868–69; however, the only certainty is that Manet's painting was listed by him in 1872 (see Paris, New York 1983, no. 107).

23. Blanche, *Manet*, p. 48, enumerates a series of accessories that Degas proposed that his friends paint: inelegant furniture, chairs in white dust covers, and so on.

24. On the grid system and *The Song Rehearsal*, see Mari Kálmán Meller, "Exercises in and around Degas's Classrooms: Pt. I," *Burlington Magazine* 130, no. 1020 (March 1988), p. 210 n. 65.

25. See Boston, Philadelphia, London 1984–85, nos. 17–19.

26. Degas's lost lithograph appears to have been based on a Nadar photograph of Manet. In Boston, Philadelphia, London 1984–85, p. 253, Reed and Shapiro reproduce and comment on this print.

27. See Norma Broude, "Degas's Misogyny," *Art Bulletin* 59, no. 1 (March 1977), pp. 95–107.

28. Private collection. See Paris, Ottawa, New York 1988–89a, no. 146.

29. Private collection. See Zurich, Tübingen 1994–95, no. 105.

30. Jean C. Harris, "Manet's Race-Track Paintings," *Art Bulletin* 48, no. 1 (March 1966), pp. 78–82. See also Paris, New York 1983, no. 99.

31. John Rewald, *Degas Sculpture: The Complete Works* (London, 1957), nos. 14, 15.

32. Reproduced in Atelier Sale IV: 230, and in *Les Dessins de Degas reproduits en fac-similé*, ed. Henri Rivière, 2 vols. (Paris, 1922–23); also in *Degas' Drawings* (New York, 1973), pl. 58.

33. See Meller, "Exercises in and around Degas's Classrooms: Part II" (see n. 6), pp. 262–63, and "Part III," *Burlington Magazine* 135, no. 1084 (July 1993), pp. 452–54.

34. Theodore Reff, "Degas, Lautrec and Japanese Art," in *Japonisme in Art: An International Symposium* (Tokyo, 1980), p. 201.

35. The greyhound was part of a small composition in which the dog gamboled alongside Léon Leenhoff on his velocipede (RW 171, 172; Ronald Pickvance, *Manet*, exh. cat., Martigny, Fondation Pierre Gianadda [Martigny, 1996], nos. 35, 36).

36. The "act of looking" has been extensively analyzed in Charles F. Stuckey, "Degas as an Artist, Revised and Still Unfinished," in Paris 1984–85, pp. 14, 28, 34, etc.; for his comments on the drawing of Manet at the racetrack, see p. 19. The drawing, in The Metropolitan Museum of Art, is part of the group of works discussed by Jean Sutherland Boggs in Zurich, Tübingen 1994–95, p. 24, and was also reproduced in Edinburgh 1979, no. 4.

37. RW 184; Mrs. John Hay Whitney Collection. See Paris, New York 1983, no. 132.

38. Lemoisne 1946–49, vol. 1, p. 128.

39. Collection Print Sale: 61–103. On Daumier's influence on Degas, see Theodore Reff's essay in this volume; on the Daumiers owned by Degas, see "Degas and His Collection," also in this volume.

40. For Degas's rare proof see Frances Carey and Antony Griffiths, *From Manet to Toulouse-Lautrec: French Lithographs 1860–1900*, exh. cat., London, British Museum (London, 1978), no. 24. See also Juliet Wilson-Bareau and Breon Mitchell, "Tales of a Raven: The Origins and Fate of *Le Corbeau* by Mallarmé and Manet," *Print Quarterly* 6, no. 3 (September 1989), pp. 276–77.

41. Claude Roger-Marx, "Les Nymphéas de M. Claude Monet," *Gazette des Beaux-Arts* 102 (June 1909), p. 528; cited by Stuckey in Paris 1984–85, p. 28.

42. Halévy 1960, p. 78.

43. Ernest Chesneau, "Le Japon à Paris," *Gazette des Beaux-Arts* 18 (September 1878), pp. 385–97, cited by Carey and Griffiths, *From Manet to Toulouse-Lautrec*, p. 41, and by Michael Pakenham in Edgar Allan Poe, *Le Corbeau*, ed. Michael Pakenham (Paris, 1994), p. 89.

44. Edmond Duranty, "Le Salon de 1870," *Paris-Journal*, May 8, 1870, p. 2.

45. On Degas's poems, see Loyrette 1991, pp. 547–50.

46. In Degas's earlier portrait of his sitter, *Madame Camus at the Piano* (E. G. Bührle Collection, Zurich), there is a small figurine whose shadow is also projected on the wall. See *The Passionate Eye: Impressionist and Other Master Paintings from the Collection of Emil G. Bührle, Zurich*, exh. cat., Washington, D.C., National Gallery of Art; The Montreal Museum of Fine Arts; Yokohama Museum of Art; London, Royal Academy of Arts (Zurich, 1990), no. 29.

47. Degas, *The Dance Class*: L 479; Philadelphia Museum of Art (Paris, Ottawa, New York 1988–89a, no. 219). Manet, *A Bar at the Folies-Bergère*: RW 388; Courtauld Institute Galleries, London (Paris, New York 1983, no. 211).

48. Antonin Proust's *Souvenirs* dissatisfied Degas, as noted in Halévy 1960, pp. 104–5, cited and discussed by Éric Darragon in "Degas sans Manet" in *Degas inédit* 1989, p. 93.

49. Charles Baudelaire, "Les Dons des fées," from "Le Spleen de Paris," in Baudelaire 1975–76, vol. 1, p. 307.

50. Sickert 1917, p. 186.

51. See the novel by Camille Mauclair, *La Ville lumière* (Paris, 1904), pp. 40–41, in which a character based on Degas is described as a "misanthrope bienfaisant"; cited in Loyrette 1991, p. 591.

52. See the inventory in D. Rouart and Wildenstein 1975, vol. 1, p. 26.

53. As revealed in Degas's unpublished notes (Degas inv.).

54. *Émile Ollivier*, 1860, Harris 1990, no. 1; Bibliothèque Nationale, Paris, Département des Estampes, *Inventaire du fonds français: Graveurs du XIXe siècle*, vol. 15, ed. Madeleine Barbin and Claude Bouret (Paris, 1985), no. 57. *Lola de Valence*, Harris 1990, no. 32.

55. The proof hand colored by Manet will be shown in the forthcoming exhibition *Manet, Monet, the Gare Saint-Lazare* (Musée d'Orsay, Paris, and National Gallery of Art, Washington, D.C., 1998).

56. A copy of *Le Corbeau* was included in the Burty sale, lot 248. It is conceivable that a complete set in its original wrappers, with Poe's text and Mallarmé's translation, formed part of Degas's library rather than his print collection, and thus escaped the sale.

57. See D. Druick and P. Zegers in Boston, Philadelphia, London 1984–85, pp. xxix–xxx.

58. The portrait was published as the frontispiece to Henri Amédée la Lorgne, Comte d'Ideville, *Gustave Courbet: Notes et documents sur sa vie et son oeuvre, avec huit eaux-fortes par A.-P. Martial et un dessin par Édouard Manet* (Paris, 1878). It was recorded in Léon Leenhoff's 1883 inventory of the contents of Manet's studio under no. 266, as a lithograph.

Fig. 276. Paul Cézanne, *Self-Portrait*, 1879–80. Oil on canvas, 13¼ × 9⅝ in. (33.5 × 24.5 cm). Oskar Reinhart Collection "Am Römerholz," Winterthur, Switzerland. Collection Sale I: 11

Degas and Cézanne: Savagery and Refinement

RICHARD KENDALL

Few cases of artistic affinity are as curious, seemingly unexpected, or ultimately engrossing as that of Edgar Degas and Paul Cézanne (1839–1906).[1] Yet for more than a century art historians have made much of the differences between the two as painters, even of their polar opposition: "Degas addressed himself to drawn forms, Cézanne to colored forms," Henri Hertz announced as early as 1920, in a formulation that has been intoned monotonously and uncritically ever since.[2] It is known that Degas and Cézanne were very unlike as individuals—separated by geographic origin and class, by temperament and social bearing—and that they developed a marked antipathy toward each other. Against such a background, it is almost shocking to discover that Degas assembled one of the very first collections of Cézanne's art, small in scale but wide ranging and modestly retrospective in scope. If we look patiently and disinterestedly through the two men's careers, we find further evidence of contact and stimulus; phases of parallel development and moments of collaboration; engagement with uncannily similar themes and conceptions; and a wary respect of each for the other's achievement. Their association never approached the close working partnership of Cézanne's early years with Camille Pissarro, nor the creative intimacy, "like two mountaineers roped together," of Pablo Picasso and Georges Braque in the early days of Cubism. But the catalogue of preoccupations shared by Cézanne and Degas points to an unusual parallelism in their developments, informing both our general sense of their significance as artists and our particular understanding of Degas the collector.

The characters of the two painters, then both largely unknown, were first publicly juxtaposed in 1872 in a story published by the critic and novelist Edmond Duranty, "La Simple Vie du peintre Louis Martin."[3] Thinly disguised as the artist "Maillobert," Cézanne appears in the text as an eccentric, longhaired provincial with the thickest of Marseillais accents, a "truly curious being" who occupies a filthy, chaotic studio piled high with bizarre portraits and shared only with his parrot, who has been taught to shriek, "Maillobert is a great painter!"[4] In contrast, Degas appears under his own name and is first encountered in the galleries of the Louvre, where, in the company of Henri Fantin-Latour and Alphonse Legros, he calmly copies a picture by Poussin. Degas, Duranty tells us, is "an artist of rare intelligence, preoccupied with *ideas*, in a way that seems strange to most of his colleagues," and one who is beginning to earn a reputation as a painter of the contemporary world, "the inventor of social chiaroscuro."[5] Other writers confirmed the contrast in their personalities, Georges Rivière recalling the uneasy encounters between Degas and Cézanne at the time of the first Impressionist exhibitions and their moments of flamboyant disagreement. "While Cézanne expressed himself with a vehemence that ended in an Olympian thunderstorm, Degas slashed at his antagonist with feline dexterity," Rivière remembered, adding that Degas's "ironic courtesy" toward Cézanne "wounded him without appearing to touch him."[6]

In the light of the two artists' personal incompatibility, Degas's eventual acquisition of eight or nine pictures by Cézanne—seven oil paintings, one watercolor, and possibly a drawing—appears baffling, perhaps more baffling than any of his accumulations of works by other contemporaries from the Impressionist era.[7] Degas's holdings of pictures by Édouard Manet, for example, can be seen as an expression of their sporadic friendship and overlapping artistic concerns; his groups of paintings by Berthe Morisot, Pissarro, Auguste Renoir, Alfred Sisley, and Mary Cassatt, many of them acquired by direct exchange, similarly resulted from professional collaborations or mutual admiration; works by less renowned individuals, such as Jean-Louis Forain, Henri Rouart, Jean-François Raffaëlli, Félix Bracquemond, and Pierre-Georges Jeanniot, were often tokens of personal loyalty; while his extraordinary series of prints, drawings, and canvases by Paul Gauguin

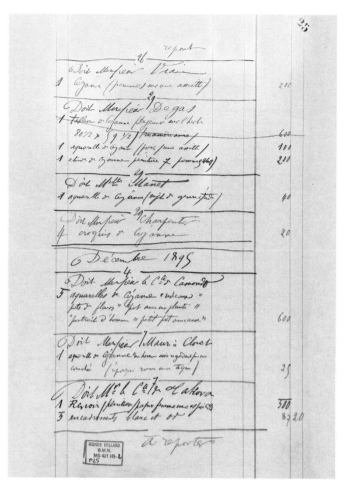

Fig. 277. Ambroise Vollard's daybook entries for November 29, 1895. Bibliothèque Centrale des Musées Nationaux, Paris, ms. 421 (2), p. 25

resulted from the two men's complex master-pupil relationship. We search in vain for a comparable explanation of Degas's involvement with the art of Cézanne. As Duranty, Rivière, and others make clear, there was neither personal warmth nor the benign instinct of patronage behind Degas's purchases, and later witnesses give no hint of a mellowing of attitudes between the artists in their maturity. On the contrary, these testimonies point to a continuing estrangement between the sophisticated, city-bred Degas (the "Bourgeois de Paris," as Rivière called him) and the rurally inclined Cézanne, whose aggressive manner aroused comment to the end of his life.[8]

Almost all Degas's purchases of pictures by Cézanne appear to have been made in the 1890s, with at least seven of the works entering his collection during a fourteen-month orgy of purchase and exchange between November 1895 and January 1897.[9] Since Degas had known Cézanne and his art since the late 1860s, it might seem that Degas's fascination with his former adversary blossomed quite suddenly, at least as far as the acquisition of his work was concerned. Accompanying Renoir on a visit to the exhibition organized by Ambroise Vollard in 1895, effectively the first

public survey of Cézanne's art, Degas was in raptures. "Degas and Renoir are enthusiasts for the works of Cézanne," Pissarro announced in a letter of December 4 to his son Lucien. "Degas so passionate over Cézanne's studies, what do you think?"[10] A few days later Julie Manet reported her own sighting of the same two artists at the gallery, where their excitement over the exhibits led to good-humored rivalry; "Monsieur Degas and Monsieur Renoir drew lots for a magnificent still-life watercolor of pears and a small one depicting an assassination in the Midi," she noted breathlessly in her diary.[11] Vollard's own ledgers and daybooks tell a similar story, if somewhat more cryptically, revealing the prices, dates of purchase, and original titles of the pictures by Cézanne that were sold to Degas at this time.[12] On November 29, 1895, for example, Vollard's accounts record the purchase for 100 francs of the watercolor *Three Pears*, which Degas had evidently carried away from the lottery with Renoir, and show that Degas also bought the exquisite small canvas *Apples* on the same occasion (figs. 278, 289). More remarkable still, and overlooked to this day, is the suggestion in Vollard's entry that the acquisition of a third and much larger picture was seriously contemplated; its details and price were entered in the dealer's records, then apparently deleted at the last moment. The entry reads, "1 tableau de Cézanne 'Déjeuner sur l'herbe' (80½ × 59½) manière noire, 600 francs," a description that matches almost exactly a large and now celebrated canvas of ca. 1870–71 (fig. 279).[13] When we consider that these early, fantastical "dark manner" pictures still puzzled or appalled most of Cézanne's contemporaries and have become widely admired only in the later years of our own century, Degas's curiosity about such a composition (to say nothing of an *Assassination in the Midi*) and his attraction to Cézanne's work in general become less, rather than more, comprehensible.

If sentimental considerations can be ruled out, we are obliged to assume that it was the qualities of Cézanne's art itself that repeatedly attracted Degas to his paintings. In assembling a miniature survey of Cézanne's output touching on most of his distinctive themes and many phases of his development, Degas signaled his serious, almost scholarly interest in the nature of Cézanne's artistic project. He also seems to have acknowledged, belatedly but eloquently, that he and his wayward colleague had long held in common certain preoccupations and thematic engagements. Degas's choice of two paintings of nudes, the *Venus and Cupid* and *Bather with Outstretched Arms* (figs. 284, 283), was a reminder that he and Cézanne were the preeminent painters of the human figure in the Impressionist circle; the acquisitions of *Victor Chocquet* (fig. 62) and the *Self-*

Fig. 278. Paul Cézanne, *Three Pears,* ca. 1888–89. Watercolor and graphite, 8½ × 12 in. (21.5 × 30.5 cm). The Henry and Rose Pearlman Foundation, Inc. Collection Sale I: 105

Portrait recognize their shared commitment to portraiture; and Degas's more surprising purchase of a total of four still lifes—a subject virtually absent from his own repertoire—might be taken as a salute from one obsessive painter of sequences and series to another. It is the addition to his collection of Cézanne's *Self-Portrait* (fig. 276), however, that is perhaps most poignant. The painting is not only a magnificent statement of many of Cézanne's concerns in his maturity but also the defiant image of a fellow artist with whom Degas seems finally—if only pictorially—to have come to terms.

A study of the parallel careers of Degas and Cézanne, from their apprentice years in Paris to their uncertain mutual interest in the 1890s, does much to illuminate the character of this aspect of Degas's collection. If twentieth-century orthodoxies are set aside, it is possible to identify remarkable similarities in the two artists' backgrounds and training, in their relationships with the art of the past, and in the tenacity with which each pursued certain distinctive

Fig. 279. Paul Cézanne, *Déjeuner sur l'herbe,* ca. 1870–71. Oil on canvas, 23⅝ × 31⅞ in. (60 × 81 cm). Private collection

Fig. 280. Paul Cézanne, *Two Fruits,* ca. 1885. Oil on canvas, 7½ × 9⅛ in. (19.1 × 23.2 cm). Galerie Yoshii. Collection Sale I: 13

motifs. There remain, of course, fundamental disagreements of taste and opinion, as well as a curiously ambivalent, and perhaps instructive, rhetoric of unease between the men as individuals. In truth, the two artists' trajectories are less like parallel tracks than like two distinct, meandering rivers, now flowing side by side through the same terrain, now curving apart idiosyncratically, only to rediscover their shared direction or to diverge once again. Enough is known about the two artists' views of each other to suggest that they had some awareness of this confluence—at least within the constraints of their separate lives and their limited knowledge of each other's works. In a way that was denied to them, we can today extend our sense of their conscious and unconscious affinity, peering into private sketchbooks and formerly unpublished correspondence, studying half-finished canvases and hundreds of unexhibited works that suggest links both historical and speculative. But even without this access, their contemporaries had begun to link Degas and Cézanne, identifying them as relative outsiders to the Impressionist enterprise and defining some of the propensities they had in common. Jacques-Émile Blanche, for example, suggested that both painters were at heart "clas-

sic," despite what he called the "anti-traditional" appearance of their art, and Maurice Denis similarly sought to appropriate the two artists for his "classical" cause.[14] Having proposed that Degas (who, he tells us, had a "great admiration" for Cézanne) was essentially a draftsman and Cézanne a colorist, Henri Hertz went on to argue that they nevertheless shared "the same motives" and were both occupied with "a synthesis of the elements of life in movement."[15]

The suggestion that Degas and Cézanne were close in certain of their artistic preoccupations still comes as a surprise to many of their admirers. It is Degas the chronicler of backstreets, racecourses, and urban spectacle—"the inventor of social chiaroscuro"—who has seized the popular imagination and who is often contrasted with a landscape-painting, formally rigorous Cézanne who stands at the beginning of modernism. Mercifully, recent studies of both artists have done much to erode these stereotypes, offering us a Degas who occasionally studied nature *en plein air,* who gradually turned his back on social documentation and left his mark as a colorist on generations of Nabis, Fauves, and Cubists; equally, the Cézanne of "the cylinder, the sphere, the cone" has become a more plausible creature, animated not just in his youth but through much of

his life by what Picasso saw as a definitive "anxiety."[16] The more we recognize the diversity and breadth, not to say the occasional contrariness, of both artists, the more evident their common concerns have become. Lillian Browse was among the pioneers of this approach, noting how "distance shows so clearly the bonds that unite these two great figures, setting them apart from the other *Indépendants*," and arguing, along with Hertz, that on certain broad principles "they finally arrived at the same conclusion."[17] Subsequently, Theodore Reff, Gary Tinterow, Jean Sutherland Boggs, and Carole Armstrong have all proposed analogies between certain themes and structural devices used by Degas and Cézanne,[18] while Götz Adriani has imaginatively compared the two painters on a number of occasions. Conceding that, as individuals, they had "little in common beyond a vast but well-concealed regard for each other," Adriani reflects on the roles of tradition and self-criticism in their work, their shared obsession with scenes of sexual conflict, and the numerous points of contact between specific drawings and paintings by the two artists.[19]

Evidence of the links between Degas and Cézanne is of three types. First, there are encounters and shared activities that were recorded by their contemporaries, and the more-or-less reliable reports of remarks each made about the other. Behind this relatively sparse narrative stand several thousand drawings, paintings, and other works of art produced by Degas and Cézanne during their roughly concurrent working lives. Finally and more generally, there are overlaps of attitude and belief, of working practices and private enthusiasms, ranging from the two men's preferences among the work of their forebears to their respective personal circumstances at the beginnings of their careers.

Initially we are presented with a pair of physically very different young men from contrasting homes and regions, divided from youth by most of the social indicators of their age. Degas was born in Paris in 1834, the scion of a faded branch of the minor aristocracy, Cézanne in Aix-en-Provence five years later, the son of a self-made local tradesman. Coincidentally, both their fathers had become bankers, enabling the two aspiring artists to grow up in relative prosperity, to enjoy a traditional, classically based schooling, and to benefit from a partially subsidized early manhood. As Robert Gordon and Andrew Forge have pointed out, Degas's success at the Lycée Louis-le-Grand (he passed his *baccalauréat* in 1853) "placed him in a small elite even within his social class," granting him a level of education that "only Cézanne among his future colleagues" was to equal when he too passed the exam several years later.[20] In practical and cultural terms, these advantages were to have lasting implications for both young men; while Renoir worked as an apprentice in a porcelain factory and Claude Monet struggled in a succession of garrets, Degas and Cézanne were able to read and study, to taste the discipline of a formal art training (in both cases, admittedly rather briefly), and, crucially, to travel. For Cézanne this meant train journeys to Paris and the wonders of the Salon and the Louvre; for the more indulged Degas it led to Italy and three years of copying, experiment, and reflection. Though the details of their experiences were different, it was Cézanne and Degas who emerged into adulthood as the two most well read and historically conscious painters of the Impressionist circle, steeped in the texts and imagery of the past and eager to extend that tradition into the present.

Their formative years were similar in at least two other crucial respects. In a way that was neither inevitable nor widely shared by their later colleagues, both gave early prominence to the practice of drawing, devoting much of their energies to sketchbook studies and copying from the masters, pencil and pen-and-ink drafts for paintings, and pondered exercises based on the human figure. It was the specific conventions of life drawing, as encountered by Cézanne at the drawing academy in Aix and the Académie Suisse in Paris and by Degas at the École des Beaux-Arts in Paris and the Académie de France at the Villa Medici in Rome, that arguably provided the strongest link between the two artists and left the deepest mark on their careers. Implicit in the practice was the centrality of the human form, not only in the great art of the past but as a continuing challenge for artists of succeeding generations. In Degas's case it has long been understood that this fusion of draftsmanship and the study of the figure was to become fundamental to his mature achievement; its pervasive importance for Cézanne, however, still awaits a detailed study. If his nervous, impassioned drawings are now granted the recognition they certainly deserve, Cézanne's lifelong dedication to the representation of the human body, not just to landscape and to still life, is frequently overlooked. In fact, almost three-quarters of Cézanne's early work was dedicated to figurative motifs. Even during the later part of his active life, figure-based works account for nearly half the total, and it is only in the artist's final decade that landscape overtakes the human form as the dominant subject.[21] From the life drawings done at the Aix academy to the large *Bathers* left unfinished at his death, by way of the mythologies, genre scenes, portraits, harlequins, and card players of his maturity, Cézanne's representations of the male and female forms constitute one of his grandest achievements.

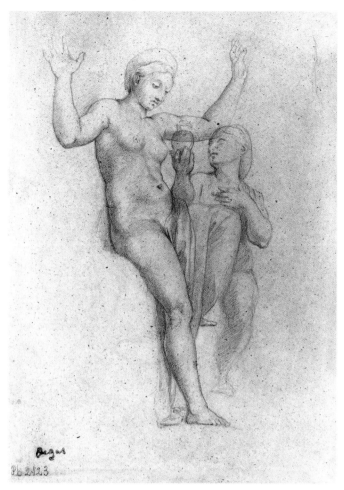

Fig. 281. Edgar Degas, *Copy after Raphael's "Venus and Psyche,"*
ca. 1853–54. Graphite, 11⅜ × 8¼ in. (29 × 21 cm). Private collection.
Atelier Sale IV: 128c

A vivid demonstration of the early kinship between Degas and Cézanne, involving both line and the study of the human form, is their shared habit of copying, an activity that pervaded not only their trainee years but the output of their maturity as well, and one that left surprisingly few traces in the work of their Impressionist peers. Copying was expected of young artists who committed themselves to an academic training, but the many hundreds of studies, paraphrases, and variants on the art of the old masters made by Cézanne and Degas in the course of their careers appear to have been largely self-directed. Both artists copied widely and promiscuously, scrutinizing antique sculpture and Renaissance drawings, paintings from the seventeenth and eighteenth centuries, and a variety of works of art from their own age, including some made by their contemporaries. Overwhelmingly, their copies were derived from the figurative tradition. Though this was predictable enough in the early years, it is notable that neither artist, not even Cézanne in his maturity, paid significant attention as a copyist to the great landscapes of the past. What is just as striking, and at times almost uncanny, is

the coincidence of their tastes for the same artists and often for the same works of art and even similar details. There are, of course, telling exceptions, and allowances must be made for the easy availability of pictures in the Louvre, which was especially significant for the less widely traveled Cézanne. But if we take as an example the Renaissance and Baroque periods, of the thirty or so artists selected for copying by Cézanne, more than twenty had already been singled out by Degas for similar treatment. While several of these were canonical—Raphael, Leonardo, Michelangelo, Titian, Veronese, and Poussin—other choices, such as Donatello, Signorelli, Pollaiuolo, Fra Bartolommeo, Perugino, Marcantonio Raimondi, Sebastiano del Piombo, Giulio Romano, Domenichino, and Hans Holbein, point to a more personal convergence of interest.[22] Even more instructive is the fact that both artists copied at least fifteen identical works, from Donatello's *Saint George* and Michelangelo's *Battle of Cascina* to Giorgione's *Concert Champêtre* and Bachiacca's *Portrait*, from Rubens's *Eve* to Eugène Delacroix's *Entry of the Crusaders into Constantinople* and Théodore Géricault's *Turkish Horse in a Stable*.[23] The temptation must be resisted, however, to imagine the two artists side by side in the Louvre copying Veronese's *Marriage at Cana* or Delacroix's *Apollo* ceiling, since Degas made his versions an average of ten years earlier than Cézanne.[24]

If we compare the graphic responses of Cézanne and Degas to a single work of art, both their shared direction and their divergent techniques and temperaments—the former's "vehemence" and the latter's "dexterity," in Duranty's words—become sharply apparent. As young men, both independently chose to copy a drawing of *Venus and Psyche* by Raphael, an artist seen as exemplary for his draftsmanship, his emphasis on the nude, and his inventiveness in figure composition. The drawing was in the Louvre, where Degas had registered as a copyist in 1853, and his rendering of the work from these early years shows him at his most timid, even self-effacing (fig. 281).[25] Reproducing Raphael's design in its entirety, Degas has also attempted to imitate the master's technique, down to his finely detailed hatching and the weight and direction of individual strokes. A decade later, Cézanne too signed the register of copyists at the Louvre, though he appears to have first tackled the Raphael drawing in the later 1860s.[26] Cézanne's version, in contrast, shows an energy bordering on arrogance: he omits an entire subsidiary figure, crops the body of Venus at mid-calf, and repositions her at the center of his sheet (fig. 282). Freely adapting the pose and modifying limbs, muscles, and contours, Cézanne has discovered his own rhythms and expressive purposes in Raphael's goddess, animating her physique with violent

slashes of the pencil and modeling her figure with coarse parallel hatch marks. Other pairs of copies by the two artists tend to echo this individuality of approach, if in a less extreme fashion and with roles occasionally reversed. Degas's superb drawing of about 1860 after another canonical work of the European tradition, Michelangelo's *Dying Slave*, for example, reveals a more confident copyist at work, here translating a sculptural form into a sensuous, near-painterly statement.[27] The serpentine rhythm of Michelangelo's subject is almost as pronounced in Degas's transcription as it is in the several studies made by Cézanne, dated variously between the 1870s and the 1890s on the basis of their style.[28] Once again, Cézanne truncates the figure in certain of these drawings, although in another set of copies, after a *Portrait* then attributed to Raphael but now given to Bachiacca, it is Degas rather than Cézanne who takes greater liberties with the picture's boundaries.[29]

To a limited extent these exercises in draftsmanship conform to the caricatural presentation of the two artists in Duranty's 1872 story, revealing a respectful Degas and an egotistical, frequently impassioned Cézanne. At the same time, it is impossible to imagine "Maillobert" submitting to the discipline of copying under any circumstances, and we would hardly suspect that he shared such a commitment with Duranty's cerebral Degas. Their copies show, on the contrary, that the flesh-and-blood artists had a great deal in common as they performed their acts of homage or invigorated their current pictorial vocabularies. When Cézanne and Degas chose to copy Bachiacca's lugubrious *Portrait*, for example, both were actively engaged in portrait painting of their own, and both were experimenting, coincidentally or otherwise, with the same close-up format and with a similar range of soulful expressions and hands raised meaningfully to the chin. Likewise, each artist's rendering of the female nude in Raphael's *Venus and Psyche* and the male form in Michelangelo's *Dying Slave* would become part of a much larger ambition toward figurative mastery—soon to adopt contemporary garb but always to remain rooted in a profound, at times stifling, reverence for the past. In the first half of the careers of both artists, the largest group of their works was dedicated to this end, and almost all their attempts to promote themselves publicly, through the preparation of large-scale canvases and the submission of ambitious paintings to the Salon, were dependent on figurative compositions. Vast family portraits, scenes from history, mythology, and the Bible, and variations on the historical or contemporaneous nude were to dominate the output of their first decades and, as we shall see, continued to resurface in various guises for years to come. Several of their most celebrated early compositions encapsulate

this ambition, combining an essentially traditional emphasis on the figure with the ironic challenges of the present: Cézanne's monumental paintings of allegorical women in rustic settings, the *Four Seasons*, which he facetiously signed "Ingres," were begun about 1860, the same date as Degas's altogether more Ingres-like *Young Spartans* (which was later "modernized" by the artist).[30] Other figurative works, such as Cézanne's *The Wine Toddy (Le Grog au vin)*, a picture rejected from the 1867 Salon, and Degas's *Mademoiselle Fiocre in the Ballet "La Source"* (fig. 89), exhibited the following year, use the human form to explore drawing, historical precedent, and the paradoxes of modernity, as each artist sought to define himself and the nature of his vocation.[31]

This same group of figure-based paintings reveals yet another theme uniting the two young artists and is a further hint that Duranty's characterizations of Degas and Cézanne should on occasion be reversed. Common to both painters at that date was a frank and at times horrifying fascination with violence, whether the wanton savagery of Degas's 1865 *Scene of War in the Middle Ages* (fig. 358) and Cézanne's 1867–68 *The Murder* or the underlying sexual antagonisms of the former's *Semiramis Building Babylon* (fig. 88) and the latter's *The Banquet* and *The*

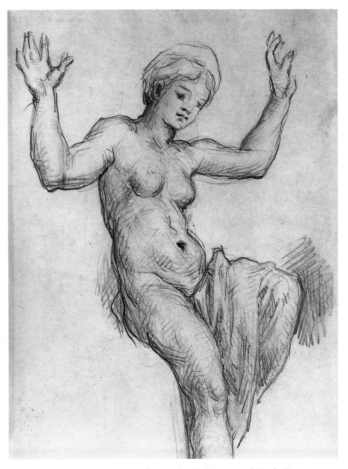

Fig. 282. Paul Cézanne, *Copy after Raphael's "Venus and Psyche,"* ca. 1866–69. Graphite, 9½ × 6¾ in. (24 × 17 cm). Private collection

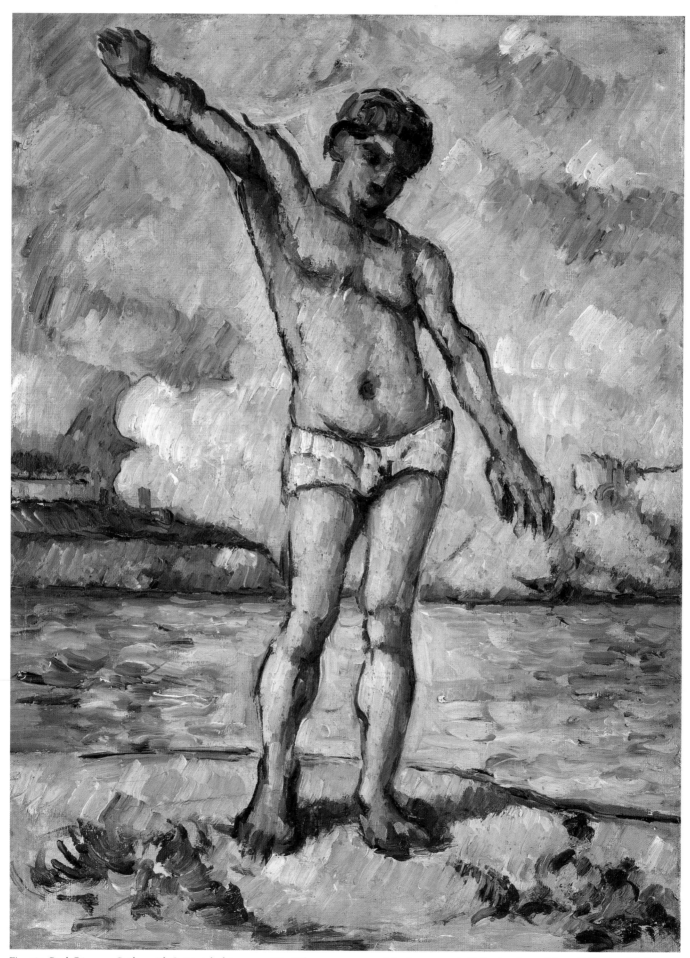

Fig. 283. Paul Cézanne, *Bather with Outstretched Arms,* ca. 1883. Oil on canvas, 13 × 9½ in. (33 × 24 cm). Collection Jasper Johns. Collection Sale I: 12

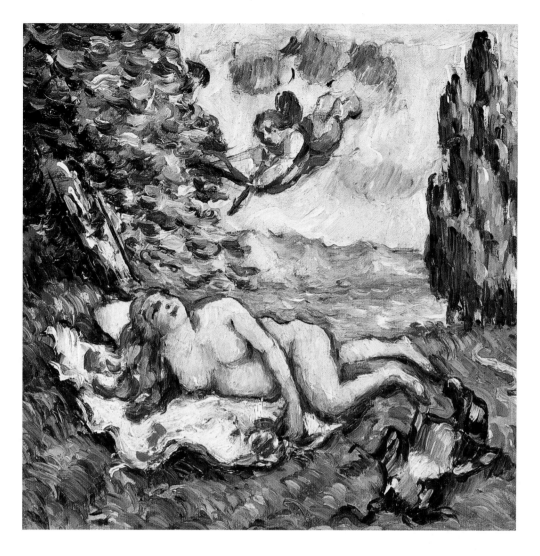

Fig. 284. Paul Cézanne, *Venus and Cupid*, 1873–75. Oil on canvas, 8¼ × 8¼ in. (21 × 21 cm). Takei Art Museum, Japan. Collection Sale I: 9

Temptation of Saint Anthony.[32] Even when historically based subjects were largely put behind them, something of this ghoulishness persisted. Again we note the effective absence of such imagery in the work of artists with whom Cézanne and Degas currently associated, while marking possible shared sources among their predecessors—notably Delacroix and certain artists of the Italian Renaissance.[33] Attempts have been made to link the discord within their pictures to the private circumstances of Cézanne and Degas, each of whom wrestled with his sexual impulses during these years and persisted in an uneasy obsession with women for the rest of his life. Adriani's claim that Cézanne's "tumultuous compositions derived their authenticity from an expressive volition born of torment and repression" finds some echoes in our imperfect understanding of Degas's sexuality, just as the effects of "paternal authoritarianism" and "perplexity over the opposite sex" perceived in Cézanne were similarly to pursue Degas into his old age.[34] Paradoxically, during his brief career as a history painter it was the more placid Degas who seems to have excelled as a painter of the macabre and the sinister. While a theatrical hysteria pervades many of

Cézanne's scenes of assault, the chilling objectivity of Degas's *Scene of War in the Middle Ages* intensifies rather than ameliorates the atrocity depicted, just as the impending but unseen violence in his *Daughter of Jephthah* (fig. 199) heightens its terrible story. Although such literal encounters disappeared from the work of both artists within a few years, Degas and Cézanne, of all the artists associated with Impressionism, were to remain the most solitary, the most abrasive in relations with their acquaintances, and, in the subsequent decade at least, the most preoccupied by scenes of modern sexual confrontation.

This shared history of engagement with pictorial aggression had muffled echoes in Degas's later life. It reverberates in his acquisition of two paintings of the nude by Cézanne, each of which is unsettling in theme and execution. In *Bather with Outstretched Arms* (fig. 283), a solitary youth stands on a deserted shore, his body distantly recalling a classical sculpture, but his gesturing arms and hands approaching the grotesque. The figure is absurdly incorrect as a study in anatomy, and the young man seems troubled, his solitude more suicidal than contemplative. In *Venus and Cupid* (fig. 284), another ostensibly playful sub-

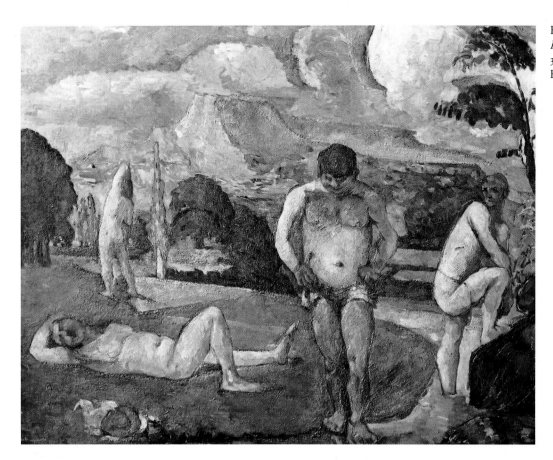

Fig. 285. Paul Cézanne, *Bathers Resting*, ca. 1876–77. Oil on canvas, 31⅛ × 38⅛ in. (79 × 97 cm). Barnes Foundation, Merion, Pa.

ject becomes unstable and physically threatening. Here a naked woman lies supine and apparently helpless before the arrows of her assailant, splashes of bright red in the foliage and on the white drapery suggesting genuine violence rather than amorous assault. Degas's choice of these two canvases, rather than some of the more innocent depictions of the nude by Cézanne, is in itself telling, and certain links with his own visual vocabulary are equally suggestive. Whereas *Bather with Outstretched Arms* might be said to have a generic affinity with the uneasy youths in Degas's *Young Spartans*, a picture that the artist continued to display with pride into his old age, *Venus and Cupid* has more complex associations. Several years before Cézanne painted this canvas, Degas had illustrated a bizarrely similar confrontation between a prostrate female and a bow-and-arrow-wielding male in his *Scene of War in the Middle Ages* (fig. 358), a work shown at the Salon of 1865, when Cézanne is known to have been in Paris. That the scene had continued resonance is confirmed by Degas's own reworking of his composition many years later, when he produced at least three variants on the same distinctive reclining figure, one at about the same time that he purchased Cézanne's picture.[35] Whether, in this case, Degas originally influenced Cézanne, or Cézanne's little picture belatedly stimulated Degas, or both, this episode points

to the persistence of certain of their concerns in a variety of guises and the often complex overlapping of their imagery.

It was about 1870 that the most frequent documented contacts between Cézanne and Degas took place and the strange convergence of their careers first became publicly evident. By the late 1860s both artists had become habitués of the Café Guerbois, where Manet and his circle mixed with novelists and critics of the Realist persuasion, among them Duranty and Émile Zola, as well as with artists who would later become the core of the Impressionist group, including Pissarro, Monet, Sisley, and Renoir. It was perhaps in the "perpetual clash of opinions"[36] (as Monet described it) at these meetings that Cézanne's "Olympian thunderstorms" were first provoked by Degas's "feline dexterity" as the wild-eyed provincial pitted himself against the urbane, top-hatted Parisian. The artistic projects of the two painters were less at loggerheads, both men persisting in their determination to exhibit at the Salon, for example, both submitting compositions based on the nude, and both promoting themselves, to varying degrees of acclaim, as painters of portraits. In 1866 Cézanne's *Portrait of a Man* was rejected by the Salon jury, while the following year Degas had two works, both entitled *Family Portrait*, accepted; in 1870 the pattern was repeated when Cézanne's

monumental study of his friend, *Portrait of Achille Emperaire*, was turned away while Degas's *Madame Camus in Red* (fig. 269) was received with muted approval.[37]

By this date, both Cézanne and Degas had come to terms in their different ways with the novelists and painters of the Café Guerbois. As John Rewald, Mary Louise Krumrine, and others have shown, several of Cézanne's figure compositions of that time were specifically rooted in the imagery of literary realism, notably in the novels of his childhood friend Zola.[38] For all its quasi-classicism, *The Rape* of about 1867, which Cézanne gave Zola as a present, appears to recall in somewhat fanciful terms their youthful reveries in the shadow of Mont Sainte-Victoire, while the gruesome *Autopsy* of about 1868 and the nightmarish *Déjeuner sur l'herbe* of 1870–71 (the picture Degas considered buying in 1895) have been linked to such narratives as Zola's *Thérèse Raquin* and *Madeleine Férat*.[39] Less expected is the discovery that Degas occupied himself with similar themes during the same period, most notably in his painting *Interior* of about 1868–69 (also known as *The Rape*; fig. 94), which Theodore Reff has likewise associated with a scene from *Thérèse Raquin*.[40] Other enigmatic representations of marital strife and sexual violence in Degas's imagery at this period may also have been suggested by contemporary literature, while his slightly later illustrations of brothel scenes from the Goncourts' *La Fille Elisa* offer the clearest proof of his engagement with such sources.[41] Distinct though their interpretations are in many aspects of facture and fidelity to the text, we are again presented with the strange fact that Cézanne and Degas turned to much the same sources, even to identical narratives, at a similar moment in their careers; and that comparable imagery is absent in the output of most of their companions from the Café Guerbois circle.

In his capacity as co-organizer of the first Impressionist exhibition, held in 1874, Degas wrote to James Tissot in an attempt to secure his participation, notoriously announcing, "The realist movement no longer needs to fight with the others, it already *is*, it *exists* . . . there must be a *salon of realists!*"[42] Whatever Degas's conception of Realism was at this date, it was clearly broad enough to embrace both his own pictures of dancers, laundresses, and the racecourse and those of Cézanne, who contributed three works to the exhibition. Apart from two Auvers landscapes, Cézanne chose this occasion to show the extraordinary *A Modern Olympia*,[43] one of several variants on the theme of female nudity and male voyeurism he produced in this period. Evoking Manet and Gustave Courbet, Delacroix and Charles Baudelaire, *A Modern Olympia* was also part of Cézanne's sustained campaign to present himself as their successor, a Painter of Modern Life who could exceed them in bravado and vigor of execution. Alongside his portraits, his scenes of reverie, his experiments with landscape and still life, in the 1860s and 1870s Cézanne produced many hundreds of studies of everyday rural and urban humanity, from strolling lovers, picnic scenes, and boating parties to bars, brothels, and domestic interiors. Some are mere thumbnail sketches, others fully rehearsed and resolved compositions, while a number—such as *The Wine Toddy* and *A Modern Olympia*—were launched into the public arena to advertise the artist's commitment to this demotic genre. Cézanne's dedication in these years to a brash, socially descriptive realism remains one of the most overlooked features of his art, conforming uneasily as it does with more orthodox conceptions of the artist's significance.[44]

While Cézanne's continued attachment to Provence is apparent in his treatment of figurative subjects, a substantial proportion of his images of modern life are unequivocally urban and probably Parisian. Drawings and paintings of female nudes in their boudoirs, scenes of carnival and public entertainment, modishly dressed youths in parks and salons, women at the piano, and even an occasional laundry scene remind us of the city-based life this reportedly rustic painter often led. During long periods of residence in Paris, Cézanne encountered the same motifs, and was attracted to or repelled by the same repertoire of experiences, as his fellow exhibitors, and there is good reason to believe that, like Manet, Renoir, and Degas (and Claude Lantier, the Cézannesque hero of Zola's novel *L'Oeuvre*), he harbored among his primary ambitions the wish to become a painter of the city. Significantly, the works of such observers of the metropolis as Honoré Daumier,

Fig. 286. Edgar Degas, *Copy of a Figure from Cézanne's "Bathers Resting,"* 1877. Graphite, 10¼ × 13¾ in. (26 × 35 cm). Bibliothèque Nationale, Paris

Constantin Guys, and Paul Gavarni left their mark on Cézanne's graphic oeuvre at this time, and his documented use of photographs and fashion plates points to a similar concern. Whether derived from Paris or Aix, Cézanne's numerous studies of bars and dance halls belong unmistakably to the urban sprawl, while his drawings and paintings of incidents in brothels bring him into the closest proximity with the *flaneur* Degas. In addition to sketchbook drafts, up to a dozen of Cézanne's smaller oil paintings show an assortment of draped and upholstered interior scenes populated by reclining nudes or by half-naked temptresses and their partners in moments of voluptuous abandon or sexually provoked violence. *Courtesans* of 1867–68 may be the first of these, though a frantic boudoir scene like *The Strangled Woman* of 1875–76, which was made within a few months of Degas's more celebrated monotypes of the brothel, demonstrates the persistence of their common program.[45]

Conspicuous for many reasons, Cézanne's voyeuristic *A Modern Olympia* was almost alone at the 1874 Impressionist exhibition in representing the naked female form. Though the subject of the nude was not formally excluded from such shows, its association with the Salon and its prevalent historicism deterred most exhibitors from the theme, at least in this early phase. The only major exception among the submissions that year was a work by Degas, a drawing entitled *Après le bain*, which has yet to be identified.[46] At the second group exhibition, held in 1876, Degas again showed bathers, while Cézanne chose to absent himself. In 1877 Cézanne returned with more than a dozen works, roughly equal numbers of still lifes, landscapes, and figurative subjects (among them, on this occasion, a full-length portrait of Victor Chocquet).[47] Included in the last group was *Bathers: Study for a Painting (Les Baigneurs: Étude projet de tableau)*, now widely considered to be identical with *Bathers Resting* in the Barnes Foundation (fig. 285).[48] As in

Fig. 287. Edgar Degas, *Edmond Duranty*, 1879. Pastel and tempera, 39⅞ × 39½ in. (100.9 × 100.3 cm). L 517. The Burrell Collection, Glasgow. Atelier Sale I: 48

1874, Cézanne's nude studies were the only such works shown by a leading painter, except for pictures by Degas, whose entries included scenes of indoor and outdoor bathing, among them the *Beach Scene* of 1869.[49] Intrigued, amused, or irritated by the coincidence, Degas took the unusual step of recording Cézanne's *Bathers* in a notebook, drawing the most prominent male figure twice on a single sheet (fig. 286). Improvised from memory at the home of Ludovic Halévy, a writer and friend of Zola, these studies echo the copying from old masters that had occupied both artists in earlier years.[50] Accurately recalling the broad masses of the boy's anatomy while clarifying its internal rhythms, Degas seems to respect and simultaneously to impose himself on Cézanne's curiously symmetrical invention, just as Cézanne himself had earlier animated Raphael's *Venus and Psyche* after his own fashion. Singling out Cézanne's picture for attention from the hundreds of other works on display, Degas appears to have been saluting

their common artistic origins and shared concerns, and conceivably taking stock of a future competitor.

Degas's purchase in 1895 of *Bather with Outstretched Arms* may have looked back to his encounter in 1877 with the almost equally fractured and disquieting *Bathers Resting,* as well as to his more general identification with Cézanne's outdoor nudes. If each artist continued in his cautious fascination with the work of the other, the outcome was rarely a direct influence of a particular picture by Cézanne on one by Degas, or vice versa. Rather we sense a meeting of minds, the consciousness of a shared pool of themes and technical challenges, as well as some common history. After more than a decade of producing historically informed variations on the figure in a landscape, Degas had begun to evolve a repertoire of distinctive modern equivalents that included spectators at the racecourse, occasional pastoral portraits, and a series of highly original seaside groups set on Normandy beaches. Utilizing land-

Fig. 288. Paul Cézanne, *Gustave Geffroy,* 1895–96. Oil on canvas, 45¾ × 35 in. (116 × 89 cm). Musée d'Orsay, Paris, Gift, reserving life interest (R.F. 1969–29)

scapes he had encountered and drawn from life, he depicted young people swimming, idling, and drying themselves after their exertions, most famously in the *Beach Scene* painted in 1869 but first exhibited in 1877.[51] In the context of the 1877 show, Degas could hardly have overlooked the parallels between his work and Cézanne's bathing scene, even as he registered their contrasting attitudes toward space, anatomy, and technique: where *Beach Scene* is suave and lightly executed in oil on paper, the canvas of *Bathers Resting* has become abraded and clogged; and where Degas's picture follows a broadly naturalistic scheme of tones, hues, and textures, Cézanne's moves uneasily between blocks of blue and green, rough texture, and rectilinear design. What can hardly have escaped either artist's attention, however, and what is arguably their fundamental point of contact, is the manifest artifice of both compositions. Though Degas and Cézanne had visited the sites of their respective paintings and encountered at first hand the experiences they portrayed, each of the paintings that resulted resists being read illusionistically. In Cézanne's, the awkwardness of the bathers and the aggressive tactility of the paint seem defiant; the steep perspective and patternlike arrangements in Degas's are more witty than optically plausible. Even the abandoned hats, present at bottom left in both works, seem like bizarre acts of professional collusion rather than believable accessories.

When Degas was asked many years later how he had painted the *Beach Scene*, he is said to have replied, "It was quite simple; I spread my flannel waistcoat on the floor of the studio and had the model sit on it. You see, the air you breathe in a picture is not necessarily the same as the air out of doors."[52] If a single statement can be said to encapsulate his sympathy with Cézanne in the early years of Impressionism, while correspondingly distancing both artists from their colleagues, it is surely this last remark. Grounded in the practices of drawing, copying, and study of the past, each artist sought a modern discipline that would embrace his lived experience and his need for a cumulative, pondered technique. Though both experimented with rapid plein-air execution, neither committed himself to "render the trembling of leaves, the shimmer of water, and the vibration of sun-drenched air," as Duranty put it in 1876. Cézanne worked on canvases for months at a time, and Degas mocked those who preferred to paint outdoors—"as if art didn't live on conventions."[53] In reality, each artist combined his own method of studying a chosen subject at first hand with long periods of studio labor; but it is the resulting imagery that most clearly declares their purposes. In the same way that *Beach Scene* and *Bathers Resting* deny the easy pleasures of trompe l'oeil

and "finish"—what Cézanne called "the final polish, which is for the admiration of imbeciles"[54]—so the structures and expressive forms of the mature works of both artists insist on their identity as art.

After critics and the public heaped scorn on his pictures at the 1877 exhibition, Cézanne famously withdrew from the cycle of Impressionist shows and virtually ceased to exhibit for two decades, drastically reducing the visibility of his art, though not necessarily his awareness of the work of others. According to Vollard, *Bathers Resting* was at some point admired by the eccentric musician Ernest Cabaner, an acquaintance of Degas, "whereupon Cézanne immediately made him a present of it"; Cabaner eventually sold the work to Gustave Caillebotte.[55] Other paintings found their way into private collections, appeared in rare mixed exhibitions, or surfaced with dealers like Père Tanguy, though it is difficult to assess to what extent Degas knew of these incidents or took an interest in Cézanne's career. Mutual friends, such as Pissarro and Renoir, who continued to meet with Cézanne and even work by his side, were a potential channel of information, and it may be significant that the few writers who maintained a commitment to Cézanne's work, such as Joris-Karl Huysmans and Gustave Geffroy, also figured among Degas's friends and advocates. Contrary to legend, Cézanne himself was not immured in Aix during this period but rented accommodations almost annually in the capital, where he persisted with his unsuccessful approaches to the Salon, met occasionally with critics, collectors, and fellow practitioners, and eagerly followed the progress of former colleagues. In a letter to Zola of April 1, 1880, for example, Cézanne announced that he had just "descended on Paris," and, having "learnt from [Armand] Guillaumin that the Impressionist exhibition was open—I rushed there."[56] It was presumably during this sojourn that Cézanne saw Degas's large portrait of Duranty (fig. 287), introduced into the exhibition to mark the sudden death of the writer, though he might also have encountered the picture the previous year.[57] Cézanne would surely have been drawn to Degas's painting by his own current activities in portraiture, and it now became his turn to commit a work by Degas to memory. More than a decade later, when Cézanne undertook to make his portrait of Geffroy, a leading critic and writer, it was the Duranty picture he used as a model, as we know from Geffroy's recollection that Degas's painting had been "imitated by Cézanne" on this occasion.[58]

The dependence of Cézanne's portrait *Gustave Geffroy* (fig. 288) on Degas's picture of Duranty, first noted by Paul Jamot in 1918 and investigated further by Reff in 1977, is an important corrective to the assumption that influence

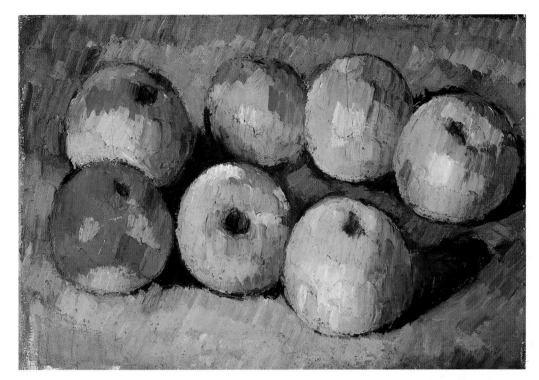

Fig. 289. Paul Cézanne, *Apples,* 1875–77. Oil on canvas, 7⅛ × 10¼ in. (18 × 26 cm). By kind permission of the Provost and Fellows of King's College, Cambridge; photo © Fitzwilliam Museum, University of Cambridge. Collection Sale I: 10

between the two artists was a one-way process.[59] In the portrait of Duranty we instantly grasp the particularity of the sitter, whose carefully constructed physiognomy and cluttered surroundings announce his "temperament, age, and social position" in a way that Duranty himself had recently advocated.[60] With the same lines and strokes of color, however, Degas reminds us of his contrivances, as he pushes the pattern of Duranty's bookshelves toward the plane of the canvas and tilts the surface of the desk downward. Spatially the image is illogical, even claustrophobic, but pictorially it vibrates and coheres in a radical new way, as Huysmans acknowledged in ecstatic references to its "novel optical mixtures" and its "marriage and adultery of colors" in a review of 1880.[61] Surprisingly, when Cézanne—whom Hertz was to call the master of "colored forms"—recalled Degas's picture while painting his *Gustave Geffroy*, he chose to subdue the vivid harmonies of the earlier work in favor of its spatial daring. Like Degas, he flattened the writer's arrangement of papers so that the viewer seems to stand above them, while presenting us with a frontal view of his human subject and the bookcase behind. Comparable also to Degas's handling is Cézanne's broad facture, the parallel pastel touches of the former finding an equivalent in the repetitive strokes of paint of the latter, both emphasizing the picture's palpable existence rather than its immateriality.

In another of the strong coincidences that haunted their relationship, Cézanne was occupied with painting the portrait *Gustave Geffroy* immediately before his exhibition in 1895 at Vollard's gallery, the occasion of Degas's rediscovery of his former colleague's art. According to Vollard, it was the long-standing friend and collaborator of both Degas and Cézanne, Camille Pissarro, who encouraged the dealer to mount this show, and it is in Pissarro's letters that we find the fullest account of the event and its reception. On November 13, 1895, soon after the exhibition opened, Pissarro told his daughter Esther that it was "very crowded" and that it contained "still lifes of an astonishing degree of finish, things that are incomplete but of an extraordinary savagery and character."[62] Six days later he wrote to his son Lucien, "Degas and Monet have bought marvelous things. I have obtained some admirable small canvases—*Bathers* and a *Portrait of Cézanne* in exchange for a poor sketch of Louveciennes!"[63] adding that his own enthusiasm was as nothing to that of "Renoir, Degas himself, who bows to the charm of this savagely refined character."[64] Before the month's end Degas had already translated his excitement into the purchase of three pictures, *Bather with Outstretched Arms* (fig. 283), the watercolor *Three Pears* (fig. 278), and the tiny oil on canvas *Apples* (fig. 289), and had come close to acquiring a fourth, the penumbrous *Déjeuner sur l'herbe* (fig. 279). Not the least astonishing feature of these purchases is their lack of equivocation; each work is among the most radical of its kind, combining dramatically stated form, dense facture, and extremes of transparent or saturated color that were almost without precedent at that time. Small in scale and different from one another in significant ways, all three were nevertheless part of a frontal assault on the conventions of picture-making, spurning one-point perspective and naturalistic detail, the

Fig. 290. Edgar Degas, *Henri Rouart and His Son Alexis,* 1895–98. Oil on canvas, 36¼ × 28¾ in. (92 × 73 cm). L 1176. Neue Pinakothek, Munich (13681). Atelier Sale I: 17

Fig. 291. Paul Cézanne, *The Card Players*, ca. 1890–92. Oil on canvas, 25¾ × 32¼ in. (65.4 × 81.9 cm). The Metropolitan Museum of Art, New York, Bequest of Stephen C. Clark, 1960 (61.101.2)

presumption of "finish," and the traditional hierarchy of motifs. As Pissarro's testimony demonstrates, many of these qualities were immediately apparent to Cézanne's admirers, if correspondingly baffling or offensive to a broader audience. "He won't understand anything of this," Pissarro commented as he arranged to take a London dealer to the show.[65]

As we have seen, Degas's motives for buying Cézanne's paintings during and after the Vollard show were often complex, combining delight and nostalgia, the thrill of acquisition ("Here is my new Van Gogh, and my Cézanne. I buy! I buy! I can't stop myself!" he told Daniel Halévy),[66] and a fascination with novelty and invention in his own declared territory. Just as he had recently rallied to the pictorial extravagances of Gauguin in the face of widespread antagonism, so Degas now rose to this art of "extraordinary savagery and character," implicitly promoting its aims and identifying with certain of its values. For Degas, the shock of recognition must have been intensified by his familiarity with Cézanne's subject matter, recalling the collision of their careers two decades earlier and their reluctant partnership in figuration. Separated, as ever, by Cézanne's engagement with still life and landscape, Degas could still identify with the painter of monumental genre scenes and rural bathers and in particular with the master of the modern lifesize portrait—all themes that were generously rep-

resented in the 1895 show. The most recent attempt to identify the works in the exhibition shows that, as on earlier occasions, Cézanne was at pains to present the full range of his skills and achievements, among which such recent portraits as *Boy in a Red Vest*, *Madame Cézanne in a Green Hat*, and *Girl with a Doll* were in all likelihood included.[67]

Some months before the exhibition, perhaps spurred on by his acquisition of a camera in 1895, Degas too had reasserted his status as a portraitist in the grand manner, initiating (and in some cases reworking) a series of large pastels and oil paintings of close friends that are both unashamedly contemporary and proudly historical.[68] One of these may have been the major canvas depicting Hélène Rouart in her father's study (fig. 130), a work begun in the 1880s but apparently strengthened somewhat later, when Degas accentuated its grid of richly varied horizontals and stark verticals, its dense color, and its overlapping planes in a way that Cézanne would instinctively have understood.[69] It was certainly in 1895 that Degas turned his attention to the older members of the Rouart family, making two dated studies and combining their subjects in *Henri Rouart and His Son Alexis* (fig. 290), a solemn, hieratic composition of two men in charcoal gray overcoats and contemporary hats.[70] Neither this painting nor any of the several variants of Cézanne's *Card Players*, which it so uncannily resembles,

Fig. 292. Edgar Degas, *Bathers*, ca. 1896. Pastel, 41⅛ × 42⅝ in. (104.6 × 108.3 cm). The Art Institute of Chicago. Atelier Sale I: 211

appears to have been placed on current exhibition, however, and we find ourselves speculating once again about their real or imagined association. In both the Rouart portrait and the Metropolitan Museum's *Card Players* (fig. 291), the fuller figure of a seated man whose arms project in front of him is offset by a remote standing companion, the timeless passivity of the subjects in strange coexistence with their ordinariness. Degas's formal city dwellers, with their grim, sightless faces, are perhaps the more terrifying, their features broadly brushed and their expressions near desperate. It is now Cézanne's majestically controlled composition that comes close to refinement, Degas's that suggests a kind of savagery.

As in 1874 and 1877, at the 1895 exhibition Degas must have felt himself in the presence of a kindred spirit. Had they become reacquainted, the two men might also have become aware of the detailed coincidence of many of their views: when Cézanne famously announced in the context of his *Bathers* that he aspired toward "a Poussin done again entirely from nature," he recapitulated a dozen remarks from the same period in which Degas was linked with the seventeenth-century master;[71] when Degas claimed, "One sees as one wishes to see," he anticipated Cézanne's state-

ment that "there are two things in a painter, the eye and the mind; each of them should aid the other";[72] and when both artists spoke of their artifice, Cézanne's ideal of a "harmony parallel to nature" echoed Degas's aim to express "truth by means of the false."[73] Though they were never to broach these matters face to face, each one's awareness of the other's works must have been intensified during these years. For example, if Cézanne saw Degas's portrait of a fashionably dressed woman in a large hat, *Conversation*, which passed through the Durand-Ruel gallery in 1896, he could hardly have missed its affinity with his own *Madame Cézanne in a Green Hat*, shown at Vollard's the previous year, while the appearance of rather different pictures of harlequins by both artists might have attracted general comment.[74] Conversely, the many opportunities for Cézanne to study Degas's recent pictures of nudes and bathers in the 1890s may well have sharpened and directed his resolve. Despite his reputation as a recluse, Degas continued to release drawings, pastels, and oils onto the market, in small groups at Camentron's gallery in 1893 and 1894, in one-man shows at Durand-Ruel in 1892 and 1896, and, increasingly, at public sales, group exhibitions, and official displays in France and abroad.[75] Finding him-

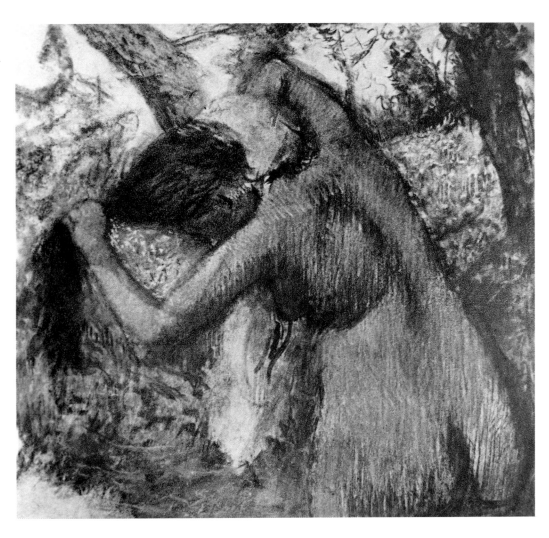

self in front of the new "series of nudes" at Durand-Ruel's gallery in 1896 ("as rich and solid as a tapestry," one of Pissarro's sons reported),[76] Cézanne would surely have reciprocated at least some of the emotions felt by Degas at Vollard's, even if the notoriously unacquisitive Cézanne did not translate his responses into purchases. At this date, Degas's pastels of women bathing were still predominantly set indoors, though they had long since shed most of their domestically descriptive trappings. *Leaving the Bath,* a work probably in the 1896 show, confronts us with broadly stated limbs and a persuasively substantial torso, the whole locked into wedges of color and encrusted chalk that defy a literal response.[77] Gone too were the last vestiges of precise detail—the "final polish" once derided by Cézanne—now subsumed in Degas's wider expressive aims, as both artists dismantled the traditions of the nude that had sustained them in their youth.

As Degas's concurrent acquisitions of pictures appear to acknowledge, it was the interlinked subjects of the face, the figure, and the naked human body that most bound his career to that of Cézanne, not just in their student beginnings and the Impressionist interlude but into the crowning achievements of their maturity. In his 1886 and

1889 exhibitions of pastels, Degas had twice staked his claim as a preeminent artist of the nude, and it is inconceivable that two such self-conscious painters would not have monitored and derived stimulation from their shared obsession. In Degas's and Cézanne's final years, bathers and nudes were to multiply and encroach on other concerns, overwhelming all but the ballet in Degas's case and accounting for the grandest and most complex canvases left unfinished at Cézanne's death. Few of these pictures are dated, and the task of winnowing out influences and shared sources, chance resemblances and acts of homage, is probably insurmountable. What the purchase of *Venus and Cupid* and *Bather with Outstretched Arms* encourages us to do, however, is examine a suite of pictures made by Degas in the 1890s that return the nude to its pastoral surroundings. As we have seen, this theme had haunted the careers of both artists, but its resurgence in Degas's oeuvre soon after the Vollard show, in some of the largest compositions of his late years, is both unexpected and insufficiently studied.[78] Less populous than most of Cézanne's bather pictures, Degas's arrangements of two, three, or four women who recline, dry themselves, or attend to their hair share a similar atmosphere of indolence or meaning-

less inactivity justified only by the purposes of art. Recalling classical sculpture and Renaissance draftsmanship, these pictures also share with Cézanne's an earthiness and occasional coarse humor, qualities that are often overlooked in the work of both men. In Degas's *Two Bathers beside the Water*, for instance, the portly rear view of the principal nude suggests a bucolic romp rather than an antique frieze, approaching caricature almost as dangerously as the nearly identical figure in Cézanne's *Three Bathers*.[79] Other bathers in Degas's scenes irreverently remove their stockings or loll on the grass, exploring a vein of rusticity, even of primitivism, that is closer to Gauguin and Pissarro than to the somewhat chaste nudity of Cézanne. It is in the densely interlocking legs, torsos, and arms of Degas's frescolike *Bathers* (fig. 292) and in single figures such as *Bather beside the Water* (fig. 293), however, that he seems most openly to signal his community of endeavor with Cézanne.[80] In the former—a work that resonates with remembered forms from Raphael and Poussin as well as recalling Degas's own *Scene of War in the Middle Ages* of 1865—a curious analogy to Cézanne's *Venus and Cupid* has been noted by several observers,[81] while in the latter the unmistakable presence of a leaning pine tree, more Provençal than Parisian, might be an ironic salute to Degas's rival.

Sometime around 1899, Degas asked a young admirer, the painter Louis Braquaval, to help him by sketching some trees for a "large painting in oil, three women bathing in a stream edged with birches."[82] Braquaval had a house at Saint-Valéry-sur-Somme, on the Picardy coast, and had already been complicit in another suite of Degas's pictures that were almost as unexpected from the urbane master as his rambunctious pastoral nudes. Depicting views in and

Fig. 294. Edgar Degas, *View of Saint-Valéry-sur-Somme*, 1896–98. Oil on canvas, 20⅛ × 24 in. (51 × 61 cm). BR 150. The Metropolitan Museum of Art, New York, Robert Lehman Collection, 1975 (1975.1.167). Retained by Degas's heirs

Fig. 295. Paul Cézanne, *Gardanne,* ca. 1885–86. Oil on canvas, 31½ × 25¼ in. (80 × 64.1 cm). The Metropolitan Museum of Art, New York, Gift of Dr. and Mrs. Franz H. Hirschland, 1957 (57.181)

around Saint-Valéry and apparently painted between 1896 and 1898, the substantial pastels and canvases from the earlier group ranged over the crumbling rooftops and fortifications of the old town, the farm buildings on its outskirts, and the tracks and alleys adjacent to Braquaval's property. Tackling subjects almost unprecedented in Degas's oeuvre, the Saint-Valéry series distantly recalls certain of the pastels made in 1869 for pictures like *Beach Scene,* while its chromatic inventiveness brings to mind the pastel-over-monotype landscapes shown by Degas in 1892. On both those occasions, Degas's excursions into the genre had evidently been quickened by the example of his peers: testing himself against Eugène Boudin, Manet, and Paul Huet with the first group, against Cassatt, Pissarro, and Gauguin in the second, Degas had aspired to exceed them all in daring of technique and conception.[83] The Saint-Valéry landscapes were another such case, following hard on the heels of Cézanne's retrospective, Monet's 1895 *Rouen Cathedrals,* recent showings of Gauguin's scenes of Tahiti, and the pictures of Rouen exhibited by Pissarro in 1896. There can be little doubt that these events prompted Degas's experi-

ments and even less that he wished to push beyond those painters' most audacious structures and inventive coloring, even beyond what Pissarro had called Cézanne's "savagery." More agricultural in his *Return of the Herd* than Gauguin, more attenuated in the harmonies of his *At Saint-Valéry-sur-Somme* than Monet, and, in his *View of Saint-Valéry-sur-Somme* (fig. 294), as vertiginous as Pissarro on his Rouen rooftops, Degas was again attempting to assert himself as the group's uncrowned leader.[84]

Pointedly absent from Degas's personal collection were examples of Cézanne's landscapes, a category of painting Degas continued to denounce in public, however hypocritically, until his last years. By this date he would have seen dozens of Cézanne's landscape canvases, including such works from the Vollard show as *The Jas de Bouffan* of about 1890–94 and the somewhat earlier *Gardanne* in the Metropolitan Museum (fig. 295), both of which present steep hillsides and distant roofs in interlocking patterns of masonry and foliage, forms that appear to resurface in the Saint-Valéry series.[85] With its substantial passages of uncovered canvas and still-evident underdrawing, *Gardanne*

would presumably have been among the pictures described by Pissarro as "things that are incomplete but of an extraordinary savagery and character." In such paintings, the crisp exchanges between line and color, structure and sensuality of Cézanne's mature landscapes are literally laid bare, contrasting them with the more developed, self-effacing works "of an astonishing degree of finish" that were also in the show. Perhaps recognizing in these frank canvases an equivalent to his own struggles with charcoal and pastel, Degas adopted a similarly open technique for his forays at Saint-Valéry. In the elevated townscape of *View of Saint-Valéry-sur-Somme,* a grid of blue and black lines articulates the geometry of his view, overlaid but not obliterated by swaths of dense green, red-brown, and silver. Contour answers pigment, formal design contains sumptuous hue, yet a glorious disregard of refinement still animates the scene. Examination of the site has shown that the artist took considerable liberties with the actual view, enlarging or reducing elements for maximum legibility in a way familiar from Cézanne but also, more radically, editing out an entire segment of the scene.[86] Degas's exploration of perceptual language in these canvases, again possibly urged on by his own work in photography, approached collage or a kind of proto-Cubist manipulation of the visible, propelling him even beyond Cézanne's most developed landscape inventions.

Despite the acquisitions for his collection, despite his acts of painterly emulation, and despite the increasing celebrity of both men at the turn of the century, Degas kept his distance from Cézanne right up to the latter's death in 1906. Something of their old antagonism survives in the recorded gossip of those years, for instance Cézanne's observation to Denis that "Degas is not enough of a painter, he hasn't enough of *that* (making a nervous gesture, as if drawing like Michelangelo)," and Degas's remark to William Rothenstein (possibly made before 1895) that he "had no great opinion of Cézanne as an artist."[87] Contrarily, the same sources also reveal further sympathies in the two painters' tastes and opinions: Joachim Gasquet's highly eclectic reminiscences of Cézanne tell us of the artist's unexpected liking for Daumier, Forain, and Henri de Toulouse-Lautrec in his later years and his near-worship of Veronese's *Marriage at Cana* (a work that also featured in Degas's pantheon), as well as views remarkably like Degas's on such matters as the supposed decline of the technique of painting since Jacques-Louis David.[88] It is in this same period that Vollard's published memoirs of both artists begin, though the normally indiscreet dealer draws a veil over professional relationships between his two prime subjects.[89] What we can now reconstruct, since the

Vollard archives have been made accessible, is the extraordinary proximity of Degas and Cézanne within the orbit of his gallery, where their comings and goings, their sales, acquisitions, and exchanges in the last years of the old century and the first years of the new are meticulously noted. On the gallery walls the two painters were also able to witness the late unfolding of each other's art as they continued to avoid or to circle round each other personally, in the disgruntled pas de deux of their old age.

When a young American painter and disciple of Degas, Maurice Sterne, visited Paris in 1905, he admitted that the work of Cézanne still left him confused. As John Rewald relates, it was a visit to the Salon d'Automne of that year, where Cézanne's pictures were shown in profusion, that began to change his mind. Encountering the elderly Degas at the exhibition dressed in "a shabby old cape," Sterne was astonished to find that his hero "was an admirer of what appeared to me uncouth daubs" and subsequently found himself reexamining his own prejudices.[90] By now almost as disreputable in appearance and violent in manner as Cézanne had been in their early days, Degas had come close to changing places with the "Maillobert" figure of Duranty's story. While Cézanne's fame was now in the ascendant, Degas refused to exhibit and rudely turned visitors away from the door of his studio, which was as chaotic as anything described by Duranty; while Degas's drawings had once been praised for their refinement, the fractured forms of his charcoal studies and the near brutalism of his bathing nudes now alarmed his closest friends; and while Degas had been hailed as a society illustrator, the inventor of "social chiaroscuro," the incandescent hues of his latest pastel dancers seemed to suggest a new identity, that of an "anarchist in art," as Pissarro dared to suggest.[91]

1. This essay is an expanded version of a work first published in French in *Degas inédit* 1989.
2. Henri Hertz, *Degas* (Paris, 1920), p. 14.
3. Edmond Duranty, "La Simple Vie du peintre Louis Martin," in *Le Siècle,* November 13–16, 1872; here cited in the posthumous edition, Edmond Duranty, *Le Pays des arts* (Paris, 1881), pp. 313–49.
4. Duranty, *Le Pays des arts,* pp. 315–16.
5. "l'inventeur du clair-obscur social." Ibid., p. 335.
6. Georges Rivière, *Mr. Degas, Bourgeois de Paris* (Paris, 1935), p. 76.
7. For the pictures acquired by Degas, see Richard Kendall, "Degas et Cézanne," in *Degas inédit* 1989, pp. 103–13, London 1996, and the present catalogue.
8. See Rivière, *Mr. Degas.*
9. For the dates of individual purchase see the Summary Catalogue, the companion volume to this publication.
10. C. Pissarro 1950, p. 392.
11. Manet 1987, p. 76.
12. The daybooks and ledgers in question are now in the collections of the Musée du Louvre and the Musée d'Orsay, Paris.

13. "1 painting by Cézanne, *Déjeuner sur l'herbe* (80½ × 59½), dark style, 600 francs." The work is V 107.

14. Blanche 1919 (1927), p. 289; Maurice Denis, *Théories 1890–1910, du symbolisme et de Gauguin vers un nouvel ordre classique* (Paris, 1912), vol. 1, p. 123.

15. Hertz, *Degas*, p. 14.

16. Picasso's remark is in Alfred H. Barr, Jr., *Picasso: Fifty Years of His Art* (New York, 1946), p. 274.

17. Lillian Browse, *Degas Dancers* (New York, 1949), p. 25.

18. Theodore Reff, "Painting and Theory in the Final Decade," in William Rubin, ed., *Cézanne: The Late Work* (New York, 1977), pp. 14–15; Gary Tinterow, "1881–1890," in Paris, Ottawa, New York 1988–89a, p. 448; Jean Sutherland Boggs, "1890–1912," in Paris, Ottawa, New York 1988–89a, p. 544; Armstrong 1991, p. 109.

19. Adriani 1985, p. 12; see also Götz Adriani, "La Lutte d'amour," in Lawrence Gowing et al., *Cézanne: The Early Years 1859–1872* (London, 1988), pp. 41–53.

20. Gordon and Forge 1988, p. 17.

21. For the details of this analysis, see Richard Kendall, "The Figure in the Landscape," in Richard Kendall, ed., *Cézanne and Poussin: A Symposium* (Sheffield, 1993), p. 91.

22. The principal sources for these comparisons are Lemoisne 1946–49; Reff 1976b; Venturi 1936; and Chappuis 1973. See also Kendall in *Degas inédit* 1989, pp. 104–5.

23. For the details of these copies, see Kendall in *Degas inédit* 1989, p. 112 n. 7.

24. Ibid., p. 112 n. 8.

25. I am much indebted to Walter Feilchenfeldt for drawing my attention to these two copies. Degas's registrations at the Louvre are summarized in Paris, Ottawa, New York 1988–89a, p. 48.

26. Cézanne registered in 1863 and 1868; see Françoise Cachin et al., *Cézanne*, exh. cat., Paris, Galeries Nationales du Grand Palais; London, Tate Gallery; Philadelphia Museum of Art (New York, 1996), pp. 532, 535.

27. The drawing was sold at Degas's fourth studio sale in 1919, Atelier Sale IV: 99(1), and is now in a private collection.

28. See, for example, Chappuis 1973, nos. 375, 473, 678, 1208.

29. The picture in question is in the Louvre; the drawings by Cézanne and Degas are reproduced in Kendall in *Degas inédit* 1989, pp. 104–5.

30. V 4–7, Musée de la Ville de Paris; L 70, National Gallery, London.

31. The identity of *The Wine Toddy* has been contested, but it is often identified with V 224; *Mademoiselle Fiocre*, L 146, is in The Brooklyn Museum of Art, New York.

32. L 124, Musée d'Orsay, Paris; V 121, Walker Art Gallery, Liverpool; L 82, Musée d'Orsay, Paris; V 92, private collection; V 103, E. G. Bührle Collection, Zurich.

33. The 1860s was a period of extensive interest in the work of Delacroix for both artists. Degas's copy of Titian's *Saint Anthony Reviving a Woman Killed by Her Husband*, L 54, is another overlooked source for such images.

34. Adriani, "La Lutte d'amour," p. 42.

35. L 854 (ca. 1885), 855 (ca. 1893–95), 1079 (1895–1905).

36. John Rewald, *The History of Impressionism* (New York, 1946), p. 197.

37. V 126, National Gallery of Art, Washington, D.C.; L 79, Musée d'Orsay, Paris; L 126, Los Angeles County Museum; V 88, Musée d'Orsay, Paris; L 271, National Gallery of Art, Washington, D.C.

38. John Rewald, *Cézanne, sa vie, son oeuvre, son amitié pour Zola* (Paris, 1939); Mary Louise Krumrine, "Parisian Writers and the Early Work of Cézanne," in Gowing, *Cézanne: The Early Years*, pp. 20–31; idem, *Paul Cézanne: The Bathers* (London, 1990).

39. Krumrine, "Parisian Writers," p. 22. V 101, Kings College, Cambridge; V 105, private collection; V 107, private collection.

40. L 348, Philadelphia Museum of Art. Reff 1976a, chap. 5; see L 348.

41. See Reff 1976b, Notebook 28, and L 41, 42, 350, 351, 353.

42. *Letters of Degas* 1947, p. 39.

43. V 225, private collection; for the submissions of both artists to the Impressionist exhibitions, see Washington, San Francisco 1986.

44. For a more extended discussion of this theme, see Kendall 1993, pp. 88–108.

45. V 122, Barnes Foundation, Merion, Pa.; V 123, Musée d'Orsay, Paris; other examples are V 106, 111–12, 223–24, 227, 254, 279.

46. See Washington, San Francisco 1986, p. 120.

47. Ibid., p. 204.

48. V 261. For a summary of the arguments that V 259 was the picture shown, see Rewald 1996, vol. 1, pp. 177–80; the Degas drawing of the work is clearly based on the Barnes painting.

49. See Washington, San Francisco 1986, p. 204; Degas's picture is L 406.

50. Reff 1976b, Notebook 28, p. 3. The notebook was kept at the Halévys', where Degas made drawings on his regular visits.

51. National Gallery, London. For these pictures, their sites, and the question of dating, see Kendall 1993, chap. 5.

52. Vollard 1937a, p. 47.

53. Washington, San Francisco 1986, p. 46. Étienne Moreau-Nélaton, "Deux heures avec Monsieur Degas," reprinted in Lemoisne 1946–49, vol. 1, p. 259.

54. John Rewald, ed., *Paul Cézanne: Letters* (London, 1941), p. 99.

55. Vollard 1937a, p. 43.

56. Rewald, *Paul Cézanne: Letters*, p. 145.

57. L 517, The Burrell Collection, Glasgow; Washington, San Francisco 1986, p. 267.

58. Gustave Geffroy, *Claude Monet, sa vie, son oeuvre* (Paris, 1924), p. 136. The painting is in the Musée d'Orsay, Paris.

59. Jamot 1918; Reff, "Painting and Theory in the Final Decade," pp. 14–15.

60. See Washington, San Francisco 1986, p. 44.

61. Huysmans 1975, pp. 18–24.

62. Bailly-Herzberg 1980–91, vol. 4, p. 113.

63. Ibid., p. 116.

64. Ibid., p. 119.

65. Ibid., p. 126.

66. Halévy 1960, p. 86.

67. National Gallery of Art, Washington, D.C.; Barnes Foundation, Merion, Pa.; Heinz Berggruen, London. Rewald 1996, vol. 1, p. 562.

68. This group of works, several of them signed and dated 1895, suggests that Degas may also have contemplated a display of portraits in this year; see L 1175–78 and BR 139.

69. For the history of this work, see London, Chicago 1996–97, pp. 108–10.

70. L 1176.

71. For the connection of Cézanne's statement to his *Bathers* rather than to the landscapes more usually associated with the remark, see Kendall 1993, pp. 94–96; for Degas and Poussin, see London, Chicago 1996–97, pp. 115–16.

72. Halévy 1960, p. 69; Émile Bernard, *Souvenirs sur Cézanne* (Paris, 1926).

73. John Rewald, *Paul Cézanne: Correspondance* (Paris, 1978), p. 262; Sickert 1917, p. 185.

74. L 1175, location unknown, and Barnes Foundation, Merion, Pa.; see London, Chicago 1996–97, pp. 43–44.

75. See London, Chicago 1996–97, chap. 2.

76. Bailly-Herzberg 1980–91, vol. 4, p. 191.

77. L 1335, Musée d'Orsay, Paris; for works in the 1896 show, see London, Chicago 1996–97, pp. 44–45.

78. L 1070–78, 1422, and BR 135.

79. L 1077, private collection; V 269, private collection.

80. L 1079, 1422.

81. See, for example, Chicago 1984, p. 189.

82. *Degas inédit* 1989, p. 392.

83. For an account of these events, see Kendall 1993, chaps. 4 and 7.

84. L 1213, Leicestershire Museums and Art Galleries, Leicester; L 1215, Ny Carlsberg Glyptotek, Copenhagen; BR 150, The Metropolitan Museum of Art, New York.

85. V 470, private collection, Japan; V 570.

86. For a fuller discussion of this painting, see Kendall 1993, pp. 266–67.

87. Maurice Denis, *Journal: 1905–1920* (Paris, 1957), p. 29; Rothenstein 1931–39, vol. 1, p. 103.

88. Joachim Gasquet, *Cézanne* (Paris, 1921), pp. 47, 65, 132.

89. Vollard 1937a and Ambroise Vollard, *Paul Cézanne: His Life and Art* (New York, 1937).

90. John Rewald, *Cézanne and America: Dealers, Collectors, Artists and Critics 1891–1921* (Princeton, 1989), p. 97.

91. Bailly-Herzberg 1980–91, vol. 4, p. 63.

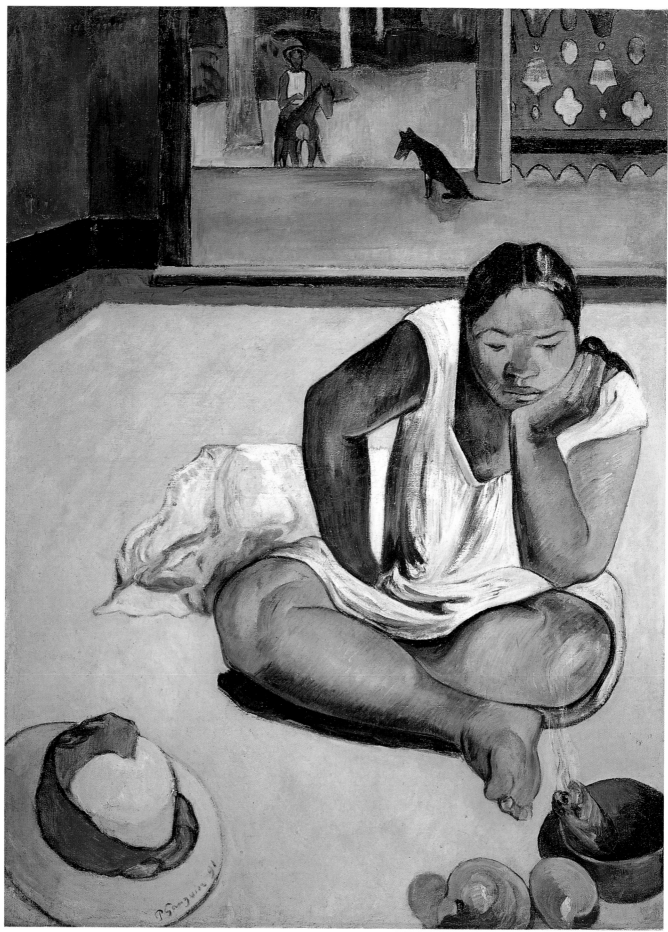

Fig. 296. Paul Gauguin, *Sulking (Te faaturuma),* 1891. Oil on canvas, 35⅞ × 26¾ in. (91 × 68 cm). Worcester Art Museum, Worcester, Mass. (1921.186). Collection Sale I: 41

Degas and Gauguin

FRANÇOISE CACHIN

At the time of their first meeting, which probably occurred in the early spring of 1879, Paul Gauguin (1848–1903) was thirty years old and Edgar Degas forty-five.[1] Degas shared pride of place with his contemporary Édouard Manet in the Indépendants movement and took center stage, alone, at the Impressionist exhibitions. (Manet, who had chosen the different strategy of showing his modern art at the Salon, never participated in the Impressionists' group shows.) For Gauguin, then, Degas was the man to learn from, to follow, and to engage. Camille Pissarro, at the time both a close friend of Degas and a protector and mentor of Gauguin, who was still a novice, introduced the two.[2] He recommended Gauguin to Degas and arranged for him to be invited to show his work in the Impressionist exhibition of 1879—although only at the very last moment, which is why Gauguin is not listed in the catalogue. From then on, however, he was part of the "club," participating in the Impressionist exhibitions of 1880, 1881, 1882, and 1886.

Still, from 1879 to 1882 Gauguin was seen by the group mainly as an interesting amateur, a "Sunday painter," and as a collector. He wrote to Pissarro on September 26, 1879, "I went to see Degas in his studio. Unfortunately [Ernest] May had bought his pastel, so I couldn't get it. Too bad, because it's really splendid."[3] This was surely *The Rehearsal Onstage* in the Metropolitan Museum (fig. 301)[4] (not to be confused with another one from the Havemeyer Collection also in the Metropolitan Museum, which was then on the British market, nor with the grisaille at the Musée d'Orsay, which by 1879 was already in the Muhlbacher Collection).

Several months later, probably by way of consolation and certainly to welcome his arrival as a painter and acknowledge his talent, Degas suggested or agreed to the idea of an exchange. Gauguin offered him—or perhaps Degas chose—*The Mandolin (On a Chair)* (fig. 297), which the artist later showed in the Impressionist exhibition of 1881 accompanied by a note in the catalogue that filled him with pride: "Owned by M. Degas." The choice is interesting, as it shows the same mandolin and the same Algerian fabric that are depicted in the first of Gauguin's paintings

to attract significant attention, the naturalistic nude called *Suzanne Sewing,* now in the Ny Carlsberg Glyptotek in Copenhagen. Whereas until then Gauguin had mainly painted small still lifes of flowers and landscapes that showed the direct influence of Pissarro, this subject was more indicative of his own personality, his bohemian aspirations, and his taste for music and exoticism. The unconventionality of the painting's composition was also something of a first for Gauguin.

In return, Degas gave him a pastel of a dancer, no doubt in memory of his thwarted purchase.[5] Although it was a generous gift—at the time, the exchange was unequal in monetary terms—the work was a relatively modest one. It was one of the first pieces from Gauguin's collection that his wife, Mette, sold later, when things got difficult for the painter-stockbroker's family. Thanks to Merete Bodelsen we have a very good idea of the contents of Gauguin's collection, which included eight Pissarros and five paintings by Paul Cézanne.[6] Gauguin owned no other works by Degas: the two did not meet until after Gauguin had given up his livelihood, and at that time Degas, who produced fairly few works, was already commanding high prices. In February 1894, when Gauguin's finances had improved somewhat and he wrote to buy back some pieces from the Danish writer Edvard Brandes, Mette's brother-in-law, who had acquired part of his collection, he asked especially for the Pissarros and the Cézannes: "You'll still have Degas, Manet, and [Armand] Guillaumin."[7] It wasn't that he did not admire Degas—quite the contrary—but rather that he rightly did not consider this pastel a major work. In fact, Degas's example was crucial to the evolution of Gauguin's art throughout his life, first and foremost because it enabled him to move beyond the very literal influence of Pissarro's Impressionism.

In the early 1880s, while he was still under Pissarro's sway in his painting, Gauguin began coming into his own in his sculpture and decorative art, as Bodelsen has shown;[8] and Theodore Reff has convincingly demonstrated how strongly Degas was associated with those developments. Degas's *The Little Fourteen-Year-Old Dancer,* which was exhibited

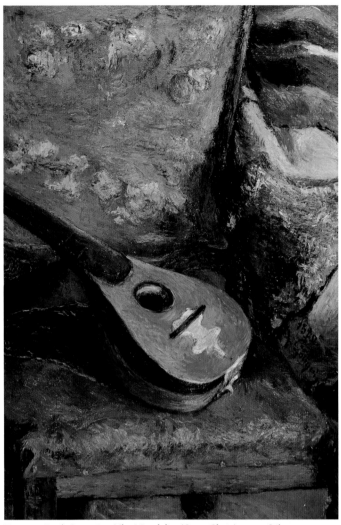

Fig. 297. Paul Gauguin, *The Mandolin (On a Chair)*, 1880. Oil on canvas, 18½ × 11¾ in. (47 × 30 cm). Private collection. Collection Sale I: 44

in 1881 but made the previous year and which Gauguin had seen in the studio, clearly served as a model: both in its combining of different materials and in its realism it stands behind Gauguin's sculptures *The Singer*[9]—whose very subject is a homage to Degas—and the *Bust of Clovis*,[10] both of which combine wood, painted wax, and glued-on fabric. Degas was greatly interested in the latter work, and a sketch of it exists in one of his notebooks.[11] In the same way, Degas's *Schoolgirl* (fig. 298) and Gauguin's wooden figurine *The Little Parisienne* (see fig. 299) are very similar, and it is difficult to know which one came first. Gauguin's figurine was exhibited in 1881; Degas's statuette was probably made slightly before that.

A few years later, in 1884, Gauguin created a very strange object (fig. 300). It is a wooden box in the center of which a carved nude lies as if in a coffin; its clasp is decorated with a glued-on Japanese netsuke; and its sides are sculpted in a style deliberately vulgar and primitive, but with motifs based on ballerinas taken from Degas's *The Rehearsal Onstage* (fig. 301), which Gauguin had wanted to buy and which he had certainly copied in sketches that have since disappeared. This was the first manifestation of a phenomenon that would recur at every decisive stage in Gauguin's career: whenever he took a new direction, the influence of Degas, superimposed on other influences (primitivism, japanism, and so forth), was never far away. Thus when in the fall of 1886 Gauguin began, with Ernest Chaplet, to make ceramics, a medium he had recently begun exploring

Fig. 298 (left). Edgar Degas, *Schoolgirl*. Bronze, after original wax modeled ca. 1880–81. H. without base 10⅝ in. (27 cm). The Metropolitan Museum of Art, New York, Purchase, Mr. and Mrs. Claus von Bülow Gift, 1977 (1977.338)

Fig. 299. Paul Gauguin, *The Little Parisienne*. Terracotta (or plaster?) version of the wood statuette Gauguin showed at the sixth Impressionist exhibition, 1881 (no. 39). H. 9⅞ in. (25 cm). Location unknown

under the influence of Japanese and Peruvian traditions, one of his very first pieces was a bowing ballerina, in imitation of Degas.[12] It may well have been a symbolic tribute, since the two artists, who had fallen out four years earlier, reconciled at precisely that time.

It is worth retracing several episodes in the tumultuous friendship between Degas and Gauguin, both of whom have acquired legendary reputations for moodiness, intransigence, and, to some extent, nastiness. Beginning in the summer of 1879, they shared a genuine mutual affection; they would meet, either at the Montmartre café Nouvelle-Athènes with Auguste Renoir, Manet, the writer Edmond Duranty, and others, or at Degas's. Gauguin was one of the few regular visitors to Degas's studio. But once Degas had,

at Pissarro's request, invited Gauguin to exhibit in the Impressionist shows, Gauguin very soon became involved in the complicated intrigues of these exhibitions, which were organized sometimes by the Renoir–Gustave Caillebotte faction and sometimes by Degas's circle. Degas wanted to bring in his friends Jean-François Raffaëlli, Federico Zandomeneghi, Jean-Louis Forain, and others whom the "pure" Impressionists refused. Gauguin imagined—somewhat unreasonably, it would seem—that Degas was trying to sabotage the group exhibitions. "For Degas, Raffaëlli is simply a pretext for breaking things up: there's something twisted about that man that destroys everything," he wrote to Pissarro in January 1882, adding, "Degas can say anything he likes, since he's hardly crawling back into his hole.

Fig. 300. Paul Gauguin, *Carved Box with Dance Motifs,* ca. 1880–81 or 1884–85(?). Wood, 8¼ × 20⅛ × 5⅛ in. (21 × 51 × 13 cm). Private collection

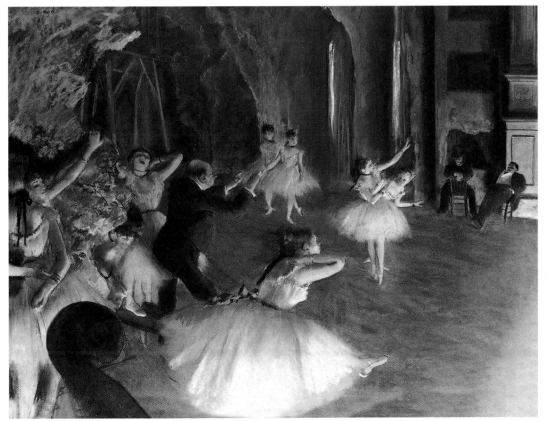

Fig. 301. Edgar Degas, *The Rehearsal Onstage,* ca. 1874. Pastel over brush-and-ink on paper laid down on board, mounted on canvas, 21 × 28½ in. (53.3 × 72.4 cm). L 498. The Metropolitan Museum of Art, New York, H. O. Havemeyer Collection, Bequest of Mrs. H. O. Havemeyer, 1929 (29.100.39)

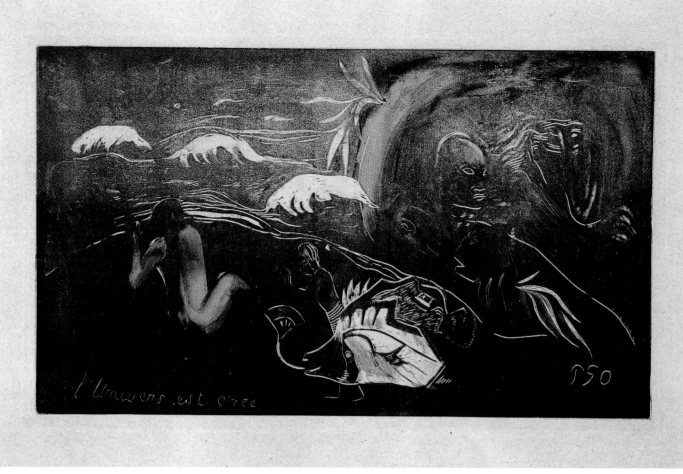

Fig. 302. Paul Gauguin, *The Universe Is Created*, 1893–94. Woodcut mounted on blue paper, 8⅛ × 14 in. (20.5 × 35.5 cm). National Gallery of Art, Washington, D.C., Rosenwald Collection (1947.12.56). Probably Collection Print Sale: 128.3

He has made his reputation and doesn't have to worry about it. He has his crowd of supporters, and even the Academy, which he jokes about, is ready to welcome him with open arms."[13]

The bitterness lasted for some years but was tempered by admiration. When Manet died in 1883, Gauguin wrote, "Manet had donned the leader's uniform; now that he's dead, it's Degas who will succeed him—and he's an Impressionist who can draw!"[14] Three years later, a letter from Pissarro to his son Lucien described the Impressionists' plans for what would be the eighth and last of their group shows: "They meet regularly. Degas himself comes to the café. Gauguin has once again become a close friend of Degas's and often goes to see him. Curious little seesawing of interests, don't you think?"[15] Whatever the interests, it is clear that Degas took Gauguin back under his wing. A reconciliation had occurred by 1886, since it was Degas who had urged the dealer Durand-Ruel to buy some of the fledgling artist's works—and from then on the friendship stayed firm.

The strongest evidence of Degas's support was his regu-lar purchase of Gauguin's works. The posthumous sales of March and November 1918 reveal the extraordinary number of those works in Degas's collection: ten paintings, in-cluding some of the artist's most important ones, spanning his entire career; one work in pastel; six monotypes; and ten woodcuts "remounted on blue paper," as the catalogue notes (fig. 302).

Degas had almost bought a painting of Pont-Aven in the fall of 1888;[16] the sale never took place, but the idea of it nonetheless gave Gauguin great pleasure: "I'm as satis-fied as can be with my studies of Pont-Aven," he wrote to the painter Émile Bernard. "Degas is going to buy *Breton Women on the Aven.* I'm very flattered, for as you know I set great store by Degas's judgment. Besides, commercially speaking, it's a very good starting point. All of Degas's friends trust him."[17] Degas's first major purchase of his work, made at the Gauguin sale of 1891, was *La Belle Angèle (Madame Angèle Satre)* (fig. 303), which, with its simplified technique and japanism, was one of the most daring can-vases in the sale. Pissarro wrote his son at the time, "I heard

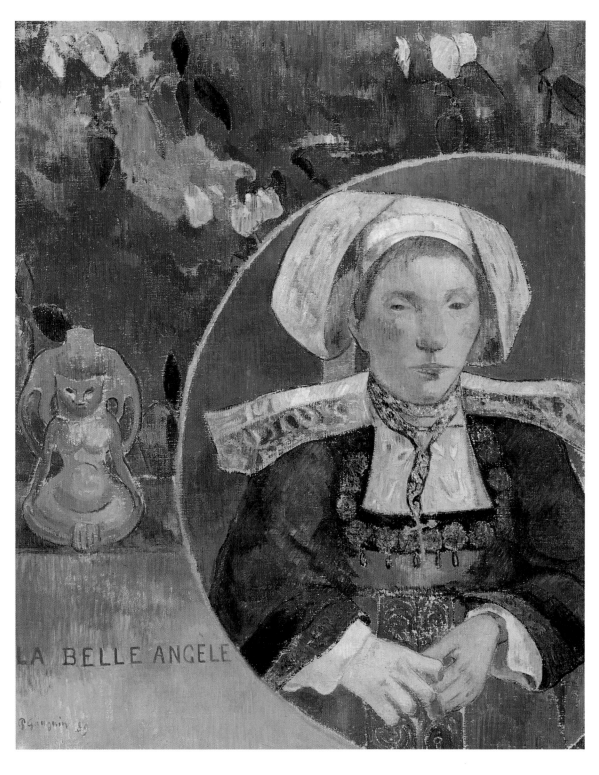

Fig. 303. Paul
Gauguin, *La Belle
Angèle (Madame
Angèle Satre),* 1889.
Oil on canvas, 36¼ ×
28¾ in. (92 × 73 cm).
Musée d'Orsay,
Paris (R.F. 2617).
Collection Sale I: 42

from Zandomeneghi that Gauguin had written to Degas, not daring to go see him, to ask for his help. Degas, who deep down is a kind soul and very sensitive to others' misfortunes, offered to help Gauguin, and bought a painting at the sale."[18] Several others who bought at that sale, such as Georges de Bellio and Michel Manzi, certainly did so on Degas's advice.

Despite Pissarro's catty insinuation, it was not merely out of charity that Degas acquired the work. Subsequent

events prove that he continued to take a great interest in Gauguin's painting and to direct his dealer and collector friends toward it. When Gauguin returned from his first stay in Tahiti, it was Degas who persuaded Durand-Ruel to host an exhibition of his works in 1893. But despite Degas's efforts to interest artists and art lovers in his protégé's paintings, it was clear from the opening day that the show would be a fiasco. Charles Morice reports that "toward the end of that disastrous day, accompanying M. Degas to

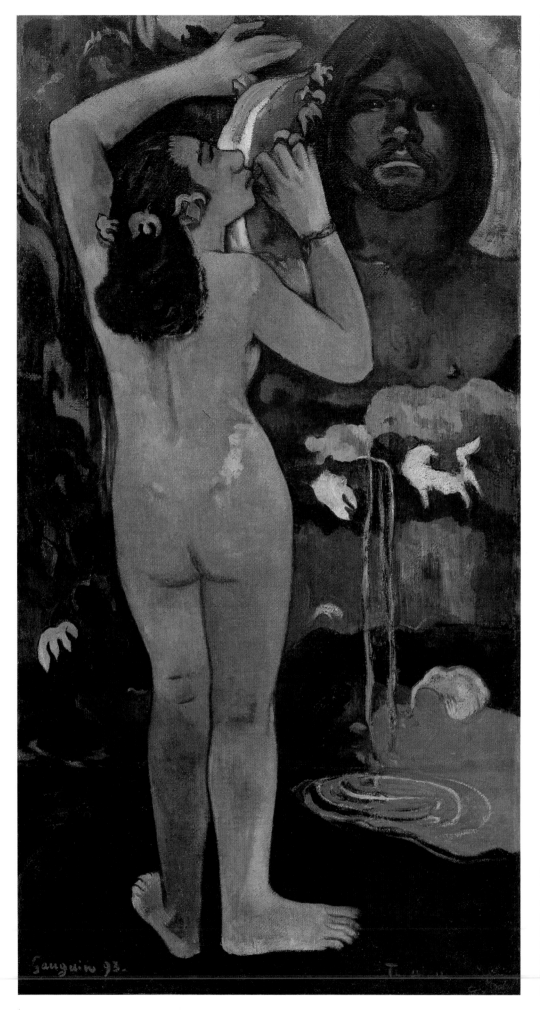

Fig. 304. Paul Gauguin, *The Moon and the Earth (Hina Tefatou),* 1893. Oil on burlap, 45 × 24½ in. (114.3 × 62.2 cm). The Museum of Modern Art, New York, Lillie P. Bliss Collection, 1934. Collection Sale I: 40

Fig. 305 (opposite). Paul Gauguin, *Woman of the Mango (Vahine no te vi),* 1892. Oil on canvas, 28⅝ × 17½ in. (72.7 × 44.5 cm). The Baltimore Museum of Art: The Cone Collection, formed by Dr. Claribel Cone and Miss Etta Cone of Baltimore, Maryland. Collection Sale I: 49

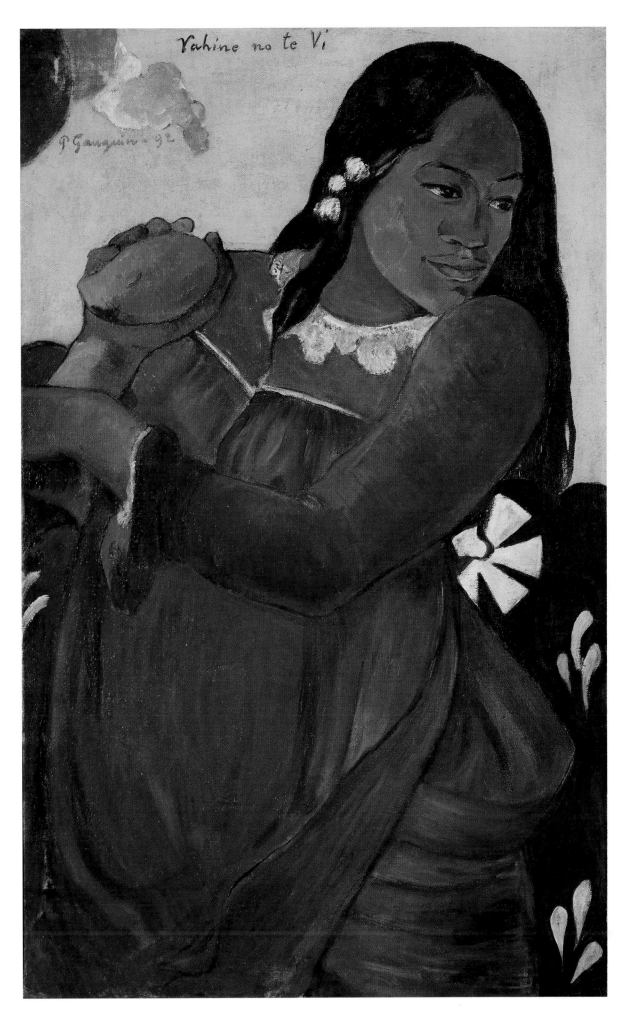

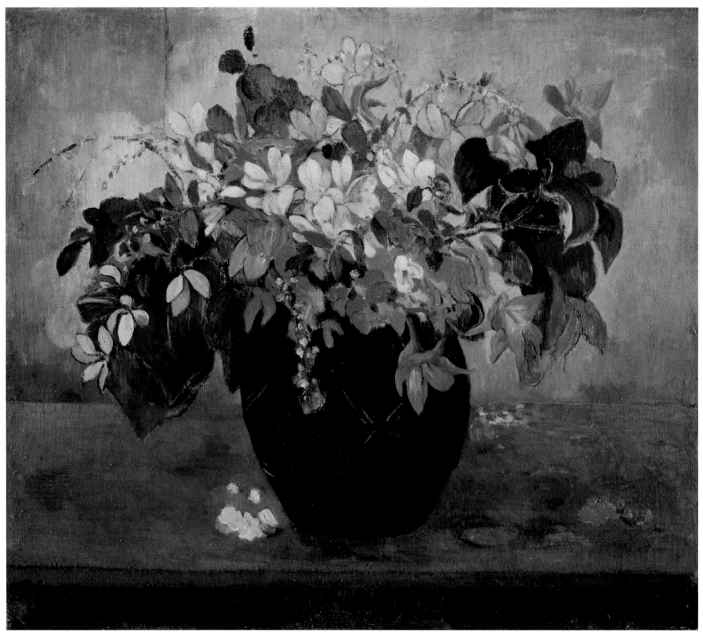

Fig. 306. Paul Gauguin, *A Vase of Flowers*, 1896. Oil on canvas, 25¼ × 29⅛ in. (64 × 74 cm). Reproduced by courtesy of the Trustees, the National Gallery, London (NG 3289). Collection Sale I: 48

the door, Gauguin didn't respond to the other's words of admiration. But as the celebrated older master was taking his leave, Gauguin said, 'You have forgotten your walking stick, Monsieur Degas'—and he was indeed holding a walking stick out to him, but one that he himself had sculpted and exhibited there and had just taken down from the wall."[19] The cane has not been found; in any case, it was not part of the Degas collection sale.

But Gauguin was more generous still: in his inventory notes Degas mentions *The Moon and the Earth (Hina Tefatou)* (fig. 304), "a nude woman [seen] from the back, drinking or speaking in the ear of a Tahitian god's head. I wanted to buy it at the exhibition at Durand-Ruel. Gauguin later

gave it to me for an exchange that I have not yet made."[20] Thus we can date this note between Gauguin's last departure for Tahiti in 1895 and his death in 1903. Degas's choice is interesting, as this is one of the paintings that had been greeted with particular sarcasm at the exhibition. It shows that he was able to ignore both the critics and, what might have annoyed him most, Gauguin's mannered symbolism. In January 1894 he acquired, as soon as Gauguin had finished it in Paris—the paint was scarcely dry—a canvas that was even more "Tahitian" and mythological than usual for Gauguin, *Day of the God (Mahana no atua)* (fig. 66).[21]

Degas also bought heavily at the sale Gauguin organized in 1895, before the latter's second and final departure in

July of that year. As if to set an example for others, he purchased the third item in the catalogue, the superb *Woman of the Mango (Vahine no te vi)* of 1892 (fig. 305). He also bought the copy that Gauguin had made in 1891 of Manet's *Olympia* (fig. 67), thereby bringing two of his friends together in his collection.[22] Degas seemed to be seized by a kind of frenzy, as described by a witness: "I was standing next to him at last month's Gauguin sale. What passion! He pushed up to, and let himself be carried away by, prices that startled even him. More than that: he hardly saw the paintings he was buying. He would ask me, 'Which one is it?' and then remember it. He bought a copy of the *Olympia* that he had never seen. He leaned over to his neighbors to ask, 'Is it beautiful?' "[23]

Still, the sale was a disaster: numbers 4 to 36 had to be "eaten," in other words were left unsold and bought back by Gauguin (two of them were purchased by his artist friends from Pont-Aven). We can imagine that a heartbroken Degas talked his friend Ludovic Halévy, who was sitting next to him, into buying *Te fare,* number 37 in the auction. It was no doubt soon after the sale that Degas bought another very important painting from Gauguin, *Sulking (Te faaturuma)* of 1891 (fig. 296).[24]

Even after the painter's final departure for Tahiti, Degas's interest in Gauguin never flagged. In 1898 he bought *A Vase of Flowers* (1896) from Georges Daniel de Monfreid (fig. 306).[25] According to a letter from Monfreid to Gauguin,[26] a Tahitian landscape was also sold, perhaps number 47 in the first Degas collection sale (see fig. 309).[27] Nor did his interest wane after Gauguin's death in 1903. He bought a landscape of Martinique from the only period in Gauguin's oeuvre not yet represented in his collection, no doubt the same one now in the Thyssen-Bornemisza Collection (fig. 311).[28] He convinced his friend Henri Rouart to buy *Delightful Days* (1896), today in the Musée de Lyon.[29]

It was Degas the art lover, the collector, the protector, who took an interest in Gauguin; the purely artistic influence went in the reverse direction. We have seen the influence of Degas on Gauguin's sculptural explorations of the early 1880s, and his influence on Gauguin the painter was just as crucial. Although his other works of this period are landscapes and still lifes of simple inspiration, Gauguin's first large-scale painting, *The Painter's Home, Rue Carcel* (1881), is completely different—a very personal painting, ambitious in its subject and its multiple implications.[30] It recalls Degas's work in its pictorial composition, the silhouetting of the figures, and the neutral masses in the foreground, elements to be found in numerous examples by the master, for instance *Cotton Merchants in New Orleans*[31] (an early version of *Portraits in an Office (New Orleans)*), which Gauguin could have seen in Degas's studio.

Similarly, Gauguin's first painting of a landscape with figures, *Bathers at Dieppe* of 1885 (fig. 307), with its colors applied in broad strokes and the rhythm of the women's silhouetted forms seen from behind as they enter the sea, clearly recalls Degas's astonishing *Peasant Girls Bathing in the Sea toward Evening* (fig. 308), which Gauguin could have seen at the Impressionist exhibition of 1877 and later on in the studio. After 1886, when Gauguin began painting outdoor nudes, we again find echoes of Degas, particularly of the pastels shown in 1886 at the eighth Impressionist

Fig. 307. Paul Gauguin, *Bathers at Dieppe,* 1885. Oil on canvas, 15 × 18⅛ in. (38 × 46 cm). National Museum of Western Art, Tokyo

Fig. 308. Edgar Degas, *Peasant Girls Bathing in the Sea toward Evening,* 1875–76. Oil on canvas, 25⅝ × 31⅞ in. (65 × 81 cm). L 377. Private collection. Atelier Sale III: 32

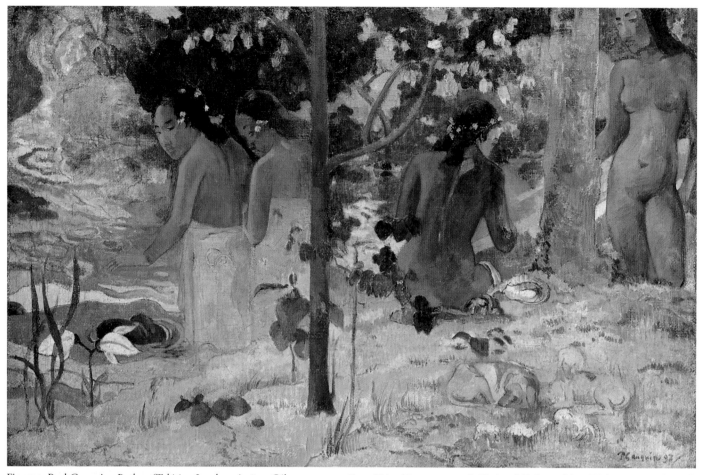

Fig. 309. Paul Gauguin, *Bathers (Tahitian Landscape),* 1897. Oil on canvas, 23¾ × 36¾ in. (60.4 × 93.4 cm). National Gallery of Art, Washington, D.C., Gift of Sam A. Lewisohn (1951.5.1). Perhaps Collection Sale I: 47

Fig. 310. Paul Gauguin, *Bathers at Tahiti,* 1897. Oil on burlap, 28⅞ × 36¼ in. (73.3 × 92.1 cm). The Barber Institute of Fine Arts, The University of Birmingham, England. Another candidate for Collection Sale I: 47, according to recent scholarship conducted in the preparation of this catalogue [Ed.]

exhibition, which attracted much critical attention. Before 1887 Gauguin had painted only one nude, *Suzanne Sewing,* whose naturalism had enchanted the writer Joris-Karl Huysmans. His *Two Girls Bathing,* dated 1887, the time of his return from Martinique, but probably begun in Pont-Aven in the fall of 1886, is marked by the memory of those Degas pastels, both in the nudes and in the arrangement: the tree that cuts the entire composition vertically recalls such pastels as *The Tub* and *The Milliner,* which were exhibited in 1886.[32]

We can see the debt to those original models in Gauguin's nudes from 1889, *In the Waves (Ondine)*[33] and even more so its companion piece, *Life and Death.*[34] And, without describing it as a model, let us recall the surprising composition of the *Study of Nudes* for *Mademoiselle Fiocre in the Ballet "La Source,"* which Gauguin might have seen

in Degas's studio.[35] In fact, *everything* Gauguin saw in Degas's studio made an impression: for instance, I believe that Manet's *The Ham* (fig. 8), which Degas had just bought at the Pertuiset auction, inspired his own *The Ham* of 1890.[36]

When in 1888 Gauguin painted his first important portraits—better conceptualized, more intellectual, and more "Symbolist" than the previous ones done under the influence of Cézanne and Pissarro—his new master was, without any doubt, Degas. Degas's portrait *A Woman Seated beside a Vase of Flowers* (fig. 202) was in fact being stored at Theo van Gogh's in 1887 and 1888, a time when Gauguin paid frequent visits there during his trips to Paris. This painting could not help but impress him, with its off-center composition, the woman's seeming indifference to being painted, and the profound psychological bond linking the model to her surroundings and to the flowers and the

Fig. 311. Paul Gauguin, *Martinique Landscape (Allées et Venues),* 1887. Oil on canvas, 28⅜ × 36¼ in. (72 × 92 cm). Carmen Thyssen-Bornemisza Collection. Collection Sale I: 45

gloves.[37] In his *Self-Portrait* (also known as *Les Misérables*), itself off center, Gauguin made the wallpaper into an expression of, he said, "the painter's innocence." In his *Portrait of Vincent van Gogh,* the sunflowers and the picture symbolically double the artist's image.[38]

A comparison of the canvases of these two artists might tempt us to object that Gauguin's technique, with paint freely applied and large flat areas of bright color, was very different from Degas's. However, particularly with the Japanese-type prints, it is indeed in Degas that we find the model for Gauguin's audacity. For example, *The Laundresses,* which was then in Degas's studio, offered Gauguin an example of enormous daring in brush and color.[39]

Later, in Tahiti, Gauguin would paint women freely enjoying the beach rather as Degas depicted his models at their toilette in their most sensual and natural state: for example, *Alone (Otahi)* borrows the positions of certain Degas nudes. Perhaps we should also see in certain "purely" Tahitian scenes a memory of Degas's Paris. In *Tahitian Pastorals,*[40] for instance, Gauguin places the Tahitian woman at the top of the composition with her face lit from below, like Degas's onstage dancers and singers.

Degas's presence is persistent in the works of the painter of Tahiti to the end of his life. Often the presence is literal, as in *Still Life with Sunflowers and Puvis de Chavannes's "Hope"* of 1901,[41] where, tacked to the wall beneath a reproduction of Pierre Puvis de Chavannes's painting, is an etching by Degas, *The Dressing Room.* We know that Gauguin owned a collection of prints by Degas and apparently valued them so highly that he asked to have them sent to him in Arles, where he was living with Vincent van Gogh in the fall of 1888. As we see here, he also brought them with him to Tahiti.

Mention must surely be made of Gauguin's last paintings from Hiva-Hoa, such as *Horsemen on the Beach,*[42] which are highly reminiscent of Degas's horse races, particularly the *Races at Longchamp* in Boston.[43] Gauguin must have seen it during his last trip to Paris; Jean-Baptiste Faure, who owned the painting, had sold it in January 1893 to Durand-Ruel, who in turn held a Gauguin exhibition in autumn of that year. The painting had been engraved by Guillermie in 1873, and this engraving might have been among Gauguin's belongings, along with the Degas prints mentioned above.

The many examples of Gauguin's work in Degas's collection are sufficient proof of his esteem for the younger artist. We have echoes of his opinion as well in several first-hand accounts: Daniel Halévy tells of a dinner in 1895 when Degas, asked about "this Gauguin" (whose works Octave Mirbeau was about to put on sale), described him

as "a boy who is starving to death and whom I respect enormously as an artist."[44] Degas could not help being touched by Gauguin's unsociable, independent, awkward, solitary nature. "You see," he is supposed to have told a visitor during the 1898 exhibition, something Gauguin later quoted in a letter to the writer André Fontainas, "Gauguin is the thin wolf, the one without a collar"—a reference to the fable by La Fontaine. Poor but free: it did not displease him that Gauguin was "still running."[45]

But the finest homage of one artist to the other was that paid by the "temperamental" Gauguin to Degas the professional grouch, from one man regarded as impossible to another with the same reputation. These two recognized, admired, and had great affection for each other. In this vein Gauguin wrote to Monfreid from Tahiti in August 1898:

I'm very happy that you met Degas and that by trying to help me out you've made some good contacts for yourself. Oh, yes! Degas is often said to be vicious and biting (so am I, according to Schuffenecker). But this is not true for those whom Degas judges worthy of his attention and respect. He has an instinct for warmth and intelligence. I'm not surprised he treated you with kindness and talent. . . . *In talent and in conduct,* Degas is a rare example of what the artist should be: he who has counted among his colleagues and admirers the most powerful people—Bonnat, Puvis, Antonin Proust, etc.—and who *never* sought any power for himself. Of *him* there has *never* been heard or seen anything base, indelicate, or low. Art and dignity.[46]

1. This is a translation from the French of an essay that first appeared in *Degas inédit* 1989, pp. 115–27.
2. Letter from Gauguin to Pissarro, April 3, 1879, in Merlhès 1984, p. 12.
3. Letter from Gauguin to Pissarro, September 26, 1879, ibid., p. 16.
4. L 498, The Metropolitan Museum of Art, New York.
5. L 699, Ordrupgaardsamlingen, Copenhagen.
6. Bodelsen 1970.
7. Letter from Gauguin to Brandes, February 1894.
8. Merete Bodelsen, *Gauguin's Ceramics: A Study in the Development of His Art* (London, 1964).
9. Ny Carlsberg Glyptotek, Copenhagen.
10. Private collection.
11. Reff 1976a, p. 263.
12. Kunstindustrimuseet, Copenhagen; Christopher Gray, *Sculpture and Ceramics of Paul Gauguin* (Baltimore, 1963), no. 12.
13. Letters from Gauguin to Pissarro, January 18 and 25, 1882; in Merlhès 1984, p. 27.
14. March 7, 1883; ibid., p. 43.
15. Letter from Camille Pissarro to Lucien Pissarro, November 16 or 23, 1886; ibid., p. 141.
16. *Breton Women,* also called *First Flowers,* W 249, Kunsthaus, Zurich.
17. Letter from Gauguin to Bernard, in Merlhès 1984, p. 274.

18. Letter from Camille Pissarro to Lucien Pissarro, May 13, 1891, in Bailly-Hertzberg 1980–91, vol. 3, pp. 81–82.

19. Charles Morice, *Paul Gauguin,* new ed. (Paris, 1920), p. 32.

20. "Femme nue de dos buvant ou parlant à l'oreille d'une tête de Dieu tahitien. Je voulais l'acheter à l'exposition chez Durand-Ruel. Gauguin me l'a plus tard donnée pour un échange que je n'ais pas encore fait." Degas inv.; information kindly communicated by Anne Roquebert. The painting is W 499.

21. W 513. Paris, Ottawa, New York 1988–89b, p. 489.

22. W 449, W 413.

23. Halévy 1960, p. 77.

24. W 440, Worcester Museum of Art.

25. W 553, National Gallery, London.

26. Letter of November 11, 1898, in *Lettres de Gauguin à Daniel de Monfreid,* ed. Victor Segalen (Paris, 1950), pp. 210–11.

27. If the dimensions were reversed in the sale catalogue. That would make it W 572, the painting now at the National Gallery of Art, Washington, D.C., a hypothesis advanced by Richard Brettell. (The landscape might also be *Bathers (Tahiti),* in the Barber Institute of Fine Arts, Birmingham, England [fig. 310], or a lost work; see the entry for Gauguin, Collection Sale I: 47 in the Summary Catalogue, the companion volume to this publication.)

28. Douglas Cooper, "An Important Gauguin Discovery," *Burlington Magazine* 123, no. 937 (April 1981), pp. 195–97.

29. W 548. This was the first painting of Gauguin's to be acquired by the French museums; it was bought in 1923 by the young Henri Focillon, who was then curator.

30. W 50, Nasjonalgalleriet, Oslo.

31. *Cotton Merchants in New Orleans:* L 321, Harvard University Art Museums, Fogg Art Museum, Cambridge.

32. *Two Girls Bathing:* W 215, Museo Nacional de Bellas Artes, Buenos Aires. Compare pastels by Degas such as L 872; *The Tub:* Musée d'Orsay, Paris; *The Milliner:* The Metropolitan Museum of Art, New York.

33. W 336, The Cleveland Museum of Art.

34. W 335, Mahmoud Khalil Museum, Cairo.

35. L 148, Albright-Knox Art Gallery, Buffalo.

36. Phillips Collection, Washington, D.C.

37. L 125, The Metropolitan Museum of Art, New York. See Henri Loyrette in Paris, Ottawa, New York 1988–89b, no. 60.

38. W 239, *Self-Portrait,* National Gallery of Art, Washington, D.C., W 296, *Portrait of Vincent van Gogh,* Van Gogh Museum, Amsterdam.

39. L 410. See the catalogue of the Impressionist exhibition of 1879, [Société Anonyme des Artistes, Peintres, Graveurs, etc.], *Catalogue de la 4ᵐᵉ Exposition de Peinture* (Paris, 1879), no. 64.

40. W 470, State Hermitage Museum, Saint Petersburg.

41. W 604, The Metropolitan Museum of Art, New York.

42. W 619, Museum Folkwang, Essen.

43. L 334, Museum of Fine Arts, Boston.

44. Halévy 1960, p. 61.

45. Letter from Gauguin to Fontainas, March 1899, in Maurice Malingue, ed., *Lettres de Gauguin à sa femme et à ses amis* (Paris, 1946), p. 289.

46. Letter from Gauguin to Monfreid, August 15, 1898, in *Lettres de Gauguin à Daniel de Monfreid,* p. 129.

Fig. 312. Edgar Degas, *Mary Cassatt at the Louvre: The Etruscan Gallery,* 1879–80, Softground etching, etching, drypoint, and aquatint, ninth state, 10½ × 9⅛ in. (26.7 × 23.2 cm). The Metropolitan Museum of Art, New York, Rogers Fund, 1919 (19.29.2). Atelier Print Sale: 50

A Printmaking Encounter

BARBARA STERN SHAPIRO

Degas who is the leader undertook to get up a journal of etch-
ings and got them all to work for it so that Mary had no time
for painting and as usual with Degas when the time arrived to
appear, he wasn't ready—so that "Le jour et la nuit" (the name
of the publication) which might have been a great success has
not yet appeared—Degas never is ready for anything—This
time he has thrown away an excellent chance for all of them—[1]

With these exasperated and prophetic words, written on April 8, 1880, Mary Cassatt's mother summarized the fate of a significant printmaking project whose participants included some of the most notable Impressionist artists. As early as the spring of 1879, at the close of the fourth Impressionist exhibition, discussions were under way on Edgar Degas's proposal to publish a journal of original prints, *Le Jour et la nuit (Day and Night)*. On May 16 of that year the novelist and librettist Ludovic Halévy recorded in his diary that he had met Degas in the company of "the independent" Miss Cassatt and learned that they were thinking of launching a journal; he asked if he might write for it. Shortly thereafter, Mary Cassatt embarked on a summer of extensive travel, but by September she had become concerned about her productivity, since the "next Annual Exposition [was] staring her in the face."[2] In October Cassatt's father wrote, "Mame is just now very much occupied in 'eaux-fortes,'"[3] a remark that makes clear the time frame for the beginning of an intense period of printmaking activity. Our knowledge of this collaboration is enhanced by an important article written by the pseudonymous "Tout-Paris" and entitled "La Journée parisienne: Impressions d'un Impressioniste" ("A Day in Paris: Impressions of an Impressionist") that appeared in *Le Gaulois* on January 24, 1880. Here the guidelines for the proposed journal were set forth and the founders were listed: "Miss Cassatt, MM. Degas, Caillebotte, Raffaëlli, Forain, Bracquemond, Pissaro [*sic*], Rouard [*sic*], et al."[4] The project would fill a gap for the new Impressionist school. Each designer/founder would be free to use any printmaking technique that best served his purposes: etching, drypoint, aquatint, or even

lithography. Unlike other journals, *Le Jour et la nuit* would be restricted in its contents to images only, along with a brief note about each artist. It would not appear at any fixed time, and its price would vary between five and twenty francs, depending on the number of prints included. Mrs. Cassatt's spring 1880 letter serves as a closing bookend to this enterprise. During its short existence, a small group of artists manipulated etching techniques in new ways and dramatically altered the taste and expectations of those who collected prints. A selection of remarkable and inventive etchings by the major protagonists confirms that the most concentrated achievements of this collaboration took place from the fall of 1879 through the early months of 1880, a period of only half a year.

That Degas was the catalyst for this intended publication comes as no surprise. Three years earlier, in the summer of 1876, his close friend Marcellin Desboutin had whimsically described the artist's enthusiasm for making prints: "Degas . . . is no longer a friend, a man, an artist! He's a zinc or copper plate blackened with printer's ink, and plate and man are flattened together by his printing press, whose mechanism has swallowed him completely!"[5] From that summer's efforts came three separate sets of brilliant monotypes that were shown in the third Impressionist exhibition of 1877. Given Degas's interest in black and white and his obvious fondness for printmaking, it was only a question of time before he would turn to making rich, tonal etchings. With his confident and forceful personality, he persuaded two devotees to join him.

Not all the artists named by "Tout-Paris" in his brief article on the proposed journal actually displayed prints in the fifth Impressionist exhibition that took place in 1880. In fact, despite all the effort devoted to the enterprise, there was relatively little to show for it. Just three artists, mentioned repeatedly in contemporary writings on the exhibition, were the main participants in the proposed "organ of Impressionism": Degas, Cassatt, and Camille Pissarro.

Félix Bracquemond (1833–1914), whose prints were number 5 in the Impressionist exhibition's small catalogue,

Fig. 313. Félix Bracquemond (1833–1914), plate from *Service with Flowers and Ribbons,* 1879. Faience. Private collection

submitted a group of etchings for the decoration of faience and porcelain plates. They probably served as patterns for the *Service with Flowers and Ribbons* (fig. 313), a dinner service designed by Bracquemond and produced during the summer of 1879 in the Haviland ceramic studios, where he was the artistic director. Each plate is signed with a <u>B</u>, used by Bracquemond on many of his prints and drawings. Cassatt owned a selection of these "Bracquemond" plates; they still belong to members of her family.[6] It has recently been demonstrated that Bracquemond actively participated in *Le Jour et la nuit* by designing an image that could have served as the cover for the folio of prints (fig. 314). The brush-and-ink drawing, traced over graphite lines, measures 36.5 × 26.5 centimeters, with a light line making a frame around the motif that measures 29.5 × 22 centimeters.[7] Although the drawing is smaller than the prints that would be contained in the folio, its inscriptions closely connect it with Degas's project. The simple design carries a cursory title, "*Le Jour / & La Nuit / Journal paraissant quelque fois*"

Fig. 314. Félix Bracquemond, *Study for the cover of "Le Jour et la nuit,"* 1879–80. Brush and ink over graphite, 14⅜ × 10⅜ in. (36.5 × 26.5 cm). Private collection

Fig. 315. Félix Bracquemond, *Edmond de Goncourt,* 1881. Etching, first state, 18⅛ × 12⅝ in. (46.2 × 32.1 cm). The Cleveland Museum of Art, Thirty-fifth Anniversary Gift (1951.158). Collection Print Sale: 8

(journal appearing occasionally), and below, a partly illegible inscription. The Art Nouveau style, similar to that of the *Service with Flowers and Ribbons,* supports the attribution of the unsigned drawing to Bracquemond.

Although Bracquemond played a definitive role in this Impressionist collaboration, and letters from Degas confirm his respect for his colleague's printmaking skills, Degas did not own any prints by Bracquemond that relate to the pro-

posed journal (though he did save many such etchings and aquatints by Cassatt and Pissarro, which appeared in the collection sales).[8] A rare and beautiful first state of Bracquemond's great portrait of Edmond de Goncourt (fig. 315), with a dedication to Degas, executed in 1881 and published in 1882, is not compatible in size or style with the suggested format of the journal. A charcoal drawing of Goncourt on canvas, signed and dated "Bracquemond

Fig. 316. Mary Cassatt, *In the Opera Box (no. 3)*, 1879–80. Softground etching and aquatint, second state, 8⅛ × 7⅜ in. (20.5 × 18.7 cm). Private collection. Collection Print Sale: 21

Fig. 317. Mary Cassatt, *In the Opera Box (no. 3)*, 1879–80. Softground etching and aquatint, fourth state, 8⅛ × 7⅜ in. (20.5 × 18.7 cm). The Metropolitan Museum of Art, New York, Gift of Mrs. Imrie de Vegh, 1949 (49.27.1). Surrogate for Degas's unlocated impression, Collection Print Sale: 21

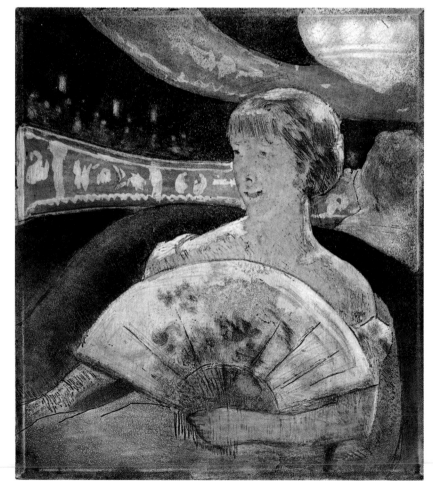

"1880," was shown in the fifth Impressionist exhibition as item number 4.[9]

As for the other *"dessinateurs"* mentioned in the *Gaulois* article, Gustave Caillebotte made only two mediocre prints, one etching and one drypoint, and thus should not be included in a grouping of prolific etchers. Neither print was in the Degas collection. Jean-Louis Forain, a good friend of Degas's, exhibited two unidentified etchings in the fifth Impressionist exhibition (nos. 53, 54) but is represented by only one monotype in the Degas sales (Collection Print Sale: 122). Jean-François Raffaëlli prepared one print with etching, drypoint, and aquatint for *Le Jour et la nuit,* entitled *The Old Ragseller.* Shown in successive states as number 167 in the 1880 Impressionist exhibition, it was probably made after a watercolor of the same name (no. 158). Raffaëlli included a number of other etchings with drypoint in the same show. Although *The Old Ragseller* was printed in an edition of fifty, only one impression (and no working state) was included in the Degas sales (Collection Print Sale: 314). The final artist mentioned by "Tout-Paris," Henri Rouart, did not make prints and offered mainly watercolors of Venetian scenes at the 1880 exhibition.

The article by "Tout-Paris" is a significant source of information, but one may wonder why the author listed a group of artists who for the most part were not especially interested in printmaking. His inventory of *dessinateurs* reflects the conflicts within the Impressionist group at this time, particularly the defection of Claude Monet, who decided to send his work to the official Salon. (Auguste Renoir, Alfred Sisley, and Paul Cézanne had already absented themselves.) "Tout-Paris" claims that the group he describes are the "best of comrades." Degas appears as "the master," appreciated for "his specialty, the dancers" and his "satiric words." The others, his disciples, are Pissarro, "sixty years old with the head of an apostle"; Cassatt, a "young American . . . with an allure and talent that are very Parisian"; and Forain, "the youngest of the Impressionists . . . [who] does not lack spirit."[10] Still, Degas's disruptions were not always admired. In a letter Caillebotte wrote to Pissarro exactly a year after the article by "Tout-Paris" appeared, the artist opined: "[Degas] has cried out against all in whom he admits talent, in all periods of his life. One could put together a volume from what he has said against Manet, Monet, you. . . . To cap it all, the very one who has talked so much and wanted to do so much has always been the one who has personally contributed the least."[11]

Discontent among members of the group, a poor critical response to this weakest of the "Impressionist" exhibitions, and a troubled economy, which discouraged acquisitions, all helped to undermine the fledgling project. Nevertheless,

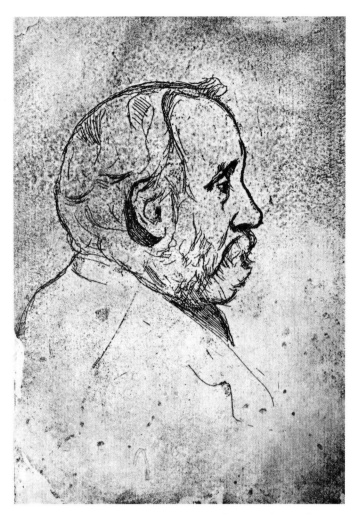

Fig. 318. Attributed to Mary Cassatt, *Portrait of Degas.* Etching with aquatint, done on an abraded plate. Location unknown. Collection Print Sale: 16

results of the printmaking efforts promoted by Degas were extraordinary. Along with Cassatt and Pissarro, Degas changed the direction and content of printed images significantly and forevermore.

Degas and Mary Cassatt (1844–1926) probably met in Paris in 1877, at which time he invited her to join him and the Impressionists in their fourth show, to be held in 1879. Degas was impressed with the work of the young American, in whom he recognized a kindred social spirit with admirable artistic ability. Shortly thereafter, in Degas's studio, Cassatt was introduced to a variety of innovative printmaking processes, including the mixing and superimposing of intaglio techniques and the unconventional use of etching, drypoint, softground, and aquatint. Cassatt abandoned her initial etching style and mastered remarkably the various complex procedures that Degas had devised. Her prolific production within a very limited period is testimony to the skills of her teacher and her innate genius as a printmaker. Preliminary states (stages in the development of the print) were enjoyed and cherished. In

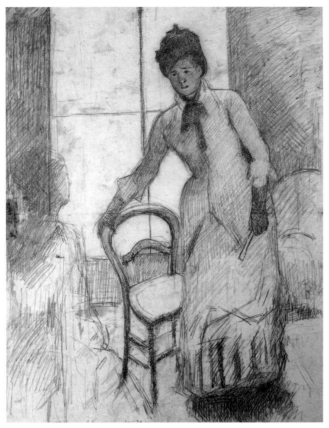

Fig. 319. Mary Cassatt, *Study for "The Visitor,"* ca. 1879–80. Graphite (on verso, softground adhering to traced lines), 15¾ × 12⅛ in. (40.1 × 30.6 cm). The Cleveland Museum of Art, Gift of Fifty Members of The Print Club of Cleveland on the Occasion of the Fiftieth Anniversary (1966.176). Collection Sale II: 82

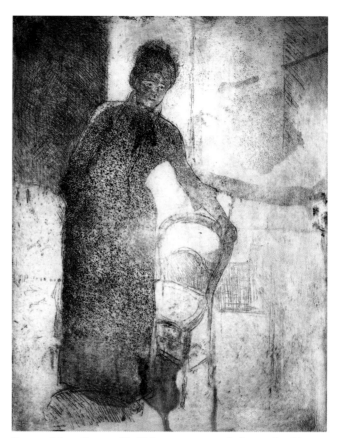

Fig. 320. Mary Cassatt, *The Visitor,* ca. 1879–80. Softground etching, aquatint, and drypoint, second state, 15⅝ × 12¼ in. (39.8 × 31 cm). Collection of Ursula and R. Stanley Johnson. Collection Print Sale: 54

1880 Cassatt and Pissarro each exhibited their preliminary *états*—some of which were signed and annotated—along with finished states as a "series" or group of related Impressionist works. Cassatt's contribution to *Le Jour et la nuit* was *In the Opera Box (no. 3)*. Shown in two states (figs. 316, 317), it was one of eight etchings among the sixteen works that she entered in the fifth Impressionist exhibition. The printed image emerges from darkened tonal areas in the early states, yet the final impression gives the effect of bright reflections and artificial backlight. The lack of clarity and unpredictable ambiguity can be fully appreciated when the prints are closely examined. Years later, Cassatt's biographer Achille Segard characterized the works as "an investigation in line, complicated by the investigation of color in white and black."[12]

When Degas's collection was catalogued after his death, it contained eighty-seven impressions plus thirteen working proofs by Cassatt (Collection Print Sale: 16–58), including a unique portrait of Degas attributed to her (fig. 318). The Galerie Durand-Ruel acquired fifty-six Cassatt impressions from the sales, among them all thirteen proofs for *The Visitor* (see figs. 319–322). Many of these were sold within the year to collectors who are well known

to us today as founders of remarkable print collections—Robert Hartshorne, Harris G. Whittemore, Albert E. McVitty, and Frederick Keppel—as well as to The Metropolitan Museum of Art.[13] *The Visitor* is one of Cassatt's most striking prints in the Impressionist style. The standing figure, seen in shade, is dynamically set against the light, curtained window, while the seated figure, in *profil perdu*, anchors this domestic scene. The rich combination of lines, tones, hatchings, and aquatint grains on one large plate emulates the effect of the two "Mary Cassatt" prints that Degas prepared for *Le Jour et la nuit.*

From the 1914 auction of prints in the collection of Roger Marx, a noted art critic and a supporter of innovative printmakers, one learns that Marx had assembled more than 130 impressions of prints by Cassatt, many of which were working proofs or varying states of the 1879–80 production. Marx owned only two prints by Pissarro and eighteen prints and two monotypes by Degas. His collection stamp on the lower corner of a sheet reliably indicates that it is a fine or unusual impression of the artist's work. A number of Cassatt's proofs were owned by "Baron" Henri M. Petiet, a renowned collector and dealer who personally knew Cassatt and many other artists of his

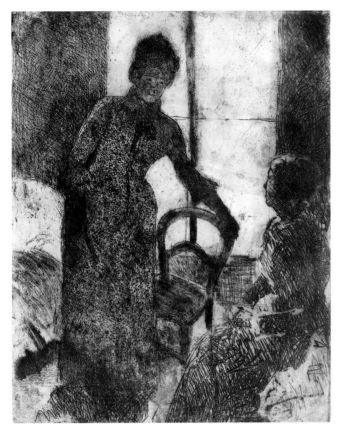

Fig. 321. Mary Cassatt, *The Visitor,* ca. 1879–80. Softground etching, aquatint, and drypoint, third state, 15⅝ × 12⅛ in. (39.4 × 30.8 cm). The Metropolitan Museum of Art, New York, Rogers Fund, 1920 (20.1.3). Collection Print Sale: 54

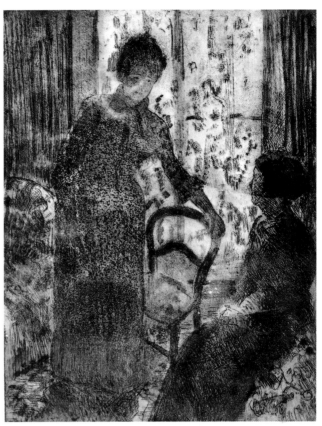

Fig. 322. Mary Cassatt, *The Visitor,* ca. 1879–80. Softground etching, aquatint, and drypoint, tenth state, 15⅝ × 12⅛ in. (39.4 × 30.8 cm). Sterling and Francine Clark Art Institute, Williamstown, Mass. (1967.4). Collection Print Sale: 54

time. The Cassatt impressions obtained by Petiet from the artist's estate frequently show a bold "M.C" in pencil, possibly added by Mathilde Valet, her longtime companion;[14] the impressions with the Degas sale stamp bear no initials or inscriptions.

These large collections of prints by Cassatt demonstrate her impressive productivity, her commitment to printmaking, and the exceptional quality of her work. The frequent use of the term *vernis mou* (softground) in the sales catalogues testifies to her experimentation with less traditional processes. Although Cassatt is readily admired for her extraordinary color prints (particularly the set of ten executed in 1890–91), her black-and-white graphic work, especially that produced during her collaboration with Degas in 1879–80, deserves the esteem in which it is held.

Since Camille Pissarro (1830–1903) lived in the outlying village of Pontoise, his printmaking activities with Degas required even greater dedication. Although he rented quarters in Paris, he frequently had to come into the city by train. Pissarro was always anxious to be part of the art milieu, however, and working with Degas during this period was essential to his artistic development. The methods he learned from realizing his contributions to *Le Jour et la nuit*

dramatically changed his printmaking skills (just as the experience did for Cassatt), and he became proficient at handling the copper and zinc plates. Later, when Pissarro moved out of Degas's orbit, his techniques and style altered again.

Some thirty impressions from about twenty plates by Pissarro were printed with, or by, Degas and figure in the catalogue of the sale of his collection.[15] Degas's active assistance is evident in the letters he sent to Pissarro containing detailed technical instructions, such as advice to use a copper rather than a zinc plate.[16] The instructions may have been meant for the printing of the unique first state of *Wooded Landscape at l'Hermitage, Pontoise,* the print later shown in four states, matted in yellow with a purple frame, at the fifth Impressionist exhibition. Pissarro intended this print to be his contribution to the journal, and Degas owned three impressions of it (figs. 323, 324), including the dense, very gray first state, which was unannotated, obviously forgotten by the artist, and unknown by his sons and by the 1923 cataloguer of Pissarro's prints, Loys Delteil. In the letters Degas cautioned Pissarro that a zinc plate would retain too much black ink. It is difficult to understand why Pissarro used different plates, but Lucien Pissarro

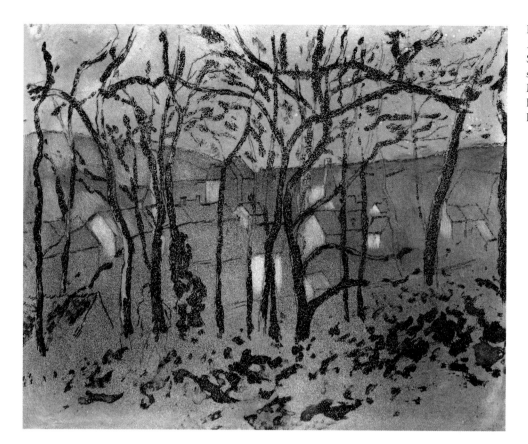

Fig. 323. Camille Pissarro, *Wooded Landscape at l'Hermitage, Pontoise,* 1879. Softground etching and aquatint, first state, 8½ × 10½ in. (21.6 × 26.7 cm). Museum of Fine Arts, Boston, Lee M. Friedman Fund (1971.267). Collection Print Sale: 310

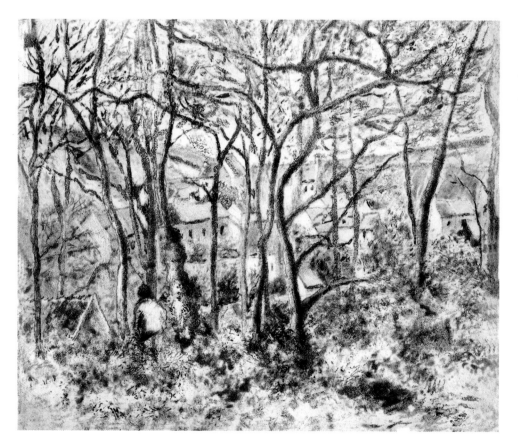

Fig. 324. Camille Pissarro, *Wooded Landscape at l'Hermitage, Pontoise,* 1879. Softground etching, aquatint, and drypoint, sixth state, 8¾ × 10⅝ in. (21.8 × 26.8 cm). The Metropolitan Museum of Art, New York, Rogers Fund, 1921 (21.46.1)

mentions in his annotated notebook of his father's prints[17] that there were two plates for this print, "cuivre et zinc" (copper and zinc). For the *Horizontal Landscape* made at the same time, which sets a similar subject in a friezelike format and was probably intended to be another contribu-

tion to the journal, Lucien Pissarro clearly indicates that there were two plates: the first two states were done on zinc, but the "definitive impressions" were printed from a copper plate.[18] Degas owned two impressions of this frieze.

Fig. 325. Camille Pissarro, *Twilight with Haystacks,* 1879. Aquatint and drypoint, third state, 4 × 7⅛ in. (10.3 × 18 cm). The Art Institute of Chicago, The Berthold Lowenthal Fund (1921.217). Collection Print Sale: 303

The closest collaboration between the two artists was on a remarkable "Impressionist" etching, *Twilight with Haystacks* (fig. 325), which Degas printed in various rich colors and Pissarro proudly inscribed "imp. par Degas" ("printed by Degas").[19] An impression now in the Bibliothèque Nationale, printed in darkish brown ink on the verso of a wedding invitation dated "Paris, 17 juin 1879," confirms the period when Degas and Pissarro were working together and illustrates how scraps of paper were used for printing. Pissarro even reworked a plate printed several years earlier: an impression of the third state of *Woman Emptying a Wheelbarrow* (fig. 326) had already been exhibited in London in 1878, but Pissarro took the plate to Degas's studio two years later and, drawing on the artists' shared expertise, dramatically revised the image. This fourth state (fig. 327) was completely altered by the addition of gray tones; the artist removed his initials and signed the plate, dated it 1880, and inscribed at least two impressions "manière grise" ("gray manner"). In later states, layers of aquatint were superimposed on the weakened drypoint lines, creating the effect of a dramatic seasonal change (fig. 328). Degas owned eight impressions of this striking print in varying working stages, including a maculature of the tenth state (a second printing from the inked plate that withdrew the remaining ink, making a unique, experimental impression).[20]

When Pissarro wrote to his friend Théodore Duret on December 23, 1880, that he had neither the time nor the means to continue to make etchings and that "we stopped abruptly," he echoed Mrs. Cassatt's disappointment with Degas's collaborative efforts. Pissarro did not take up printmaking again until 1883.[21]

Undoubtedly, Degas's fascination with the latest technical inventions had stimulated him to propose an illustrated journal that would be a vehicle for his experimentations in printmaking. Financial gain was not a compelling motive; rather, a desire to entice other artists to try their hands at innovative methods and to support his personal enthusiasm was probably the underlying reason for this printmaking endeavor. Although it is generally assumed that *Mary Cassatt at the Louvre: The Etruscan Gallery* (fig. 312) was Degas's contribution to *Le Jour et la nuit,* there are at least a half-dozen prints that could have been candidates for inclusion. Still, the fact that fifty-nine impressions of the last state of the *Mary Cassatt at the Louvre* print (forty-four on oriental paper) were in the Degas atelier sales suggests that this was the print destined for publication in the first issue of the new journal. (Thirty-two impressions of *Mary Cassatt at the Louvre: The Paintings Gallery* [fig. 337] were found in his studio after his death.) It is known that Degas presented only a limited number of prints to friends, and he did not offer any of them for sale; many of these

Fig. 326. Camille Pissarro, *Woman Emptying a Wheelbarrow*, 1878. Drypoint, third state, 12⅝ × 9 in. (32 × 22.9 cm). Private collection

Fig. 327. Camille Pissarro, *Woman Emptying a Wheelbarrow*, 1880. Drypoint and aquatint, fourth state, 12⅝ × 9 in. (32 × 22.9 cm). The Art Institute of Chicago, Joseph Brooks Fair Collection (1957.329). Collection Print Sale: 304.4

unknown and hoarded impressions were auctioned in November 1918.

The prints of this period by Cassatt, Pissarro, and Degas constitute a major departure from any printed work being produced by their colleagues. Of all the painters who participated in the various Impressionist exhibitions, only these three seized on the creative possibilities of the etching medium. For a brief time—most notably during the six-month period before the fifth Impressionist exhibition—a veritable cuisine of intaglio processes was explored. Innovative techniques included the little-known softground, the novel and extensive use of aquatint, dusting of resin grains, the salt grain method, the use of unique tools (for example, a carbon rod, found in electric arc lamps), and the use of such materials as silvered photographic plates and emery stones to create tone. The artists also incorporated printing imperfections and accidental effects of the acid into the design of the intaglio compositions. Their proficiency with traditional drypoint and etched lines served as the brilliant foundation for their inventive experiments. Although other friends, such as

Bracquemond, their adviser, and probably Desboutin, an expert practitioner of drypoint, must have offered opinions related to this unique venture, Degas was its driving force.

The three most constant practitioners developed a consistent group language in their prints, a black-and-white Impressionism. Making painterly prints was one viable alternative in the search for a unified painting style. While in painting the last layer of paint covers previous trials, tests, and errors of brushwork, the various states or stages in the development of a print dramatically document the artist's manipulation of ideas. By examining the successive states, Degas, Cassatt, and Pissarro were able to witness these transformations. Stylistic similarities among their prints are evident: the subjects emerge out of dark tonal backgrounds, or in some cases the composition was painted, sometimes with acid, directly on the prepared plate, and patches of burnished light were distributed throughout the image. The accumulated layers of proofs and states that demonstrate this technical mastery were preserved in Degas's studio and are now found in many collections and museum print rooms. These artists transformed the

Fig. 328. Camille Pissarro, *Woman Emptying a Wheelbarrow*, 1880. Drypoint and aquatint, tenth state, 12⅜ × 9 in. (32 × 23 cm). The Art Institute of Chicago, Berthold Lowenthal Fund (1921.216). Collection Print Sale: 304

prismatic spots of color on their canvases into gradations of black and white; the constraints inherent in the very nature of the medium made these prints more powerful and, simultaneously, gave them a new intimacy.

In 1910 the art critic Sadakichi Hartmann wrote: "Grey is the colour of modern life. . . . The modern painter uses a more limited scale of colour, and the tendency is toward grey. . . . Even the impressionists, by the very character of their technical innovations, notably the abolition of browns, the struggle for a higher pitch of light by the interaction of purely applied colours and the exaggeration of the transparency of shadows are pursuing the grey phantom of modern art." And writing about J. A. M. Whistler, Hartmann observed that the artist "laid special stress upon texture; its detached shapes creep over the paper like grey moss over a stone."[22] These evocative words describe equally well the remarkable black-and-white (and gray-toned) contributions of Degas, Cassatt, and Pissarro to a brilliant, but unrealized, project. By championing unorthodox methods and sharing them with his companions in their printmaking encounter, Degas made possible the produc-

tion of many of the most original and remarkable prints created in the nineteenth century.

1. Letter from Mrs. Robert Cassatt to her son Alexander Cassatt, quoted in Nancy Mowll Mathews, *Mary Cassatt, A Life* (New York, 1994), p. 146.
2. Mathews 1984, p. 147.
3. In Boston, Philadelphia, London 1984–85, p. 169.
4. Paris, Ottawa, New York 1988–89a, p. 218; Washington, Boston, Williamstown, Mass. 1989–90, p. 58.
5. Letter from Marcellin Desboutin, in Boston, Philadelphia, London 1984–85, p. xxix.
6. A selection of plates was exhibited in 1978; see Barbara Stern Shapiro, *Mary Cassatt at Home*, exh. cat., Boston, Museum of Fine Arts (Boston, 1978), no. 59.
7. Jean-Paul Bouillon, "Bracquemond: *Le Jour et la nuit*," in *Degas inédit* 1989, pp. 251–59; first delivered as a paper by Bouillon at the Degas symposium, Musée d'Orsay, Paris, April 18–21, 1988.
8. Collection Print Sale: 16–58 and 301–11, respectively.
9. Reproduced in Washington, San Francisco 1986, p. 318. Bracquemond exhibited a group of etchings in the first Impressionist exhibition (1874), including *The Locomotive, After Turner* (plate unfinished), in which the swirls of hatching and cross-hatching suggest rain, light, shade, and motion. Bracquemond exhibited several etchings in the fourth Impressionist exhibition in 1879 (nos. 3–6), including an inventive color etching and two successful prints that reveal his interest in light and atmosphere. The "impressionist" effects in these works are related less to the productions of Degas, Cassatt, and Pissarro than to Rembrandt's etched landscapes, in particular *The Three Trees* (1643).
10. Loyrette 1991, pp. 373–74.
11. Quoted in Washington, San Francisco 1986, p. 308.
12. Quoted in Washington, Boston, Williamstown, Mass. 1989–90, p. 54 n. 21.
13. Stockbook, Galerie Durand-Ruel, New York, 1904–24, pp. 172–73.
14. Kevin Sharp of The Art Institute of Chicago has shared with me information from a letter written by the art dealer Ambroise Vollard to Cassatt on July 28, 1914. Vollard expressed dismay that some of the artist's prints and drawings were signed "M.C" when "habitually you sign Mary Cassatt." By that time Cassatt was in poor health, with declining vision; her late signatures, in fact, are irregular and at times nearly illegible. Since the letters "M.C" are boldly inscribed, one can hypothesize that Cassatt's companion, Mathilde, probably with the artist's authorization, initialed the numerous works on paper that had accumulated in her studio.
15. Collection Print Sale: 300–11.
16. Shapiro 1992, pp. 296–97.
17. The notebook is in the Pissarro Archive at the Ashmolean Museum, Oxford.
18. See Bailly-Herzberg 1980–91, vol. 2, pp. 281–85, for Pissarro's list of the prints he sent to Henri Beraldi for his catalogue of nineteenth-century printmakers. Pissarro describes these two prints as "aquatint on zinc converted to copper 'par le galvano'" (a process using an electrical current).
19. Shapiro 1992, pp. 297–98. Unlike the impressions printed in color by Degas that Pissarro obviously cherished, the black-and-white impression in this exhibition is the one owned by Degas himself. Some of the black-and-white impressions were printed by the professional printer Salmon.
20. Boston, Philadelphia, London 1984–85, p. 126 and n. 6. See also London, Paris, Boston 1980–81, p. 209.
21. Bailly-Herzberg 1980–91, vol. 1, no. 83, p. 141. The letter continues, "The need to sell work has obliged me to paint watercolors; etching has been forgotten for the time being."
22. Sadakichi Hartmann, *The Whistler Book* (Boston, 1910), pp. 168–72. Eugenia Parry brought this book to my attention.

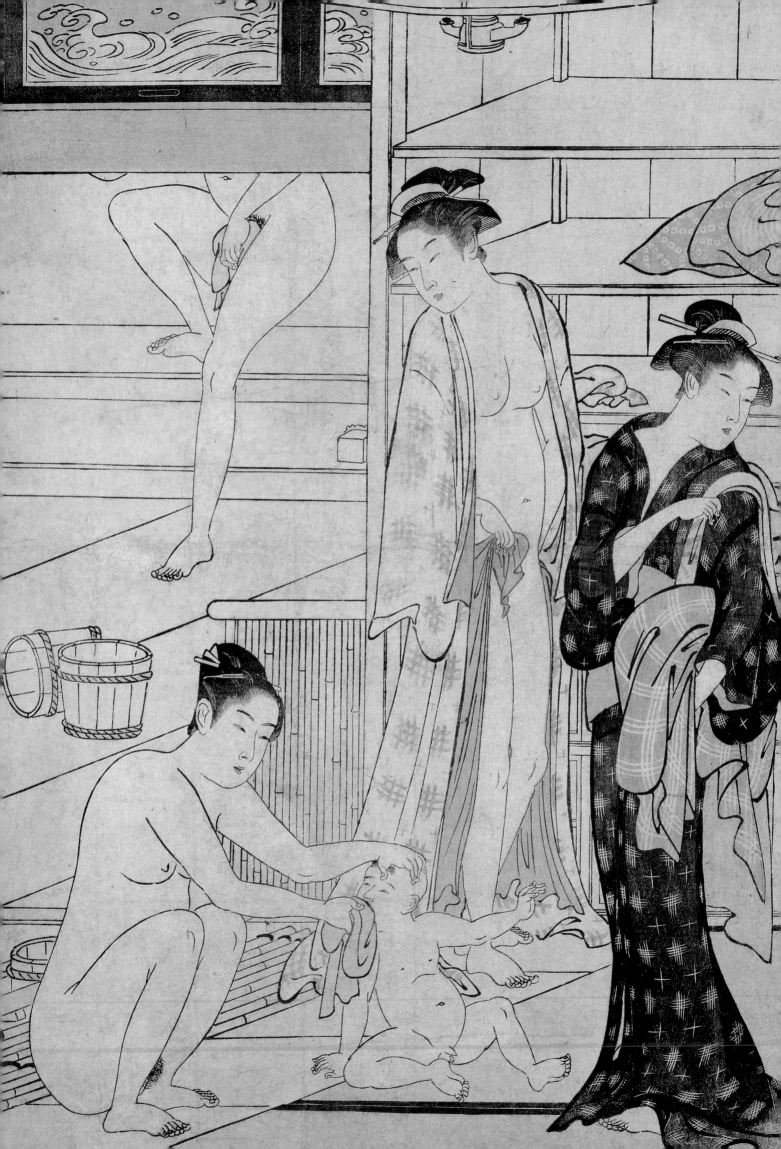

Degas, Japanese Prints, and *Japonisme*

COLTA IVES

Edgar Degas was probably unaware of the extent to which his far-ranging tastes in art were a matter of interest to his contemporaries.[1] The critic Julius Meier-Graefe told the story of a German art collector named Jaeger who used his understanding of Degas's special passions to devise a way of gaining entrance to the painter's home, where visitors (especially unknown foreigners) were generally unwelcome. When Jaeger presented himself at Degas's door in the early 1890s, he carried two portfolios. "In one of them," wrote Meier-Graefe, "were a few drawings by Ingres . . . and in the other, a dozen of his best Japanese color prints." Thus armed, Jaeger won the coveted invitation: "The Ingres gave him entrée into the living rooms in the rue Victor Massé, and the Japanese color prints unlocked for him the doors of Degas's studio."[2]

Herr Jaeger must have smiled with satisfaction on entering Degas's private chambers, where above the bachelor's bed there hung a diptych of a women's bath house by the Japanese printmaker Torii Kiyonaga (1752–1815) (figs. 329, 331) and, close by, drawings by J.-A.-D. Ingres for *The Golden Age* (fig. 332). Moreover, in the dining room he would have found a vitrine displaying albums of Japanese woodcuts alongside a plaster cast of Ingres's hand.[3] Here was unequivocal evidence that Degas's eye delighted in the visible friction between Kiyonaga's nonchalant naked women and the classic nudes of Ingres. Indeed, it was within easy reach of these arresting models from opposite ends of the world that Degas shaped his art.

When Degas's collection was dispersed at auction in 1918, more than one hundred paintings, drawings, and prints by Ingres were sold, as well as more than one hundred printed pictures, books, and drawings by Japanese artists. Little information about the oriental works was provided in the auction catalogue (see fig. 330), and thus it has been impossible to identify precisely many of the images Degas owned. However, the names—Kiyonaga,

Sukenobu, Utamaro, Hiroshige, Yeizan, Shunsho, Yeisho, Toyokuni, Shunman, and Hokusai—represent the best of the Ukiyo-e school of art that developed during the eighteenth century with the intention of portraying the transient beauty and pleasures of everyday life. (Ukiyo-e are "pictures of the floating world.") Adopting a frame of reference similar to that of the Impressionists, who also revolted against academic rules and assumptions, ukiyo-e artists rejected history and fables from the past to celebrate ordinary

Fig. 330. Entries in the catalogue of the Degas collection print sale held on November 6–7, 1918, pp. 59–60

Fig. 329. Detail, Torii Kiyonaga, *The Bath House*, 1787 (see fig. 331)

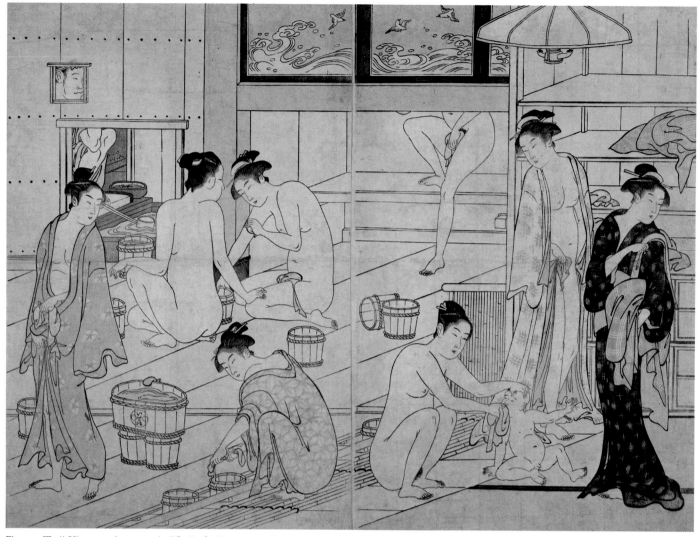

Fig. 331. Torii Kiyonaga (1752–1815), *The Bath House*, 1787. Color woodcut, diptych, 15¼ × 20⅛ in. (38.7 × 51 cm). Courtesy Museum of Fine Arts, Boston, William Sturgis Bigelow Collection, by exchange (30.46-7). Collection Print Sale: 324

scenes and daily pastimes: picnics and boating parties, the theater and the café, public streets and private households.

Like many of the artists and art lovers of his time, Degas assembled his own collection of Japanese woodcut prints, whose appealing, exotic vision somehow aligned with his. These flimsy, colorful pictures had become novelties of enormous popularity after Japanese ports reopened to trade with the West in 1854; the ending of a two-hundred-year ban on contact with foreigners, previously imposed by the Tokugawa rulers, brought a flood of Japanese products to European shores. When Japan took a pavilion at the Paris World's Fair of 1867, Parisians saw their first formal exhibition of Japanese artworks, and Japanese arts and crafts of all kinds soon began pouring into France.

It is said that J. A. M. Whistler discovered Japanese prints in a Chinese tearoom near London Bridge and that Claude Monet first came upon them used as wrapping paper in a spice shop in Holland. During the 1850s and early 1860s it was still possible to find prints at bargain prices in such haphazard ways. But *"japonisme,"* an appreciation for things Japanese—including fans, kimonos, lacquers, bronzes, and silks—spread quickly through Parisian literary and artistic circles, fueling demand at shops selling oriental bric-a-brac: La Porte Chinoise and Decelle's À l'Empire Chinois, both on the rue Vivienne, and Mme de Soye's boutique on the rue de Rivoli, which opened in 1862.[4]

In 1867 Émile Zola defended Édouard Manet's unusually bold and simplified style by comparing it to that of ukiyo-e color prints, with their "strange elegance" and "glorious splotches of color."[5] The following year, when he painted Zola's portrait, Manet himself acknowledged an artistic debt to Japan by placing behind his champion's likeness a mounted woodcut of a sumo wrestler by Kuniaki II.[6]

About the same time, Degas made reference to the effect of *japonisme* on the art of his friend James Tissot by portraying Tissot seated in a studio with an oriental costume study of the kind he was then painting hanging over his

head (fig. 333).[7] Both Tissot and Degas were among those cited as the earliest collectors of Japanese art in France by Ernest Chesneau, who reported on the phenomenon of *japonisme* in connection with the 1878 Paris World's Fair.[8] But unlike Tissot, Whistler, Monet, and other painters described by Chesneau as having come under the spell of Japan, Degas avoided staging *japoneries*, which featured models dressed in kimonos and the conspicuous display of decorative oriental props.[9] Like his friend Manet, Degas absorbed qualities of the Japanese aesthetic that he found most sympathetic and, in the process, redoubled his originality.

A taste for orientalism, probably spurred by his admiration for the exotic themes of Ingres, Eugène Delacroix, and Gustave Moreau, emerged in Degas's work about 1860, when he was commencing elaborate preparations for the ambitious painting entitled *Semiramis Building Babylon*

(fig. 88). The historical subject, which in the 1820s had provided the basis for Gioacchino Rossini's tragic opera *Semiramide*, propelled Degas into a concentrated study of Assyrian reliefs, Mughal miniatures, Egyptian and Persian wall paintings, and the classical frieze of the Parthenon.[10] His labored reconstruction of the ancient East reveals the young artist's ability to blend diverse foreign elements and submerge them in a completely personal expression: thus, in his vision of Babylon one can also find a dreamy recollection of his then-recent travels through the hill towns and frescoed churches of Tuscany.[11]

Because he had a voracious visual appetite, Degas was alert to novel pictorial effects wherever they could be found, be they in the grand paintings of Mantegna, the caricatures of Honoré Daumier, or the nascent practices of photography. Thus, the characteristic elements of Japanese art that he absorbed were mixed with so many other influences

Fig. 332. J.-A.-D. Ingres, *Seated Female Nude, Study for "The Golden Age."* Graphite, 13 × 9 in. (33 × 23 cm). By kind permission of the Provost and Fellows of King's College, Cambridge; photo © Fitzwilliam Museum, University of Cambridge. Collection Sale I: 207

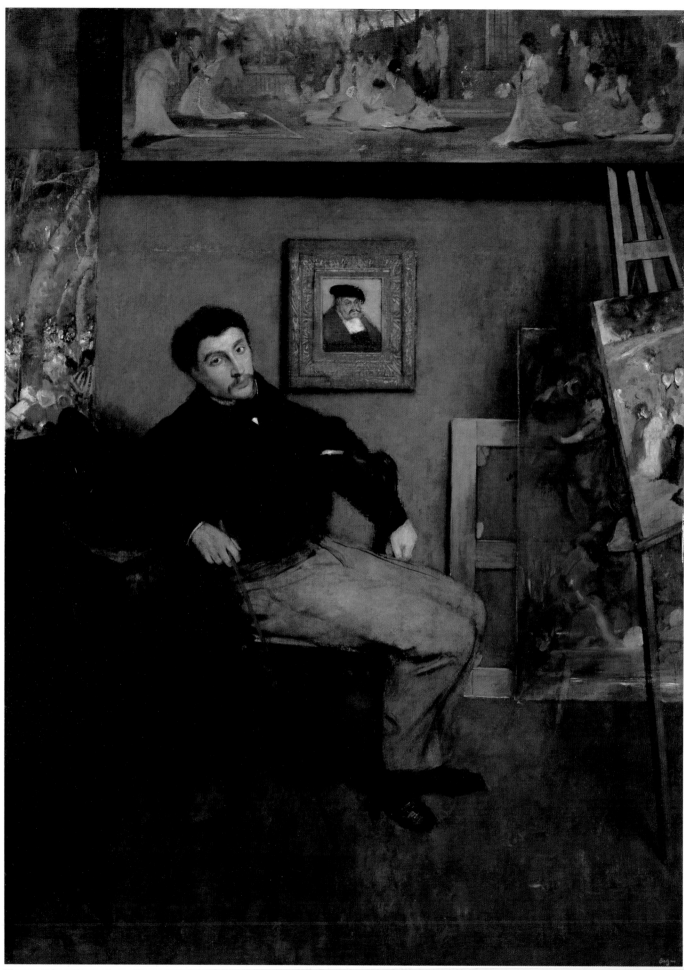

Fig. 333. Edgar Degas, *James Tissot*, 1867–68. Oil on canvas, 59½ × 44⅞ in. (151 × 112 cm). L 175. The Metropolitan Museum of Art, New York, Rogers Fund, 1939 (39.161). Atelier Sale I: 37

that it is difficult to track and to define them, especially because an attraction to ukiyo-e colored his creative output in many varied ways over a period of at least thirty years.

Degas seems to have been both liberated and stimulated by the fresh approach Japanese prints offered. They revealed to him not only a strange and unknown place but also an entirely new way of looking at the world. Like many of his contemporaries, he was undoubtedly both startled and amused by these often lighthearted scenes; but, unlike the others, he went further, parsing the grammar of the art in order to understand peculiarities of composition, perspective, and figural arrangement, as well as refinements of color, decorative pattern, and line.

Acutely sensitive to evidence of *japonisme,* Zola discerned something of the influence of ukiyo-e in Degas's *Mademoiselle Fiocre in the Ballet "La Source"* when it was displayed at the Salon of 1868.[12] However, distinctive traits of the Japanese style are not generally recognizable in Degas's work until the early 1870s, when he began to direct his attention toward subjects drawn, as ukiyo-e art was, from contemporary life. Ballet rehearsal halls, theaters, museums, cafés, private salons, bedrooms, studios, and offices became the stage for Degas's intensely animated figures. Frequently these interiors present the boxed-in spaces, stilled air, and tilted planes that also mark Japanese prints and are the backdrops for eye-catching, sometimes surprisingly awkward human activity. Floors rise up, walls fold in or fly off to the sides, and often the horizon line arrives where it is least expected: oddly high, low, or slidng through the picture on a diagonal.

A singular feature of Degas's interior scenes is their firmly articulated structure defined by the vertical and horizontal architectural elements of a room. In *Portraits in an Office (New Orleans)* (fig. 334), the unusually complex grid that provides a geometric backdrop to a chaotic scattering of figures suggests that Degas had noticed an organizing technique of ukiyo-e artists in which figures and ground were bound together by the crisscrossed outlines of floorboards, tatami mats, pillars, and shoji screens. Thus individual figures could be anchored to a scene even though they stood totally aloof from one another, focused on their own activities or gazing off in opposite directions.[13]

Degas regularly employed this technique in his portraits in order to reveal a sitter's surroundings as a virtually inseparable extension of the self. He accomplished this by the artful positioning of his subjects in relation to framed pictures, books, furniture, mantelpieces, and doorways, all of which gain emphasis by being thrust toward the picture surface—a "tilt" that resembles the inverted perspective of oriental views. Thus, the long, low-slung factory shown behind Henri Rouart in Degas's austere portrait of the industrialist was placed high on the canvas, at the peak of converging train tracks and level with Rouart's gaze.

Degas had succeeded in gaining access to a special enclave,

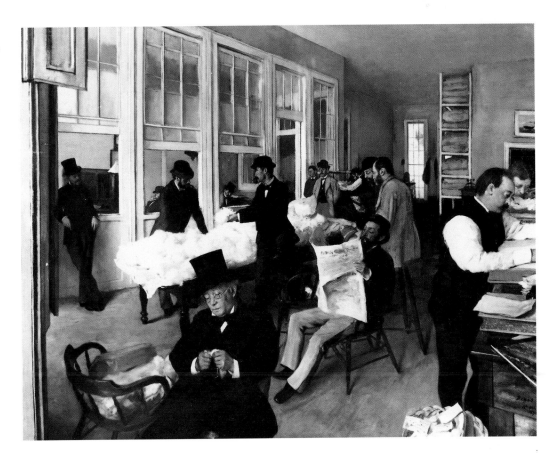

Fig. 334. Edgar Degas, *Portraits in an Office (New Orleans),* 1873. Oil on canvas, 28¾ × 36¼ in. (73 × 92 cm). L 320. Musée des Beaux-Arts, Pau (878.1.2)

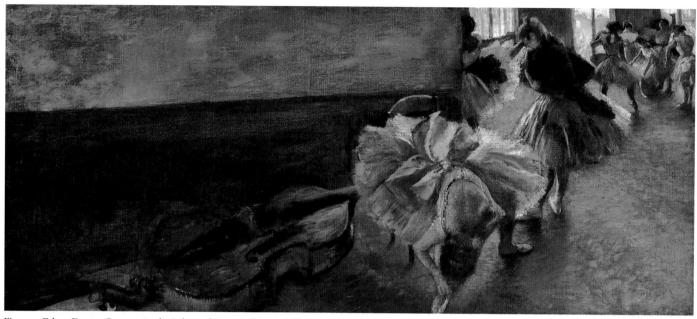

Fig. 335. Edgar Degas, *Dancers in the Rehearsal Room, with a Double Bass,* ca. 1882–85. Oil on canvas, 15⅜ × 35¼ in. (39 × 89.5 cm). L 905. The Metropolitan Museum of Art, New York, H. O. Havemeyer Collection, Bequest of Mrs. H. O. Havemeyer, 1929 (29.100.127)

the ballet practice room; and he apparently associated this rarefied feminine world with that of the geishas and courtesans costumed in colored silks who gather to promenade, picnic, or bathe in ukiyo-e prints. In more than one of his ballet paintings, following the style of the Japanese folding or sliding screen, he placed his key motif far off center at right, at an oblique angle to a long rectangular picture format (fig. 335).

Degas's intense admiration of the fine design seen in Japanese decorative objects is also eloquently expressed in

twenty-five fan-shaped paintings on silk.[14] Although two early examples, dating about 1868–69, were inspired by mid-century *hispagnolisme* and show dancers in Spanish dress, most owe a debt to *japonisme* and were produced about 1879; Degas encouraged Camille Pissarro, Berthe Morisot, Jean-Louis Forain, and Marie and Félix Bracquemond to join him in devoting a gallery to fan paintings at that year's exhibition of the Indépendants. Within the arched format of the fan design, the ballet dancers, rehearsing, waiting in the wings, or performing onstage, appear

Fig. 336. Edgar Degas, *Fan: Dancers,* 1879. Watercolor and silver and gold paint on silk, 7½ × 22¾ in. (19.1 × 57.9 cm). L 566. The Metropolitan Museum of Art, New York, H. O. Havemeyer Collection, Bequest of Mrs. H. O. Havemeyer, 1929 (29.100.555)

less as human figures than as decorative motifs. Degas sprinkled his ballerinas across the fan shape or clustered them near the center, where they seem to emerge from the core (fig. 336). Quirky little creatures—like the plump prostitutes Degas put into his monotypes of brothels about the same time—these figures have the comic vitality of acrobats by Hokusai. Luxuriously painted in gold, they owe something to the diminutive images printed as *surimono* (greeting cards) that were enriched with brass and mica dust. In Degas's painted scenes of ballet both dancers and spectators can be seen holding fans, but in none of his canvases does the artist break so openly with Western tradition to re-create the stylized abstraction of Japanese design.

Mary Cassatt at the Louvre: The Paintings Gallery (fig. 337) is among the most deliberately *japonesque* of Degas's efforts to present a momentary view as a decorative arrangement. It too has the characteristics most frequently cited as Japanese-inspired in Degas's art: aerial perspective, an asymmetrical composition, decorative surface pattern, and a snapshot effect enhanced by the cropping of figures. Here the tall, narrow format derives from *hashira-e*, prints designed for display on the pillars of houses, in which overlapping figures are generally compressed into a carefully articulated, shallow space. The Japanese effect is reinforced by the narrow strip of marbleized doorway at the left, which serves to interrupt the view of Cassatt and her sister but also recalls the bands of brocade on the mounts of *kakemono-e*, or hanging scrolls.

Degas's elaborate preparations for this technically complex etching, made about 1879–80, coincided with his production of fan designs and of some of his most decorative ballet pictures. Since the period followed his decision to pay off debts incurred because of the bankruptcy of his family's business, he may have thought of capitalizing on the fashion for things Japanese. In connection with the World's Fair of 1878 there were two exhibitions of Japanese art in Paris, one showing recent products in the country's wooden pavilion on the rue des Nations, the other a display of fine art from French and Japanese collections in the Trocadéro. Japan also constructed a garden, a teahouse, and a rustic farmhouse, all of which were popular with the fair's sixteen million visitors. There were some critics, among them Victor de Luynes, who believed French culture had been undermined by the current fad: "Japonisme! Attraction of the age, discordant rage, which has invaded everything, taken command of everything, disorganized everything in our art, our customs, our taste, even our reason."[15]

By this time Degas is likely to have owned his own examples of ukiyo-e. Moreover, opportunities to become acquainted with literally hundreds of Japanese woodcuts lay immediately at hand in the extensive collections of

Fig. 337. Edgar Degas, *Mary Cassatt at the Louvre: The Paintings Gallery*, 1879–80. Etching, softground etching, aquatint, and drypoint, nineteenth state, 14⅜ × 9¼ in. (36.5 × 23.6 cm). The New York Public Library, Astor, Lenox and Tilden Foundations, Samuel P. Avery Fund

Fig. 338. Nishikawa Sukenobu (1671–1751). Three illustrations from *One Hundred Qualities of Women (Hyakunin Joro shina sadame),* 2 vols., 1723. Woodcuts, each 11¼ × 7⅜ in. (28.5 × 19.5 cm). Trustees of the British Museum, London. Surrogates for Degas's impressions, Collection Print Sale: 325

Fig. 339. Edgar Degas, *After the Bath*, ca. 1895. Pastel, 27⅝ × 27⅝ in. (70 × 70 cm). L 1335. Musée du Louvre, Paris, Gift of Hélène and Victor Lyon (R.F. 31343)

It was during the late 1870s that Degas became intensely involved in printmaking himself. Having first made etchings as a student twenty years earlier, he now entered a phase of experimentation with various graphic techniques that led to his extraordinary production of printed drawings, or monotypes, and a group of etchings produced in mixed media, including drypoint and aquatint. He rightly guessed that the exacting procedures entailed in the production of Japanese woodcuts, particularly the fine carving and printing from color-washed blocks, would not be practicable for an artist like himself, although he suggested to Pissarro in 1880 that they might enliven their etchings by inking parts of them with watercolored blocks of wood.[16]

Degas's friend Mary Cassatt, with whom he shared printmaking projects, also shied away from making woodcuts, although she admired ukiyo-e and particularly Utamaro's domestic scenes to such a degree that in 1891 she painstakingly produced a suite of ten color etchings in imitation of them.[17] Together, Cassatt and Degas visited the large exhibition of Japanese prints at the École des Beaux-Arts in Paris during the spring of 1890. But while she was profoundly inspired by the experience, he, writing to his friend Albert Bartholomé, declared the show decidedly "old hat." "Alas, alas," he added, "this is the fad everywhere."[18]

Degas's singular devotion to the study of the nude, which intensified after 1880, allows us to examine his commitment to the classic and simultaneously to a modern aesthetic. It appears that once the allure of documenting

his friends Alexis and Henri Rouart, Michel Manzi (whose Japanese prints helped form the important Camondo collection of the Louvre), the critic Philippe Burty (whose holdings numbered in the thousands), and Degas's dealer, Alphonse Portier, a well-known connoisseur of Japanese prints.

Fig. 340. Edgar Degas, *The Coiffure*, ca. 1896. Oil on canvas, 48⅞ × 59⅛ in. (124 × 150 cm). L 1128. Reproduced by courtesy of the Trustees, the National Gallery, London (NG 4865). Atelier Sale I: 44

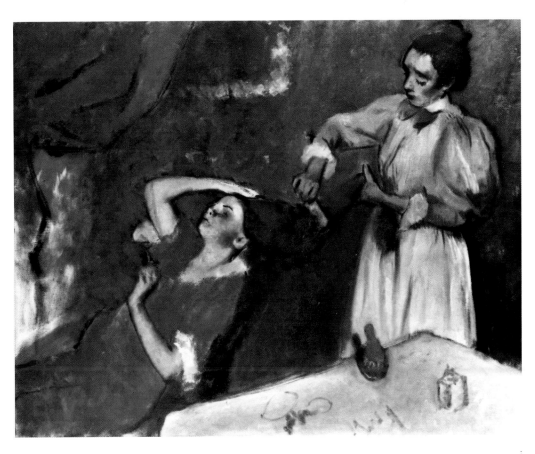

behind-the-scenes preparations and public performances at theaters and cafés began to pale for him, Degas swept aside costumes and props, the musicians and the audience, to focus upon the eternally gratifying forms of the female figure. From his long study of art of all kinds and from the combined influences of East and West, old and new, there emerged a hybrid that owed its inspiration as much to Kiyonaga, Utamaro, and Hokusai as to classical sculpture, Delacroix, and Ingres. Thus, within the elastic contours of Degas's bathers kneeling in washbasins, climbing into tubs, or crouched on their haunches, there stirs the vitality and sometimes graceless spontaneity of ukiyo-e's unclad women, whom we also find awkwardly bent over their tubs, legs akimbo, elbows askew. In prints by Kiyonaga and Nishikawa Sukenobu (fig. 338) that are known to have been in Degas's possession, innumerable figures appear that bear a relation to his own loosely robed women washing themselves or being attended to by maids who provide towels or comb out their hair (figs. 339, 340).

It is testimony to Degas's discernment that Japanese prints securely identified as having been in his collection are particularly remarkable examples of ukiyo-e. His two-album set of Sukenobu's *One Hundred Qualities of Women (Hyakunin Joro shina sadame)*, published in 1723, which surveys the daily activities of women of all ranks, is the work of an early and extremely influential ukiyo-e artist: Sukenobu replaced the grandiloquent courtesan of early Japanese art with a more natural and engaging creature on which depictions of women in Japanese prints were modeled for decades.[19]

Kiyonaga's diptych *The Bath House* (1787), which hung above Degas's bed during the final decades of the artist's life,[20] is one of the most unusual works by "le grand dessinateur," considered a supreme master by the French (fig. 331).[21] It is a work remarkable for its extensive display of nudity, a fact that may explain why only two impressions of this color woodcut survive. In 1893 the Parisian jeweler Henri Vever purchased an impression of the print from Boussod Valadon & Cie for 5,000 francs, then the highest price ever paid for a ukiyo-e woodcut in France. In 1911 the work was exhibited in Paris at the Musée des Arts Décoratifs and described in the catalogue as "the famous and exceptionally rare print known as 'Kiyonaga's Bath House.'"[22] Seven years later, Vever, well on his way toward amassing the world's finest private collection of Japanese prints, purchased Degas's print too, the only other existing impression of the diptych. He paid 3,500 francs for it, the second highest price for any print sold in the 1918 collection sale.[23]

Degas had acquired his great bathhouse woodcut from the Japanese dealer Hayashi Tadamasa, from whom he evidently obtained prints in exchange for his own works. On

Fig. 341. Albert Bartholomé, *Mask of Hayashi Tadamasa*, 1892. Bronze, 11¼ × 7⅞ × 5⅞ in. (285 × 185 × 145 cm). Musée des Beaux Arts et de la Dentelle, Calais. According to his own inventory, Degas had the plaster cast for this bronze in his collection.

one occasion, for "a few precious drawings" he secured a number of ukiyo-e albums, among them an erotic picture book by Moronobu, which, the connoisseur Raymond Koechlin observed in 1913, Degas "almost worships"—not a surprising report, given the artist's enthusiastic production of brothel scenes that were to some degree inspired by Japanese "spring pictures," or *shunga*.[24] After Hayashi sent him the Kiyonaga woodcut of nude bathers, Degas reciprocated by sending the dealer one of his own works. But later he was embarrassed to learn of the print's extraordinary rarity and value and reckoned that he owed Hayashi another picture.[25]

A familiar figure in Degas's circle, Hayashi acted not only as a dealer but also as a teacher, adviser, and friend, who helped Edmond de Goncourt write his books *Utamaro* (1890) and *Hokusai* (1896) and who sat for his Nō-mask-like portrait by Bartholomé (fig. 341), the plaster cast of which the sculptor gave to Degas.[26] Hayashi had arrived in Paris to serve as an interpreter during Japan's preparations for participation in the 1878 World's Fair. He stayed on to be trained in the art trade by the antiquarian Wakai Kenzaburo, and soon he assigned his wife the task

Fig. 342. Watanabe
Seitei, *Birds on a Branch*,
1878. Watercolor, 9⅝ ×
7⅝ in. (24.4 × 19.4 cm).
Inscription, in Japanese,
translates: For Mr. Degas /
Seitei / at a party. Sterling
and Francine Clark Art
Institute, Williamstown,
Mass. Collection
Sale II: 160

of foraging for salable ukiyo-e throughout their homeland. Between 1889, when he established his own business in an attractive apartment on the rue de la Victoire, and 1900, when he ceased commercial activity, Hayashi imported the staggering number of 160,000 ukiyo-e prints and nearly 10,000 illustrated books. So successful was he (and other dealers, like Siegfried Bing) in distributing this material among Westerners that by the mid-1890s he was pleading with his French customers to sell some prints back to him for the sake of Japanese clients.[27]

Certainly the most well-known Japanese person in Paris during the last decades of the century, Hayashi brought his

culture and his countrymen in contact with the French whenever possible. Edmond de Goncourt, in his journal entry for November 28, 1878, described at length the "curious and instructive" evening he spent at the home of Philippe Burty, where Hayashi had arrived accompanied by a Japanese artist, Watanabe Seitei. A specialist in painting birds, Seitei entertained Burty's guests, who also included Degas, Manet, and Giuseppe de Nittis, with an impressive demonstration of Japanese brush-and-ink painting. Degas, along with others present, received a souvenir of the performance, painted and dedicated to him by Seitei (fig. 342). Taking Seitei's brush in hand, Degas created a

Fig. 343. Edgar Degas, *Bather Stepping into a Tub,* ca. 1890. Pastel and charcoal on blue paper, 22 × 18¾ in. (55.9 × 47.6 cm). L 1031bis. The Metropolitan Museum of Art, New York, H. O. Havemeyer Collection, Bequest of Mrs. H. O. Havemeyer, 1929 (29.100.190)

gift in return, but he admitted it was a "miserable sketch" of which he was rather "ashamed."[28]

Hayashi also initiated efforts to export French art to Japan, and in 1890 he arranged for a showing of works by Degas, Théodore Rousseau, Jean-François Millet, Charles Daubigny, and others at the Third National Domestic Fair in Tokyo.[29] At the same time he was assembling with considerable enthusiasm his own collection of contemporary French art, which he hoped would eventually find its way to Japan's museums. Along with Monet, Auguste Renoir, Pissarro, Cassatt, and other artists of the day, Degas was prominently represented in Hayashi's collection by at least a dozen works, most of which were very fine late pastels, including two of female nudes engaged in rituals of the bath (fig. 343).[30]

Hayashi evidently acquired the first of his Degas pictures in 1891, when he purchased a pastel of a dancer from the artist's dealer, Portier. In 1895 he bought three works from Durand-Ruel, a fan design and two pastels of women, and he returned the following year to add four of Degas's landscape monotypes with pastel.[31] Hayashi clearly responded to the Japanese character of these works (fig. 344),

perhaps recognizing in the colorfully inked prints parallels to the bold, abstract vistas found in Hiroshige's landscape woodcuts, about thirty of which Degas owned. Viewers of the exhibition of Degas's monotype and pastel landscapes at the Durand-Ruel gallery in 1892 perceived immediately their oriental flavor. The American painter Philip Hale remarked in his review, "They more resemble a Japanese print of the more expensive sort (such as one buys *chez* Bing) than anything else I can think of." And Daniel Halévy reported to his brother: "The Japanese series is the most beautiful. It is Japan, pure Japan, and not the exaggerated and enlarged Japan of Monet and his consorts. The color is exactly the fresh and brilliant color of the prints that Manzi has."[32]

Although these remarks show that his contemporaries had perceived Degas's appreciation for the special qualities of Japanese art, an appreciation that emerged periodically as one of the most remarkable features of his work, Degas's own references to the art of Japan were generally oblique and vague. The enormous range of his collecting interests demonstrates his unusual visual sophistication. He had an apparently limitless capacity to assimilate what he saw,

Fig. 344. Edgar Degas, *Pathway in a Field,* 1890. Monotype and pastel, 11⅞ × 15½ in. (30 × 39.5 cm). L 1046. Yale University Art Gallery, New Haven, Conn.

which enriched his art while yielding its own identity to his. What Degas shared with ukiyo-e masters was a heightened awareness of the world about him. His eye, like theirs, was trained on the remarkable in the ordinary, the timeless in the momentary. Expressing admiration for the cultural heritage that encouraged such acute sensitivity, he questioned a young Japanese student's reasons for enrolling at the École des Beaux-Arts: "When one has the good fortune to be born in Japan, why come here to subject oneself to the discipline of professors . . . ?"[33]

Nothing could be further from the traditions of old master painting, in which Degas's art was firmly rooted, than the often whimsical content and schematic plan of the Japanese print. However, Degas not only relished the unexpected but also shared with ukiyo-e masters a talent for eloquence in line and for carefully plotted compositions in which empty spaces are as valuable as filled ones. Although he was thus naturally drawn to ukiyo-e, he discriminatingly selected only those Eastern traits that could be absorbed within the framework of his Western heritage. Our enduring fascination with Degas's art rests to a large extent on the intriguing tension between its fundamentally European realism and the Japanese direction of its simplified, decorative design.

1. Portions of this essay are adapted from Colta Ives, *The Great Wave: The Influence of Japanese Woodcuts on French Prints,* exh. cat., New York, The Metropolitan Museum of Art (New York, 1974). Since that publication much has been written on *japonisme;* see Gabriel P. Weisberg and Yvonne M. L. Weisberg, *Japonisme: An Annotated Bibliography* (New York and London, 1990). Published more recently in English translation is the important work by Klaus Berger, *Japonisme in Western Painting from Whistler to Matisse,* trans. David Britt (Cambridge, 1992).

 The active participation of Mary C. Weaver in the collection of information for this essay is gratefully acknowledged.
2. Julius Meier-Graefe, *Degas,* trans. J. Holroyd-Reece (New York, 1923), p. 65.
3. Lemoisne 1946–49, vol. 1, pp. 176–77, where it is noted that the dining-room vitrine also contained the casts of a Javanese woman's hands and some Neapolitan puppets.
4. Gabriel P. Weisberg, "Japonisme: Early Sources and the French Print-maker 1854–1882," in *Japonisme: Japanese Influence on French Art 1854–1910,* exh. cat., The Cleveland Museum of Art; New Brunswick, Rutgers University Art Gallery; Baltimore, Walters Art Gallery (Cleveland, 1975), pp. 1–19.
5. "élégance étrange" and "taches magnifiques." "Édouard Manet, étude biographique et critique" (1867), in Émile Zola, *Écrits sur l'art* (Paris, 1991), p. 152.
6. Jay Martin Kloner, "The Influence of Japanese Prints on Édouard Manet and Paul Gauguin," Ph.D. diss., Columbia University, 1968, p. 100.

7. See Reff 1968b, pp. 133–40, where a letter of 1864 by the English painter Dante Gabriel Rossetti is quoted: "I went to the Japanese shop [of Mme de Soye], but found that all the costumes were being snapped up by a French artist, Tissot, who it seems is doing three Japanese pictures, which the mistress of the shop described to me as the three wonders of the world."

8. Ernest Chesneau, "Le Japon à Paris," *Gazette des Beaux-Arts* 18 (September–November 1878), pp. 385–97, 841–56; see especially pp. 387, 396.

9. Degas's 1870 *Portrait of Madame Camus in Red* (National Gallery of Art, Washington, D.C.) portrays the wife of a collector of oriental ceramics holding a bamboo fan. Theodore Reff suggests that Japanese textiles appear in two other early portrait paintings: *The Collector of Prints*, 1866 (The Metropolitan Museum of Art, New York) and *Hortense Valpinçon*, 1871–72 (Musée d'Orsay, Paris). See Reff 1968b, p. 132, and Theodore Reff, "Degas, Lautrec, and Japanese Art," in *Japonisme in Art: An International Symposium* (Tokyo, 1980), p. 191.

10. Theodore Reff suggests that "the earliest example of Degas's contact with Japanese art" is evidenced by "the light, conspicuously unmodelled female head" of one of Semiramis's attendants. See Reff 1964a, p. 256 n. 69.

11. See Henri Loyrette in Paris, Ottawa, New York 1988–89a, pp. 89–96.

12. Émile Zola, *Mon Salon: Manet, Écrits sur l'art* (Paris, 1970), p. 165, noted by Richard Kendall in Kendall 1993, pp. 78–79.

13. Nearly every writer discussing Degas's *japonisme* remarks upon the unsettling spatial peculiarities of his compositions, which sometimes have been explained with reference to contemporary photography. See particularly Berger, *Japonisme in Western Painting from Whistler to Matisse*, pp. 47–65, and Kirk Varnedoe, *A Fine Disregard: What Makes Modern Art Modern* (New York, 1990), chap. 2.

14. The most complete discussion of this material is Marc Gerstein, "Degas's Fans," *Art Bulletin* 64, no. 1 (March 1982), pp. 105–18.

15. See Deborah Levitt-Pasturel, "Critical Response to Japan at the Paris 1878 Exposition Universelle," *Gazette des Beaux-Arts* 119 (February 1992), pp. 68–80, in which de Luynes is quoted from Weisberg, "Japonisme: Early Sources and the French Printmaker, 1854–1882," p. 147.

16. "I also have other ideas for the color plates. . . . Can you find anyone at Pontoise who is able to cut something you would draw out of very thin copper? This sort of pattern might be placed on a line or softground etching and the uncovered parts then printed by means of porous woodblocks saturated with watercolor. Some pretty trial prints in color, original and curious, might thus be produced . . . I will shortly send you some experiments of my own in that direction. It would be economical and a novelty. . . ." Degas from *Lettres de Degas* 1945, pp. 52–54.

17. See Ives, *The Great Wave*, pp. 45–55, and Washington, Boston, Williamstown, Mass. 1989–90.

18. Referring to hackneyed still-life paintings that employed oriental motifs, Degas dubbed *japonisme* "a fireman's helmet on a frog." Marcel Guérin, ed., *Lettres de Degas* (Paris, 1931), no. 132 (April 29, 1890), p. 148.

19. The first volume of Sukenobu's book shows women of the court, the nobility, religious orders, and military households, as well as townspeople, and includes detailed depictions of women working with their hands or doing physical labor. The second volume focuses on courtesans and prostitutes in scenes from the entertainment district of Shimabara in Kyoto and Yoshiwara in Edo (Tokyo).

20. Étienne Moreau-Nélaton recorded that in 1907 there was a screen mounted at the head of Degas's bed: Moreau-Nélaton 1931, p. 269. He was presumably referring to the framed two-part Kiyonaga print.

21. "Kiyonaga is the master draftsman who restored to printmaking the noble style of earlier days, by creating striking compositions, admirably executed, and adding the richness of delectable color." Samuel Bing, *Collection Hayashi: Dessins, estampes, livres illustrés du Japon* (Paris, 1902), p. iv.

22. M. Vignier and M. Inada, *Kiyonaga, Buncho, Sharaku: Estampes japonaises . . .*, exh. cat., Paris, Musée des Arts Décoratifs (Paris, 1911), no. 118. Of the 139 prints by Kiyonaga included in the exhibition

catalogue, only the "Bain" diptych was described as either famous or rare.

23. *Le Ballon*, a lithograph by Manet (Collection Print Sale: 269), fetched 4,100 francs. The copy Vever first owned of Kiyonaga's *Bath House*, an impression of the print's first state, reveals the private parts of the young woman standing at right. It was not sold during the 1974–75 Sotheby's New York auctions of Vever's collection and remains in the possession of the Vever family. See Jack Hillier, *Japanese Prints and Drawings from the Vever Collection* (New York, 1976), vol. 1, no. 373. Degas's impression is of a later state of the diptych, in which parts of the woman's body are concealed behind the cloth she holds; it was sold by Vever in 1927 to the New York dealer Yamanaka, who sold it to the Museum of Fine Arts, Boston, in exchange for duplicate Japanese prints in the museum's collection. An early mount, now separated from the print but retained with it, bears the Degas collection stamp and the inscription: "Paris le 27 octobre 1927, pour être agréable à Monsieur Yamanaka, j'ai consenti à me dessaisir de cette estampe et à la lui céder, en possédant déjà une épreuve. H. Vever." ("Paris, October 27, 1927: To oblige Monsieur Yamanaka I have agreed to part with this print and surrender it to him, since I already own an impression of it. H. Vever.")

24. Raymond Koechlin, "Hayashi's Collection of French Pictures," in *Illustrated Catalogue of the Important Collection of Paintings, Watercolors, Pastels, Drawings and Prints Collected by the Japanese Connoisseur, the Late Tadamasa Hayashi*, exh. cat., New York, The American Art Association (New York, 1913), unpaginated [23]. See also Raymond Koechlin, *Souvenirs d'un vieil amateur d'art de l'Extrême-Orient* (Chalon-sur-Saône, 1930), p. 580. We do not know which book by Moronobu Degas owned, but it is likely to have been included in the 1918 sale of his print collection, lot 331.

25. Pietro Romanelli, "Comment j'ai connu Degas: Souvenirs intimes," *Le Figaro littéraire*, March 13, 1937, quoted in Roquebert 1989, p. 73 n. 58.

26. Degas inv., in Dumas 1981, no. 4.

27. Julia Meech-Pekarik, *The Matsukata Collection of Ukiyo-e Prints: Masterpieces from the Tokyo National Museum*, exh. cat., New Brunswick, N.J., Jane Voorhees Zimmerli Art Museum, Rutgers University (New Brunswick, N.J., 1988), pp. 19–21.

28. The watercolor Seitei dedicated to Degas was sold on November 16, 1918, Collection Sale II: 160, as "École japonaise: Oiseaux." The information given here regarding Degas's encounter with Seitei is assembled from the following sources: Degas inv., in Dumas 1981, no. 174; Edmond de Goncourt and Jules de Goncourt, *Journal* (Paris, 1956), vol. 2, pp. 806–7; and Toru Arayashiki, "Degas and Hayashi Tadamasa: Notes on Their Friendship," in *Edgar Degas*, exh. cat., Tokyo, Isetan Museum (Tokyo, 1988), pp. 253–54.

29. Meech-Pekarik, *The Matsukata Collection of Ukiyo-e Prints*, p. 21.

30. The 1913 sale catalogue of Hayashi's collection lists and illustrates eleven Degas pastels: no. 54, *Bayadère* (L 863); no. 66, *After the Bath: Woman Drying Her Foot* (L 836); no. 67, *Landscape* (L Suppl. 136); no. 68, *Landscape in the Mountains* (L 1038); no. 69, *Pathway in a Field* (L 1046); no. 70, *Rocky Coast* (L 1060); no. 71, *Dancer* (not in Lemoisne or Suppl.); no. 72, *Head of a Woman* (L 951bis); no. 85, *Bather* (L 1031bis); no. 87, *Woman Braiding Her Hair* (L 1046); no. 88, *Woman on a Bed* (L 1141). According to Lemoisne, Hayashi also owned the pastel *Woman before a Washstand* (L 749).

31. Receipts kept by Hayashi document the following purchases: August 1891, Portier, *Dancer*, pastel, 1,500 francs; May 1895, Durand-Ruel, *Dancer* (fan), etc., 2,500 francs; September 1895, Durand-Ruel, *Head of a Woman* and *Reclining Woman*, pastels, 5,200 francs; March 1896, Durand-Ruel, four landscapes, pastel, 6,000 francs. From Yasuko Kigi, *Hayashi Tadamasa to sono jidai: seikimatsu no Pari to Japonisumu* [Hayashi Tadamasa and His Age. Fin-de-siècle Paris and Japanese Art (Tokyo, 1987)], quoted in Arayashiki, "Degas and Hayashi Tadamasa: Notes on Their Friendship," p. 253.

32. Philip Hale, "Art in Paris," *Arcadia* 1, no. 16 (December 15, 1892), p. 326. Halévy is quoted in Loyrette 1991, p. 563. Both comments are quoted in Kendall 1993, p. 200.

33. Quoted in Lafond 1918–19, vol. 1, p. 148.

THE DISPERSAL

Fig. 345. Paul Helleu, *The Auctioneers at the Edgar Degas Atelier Sale*, 1918. Graphite and black, red, and white chalk on the cover of the second atelier sale catalogue, 10¼ × 14¾ in. (26 × 37.5 cm). Private collection

Behind the Scenes: Durand-Ruel and the Degas Sales

CAROLINE DURAND-RUEL GODFROY

When Edgar Degas died on September 27, 1917, he left behind a collection that my grandfather Joseph Durand-Ruel (1862–1928) described in these terms: "The collection that nobody knows has been stacked for years in two apartments on boulevard de Clichy. It contains several masterpieces, but almost everything is in a piteous state. It would take months to examine everything and stretch canvases and mount pastels on frames."[1] It was perfectly natural that my family, to whom Degas had been selling paintings since 1872, should inherit the task of inventorying that collection.[2]

In fact, it was my grandfather (fig. 346) and the art dealer Ambroise Vollard who made the inventory. My great-grandfather Paul Durand-Ruel was too old, eighty-seven, and participated only later, to authenticate the paintings. As for my granduncle George Durand-Ruel (1866–1931) (fig. 347), he left to run our New York office on November 18, 1917, before any decisions had been reached about the Degas estate, and did not return until the evening of April 28, 1918, "just in time to see the Degas collection in our galleries" before the hanging for the first atelier sale, which took place on May 6–8.[3]

Degas's celebrity and personality, as well as the collection he had amassed, made the inventory and sale of his studio a major event. But these operations become all the more significant because we were in the middle of a world war; consequently, business transactions in Europe and America were almost at a standstill. The Durand-Ruel gallery's correspondence from that period gives a clear picture of all the tasks that my grandfather had to perform. Even before the preparations for the sales, Joseph Durand-Ruel and Vollard had to deal with the complexities of settling the Degas estate. Degas's heirs—his brother René and his nieces and nephews, the Fevres—did not get along and were threatening each other with lawsuits.[4] This delayed the process for a while. But on December 4, 1917, the day after the seals were removed from the Degas studio, Joseph Durand-Ruel could write to his brother in

New York: "I have been definitively named expert for the Degas estate, along with Vollard; in addition, they appointed me curator for the paintings. . . . The auctioneers are Lair-Dubreuil, Petit, and Baudoin. . . . There will probably be several sales. . . . I expect we'll have a lot of trouble with the framing, given the lack of qualified workmen and raw materials, glass, etc., for the pastels." He added, "After our rapid examination yesterday, Vollard and I were astonished by the considerable number of superb drawings and pastels that Degas had never shown anyone." (See Appendix.)

The inventory was begun in the first days of December and completed roughly a month and a half later, at the end of January 1918. It was done first in Degas's studio, then in our offices, since the boxes of pastels and drawings had been transported to the gallery. There was "a horrifying amount of dirt and dust"[5] in that studio, which was also unheated, and harsh everyday reality soon caught up with the thrill of discovering unknown masterworks. On December 10, for example, Joseph Durand-Ruel wrote to his brother, "Lately I've been working like a madman on the Degas inventory; we've been at it for up to six hours a day." On December 18 we find him telling my granduncle, "We're still going to the Degas studio about three days a week. It's very cold there, and it's tiring and rather tedious work to move those filthy things about."[6] The whole business ended with "an extremely violent flu"[7] and laryngitis for my grandfather and a bad chest cold for Vollard.[8] Degas's studio was decidedly not a comfortable place!

Finally, on January 22, 1918, Joseph Durand-Ruel announced to his brother with evident relief, "The inventory of everything Degas had is finally finished: it contains 2,715 items representing, with subdivisions, 5,148 objects. . . ."[9] The number still did not include batches of prints by Honoré Daumier, Paul Gavarni, Édouard Manet, and others. And two days later my grandfather wrote to Auguste Renoir: "The Degas inventory is finally finished. There are a great number of paintings, pastels, and drawings. Degas had always said no one would know

until after his death how hard he had worked throughout his life."[10] Shortly afterward, on February 6, my grandfather wrote to Mary Cassatt: "Everything is now at our place and we're beginning to show the major canvases to the collectors who come here. The paintings occupy the three large rear galleries on rue Le Peletier. The sale of the collection will be held at the end of March, and the first atelier sale, consisting of 350 items, at the beginning of May. These two auctions will take place at the Salle Petit. I would rather have used the Salle Manzi, but Maître Lair-Dubreuil preferred the other one."[11]

By January 8, 1918, even before the completion of the inventory, the dates for the first sales of the Degas collection and of the Degas atelier had been set. It was also at that time that my grandfather and Vollard decided to involve other art dealers: the Bernheim brothers in the sale of the paintings, and Loys Delteil in that of the engravings and small drawings.[12] Right away, therefore, they had to

think about speeding up the restoration of the objects, photographing them, and writing and printing the sale catalogues. In a letter to his brother on January 15, Joseph Durand-Ruel wrote: "I think we have gone much too quickly, but no one asked my opinion. I would certainly have preferred to wait until the fall to hold the sales, which would have allowed us to plan them more thoughtfully."[13] My grandfather was absolutely right: the catalogues for the first collection and atelier sales would not be ready in time to reach the United States,[14] thus preventing the vast majority of American buyers from placing orders.[15]

All that organization demanded an enormous amount of work, and on February 9 a letter from Joseph Durand-Ruel to the auctioneer Lair-Dubreuil listing all the expenses incurred by the estate showed to what extent the Durand-Ruel gallery had been taken over: not just one room but three were occupied by Degas's collection and his own works, depriving my family of the use of those

spaces. On top of that, they had to install new walls to separate the lots and two doors to close off those rooms from the public. My grandfather took charge of getting the lots photographed and the pastels and drawings cleaned and restored. He also had to pay the framing bills from the firm of Adam-Dupré, Degas's framer, who was accustomed to handling his pastels and who, because of insufficient time and personnel, turned out "the simplest kinds of frames, strips of fake gold, or sometimes just unpainted wood."[16]

Finally, the staff of the gallery, which was down to three employees because of the war,[17] was kept busy full-time handling the material chores and meeting with dealers and collectors. And, paradox of paradoxes, in the midst of a German offensive, my grandfather, who had learned that one of his mobilized employees was stationed near Paris, did not hesitate to ask the commander for authorization to have the man come work at the gallery for a few hours a day.[18]

The February 9 letter to Lair-Dubreuil does not mention three stamps for the Degas sale (fig. 349) that were ordered on February 13 from Monsieur Devambez, which would explain why the lots for the studio sale were photographed before being stamped. On the other hand, that same letter mentions the troubling fact that the Degas estate, already insured against fire, was also going to be insured against war risks. Indeed, World War I would be another player in this drama. Germany was on the verge of signing an armistice with Russia, which would allow it to concentrate all its energies on the Western front. The German army was heading toward Paris. First, enemy planes would bomb the capital; then, the long-distance cannons—sadly made famous by "Big Bertha" and "Long Max"—would go into action. The bombardments would take place sporadically from February 1918 until the summer. In a letter dated February 6, my grandfather could only advise Mlle Fevre "to agree to take out insurance [against war risks] for the Degas collection. The paintings are totally exposed in our galleries, under a simple glass ceiling, and we can't store them in the basement because we're still conducting the inventory. . . . Your entire inheritance is here, and could be wiped out in an instant."[19] The suggestion was certainly prudent, since the area around rue Laffitte was not far from the firing range of enemy cannons, and shells were falling all over the neighborhood.[20] That March one of them destroyed part of the building at 15, rue Laffitte, just across from us, shattering one of the gallery windows.[21]

This was the setting, then, for the first sales of the Degas collection and the Degas studio, featuring approximately three hundred items, including some of the most beautiful

Fig. 348. Title page of the catalogue for the first Degas collection sale, March 26–27, 1918

Fig. 349. Stamp of the Degas atelier sales

ones.[22] The collection sale was held on March 26 and 27, 1918, and the atelier sale on May 6–8, 1918. Claude Monet, who was absolutely set on attending the exhibition of works from Degas's atelier, worried whether the auction would take place at all.[23] As for my grandfather, he believed it would be "a great success despite political events; bombardments of Paris never have much effect."[24] Degas was very well known, and the sale of his personal collection and his considerable studio holdings constituted an event of the first importance for art lovers and dealers, both in France and in America. In New York, as George Durand-Ruel wrote, everyone seemed interested in the collection left by Degas.[25] Moreover, Louisine Havemeyer had come to ask him if the time was right to sell one of her Degas pictures.[26] In Paris this was not a problem: purchases and sales of Degas's works were nonexistent, as everyone was holding out for the upcoming auction.[27]

Joseph Durand-Ruel also exhibited the large paintings by Degas that, because they took up so much space, the artist had left with us after he moved to the boulevard de

Fig. 350. Title page of the catalogue for the first Degas atelier sale, May 6–8, 1918

Clichy in 1912.[28] These were *Runaway Horse* and *Woman in a Tub,* along with four works that had been sent for safekeeping in November 1914 to a family property in Périgord that belonged to my granduncle, from where they had just been shipped back to Paris:[29] *Dancer with a Bouquet* and *Four Dancers,* numbers 1 and 10, respectively, in the first atelier sale, and *Semiramis Building Babylon* (fig. 88) and *Family Portrait (The Bellelli Family)* (fig. 90). The show drew a sizable crowd, even though no invitations had been sent out, and "everyone agreed that [the paintings] would fetch very high prices."[30] Mary Cassatt, always on the lookout for masterpieces for Mrs. Havemeyer, advised her friend and patron (as well as The Metropolitan Museum of Art in New York) to buy *Family Portrait.*[31] Cassatt asked my grandfather for an appraisal of the painting,[32] to which he could not give her an immediate answer: it was a very large work, and therefore difficult to place, although several people had expressed interest. Moreover, there was a rumor that the French government wanted to acquire it to put it first in the Musée du Luxembourg and then in the Louvre. As for price, Joseph Durand-Ruel thought that it was worth at least 300,000 francs.[33]

The government did buy the painting, on May 2, just before the first atelier sale, for 400,000 francs.[34] The Metropolitan Museum had been keenly interested, and a disappointed Cassatt wrote to us: "I'm very sorry that the large family portrait was sold to the Louvre. It seems to me that it isn't really the moment for the State to be spending so much money on a painting by Degas. . . . That amount could have financed the purchase and renovation of a property . . . to set up a sanitarium for young soldiers suffering from tuberculosis."[35]

May 5 was the eve of the first studio sale. The catalogues had not reached America in time, and thus there were "no orders from the United States."[36] Already foreseeing this state of affairs in January, my grandfather had advised "pointing out to American clients that the studio contained a considerable number of works and that there would be many bargains they would later regret having missed. There will no doubt be a drop in prices for two or three years, then a sharp rise when Degas's works have been dispersed and become better known to the general public."[37]

In the event, my family acquired 165 lots from the four sales of the Degas atelier and also struck a deal with Jacques Seligmann, Vollard, and the Bernheims to buy sixty-nine lots jointly from the first atelier sale. Georges Viau sold off his own collection "so as to be able to buy some of the artist's major works."[38] Indeed, Viau bought

Fig. 351. Paul Helleu, *At the Fourth Atelier Sale,* 1919. Graphite on the cover of the sale catalogue, 8¼ × 10¼ in. (21 × 26.2 cm). Private collection

fifty-five items at these sales. My grandfather always believed the sales would be a success, "unless politics comes along to spoil everything." He thought that the French, Swiss, and Swedish dealers and collectors would buy heavily.[39] A crowd of collectors came to see the exhibition of the first studio sale,[40] and sale prices ranged, depending on a work's importance, between 5,000 and 80,000 francs.[41] A week later George Durand-Ruel wrote to Cassatt: "As you have no doubt seen in the newspapers, prices at the Degas sale were very high; the total—5,600,000 francs, not counting the piece bought by the Louvre—greatly surpassed my expectations. Prices were higher on the second day than on the first, and still higher on the third day, because a number of collectors had waited in hopes of finding better deals at the end of the sale, but just the opposite occurred. Having gotten nothing at the beginning, they fought over what was left."[42] And he wrote to our New York office, "Pastels that were more or less sketches, just like the ones that had sold for 8,000 to 12,000 francs on the first day, were going for 25,000 to 30,000 francs on the third."[43] Moreover, the war was coming to an end; in October Joseph Durand-Ruel predicted that "with the success of the current offensive, it is likely that we'll have a very profitable season."[44]

I should also mention the second sale of the Degas collection, which was held on November 15 and 16, 1918, for that sale featured a certain number of paintings designated "Modern School." Many were surely by Degas, although the experts could not authenticate them as such. Though there were some protests against the decision not to authenticate, no unanimous opinion was reached, and the canvases that some maintained were Degas's work were challenged by others. My grandfather thought that an announcement to this effect could be made before the sale, so that the experts would not be accused of buying works by Degas at rock-bottom prices (see Appendix). This sale, which featured little of note, brought in 37,941 francs—three times more, my grandfather felt, than if it had been an ordinary sale. He expected equal success for the sale of Degas's engravings, which took place that same week.[45]

For the second studio sale, on December 11–13, 1918, as great a turnout as for the May auction was expected[46]—but not as great a profit, as the paintings and pastels were in general less important. The Salle Petit was completely filled with three rows of framed pictures squeezed one against the other.[47] This second atelier sale was, once again, such a success that my family refused to give exact appraisals for the lots of the third session, held on April 7–9, 1919. Indeed, in December 1918 certain touched-up drawings appraised at 3,000 francs had sold for between 15,000 and 18,000 francs each.[48] That third auction also went well, although the second day was weaker: there were fewer people, since overall the objects were less significant, and Lair-Dubreuil had not been able to con-

duct the sale himself. (George Durand-Ruel felt the results would have been better if Lair-Dubreil had been present.) My granduncle was convinced that when the dust settled, the prices for all of Degas's works would rise sharply.[49]

The fourth and last atelier sale, held on July 2–4, 1919, was a resounding success. Still, as my grandfather wrote to our New York office the day after the event: "What we sold was generally not very important, and a few years ago would have gone for next to nothing. As it is, we took in more than 480,000 francs, which is very good. Almost every item went for a price higher than our appraisals. . . . We had the greatest success with the small pastels of landscapes, which we had appraised at around 1,000 francs each because of the current overpricing of Degas's works and which, to our great surprise, sold for between 3,000 and 20,000 francs. Those prices are sheer folly."[50]

I often heard that particular remark of my grandfather's echoed later by my father. The considerable rise in price for Degas's works, predicted by my grandfather and my granduncle, did indeed come about, surpassing even their most optimistic projections. If they were already describing the 1919 prices as "sheer folly," I cannot imagine what term they would use today.

Appendix

Excerpt from a letter from Joseph Durand-Ruel to George Durand-Ruel:

Paris, December 4, 1917

Messieurs Durand-Ruel
New York

Dear George,

I have been exceedingly busy these days, and it's only going to get worse. I have been definitively named expert for the Degas estate, along with Vollard; in addition, they appointed me curator for the paintings, which I was quite prepared to refuse had the paintings been anywhere but with us. We first tried to rent an apartment in the area; impossible to find one without signing a lease for 3, 6, or 9 [years]. Moreover, we would have had to hire a live-in guard, and Vollard and I would have had the bother of having to go there constantly, leaving the business untended; on top of which, we would have had to contend with problems of lighting and heating. It would also have been difficult to take the many photographs on site, surely a few hundred of them, that will be indispensable. At first I was hesitant to bring the collection to our gallery. I decided to do it only after realizing that the whole thing could fit in the back room, with at most the addition of some new shelves. We'll leave all the furniture, easels, frames, and unused canvases in Degas's two apartments, which they're keeping, along with a pile of trinkets that aren't by Degas and aren't worth anything. We're taking only the paintings, drawings, and pastels. We'll also have the wax figures, but I'll keep them in another location, in the small room on the second floor between our galleries.

Yesterday was the first visit. The seals were temporarily removed to let us view the apartments. A lot of people were in attendance: the whole family, notaries, attorneys, auctioneers, experts, and all their clerks and employees. The auctioneers are Lair-Dubreuil, Petit, and Baudoin; unfortunately, only the first two will be listed in the catalogue, even though they're splitting the fee three ways. A new ruling by the employers' federation for auctioneers forbids more than two from working at the same sale, and since Baudoin is the youngest, he has to defer to his two colleagues.

On Thursday, Friday, and Saturday, Vollard and I will be on the premises from nine o'clock to noon and from two to four; before and after each visit, the court clerk has to remove the seals and then replace them. Each object we want to remove will be numbered, recorded in the register, and marked with a special stamp; after each visit we can take away the catalogued objects, for which we will then be responsible.

We will also receive compensation for housing the Degas collection at our gallery for an amount to be negotiated, which will probably come to about 800 francs a month.

Despite all the headaches the collection might cause us, there are so many advantages that I prefer this arrangement. We will have better facilities for taking photographs, and having our men around will make the works easier to guard. Since Vollard is nearby, he can more easily come help me, and as for me, I won't have to go anywhere, since I'm always here.

There will probably be several sales; after studying the works, we'll decide how best to arrange them and which seem to be the best periods. I expect we'll have a lot of trouble with the framing, given the lack of qualified workmen and raw materials, glass, etc., for the pastels.

After our rapid examination yesterday, Vollard and I

were astonished by the considerable number of superb drawings and pastels that Degas had never shown anyone. There's a whole row of albums filled with these drawings and pastels.

Excerpt from a letter from Joseph Durand-Ruel to George Durand-Ruel:

Paris, November 15, 1918

M. George Durand-Ruel
Les Balans

Dear George,

Today is the first day of the [second] sale of the Degas collection. At the viewing yesterday at the Hôtel Drouot there was a great crowd of visitors. A fairly large number of paintings of the Modern School, which are certainly by Degas, although it would be impossible to guarantee them as such. There were a lot of protests against the experts' decision; nonetheless we acted soundly, as it wasn't unanimous, and the paintings that some say are by Degas have been challenged by others. So that no one can accuse the experts of cataloguing the works as such in order to buy them themselves at rock-bottom prices, we're going to check with Lair-Dubreuil if there isn't some way to run an announcement before the auction saying that certain paintings might be by Degas but that the experts cannot guarantee it.

All sources cited are in the Durand-Ruel archives, Paris.

1. Letter from Joseph Durand-Ruel to Monsieur Avril, October 13, 1917.
2. This is a translation from the French of an essay that first appeared in *Degas inédit* 1989, pp. 262–75.
3. Letter from George Durand-Ruel to Durand-Ruel New York, May 2 1918.
4. Letter from Joseph Durand-Ruel to Durand-Ruel New York, October 8, 1917.
5. Letter from Joseph Durand-Ruel to Auguste Renoir, January 24, 1918.
6. Letters from Joseph Durand-Ruel to George Durand-Ruel, December 10 and 18, 1917.
7. Letter from Joseph Durand-Ruel to George Durand-Ruel, December 28, 1917.
8. Letter from Joseph Durand-Ruel to Mary Cassatt, February 6, 1918.
9. Letter from Joseph Durand-Ruel to George Durand-Ruel, January 22, 1918.
10. Letter from Joseph Durand-Ruel to Auguste Renoir, January 24, 1918.
11. Letter from Joseph Durand-Ruel to Mary Cassatt, February 6, 1918.
12. Letter from Joseph Durand-Ruel to George Durand-Ruel, January 8, 1918.
13. Letter from Joseph Durand-Ruel to George Durand-Ruel, January 15, 1918.
14. Letter from Joseph Durand-Ruel to Maître Lair-Dubreuil, January 24, 1918.
15. Letter from George Durand-Ruel to Durand-Ruel New York, May 10, 1918.
16. Letter from Joseph Durand-Ruel to Lair-Dubreuil, February 9, 1918.
17. Tax declaration of remuneration and salaries for the year 1917.
18. Letter from Joseph Durand-Ruel to the Lieutenant Commander, 21st Artillery Brigade, 1st Group, 285th Regiment, February 27, 1918.
19. Letter from Joseph Durand-Ruel to Mlle Fevre, February 6, 1918.
20. Letter from Joseph Durand-Ruel to Maufra, April 5, 1918.
21. Letter from Joseph Durand-Ruel to Mary Cassatt, March 13, 1918.
22. Letter from Joseph Durand-Ruel to George Durand-Ruel, January 8, 1918.
23. Letter from Claude Monet to Joseph Durand-Ruel, April 10, 1918.
24. Letter from Joseph Durand-Ruel to Durand-Ruel New York, April 9, 1918.
25. Letter from George Durand-Ruel to Durand-Ruel Paris, December 21, 1917.
26. Letter from George Durand-Ruel to Durand-Ruel Paris, December 4, 1917.
27. Letter from Joseph Durand-Ruel to Monsieur Migeon, December 28, 1917.
28. Letter from Joseph Durand-Ruel to George Durand-Ruel, November 27, 1917.
29. Letter from Durand-Ruel Paris to Monsieur Borniche, insurance agent, October 16, 1917.
30. Letter from Joseph Durand-Ruel to George Durand-Ruel, November 27, 1917.
31. Letter from Mary Cassatt to Joseph Durand-Ruel, February 29, 1918.
32. Letter from Mary Cassatt to Joseph Durand-Ruel, March 13, 1918.
33. Letter from Joseph Durand-Ruel to Mary Cassatt, March 13, 1918.
34. Telegram from George Durand-Ruel to Mary Cassatt, May 3, 1918.
35. Letter from Mary Cassatt to Durand-Ruel Paris, May 5, 1918.
36. Letter from George Durand-Ruel to Durand-Ruel New York, May 10, 1918.
37. Letter from Joseph Durand-Ruel to George Durand-Ruel, January 15, 1918.
38. Letter from Joseph Durand-Ruel to George Durand-Ruel, February 21, 1918.
39. Letter from Joseph Durand-Ruel to George Durand-Ruel, February 26, 1918.
40. Letter from George Durand-Ruel to Joseph Durand-Ruel, May 2, 1918.
41. Letter from George Durand-Ruel to Monsieur Douillet, May 3, 1918.
42. Letter from George Durand-Ruel to Mary Cassatt, May 14, 1918.
43. Letter from George Durand-Ruel to Durand-Ruel New York, May 10, 1918.
44. Letter from Joseph Durand-Ruel to Durand-Ruel New York, October 3, 1918.
45. Letter from Joseph Durand-Ruel to Durand-Ruel New York, November 19, 1918.
46. Letter from George Durand-Ruel to Mary Cassatt, December 6, 1918.
47. Letter from George Durand-Ruel to Durand-Ruel New York, December 9, 1918.
48. Letter from George Durand-Ruel to Baron Caccamisi, March 21, 1919.
49. Letter from George Durand-Ruel to Durand-Ruel New York, April 10, 1919.
50. Letter from Joseph Durand-Ruel to Durand-Ruel New York, July 5, 1919.

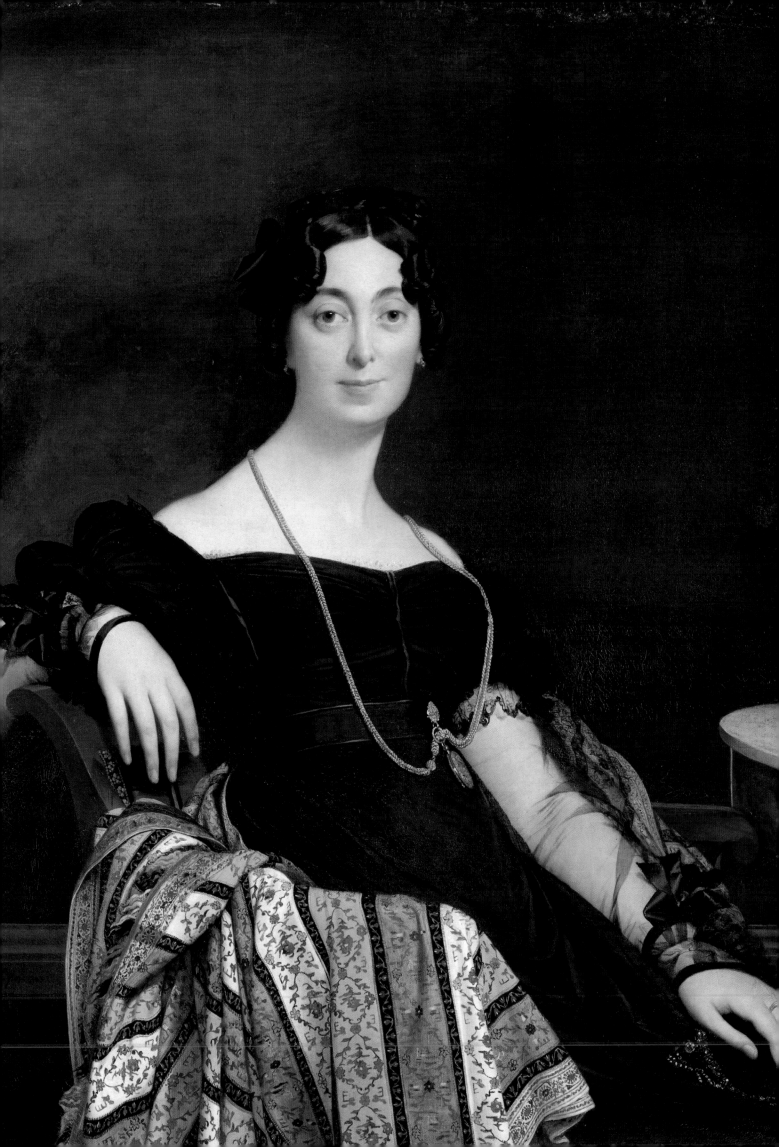

The Metropolitan Museum's Purchases from the Degas Sales: New Acquisitions and Lost Opportunities

SUSAN ALYSON STEIN

Fulfilling all predictions and exceeding all expectations, the Degas sales were an enormous success, but one that had little to do with American purchases. Only a handful of private collectors, including Louisine Havemeyer, Robert Sterling Clark, and Isabella Stewart Gardner, bought works directly from the Degas sales in 1918,[1] and only one American museum: The Metropolitan Museum of Art. The war, which disrupted all normal channels of communication—delaying the shipment of sale catalogues, letters of inquiry, and cables of intent—made bidding from across the Atlantic difficult. This was certainly true for the Metropolitan, where catalogues that arrived late, in short supply, or not at all made it necessary to consult photographs and even magazine illustrations; to rely on advice from abroad that was often slow in coming and not kept in the strictest confidence; and to accept the inevitable disappointments of losing works at auction simply because cables did not arrive. Under these less-than-favorable circumstances, the Metropolitan succeeded in acquiring from the sales the celebrated portraits of M. and Mme Leblanc by J.-A.-D. Ingres (figs. 22, 21) and an admirable group of ten portrait and figure drawings by Edgar Degas (figs. 366–375). That these acquisitions represented the Museum's first paintings by Ingres and its first works by Degas perhaps explains why, given the exigencies of war, they were pursued at all.

For more than a decade prior to the Degas sales, curators at the Metropolitan had eagerly sought to acquire paintings by both artists. The acquisition of the portraits of M. and Mme Leblanc brought to a glorious conclusion the long search for outstanding examples of Ingres's portrai-

ture that had been initiated by the English critic Roger Fry during his brief tenure as curator of paintings in 1906–7 and carried on by his successor, Bryson Burroughs, in the years that followed. The drawings by Degas, though they were a handsome and significant addition to the Museum's collection, did not satisfy the equally great desire, which lingered on another decade, for an important and representative painting by Degas. This lacuna would not be filled until 1929, when the bequest of Mrs. H. O. Havemeyer transformed the Museum's fledgling collection of French art of the late nineteenth century into one of the premier collections in the world and brought to it fourteen paintings by Degas (as well as some twenty-five pastels and drawings, a half-dozen prints, and a set of bronze sculptures). But in the aftermath of the Degas sales, when this eventuality was by no means certain, Burroughs, despite the drawings in hand, could only lament: "The most conspicuous lack in the Museum collection of modern pictures is the absence of any painting by Degas."[2]

Fry had initiated the campaign to acquire paintings by both artists in 1906, when he proposed buying a *Café chantant (Les Musiciens à l'orchestre)* by Degas (which must be *Orchestra Musicians* [fig. 353], though a dancer, not a singer, takes center stage) and a *Portrait of a French Cavalier* by Ingres (presently unknown). The acquisition of the Degas was authorized by the Committee on Purchases, but at considerably less than its asking price, and since "Messrs. Durand-Ruel were not willing to let the work go for that amount," it suffered the same fate as the Ingres: neither purchase was approved.[3] In 1907, under Fry's curatorship, the Museum bought what were then regarded as its first drawings by Ingres, *Study of a Hand* (07.282.15, now considered French school) and two figure studies

Fig. 352. Detail, J.-A.-D. Ingres, *Madame Jacques-Louis Leblanc* (see fig. 21)

Fig. 353. Edgar Degas, *Orchestra Musicians*, ca. 1870–71, reworked ca. 1874–76. Oil on canvas, 27⅛ × 19¼ in. (69 × 49 cm). L 295. Städtische Galerie im Städelschen Kunstinstitut, Frankfurt (SG237)

Burroughs commented in a letter that spring: "It is hard to get the Committee to appreciate how very expensive certain French pictures are. Still if we get a stunner there is always a chance."[6]

Burroughs's efforts to find a "stunner" that would have a chance with the committee led him to consider many pictures by both Degas and Ingres that for one reason or another were never formally proposed.[7] Price was the major obstacle, but there were other criteria that proved restrictive. As one dealer remarked, Burroughs would have had a "much better choice" among available works by Degas "if [the Museum] could buy a pastel," but the funds at his disposal—the Catharine Lorillard Wolfe Fund, which enabled the Metropolitan to buy Auguste Renoir's *Madame Charpentier and Her Children* (07.122) in 1907 and Paul Cézanne's *View of the Domaine Saint-Joseph* (13.66) from the Armory show in 1913—were limited to the purchase of "modern paintings."[8] He presumably saw many works and learned of others, such as a privately owned painting that turned out not to be of museum quality, and a pastel at an "outrageous" price that "was only a single figure."[9] Nothing came of either this search or the one for a portrait by Ingres. Because two male por-

(07.282.16 and .17, now "attributed to Ingres"). (The present designations confirm Fry's observation at the time that the studies "differ entirely in effect from the deliberate and highly finished portrait drawings by which Ingres is better known.")[4]

With Fry's resignation from the Museum in 1907, Burroughs took up the cause. Literally following in his predecessor's footsteps, in 1909 he proposed the purchase of the same *Orchestra Musicians* by Degas, and witnessed the same outcome. As Burroughs explained to Joseph Durand-Ruel in a letter of March 17, 1909, the committee could not justify the purchase, making the only alternative a gift: "Amongst your clients do you happen to know of any public spirited person who might be induced to give it to us? I am speaking to several about it. It has been a great pleasure to live with the picture these last two days."[5] Burroughs's pleasure remained short-lived. Two years later, in 1911, he tried again, bringing two works before the Committee on Purchases: a *Portrait of a Man* by Ingres, offered by Bernheim Jeune (probably *Portrait of Monsieur Devillers*, W 79, fig. 354), and *Foyer de la danse* by Degas, from Durand-Ruel (probably L 1107; fig. 355). Both pictures were declined. Frustrated but still optimistic,

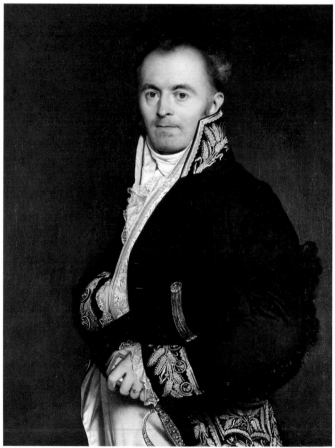

Fig. 354. J.-A.-D. Ingres, *Portrait of Monsieur Devillers*, 1811. Oil on canvas, 38¼ × 30¾ in. (97 × 78 cm). E. G. Bührle Collection, Zurich

Fig. 355. Edgar Degas, *Foyer de la danse,* now called *Ballet Rehearsal,* ca. 1885–90. Oil on canvas, 15⅛ × 34½ in. (36.2 × 87.6 cm). L 1107. Yale University Art Gallery, New Haven, Gift: Duncan Philips, B.A. 1908

traits by Ingres did not pass muster with the board, Burroughs had more or less narrowed his search to "an attractive portrait of a woman."[10] Of those brought to his attention, however, in one the sitter was too old, in another too unattractive, and in another purportedly "beautiful" but unattainable at any price. The type of portrait that would be "just right," in the apt words of Goldilocks, was described by Burroughs: "If we could [only] get hold of one of the charming female portraits, like the Mme d'Hausonville [*sic*] at the Château de Coppet"[11] (naming one of the most astounding achievements of Ingres's career, the *Comtesse d'Haussonville,* acquired in 1927 by Henry Clay Frick; fig. 356). After the 1911 Ingres retrospective held at the Galerie Georges Petit in Paris, prices skyrocketed, and Burroughs "supposed it is a bad time to look for Ingres now . . . there will be a better chance after the enthusiasm from this exhibition has died down."[12] That chance did not next present itself until 1918,[13] when Burroughs proposed the acquisition of Ingres's portraits of M. and Mme Leblanc from the Degas collection sale. For Burroughs, this was in fact a second chance. He had actually seen, and even been offered the opportunity to buy, these portraits before.

The original offer came in December 1909 from Robert Dell, a British journalist who had moved to Paris and become a picture dealer. It was prompted by a visit to Degas's studio that Burroughs and Dell had made a few months earlier in the company of Roger Fry. From the visit (as is documented in the letters included in the Appendix to this essay), Dell had gleaned that Burroughs's interest in paintings by Degas was rivaled only by his interest in portraits by Ingres. Dell had also learned that Degas "wanted

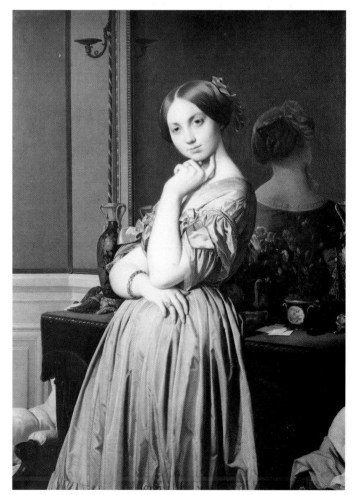

Fig. 356. J.-A.-D. Ingres, *Comtesse d'Haussonville,* 1845. Oil on canvas, 51⅞ × 36¼ in. (131.8 × 92 cm). © The Frick Collection, New York (27.1.81)

money" and was eager to sell the Metropolitan Museum one of his own paintings. What Dell had failed to understand was that Degas would never have parted with any of the prized possessions Dell unwittingly offered Burroughs in this letter of December 31, 1909:

> You will remember the three superb portraits by Ingres that we saw in Degas' studio. If Degas could be persuaded to part with one of them at anything like a reasonable price, would the museum be disposed to buy one? I have no idea whether Degas would consent to sell one and have not yet said a word to him about it, as it is useless to do so unless there is a very good chance of the picture being bought; it is quite probable that he would refuse to sell. But I know that he wants money and I might possibly induce him to consent; only I do not want to mention the matter to him at all unless a purchase is pretty nearly certain, as he would only be

offended if nothing came of it. If you still want an Ingres, you could not possibly find one finer than either of these three. The worst of it is that I should probably have a great difficulty in inducing Degas to have the pictures of either of them photographed; he says now that he regrets having allowed his own picture to be photographed. And I suppose that you could do nothing without a photograph? Would not the committee in a case like this authorise you to buy the picture without showing them a photograph? All the three portraits are well-known and are extremely fine examples of Ingres. You will remember that there were a pair of portraits of a man and his wife and another portrait of a man; if Degas sold at all, it would probably be the last, as he would not like to divide the pair.[14]

Degas, in fact, owned four portraits by Ingres, but perhaps the three that impressed Dell and that many years later lingered in Burroughs's mind's eye when at last he had a real opportunity to buy "one or more" of them[15] were those recorded in a little sketch he made at the time of the Degas collection sale (fig. 357).

Burroughs's response to this letter of December 1909 is not known, but he made no formal proposal for acquiring the "pair of portraits" of M. and Mme Leblanc or the "portrait of a man," whether *Monsieur de Norvins* or the *Marquis de Pastoret*, referred to by Dell. Nor did Burroughs formally present to the Committee on Purchases the other picture alluded to in this letter from Dell (and discussed in other letters; see Appendix): namely, the painting by Degas that the artist *had* "allowed . . . to be photographed" for this purpose.

Remarkable as it may seem, given what is known about Degas's often irascible behavior toward museum officials, he appears to have been most accommodating to Burroughs at the time of his visit, probably in September 1909. Degas had then graciously entertained the prospect of selling one of his own paintings to the Metropolitan, offering Burroughs a large, "important" picture and going to the trouble of having it photographed in compliance with Museum policy. The painting, which cannot be identified with certainty, is probably *Scene of War in the Middle Ages*, the impressive but unusual allegorical picture shown in the Salon of 1865 (fig. 358).[16] If it is, one can well understand the initial reservations voiced by Burroughs and Fry, especially given Degas's presumed asking price of 100,000 francs (nearly twice what the French government would pay for the *Scene of War in the Middle Ages* at the Degas atelier sale in 1918). Already forewarned, Dell was not surprised to learn from Burroughs in November 1909 that "the Degas is out of the question. We have not that

Fig. 357. Bryson Burroughs, *Notes on Ingres Portraits, with Sketches*, March 1918. Department of European Paintings Archives, The Metropolitan Museum of Art, New York

Fig. 358. Edgar Degas, *Scene of War in the Middle Ages* (erroneously called *The Misfortunes of the City of Orléans*), ca. 1863–65. Essence on several pieces of paper joined and mounted on canvas, 31⅞ × 57⅞ in. (81 × 147 cm). L 124. Musée d'Orsay, Paris (R.F. 2208). Atelier Sale I: 13

amount available and the price is considered too high . . . there is no chance of its purchase." (Burroughs must have recognized the futility of the acquisition either on his own or by sounding it out informally with members of the Committee on Purchases, since it was never actually submitted for approval.) Degas, on the other hand, who seems not to have anticipated this outcome, had been "rather impatient," then "depressed," then "very sad when he heard the museum had not bought his picture, and at first rather angry, but he soon got over that."

Still, Dell continued to visit Degas and to correspond with Burroughs on the subject of pictures by Degas, and by Ingres, that might be of interest. Besides suggesting the "superb portraits by Ingres" in December 1909, he wrote Burroughs after another visit, in February 1910, that he was willing to "see what [he could] do with Degas" as regards "the superb pastel" *Edmond Duranty* (fig. 287). Somewhat miffed, Burroughs, who had "already explained" to Dell "the difficulties we have in regard to the purchase of pastels," replied: "The Duranti [*sic*] is a magnificent picture, but the one we buy should be to my mind, one of his figure subjects, having his characteristic qualities." Needless to say, the offer was not pursued.

Whether Burroughs might have reconsidered at the time of the Degas sales the painting that Degas had earmarked

for the Metropolitan, or the portrait *Edmond Duranty,* is not known, since he wasn't given the chance. The catalogues for the first atelier sale in May 1918, which included these pictures, did not arrive in New York until after the sale. Later he did choose, from the drawings illustrated in the catalogue of the second atelier sale in December 1918, the studies Degas made for the "magnificent" portrait of the critic (figs. 369, 370). As for the portraits of M. and Mme Leblanc by Ingres that he had seen in the artist's studio many years before: from the moment Burroughs learned that they were being offered in the Degas collection sale he was determined—indeed, even frantic—not to lose this opportunity again.

On February 18, 1918, Burroughs was in a mad rush to submit his "Recommendation for Purchase" papers for the Degas collection sale, since he was under the "delusion" that the auction was to take place the following week rather than a month hence! He had learned of the sale from George Durand-Ruel (of the New York branch of the firm) and had apparently made his initial selection of works—under some duress and without the benefit of the sale catalogue—on the basis of photographs and a list of works provided by the dealer. As he confessed in a letter written to trustee George Blumenthal on February 20, "I made a most foolish and unexplainable mistake in the date

of the Degas sale. It is March 26 and 27 and not this month. When Mr. Durand-Ruel said we would not have time to receive the catalogues I got it intently fixed in my mind that it was February and was in this delusion until corrected yesterday afternoon."[17] (The original paperwork shows that the erroneous typewritten date was later corrected in pen.) The letter to Blumenthal—a member of the Committee on Purchases—suggests, given its apologetic and embarrassed tone, that Burroughs had caused quite a commotion, doubtless in an effort to solicit advice and approval from the necessary committee members in time. He turned to Blumenthal, a respected trustee (and later Museum president), for that support. He also sought advice from other quarters during that anxious twenty-four-hour period: from the collector and the artist most intimately familiar with Degas, Louisine Havemeyer and the "godmother of [her] collection," Mary Cassatt. Already on the morning of February 19, Burroughs had "consulted with Mrs. Havemeyer . . . and at her dictation sent [a] cablegram to Miss Cassatt, which read: 'Metropolitan requests me to cable would you advise purchase Degas Ingres Leblanc or another and at what valuation.'"[18] Cassatt cabled her reply six days later, on February 25: "I prefer mans [*sic*] portrait both cracked. The[y] sold together mai [*sic*] bring 100,000 each."[19] There would be time to decipher her cryptic reply, since, fortunately, the sale was a month, not a day, away.

Burroughs's month-long reprieve, though it allowed him the opportunity to study the sale catalogue and to receive fuller and more detailed advice from abroad, did not change his original selection, which seems to have been well considered, even if prepared in haste. However, the intervening weeks did allow for two meetings of the Committee on Purchases—a special meeting held on March 5 and another on March 18—where his selection was reviewed and, ultimately, edited.

From the start, as can be gathered from the cables quoted above, the works of most interest to Burroughs were the celebrated portraits of M. and Mme Leblanc by Ingres. But there were also drawings he was keen to acquire for the Museum: two by Ingres, *Study for "La Grande Odalisque"* (fig. 359) and *Study for "The Apotheosis of Homer;"* and one by Honoré Daumier, *The Tribunal* (fig. 360). Before arriving at this list of five works, Burroughs had considered various other drawings and strategies for obtaining them at auction. Some handwritten notes and marginal calculations on a scrap of paper reveal how Burroughs, if left to his own discretionary budget, might have spent "the $2000 allotted [him] for the purchase of drawings." It would have gone "to drawings by Ingres."[20] Mindful of the order in which the lots would be offered in the upcoming sale as well as the current rate of conversion—five francs to the dollar—he devised a bidding scheme involving four drawings, for which he would bid up to 5,000 or 6,000 francs apiece ($1,000 to $1,200); "if any money remains," it would go to the next item of interest. In light of the bids that actually won these drawings at auction, the strategy might very well have secured as many as three of the four

drawings named: *Seated Woman, Study for the Odyssey in "The Apotheosis of Homer"* (lot 189), acquired by the Louvre for 800 francs (fig. 31); *Seated Female Nude, Study for "The Golden Age"* (lot 207), acquired by Knoedler for 1,900 francs (now, Fitzwilliam Museum, Cambridge; fig. 332); and *Roger Freeing Angelica* (lot 213), acquired by Bernheim for 3,200 francs (now, Fogg Art Museum, Cambridge, Mass.; fig. 192). Yet the *Study for "La Grande Odalisque"* (lot 204), which fetched a sum of 14,000 francs and was estimated to bring even more (now, Courtauld Institute Galleries, London), would have escaped. Perhaps this is why Burroughs scrapped the idea.

However clever this contingency plan — to expedite the acquisition process by using discretionary funds that did not require board approval—it was not realistic, as Burroughs must have immediately learned from Blumenthal, who was knowledgeable about drawings, or from Durand-Ruel, who had prepared estimates. Indeed, the figures Burroughs gave on his formal purchase proposal for the two drawings by Ingres, the studies for *La Grande Odalisque* and *The Apotheosis of Homer,* significantly exceeded his allotment. (Curiously, they were so inflated as to make his allotment seem puny.) Pursuant to review by the director and the Committee on Purchases, the suggested bids for these two drawings and for the third, by Daumier, were (to quote from the minutes of the special meeting of the Committee on Purchases on March 5) "adjusted in view of reports received." They were "reconsidered" again at the subsequent meeting on March 18, with the result that the purchase prices authorized for Ingres's *Grande Odalisque* study and Daumier's *Tribunal* were again lowered while the *Study for "The Apotheosis of*

Homer" was abandoned altogether.[21] Though reduced, the bids placed with Durand-Ruel at the time of the sale on March 26–27 should have ensured the Museum's acquisition of these two drawings at auction, but this did not occur. For reasons not revealed, "the opportunity to purchase the drawings was lost":[22] the sublime nude by Ingres went to Halvorsen for 14,000 francs and the powerful courtroom scene by Daumier to the dealer Trotti for 13,600 (now, Ny Carlsberg Glyptotek, Copenhagen).[23]

The Museum did, however, succeed in acquiring the Leblanc portraits by Ingres—though in retrospect, this outcome was far from predictable. In the weeks prior to the sale, the opinions received from abroad were not entirely favorable, especially toward the portrait of Mme Leblanc, for reasons that seem largely to do with personal taste. Mary Cassatt's cable of February 25 expressed a decided preference for what most authorities, then as today, would regard as the portrait of lesser importance.[24] (It was not the "man's portrait" preferred by Cassatt but rather *Madame Jacques-Louis Leblanc* that Ingres worked up with numerous preparatory studies and exhibited twice, at the Salon of 1834 and the Paris World's Fair of 1855.)

As it turns out, however, Cassatt had been neither entirely candid nor particularly discreet about the matter at hand. Immediately upon receipt of the Museum's telegram she cabled Joseph Durand-Ruel for advice; then, in replying to the Museum, she simply reworded, with some changes in emphasis, the cable she had received back from him. Durand-Ruel's cable to her read: "Portrait of the man is perhaps superior but opinion is divided. The two are cracked, especially the man. They will probably be

Fig. 360. Honoré Daumier, *The Tribunal,* 1850–60. Graphite, India ink, and gouache, 8½ × 13⅝ in. (21.5 × 34.5 cm). Ny Carlsberg Glyptotek, Copenhagen (I.N.1901). Collection Sale I: 108

Fig. 361. Edgar Degas, *The Steeplechase,* 1866, reworked 1880–81. Oil on canvas, 70⅞ × 59⅞ in. (180 × 152 cm). L 140. Collection of Mr. and Mrs. Paul Mellon, Upperville, Va. Atelier Sale I: 19

Fig. 362. Detail, Edgar Degas, *Family Portrait,* also called *The Bellelli Family,* 1858–67. Oil on canvas, 78¾ × 98⅜ in. (200 × 250 cm). L 79. Musée d'Orsay, Paris (R.F. 2210). Atelier Sale I: 4 (purchased by the Musée du Louvre before the sale)

sold together. Can expect to bring 100,000 each but perhaps less."[25] Cassatt had further learned from the dealer that "the two paintings are expected to be sold separately, though the buyer of the first one will have the right to acquire the second, if desired." In the same cable he told her that catalogues would be sent to New York on February 23.[26] A week later Cassatt wrote to Durand-Ruel: "I have cabled New York that I prefer the portrait of the man and that the two paintings are cracked. I found them to be in rather bad state, and I remember that M. Degas had the opportunity to [comment] on the manner of painting in our time, declaring that in his youth he had seen these portraits and that, at that time, they were in excellent condition."[27] (Despite the pronounced craquelure, caused by the drying process of certain passages of paint, and the presence of pentimenti in *Madame Jacques-Louis Leblanc,* the portraits were in sound condition.)

Apparently these opinions prompted some consternation at the Museum as the date of the collection sale grew closer. That there may have been—just prior to the March 18

meeting of the Committee on Purchases—second thoughts about the portraits of M. and Mme Leblanc is suggested by a cable Cassatt sent Durand-Ruel on March 17: "Metropolitan Museum requests advice on male portraits by Ingres. I will respond if Pastoret is in good state. Would like advice and estimate by telegram."[28] The following day Joseph Durand-Ruel replied: "I have received your dispatch telling me that the Metropolitan Museum requests your advice on the male portraits by Ingres in the Degas sale. I won't discuss the portrait of M. Leblanc, since I have already written you on this subject. The two others are very beautiful; the portrait of M. Norvins [fig. 186] is less amusing than the other, but of superb quality; as regards the portrait of the Marquis de Pastoret [fig. 20], it wins all the votes ["réunit tous les suffrages"], being just as pleasing to those who know nothing about painting as to true collectors. The two paintings are in perfect condition. To give you an evaluation is difficult: these two male portraits are each worth between 50 and 100,000 francs. M. Lapauze, whose opinion is of interest on the subject of Ingres, values

Fig. 363. Edgar Degas, *Édouard Manet Seated, Turned to the Right*, 1866–68. Etching and drypoint, fourth state, 9⅞ × 6⅞ in. (25 × 17.3 cm). The Baltimore Museum of Art: Blanche Adler Fund (1952.76). Atelier Print Sale: 21

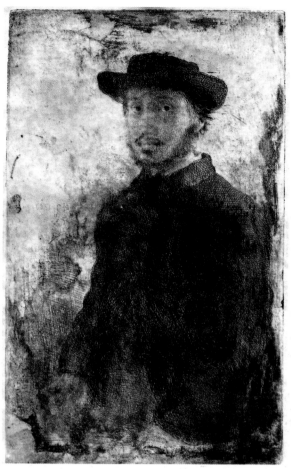

Fig. 364. Edgar Degas, *Self-Portrait,* 1857. Etching and drypoint, third state, 18⅛ × 12¼ in. (46.2 × 31 cm). The Metropolitan Museum of Art, New York, H. O. Havemeyer Collection, Bequest of Mrs. H. O. Havemeyer, 1929 (29.107.53). Surrogate for the impression sold in Atelier Print Sale: 3 or 3bis

the portrait of M. de Norvins at 150,000 francs. Whatever their prices, they are beautiful canvases that would do honor to any museum. At your request, I am sending you a telegram giving my evaluations of these paintings."[29]

Cassatt's preference for male portraits by Ingres and for the *Marquis de Pastoret* in particular—a portrait of a distinguished gentleman, in an excellent state of conservation—seems characteristic of her taste in general. Here one is reminded of the picture that two years earlier Cassatt had encouraged Louisine Havemeyer to buy, Ingres's *Joseph-Antoine Moltedo* (now The Metropolitan Museum of Art, 29.100.23). From extant documents we can only presume that she "advised the Metropolitan Museum of Art to buy" the portrait of Pastoret, as this is what she told the dealer Réne Gimpel on March 20.[30] Yet, in the end, Cassatt's advice—whether received too late or not at all, or ignored—perhaps mattered less than her indiscretions. No doubt these had an impact on the animated bidding for the portraits of M. and Mme Leblanc at auction.

It is perhaps only natural that once Cassatt had been asked for her opinion on these acquisitions she would start

mulling over other works she felt "the Museum would do well to acquire."[31] Her thoughts immediately turned to the paintings by Degas that would be offered at the first atelier sale in May. She had two in mind. One was Degas's *The Steeplechase* (L 140; fig. 361), a painting that Cassatt had wanted to buy for her brother years before. Because there were certain passages that appeared "unfinished" or "washed out,"[32] Degas had instead held on to it, endeavored to rework it, and in the process "spoiled" it.[33] As Cassatt confided to Durand-Ruel, she would have counseled the Museum "to buy the great painting of horses, if it weren't so destroyed. My recollection is that the large strokes that [Degas] added to it make it impossible for the Museum."[34] Hence she abandoned the idea. The other possible acquisition, which she did recommend—first to Louisine Havemeyer, then to the Metropolitan—seemed a more viable and even a more desirable one, namely, *Family Portrait (The Bellelli Family)* (figs. 362, 90). Cassatt wasted no time. After first broaching the subject on February 29, she took it upon herself in mid-March to obtain an estimate from Durand-Ruel. The dealer found it "difficult,"

Fig. 365. Edgar Degas, *Woman in a Ruffled Cap,* 1859–60. Etching, first state, 4½ × 3⅜ in. (11.5 × 8.5 cm). National Gallery of Art, Washington, D.C., Rosenwald Collection (1952.8.225). Impression of the print sold in Atelier Print Sale: 5

nearly "impossible to say," owing to the large scale of the picture, the potential interest the French government might have in this important and impressive early work, and the conflicting wishes of Degas's heirs. Notwithstanding, Durand-Ruel came up with a figure of at least 300,000 francs, but added, "it is possible that this price could double if a number of foreigners really want it, which I think is probable."[35] (How might he have gotten that idea?)

It was not until after the Museum had acquired the Ingres portraits of M. and Mme Leblanc at the collection sale on March 26 that Bryson Burroughs was able to focus on *Family Portrait,* which would not come up for sale until early May. Trying to follow up on Cassatt's recommendation seems not to have been easy. The catalogue for the May atelier sale was not available in New York (as noted, it did not arrive until after the sale). On April 14, however, the local branch of Durand-Ruel was able to let Burroughs borrow their copy of *Les Arts,* which, he was told, "has reproductions of a few Degas, including the one you were so interested in, 'Portrait de famille.'"[36] The impression

made by Burroughs's first glimpse of this picture, even in reproduction, seems to have been immediate and profound. A week later he called for a special meeting of the Committee on Purchases to consider acquiring the painting. On May 3 the meeting was held and funds were approved for the purchase of *Family Portrait.* Unbeknownst to the Metropolitan, the Louvre had bought the picture the day before.[37]

On the heels of these missed opportunities—from the loss to the Louvre of *Family Portrait* to the late arrival in New York of the sale catalogue, which precluded consideration of other pictures by Degas in the May sale—Bryson Burroughs sat down that summer to write a piece for the Museum's *Bulletin* entitled "Nineteenth-Century French Painting." His remarks on Degas resonate with his newly won insight into the artist's habits as a collector and conclude with a note on all that was lost: "Degas represents the same fusion of classic and realist principles [as Corot]. His power of drawing and his sense of order are equal if not superior to Ingres, and he is far more sensitive and impressionable. His pictures (the novel arrangements seem to have been inspired by the Japanese prints) have a reality that equals Manet. His caustic outlook on life has a precedent in Daumier's pictures of manners. He is the most cultivated and intellectual artist of the century. The Museum owns no work by him. . . ."[38]

This situation changed at the end of the year, but not without another upset along the way. A week before the Degas print sale of November 22–23 was to take place, the recommendations of William B. Ivins, the curator of prints, were cabled to the dealer Jacques Seligmann, who was to bid for the Museum. But "the cables never reached Paris, therefore the opportunity to secure prints was lost."[39] Among the works Seligmann had been asked to bid on were Degas's etching *Édouard Manet Seated, Turned to the Right* ("lot 21," which included five proofs of the print's fourth state; fig. 363), a *Self-Portrait* (either "lot 3 or 3bis"; fig. 364), and one of the impressions of *Woman in a Ruffled Cap* ("one of numbers 4–7," which offered various states of the print identified in the catalogue as "Aged Woman [the artist's mother?]"; fig. 365). These recommendations were made conditionally—"unless you consider [them] inadvisable"—and it was also left to Seligmann's discretion to choose "any other engraving or lithograph you favor" as long as the total expenditure did not exceed the allotted sum.[40] Since the cable never reached Paris, the Museum did not acquire its first prints by Degas until the following year.[41]

The Museum's faith in Seligmann's judgment was richly rewarded, however, when, at the second Degas atelier sale on December 11–13, the Museum finally acquired its first

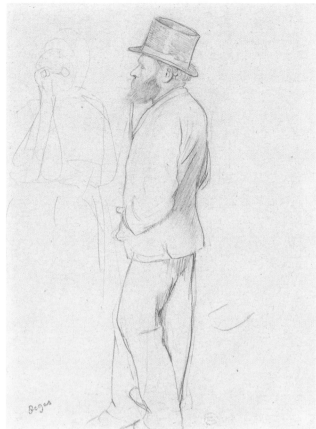

Fig. 366 (above left). Edgar Degas, *Édouard Manet Seated,* ca. 1866–68. Graphite on faded pink paper, 14⅛ × 11 in. (35.9 × 27.9 cm). The Metropolitan Museum of Art, New York, Rogers Fund, 1918 (19.51.6). Atelier Sale II: 210.1

Fig. 367 (above). Edgar Degas, *Manet at the Races,* ca. 1866. Graphite on light brown paper, 12⅝ × 9⅝ in. (32.1 × 24.4 cm). The Metropolitan Museum of Art, New York, Rogers Fund, 1918 (19.51.8). Atelier Sale II: 210.3

Fig. 368 (left). Edgar Degas, *Édouard Manet Seated,* ca. 1866–68. Black chalk and estompe, 13 × 9 in. (33.1 × 23 cm). The Metropolitan Museum of Art, New York, Rogers Fund, 1918 (19.51.7)m. Atelier Sale II: 210.2

works by Degas: ten handsome portrait and figure drawings in pencil, charcoal, and pastel. A month before the sale, Burroughs had drafted a list of recommended purchases. He was quick to note that his list was provisional: the items (which he had designated by lot number) were "those we were particularly interested in . . . but beyond this indication, I would suggest we rely on the judgment of the bidder."[42] The Museum was not averse to receiving recommendations from abroad or to altering its selection accordingly, since, as George Blumenthal noted in his letter to Seligmann of November 21, 1918, "we have only the catalogue to go by."[43] The dealer whose judicious eye and keen knowledge of drawings had made him a respected adviser to collectors like Blumenthal and J. Pierpont Morgan was given considerable latitude in selecting draw-

Fig. 369. Edgar Degas, *Study for "Edmond Duranty,"* 1879. Black chalk, heightened with white chalk, on faded blue laid paper, 12⅛ × 18⅝ in. (30. 8 × 47.3 cm). The Metropolitan Museum of Art, New York, Rogers Fund, 1918 (19.51.9a). Atelier Sale II: 242.2

ings from the Degas sale for the Metropolitan Museum. Seligmann was asked to buy drawings "at prices which you consider not excessive, and provided, upon examination, you find they are worth buying. . . . It is quite easily possible that the [works chosen] will not absorb the total amount [allotted]," and should he "consider any other numbers in the sale particularly desirable for the Museum," he was authorized to "include them in [his] purchase."[44]

Over the next month, Burroughs and Blumenthal at the Metropolitan and Seligmann in Paris corresponded on the subject. In the process, the list of recommended purchases went through various permutations that brought it further away from, and then closer to, Burroughs's original draft.[45] In the first go-round, only two of the six lots that Burroughs had designated—the three portrait drawings of Manet (figs. 366–368) and the studies for the portrait *Edmond Duranty* (figs. 369, 370)—made it on the list suggested by Blumenthal in consultation with Seligmann.[46] There were no studies of bathers, though Burroughs's list had included three (L 1008, L 892, and Atelier Sale II: 316); there were instead two drawings of horses (Atelier Sale II: 236.1–2). There were welcome additions, such as the arrestingly beautiful *Violinist* (fig. 371), and also some not very welcome substitutes. Though Burroughs raised no objections to seeing a pastel, *Woman in a Pink Hat* (*Madame Dietz-Monnin*, L 535) replaced by two others of equal charm—*Madame Lisle* and *Madame Loubens* (figs. 372, 373)—or to the inclusion of two supple pencil studies for *Portrait of a Woman* (Atelier Sale II: 241.1–2), he was "sorry to give up" the three preparatory

Fig. 370. Edgar Degas, *Study of Bookshelves for "Edmond Duranty,"* 1879. Charcoal, heightened with white chalk, on faded blue paper, 18½ × 12 in. (46.9 × 30.5 cm). The Metropolitan Museum of Art, New York, Rogers Fund, 1918 (19.51.9b). Atelier Sale II: 242.1

Fig. 371. Edgar Degas, *Violinist, Study for "The Dance Lesson,"* ca. 1878–79. Charcoal and pastel on green paper, squared for transfer, 15⅜ × 11¾ in. (39.2 × 29.8 cm). L 451. The Metropolitan Museum of Art, New York, Rogers Fund, 1918 (19.51.1). Atelier Sale II: 171

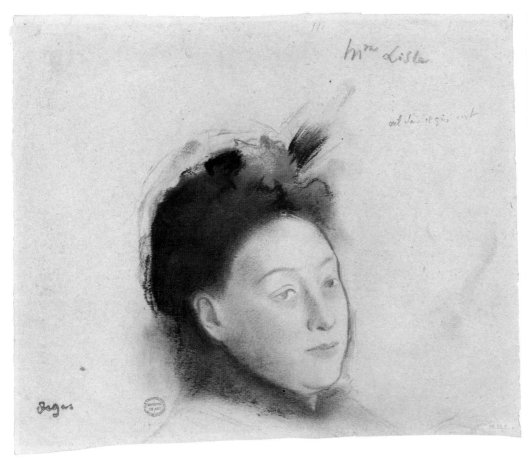

studies for the portrait *Victoria Dubourg* (Atelier Sale II: 239.1–3). He felt they would be "very valuable to students" and was "inclined to prefer" them "in the catalogue reproduction" to the female portrait studies listed instead.[47] These studies were reinstated and, along with other additions and substitutions, were on the last list cabled to Seligmann on December 4 naming drawings he was asked "to buy at the Degas sale provided you consider them good enough for the Museum."[48] Seligmann bid successfully on five lots at the December 11–13 sale, and the Museum acquired its first ten drawings by Degas.

While there were some disappointments, among them the studies for *Victoria Dubourg* (now, private collection), which went to another bidder, there were also some happy and unexpected surprises: witness the acquisition of two striking charcoal studies of bathers (figs. 374, 375), one of which was quite close to the study of a nude drying herself that Burroughs had originally chosen from the catalogue (fig. 376). Ultimately the group of works turned out to be precisely the kind of drawings that Burroughs had desired for the collection, even if they were not—excepting the portrait studies of Manet and of Duranty—precisely those he had picked. The final selection reflected not only Burroughs's interest in portrait drawings of great documentary value and visual appeal but also his penchant for Degas's studies of bathers.

When the works arrived in mid-March 1919, Burroughs wrote Seligmann that he was "particularly delighted with the drawings which were added to our list at your suggestion,

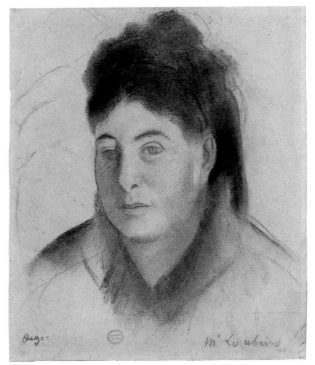

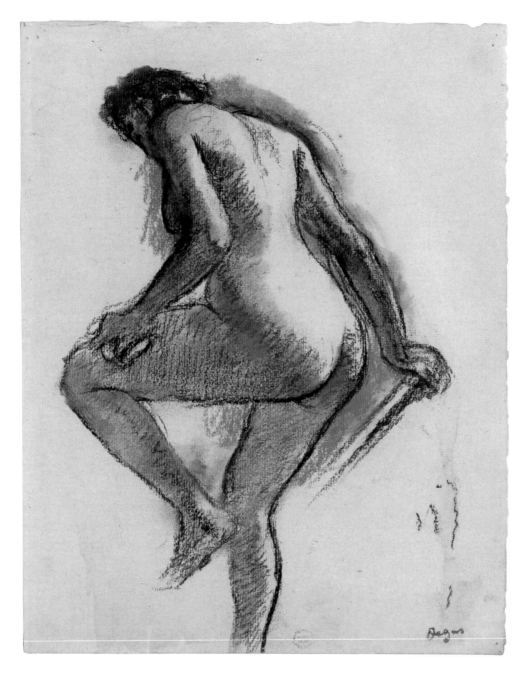

Fig. 374. Edgar Degas, *Standing Bather,* ca. 1883–84. Charcoal, pastel, and watercolor. 12⅛ × 9⅜ in. (30.8 × 23.8 cm). BR 112. The Metropolitan Museum of Art, New York, Rogers Fund, 1918 (19.51.3). Atelier Sale II: 222.2

namely the pastel of the Violinist and the two masterly drawings of women's heads. The illustrations of these gave but a poor idea of their importance. . . . We were fortunate to have had your help."[49] An even more telling indication of Burroughs's evaluation of the drawings and of their relative importance comes across in the article he wrote, "Drawings by Degas," for the Museum's *Bulletin* that May. In it he devotes a flattering phrase to *Violinist,* "a masterly and rapid pastel sketch in full color . . . evidently . . . made in preparation for one of his pictures of ballet girls practicing," and only mentions in passing the portraits *Madame Loubens* and *Madame Lisle.* Entire paragraphs and great enthusiasm were given over to the portrait studies of Manet and Duranty he had chosen and to the *Bather Drying Herself* (fig. 375), "one of a series of studies of the same position," of which "at least eight" were included in the

same sale "at which our works were bought."[50] For those who could read between the lines: one of the eight was the nude that Burroughs had originally selected for the collection.

In May 1919 the drawings were placed on view in the recent accessions room at the Museum. One critic called them a "special boon" to the collection and praised the "good judgment with which this group was formed . . . balanced in just the right way, so as to give a really comprehensive idea of the master's traits as a draftsman." After favorably remarking on all the works, he ended his *Tribune* article on precisely the same note that Burroughs began his in the Museum's *Bulletin:* "There ought to be a painting by Degas at the Metropolitan. While we are waiting for one, the drawings offer the best kind of consolation."[51] Two months later Louisine Havemeyer drafted the first codicil to her will, ensuring that what Burroughs had called the

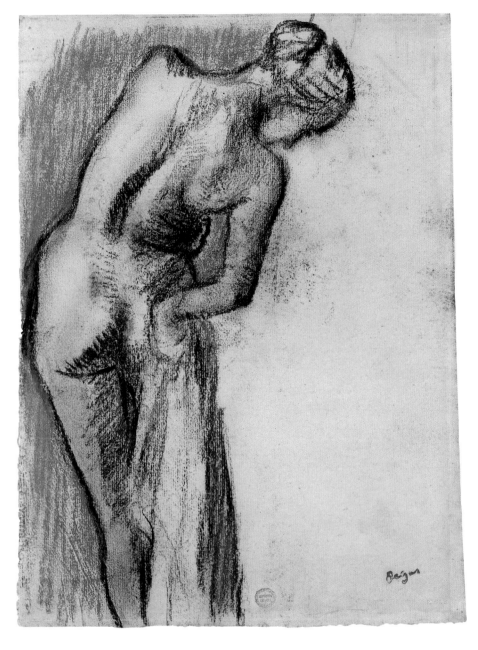

Fig. 375. Edgar Degas, *Bather Drying Herself,* ca. 1883–84. Charcoal and pastel, 12⅝ × 9¾ in. (32.1 × 24.8 cm). L 708. The Metropolitan Museum of Art, New York, Rogers Fund, 1918 (19.51.2). Atelier Sale II: 222.1

Fig. 376. Edgar Degas, *Bather Drying Herself.* Charcoal on tracing paper, 13¾ × 9 in. (35 × 23 cm). Location unknown. Atelier Sale II: 316

"most conspicuous lack in the Museum collection of modern pictures"[52] was only temporary and, given the windfall bequest that came in 1929, well worth the wait.[53]

The debut at the Museum in June 1919 of Ingres's portraits of M. and Mme Leblanc proved a more newsworthy item. Reporters found a story replete with wartime drama and even suspense, since the pictures, which had first been stored in Dordogne by Durand-Ruel, did not arrive for more than a year. As one journalist recounted: "Bought in Paris at the sale of the Degas collection in March 1918, while the shells of the last great German offensive were falling in the streets of the French capital, and stored there until the armistice removed the risk of transportation across the ocean, the celebrated portraits of M. and Mme Leblanc by Ingres have arrived safely in New York, to make their debut in the room of recent accessions at the Metropolitan Museum."[54] In the less-than-perfect setting of that room, the famous portraits by Ingres were hung alongside examples of "present-day portrait painting," a comparison that was apparently more "disastrous" to Anders Zorn's *Portrait of Edward Bacon* (19.112) than it was to the more conservative (less "flashy") *Portrait of Charles Foster* by Montague Flagg (19.114; deaccessioned and sold at auction in 1956).[55]

Eventually the Metropolitan's first portraits by Ingres were installed in more congenial surroundings, where they filled a long-lamented lacuna in the Museum's representation of French nineteenth-century painting. For Burroughs it was a story with a happy ending. "It is pleasant," he wrote, "to think that our pictures belonged to so great an artist as Degas, and that he treasured them as he did—more so than any of his belongings, as a matter of fact.

One can guess how they inspired him, and cheered the times 'when his thoughts were heavy upon him.' Theirs is a proud history! And now, after their stay in the dusty studio at Montmartre, they find their resting place in our museum, as ready here as there to charm, to teach, to console. Truly a work of art is like the never-emptied magic pitcher of the fairy-tale, from which all the travelers drank their fill as often as they pleased."[56]

Appendix

The following are notes on and excerpts from the unpublished correspondence between Bryson Burroughs and Robert Dell apropos of a visit to Degas's studio in 1909.[57]

Bryson Burroughs's visit to Degas's studio, in the company of Roger Fry and Robert Dell, seems to have taken place in September 1909, at Fry's initiative. On this occasion, as has been documented elsewhere, Fry presented Degas with a copy of Robert Ross's book *Masques and Phrases* and found the artist "as witty in his way" as the author.[58] Fry later recalled that while he had seen various pictures by other artists in Degas's collection he had only a vague memory of them, as it was "a visit occupied mainly in the study of Degas's own works."[59] Through Dell, a British journalist who had two years earlier moved to Paris as the foreign correspondent for *Burlington Magazine* and become a picture dealer, the Museum acquired two paintings in 1909: a tondo by Lorenzo di Credi (09.197) and *Don Quixote and the Dead Mule* by Daumier (09.198). Dell did not have the same success with any of the paintings he tried to sell to the Museum on Degas's behalf, including the one that Degas had actually wanted to sell.

The letters between Burroughs and Dell are revealing on several counts, though they do not identify the subject of the proposed painting by Degas (a photograph was made and perhaps sent to New York but was long ago lost or discarded). However, we do have some tantalizing clues. Two facts—the dimensions (85 × 146 cm) and Degas's ownership of the painting in 1909—seem to narrow the choice to two very different works. We learn that Degas was eager to sell this "important" painting to the Metropolitan for 100,000 francs ($20,000), that he would "not hear of" offering it to the Musée du Luxembourg, despite a French curator's interest, and that he refused to lend it to an exhibition of French paintings at Brighton. The picture had appealed to Burroughs (and Fry) enough to consider it, but there were reservations about its viability as an acqui-

sition, especially at Degas's asking price, and it was not proposed.

Of the two candidates for the identity of this picture, perhaps the most likely is the odd, allegorical history painting that Degas exhibited in the Salon of 1865, *Scene of War in the Middle Ages* (also erroneously known as *The Misfortunes of the City of Orléans*), which was purchased at the first atelier sale in May 1918 by the Musée du Luxembourg and is now in the Musée d'Orsay (fig. 358). The dimensions, the importance, and the subsequent provenance of the work seem a perfect match. Degas's willingness to sell it accords with Henri Loyrette's observation that Degas seems not to have been particularly fond of this picture (although he had held on to it for decades).[60] No doubt the matte finish and muted tonality of this allegory, reminiscent of Pierre Puvis de Chavannes, would have appealed to Burroughs (who was himself an artist, in the manner of Puvis), while its unusual and violent subject matter—so uncharacteristic of the still-unrepresented "painter of dancers"—surely would not have won success with the Committee on Purchases. The other painting that Degas might have been willing to part with is one of the late dancers of the type so admired by Roger Fry. This was the bold, vibrantly colored *Two Dancers in Green Skirts* of 1894–99, of roughly the same size (albeit with the dimensions reversed), which was also sold from the artist's estate in May 1918 and is now in a private collection (L 1195).

Dell first mentions the painting in question in a letter to Burroughs dated October 6, 1909:

I have also got a price in dollars for the picture by Degas, which is lower than the price given in my letter to Fry. I have done this by the simple process of consenting to reduce my commission, as I very much want the museum to have the picture; it will never find such another. The price of this picture is now $22,500. [Since the lower price was a result of Dell reducing his commission, probably from the usual 5 percent to 2½ percent, the asking price must have been 100,000 francs ($20,000).] The size of the picture is 0 m. 85 × 1 m. 46 (i.e., about 34 × 48 inches). The photograph was successfully taken yesterday & I will send you a print as soon as I have one. You will find that one part of the picture is darker than the rest on account of the lighting of the studio where it was taken, but I think that the photograph will give a sufficient idea.

On October 29 Dell informs Burroughs:

The great man D. is also rather impatient, quite unreasonably so, as you have not had much time yet. I hope you can pull the matter through.

Burroughs replies on November 9:

> I am afraid the Degas is out of the question. We have not that amount available and the price is considered too high. I think the price is high also, but admire the picture enormously and regret that there is no chance of its purchase.

Apparently their letters cross in the mail, for on November 10, Dell writes:

> I hope, for its own sake, that the Museum will get the Degas; it is such a fine picture.

On November 18 Dell, who had just received Burroughs's letter, replies:

> I gather from what you say in your letter . . . that the museum has not bought [the Degas]; I am sorry, but not surprised, as I feared that it would be so after what you and Fry said when you were here. I have not told Degas yet, in case the matter should not be finally settled and there should be any question, for instance, of trying to get the picture at a lower price. I fear that it would be of no use to try, but nevertheless I do not wish to speak to Degas until I know for certain what the situation is. I told him last time I saw him that I expected a decision next week. I think that there will be no difficulty in selling the picture here, if Degas will consent to sell it to a private person, which is by no means certain. He was in bed with influenza when I saw him last week and was very depressed, poor man; he would hardly speak at all. I am afraid that he will not live long; he seems quite broken down, physically and morally.

Then on December 9:

> I have seen Degas, who is in much better health but still extremely depressed. He was very sad when he heard that the museum had not bought his picture, and at first rather angry, but he soon got over that. I reminded him that you had told him explicitly that you were not authorised to buy without consulting the committee and that it was for that reason that the picture was photographed. I want him to propose it to the Luxembourg, but he will not hear of it. I am sure that Bénédite [Léonce Bénédite, curator, Musée du Luxembourg] would do his utmost to buy it. I showed the photograph in confidence to [Camille] Benoît of the Louvre who was most enthusiastic about it and wanted to speak to Bénédite at once, but I told him that I could not let him do so without Degas' permission. . . . I am on the track of another painting by

Degas, which belongs to a private person here; I have not see[n] it yet.

On December 17 Dell reports, "I saw Degas again on Monday; he was in better spirits and was most amiable." On the 29th Burroughs asks him for a photograph "of the other Degas." Dell writes to Burroughs on December 31 about the portraits by Ingres (see essay above), and two weeks later returns to the subject of the "other Degas," writing on January 14, 1910:

> The Degas of which I heard turned out to be of no use; it was not a picture for the museum and the owner, a private person, asked 80,000 francs for it; a price relatively far higher than that which Degas asked for the picture that you saw, which is far more important. The people who own paintings by Degas cannot be persuaded to sell. If you could buy a pastel, you would have a much better choice. However I may find something sooner or later, but I fear that, if it is very good, it will also be dear.

Burroughs replies on January 29:

> The particular fund out of which we could most easily purchase a Degas is for oil paintings only, but if you find a good pastel at a favorable price I might urge them to buy it out of another fund.

Dell notes on February 21 that he is "taking steps to find a pastel by Degas." A couple of days later, apropos of another visit to Degas, Dell proposes a new picture, the portrait *Edmond Duranty* (which was sold in the first atelier sale in May 1918 and is now in The Burrell Collection, Glasgow; fig. 287), in a letter to Burroughs on February 25:

> I saw Degas a day or two ago. He still has in his studio that superb pastel, the portrait of Duranti [*sic*] sitting in his library with the book-cases forming the background of the picture. You will remember this pastel and, if you think it at all likely to suit the museum, I will see what I can do with Degas; but it will be very difficult to induce him to allow it to be photographed. He has other pastels in his studio but most of them, according to him, are unfinished. He is a strange person; I asked him to lend the picture that we proposed to the museum for the exhibition at Brighton ["Work of Modern French Artists," June 10–August 31, 1910, Public Art Galleries] and he refused on the ground that he objects to exhibitions. I have just heard that there is an important painting by Degas for sale; if this turns out to be the case, it will be better to see about that before looking for a pastel. I shall have further particulars shortly.

Burroughs replies on March 10:

I believe I explained to you the difficulties we have in regard to the purchase of pastels. Should you find a good one by Degas at a favorable price please write me about it and I will see what can be done. The Duranti [*sic*] is a magnificent picture, but the one we buy should be to my mind, one of his figure subjects, having his characteristic qualities.

The last letter in this series comes from Dell on March 30:

I will let you know at once if I can find anything by Degas, either a painting or a pastel, but his things are very scarce and their prices are becoming terrible. I heard of one rather large pastel, but it was only a single figure and the owner demanded 80,000 frs. for it, which is quite outrageous, so I left it.

In these notes, the abbreviation MMA stands for The Metropolitan Museum of Art, New York.

1. Louisine Havemeyer bought only one picture, Mary Cassatt's *Girl Arranging Her Hair* (now, National Gallery of Art, Washington, D.C., Chester Dale Collection), from the first Degas collection sale in March 1918; Joseph Durand-Ruel bid on her behalf. No doubt the dealer, whose frustration is recorded in correspondence, had expected Mrs. Havemeyer to be a more active buyer at the sales, but she was preoccupied at the time with the woman suffrage movement (letter from Joseph Durand-Ruel to Mary Cassatt, February 18, 1918, and letter from Cassatt to Durand-Ruel, February 21, 1918; transcripts in Weitzenhoffer files, Department of European Paintings, MMA). Robert Sterling Clark, a newlywed living in Paris at the time of the Degas sales, bought an eclectic mix of drawings by Delacroix, Raffet, and others from the second sale of the collection in November 1918, and he bought some seventeen drawings by Degas from the fourth atelier sale in July 1919, later regretting "that [he] did not buy more" (David S. Brooke, "A Passion for Drawings," in *Master Drawings: Sterling and Francine Clark as Collectors*, exh. cat., Williamstown, Mass., Sterling and Francine Clark Art Institute [Williamstown, Mass., 1995], p. 11). Mrs. Gardner acquired several drawings by Degas (out of the eleven items she had instructed her agent Fernand Robert to buy) from the July 1919 atelier sale (Philip Hendy, *European and American Paintings in the Isabella Stewart Gardner Museum* [Boston, 1974], p. 76). M. Knoedler and Co., New York, had one or two American clients interested in works being offered in the March 1918 Degas collection sale, including Cleveland collector Ralph M. Coe; either Coe or another client asked the firm to obtain estimates and advice on works by Ingres, though it is not clear whether bids were actually placed (unpublished archives, Knoedler and Co., New York, Letterbook, 1917–21). It should be noted that dealers bought heavily and in consortiums to ensure that American collectors would have ample opportunities to buy works from the Degas sales after the war. These later purchases (as opposed to purchases made directly from the sales) account for the large number of works from the artist's estate that are now in American private and public collections.

2. Burroughs 1919, p. 115.

3. "Recommendation for Purchase" papers submitted by Burroughs on March 12, 1909, in which he again proposed the acquisition of the Degas. MMA Archives. According to minutes of the meeting of the Committee on Purchases, December 13, 1906, the Ingres was offered by Louis Ehrich, a name that does not appear in the provenance entries in Wildenstein 1954, the Ingres catalogue raisonné. In 1906, the painting by Degas was recorded in the acquisition proposal papers and in the minutes of the meeting of the Committee on Purchases as *Café Chantant* and in 1909 as *Café Chantant (Les Musiciens à l'orchestre)*. Of the paintings listed in the stockbooks of the New York branch of Durand-Ruel, the *Orchestra Musicians* (L 295), now in Frankfurt, seems to be the only likely candidate for the picture proposed as an acquisition. It was with Durand-Ruel, New York, from December 1899 until February 1910, with an asking price that accords with the figures documented in the Museum's papers. For the provenance of the Frankfurt picture, see Paris, Ottawa, New York 1988–89a, no. 98, p. 164.

4. R. E. F. [Roger E. Fry], "Drawings," *Metropolitan Museum of Art Bulletin* 2, no. 12 (December 1907), p. 202.

5. Letter from Bryson Burroughs to Joseph Durand-Ruel, March 17, 1909. MMA Archives.

6. Letter from Bryson Burroughs to Robert Dell, June 21, 1911. MMA Archives. According to the stockbooks of Durand-Ruel, New York, the painting now in New Haven (L 1107) was transferred to the New York branch of the firm in February 1910 and returned to Durand-Ruel, Paris, in December 1912. These dates make it likely that the New Haven picture was the work presented and declined as an acquisition in 1911. Durand-Ruel's hopes of finding an American buyer for this picture were quashed not once but twice: after the Museum failed to purchase *Foyer de la danse,* it was bought in April 1912 by Albert C. Barnes, who sold it back to the gallery that October.

7. Nor had Fry ended up proposing all the pictures he had considered, including one by Degas that he had taken J. Pierpont Morgan to see at Durand-Ruel's in Paris in June 1906 and that both had felt would be too objectionable, "in spite of its beauty." See Denys Sutton, ed., *Letters of Roger Fry,* 2 vols. (New York, 1972), vol. 1, p. 266, letter from Fry to A. F. Jaccaci, June 18, 1906. Sutton suggests that this picture was Degas's *Interior* (also called *The Rape*), now in the Philadelphia Museum of Art (fig. 94).

8. Letter from Robert Dell to Bryson Burroughs, January 14, 1910. MMA Archives. This and other letters on the subject of Degas pastels are excerpted in the Appendix to this essay. In 1887 Catharine Lorillard Wolfe bequeathed to the Metropolitan Museum her sizable collection of nineteenth-century paintings and a fund to be used for the conservation and purchase of "modern oil paintings" that would enhance the collection.

9. Letters from Robert Dell to Bryson Burroughs, January 14 and March 30, 1910. MMA Archives (see Appendix).

10. Letter from Bryson Burroughs to Robert Dell, July 4, 1911. MMA Archives.

11. Letter from Bryson Burroughs to Robert Dell, June 21, 1911. MMA Archives. Among the portraits by Ingres that dealers brought to Burroughs's attention during the period 1909–11 were the *Portrait of Madame Ingres* (acquired by Lapauze in 1910, now, private collection; Wildenstein 1954, no. 107), and a *Portrait of Madame Séraphine,* signed and dated 1854, owned by Frank Chaveau, which Burroughs felt was either "perfunctory" or of doubtful authenticity (per a letter to Robert Dell of November 21, 1911); it does not appear in Wildenstein 1954.

12. Letter from Bryson Burroughs to Robert Dell, November 21, 1911. MMA Archives.

13. In the interim, no further acquisition proposals were made for portraits by Ingres, and the only work by Degas that was proposed was a drawing of "Ballet Girls," from M. Knoedler and Co. Burroughs submitted this proposal in 1915 at the behest of trustee and American artist J. Alden Weir. It was not approved.

14. Letter from Robert Dell to Bryson Burroughs, December 31, 1909. MMA Archives.

15. In the "Recommendation for Purchase" papers that Burroughs submitted to the Director and Committee on Purchases on February 18, 1918, he wrote: "I wish to propose for purchase one or more paintings by Ingres (Degas sale). . . ." MMA Archives.

16. On this subject and for quoted passages in the discussion that follows, see Appendix.

17. Letter from Bryson Burroughs to George Blumenthal, February 20, 1918. MMA Archives.

18. Ibid.

19. Cable from Mary Cassatt, February 25, 1918. MMA Archives.

20. Burroughs's undated, handwritten notes are preserved in the Paintings files of the Department of European Paintings, MMA.

21. Minutes of the committee meetings held on March 5 and March 18, 1918. MMA Archives.

22. Minutes of the meeting of the Committee on Purchases of the Trustees of the Metropolitan Museum, April 22, 1918. MMA Archives.

23. The following year, at the sale of the François Flameng collection (Galerie Georges Petit, Paris, May 26–27, 1919), the Museum acquired two exceptionally fine drawings by Ingres: a *Portrait of a Man* (19.125.1) and *Three Studies for a Male Nude* (19.125.2). In the fall of 1918 Burroughs tried to acquire an "Odalisque" as well, proposing on October 20, 1918, the purchase of Ingres's oil painting *Odalisque and the Slave* (now, Walters Art Gallery, Baltimore; Wildenstein 1954, no. 237). It was not approved by the Committee on Purchases, "in consideration of present financial conditions." Twenty years later he finally succeeded in making up for the lost "Odalisque" with the purchase of the *Odalisque in Grisaille* (39.65, now considered Ingres and Workshop) in 1938.

24. Degas may have shared Cassatt's preference for the portrait of M. Leblanc; see the Appendix to Theodore Reff's essay in this volume.

25. Cable from Joseph Durand-Ruel to Mary Cassatt, February 22, 1918. Transcript in Weitzenhoffer files, Department of European Paintings, MMA.

26. Ibid.

27. Letter from Mary Cassatt to Joseph Durand-Ruel, February 29, 1918. Transcript in Weitzenhoffer files, Department of European Paintings, MMA.

28. Cable from Mary Cassatt to Joseph Durand-Ruel, March 17, 1918. Transcript in Weitzenhoffer files. Department of European Paintings, MMA.

29. Letter from Joseph Durand-Ruel to Mary Cassatt, March 18, 1918. Transcript in Weitzenhoffer files, Department of European Paintings, MMA.

30. Gimpel 1966, p. 11 (diary entry of March 20, 1918).

31. Letter from Mary Cassatt to Joseph Durand-Ruel, February 29, 1918. Transcript in Weitzenhoffer files, Department of European Paintings, MMA.

32. Letter from the artist's mother, Katherine Cassatt, to her brother Alexander Cassatt, December 10, 1880; quoted in Mathews 1984, pp. 154–55.

33. Letter from Mary Cassatt to Louisine Havemeyer, September 22, [1918]. MMA Archives. Quoted at length in this catalogue by Gary Tinterow and discussed by him in Paris, Ottawa, New York 1988–89a, p. 563.

34. Letter from Mary Cassatt to Joseph Durand-Ruel, March 13, 1918. Transcript in Weitzenhoffer files, Department of European Paintings, MMA.

35. Letter from Joseph Durand-Ruel to Mary Cassatt, March 13, 1918. Transcript in Weitzenhoffer files, Department of European Paintings, MMA.

36. Letter from W. H. Holston (of Durand-Ruel) to Bryson Burroughs, April 14, 1918. MMA Archives. The painting was reproduced on page 3 of *Les Arts* 14, no. 166 (1918), an issue that also included Arsène Alexandre's article "Essai sur Monsieur Degas," excerpted in this volume; see Rebecca A. Rabinow's compilation of reviews and articles.

37. According to documents in the MMA Archives, the special meeting of the Committee on Purchases of May 3, 1918, was "called for" by Burroughs on April 22, 1918.

38. B. B. [Bryson Burroughs], "Nineteenth-Century French Painting," *Metropolitan Museum of Art Bulletin* 13, no. 8 (August 1918), p. 180.

39. This turn of events was reported to the Committee on Purchases on February 17, 1919, according to a notation on the "Recommendation for Purchase" papers submitted by William B. Ivins on November 13, 1918. MMA Archives.

40. This (lost) cable was sent to Seligmann on November 15, 1918. MMA Archives.

41. The Museum purchased its first three Degas prints from M. Knoedler and Co., New York, in March 1919: an etching, *Joseph Tourny* (19.29.1, which was subsequently returned and exchanged for a different print; the subject is represented in the collection by two other impressions); a

softground etching and aquatint, *Mary Cassatt at the Louvre* (19.29.2); and a lithograph, *Mademoiselle Bécat at the Café des Ambassadeurs* (19.29.3).

42. "Recommendation for Purchase" papers submitted by Burroughs on November 13, 1918. MMA Archives.

43. Letter from George Blumenthal to Jacques Seligmann, November 21, 1918, marked "Confidential." MMA Archives.

44. Ibid.

45. Burroughs had originally, on November 13, 1918, listed the following drawings as those "we are particularly interested in": lot nos. 88, 210, 212, 239, 242, 316. MMA Archives.

46. Letter from Bryson Burroughs to George Blumenthal, November 18, 1918, includes this list of suggested works: lot nos. 171, 210, 236, 237, 241, 242. MMA Archives.

47. Ibid.

48. Cable from George Blumenthal to Jacques Seligmann, December 4, 1918, regarding lot nos. 171, 210, 236, 237, 239, 241, 242. MMA Archives.

49. Letter from Bryson Burroughs to Jacques Seligmann, March 13, 1919. MMA Archives.

50. Burroughs 1919, pp. 115, 117.

51. Newspaper clipping, *Tribune*, May 25, 1919. MMA Archives.

52. Burroughs 1919, p. 115.

53. The drawings that the Museum bought from the Degas sale in 1918 tend to complement rather than duplicate the many examples that later came from the Havemeyer collection. This seems more a matter of chance than design.

 Louisine Havemeyer drafted the first codicil to her will on July 24, 1919, designating six paintings and seven drawings by Degas for The Metropolitan Museum of Art. She added two paintings in a second codicil of June 26, 1922 (see Frances Weitzenhoffer, *The Havemeyers: Impressionism Comes to America* [New York, 1986], pp. 254–57), but her intentions seem to have been kept secret. Otherwise, it is hard to understand, given limited acquisition funds and the other considerable gaps in the collections, the continued efforts to acquire a Degas painting. In 1927, the Museum authorized the purchase of and placed a bid on Degas's great double portrait *Monsieur and Madame Edmondo Morbilli* of about 1865 (Museum of Fine Arts, Boston; fig. 91), which was included as lot no. 71 in the 1927 sale of works from the estate of the artist's brother René de Gas (Hôtel Drouot, Paris, November 10, 1927). On advice received from abroad, the bid was withdrawn at the last minute (and was too low in any event to have secured the picture). In 1928 Burroughs made what would be his last attempt to acquire a painting by Degas when on November 15 he proposed to the Director and the Committee on Purchases the acquisition of *Aux Courses, avant le départ* from Durand-Ruel. In recommending the purchase, Burroughs wrote: "This is as fine as any race horse picture by Degas. Only on one other occasion in the last ten years has a Degas of equal importance, the family portrait now in the Luxembourg, come on the market. Nothing is more needed in the collection than a fine Degas. We are justly criticized on this account." The purchase was not authorized; it was a question of money. MMA Archives.

54. "Ingres' Leblancs Reach New York," *Christian Science Monitor,* June 30, 1919.

55. Ibid.

56. B. B. [Bryson Burroughs], "Portraits of M. and Mme. Leblanc by Ingres," *Metropolitan Museum of Art Bulletin* 14, no. 6 (June 1919), p. 134.

57. This correspondence, preserved in the MMA's Archives, was fortuitously discovered in the course of researching the present essay. The letters had long ago been filed away with sundry other offers from dealers that had not been proposed or authorized as acquisitions. I am grateful to Museum archivist Jeanie James for bringing the "XP files" to my attention.

58. See Sutton, ed., *Letters of Roger Fry,* vol. 1, p. 326, letter from Roger Fry to Robert Ross, October 12, 1909, no. 273.

59. Fry 1918, p. 118, reprinted in this catalogue: see Rebecca A. Rabinow's compilation of reviews and articles.

60. Henri Loyrette in Paris, Ottawa, New York 1988–89a, p. 105.

Fig. 377. Honoré Daumier, *Collectors at the Salle Drouot.* Pen and brown ink and wash, 4⅛ × 4⅞ in. (10.5 × 12.4 cm). Museum of Art, Rhode Island School of Design, Providence, Gift of Mrs. Gustav Radeke. Collection Sale I: 107

"The Most Talked-about Sale of the Season": Critical Reaction to the Degas Collection Sales

REBECCA A. RABINOW

During Edgar Degas's lifetime, few people realized the extent of his passion for collecting. There were occasional published references to works he owned, but it was the reviews of the 1918 Degas collection sales that offered an interested public its first opportunity to learn about the pictures with which the famous artist had surrounded himself. Reports of the sales, both French and foreign, provide insight into contemporary attitudes regarding Degas's collection and the impact of the war on its dispersal. It was commonly believed that the discovery of Degas's collection helped illuminate and better explain both the artist and his art.

The first accounts of Degas's collection appeared just days after the artist's death on September 27, 1917. The French art review *Le Cousin Pons* reported in an obituary that Degas "had assembled a magnificent collection of paintings, pastels and drawings during his lifetime. . . . If this collection is put up for sale, we hope that our major museums, particularly the Louvre, will recognize their duty and purchase almost all of these beautiful works, carefully gathered together by such a great artist."[1]

Within several months, news of Degas's collection had crossed the Atlantic. In February 1918 the savvy art critic of the *New York Tribune*, Royal Cortissoz, devoted a full-page article to it, liberally illustrated with images by Camille Corot (fig. 378), J.-A.-D. Ingres, Eugène Delacroix, Jean-Louis Forain, Édouard Manet, and Auguste Renoir.[2] Cortissoz explained to his American readers that a familiarity with Degas's collection would allow them "to reconstruct something of the artist's inner life and get that much closer to the secret of his genius." "It is not too much to say," the author asserted, "that the public exhibition of no collection of our time has been awaited with a tithe of the curiosity excited by the '*Collection particulière E. Degas.*'"

Two weeks later, *American Art News* printed its own illustrated preview of the sale: "The coming [Degas collection] sale . . . will bring on the market a number of pictures and drawings that will be eagerly fought for by collectors who have known of their fine and rare quality, and whose possession by Degas gives them, as it were, a hallmark. . . . The dispersing of this great artist's treasures, which so well evidences his taste, discernment, and knowledge, will be watched with the greatest interest by collectors the world over."[3]

Back in Paris, despite wartime paper rationing that limited the number of pages in French newspapers, the press made much of the first sale, scheduled for March 26 and 27, 1918. Announcements appeared in most of the local newspapers and art journals. On March 10 the *Écho de Paris* published the first of seven notices of the sale, which "so passionately interests all collectors of art." The Paris edition of the *New York Herald* began its multi-article coverage of the Degas collection sale, "one of the most important painting sales of the season," on March 12;[4] *Le Figaro*'s first announcement was published the following day. A week later its art correspondent, Valemont, reported, "The world of artists and art lovers is abuzz over this, and everyone is impatiently waiting for [the sale preview]."[5] *Le Temps* too promoted the Degas sale as "the big event of the season."[6]

The Degas collection sales were inextricably linked to the First World War. Paris was under heavy attack during the third week of March. Newspaper headlines trumpeted "Paris Just Laughs as Germans Again Bombard the City" and "Degas Collection Sold; Shelling of Paris Fails to Interfere with Art Sale."[7] That the Degas sale was temporarily halted during an air raid seems to have incited more amusement than fear in the audience. Because of this and because the pictures sold for such high prices, the Allied press asserted that the success of the first Degas collection sale was "convincing proof, if such were needed,

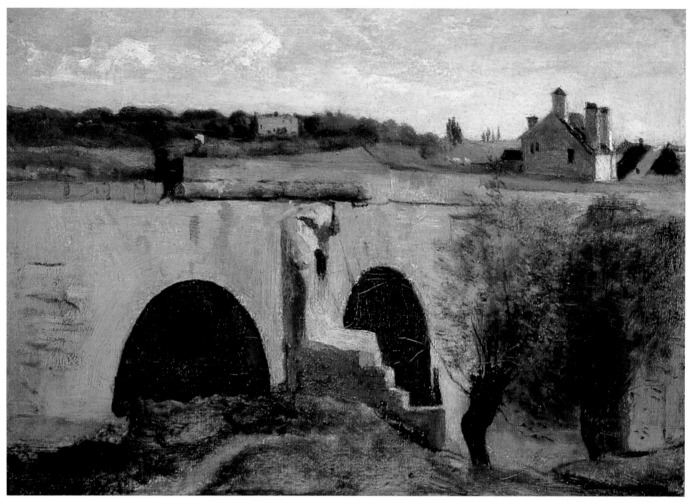

Fig. 378. Jean-Baptiste-Camille Corot, *The Limay Bridge, with the Château des Célestins*, 1855–60. Oil on canvas 9¼ × 13⅝ in. (23.5 × 34.5 cm). Oskar Reinhart Collection "Am Römerholz," Winterthur, Switzerland. Collection Sale I: 16

not only of the bravery and sang froid of the French, but of their devotion to art matters."[8] *Le Temps* specifically claimed the Degas collection sales as testimony to Parisian calm and serenity under fire, and *Le Figaro* reported that "despite everyone's preoccupations, the bids yielded results that show how much faith everyone has in our victory."[9] The widely read newspaper *L'Intransigeant* expressed the hope that the pictures purchased by foreigners had been acquired on behalf of Americans or other Allied collectors.[10]

Most reports contained expressions of surprise at just how elevated the final prices were. "Where do the dealers find all that money?" queried one critic.[11] The most talked about lots were portraits: Ingres's paintings of M. and Mme Leblanc (270,000 francs for the pair) and of the Marquis de Pastoret (90,000 francs), Delacroix's likeness of Louis-Auguste Schwiter (80,000 francs), and Manet's pastel of his wife (62,000 francs). Reporters delighted in citing examples of the paintings' appreciation in value. A favorite was El Greco's *Saint Ildefonso*, which the artist Jean-François Millet had once purchased for 20 francs and which sold at the Degas collection sale for 82,000.[12] Similarly, the correspondent of the London *Times* noted the "£640 given for

Paul Gauguin's 'Tahiti' and 'Martinique,' which 20 years ago were worth not more than £160."[13]

The substantial prices paid for the contemporary art Degas had owned elicited a mixed response. The reporter for *L'Intransigeant* joked that a forward-thinking millionaire could have organized a feast with offerings from the sale: "A ham (appetizing, for that matter) by Manet, 30,600 frs.; an apple and a glass by Sézanne [*sic*], 24,500 frs.; a selection of fruit by Van Gogh, 16,000 frs [fig. 379]. And to decorate the sumptuous table on which meals for billionaires are served, two sunflowers by Gauguin [actually by Vincent van Gogh], 19,200 frs."[14] Humor did not always feature in the reports, however, especially when it came to the prices paid for the Gauguins and the Van Goghs. One member of the French press referred to Degas's paintings by Gauguin as "sinister wares of the dealers" and as "maggots [that] sold for between 12,000 and 14,000 [francs]."[15] The *New York Herald*'s critic confessed to be "almost frighten[ed]" by the prices of the Van Goghs; the sums fetched by the Gauguins, he wrote, simply "defy common sense."[16]

German publications made light of the high bids. While contending that "it is something of a miracle that the French

showed any interest in purchasing works of art," given "the shelling of Paris during our enormous offensive against Amiens," one author reminded his readers that the prices paid for Degas's paintings by Ingres set no records and that the prices paid for the Manets and Cézannes were perfectly reasonable. Also, he cautioned, "one must not forget that the French franc is relatively stronger than the mark." The author asserted that even though "mediocre art commands high prices in France, . . . higher than good art in Germany," the French public still did not adequately appreciate its own pictures.[17]

Ironically, the two factors predicted to have the greatest negative effect on the sales—the war and a proposed tax increase—may actually have boosted awareness and raised bids. Wartime speculation was credited with playing an important role. It was commonly believed that "a goodly number of Europeans, enriched by the war, even if not blessed with any art knowledge or taste, and a percentage of others, really connoisseurs and collectors . . . who have been able to retain any of their former wealth, are turning to art as the best possible investment in these troubled times."[18]

The second factor that, according to reviewers, had an impact on prices was the much-discussed French tax on luxury goods, including all works of art, scheduled to go into effect on April 1, 1918. In the first of many warnings, *American Art News* reported in early February of that year that the new law would levy a 10 percent tax on the purchase price each time an artwork was bought or sold. Thus a single transaction would incur a 20 percent increase. In other words, a buyer would have to pay 40 percent more than the hammer price to cover both the new taxes and the auction house fees.[19] There was great confusion—particularly

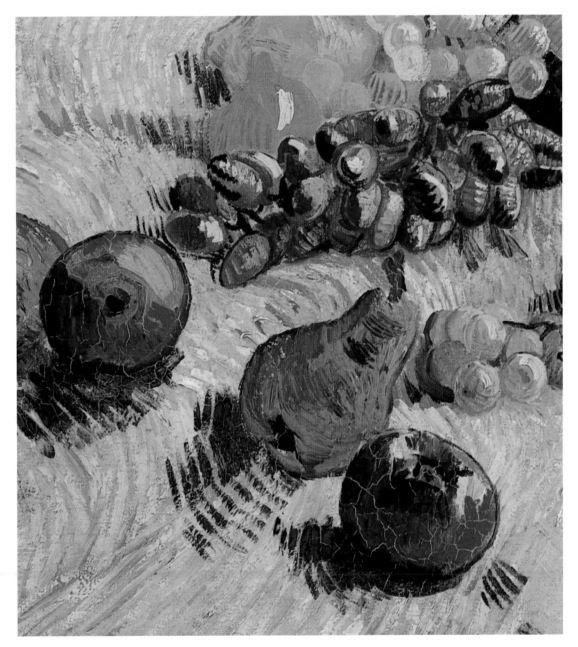

Fig. 379. Detail, Vincent van Gogh, *Still Life with Fruit*, 1887. Oil on canvas, 18¼ × 21¾ in. (46.5 × 55.2 cm). The Art Institute of Chicago, Gift of Kate L. Brewster (1949.215). Collection Sale I: 92

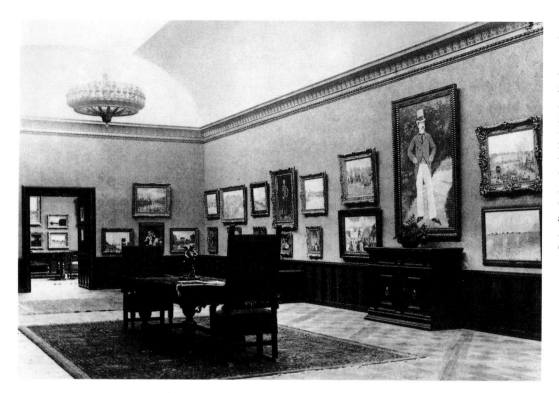

Fig. 380. The paintings wing in Wilhelm Hansen's home in Ordrupgaard, Denmark, constructed in 1918 to display his growing collection of French pictures. On the wall are three paintings purchased from the Degas collection sales: in the foreground, Manet's large portrait of Armand Brun (fig. 382); to the lower left of it, Manet's *Departure of the Folkestone Boat* (fig. 262); and on the far wall at the lower right, Sisley's *The Factory during the Flood* (fig. 160).

among the Americans—as to when the tax would be initiated. There were also rumors that the French government was planning to prohibit exportation of all works of art after April 1.[20] Collectors and dealers were advised as a precautionary measure "to have already-purchased goods and articles shipped [from France] at once, and also to conclude impending purchases quickly."[21] That the first Degas collection sale had been scheduled for March—making it the last major art sale held in France before the new tax went into effect in early April—did not pass unnoticed by the press. The French newspaper *Excelsior* questioned whether the Degas collection sale had been hastily arranged specifically to avoid the new tax.[22] Other papers suggested that the "extraordinary ardor in the bidding" at the sale was fueled by dealers and collectors who wished to purchase their art before the imminent tax increases.[23]

Published reports of the sale did not dwell on the identities of those willing to pay such high prices. Dealers' names were bandied about (primarily Durand-Ruel and M. Knoedler and Co., New York), along with references to an unnamed Danish collector who was interested in Impressionism (certainly Wilhelm Hansen of Copenhagen; see fig. 380).[24] The chief lament among journalists was that the French state was unable (or did not choose) to acquire more works than it did. Prior to the sales, the art critic Armand Dayot publicly suggested that the Louvre, which he claimed already owned a sufficient number of portraits by Ingres, acquire instead Delacroix's "superb portrait of Baron de Schwiter" and Manet's "lively and fresh image of

Fig. 381. Eugène Delacroix, *Louis-Auguste Schwiter*, 1826–30. Oil on canvas, 85¾ × 56½ in. (217.8 × 143.5 cm). Reproduced by courtesy of the Trustees, the National Gallery, London (NG 3286). Collection Sale I: 24

Fig. 382. Édouard Manet, *Monsieur Armand Brun*, 1880. Oil on canvas, 77⅛ × 45⅜ in. (196 × 116 cm). National Museum of Western Art, Tokyo (S.M.12). Collection Sale I: 73

M. X . . ." (figs. 381, 382).[25] The Louvre purchased neither. *Le Temps* was indignant that M. Knoedler and Co., New York, bidding on behalf of London's National Gallery, had won the portrait *Louis-Auguste Schwiter.* "Its place is in the Louvre, where there are no portraits by the master. The work is certainly not without faults . . . [but] it is extremely regrettable that our museums did not make the necessary effort. *Count de Mornay's Apartment,* for which the Louvre paid 22,000 [francs], is surely a charming canvas but does not compensate for the loss of the other."[26] One of the Louvre's few purchases that was unanimously praised in the French press was Manet's pastel of his wife reclining on a blue sofa. Louis Dimier opined that it was the only picture that had sold at its true value (62,000 francs): "Let us congratulate the Louvre for having bought it as such."[27] The Manet notwithstanding, most experts lamented the French government's inability "to keep together in the Louvre this magnificent collection, a collection chosen with a discrimination that no board of museum directors can ever hope to rival."[28]

Almost eight months were to pass before the next Degas collection sale. In the meantime, news items about the sales continued to appear. Several papers carried the story of the gentleman who was the subject of Manet's portrait *Monsieur Armand Brun* (listed in the sale catalogue as *Portrait of Monsieur X . . .*). It seems Monsieur Brun had requested that his identity not be publicly divulged. The press could not understand his reticence. One journalist wondered: "Was it from modesty, fear of publicity? Or could it be because, having once rejected this portrait, he is now disappointed to learn that he disdained a masterpiece?"[29] Another opined: "He no doubt regrets having underestimated the image the great painter made of him."[30]

There was less journalistic interest in the November sales than there had been the previous spring, primarily because of the war's end. The Armistice document was signed on November 11, 1918, just four days after the sale of Degas's print collection and just four days before the final collection sale. *Le Figaro* and other French newspapers did manage to make room for the sale results; most accounts noted Honoré Daumier's *The Legislative Belly,* which fetched 1,500 francs, as well as pictures by Delacroix, Manet, J. A. M. Whistler, and various Japanese artists.

The most interesting reports of the November sales focused not on the prices but on pictures that had been misattributed in the sales catalogues. There were a number of claims that certain works listed as "Modern School" were actually by Degas and other identifiable artists. In a letter to the editor of *Le Cousin Pons,* one collector explained in detail why his "Modern School" sketch, purchased in

the second Degas collection sale, could be attributed to Delacroix.[31] Similarly, an article in *Le Carnet de la semaine* asserted that several of the drawings sold as by Delacroix had in fact been created by his student Pierre Andrieu.[32]

Almost every aspect of the Degas collection sales was fodder for the press. The principal reason the sales commanded such intense interest was the widely held belief that disclosure of the collection's contents allowed the illustrious Degas to be better understood. Some critics and art historians viewed the collection as consisting of three categories: old masters (El Greco [fig. 383], Aelbert Cuyp, and Jean-Baptiste Perronneau), early-nineteenth-century artists (Ingres and Delacroix), and Degas's contemporaries (the Impressionists). The most notable absence from this last category was Claude Monet, who had exhibited with Degas in four of the so-called Impressionist exhibitions. Cortissoz was the first to comment on this exclusion: "Of Claude Monet, there is, suggestively, no sign at all. Had they some personal cause of disagreement, or did Degas, painting ballet girls over and over again, in infinite variety, rebel against the somewhat monotonous tendency in his contemporary's similar devotion to haystacks and cathedrals? The omission is indubitably a little odd."[33]

The critic Raymond Bouyer approached the collection differently, suggesting that apart from the three old masters, Degas's collection should be considered a rapid overview of modern art, from Romanticism to Impressionism, with a concentration on the "antithesis between Olympian line and impatient color."[34] Still other critics voiced their interest in Degas's unexpected choices: Degas as one of the first champions of El Greco, or as the owner of a handful of drawings by the largely forgotten Charles-Emmanuel Serret. Louis Vauxcelles, writing under the pseudonym Pinturrichio for *Le Carnet de la semaine,* pointed out that in spite of his anti-Semitism Degas had owned works by both Édouard Brandon ("[the artist of] Jewish gatherings and synagogue interiors") and Camille Pissarro (who was Jewish) (fig. 384).[35]

While some waxed enthusiastic over the pictures, others were disappointed by the collection's uneven quality: "When a man such as Degas leaves behind a collection, one . . . seeks to measure the taste of the artist who assembled [it]. With the knowledge that Degas had of his art, let us confess to having expected a more decisively superior ensemble."[36] There were assertions that Degas's collection belied the "rather haphazard manner" in which it had been assembled. "It neither indicated any pronounced prejudice, nor any fixed, narrow lines of choice," wrote a correspondent. "One may conclude that Degas . . . had around him such examples as were useful to him in his work, just as a writer has such books of references most at hand as

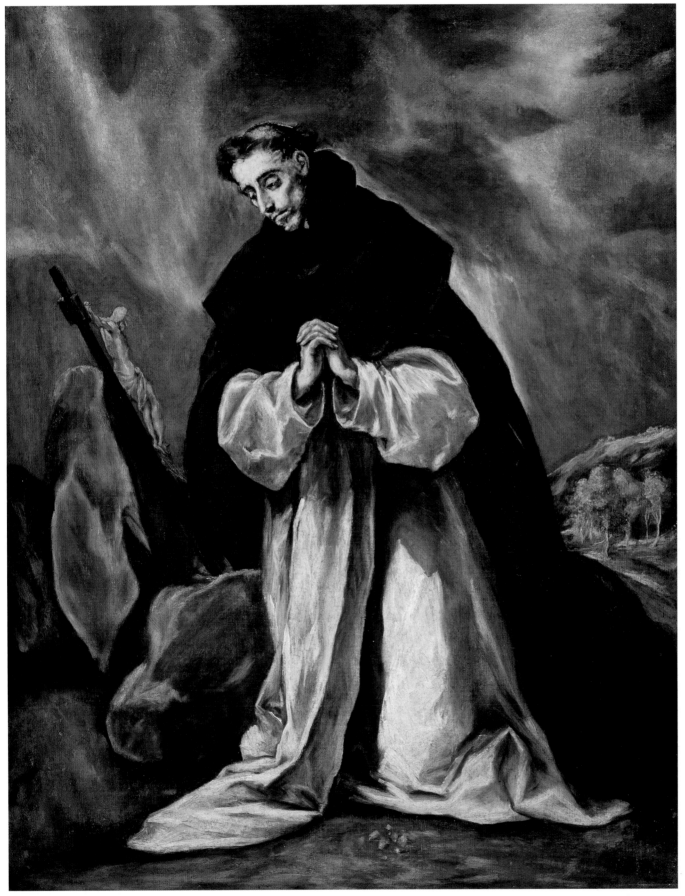

Fig. 383. El Greco (Domenikos Theotokopoulos), *Saint Dominic,* ca. 1605. Oil on canvas, 41¼ × 32⅝ in. (104.7 × 83 cm). Courtesy, Museum of Fine Arts, Boston, Maria Antoinette Evans Fund (23.272). Collection Sale I: 3

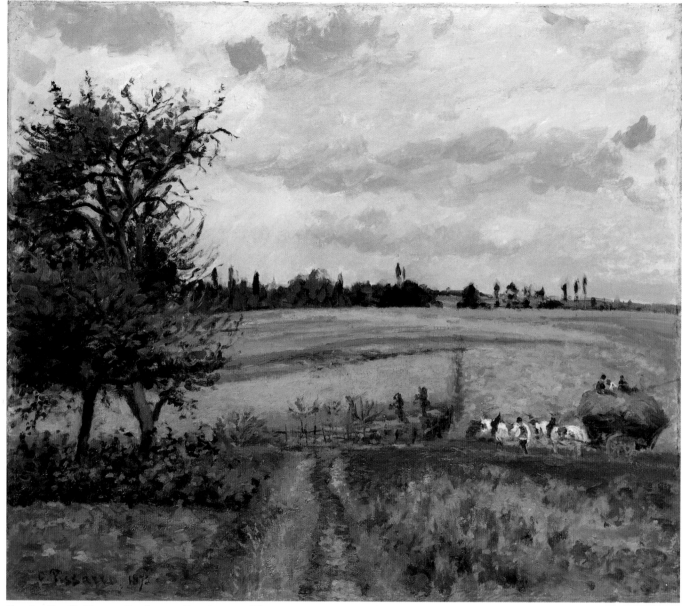

Fig. 384. Camille Pissarro, *Landscape at Pontoise*, 1872. Oil on canvas, 18⅛ × 21⅝ in. (46 × 55 cm). The Visitors of the Ashmolean Museum, Oxford. Collection Sale I: 85

serve him most."[37] Similarly, the *Excelsior* reported that Degas's collection contained works of art "of such divergent and contradictory tendencies that one is somewhat amazed to find them united. Degas . . . seems to have wanted to defy public opinion by grouping them together."[38]

Roger Fry, the British art critic who was briefly a curator at The Metropolitan Museum of Art, attempted to explain this dichotomy in Degas's collection. "There are only two motives apparent; one, friendly personal feeling towards artists whom Degas knew, and this accounts for certain secondary works; and two, Degas's insatiable and pure love of the highest artistic quality. . . . In so many cases Degas has chosen pictures which, though rarely important or ambitious works, reveal the fundamental qualities of the painters at their purest and highest."[39]

No matter what any reporter or art historian thought of Degas and his collection, it was impossible to dispute the success of the Degas collection sales. In 1919 *Annuaire des ventes* included the sales in its roster of the most significant auctions of the previous year,[40] and *Art et décoration* published a concise summary: "Begun under the bombardment, [the Degas sales] ended in the joy of victory and reached the impressive figure of 10,827,826 francs. (The Doucet sale, the only one in France that had surpassed this record, produced 13,884,460 francs in 1913.) In the Degas sales, the studio [contents] alone brought in 8,649,573 and the collections, 2,178,253 [francs]."[41] Thus the sales became part of Degas's legacy. For art lovers, the revelation and dispersal of Degas's collection were a cultural high point of the wartime era.

1. "Nos Échos: . . . La Collection Degas," *Le Cousin Pons* 2, no. 34 (October 15, 1917), pp. 269–70.

2. Royal Cortissoz, "Degas as a Collector of the Art of Other Men: A First View of His Treasures, Presently to Be Sold in Paris—Ingres, Delacroix and the Impressionists," *New York Tribune,* February 24, 1918, p. 3.

3. B. D., "Paris Letter: Degas Sale in Paris," *American Art News* 16, no. 22 (March 9, 1918), p. 5. *Le Figaro* concurred: "The name of the man that formed [the collection] is sufficient to [commend] its attention. . . ." (Valemont, "Les Grandes Ventes: La Collection Edgar Degas," *Le Figaro,* March 13, 1918, p. 3).

4. J. de C., "La Curiosité," *Écho de Paris,* March 16, 1918, p. 2; "Ventes prochaines," *New York Herald* (Paris edition), March 12, 1918, p. 3.

5. Valemont, "Les Grandes Ventes: La Collection Edgar Degas," *Le Figaro,* March 19, 1918, p. 4.

6. "Art et curiosité: La Collection Edgar Degas," *Le Temps,* March 17, 1918, p. 3.

7. *New York World,* March 26, 1918, p. 3, and *New York Times,* March 28, 1918, p. 11. See also "Art Sale in Paris Best of War Time: Edgard [*sic*] Degas' Collection Brings $320,000 Despite Raids and Bombardment," *New York Herald,* March 28, 1918, p. 7. On the first day of the Degas sales (day 1,332 of the war, according to *Le Figaro*), the *New York Tribune*'s correspondent reported that despite the German onslaught, "which is undoubtedly leading to the greatest military events in history, . . . [t]he boulevard cafés are enjoying normal patronage, and the crowds are discussing the latest events calmly. . . . Everybody is talking about this history in the making, but seldom is there a word of pessimism heard anywhere" ("Paris Looks Crisis in the Face and Reflects Calm Optimism," *New York Tribune,* March 28, 1918, p. 3).

8. "Art Sales in War Time," *American Art News* 16, no. 25 (March 30, 1918), p. 4.

9. "Art et curiosité: La Collection Degas," *Le Temps,* March 29, 1918, p. 3, and Valemont, "Les Grandes Ventes: La Collection Edgar Degas," *Le Figaro,* March 27, 1918, p. 4.

10. "La Vie chère!" *L'Intransigeant,* March 27, 1918, p. 2.

11. Ibid.

12. "Nos Échos: La Vente Degas," *Le Siècle,* March 29, 1918, p. 2.

13. "Degas Sale Continued: Highest Prices for Ingres," *Times* (London), March 29, 1918, p. 3.

14. "La Vie chère!" *L'Intransigeant,* March 27, 1918, p. 2.

15. Louis Dimier, "Les Arts pendant la guerre: La Collection Degas," *L'Action française,* April 2, 1918, p. 4.

16. "Details of Sensational Degas Vendue in Paris," *New York Herald,* May 12, 1918, "L. & L. section," p. 5.

17. A. L. M., "Nochmals die Versteigerung Degas," *Der Kunstmarkt* 15, no. 29 (May 3, 1918), p. 194.

18. "High Art Prices Abroad," *American Art News* 16, no. 16 (January 26, 1918), p. 4. Twenty days before the first Degas collection sale, an article appeared in *Le Temps* in which the author marveled at the current interest in auctions and at the high prices fetched by paintings, prints, furniture, and objets d'art. While attributing some of the high prices to speculation on the part of wartime buyers, he extolled the idea of according value and prestige to beauty (J. B., "L'Art et l'argent," *Le Temps,* March 6, 1918, p. 1).

19. "New French Art Law," *American Art News* 16, no. 18 (February 1, 1918), p. 1; B. D., "Paris Letter," *American Art News* 16, no. 30 (May 4, 1918), p. 5.

20. A letter dated March 15, 1918, from the New York gallery of M. Knoedler and Co. to its Parisian counterpart reports, "There may not be any truth in this, but we have heard remarks to that effect. Please keep us posted about this, as it would naturally prevent our buying abroad." Unpublished archives, Knoedler and Co., New York, Letterbook, 1917–21, p. 90.

21. "Warning to the Art Trade," *American Art News* 16, no. 19 (February 16, 1918), p. 4.

22. Le Veilleur, "Bloc-Notes: À l'Hôtel de Ventes," *Excelsior,* April 1, 1918, p. 4.

23. B. D., "Paris Letter," *American Art News* 16, no. 30 (May 4, 1918), p. 5.

24. "Art et curiosité: La Collection Degas," *Le Temps,* March 29, 1918, p. 3.

25. Armand Dayot, "L'Atelier de Degas," *L'Illustration* 76, no. 3915 (March 16, 1918), p. 256.

26. "Art et curiosité: La Collection Degas," *Le Temps,* March 29, 1918, p. 3.

27. Dimier, "Les Arts pendant la guerre: La Collection Degas," *L'Action française,* April 2, 1918, p. 4. See also Le Veilleur, "Le Pont des Arts," *Excelsior,* March 30, 1918, p. 4.

28. Fry 1918.

29. Pinturrichio [Louis Vauxcelles], "Le Carnet des ateliers: Portraits refusés," *Le Carnet de la semaine* 4, no. 151 (April 28, 1918), p. 8.

30. "Nos Échos: M. X . . . , par Manet," *Le Cousin Pons* 3, no. 46 (April 15, 1918), p. 363.

31. "Amateurs et experts," *Le Cousin Pons* 3, no. 53 (December 1, 1918), pp. 421–22.

32. "Le Carnet des ateliers: Cézanne, Delacroix et les faux tableaux," *Le Carnet de la semaine,* February 9, 1919.

33. Cortissoz, "Degas as a Collector of the Art of Other Men," p. 3.

34. Raymond Bouyer, "Mouvement des arts: La Collection Edgar Degas," *La Chronique des arts et de la curiosité* (March 1918), p. 86.

35. Pinturrichio, "Le Carnet des ateliers: Chez M. Degas," *Le Carnet de la semaine* 4, no. 144 (March 10, 1918), p. 7.

36. Dimier, "Les Arts pendant la guerre: La Collection Degas," *L'Action française,* April 2, 1918, p. 4.

37. B. D., "Paris Letter," *American Art News* 16, no. 27 (April 13, 1918), p. 5.

38. "Bloc-Notes: Degas," *Excelsior,* March 22, 1918, p. 4.

39. Fry 1918, p. 118.

40. M. A. Frappart, "Les Principales Ventes de 1918," in *Annuaire des ventes . . . ,* 1 (October 1918–July 1919), p. 19.

41. "Les Ventes," *Art et décoration* 36 (July–August 1919), p. 12. The Doucet sale referred to took place on June 5–8, 1912, when Jacques Doucet (1853–1929), a Parisian couturier, sold many of his older pictures in order to focus on his collection of contemporary art. The total value of the three Degas collection sales, as cited in published accounts, ranged between 2,174,533 and 2,178,533 francs, a discrepancy attributable to conflicting reports of the amount raised at the print sale.

The Degas Collection Sales and the Press:
Selected Reviews and Articles

COMPILED BY REBECCA A. RABINOW

The following material, dating largely from 1917–18, is culled from the extensive international press coverage of the Degas collection sales. The selection emphasizes reports that provide a sense of the public reaction to the works in Degas's collection and to the sales in general, as opposed to cursory announcements and accounts of the prices obtained. French and German texts were translated into English, but to preserve the integrity of the documents, inconsistencies in the citation of titles and sale prices have not been corrected.

"Talk of the Town: . . . The Degas Collection" ("Nos Échos: . . . La Collection Degas")
Le Cousin Pons 2, no. 34 (October 15, 1917), pp. 269 –70
The great artist who recently died assembled a magnificent collection of paintings, pastels, and drawings during his lifetime.

Fig. 385. Paul Gauguin, *Copy after Manet's "Olympia,"* 1891. Oil on canvas, 50⅜ × 35⅛ in. (128 × 89 cm). Private collection. Collection Sale I: 46

His friends especially admired, among his acquisitions, three superb paintings by Ingres: *M. and Mme Leblanc, M. de Norvins,* and a replica of *Roger Freeing Angelica;* several Delacroix, including *Baron Schwiter, Studio Interior* [*Count de Mornay's Apartment*], and various portraits, all the more precious in that they date from the painter's first period; a very beautiful El Greco; several Manets, among them a stunning pastel of a woman in white on a blue sofa; an excellent Cuyp; some Cézannes; and some Gauguins, including one very interesting canvas, a copy of Manet's *Olympia* [fig. 385].

As for the drawings by Ingres and Delacroix that Degas owned, they are quite numerous and form a uniquely beautiful ensemble.

If this collection is put up for sale, we hope that our major museums, particularly the Louvre, will recognize their duty and purchase almost all of these beautiful works, carefully gathered together by such a great artist.

"Studio Diary: The Degas Sale" ("Le Carnet des ateliers: La Vente Degas")
Le Carnet de la semaine 4, no. 140 (February 10, 1918), p. 7
In only a few weeks, the late Degas's collection will be auctioned off. Apart from the pastels, drawings, and even sculptures by the deceased painter, there will be much competition for the canvases that he amassed with clairvoyant wisdom. M. Degas owned works by Ingres and Delacroix; of these two masters he seems to have preferred the former, and he liked to repeat the sculptor Préault's piquant remark: "Ingres is the constipation of color, Delacroix the diarrhea."

M. Degas never ran short of anecdotes about the painter of *Mme de Senonnes*. "Ah! how modest he is!" M. Degas would say. "When Ingres was poor and in dire need, they suggested he do portraits; and he answered, 'I would not know how'—this from the man who would paint *M. Bertin!*"[1] M. Degas still enjoyed recounting this witticism: One day they found M. Ingres at the Louvre copying a Florentine primitive: "Monsieur Ingres, at your age!" "Yes," answered the man who had a reputation for being so haughty, *"I'm trying to learn . . ."*

M. Degas had no less affection for Corot and owned luminous paintings from his second trip to Italy. Once the Neapolitan virtuoso De Nittis, annoyed by M. Degas's eulogies, grumbled to him, "Oh, Corot, it's easy to do a Corot . . ." "Easy for Corot," replied M. Degas.

Royal Cortissoz, "Degas as a Collector of the Art of Other Men: A First View of His Treasures, Presently to Be Sold in Paris— Ingres, Delacroix and the Impressionists"
New York Tribune, February 24, 1918, section 3, p. 3
In the fragments reprinted in this place last Sunday from Mr. George Moore's memories of Degas something was said about the obscurity in which the great artist's solitary home life was plunged. For years his door was sealed to all save a few intimates, and, once within, not even his old friends could feel that they were made really free of all his possessions. In perennial dust and gloom, as Mr. Moore has told us, the vast canvases of his youth were piled up in formidable barricades, and though many works from other hands were visible on the walls no visitor ever came away with a precise and comprehensive knowledge of just what the apartment in the Rue Pigalle contained.

All that was generally known was that Degas had accumulated a lot of fine things, among which the productions of Ingres were conspicuous. The rest was legend. For art lovers throughout the world, fascinated by his own works and doubly interested in the question of his taste because it had its mysterious aspects, he became a figure not unlike one of Balzac's *collectionneurs*—shadowy, reticent, a little bizarre, and, in the matter of furnishing surprises, presumably capable of anything. It is not too much to say that the public exhi-

bition of no collection of our time has been awaited with a tithe of the curiosity excited by the *"Collection particulière E. Degas."*

And now at last this curiosity is to be gratified. His old and modern paintings and drawings will be shown in Paris on March 24 and 25 and will be sold on March 26 and 27. Some three hundred of his own pictures, pastels, etc., will be placed on view on May 4 and 5 and will be sold on May 6, 7 and 8. The mere announcement of these dates must have in it a certain excitement for the connoisseur of Degas. But through the courtesy of M. Durand-Ruel, whose firm is assisting in the organization of the sale, we have had the opportunity to examine a list of 247 pieces in the collection to be disposed of next month, a list accompanied by a quantity of photographs. The Tribune is thus happily enabled to give its readers the first authentically documented view of that Balzacesque interior over which a curtain was hung for a long lifetime.

A bundle of photographs is not, ordinarily, the most eloquent thing in the world, but this one is truly revealing. With its aid, reinforced by the scant biographical data available, we may reconstruct something of the artist's inner life and get that much closer to the secret of his genius. The small number of old masters in the list— an early copy after Cuyp, an eighteenth century French portrait, a typically elegant Perronneau, a sketch by Tiepolo and a couple of pictures of saints by El Greco—is in no wise to be misunderstood.

For his old masters Degas naturally went to the museums. He prospered exceedingly, but he was never rich enough to make for himself another Louvre. How he haunted that institution and the Italian galleries we know. In his earlier period he was all for the old masters and the world well lost. It is said that he spent a year copying Poussin's *Rape of the Sabines*, and according to George Moore the copy is as fine as the original. There are stories, too, of his copying Clouet and Holbein, and whether he studied Ghirlandajo [*sic*] for the same purpose or not it is known that he sat reverently at the feet of that Renaissance Florentine. M. Lemoisne cites also a copy from Sir Thomas Lawrence, an odd type to be found in this gallery. What is it that he sought among the Primitives? The answer is disclosed the more luminously as we postpone it to the hour of his *éclosion* as an artist.

It is tempting to the student of Degas, familiar with the works characteristic of the greater part of his life, to see him as so essentially allied to the modern, impressionistic group as to have, otherwise, no antecedents. The influence of Ingres is often reckoned with, by commentators on him, as though it were a deliberately adopted elixir, something poured out of a bottle. As a matter of fact, the passion for sound drawing was in his blood. It was that that drew him to the Primitives. It was that that made him choose the friendships of his youth. Lamothe, his master at the Ecole des Beaux-Arts, was the pupil of Ingres and Flandrin. Ingres begat Lamothe and Lamothe begat Degas—so the framers of artistic pedigrees might put it. When Degas went to Rome in the '50s he found there Elie Delaunay, whom he had known at Lamothe's; he found Paul Dubois and Chapu, the sculptors, and his old comrade Bonnat.

All these men were conservators of the old French tradition of classically sound workmanship. He knew in Rome, too, by the way, the composer Bizet and that intense romanticist Gustave Moreau, and his relations with both were sympathetic. But his ideals remained those of the Villa Medicis, the time-tried, sterling ideals of French art. Neither the passion of *Carmen* nor the phosphorescent pageantry of Moreau suggests the key in those formative years to his natural development. He was nearer to Bonnat (whom he painted then, wearing a prodigious top hat, in a portrait we remember at Bayonne) as he was nearer to every artist dedicated to

research into form. And he had already been initiated into the circle of Ingres.

His initiation would appear to have dated from his youth. Degas was born in 1834. He was old enough when he frequented the house of Mme. Valpinçon, the master's friend, to profit by his few encounters there with the august potentate. Ingres lived on until 1867. Doubtless before the end Degas had precept as well as example to make the *ménage* Valpinçon memorable to him, counsels for the confirmation of which he had only to turn to the pictures given to his hostess by her friend. At any rate, it puts no strain upon the imagination to figure him as making, almost as though under the eye of Ingres, the famous *Étude pour Semiramis,* which Ingres himself would not have disdained. We think of Degas as the painter of jockeys, ballet girls and laundresses. We forget the picture on which he labored so devotedly in 1861, this *Semiramis Building the Walls of Babylon*. That mood of his, we say, long ago went down the wind. It stayed with him, to tell the truth, down to the day he died. For it was not an archaeological mood. It was the mood for form, for contours finely drawn, for draperies handled as so much sheer linear beauty. It was the mood of Ingres. Here we resume our bundle of photographs and look at the list.

Montauban itself could hardly furnish forth a purer light on the subject. The collection there is more voluminous, of course, but it

Fig. 386. Detail, J.-A.-D. Ingres, *Jacques Marquet, Baron de Montbreton de Norvins (1769–1854),* 1811–12. Oil on canvas, mounted on panel, 38¼ × 31 in. (97.2 × 78.7 cm). Reproduced by courtesy of the Trustees, the National Gallery, London (NG 3291). Collection Sale I: 53

contains no finer things than the works in the Degas collection. There is, to begin with, a group of the full dress portraits, a *Monsieur de Norvins* [fig. 386], which seems almost as impressive as the *Bertin* in the Louvre; a *Marquis de Pastoret*, which makes for it a fit companion, and, to complete the trio, an unmistakably superb portrait of a lady, this one *Madame Leblanc*. Evidently in painted portraiture Degas contrived to get a full and authoritative representation of his master; in the matter of subject pictures he was no less fortunate, acquiring a version of the *Roger délivrer* [*sic*] *Angelique*, as well as half a dozen other mythological or historical studies, and then, having formed a sufficient gallery of the paintings, he proceeded fairly to luxuriate in the drawings. The titles fill a couple of pages in the list, a veritable mine of glorious draftsmanship, and the photographs more than confirm our impression. He missed no aspect of the great artist's genius.

A study for the *Roger* gives us his measure in the sphere of pictorial invention; there are portraits, and dozens of the incomparable nudes, including one gem-like study for *The Grand Odalisque*. We could dilate upon them all, one by one. But we turn rather to their broad significance, visualizing Degas throughout the years of his maturity, coming home to that quiet studio of his to paint a ballet girl—but painting under the influence of these drawings, drinking in their inspiration day by day, living constantly in the spirit of the classicist he adored. At the bottom of his work you find Ingres, which is to say not the imitation of a style but the application of a principle.

It is an instance of the thinking artist, that always rare type, the man whose hand is fed by his brain, who practices his own method, but is steadily open to other impressions, allowing them to fertilize his genius without governing it. There are no contradictions in the life of such an artist. He does not "dislike" one master because he "likes" another. All is fish that comes to his net.

But you find a pretty clearly defined catch when you look into the net of an artist like Degas. After Ingres he was enthusiastic for Delacroix, of all men. We say "of all men" because the antithesis between Ingres and Delacroix is so strong. Each fairly hated what the other did. Just why Degas, loving Ingres, loved also his romantic rival is, we confess, a little difficult to surmise even with the evidence before us. The evidence, in fact, is so mixed. The early portrait, *Baron de Schwitzer* [*sic*], supplies something in the nature of a clew. It is a simple, beautifully drawn thing. Ingres would have praised it—if he could have praised anything by Delacroix. The rest is all pure romanticism—Delacroix the disciple of Rubens, Delacroix the Orientalist, Delacroix the painter of battle scenes, of hunting episodes, of religious subjects à la Titian. There are drawings here, as in the Ingres contingent, but one suspects it was the colorist in Delacroix that won Degas. At all events, he is in this collection, as in the days when the two men were living, the rival of Ingres. They are the twin pillars bearing the arch, as it were, of that aesthetic fabric which Degas reared in his home, under which he dreamed his dreams and did his work.

No other individual looms quite so large in our list. But just one comes very near to doing so. This is Manet. There is a curious leap, if we may so define it, from period to period in the Degas collection. One is aware in the first place, as we have indicated, of the pervasive influences of Ingres and Delacroix. Then a silence befalls. It is the Salon and all its works being haughtily ignored.

Was he attracted at that juncture by the Barbizon men? Yes, by Corot. There are seven of that master's works in the collection, evidently in more than one of his manners. The photograph gives an enchanting account of an early mountain scene done in the Morvan. There are others, like *Le Pont de Limy* [*sic*], which seem even in a photograph to be made of the pure gold of Corot. Moore has a note that is appropriate here, a note on Degas at a Bougival dinner, looking at some large trees massed in shadow. "How beautiful they would be," he said, "if Corot had painted them." There is one Rousseau, and we observe a couple of studies by Millet. There is nothing of Dupré, of Diaz, of Daubigny, as there is nothing, on the purely romantic side, of Decamps or Gericault. Troyon, obviously, is likewise absent. One cannot see Degas ecstatic before a painted cow. Barbizon, in short, as Barbizon, and "1830" as a battle cry, it is plain, meant nothing to Degas. He was bored by "schools," "movements," and we know nothing more characteristic of him. Let us revert to that leap to which we have just alluded. Barring his pause upon the beauty of Corot, it took him straight to the camp of the Impressionists, to Manet and the rest.

Fig. 387. Eugène Delacroix, *Landscape with River (Champrosay)*, 1850? Oil on canvas, 10¼ × 15¾ in. (26 × 40 cm). Collection Mrs. Ulla Toll. Collection Sale I: 32

Fig. 388. Camille Pissarro, *Ploughed Fields near Osny*, 1873. Oil on canvas, 18⅛ × 21⅞ in. (46.5 × 55.5 cm). Private collection. Photograph: Document Archives, Durand-Ruel. Collection Sale I: 86

The Manets will make a sensation at the sale. They include a number of works that are "important," as the jargon of criticism has it, stunning, finished pictures like the *Indienne Fumant*, or the half humorous *Portrait of M. Brun*, masterly still lifes like the *Jambon* and the *Poire* (which in the photograph has the air of a miracle), and so on through a group of paintings, studies and pastels, twenty pieces in all. There are in this little collection some items of

quite extraordinary interest, a strange, fragmentary version of *The Execution of Maximilian*, a portrait of Berthe Morisot that is like a sudden flashlight effect thrown upon a screen.

We have heard from Moore and others of the deep rooted affection Degas had for Manet. These pictures seem echoes of it. Some, possibly all of them, may have been purchased, but from their quality one takes them to have been fraternal gifts or exchanges. They have the character of personal souvenirs. As in the case of Corot we feel in the presence of the essential artist. No one else in the Impressionistic *cénacle* appears to have had anything like the same hold upon Degas. Pissarro turns up with four or five landscapes [fig. 388], Sisley with one, and there are traces of Caillebotte and John Lewis Brown. By Berthe Morisot there is a good sketch, and by the American disciple of Manet, Mary Cassatt, there are no fewer than four pictures. Boudin is present in a couple of sky studies and a water color, and Renoir in a good head of a woman. Of Claude Monet, there is, suggestively, no sign at all. Had they some personal cause of disagreement, or did Degas, painting ballet girls over and over again, in infinite variety, rebel against the somewhat monotonous tendency in his contemporary's similar devotion to haystacks and cathedrals? The omission is indubitably a little odd.

He took with a good will the step from impressionism to post-impressionism. One of his Gauguins is a curious momento of the point of contact between the two, a copy of Manet's *Olympia*, which in the photograph would easily pass for an original study. He had at least ten of Gauguin's paintings, most of them relics of the painter's sojourn in Tahiti. Cézanne is almost as fully represented, with portraits, figure subjects and still life, and Van Gogh also has his modest place, being given three numbers in the catalogue. Turning over the photographs and recalling the good old rule that

Fig. 390. J.-A.-D. Ingres, *Head of a Young Woman*, 1804. Black chalk, 15⅝ × 12⅝ in. (39.8 × 32 cm). Fogg Art Museum, Harvard University Art Museums, Cambridge, Bequest of Grenville L. Winthrop (1943.844). Collection Sale I: 214

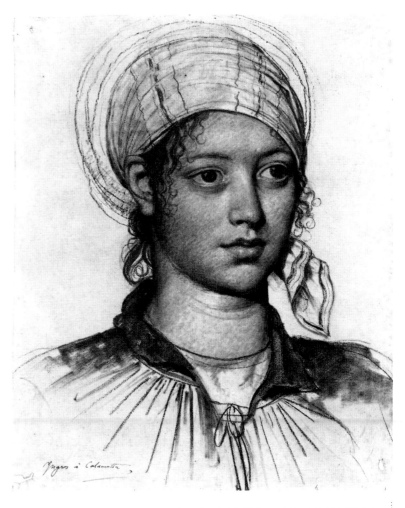

Fig. 389. Jean-Louis Forain, *The Colonel's Drink*, 1898. Pen and ink, 11 × 13⅜ in. (28 × 34 cm). The Metropolitan Museum of Art, New York, Gift of A. E. Gallatin, 1920 (20.167). Collection Sale I: 174

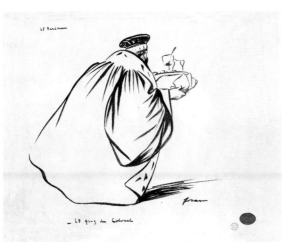

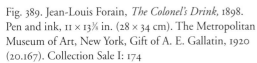

the king can do no wrong, we realize that we ought to be deeply impressed by the inclusion of these things in the collection of Degas. In some pious quarters, we know, it could only be taken as a kind of pontifical ratification, and we are quite sure that the episode will serve, in those quarters, to give the post-impressionist hypothesis a new lease of life.

For our own part we can only look upon this small section in the mass as an incongruous pendant, difficult to reconcile—even for the "thinking artist" to whom we have referred—with the atmosphere and principles otherwise disclosed. The "going," so to say, is easier when we pass to the remaining pieces in the list, the paintings by Daumier, Puvis and Legros, the dozen drawings by Forain [fig. 389]—one of the master's peculiar admirations—and a few oddments by Jeanniot, Guillaumin, Ricard, Bartholomé (the sculptor), and the portrait painter of the Second Empire, Heim. There is also a single work of German origin, an example of the great draftsman, Menzel.

These things fit into the picture, the picture of a gallery and a mind. It is an ancient axiom that a man is known by the company he keeps. An artist is certainly known by his predilections among other artists. That is why we have found so lively an interest in a bundle of insensate photographs. In the memories they awaken of Ingres and Delacroix, Manet and Corot, Daumier and Forain, they illuminate and explain Degas. We know him better, and thus better understand his own work, in knowing the masters with whom he most cared to live.

[Published with six illustrations: Ingres, *Head of a Young Woman* [fig. 390]; Manet, *Monsieur Armand Brun;* Forain, *The Secrets of State;* Renoir, *Mademoiselle Henriette Henriot;* Corot, *The Limay Bridge, with the Château des Célestins;* Delacroix, *The Death of Charles the Bold at the Battle of Nancy.*]

B. D., "Paris Letter: Degas Sale in Paris"
American Art News 16, no. 22 (March 9, 1918), pp. 5–6
The coming sale at the Georges Petit Galleries in Paris, Mar. 26 and 27 next, of the art collection, formed by the famous artist, the late Edgar Degas, is naturally an event of importance to art collectors and lovers the world over, as Degas not only rose through his own inimitable art to be so prominent a figure in the art world, but possessed a taste and acumen in the selection of the work of other painters of his time, as well as that of earlier artists—as to make each and every art work of his choice doubly valuable. Those fortunate collectors who may secure a work or works at this coming sale and at the sale of his own works, to be held in Paris in May next, will be proud of the fact that their prize or prizes came from the sale of Degas' own collection.

The "experts" for the sale are Durand-Ruel and MM. Vollard and Bernheim Jeune, and the auctioneer will be M. Lair-Dubreuil, which, in itself, augurs well for the success of the coming auction.

The Old Masters. There are five old masters in the collection, two fine examples of El Greco, *Saint Ildefonse* and *Saint Dominique,* a beautiful bust portrait of a *Mondaine* by Perronneau, a striking *Portrait of a Man* (XVIII century French School), and an old and good copy of a painting of a horse by Albert Cuyp.

Varied Array of Moderns. The moderns in the collection comprise 89 oils and 155 aquarelles, pastels and drawings. M. Degas was especially fond of the works of Ingres, Delacroix, Manet, Gauguin, Cézanne, Daumier, Van Gogh, Corot, Rousseau, Sisley, Pissarro, Renoir and Mary Cassatt, and had oils by all of these, as also an example each in oil by Caiillebotte [*sic*], J. L. Brown, Bartholome, Forain, Legros, Mlle. Forestier, Berthe Morisot, Piette and Ricard.

It is of course impossible to describe in detail the works that make up this unusual and intimate collection. The same indisposition to sell any of his own productions, so much sought after, for many years before his death and even when as frequently happened, he was pressed for money, extended to his collection of other artists' works. Thus it happens that the coming sale this month will bring on the market a number of pictures and drawings that will be eagerly fought for by collectors who have known of their fine and rare quality, and whose possession by Degas gives them, as it were, a hallmark.

Fig. 391. Eugène Delacroix, *Landscape with Setting Sun.* Pastel, 8⅝ × 10 in. (22 × 25.5 cm). Trustees of the British Museum, London (1975.3.1.34). Collection Sale I: 111

Fig. 392. Mary Cassatt, *Young Woman in a Loge,* ca. 1879. Pastel and metallic paint on canvas, 26¾ × 32½ in. (65.1 × 81.3 cm). Philadelphia Museum of Art: Gift of Mrs. Sargent McKean (50-52-1). Collection Sale I: 102

Fig. 393. Jean-Honoré Fragonard (1732–1806), *Study of a Young Girl (Sedaine Family).* Red chalk, 7½ × 7½ in. (19 × 19 cm). Trustees of the British Museum, London (1975.3.1.33). Collection Sale I: 109, as by Jacques-Louis David

The collection also appeals to many and varied art tastes. The admirers of the great and first of the so-called "Modernists," Cézanne, will find no less than seven unusual examples of his virile brush, while the earlier and classical painter, Ingres, one of the strongest artists even France has produced, is represented by 20 oils and 34 drawings, among them the portraits of M. Pastorel [*sic*] and Mme. Blanc [*sic*], reproduced on this page, his *Oedipus and the Sphinx,* the famous *Roger Delivering Angelica,* the equally famous *Dante Offering his Works to Homer,* the *Achilles* and the *Duke D'Alba and Saint Cordula.*

From the powerful brush of the great Delacroix there are among his 12 oils and 57 drawings and watercolors, the well known oils, *Battle of Nancy,* a *Pietà, Christ in the Tomb, Hercules Delivering Hesione, Henry IV Giving the Regence to Marie de Medicis* and the fine portraits of the *Baron de Schwitzer* [*sic*] and of *Amédee Berny d'Ourville,* and among the watercolors and drawings, the *Landscape at Sunset,* several of his Hamlet studies, and the *Lion Chase.* Of the Barbizons in the collection, mention must be made among the seven examples of Corot, of his *Pont de Limay,* the *Route en Normandie,* the *Mountains of Auvergne,* his Italian period pictures, *Ruins in the Roman Compagna, Villa d'Este at Tivoli* and his *Young Italian Woman Seated,* of a *Head of a Woman* by Millet, and of Rousseau's *Valley of St. Victor.*

Degas admired Manet and owned eight oils and twelve drawings and studies by that master. Perhaps the most interesting of the oils are the well known *Indian Woman Smoking,* the standing *Portrait of M. Brun* in high white hat, black coat and white trousers, the delicate, graceful presentment of *Mlle. Berthe Morisot, the Painter,* the *Departure of the Steamboat,* a fragment of that powerful and dramatic canvas, *The Execution of Maximilian* and the *Portrait of Mme. Manet.*

The "Modernists" Represented. From the brushes of the advanced "Modernists," Gauguin and Van Gogh, are the former's *Tahitienne, La Belle Angèle, Siesta at the Seaside, Tahiti,* two Tahitian landscapes and his well-known *Olympia* (after Manet), and from the latter a fine still-life of *Apples, Pears, Lemons and Grapes* and his *Tournesols.*

Renoir is represented by a *Head of a Woman,* Sisley by *The Inundation of 1873,* Pissarro by three landscapes, all characteristic, and Mlle. Morisot by her *Woman and Child at the Seaside.* Boudin, Barholme [*sic*], J. L. Brown, David and Mary Cassatt are exemplified among the watercolors and drawings, the last by her well known *Le Loge* (woman with a fan) [fig. 392], a bust *Portrait of a Girl* and a *Girl with Brown Hair.* There are 20 examples of Forain, including his *Tashoda,* his oil *The Tribunal,* and two of the great Daumier, the celebrated *Tribunal* and *The Amateurs of Painting.*

Other artists of renown represented in this remarkable collection are Mlle. Forestier, with a striking portrait of Ingres, Jeandiot [*sic*], Legros, David [now attributed to Fragonard], a *Study of a Young Girl* [fig. 393], Guillaumin (bust portrait of a woman), Haim (three portraits), Puvis de Chavannes, Raffet (5), Tiepolo and Menzel, Serret, Tiepolo [*sic*] and Mery.

The dispersing of this great artist's treasures, which so well evidences his taste, discernment and knowledge, will be watched with the greatest interest by collectors the world over.

[Published with six illustrations: Cézanne, *Self-Portrait;* Daumier, *The Tribunal;* Delacroix, *Arab Tracking a Lion;* Ingres, *Madame Jacques-Louis Leblanc* and *Marquis de Pastoret;* and Manet, *Madame Manet on a Blue Sofa.*]

Pinturrichio [Louis Vauxcelles], "Studio Diary: At M. Degas's" ("Le Carnet des ateliers: Chez M. Degas")
Le Carnet de la semaine 4, no. 144 (March 10, 1918), p. 7

For fifty years running, M. Degas was the finest and most patient of collectors. He was one of the first to understand the bitter and tormented genius of El Greco. Two canvases by the old Cretan are included in his collection, on display for the past week at Durand-Ruel. At a time when Corot's figures were compared to country bumpkins and stuffed dolls by Paul de Saint-Victor and Edmond About,[2] he sought out and acquired for a few *louis* those delicate marvels worthy of Vermeer's brush. He also had Cézannes and Van Goghs, which Tangny [*sic*] and Portier[3] sold him for less than two *louis.* His insightful taste led him to gather in his studio works by

Fig. 394. Charles-Emmanuel Serret (1824–1900), *Woman Reading,* 1868. Graphite, 7 × 7 in. (17.8 × 17.7 cm). Private collection. Collection Sale II: probably one of the drawings included in lots 244–247

the unknown and underrated. Indeed, we find in Degas's collection a dozen charming drawings by Serret [fig. 394], a man forgotten by the current generation, who depicted exquisite scenes of childhood in the discreet and ashen style of Seurat and Pissarro.

I remember once having seen some stunning Serrets at Vollard's. It might be time for a small retrospective of his work. The same for Brandon, who depicted Jewish gatherings and synagogue interiors. Few collectors know Édouard Brandon, who is often every bit as good as Bonvin. M. Degas—despite the fierce anti-Semitism that estranged him from his friend Ludovic Halévy during the Dreyfus Affair[4]—bought works by Brandon. By Pissarro, too, even though Pissarro was Jewish.

Among the other interesting paintings discovered while studying the collection assembled by the master of the *Dancers*—in addition to his Ingres, his Delacroix, his Corots, and his Manets—I should mention a curious copy by Gauguin of the *Olympia;* a sketch of this same *Olympia,* this time by Manet; a "Theater Scene" by M. Bartholomé; and Degas's own copies of works by Poussin, Rubens, and Tintoretto.

"Upcoming Auctions" ("Ventes prochaines")
New York Herald (Paris edition), March 12, 1918, p. 3
One of the most important painting sales of the season will be the sale of modern and a few older paintings comprising the collection of the famous, now-deceased painter Edgar Degas. This auction, which will be conducted by Messrs. Lair-Dubreuil and Edmond Petit, assisted by the experts Durand-Ruel, Bernheim-Jeune, and Vollard, will be held in the Salle Petit on Tuesday and Wednesday, the 26th and 27th of this month, after a two-day exhibition. The collection includes, among the older works, two remarkable pieces by El Greco and a portrait of a woman by Perronneau. Among the moderns are important works by Delacroix and Ingres, as well as by Corot, Daumier, David, Manet, Forain, and Millet, to name only a few. The first sale of paintings from the artist's studio, in other words of his own works, will be held at the beginning of May.

Valemont, "The Big Auctions: The Edgar Degas Collection" ("Les Grandes Ventes, La Collection Edgar Degas")
Le Figaro, March 13, 1918, p. 3
The last week of this month will be marked by the sale of an important collection of old and modern paintings at the Georges Petit gallery. The name of the man who assembled the collection is, in itself, enough to command attention: Edgar Degas. Many people in the art world are talking about this sale, which will take place on Tuesday, March 26, and Wednesday, March 27. The works will be

Fig. 395. Jacques-Louis David (1748–1825), *Male Nudes, Studies for "Le Serment du Jeu de Paume,"* 1790. Recto and verso, graphite, 9⅝ × 11⅜ in. (24.5 × 28.9 cm). Musée du Louvre, Paris, Département des Arts Graphiques, life-interest gift of Louis-Antoine and Véronique Prat (R.F. 44330). Collection Sale I: 159, as by Eugène Delacroix

on exhibit for two days, privately on Sunday the 24th, publicly on Monday, March 25.

[. . .] As for the Edgar Degas studio, it will take several auctions to sell it off, and the first of these will be held next May 6, 7, and 8, at the Georges Petit gallery.

Armand Dayot, "Degas's Studio" ("L'Atelier de Degas")
L'Illustration 76, no. 3915 (March 16, 1918), pp. 256–59

It could not, in all honesty, be compared to the "marble and gold" studio of the late Alma-Tadema, nor even to Reynolds's "vast dwelling traversed by well-lit galleries in which the great painter exhibited, as if in a museum, the numerous works of art that he had acquired in France and Italy, and which became, in Leicester Square, the joyful gathering place of London's artistic, literary, and elegant society."[5]

After his departure from the rue Victor Massé, a departure due to the demolition of the building that had housed him for more than two decades, Degas, old, nearly blind, increasingly filled with an incurable and belligerent misanthropy, and separated from most of his few friends by death or abandonment, ended up in the most banal of apartments on the boulevard de Clichy, with the innumerable artistic treasures that he had discovered thanks to his well-informed curiosity. They will be dispersed a few days from now with the dry tap of the auctioneer's gavel.

This apartment, or rather this suite of apartments, was composed of numerous small rooms in which all those works lay piled on the floorboards, against the walls, stuffed into old trunks or kitchen cabinets. . . . Works stacked every which way, in a disorder that was disastrous for a good number of them, especially the pastels; works signed El Greco, Aelbert Cuyp, Peyronneau [*sic*], J.-B. Tiepolo, David, Ingres, Delacroix, Daumier, Rousseau, Corot, Raffet, Millet, Heim, Manet, Puvis de Chavannes, Sisley, Menzel, Pissarro, Berthe Morisot, Van Gogh, Cézanne—to mention only the deceased [artists]. The strict interdiction never to touch these stacks of masterpieces, not even with the tip of a feather duster, allowed spiders to spin their webs freely there and allowed the subtle Parisian dust to envelop them a bit more each day. Meanwhile the old artist, in his melancholy isolation amid these marvels that he could no longer admire, strove to throw some light into the heavy shadows of his final hours by attempting to bring gracious female forms to life from a block of wax, under the groping caress of his feverish and trembling fingers.

Moreover, this extraordinary shambles that was Degas's studio contained not only works acquired by the master but also his own works: works from his youth; paintings from his [artistic] maturity, such as his quite remarkable self-portrait at age twenty-five, which we reproduce here, and the superb portrait of Duranty (more interesting, in our view, than the one in the Camondo collection);[6] pastels from his final years; innumerable drawings and sketches; delicate monotypes that will be much in demand. The number of these paintings, pastels, drawings, engravings . . . will most likely comprise a catalogue of several thousand items at the upcoming sale.

Degas's private collection is not the sudden result of an auction or private sale. Nor does it come from bulk acquisitions, made with vain ostentation. The great artist was an astute connoisseur and the shrewdest of buyers. A tireless rummager, possessing uncommon savvy, he spent his leisure hours pacing those dangerous valleys of temptation called the rues Laffitte, Le Peletier, la Boëtie, de Rennes, de Seine . . . and others still, and also the neighborhoods of Montparnasse and Montmartre. How many times did I see him, his

hands stuffed in the pockets of his overcoat, his sardonic face half buried in the wrap of a thick scarf. He was well known and feared by the art dealers, who would watch him cross the thresholds of their galleries with a shiver of dread and pride. His examination was rapid, his offer brief and imperious; and the dealer, almost always overcome by the affirmative power of the awesome visitor, gave in without resistance, with a kind of respectful resignation.

[Degas] also was seen, rather frequently, at the Salle Drouot. He—like so many others—was not afraid to brave the toxins of that malodorous building, so notoriously unworthy of Paris, in order to seek out "a good deal." And he often found one. It was in that place, where my strolls very rarely led me, that I happened to cause him a violent and unpleasant shock. The anecdote is worth recounting.

It was a few years before the war, at a sale featuring, among mostly rather mediocre works, the two remarkable portraits of M. and Mme Leblanc, portraits that are now part of his private collection and that can be admired in a few days at the Petit gallery.[7] The sale of these two pieces was already well under way when I entered the room—to which, I repeat, chance alone had led me. Degas and Bartholomé (the latter was an old and faithful friend of the painter), seated next to each other, were following with visible anxiety the progress of the auction, which otherwise was rather dull.

"Sold!" the auctioneer suddenly called out . . . to the great joy of Degas, whom my entrance, it seems, had cruelly upset.

I later heard from Bartholomé that Degas, seeing me come in, imagined the intervention of a dangerous rival whose wallet had been stuffed with thousand-franc notes by the arts ministry (an unlikely hypothesis) in the event of "a good deal." It was nothing of the kind, and I regret it still. Degas, in high spirits, was able to pack those two magnificent works into a hansom cab and put them in his bazaar on the rue Victor-Massé. He paid 12,000 francs for them.

What price will their next owner pay a few days from now? And how delightfully ironic it would be to see the State get them at last! To tell the truth, I do not believe that will ever come to pass, and I do not wish it. Our Louvre museum is rich enough in portraits by Ingres, and if the State must devote part of its all-too-limited luxury funds to the purchase of two important works from this outstanding sale, I would rather see it choose the superb portrait of Baron Schwiter, an exceptional painting by Delacroix (by whom, if I am not mistaken, the Louvre owns only one portrait, the artist's self-portrait),[8] and Manet's lively and fresh image of Mr. X . . . [*Monsieur Armand Brun*], who stands out so luminously and vibrantly against the sunlit green of a garden.

To my mind, not only the techniques of the Romantic and Impressionist schools, but also the "look," the outward appearance of these two periods, have never been synthesized with more precise eloquence than in these characteristic figures.

Finally, as long as we are traveling through the infinite domain of dreams, let us hope that the State will also snap up *Saint Ildefonso Writing under the Dictation of the Virgin* by El Greco. It is surely one of the Spanish master's richest and most powerful paintings. That great and curious artist, whose influence on our contemporary school has been so profound—though not always very favorable—is inadequately represented in the halls of the Louvre.

This exhibition of Degas's private collection will be followed by another exhibition which promises to be just as sensational and which will feature the great artist's personal works found in his studio. . . .

Extremely varied judgments have been made about Degas, both as a man and as an artist. But what needs to be emphasized, espe-

Fig. 396. Edgar Degas, *Dancers Practicing at the Barre,* 1876–77. Mixed media on canvas, 29¾ × 32 in. (75.6 × 81.3 cm). L 408. The Metropolitan Museum of Art, H. O. Havemeyer Collection, Bequest of Mrs. H. O. Havemeyer, 1929 (29.100.34)

cially after a careful and admiring examination of all these works known up until now by only a privileged few—works (or rather masterpieces) piled up with complete indifference and, to be frank, the sheerest disinterest, in hideaways, boxes, drawers, trunks, cabinets—is that the great artist, despite his personality flaws and his bitter "nastiness," had only the noblest disdain for money and vain pleasures (a fairly rare phenomenon these days).

He died at the age of eighty-three, a pauper in the midst of incomparable treasures that he could so easily have cashed in, and having refused to accept any honors. He was a hero of artistic life.

Many stories have been told about Degas. Here is one more in conclusion. Some may have heard it, but it bears retelling, as all the disdainful pride of the master's nature shines through in it. We offer it as a topic of meditation to our young and impatient careerists of today.

When, at auction a few years ago, his painting *The Watering Can* [*Dancers Practicing at the Barre;* fig. 396] reached the price of 470,000 francs (after Degas had been paid only 500 francs for it), a reporter rushed into the room where the great artist was awaiting the results of the sale.[9]

Fig. 397. Eugène Delacroix, *Hercules Rescuing Hesione, Study for the Old Hôtel de Ville,* 1852. Oil on canvas, 9 × 18½ in. (24.5 × 47.5 cm). Ordrupgaard, Copenhagen. Collection Sale I: 34

"Monsieur Degas!" he cried out of breath. "Your painting *The Watering Can* was just sold for 470,000 francs!"

Degas, without a trace of surprise, remarked, "That's not a bad price."

"What? Aren't you furious that they've paid such a huge sum and you're not seeing any of it?"

"Sir," Degas answered coldly, "I am like the racehorse who has won the Grand Prix: I am content with my ration of oats . . ."

[Published with seven illustrations: Ingres, *Madame Jacques-Louis Leblanc;* Delacroix, *Louis-Auguste Schwiter;* Manet, *Monsieur Armand Brun;* and four Degases: *Portrait of Edmond Duranty, Self-Portrait at the Age of Twenty-Five, Semiramis Building Babylon,* and *The Bellelli Family.*]

"Arts and Curiosities: The Edgar Degas Collection" ("Art et curiosité: La Collection Edgar Degas")
Le Temps, **March 17, 1918, p. 3**

The wonderful painter we lost this autumn, Edgar Degas, was not only a fanatical admirer of Delacroix and Ingres; he also united a considerable number of masterworks and studies [by other artists]. He included works by those who revived the arts of landscape and figure painting in France: Corot, Manet, Renoir, Cézanne, Pissarro, Sisley, Gauguin. Whence the magnificent group of modern and older paintings—among them are two El Grecos and a Perronneau—as well as pastels, watercolors, and drawings that will be put up for sale in Georges Petit's main gallery on March 26 and 27. Messrs. Dubourg and Delvigne will preside, replacing Messrs. Lair-Dubreuil and Petit, who have been mobilized.

The exhibition will last two days, Sunday, March 24, and Monday the 25th. On display will be seven Corots, seven Cézannes, a Daumier, thirteen Delacroix, ten Gauguins, twenty Ingres, eight Manets, three Pissarros, a Renoir, a Th. Rousseau, a Sisley, and two Van Goghs, not to mention watercolors, pastels, and drawings, in which Delacroix is represented by fifty-six pieces, Ingres by thirty-three, and Manet by fifteen. This sale will be the big event of the season.

Valemont, "The Big Auctions: The Edgar Degas Collection" ("Les Grandes Ventes, La Collection Edgar Degas")
Le Figaro, **March 19, 1918, p. 4**

The world of artists and art lovers is abuzz over this [upcoming sale], and everyone is impatiently waiting for Sunday, March 24, when the private showing of the old and modern paintings that the Master contemplated with fervent joy will open at the Georges Petit gallery.

We know that the collection, apart from important works by Delacroix and Ingres, also contains remarkable pieces by Boudin, John-Lewis Brown, Caillebotte, Mary Cassatt, Cézanne, Corot, Daumier, David, Forain, Gauguin, Guillaumin, El Greco, Legros, Manet, Millet, Berthe Morisot, Perronneau, Pissarro, Puvis de Chavannes, Raffet, Renoir, Ricard, Th. Rousseau, Serret, Sisley, Van Gogh, Zandomeneghi, etc. . . .

Raymond Bouyer, "Movement in the Arts: The Edgar Degas Collection" ("Mouvement des arts: La Collection Edgar Degas")
La Chronique des arts et de la curiosité, **Supplement to the Gazette des Beaux-Arts, [March] 1918, pp. 85–87**

The studio of an original artist who also happens to be an intelligent collector provides, when it is inevitably dispersed, a double

prey: a private collection, an indicator of his tastes, that will be sold first; and his own work, a portrait of his personal evolution, that will prove astonishing even to the superficial minds who persist in seeing Degas only as the painter or pastel artist of *foyers de la danse*[10] and decrepit backstage views. A second sale, to be held next spring, will contain several subjects from Assyrian or medieval history, as well as some of those large interior scenes that ought to hang next to Whistler in the Luxembourg or Fantin-Latour in the Louvre.

When one of the sharpest critics of modern art wrote a work entitled *Our Masters* [*Nos Maîtres*],[11] we had a glimpse of a new psychological method that would allow us to explore more deeply the personality of a writer based on his choice of authors and his own tastes. This collection, haphazardly assembled during a long life by the sardonic and cannily refined, independent Edgar Degas, offers us an analogous experience. And what do we find? Few older paintings—only three—but significant ones, and of the first rank: two mysterious El Grecos and a charming Perronneau.

A "retrospective" at the Salon d'Automne in 1908, as well as the Henri Rouart and Marezell de Nemes sales of 1912 and 1913, had begun familiarizing Parisian collectors with Domenico Theotocopuli, nicknamed El Greco at the end of the sixteenth century by the Venetians, his first masters.[12] He was an unusually affecting innovator and precursor, whose strange evolution had two phases, one of sumptuous Italianism and one of the wildest originality. It is to that last solitary period, in which Maurice Barrès glimpsed "the secret of Toledo," that *Saint Ildefonso Writing under the Dictation of the Virgin* belongs: emaciated but inspired, with ashen skin, staring eyes, nervous and trembling hands, the saint's entire being exudes "the visible soul" of the ascetic exhausted by ecstasy and fasting, in a harmony of austere purple and cold gray on a background of mystic shadows, burning with all the ardor of polychromatic Spanish statuary. The kneeling *Saint Dominic in Prayer* appears in a more Bolognese atmosphere, but in striking chiaroscuro.

Not far from these solitary retreats, the smile of a gracious woman evokes the spiritual well-being of our eighteenth century, and the painter Perronneau proves to be a virtuoso in conveying the transparent "softness" of black lace over a white bodice, bordered with pink like a variegated carnation.

Composed of only 247 catalogued items, the Degas collection includes 93 paintings and 154 drawings, watercolors, or pastels, by forty different artists. From Romanticism to Impressionism, modern art rapidly, but very deliberately, retraces its principal stages.

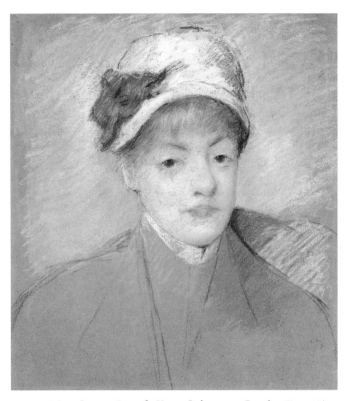

Fig. 398. Mary Cassatt, *Bust of a Young Girl*, ca. 1885. Pastel, 16⅞ × 15¼ in. (42.9 × 38.6 cm). The Fine Arts Museums of San Francisco, Achenbach Foundation for Graphic Arts, Dr. T. Edward and Tullah Hanley Collection (69.30.22). Collection Sale I: 104

The interest here lies in the antithesis between Olympian line and impatient color, which pits 20 paintings and 33 drawings by Ingres against 13 canvases and 56 studies or sketches by Eugène Delacroix! These figures speak louder than any commentary.

Degas, who knew from experience that true freedom is the child of knowledge, literally adored Ingres's line. His sarcasm was warmed by the lovely fire of enthusiasm, and he found beauty in a pencil sketch such as the incomparable *Study for the Large "Odalisque,"* in which the downstrokes and upstrokes of a consummate script manage to suggest the gentle harmonies of young flesh: a masterpiece, which conveys not only "the integrity of art," but also the most sensual poetry of drawing! The Musée de Montauban

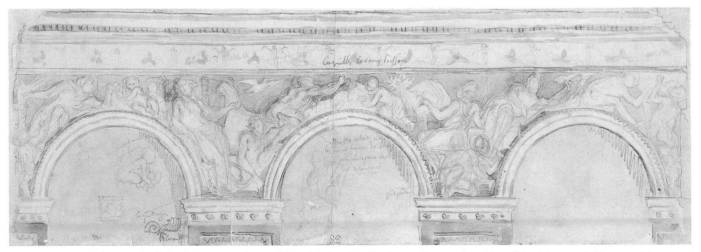

Fig. 399. Eugène Delacroix, *Study for the Decorative Frieze of the Palais-Bourbon*. Graphite and watercolor, 7⅛ × 21⅝ in. (18 × 55 cm). Trustees of the British Museum, London (1975.3.1.39). Collection Sale I: 134

Fig. 400. Eugène Delacroix, *Strait of Gibraltar: African Coast,* 1832. Watercolor and pencil heightened with gouache, 6¼ × 9¼ in. (16 × 23.5 cm). Musée du Louvre, Paris, Département des Arts Graphiques (R.F. 4510). Collection Sale I: 124

Fig. 401. Eugène Delacroix, *Moroccan Site,* 1832. Watercolor, 5⅓ × 9½ in. (14 × 24 cm). Private collection. Collection Sale I: 120

has no drawing more eloquently pure than this charcoal study, which came from the Coutan-Haughet sale in 1889.

Two more pearls that retrace the entire career of the passionate classicist: *The Fury of Achilles,* his sketch for the first Grand Prix de Rome, which David's innovative student won in 1801 (the pink of Ulysses's tunic against the greenish azure of the sky, in a sculptural decor, is reminiscent of Flaxman, who was smitten with Greek vases and ancient paintings); and the *Nude Reclining in an Alcove with Blue Curtains,* revealing an exquisite intimacy which is no longer that of the eighteenth century. . . . These flashes of spirit are more moving than the large, formal portraits of *M. de Norvins, M. and Mme Leblanc* (1823), and the young *Marquis de Pastoret* (1826). And let us not forget the small versions of *Oedipus Solving the Riddle of the Sphinx* (1808) and *Roger Saving Angelica* (1819), nor the quickly abandoned project for a *Duc d'Albe at Sainte-Gudule de Bruxetles* [*sic*], in the cold tones of the *Sistine Chapel.*

Amid so many drawings for the serene *Apotheosis of Homer,* which reminds us that style does not mean an inability to be truthful, let us note the *Family of M. Forestier,* "former judge at Saint-Nicolas, in Paris." We also have, by Mlle Julie Forestier, David's sage pupil, a *Portrait of Ingres* at twenty-five, before his departure for Rome at the end of 1806. These two works illustrate the "romance" of his industrious youth, which knew no other passion than the Italy of Raphael and the Ancients.

Having no Prud'hon to underscore the contrast, here is Delacroix, the grandiose conjurer of religious drama in a small *Pietà,* from the Desfossés sale in 1899. It is not a "variant" of the *Entombment* (hidden away since 1844 in the darkness of Saint-Denis-du-Saint-Sacrement), but a moving and indistinctly colored reduction of the great and celebrated canvas acquired by a certain comte de Geloës after the Salon of 1848.[13]

Here is Delacroix, a still underrated decorator, abounding in projects for the Luxembourg library or the Palais Bourbon; Delacroix, the tumultuous historian of our Middle Ages, with a sketch for his *Battle of Nancy,* under a stormy sky and clearly bearing the date 1834; Delacroix, the astonishing copier of Rubens; Delacroix, the portraitist, isolating *Baron Schwiter* in a rather British landscape; Delacroix, the superb intimate painter of *Count de Mornay's Apartment;* Delacroix, watercolorist and traveler, noting in a brush stroke *The Strait of Gibraltar or The African Coast* [fig. 400]; Delacroix the Orientalist and pastel-artist, drawing from memory an *Arab Stalking* a huge lion; Delacroix the landscape artist and painter of flowers, drawing, constantly drawing from the endless spring from which vibrant and lively ideas flow. . . .

As much by his age as by his gentle Virgilian genius, Corot personifies the enchanted arbiter between past style and contemporary light. From his *Study of Trees at the Villa d'Este,* painted with the precise spareness of his first manner and first trip [to Italy], to the powdery vagueness of the small *Road in Normandy,* via the rough *Mountains of Auvergne* and the *Clump of Chestnut Trees* in the Morvan, Corot was represented in Degas's collection by seven canvases. The pearl of the lot was *The Limay Bridge, near the Château des Célestins,* with its harmonious grisaille. As for the *Ruins of the Claudian Aqueduct,* its pink patches in the harsh Roman countryside rendered in unusual greens, it is one of those loyal nature studies that justify Poussin's bluish backgrounds and vast cloudy skies.

A small *Seated Italian Woman* reminds us that Corot was also a painter of human figures, foreshadowing Manet. Without renouncing Ingres, Degas surrounded himself with the contemporaries who were his friends: here, then, are 22 Manets, 10 extremely varied paintings, among which the *Ham* stands out for its admirable freshness of tone, without detracting from the *Departure of the Folkestone Boat,* from the Baudelairian *Portrait of Berthe Morisot,* from the *Indian Woman Smoking a Cigarette,* or from the remounted fragments of the *Execution of the Emperor Maximilian;* nor from the 12 pastels and drawings, among which *The Blue Sofa* gives so velvety a setting to Mme Manet's repose.

Eight works, including a watercolor, express the perseverance of Cézanne, who seemed to reinvent painting anew every time, and who, because of that, is of great interest to painters. Here are ten Gauguins: Tahitian and decorative impressions, surrounding a curious copy of the *Olympia;* and two older Van Goghs: flowers and fruits already gilded by the patina of time.

The evolution of the last century still counts a vigorous study by Théodore Rousseau dated 1830; a portrait dating from Millet's timid youth; a Ricard in advance of Fantin; and, except for Claude Monet, all the initiators of Impressionism after 1870, with an eloquent head by Renoir, three very rustic landscapes by Pissarro, the elegant and vaporous nimbleness of Berthe Morisot, the reflective solidity of Mary Cassatt, pastel-artist and painter of contemporary womanhood, not to mention Sisley, Guillaumin, John-Lewis Brown, Piette, and Caillebotte [fig. 402].

Among the numerous drawings, alongside an allegory by Tiepolo, a red-chalk drawing (still very eighteenth century) by David, the classical craft of the elderly Heim, and the inspired craft of Raffet,

Fig. 403. Federico Zandomeneghi (1841–1917), *Young Girl Writing*. Charcoal heightened with colored chalk, 20⅞ × 18⅛ in. (52.5 × 44.5 cm). Document Archives, Durand-Ruel. Collection Sale I: 246

Fig. 402. Gustave Caillebotte (1848–1894), *Yellow Roses in a Vase,* 1882. Oil on canvas, 21⅝ × 18⅛ in. (55 × 46 cm). Private collection, U.S.A. Collection Sale I: 7

we find the creative and distorting power of the great Daumier, who haunts his heirs: Forain, the painter of the *Tribunal,* and Jeanniot. And we meet the realism of Menzel; the suavity of Puvis de Chavannes and the sculptor Bartholomé; the tight style of Alphonse Legros; the highlighted drawings of Charles Serret (1822–1890), a friend of Millet's whose carefree childlike quality remains as unknown today as it was during his long, quiet life; and finally the lovely pastels of the Venetian Zandomeneghi [fig. 403], who died at the beginning of the year. And there are simple but superb *Studies of the Sky* in pastel that draw our attention to Eugène Boudin, whom Baudelaire lengthily praised at the end of his *Salon of 1859*—after having contrasted in his prose (like Degas in his collection) the rigorous mastery of Ingres with the *furia francese* of Eugène Delacroix.

[Published with prices for all works in the sale and with five illustrations: El Greco, *Saint Ildefonso;* Manet, *Gypsy with Cigarette;* Delacroix, *Arab Tracking a Lion;* Ingres, *Study for the "Portrait of Madame Moitessier";* Daumier, *Collectors at the Salle Drouot*]

Roger Fry, "A Monthly Chronicle: The Sale of Degas's Collection"
The Burlington Magazine 32 (March 1918), p. 118
On March 26 and 27 will be held by Georges Petits [*sic*] the sale of pictures belonging to the late Edgar Degas. We have received the

illustrated catalogue of this sale from Messrs. Lair Dubreuil, and it merits special notice. Most collections reflect, of course, in some way the characters of the men who formed them, but the selections made by the ordinary rich man who takes up collecting are generally formed by many conflicting desires. Here, on the contrary, there are only two motives apparent; one, friendly personal feeling towards artists whom Degas knew, and this accounts for certain secondary works; and two, Degas's insatiable and pure love of the highest artistic quality. This passion was in Degas so clear-sighted and discriminating that he was able to recognize quality under any aspect of style, and willing to accept it under the most diverse forms.

A mere list of some of the names which figure in the catalogue will show at once what an unfamiliar kind of collection this is— and it must be remembered that it is a small collection made by a relatively poor man, and not at all on the princely scale of the American financiers. I begin with the old masters—Cuyp, El Greco, Perronneau—then in the 19th century a number of Ingres, both paintings and drawings, Delacroix, Corot, Daumier, Manet, Pissarro, Sisley, Renoir, Cézanne, Gauguin, Van Goch [*sic*].

When one reflects that there are only 93 paintings, this is a surprising list. One may safely say that only an artist of rare critical power could have disregarded so completely the catchwords of the schools and the quarrels of the contemporary critics as to comprehend in his collection Perroneau [*sic*], Gauguin and Van Goch [*sic*].

But even more surprising than the wide sympathies and penetrating judgment which the list of names reveals is the actual quality of the pictures; in speaking of these I must go mainly by the illustrations in the catalogue, as my personal recollection of Degas's pictures depends on a single visit paid a good many years ago, a visit occupied mainly in the study of Degas's own works. In so many cases Degas has chosen pictures which, though rarely important or ambitious works, reveal the fundamental qualities of the painters at their purest and highest. There are, of course, more striking El Grecos than Degas's *S. Ildefonso Writing under the Dictation of the Virgin*, but few which reveal more startlingly his singular power of design.

Corot, I am sure, never did anything more austerely planned or more architecturally constructed than his *Pont de Limay*. The portrait of Baron de Schwiter throws for me an entirely new light on Delacroix's genius. I confess I found it hard to understand the enthusiasm of almost all great French painters for Delacroix, but this portrait makes me suspect that underlying what appears to us the tiresome romantic rhetoric of Delacroix's designs, there must be the same qualities which are here manifest enough.

The Ingres are all of the fresh and most uncompromising kind, whilst his collection of Ingres's drawings is almost impeccable.

Manet, too, comes out in almost a new light in his *Depart du bateau à vapeur* [*Departure of the Folkestone Boat*], and at the best of his more familiar moods in the *Portrait of M. X.* [*Monsieur Armand Brun*].

It seems a pity that the French nation is not able to keep together in the Louvre this magnificent collection, a collection chosen with a discrimination that no board of museum directors can ever hope to rival.

"Notes: Degas" ("Bloc-Notes: Degas")
Excelsior, March 22, 1918, p. 4

The collection of the great painter Degas, who died last year, will be sold several days from now.

It contains only excellent works of art, but of such divergent and contradictory tendencies that one is somewhat amazed to find them united.

Degas, who was a kind of rebel, seems to have wanted to defy public opinion by grouping them together.

Alongside very academic and very stilted portraits painted by Master Ingres are rustic images coarsely brushed by the great naïf Cézanne.

This singular jumble will certainly arouse curiosity, and fabulous auction prices are expected.

After the [sale of the] illustrious artist's collection, his own masterpieces will be sold.

There are quite a number of them. Degas kept hundreds and hundreds of canvases in his studio, stacked one on top of the other.

"Curiosities: The Edgar Degas Collection" ("La Curiosité: La Collection Edgar Degas")
Journal des débats, March 23, 1918, p. 3

The dispersal of the personal collection belonging to the admirable and delightful painter whom we lost last year will be the event of the season: collectors of modern painting will have the opportunity to fight over works of consummate beauty from the brushes of our greatest masters, such as *Delacroix, Ingres, Cézanne, Corot, Manet, Millet, Pissarro, Renoir,* and *Sisley.*

Fig. 404. Denis-Auguste-Marie Raffet (1804–1860), *Prussian Infantry*, 1851. Graphite, black chalk, watercolor, and gouache on buff paper, 16⅛ × 9⅞ in. (41 × 25 cm). Sterling and Francine Clark Art Institute, Williamstown, Mass. (834). Collection Sale I: 238

This remarkable grouping, complemented by watercolors, pastels, and drawings by *Daumier, Forain, Puvis de Chavannes, Raffet* [fig. 404], etc., as well as by two magnificent *El Grecos* and a charming portrait by *Perronneau*, will be exhibited on March 24 and 25 at the G. Petit gallery and sold on the 26th and 27th by Messrs. Dubourg and Delvigne, replacing Messrs. Lair-Dubreuil and E. Petit, who have been mobilized, and the experts Bernheim-Jeune, Durand Ruel, and A. Vollard.

"Degas Sale" ("Vente Degas")
New York Herald (Paris edition), March 23, 1918, p. 3

Tomorrow, Sunday, the Salle Petit will hold a private exhibition of the paintings collected by Edgar Degas, the famous painter who died last year. The sale of these paintings will take place after another day of exhibition, on Tuesday and Wednesday, under the gavel of Messrs. Lair-Dubreuil and Petit, assisted by the experts Bernheim-Jeune, Durand Ruel and Vollard. The collection contains 93 paintings and 152 pastels, drawings, and watercolors. Degas, a fervent

and passionate admirer of Ingres, had managed to acquire some twenty paintings by the master, as well as a large number of his drawings—thirty-four to be exact. Among the former, we should cite portraits of the Marquis de Pastoret, M. de Norvins, M. Leblanc and Mme Leblanc, as well as a slightly academic composition, *Angelica and Renaud* [sic]. The drawings include interesting studies of all kinds, as well as the portrait of a woman and that of the Forestier family. Eugène Delacroix also is abundantly represented, notably by a full-length portrait of Baron Schwiter, the historical and allegorical composition *Henri IV Entrusts the Regency to Marie de Médicis,* a sketch of the Battle of Nancy and of Christ in the tomb, as well as by numerous drawings and watercolors. Several landscapes by Corot, including *The Bridge of Limay* and *Clump of Chestnut Trees,* should also be mentioned. We should signal as well important works by Manet, one of which is a large portrait of a very well known Parisian gentleman, M. Armand Brun; paintings by Cézanne; and even, to venture further into the excessive style, some Van Goghs and Gauguins, including the latter's figure of a Tahitian woman that strikes me as the height of ugliness. Mary Cassatt, Berthe Morisot, Pissarro, and especially Forain also are represented in this collection (the last by numerous drawings), as are El Greco by two remarkable works and Perronneau by a woman's portrait in oils. The first sale of Degas's own works will be held on May 6, 7, and 8.

Pinturrichio [Louis Vauxcelles], "Studio Diary: M. Bonnat and Renoir" ("Le Carnet des ateliers: M. Bonnat et Renoir")
Le Carnet de la semaine 4, no. 146 (March 24, 1918), p. 7
M. Léon Bonnat came to Durand-Ruel's the other morning to see the collection of his friend Degas. We know that the two artists were friends in their youth, and a certain small portrait in the Musée de Bayonne bears witness to their camaraderie (the portrait is good . . . it is by Degas).[14] In the past thirty-odd years, the two saw little of each other, one having taken the road to glory, the other the path to the Institute. But M. Bonnat, while you know what he paints, has maintained a fine appreciation for art, and his house on the rue Bassano contains some marvels.

So, under the watch of the vigilant Prosper, M. Bonnat inspected the Ingres, Delacroix, Daumiers, Cézannes, and Van Goghs. Suddenly he stopped short before an admirable Renoir [*Mademoiselle Henriette Henriot*]. "How much will this painting go for?" asked the official portraitist. "Between twenty and thirty thousand [francs]." "That's not very much," replied M. Bonnat. "It's first-rate." It would be something for M. Bonnat to acquire a Renoir. Then again, why not? M. Flameng has a Velasquez; recently M. Legoût-Gérard was on the point of buying a nude by the master of Cagnes.[15] One can be a bad painter and still have good taste. . . .

"Talk of the Town: People Are Saying . . ." ("Nos échos: On dit que . . .")
L'Intransigeant, March 25, 1918, p. 2
This collection of works, assembled by the great painter Degas, that is for sale excites the lust of connoisseurs. The select few have been allowed to admire at Durand-Ruel's the *Portrait of a Young Man* [*Louis-Auguste Schwiter*] by Delacroix; two canvases by El Greco; three large portraits by Ingres, whose *Woman with a Scarf* [*Madame Jacques-Louis Leblanc*] is one of the most complete works by the artist; a *Woman at the Seashore* [*In a Villa at the Seaside*] by Berthe Morizot [sic]; an astounding Renoir [actually a Manet], *Woman in*

Gray on a Blue Sofa, which displays all the artist's virtuosity; a small Ingres, *Reclining Nude,* in the manner of Fragonard, etc.

There are drawings by Ingres that will go for insane prices at auction, and people will fight over the drawings signed by Degas, which the painter stacked in boxes, and many of which were utterly unknown, even to his closest friends. . . .

"The Degas Sale" ("La Vente Degas")
New York Herald (Paris edition), March 26, 1918, p. 3
The two-day exhibition of the Degas collection in the Salle Petit has once again proven that nothing can deter some of our citizens from their love of the arts, especially when some speculative interest is combined, for rarely does one see as large a crowd as yesterday and the day before at the galleries on the rue de Sèze. I would be surprised if the total sales were not in the neighborhood of a million and a half [francs].

On the rear wall, the place of honor was given to a large, full-length portrait of a man in frontal view, Delacroix's *Baron Schwiter,* which apparently was exhibited at the Salon in its day, and which the Louvre now covets.[16] The experts will no doubt ask at least 50,000 frs. for this beautiful portrait, slightly reminiscent in style of the masters of the old British school. Still, I have every reason to suppose that the portraits by Ingres will fetch the highest prices. In order of preference, I give first place to the portraits of M. and

Fig. 405. Paul Gauguin, *In Brittany,* 1889. Watercolor, gold paint, and gouache, 14⅞ × 10⅝ in. (37.7 × 27 cm). The Whitworth Art Gallery, The University of Manchester (D.1926.20). Possibly Collection Sale I: 177

Fig. 406. Jean-Baptiste-Camille Corot, *Road in Normandy*, ca. 1860–65. Oil on canvas, 7⅞ × 12 in. (20 × 30.5 cm). Collection André Bollag-Bloch, Switzerland. Collection Sale I: 17

Mme Leblanc, even though the paint for these two has cracked a little here and there. The portraits of the marquis de Pastoret, minister under Charles X, and M. de Norvins, Napoleon's biographer, also are bound to command high prices. On the same central panel, where the most important paintings in the sale generally are displayed, also figure two very interesting works by El Greco, *Saint Ildefonso Writing under the Dictation of the Virgin,* which Degas purchased in 1894 at the sale of the painter Millet's widow, and *Saint Dominic.*

Next to these are two more paintings by Delacroix, *Henri IV Entrusts the Regency to Marie de Médicis,* after Rubens, and the *Entombment,* which was in the Desfossés sale in 1899; and finally a bust of a woman by Perronneau, as well as a small landscape by Corot, *Road in Normandy*—though this work is not as important as another canvas by the same master, *The Limay Bridge, with the Château des Célestins,* originally sold at the Goupy auction in 1898. I should also mention among the Ingres a very small panel, 11 × 14 cm, *Nude Woman Seen from Behind, Reclining on a Bed with Blue Curtains,* the final price for which will no doubt be in inverse proportion to the work's dimensions. We also must note an interesting picture by Mary Cassatt, *Girl Arranging Her Hair;* a very good portrait of the young Ingres by Mlle Forestier; and *The Hunting Cry* by John-Lewis Brown. I will stop listing titles here, though not before adding that the thirty-four Ingres drawings, one of the great attractions of this collection, will be sold today, and the others tomorrow. I remain silent about the paintings by Gauguin and Van Gogh, whose merits I still cannot understand; as for the works by Manet represented here, they did not strike me as among the master's best.

Valemont, "The Big Auctions: The Edgar Degas Collection" ("Les Grandes Ventes, La Collection Edgar Degas")
Le Figaro, **March 27, 1918, p. 4**
The sale of the Edgar Degas collection began yesterday at the Georges Petit gallery. . . . The sale took place before an audience that was as numerous as it was brilliant, and despite everyone's preoccupations, the bids yielded results that show how much faith everyone has in our victory. . . .

"Life Is Expensive!" ("La Vie chère!")
L'Intransigeant, **March 27, 1918, p. 2**
At the Georges Petit gallery yesterday, you would never have known that "there's a war on." A happy, curious, chattering crowd rushed to the sale of the Degas collection.

The Ingres, notably, were fought over: the two portraits of the Leblanc family went for 235,000 francs; the Marquis de Pastoret for 90,000 frs.; the large portrait of a young man by Delacroix for 80,000 frs.; a small female nude by Ingres, in the manner of Fragonard, for 19,500 frs.

Repercussions of the expensive life: a ham (appetizing, for that matter) by Manet [went for] 30,600 frs.; an apple and a glass by Sézanne [*sic*], 24,500 frs.; a selection of fruit by Van Gogh, 16,000 frs. And to decorate the sumptuous table on which meals for billionaires are served, two sunflowers by Gauguin [actually by Van Gogh] for 19,200 frs.

The sale raised a million and a half [francs]. Where do the dealers—who did most of the buying, often as proxies—find all that

money? If they are acting on behalf of American or Allied collectors, that's all well and good! But we would like to see a review of all these paintings in three or five years to know where they ended up.

"The Degas Sale" ("La Vente Degas")
New York Herald (Paris edition), March 27, 1918, p. 3

Despite the circumstances surrounding these events, the sale of the Degas collection attracted a considerable crowd of dealers, collectors, and onlookers to the Salle Petit—so many that at a certain point it was difficult to enter the auction room. Prices rose with extraordinary speed under the direction of M. Dubourg, assisted by the experts Durand Ruel, Bernheim-Jeune, and Vollard, and total sales reached 1,605,000 frs., surpassing even the most optimistic projections.

Ingres's works were the stars of the day, and in the forefront, as I had predicted, were the portraits of M. and Mme Leblanc, the object of spirited bidding between M. Nicolle of the Trotti firm and M. Durand Ruel; they were finally sold to the latter for 235,000 frs. The portrait of the marquis de Pastoret, for which the experts asked 75,000 frs., went for 90,000 to M. Lair-Dubreuil on behalf of an anonymous collector.

M. Knoedler bid 70,000 frs. for the portrait of M. de Norvins. The portrait of Baron Schwiter, by Eugène Delacroix, also was purchased by Knoedler for 80,000 frs., the Louvre having been the underbidder. Among the other paintings by Delacroix . . . the *Entombment*, 52,000 frs., to M. Rosenberg, art dealer; *The Comte de Mornay's Apartment*, 22,000 frs., to the Louvre.

Other works by Ingres also commanded high prices. The very small painting, *Nude Woman Reclining on a Bed with Blue Curtains*, was sold for 19,500 frs. to Mme. Cabanel. . . . And considerable sums were paid for all the others.

As for Manet's works, they went for extremely high prices. *The Departure of the Steamboat*, 40,500 frs. to Mr. Trotti, who also acquired the portrait of *Mr. X—(M. Armand Brun)*, for 31,000 frs. *The Ham* sold for 30,600 frs., *The Execution of Maximilian*, for 23,200 frs.

Meanwhile the Gauguins commanded prices that I cannot understand and that defy all common sense. *The Tahitian Woman [The Moon and the Earth (Hina Tefatou)]*, a true horror, was sold for 14,000 frs.; *Seated Woman [Sulking (Te faaturuma)]* for 14,100 frs.; *Tahitian Women Bathing [Day of the God (Mahana no atua)]* for 12,600 frs. . . .

The works by Cézanne that attained the highest prices: *Venus and Cupid*, 16,200 frs.; a *Portrait of the Artist*, 30,500 frs.; *Bather at the Seashore*, 23,000 frs.; *Apple and Glass*, 24,700 frs.; *Portrait of M. Chocquet*, 22,500 frs. Here again, we see an inflation beyond all reason.

But just as appalling are the prices paid for two paintings by Van Gogh: one depicting apples, pears, and lemons was sold for 16,500 frs., and the other, whose subject is two sunflowers, for 19,200 frs. Sisley's *The Flood*, whose pictorial qualities are far superior to the other eccentricities that went for higher prices, did not fetch more than 15,000 frs. And Corot's charming landscapes brought in only these prices: *The Limay Bridge*, 20,500 francs; *Clump of Chestnut Trees*, 23,500 francs; *Road in Normandy*, 6,600 frs. [fig. 406]. The portrait of Ingres by Mlle Forestier reached 8,000 frs., and J.-L. Brown's *The Hunting Cry*, 5,700 frs.

The sale will conclude today with older paintings, pastels, and drawings, which will bring the total for the auction well above my estimated 1,500,000 frs.—a figure that already seems rather high to me.

[Much of this account later appeared in English in "Details of Sensational Degas Vendue in Paris," *New York Herald*, May 12, 1918, "L. & L." section, p. 5.]

"Talk of the Town: The Degas Collection" ("Nos échos: La Collection Degas")
Le Siècle, March 27, 1918, p. 2

They are going to sell off the Degas collection; for there was—and still is—a Degas collection.

But did the public know about it? . . . No! Since the most reclusive of painters never showed it to any but a few close friends.

First and foremost, there are twenty paintings and thirty-three drawings by Ingres in the Degas collection.

There are thirteen paintings and fifty-six watercolors by Delacroix, among them *Count de Mornay's Apartment*. There are Manets and Corots.

There are also Degases. And they won't be the least expensive items for sale, either. . . .

"Sale of Degas Collection"
The Times (London), March 27, 1918, p. 5

The collection of modern and ancient paintings, water-colours, and drawings formed during his lifetime by the artist Degas is now being sold in Paris at the Georges Petit Galleries. The sale is beginning with the modern works.

Fig. 407. J.-A.-D. Ingres, *Bust of a Man (Noël-Thomas-Joseph Clérian)*, 1814. Graphite with white chalk, 7¾ × 5⅞ in. (19.8 × 14.9 cm). Private collection. Collection Sale I: 209

Among the biggest bids were:—Cézanne's portrait of himself, £1,220; his *Bather*, £920; his *Apples and Glass*, £988; Corot's *Clump of Chestnut-trees*, £940; Delacroix's *Portrait of Baron de Schwiter*, £3,200.

Ingres's works, of which there were nearly a score of examples in oils, fetched high prices, the chief at the moment of telegraphing being the portraits of Mme. Le Blanc, £10,800; M. Le Blanc, £2,240; and the Marquis De Pastoret, £3,600. There were numerous Ingres drawings, of which *A Man's Bust* [*Bust of a Man (Noël-Thomas-Joseph Clérian)*; fig. 407] fetched £500, and *The Forestier Family*, £724.

The sale will be continued to-morrow.

Valemont, "The Big Auctions: The Edgar Degas Collection" ("Les Grandes Ventes: La Collection Edgar Degas")
Le Figaro, **March 28, 1918, p. 2**
The first day of the sale of this collection at the Georges Petit gallery yielded a total of 1,605,075 francs. The second session, which was held yesterday under the direction of Messrs. Lair-Dubreuil and Edmond Petit, assisted by the experts Bernheim-Jeune, Durand Ruel, and Vollard, took place . . . with equal success and ended on a grand total of 2,055,075 francs.

"Curiosities" ("La Curiosité")
Journal des débats, **March 29, 1918, p. 2**
The sale of the Degas collection ended on a total of 1,966,220 francs. One of the highest prices in the second session was fetched by a pastel, *Mme Manet on a Sofa* by Manet, which sold for 62,000 francs to the Louvre. The Louvre also purchased a drawing, *Study of a Nude* by Millet for 520 frs.; and four watercolors by Delacroix: *Flowers* (*Hydrangeas and Lilies*) [fig. 408] for 2,800 frs., *Young Arab Musician* [by Edmond Dehodencq, erroneously listed in the Degas sale catalogue as by Delacroix] for 1,650 frs., *Strait of Gibraltar* for 3,300 frs., and a *Cloud Study* for 1,700 frs. A drawing by Daumier, *The Tribunal*, went for 13,600 frs.; *The Loge, Woman with a Fan*, a pastel by Mary Cassatt, for 10,000 frs.; *Arab Stalking*, a pastel by

Delacroix, for 8,100 frs.; *Pears*, a watercolor by Cézanne, for 4,400 frs., etc.

Of the four older paintings that completed this magnificent collection, *Saint Ildefonso Writing under the Dictation of the Virgin* and *Saint Dominic* by El Greco went up to 82,000 and 52,500 frs., respectively, and *Bust of a Woman* by Perronneau to 32,100 frs.

"Degas Sale" ("Vente Degas")
New York Herald **(Paris edition), March 28, 1918, p. 3**
The second and last session of the Degas sale yielded 361,155 frs., which brings the total to 1,966,220 frs., a result surpassing every expectation. The gap between this and reasonable estimates seems to me to be due to the inflated prices paid for the works of Cézanne, Gauguin, and Van Gogh. Yesterday the sale included four older paintings, which sold very well: *Saint Ildefonso* by El Greco went for 82,000 frs., although its estimate was 30,000 frs.; *Saint Dominic*, by the same painter, sold for 52,500 frs.; Perronneau's bust of a woman for 32,100 frs.; and a saddled horse, by Cuyp, for 800 frs. . . .

"Art Sale in Paris Best of War Time: Edgard [*sic*] Degas' Collection Brings $320,000 Despite Raids and Bombardment"
New York Herald, **March 28, 1918, section 2, p. 7**
While Paris was afflicted by raids of German airplanes and bombarded by the German long distance guns yesterday the art collection of the late Edgard [*sic*] Degas was dispersed at auction. The proceeds were 1,600,000 f. ($320,000). The results exceeded the expectations of experts, and the sale is regarded as the most important of its kind held in Paris since the war began.

The works of Jean D. A. Ingres fetched the highest prices. A pair of portraits of Monsieur et Madame Leblanc brought 235,000 f. ($47,000). Portraits of Marquis de Pastoret and Monsieur de Norvins brought respectively 90,000 f. ($18,000) and 70,000 f. ($14,000).

A portrait of Baron de Schwitzer [*sic*] by Eugene Delacroix was sold for 90,000 f. ($18,000). One of Cézanne, by himself, brought

30,500 f. ($6,100). Several paintings by Edouard Manet sold for from 25,000 f. ($5,000) to 40,000 f. ($8,000).

[Similar versions of this article, based on an Associated Press report, appeared as "Degas Collection Sold; Shelling of Paris Fails to Interfere with Art Sale," *New York Times,* March 28, 1918, p. 11, and "Degas Collection Sold," *American Art News* 16, no. 25 (March 30, 1918), p. 1.]

"Talk of the Town: The Degas Sale" ("Nos Échos: La Vente Degas")
Le Siècle, March 29, 1918, p. 2

Nothing impeded the sale of two million francs' worth of paintings yesterday and the day before.

And this sale proved, once again, the official juries' lack of understanding.

For example, the Delacroix (the portrait of Baron Schwiter), which was sold for 80,000 frs., had been rejected by the Salon.[17]

This [auction] even proves that the dealers don't know any more than the juries, since El Greco's *Saint Ildefonso,* which took in 82,000 francs, had been bought by Millet for 20 francs.

Which also proves that it is the painters who are the real connoisseurs.

"Arts and Curiosities: The Degas Collection" ("Art et curiosité: La Collection Degas")
Le Temps, March 29, 1918, p. 3

Throughout the entire bombardment by the monstrous cannon, Paris kept smiling. If proof were needed of its serenity, its calm and confidence, it could be found—and so convincingly!—in the passionate attention with which collectors and dealers followed the auctions of the Degas sale in the Georges Petit gallery yesterday and the day before.

It was on Tuesday that the highest bids were reached, sums that were almost always considerably greater than the estimates. They certainly were selling paintings that day, and what paintings! On one hand, masters of the first half of the nineteenth century: Corot, Ingres, Delacroix; on the other, those of the end, Manet, Berthe Morisot, Gauguin, Pissarro, Renoir, and Sisley. A small canvas by Corot, *Road in Normandy,* went for 6,600 francs; his *Ruins in the Roman Countryside* for 5,600; and his landscape of Morvan or the Auvergne, *Clump of Chestnut Trees,* for 23,500. Daumier's *Seated Man [Don Quixote Reading]* was sold for 20,000 francs.

As for the series of Delacroix, here are the prices: the *Portrait of Baron Schwiter,* which the national museums pushed to 79,000, was bought for 80,000 by M. Knoedler. It will go to America. Its place is in the Louvre, where there are no portraits by the master. The work is certainly not without faults, like any youthful work of even the most gifted artist, but it is as characteristic as can be, and it is extremely regrettable that our museums did not make the necessary effort. *Count de Mornay's Apartment,* for which the Louvre paid 22,000, is surely a charming canvas but does not compensate for the loss of the other. *The Battle of Nancy* was sold for 31,000 to a Danish collector, who had already acquired Corot's *Chestnut Trees;*[18] and *Christ in the Tomb* [was sold for] 52,000 [frs].

So much for the high prices fetched by Delacroix. Now for Ingres. His *Marquis de Pastoret* sold for 90,000; his *Norvins* for 70,000; and his portraits of *M. and Mme Leblanc* for 271,000. The master's very beautiful studies for *Jupiter and Thetis* or for the *Apotheosis of Homer* were bought for between 5,000 and 9,000.

The Gauguins commanded prices ranging from 8,000 to 15,000. The *Portrait of Cézanne,* by the artist himself, went up to 30,500; his *Bather* to 23,000; his *Portrait of M. Chocquet* to 22,500; and a still life, *Apples and Glass,* to 24,700. *Sunflowers* and *Apples, Pears, Lemons, and Grapes* by Van Gogh were sold for 19,200 and 16,500, respectively.

The Manets went for royal sums: 40,500 for *The Departure of the Folkestone Boat,* bought by Denmark; 31,000 for *Portrait of M. X. . .* [*Monsieur Armand Brun*]; 30,600 for the *Ham;* 27,600 for the portrait of *Mme Berthe Morisot;* 25,500 for *Woman with Cat;* 32,000 for *Indian Woman Smoking.* A Berthe Morizot [*sic*] of exquisite delicacy, *Woman and Child in a Meadow,* fetched 27,000, and a *Woman's Head* by Renoir, 32,000.

Drawings by Ingres were also sold during the Tuesday sale. They had no less success than the paintings, and someone paid 14,000 francs for a charcoal sketch—a pure marvel, incidentally—depicting a nude woman, a study for the *Odalisque. . . .*

The first day yielded proceeds of 1,605,075 francs; the second, 361,155 francs. The total was 1,966,230 francs.

"Degas Sale Continued: Highest Prices for Ingres"
The Times (London), March 29, 1918, p. 3
(From our own correspondent, Paris, March 27)

At the sale of the Degas collection yesterday £64,000 was realized. Delacroix's *Apartment of the Comte de Mornay* was bought for £880 by the Louvre. This is the only State purchase.

Among the sales to be noted was the £640 given for Gauguin's *Tahiti* and *Martinique,* which 20 years ago were worth not more than £160.[19] A copy of *Olympia,* by Manet, fetched £5,040. The Manets brought in anything between £1,000 and £1,600. His *Pear,* measuring 8-1/2 in. by 6 in., reached the remarkable price of £258.

The credit of achieving the greatest success of the sale rests with Ingres, whose *Marquis de Pastoret* and *Monsieur de Morvins* [*sic*] fetched £3,600 each, whilst the portraits of Mme. and M. Le Blanc, as previously stated, went for £10,800 and £2,240 respectively. It is a matter for satisfaction here that the majority of the pictures remain in France.

To-day five masterpieces, in addition to drawings and watercolours, were sold. Greco's *St. Ildefonse Writing at the Dictation of the Virgin* and *St. Dominic* fetched £3,280 and £2,100 respectively. Perroneau's [*sic*] *Woman's Bust* was sold for £1,200.

Among the drawings Daumier's *Tribunal* fetched £660, Delacroix's *Arab Stalking* £320, Manet's *Portrait of his Wife* £250, and Morisot's *Woman and Child in a Meadow* £220.

"Art Sales in War Time"
American Art News 16, no. 25 (March 30, 1918), p. 4

It was a surprise to learn by cable on Thursday morning that with Paris actually under bombardment from the "mystery gun" and airplanes, the sale of the art treasures owned by the late Edgar Degas should have taken place in that suffering city as scheduled, and was moreover unexpectedly successful.

This was certainly convincing proof, if such were needed, not only of the bravery and sang froid of the French, but of their devotion to art matters.

It will be interesting to know whether or not the sale of the art collections of the late Baron Oppenheim, announced to be held in Berlin this week, took place.[20] It seems almost incredible that the attention, even of collectors and buyers from neutral countries, could have been directed to art sales, no matter of what impor-

tance, with this "great battle in the West" raging. This battle, which, if ever there was fought one on which the fate of civilization hung, the greatest in history, and on whose result the entire world waits with baited breath, would have been thought likely to have too completely absorbed men's minds to permit their giving attention to other matters. . . .

Le Veilleur [The Watchman], "The Pont des Arts" ("Le Pont des Arts")
Excelsior, March 30, 1918, p. 4
At the Degas sale, Manet's pastel *Mme Manet on a Sofa* was bought by the Louvre. It is a true masterpiece.

L. Dimier, "The Arts during the War: The Degas Collection" ("Les Arts pendant la guerre: La Collection Degas")
L'Action française, April 2, 1918, p. 4
When a man such as Degas leaves behind a collection, one is curious about more than the pieces themselves; one seeks to measure the taste of the artist who assembled them.

With the knowledge that Degas had of his art, let us admit to have expected a more decisively superior ensemble. Much of it was good to average; the only truly stellar things were one Corot and his Manets. The master's famous worship of Ingres was on full display in a series of studies by the latter, some of which were interesting and beautiful, and in some less well chosen paintings. One of these paintings, a version of *Roger,* was actually rather poor. The portraits vied among themselves for first place in ridicule and failure. The Leblanc couple, the pallid reflections in their faces worthy of Girodet, frankly represented the dregs of that art, and viewers in high spirits no doubt had a good laugh at M. de Pastoret's skinny torso bound into a black suit, crowned with a fat head like the knob of an umbrella.

Degas was on close terms with the late Henri Rouart, the collector who made his reputation. Common tastes brought them together, and also a certain ostentation in these tastes. One might therefore expect similar possessions; but not so. With the collector, the finest discernment reigned over even the most unexpected choices, whether of some forgotten older painter or of the most scandalous modernist. The artist, on the other hand, faltered in this area; he lacked the necessary sureness to venture onto these outer limits of taste, where every rule becomes pointless, where one judges on a case-by-case basis, where one must take full responsibility for one's convictions and say *that's good* or *that's bad.*

Whence the presence in this collection of a rather dull woman's head by Millet; whence, at the other extreme, a display of Gauguins about which the most one can say is that they are not exactly beautiful.

Only one, an island landscape dated 1887 [*Martinique Landscape (Allées et Venues)*] might seduce art lovers with its marriage of opulent greenery and precious reds that indicate the presence of rooftops in the foliage. But as for the rest, what sinister wares of the dealers! And how odd to see such an artist fall so wholeheartedly into bourgeois snobbery! Perhaps too great an inclination to jeer at the bourgeois, willfully to run counter to its tastes, had led him there: nothing is so bourgeois as a hatred of the bourgeois, and nothing more surely throws us into the worst kind of ridicule than rage at not being like them.

Let us look at who bought what, and beyond: to Corot's *Chestnut Trees,* a work executed in the finest style, like that of the

Villa d'Este in the Rouart collection.[21] The foliage is modeled with unparalleled perfection, the surface planes arranged with precision, the various parts joined together with inexpressible strength. Moreover, nothing could show better than this piece the relations between Corot and the old school of French landscape painters: Bertin, Michallon, and later Aligny.

The collection of Manets shone mainly in three works, which, for those who had never seen them, will add considerably to our knowledge of and respect for the master. One is the *Indian Woman with a Cigarette,* in an admirable warm red palette. Certain paintings by Frans Hals produce a similar effect. This is practically the only painting by Manet that can be likened to that master, but it shows no strain of imitation. *Woman with a Cat* is just a sketch, although almost life-size, but what freshness, almost reaching the point of brilliance! Finally, the pastel of Mme Manet stretched out on the sofa with her feet together is so polished that one does not know how to begin praising it. As with the Dutch, the perfect finish does not diminish from the atmosphere, and there is a freshness of tone that is almost unknown in such compositions.

Someone remarked to me: That is a loud blue. It is true, but it is loud in a very natural way, which makes it enchanting. Note that this is one of Renoir's effects, rather than Manet's; but Renoir never did it so well.

I will not conclude this article without mentioning an interior by Delacroix: *Count de Mornay's Apartment,* which won everyone over with its brilliance, delicate perspective, and careful execution.

Some of the bids were not very interesting, others were fairly ridiculous. The beautiful Corot [*Rocky Chestnut Wood*] was sold for 23,500 francs; Manet's *Indian Woman* for 32,000; Delacroix's interior for 22,000, to the Louvre. Gauguin's maggots sold for between 12,000 and 14,000; those of Ingres—I mean the Leblanc couple—for 270,000 francs, the pair. The *Blue Sofa* by Manet went for 62,000 francs. It is the only work that was sold at its true value. Let us congratulate the Louvre for having bought it as such.

"The Week"
The Nation 106, no. 2753 (April 4, 1918), p. 387
The sale of the Degas collection in Paris gives practical proof again of the oft-repeated assertion that artists are often the best judges of paintings. An artist's own manner may indicate to us no more than his limitations. Coleridge proved his universality more as appreciator of literature than as poet. Masefield does not let his own peculiarities of style blind him to other aesthetic values. And now it appears that Degas, who painted in a narrow vein, was a collector of catholic taste and sound discrimination. Pictures of almost all the modern schools, Ingres, Delacroix, Manet, appear in the sale catalogue. That they are excellent examples is proved by the prices they fetch in spite of the bombardment of the capital which the bidders can hear from the auction rooms. This sale is, in respect of evenness of merit, in contrast with that of the collection of a well-known connoisseur, not an artist, which was recently held in New York.[22]

"Foreign Art Sales in War"
American Art News 16, no. 26 (April 6, 1918), p. 4
The recording for our readers of the results of the important art sales scheduled for last week in Paris and Berlin, under the present conditions, the great battle on the Western front—still undecided—and the consequent congestion of European cables, is both difficult and unsatisfactory.

Fig. 409. Attributed to Alphonse Legros, *Young Women in a Garden.* Oil on canvas, 35¼ × 28 in. (89 × 71 cm). Musée des Beaux-Arts de Dijon (4098). Collection Sale I: 71

While our Paris correspondent, as well as the Associated Press, sent over, just in time for our issue of March 30, the result of the first day's sale in Paris, March 26 last, of the pictures owned by the late Edgar Degas, both failed to send (and noone [*sic*] here has received) the result of the second day's sale, March 27, while we have been unable to get any word as to whether or not the Oppenheim sale, scheduled for March 28–29 in Berlin, took place.

Further than this the cabled reports of the first session of the Degas sale were incorrect, inasmuch as they gave the total as 1,000,000 francs, when it was really 1,600,000 francs, a decided difference.

The prices at this Degas sale, held while Paris was under bombardment from airplanes and the "mystery gun," were astonishingly good. The two fine portraits by Ingres of M. et Mme. Le Blanc were purchased by Durand-Ruel, for a client, for the surprisingly high figure of 270,000 francs, which, with the selling tax of 10%, made them bring some 297,000 francs, or approximately nearly $60,000.

Arsène Alexandre, "Essay on Monsieur Degas" ("Essai sur Monsieur Degas")
Les Arts 14, no. 166 (1918), pp. 2–24 [excerpt from pp. 12, 21–23]

It was a rare treat, after a dinner [with Degas], to leaf through his boxes of drawings by Ingres and Delacroix—whom he called "the least expensive of all the great masters"—for that was the period when he became an avid collector. From that point on, the two floors of the rue Victor Massé became crowded with large portraits by Ingres: *M. and Mme Leblanc, M. de Pastoret, M. de Norvins*, plus a portrait of *Baron Schwiter* by Delacroix, paintings and drawings by Manet, and works by Gauguin and Cézanne. . . . Later on I will provide more details about the collection, which here would only lead us further astray from the portrait we have begun.

. . . If [Degas] had not been well known as a painter, he would have become famous as a collector—after his death, of course, for he allowed very few people to share his joys. The proud modesty that was one cause of his isolation (and I mean *modesty* in an essentially intellectual sense) would have made him suffer too greatly to

hear inanities spoken before the objects he had chosen. The person who collects out of vanity is not particular about the quality of his audience. The collector who *knows* and *loves* does not tolerate such promiscuity.

During a certain period (between 1892 and 1900), Degas put so much ardor—we might almost say so much *furia*—into his artistic acquisitions, that one day at a public auction I saw him top his own bid. The auctioneer, M. Chevalier, was honest enough to point it out to him; if not for that, who knows what would have happened?

Auctions nourished his collection, but they were not alone. Various sources provided him with some Manets and a fair number of drawings by Ingres and Delacroix, as well as various Cézannes, not all of which he kept. When it came to [the work of] his contemporaries, he bought through an agent, and when one day he conceived a fancy for Gauguin—who would be well represented in his collection, as we shall see—he acquired them indirectly. It even happened that Gauguin, who fancied himself a savage Inca, was utterly floored when he learned that his first important work had been sold to a master artist for whom he feigned respect tinged with sarcasm. "I am quite astounded by Degas's decision," he wrote, more with unspoken satisfaction than ill-concealed astonishment.

In short, the great painters who have pride of place in this collection are Ingres, Delacroix, and Manet; then El Greco. Nor should we forget that Berthe Morizot [*sic*], for whom the entire Impressionist and Independent group felt such great affection and such justifiable admiration, is also represented by one or two sketches, as well as in effigy with her dramatic portrait by Manet. But I do not wish to provide further detail, for my task here is not so much to explore a collection that will soon be offered for sale, as to seek out the ways in which it more deeply explains Degas and what we might call his artistic motives.

Fig. 410. Mary Cassatt, *Little Girl with Brown Hair, Looking to the Left,* ca. 1913. Pastel on cardboard, 19¾ × 19 in. (50.2 × 48.3 cm). Private collection. Collection Sale I: 103

The Ingres (with *M. de Pastoret, M. de Norvins, M. and Madame Leblanc,* a version of *Roger and Angelica,* and a quantity of handsome drawings) represent something like a youthful debt toward the works of the strict master that had helped form him, and that he had, toward the middle of his career, surpassed while continuing to greet them respectfully. These paintings, of high quality, in which a kind of classical majesty, an integrity and a severe taste almost make us forget their coldness, remained in his memory, perhaps [used as a] means of control, or rather as devotional objects inspiring true ardor. There was too wide a divergence [between this work and his own.]

The proof, moreover, is that Delacroix, Manet, Gauguin, even Cézanne and Van Gogh are in the majority here, not by chance, but as part of [Degas's] evolution. A fascinated and exclusive lover of Ingres would not easily have admitted these neighbors. Regarding Delacroix, it is more than a similarity of objectives and temperament, but rather the attention paid by one nature of great distinction to another, very different nature also of superior distinction. The portrait of *Baron Schwiter,* the most important piece of this part of the collection, and *The Entombment,* the most dramatic piece, are complemented by a large group of drawings, which I know for a fact Degas truly admired and which certainly, in the later part of his production, stimulated him much more than the drawings of Ingres, who had inspired his beginnings.

As for Manet, it was the memory of years of struggle in the company of a charmer and, at the same time, a veritable admiration for his technical serenity. Even before he acquired the *Ham*... I remember him talking to me, in the tones of a gourmet, about the "essence of art flowing before" the painting. In the same way, I saw him around 1894, agitated, like a young man fretting over his first love, out of fear that the ravishing pastel *Mme Manet on a Blue Sofa* might get away from him.

I have already said enough about Gauguin, who here puts such felicitous and subtle docility into his study of Manet's *Olympia.* There are other valuable pieces as well, such as the Legros [fig. 409] and the two El Grecos, which [Degas] liked because they linked his taste to that of Millet, to whom they had belonged,[23] and to his friend H. Rouart, who had several typical ones in his collection. Finally, I will say that he acquired works by Cézanne in a fit of curiosity, and that he let go the most important of these in a similar fit of indifference. But we have delved into this collection only by way of explanation. . . .

[Published with 14 illustrations: El Greco, *Saint Dominic;* Ingres, *Roger Freeing Angelica;* Delacroix, *The Entombment;* Gauguin, *The Beautiful Angèle (Madame Angèle Satre), Olympia (copy after Manet);* Manet, *The Ham, Berthe Morisot, Monsieur Armand Brun, Madame Manet on a Blue Sofa, Gypsy with Cigarette;* Cézanne, *Victor Chocquet;* Renoir, *Mademoiselle Henriette Henriot;* Van Gogh, *Two Sunflowers.*]

Pinturrichio [Louis Vauxcelles], "Studio Diary: King Lear; Living [Artists] in the Collection; Manets in the Collection" ("Le Carnet des ateliers: Le Roi Lear; Les Vivants de la collection; Les Manets de la collection")
Le Carnet de la semaine 4, no. 148 (April 7, 1918), p. 8
King Lear. Arsène Alexandre, speaking of the last moments of M. Degas's life, tells us that the old man, having become blind, would leave [his apartment on] the boulevard de Clichy every afternoon and walk aimlessly and with great strides throughout Paris, not

stopping until nightfall. He returned home very late, and the few people with whom he still associated often feared that some harm had befallen him. But M. Degas would not allow himself to be accompanied on these headlong journeys. Like an old King Lear of painting, he left, chased from his home by a horror of solitude; he admitted that his despair at no longer painting and his dread of death haunted him to the point of obsession.

After an expropriation forced [Degas] to leave his double apartment, his collection became jumbled: El Greco with Perronneau, Gauguin next to Ingres, on the floor, in the studio. No one had the right to touch them, to turn the canvases over or dust them.

Is there anything more pathetic than the final days of this misanthropic, lonely artist, refusing to talk to a living soul, dying without children or household, among masterpieces that his eyes could no longer adore? We are reminded of the death of the great Tolstoy, who ran away one night, haggard and wild, and who was found half-naked, shivering with cold on the bench of a Russian train station.

Living [Artists] in the Collection. For a living painter, it is a consecration to have figured in the Degas collection. The taste of the old, severe artist was actually of exquisite purity, and he let no Gervexes or Scotts into his house.[24] The rare living artists whose works M. Degas had chosen were Miss Cassatt, Renoir, Bartholomé, Forain, Jeanniot. As for Renoir, nothing surprising there. For Bartholomé, whose painting is little known and who possesses a discreet charm, we know that the eminent author of the *Monument to the Dead*[25] was a close friend of M. Degas, perhaps the only one with whom he never fell out. Forain was "the student," and the master appreciated his drawings more than his paintings. Miss Mary Cassatt, the famous American, was also one of his intimates. She is a woman of the highest culture who has long resided in France, a friend of our Impressionists. And, finally, Jeanniot, who had the honor of seeing his best painting, *The Recruit's Medical Examination,* hung in the rue Victor Massé. If life had not forced him to "create illustrations," Jeanniot might have numbered among our strongest realists. He was encouraged by Manet and Degas. In his youth, while he was still an infantry officer, he took the chance of submitting his work to Manet; the latter told him, "My friend, you're one of us." And that simple remark filled him with justifiable pride.

With regard to the Degas collection, one of our colleagues, in the course of an otherwise admirable magazine piece on the painter of the *Dancers,* wrote that Degas, having owned large compositions by Cézanne, "got rid of them with indifference" [see article by Arsène Alexandre, above]. Nothing could be less certain. Degas appreciated Cézanne for his talents, and the latter's portrait of *Chocquet* is every bit as beautiful as the portrait of the same Chocquet by Renoir.[26] Moreover, the elevated prices paid for the Cézannes in Degas's collection clearly show that this magnificent colorist has not fallen into disfavor. On the contrary.

Manets in the Collection. Manet, as is only normal, triumphed at the Degas sale. Do people know that this prodigious painter was a man of exceedingly caustic wit? His sallies and retorts are equivalent to Degas's remarks, though are never quite so corrosive. He spoke plainly and soberly, the way he painted. . . .

B. D., "Paris Letter"
American Art News 16, no. 27 (April 13, 1918), p. 5

Except for a few of the pictures in the recently sold Degas collection it might easily be inferred that the collection was made in a rather

Fig. 411. J.-A.-D. Ingres, *Portrait of a Woman (Madame Poussielgue, née Elisa Leblanc),* 1834. Graphite, 12⅝ × 9⅜ in. (32.2 × 23.8 cm). Collection Jan and Marie-Anne Krugier-Poniatowski. Collection Sale I: 205

haphazard manner. It neither indicated any pronounced prejudice, nor any fixed, narrow lines of choice. It is surprising that it was not more comprehensive. But one may conclude that Degas was actuated as much by his needs as by his likings. In other words, he had around him such examples as were useful to him in his work, just as a writer has such books of references most at hand as serve him most.

Pinturrichio [Louis Vauxcelles], "Studio Diary: Final Mention; How to Run a Good House" ("Le Carnet des ateliers: Dernier Écho; Comme on fait les bonnes maisons")
Le Carnet de la semaine 4, no. 149 (April 14, 1918), p. 8

Final mention. At the henceforth famous sale of the Degas collection, a portrait of a man, from the eighteenth century, unsigned, was acquired for a very reasonable price by one of our leading dealers in modern art. A few people were surprised that this dealer should have bought a canvas so different from what one normally finds in his gallery. The people who noticed this small mystery are not mistaken. In fact, that anonymous portrait was nothing other than the copy of an old painting by M. Degas himself.[27] Now, if the original was hardly worth more than the price paid, a copy of it by Degas—at the rates being offered for the late master's works—is worth twenty times as much. The dealer was therefore wise. He saw clearly, which is not always the case among his colleagues, some of whom have recently purchased paintings by an Impressionist who

died ten years ago, paintings that to their dismay are being challenged by the experts. . . .[28]

How to run a good house. The Louvre bought a delightful little Delacroix at the Degas auction. Well done. It would have been better to buy Delacroix years ago, when they could be obtained more cheaply. It is a tradition among our museum curators always to be half a century behind. . . .

"Talk of the Town: Mr. X . . . , by Manet" ("Nos Échos: M. X . . . , par Manet")
Le Cousin Pons 3, no. 46 (April 15, 1918), p. 363

People have been wondering who served as the model for this portrait by Manet, which was bought from the Degas collection for 31,000 francs.

At the time he painted it, Manet was keenly interested in the problem of outdoor portraits. One of his friends gladly lent himself to a test of Manet's theory, but he was not very satisfied with the result, and left his image with the great painter. Thus Degas became the beneficiary of that very interesting canvas.

These things happened in the good old days of the Nouvelle-Athènes, when Manet, Degas, Stevens, Desboutins, Duranty, and others would gather in the back room of the café, and the passionate arguments that took place there would establish the laws of artistic evolution.

Monsieur X…, who rejected the portrait by Manet in the Degas sale, prefers that his name not be revealed. He no doubt regrets having underestimated the image the great painter made of him. But I should also say, in defense of the dissatisfied model, that Albert Wolff and Henri Rochefort were no more satisfied than he was with the portraits Manet painted of them, in the open air of which he was so fond.[29]

A. Damécourt, "Auction Chronicle" ("Chronique des ventes")
Le Cousin Pons 3, no. 46 (April 15, 1918), p. 367

In my last article I predicted the huge success achieved by the sale of the Degas collection, the total of which was over 2 million [francs]. And yet this sale took place during a particularly tragic week, and, one may say, to the sound of "Boche" cannons bombarding the capital. But the fire of the enemy did not stop the bidding, and collectors and dealers, maintaining their serenity, bid on Impressionist and academic works with the same calm as if the sale had been held in times of peace.

I have already spoken of the paintings themselves, so there is no need to say any more about them.

Regarding the drawings, the Louvre acquired a pastel by Manet depicting *Mme Manet on a Sofa* for 62,000 francs. The asking price had been only 20,000 francs.

For the Ingres drawings, 18,100 francs was paid for *The Forestier Family* and 14,000 francs for the *Study for the Odalisque*, which had been sold for only 850 francs at the Coutau Hauguet sale in 1889.

Also of note, *Bust of a Man* [*Noël-Thomas-Joseph Clérian*], 11,500 francs; *Portrait of a Woman* [*Madame Poussielgue, née Elisa Leblanc;* fig. 411], 6,200 francs, and other drawings ranging from 1,000 to 6,000 francs.

In the group of Delacroix drawings, a pastel, *Arab Stalking,* brought in 8,100 francs, and a watercolor, *Moroccan* [*Seated Moroccan in an Interior*], 2,800 francs.

The bidding on a pastel by Mary Cassatt, *The Loge,* reached 10,000 francs.

M. R., "The Auction of the Edgar Degas Collection in Paris" ("Die Versteigerung der Sammlung Edgar Degas in Paris")
Der Kunstmarkt (Leipzig) 15, no. 27 (April 19, 1918), pp. 177–78

In late March some of the major Parisian newspapers, such as *Le Temps* and *Le Figaro*, reported on the first great art auction to take place during this war, that of the collection of the painter Edgar Degas. Neither proud announcements of huge prices nor long-winded descriptions of the atmosphere in which the sale took place, these reports are simply short notices of the principal results. The auction, after all, occurred during the first days of a major German offensive; the French certainly had other matters on their mind than art auctions. The Parisians were more concerned about the shots of the first long-range German guns to hit the city than with the results of an auction that at any other time would have been regarded as a major event. Aside from these circumstances, the auction took place in typically French fashion, with results very different from the numerous sales that had previously been held in Germany.

That the Degas auction was the first substantial art auction to take place in the art capital during the war says it all. But the prices! The total proceeds came to nearly two million francs. Certainly, record amounts were achieved, at least for Ingres, whose portraits of M. and Mme Leblanc, for which Degas had paid at auction only 12,000 fr., brought 271,000 fr. Ingres's *Marquis de Pastoret* brought 90,000 fr., and his *Norvins* 70,000 fr. Delacroix's famous portrait of *Baron Schwiter* was purchased by Knoedler for the American market for the considerable sum of 80,000 fr., outbidding the Louvre. The Louvre succeeded in purchasing another Delacroix, *Count de Mornay's Apartment*, for 22,000 fr. *The Battle of Nancy* was sold to a Danish buyer for 31,000 fr.

I do not believe that the German art market during the war has had the opportunity to establish the values of Delacroix's paintings, let alone Ingres's important works. However, how should one react to the sale of a small Corot, *A Street in Normandy*, which brought 6,600 fr., while the *Ruins of the Roman Countryside*, clearly an important work, realized only 5,600 fr. and *Rocky Landscape in the Auvergne* 23,500 fr.? *A Seated Male* [*Don Quixote Reading*] by Daumier brought 20,000 fr. Even more astonishing were the prices paid for Impressionist works. *Le Temps* found extremely high the 40,000 fr. paid by Denmark for Manet's *Departure of the Steamboat*, while his important *Portrait of a Man* [*Monsieur Armand Brun*] brought 30,000 fr., a *Still Life with Ham* 30,600 fr., a portrait of *Berthe Morisot* 27,600 fr., *Woman with a Cat* 25,500 fr., and *Indian Woman Smoking* 32,000 fr. Prices for Cézanne were as follows: *Self-Portrait*, 30,500 fr.; *The Bather*, 23,000 fr.; the well-known *Portrait of M. Chocquet*, 22,500 fr.; *Still Life with Apples and Glass*, 24,700 fr. *Sunflowers* by Van Gogh went for 19,200 fr., and *Still Life with Apples, Pears, Lemons, and Grapes* brought 16,500 fr. *Portrait of a Woman* by Renoir brought 32,000 fr., Sisley's *The Flood* brought 15,000 fr. Various paintings by Gauguin sold for anywhere between 8,000 and 15,000 fr.

These are handsome sums but within the range of prices seen prior to the war, and are in any case considerably less than the greatly inflated prices occasionally reported here from Germany before the war. It is not easy to find an explanation for this striking difference. The supply of the comparatively small number of French Impressionist works available in Germany had of course been almost completely exhausted. But the same high prices extended to other works as well, causing concern even to level-headed people. Love of art is a praiseworthy thing, and no one will deny it to Germans, even in war, which actually seems to have

increased this fondness. But are we really seeing a love for art, or do high prices themselves have an escalating effect?

I recall a letter from a Dutch connoisseur published by Von Bode[30] in the early years of the war. This was the voice of an admirer of German culture who warned against the German penchant for the colossal. That he was correct is already evident to many Germans. I doubt whether other countries were aware of this letter, but I do know that French newspapers today in their fury against Germany do not fail to use such words as "colossal," even emphasizing it by capitalizing the "C." It is well known that hate sharpens the ability to see clearly, and in this respect an inherent weakness in the German character may have been touched on. This penchant for the "colossal" implies a certain sentimentality, which the clever Mr. Bethmann-Hollweg[31] suggested Germany had relinquished. Nobody actually believed this, and it would be a shame if it were true, but it is a fact that other nations are more down-to-earth.

To return to the subject, since I think I have made my point: I believe that the French evaluate the dollar value of their own art more realistically. It is true that French Impressionist works seem to have had more admirers in Germany than in France, and prices might well have been higher had German dealers and collectors not been excluded from the auction. But that still does not explain the differences that would have been realized had such an auction taken place in Berlin. Not even variations in the foreign exchange rate can explain such a discrepancy. Even in money matters psychology plays a part.

This short explanation touches on only one facet of the problem; there are many. However, since your readers do not have access to news from France, this report concerning the auction prices should be of great interest. Finally, El Greco's *Saint Ildefonso*, originally purchased by Degas from the estate of the painter Millet for 480 fr., now sold for 82,000 fr., while El Greco's *Saint Dominic* realized 52,000 fr. I thought the news of the astonishing events in the art market, from a concerned neutral citizen, would be useful.

[Original footnote:] This report has been submitted to the editor of *Kunstmarkt* by a knowledgeable Swiss art connoisseur who resides near Geneva. We asked him for a report on the Degas sale, and he used the opportunity to make general observations. Obviously he is more familiar with the situation in France than in Germany, even though he has frequently visited here. We feel that the observations of a well-intentioned neutral are noteworthy.

"Degas Sale in Paris"
American Art News 16, no. 29 (April 27, 1918), p. 1

"War's alarms" did not prevent the sale of the art properties of the dead painter, Edward [*sic*] Degas. People seem to be convinced that there are still to be "cakes and ale," in spite of long distance bombardments and the approach of the German attack to points within two hours' automobile ride of Paris. The Degas sale proved one of the most remarkable held in France in a long time. The modern pictures on the first day realized more than $200,000. A portrait of Cézanne by himself fetched $6,600, although the upset price was only $2,200; a small still life [*Glass and Apples*], $5,470; a nude, $5,080; a figure piece, *Venus et l'Amour*, $3,540; and a portrait of M. Choquet, $4,950. The prices of the Gauguins ranged from $1,760 to $3,080. Sharp competition developed over the paintings by Manet, with prices as follows: *Départ du Bateau à Vapeur*, $8,900; *portrait of Mme. X* [*sic*; *Monsieur Armand Brun*], $6,820; *Exécution de l'Empéreur Maximilien*, $5,100; *Le Jambon*, $6,730; *Portrait of*

Mlle. Morizet [*sic*], $6,070; *La Femme au Chat*, $5,600; and *Indienne Fumant*, $7,040. A characteristic painting by Mary Cassatt, *Young Girl Doing Up Her Hair*, was sold for $4,600. Among the Corots, $4,500 was given for *Le Pont de Limay* and $5,170 for *Chataigneraie Rocheuse*.

The greatest prices were paid for works of Delacroix and Ingres, as follows: Delacroix: *Portrait of Baron du Schwiter*, $17,600; *Henri IV Donnant la Régence à Marie de Médicis*, $5,280; *La Bataille de Nancy*, $6,800; *Le Christ au Tombeau*, $11,440. Ingres: *Portrait of the Marquis de Pastorel* [*sic*], $19,000 ("expert's" estimate $16,500); *portraits of M. and Mme. Leblanc*, $59,400 (upset price $44,000); *Roger Délivre Angélique*, $7,040. The best price for a drawing by Ingres was $3,980—*La Famille Forestier*.

Pinturrichio [Louis Vauxcelles], "Studio Diary: Rejected Portraits" ("Le Carnet des ateliers: Portraits refusés")
Le Carnet de la semaine 4, no. 151 (April 28, 1918), p. 8

The model for the admirable portrait of a man in a blue-gray suit in the Degas collection is still living, though not exactly in the first blush of youth, as Manet painted him forty years ago. It is said that he had asked the press not to reveal his name. Was it from modesty, fear of publicity? Or could it be because, having once rejected this portrait, he is now disappointed to learn that he disdained a masterpiece? I am fairly sure that is the reason for his reticence. And yet, while recognizing that he lacked intuition in refusing a Manet—and what a Manet!—we should nonetheless praise this collector for having commissioned it, at a time when the master of the modern school was still barely understood. . . .

A. L. M., "Once Again, the Degas Auction" ("Nochmals die Versteigerung Degas")
Der Kunstmarkt (Leipzig) 15, no. 29 (May 3, 1918), p. 194

The report by "the knowledgeable Swiss art connoisseur" in *Kunstmarkt*, no. 27, concerning the Degas estate auction, demands a reply. Obviously, the shelling of Paris during our enormous offensive against Amiens must have diminished the appetite of buyers. Indeed, it is something of a miracle that the French showed any interest in purchasing works of art at such a time. The "record prices" for the works of Ingres are by no means a record since even before the war Ingres was much in demand and his works realized high prices. Under normal circumstances, paintings by Ingres and Delacroix would have fetched higher prices, even without participation by Germans in the sales. Prices paid for both Manet and Cézanne are certainly not excessive at all. In this connection, one must not forget that the French franc is relatively stronger than the mark. Furthermore, in many cases the works in question were either studies or even fragments or works of small dimension. Our Swiss friend should know from last year's French exhibition in Zurich that large works by Cézanne, Renoir, etc. commanded high figures. French buyers as well as their Swiss counterparts demonstrated a penchant for the colossal, something usually attributed to us Germans! It's not true that the French do not pay high prices for their own art. Mediocre art commands high prices in France just as in other countries, and still higher than good art in Germany. The Parisian newspapers reporting on the Degas auction found the high prices for what they consider modern garbage a sign of the failure of this art so beloved by Germans, demonstrating anew that the French public is as far from appreciating its own good art as it was when the first exhibition of Manet's painting was received so

unsympathetically and the first performance of Bizet's *Carmen* was panned.

B. D., "Paris Letter"
American Art News 16, no. 30 (May 4, 1918), p. 5

. . . I am disposed to think that the anticipation of [the new French tax on luxury goods, including art] had much to do with the extraordinary ardor in the bidding at the last important auction sale, that of the Degas collection. It just escaped the new taxation. Those who took this into account and desired to put their free capital into art were eager to make the best use of their last opportunity to do so, under old conditions, before the end of the war.

This is not, however, the opinion of all the well informed art dealers and "experts." There are many who profess to see in the large prices paid at the Degas sale only a normal indication of the continued increase in value of the works of the masters of the two great modern schools, that of the mid-nineteenth century and that of the impressionists. . . .

Paul Jamot, "Degas (1834–1917)"
Gazette des Beaux-Arts 14, no. 695 (April–June 1918), pp. 123–66
[excerpt from p. 142]

The collection that [Degas] assembled for his personal pleasure is the most eloquent of homages. Nor is it a negligible testimony to Degas himself, his tastes, his culture, and his independence of judgment. To be so interested in someone else's works that one is willing to spend money to have them in one's possession, before one's eyes, is not a common trait among painters—especially when the works are by one's contemporaries. Apart from Ingres, Delacroix, and Corot, the Degas collection contained well-chosen pieces by Manet and made a significant place for Cézanne* and Gauguin. Four large portraits, some twenty paintings or studies, and thirty-five drawings ensured Ingres's primacy. Nonetheless, the number and rare quality of the pieces bearing Eugène Delacroix's name were another surprise of this jealously guarded collection. The man with the beautiful drawings and charming watercolors who united the heartrending *Entombment;* the exquisite, dazzling, delicate interior study known as *Count de Mornay's Apartment;* the *Portrait of Baron Schwiter,* in which the painter equals Lawrence in ease and infinitely surpasses him in expression; and finally the admirable copy after Rubens (*Henri IV Entrusts the Regency to Marie de Médicis*), clearly had a lively, intimate, and profound sense of Delacroix's genius.

By the time Degas became a collector (especially after 1890), a passionate admirer of Ingres could also cultivate an appreciation of Delacroix, without apostasy. The time of the merciless battles between the two masters and their supporters had passed. Baudelaire—in studies that, sixty years after the fact, remain the pride of and model for art criticism—set the example. He devoted his efforts to defending, commenting, and explaining the great painter of the Apollo Gallery and the *Entry of the Crusaders into Constantinople,*[32] when the latter was still the object of fierce hatred. He had the foresight and grace to write several memorable pages on Eugène Delacroix's illustrious rival as well: going beyond trite phrases and made-to-order praise, he acknowledged for the first time the essence and originality characteristic of that master. Since Baudelaire, it has become permissible and even commonplace simultaneously to understand and appreciate both Ingres and Delacroix. Still, it is no arbitrary hypothesis to see them as belonging to successive periods of Edgar Degas's life. It might even be pos-

sible to date, via certain of [Degas's] mature works, the entry of Delacroix into an empire over which Ingres had hitherto reigned supreme. . . .

*[Original footnote] Was Degas's respect for the solitary painter of Aix-en-Provence dampened, was he offended by certain irrationalities of prejudice or speculation? In any case, let us note that he was disappointed in several of Cézanne's canvases.

Charles-Henry Hirsch, "The Lesson of E. Degas" ("La Leçon d'E. Degas)
L'Oeuvre, May 9, 1918

Edgar Degas would have hated the current hoopla surrounding his great name. It is a cacophony of eulogies, insults, and numbers, all focused on an illustrious man who was always a silent and disinterested worker. He avoided art critics; he disdained public opinion and was loath to sell his works, jealously holding onto them, either because they had succeeded or because they fell far too short of his expectations. He knew their market value from having received so many purchase offers. Better than anyone, he knew the double value—ideal and venal—of the paintings and drawings that he had collected for his own artistic joy. Through them, he lived in the atmosphere of beauty that was indispensable to his nature. The fierce isolation in which his fertile maturity turned into contemplative old age, far from all the commerce, is the lofty lesson of his stormy integrity in a century where money predominates.

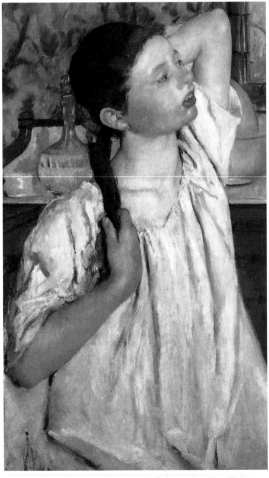

Fig. 412. Detail, Mary Cassatt, *Girl Arranging Her Hair,* 1886. Oil on canvas, 29⅝ × 24½ in. (75 × 62.3 cm). National Gallery of Art, Washington, D.C., Chester Dale Collection (1963.10.97). Collection Sale I: 8

Fig. 413. Eugène Delacroix, *Moroccan House,* 1832. Graphite and watercolor, 4 × 5⅞ in. (10 × 15 cm). Private collection. Collection Sale II: 93.1

Fig. 414. Eugène Delacroix, *Algerian Interior,* 1832. Watercolor and graphite, 4¼ × 6¼ in. (10.8 × 16 cm). Musée du Louvre, Paris, Département des Arts Graphiques (R.F. 4527). Collection Sale II: 131.2

His heirs did not understand this, since it was by their consent that the admirable collection he had amassed was auctioned off and dispersed—the collection that, after he had enjoyed it, was intended to be of educational value in a museum. In their greed, they are now clearing out the deceased's studio. To the millions [of francs] already obtained, they will add additional millions. The upcoming auctions will enrich them still further. For all their haste to "cash in," they have not overlooked a single piece of cardboard, scrap of paper, or shred of canvas. The mind of the scrupulous Degas is completely and publicly exposed in order to extract every last cent from the works the master insisted on hiding and from the signature that he refused even the most generous collectors. . . .

"At Degas's Art Sale in Paris: Paintings by Ingres and Mary Cassatt Attracted Much Attention"
Springfield Sunday Republican **(Springfield, Mass.), June 2, 1918, magazine section, p. 15**
At the recent sale of Degas's collection of paintings, the paintings of Ingres carried off the honors. The portraits of M and Mme Leblanc were bought for the Metropolitan museum. Knoedler & Co. bought the portrait of M. de Nowins [*sic*] and also Delacroix's portrait of Baron de Schwitzer [*sic*]. The Louvre, so the *American Art News* tells us, was the underbidder for these paintings. This sale, which will pass down in the annals of art history as one of the greatest sales on record, has been lent especial interest because of its taking place during one of the most serious periods of the war, part of the time while Paris was actually being bombarded.

Many people have expressed surprise that there were people who could take an interest and spend great sums of money on pictures at such a time. It must be remembered, however, that art is one of the great civilizing forces of life, and that those museums and individuals who buy are buying for a future time; also, anything that stimulates and preserves the love for beauty is of value in these days when the horrors of war are omnipresent and when so many art treasures have already been destroyed. . . .

Another interesting sale was that of Mary Cassatt's *Young Girl Dressing Her Hair* [fig. 412]. This canvas brought $4200. Miss Cassatt is an American although long identified with Paris. She was one of the few people Degas cared to teach, and she, together with

Berthe Morisot, Manet's sister-in-law, were the only women of note that the impressionistic movement brought forth. Degas had examples of both of their work in his extraordinary collection, a collection which reflected the unerring judgment of a master of art. . . .

Fig. 415. Suzanne Valadon (1865–1938). *The Artist's Son, Maurice Utrillo, Standing Nude, His Foot in a Basin,* 1894. Black chalk, 16⅛ × 9 in. (41 × 23 cm). Marc Blondeau, S.A., Paris. Collection Sale II: 255

Fig. 416. Édouard Manet, *Berthe Morisot*, 1872. Lithograph, first state, 8⅛ × 5⅝ in. (20.5 × 14.3 cm). Nasjonalgalleriet, Oslo (NG. K&H.A.16730). Collection Print Sale: 277

Fig. 417. Édouard Manet, *Cat and Flowers,* 1869. Etching and aquatint, first state, 7⅞ × 6 in. (20 × 15.2 cm). Nationalmuseum, Stockholm (NM G 316/1924). Collection Print Sale: 252

A. Damécourt, "Auction Chronicle" ("Chronique des ventes")
Le Cousin Pons **3, no. 51 (October 1, 1918), p. 407**
After another summer and off season, I hope I will soon be able to inform the faithful readers of *Le Cousin Pons* about results of the kinds of auctions that were all too rare last spring.

Indeed, in the spring, around Easter, when the season was promising to be brilliant and the Degas sale had achieved a resounding success, circumstances put a sudden halt to the fine artistic momentum that was just getting started.

But times are transformed since then; events have entirely changed and, judging from the information I have been able to gather, the autumn and winter seasons will be quite animated and will offer some important sales. . . .

**Charles Saunier, "Movement in the Arts: The Next Big Auctions"
("Mouvement des arts: Les Grandes Ventes prochaines")**
La Chronique des arts et de la curiosité, **Supplement to the**
Gazette des Beaux-Arts, **1918, pp. 144–46**
Victory has liberated the French land, people are returning to Paris, and, with the reappearance of migratory birds, life returns to normal. Similarly, the important art sales are resuming. Given the seriousness of the times, if it were only a matter of money, the matter would not merit our attention. But these art sales—flourishing increasingly from year to year or, more precisely, with each new recognition of the supremacy of French genius by both American and European collectors—have such a beneficial effect on people's spirits that we couldn't possibly wish for their postponement. Did not we see during the war, not once but ten times, auctions of works by our masters that fetched prices so high, even in Berlin, that they disconcerted our most ardent art lovers?

In October we pulled ourselves together, dug in; but in November and December we must make up for lost time. And at the Hôtel Drouot, in the Georges Petit and Goupil galleries, sales will follow each other almost without interruption: the Degas sales, the Vicomte de Curel sale, the Charles-Roux sale.

As far as the Degas studio and collections are concerned, the two large sales of last spring were only the beginning, and no matter how beautiful the works presented, no matter how sensational the prices obtained, they still did not fully reveal the tastes and "secret life" of that magnificent artist in whom the collector was inseparable from the creator.

An adorer of form and exceptional brushstroke, [Degas] never stopped seeking these out with his pencil and his brush; nor did he fail to welcome them whenever he thought he discerned a new accent in someone else—regardless of whether it was a finished work or a quick sketch, and without caring about its signature or its provenance. We will see much evidence of this at the exhibition of paintings and drawings that form the second part of his private collection. Works by the David-influenced Destouches will hang next to canvases by Brandon, Jeanniot, and many others. But the attention of the important collectors, and still more so of the artists themselves, will be especially captured by the group of drawings: numerous and important drawings by Ingres, Delacroix (studies of horses, of Morocco), and the underrated Riesener. There will also be handsome works by Aligny, Tissot, Guiguet, P. Mathey, Suzanne Valadon, the model whom he elevated to a student [fig. 415], and several older works, notably by Tiepolo.

All of these works will be sold on Friday and Saturday, November 15 and 16, in other words, a few days after the sale of his collection of prints, which will be auctioned off on Wednesday and Thursday, November 6 and 7.

Fig. 418. Paul Gavarni, from The *Lorettes*, plate 68, 1843. Lithograph, 7⅞ × 6⅛ in. (20 × 15.6 cm). Trustees of the British Museum, London (1980.5.10.172). Collection Print Sale: 144.7

Fig. 419. Paul Gavarni, from The *Lorettes*, plate 79, 1843. Lithograph, 8½ × 6⅛ in. (21.5 × 15.6 cm). Trustees of the British Museum, London (1980.5.10.174). Collection Print Sale: 144.9

If we remove from the latter collection four older pieces and a few names that occupy only a negligible place in it, the number of artists represented is not very large, but it is quite significant. Delacroix, Daumier, and Gavarni are among them, as is Miss Cassatt, his faithful student. But it is especially Manet who is handsomely represented by choice works [figs. 416, 417]; the rarest and most beautiful among them derive from the portfolios of the astute and discerning collector Philippe Burty.[33] Art lovers will be deeply moved by such a grouping, and we can predict that these pieces will go for handsome prices at auction. The print of *Polichinelle,* for example, is inscribed with the words: "Unique proof, E. M."; *Hat and Guitar,* in its first proof, bears an inscription from Manet to Ch. Baudelaire. *Lola de Valence, The Guitar Player, Cat and Flowers, Olympia,* and *The Candle Seller* are in their first proofs as pure etchings. Also in first proof, on a sheet of deluxe stock [*chine volant*], is *Dead Christ with Angels.* And then there are rarities: an unknown frontispiece that Ph. Burty, who once owned it, claims was printed in only two proofs. Two variants of *Boy with a Sword* are the only ones known. The large and amusing lithograph *The Balloon,* if it does not exactly qualify as unique, is at least extremely rare. To say that Miss Cassatt's engraved works exist in exceptional proofs would be redundant; and the same for the drypoints of Mme Morisot. These two artists were close friends of [Degas], as was, right to the end, Jeanniot, represented here by *The Recruit's Medical Examination,* an engraving related to the painting of the same name, also owned by Degas. There are monotypes by Gauguin as well.

At the time when Gavarni and Daumier entered his collection, beautiful proofs were still within everyone's price range. And so the great artist did not fail to reap a fine harvest. He had *Rue Transnonain* and most of the other important works from the Association Mensuelle.[34]

As for Gavarni, Degas's energies went toward seeking out [pictures of] elegant men, whose outfits the artist enjoyed capturing with his pencil. There is a series of portraits of dandies, in which the pleasant subject is enhanced by the attractiveness of perfect prints. But the selections by Delacroix outshine even these. One can find the seven lithographs from *Goetz de Berlichingen* in extremely rare proofs on deluxe stock [*chine*], all except for the third in the first and second states. [There is also] a second state, on deluxe stock, of *Faust and Mephistopheles in the Hartz Mountains.* Almost as rare is the third state of *Tiger Lying in the Desert.* Ingres is represented by a good impression of the only etching known to be by him, the portrait of the bishop *Gabriel Cortois de Pressigny,* which moreover is an absolute masterpiece. This noble piece is accompanied by two strikingly beautiful lithographic portraits, of *Frederic Sylvester Douglas* and the *Baron de Norvins,* and finally by a proof of the *Odalisque.* Also notable is the presence of a small selection of early impressions of Japanese prints.

But the interest of this first sale is superseded by the one following it [that of Degas's own prints.] The latter will include the master's engraved works, 317 items breaking down into 35 etchings, soft grounds, and aquatints; 16 lithographs; and 167 monotypes, including the 37 illustrating *La Famille Cardinal* by Ludovic Halévy. . . .

[Published with prices for all the works in the November Degas collection sales.]

Fig. 420. Honoré Daumier, *Freedom of the Press,* 1834. Lithograph, 12.8 × 17 in. (30.7 × 43.1 cm). The Metropolitan Museum of Art, New York, Purchase, Jacob H. Schiff Bequest, 1922 (22.60.2). Surrogate for Degas's unlocated impression, Collection Print Sale: 66, 67

"Curiosities: The Degas Sales" ("La Curiosité: Les Ventes Degas")
Journal des débats, **November 3, 1918, p. 3**

The sales that took place last spring and that met with such resounding success scarcely dipped into the riches left behind by *Ed. Degas,* the great master whose oh-so-characteristic art will forever remain famous. This November and December, collectors and art lovers once again will face an embarrassment of riches in a group of remarkable works.

Messrs. *Lair Dubreuil and Ed. Petit* have organized the series of four sales in rapid succession and will direct them in association with the experts *Bernheim-Jeune, Durand Ruel,* and *Vollard* and *Loys Delteil* for the prints. On November 6 and 7 (after an exhibition on the 5th) in room 6 of the *Hôtel Drouot,* they will sell some delightful older and modern prints, works by *Mary Cassatt, Daumier, E. Delacroix, Gavarni, Ingres, Manet, Pissarro, Whistler,* etc., that Degas took such pleasure in collecting. On November 15 and 16, in room 1 (after an exhibition on the 14th), there will be the sale of older and modern paintings and drawings comprising the second part of that personal collection that in its first half included works of such great beauty, notably the famous works by *Ingres. . . .*

"Curiosities" ("La Curiosité")
Journal des débats, **November 8, 1918, p. 3**

The majority of prints from the Degas Collection sold yesterday by M. Lair-Dubreuil at the Hôtel Drouot were signed Mary Cassatt, Daumier, Gauguin, and Gavarni. For the most part, prices ranged between 400 and 1,000 frs., except for a Daumier, *The Legislative Belly,* a beautiful proof on *chine* that went as high as 1,150 frs. [Other prices given.]

Valemont, "The Big Auctions: The Degas Sales" ("Les Grandes Ventes: Les Ventes Degas")
Le Figaro, **November 9, 1918, p. 4**

At the Hôtel Drouot, room 6, the sale of older and modern prints comprising the Edgar Degas collection . . . ended with a total figure of 73,600 francs.
[Other prices given.]

"Curiosities" ("La Curiosité")
Journal des débats, **November 10, 1918, p. 3**

At the *Hôtel Drouot.*—Apart from the 1,500 frs. fetched by Whistler's *The Lime Burner* and the 3,500 frs. by a Japanese print, *Women Bathing* by Kyionaga, the highest prices at the second sale of prints collected by Degas went for a large series of beautiful prints by E. Manet. Among them, *The Balloon* was sold for 4,100 frs.; *Olympia* for 1,650 frs.; *The Guitar Player* for 1,256 frs.; *The Rabbit* for 1,120 frs.; *Dead Christ with Angels* for 1,020 frs.; *The Execution of the Emperor Maximilian* for 1,000 frs.; *The Barricade* for 1,000 frs.; *At the Prado* for 920 frs., etc. Messrs. Lair-Dubreuil and Ed. Petit obtained a total of 74,092 frs. for this entertaining collection.

"Arts and Curiosities: The Prints from the Degas Collection" ("Art et curiosité: Les Estampes de la collection Degas")
Le Temps, **November 10, 1918, p. 3**

The first of the four Degas sales, devoted to modern prints and including, among others, etchings by Manet and lithographs by Eugène Delacroix and Daumier, ended with a total of 73,600 francs.

The seven lithographs executed by Delacroix for Goethe's *Goetz de Berlichingen* were sold for 1,250 francs; Daumier's *The Legislative Belly,* for 1,150 frs.; *Rue Transnonain,* the *Divorcées,* the *Pastorals,* and *Freedom of the Press* [fig. 420], by the same artist, went for 955 frs., 585 frs., and the last two 505 francs each.

Manet triumphed with *The Balloon,* a scene from a popular fair and an admirable piece for that matter, at 4,100 frs.; *Lola de Valence,* three proofs on deluxe paper before aquatint, at 1,950 frs.; the *Guitar Player,* 1,256 frs.; *Dead Christ with Angels,* 1,020 frs.; the *Execution of the Emperor Maximilian,* 1,000 frs.; the *Barricade,* 1,000 frs.; the *Rabbit,* 1,120 frs.; *At the Prado,* 920 frs., etc.

Gauguin's Tahitian monotypes rose to very high prices, between 500 and 600 frs. *The Lime Burner* by Whistler fetched 1,500 francs. A few colored Japanese prints from the eighteenth century sold equally well: 3,500 francs for *Women Bathing* by Kiyonega; 1,500 francs for a group of pieces by Outamaro, Hiroshige, etc.

"Curiosities" ("La Curiosité")
Journal des débats, **November 18, 1918, p. 3**

The sale of the second part of the Degas collection ended on a total of 137,941 frs. During yesterday's sale we noted, among the paintings of the Modern school, *Man Seated at a Table and Smoking a Pipe* [now attributed to Degas; fig. 425], 7,000 frs.; *Bust of a Man,* 4,700 frs.; *Study for the Portrait of a Woman,* 4,350 frs.; and *Bust of a Young Girl,* 3,500 frs. Among the watercolors by Delacroix, four studies, including one for the *Portrait of Count Palatiano,* 2,800 frs.; *Seated Arab in Tangiers,* 2,300 frs.; and *A Horse in a Stable,* 2,000 frs. Finally, a drawing by Legros, *Portrait of Degas,* and another by Manet, *Study for a Seated Nude* [*Leaving the Bath*], went for 3,000 and 1,400, respectively.

"Collectors and Experts" ("Amateurs et Experts")
Le Cousin Pons 3, no. 53 (December 1, 1918), pp. 421–22

At the last Degas sale, a considerable number of canvases—four pages' worth in the catalogue—that the heirs and experts did not particularly value were presented at auction under the vague rubric: Modern School.

Among these items figured some Degases that collectors

Fig. 421. Alfred Robaut (1830–1909), *Sketch after Delacroix's Apollo Ceiling* in the Musée du Louvre, Paris. From Robaut 1885, p. 296

acquired but that neither the family nor the experts will acknowledge as such. They will be illegitimate Degases.

There were also paintings by other masters, prompting one of our subscribers, M. Arthur Merrheim, to write us the following letter:

To the Managing Director of the newspaper *Le Cousin Pons:*

Dear Sir: Once again, the heat of auctions has favored the persistent seeker who does not rely entirely on the judgment of experts, no matter how competent.

Your readers who admire E. Delacroix will no doubt learn with pleasure that at the Ed. Degas sale, four paintings by Delacroix catalogued "Modern School" are indeed by the master and irrefutably signed.

The most remarkable, of which I am the fortunate owner, is his painting depicting a study for the Apollo Gallery ceiling [in the Louvre]. I do not wish to describe the explosion of colors in this piece, but only to point out, for the history of the master's oeuvre, the compositional differences between the study and the ceiling itself, as it was drawn by Robaut [fig. 421].[35]

Here are the variants:

At the top [of the study], in the half-arch, the woman grasping the large veil with both hands holds her head erect, whereas she leans to her right in the final work. The head of the third horse is noticeably higher, while the head of the fourth is not bent so far forward in the study.

In the group below the horses on the left, the shadowy figure chased off by the two illuminated cupids does not turn his face toward the void, as in Robaut, but looks at the radiant god; the body of the cupid nearest the center is not horizontal, but leans forward, like the one holding the torch.

The two incomplete bodies thrust into the abyss do not have the same movement. [In the final composition,] the monster in the left foreground does not have a right forepaw as seen in the study.

The Angel of Darkness in the right foreground does not lean forward, as if falling, and in my version is almost in a vertical position. The Hercules brandishing his club immediately to the right is not attacked in the same way by the Angel of Darkness. In the study in question, the figure bites Hercules's right leg, just in front of his right hand, with which he holds the god's leg. The artist judiciously rectified this in the final version by raising the right hand to the top of the leg, while in his rage the vanquished Angel tries to bite the hero's ankle.

The position of Hercules's head is not the same in the study. The head is slightly hidden by his raised arm.

Moving to the upper right, we notice that the cupid who is next to Juno is placed a little lower in the study. His right arm, instead of being raised, is turned toward the left, framing his head, to balance the goddess's left leg. The peacock is absent. The goddess's head is upright, in profile; her left shoulder is lower because of her right arm, which is raised a bit higher than in the final work.

The study is on paper, mounted on canvas. The painted surface is exactly 485 × 560 mm, whereas the catalogue gives the dimensions of the canvas: 580 × 500 mm. The edges have the same shape as the work itself.

The master's signature is perfectly visible to anyone who knows his work. It is composed of a capital E and D, followed by the famous cross, the vertical bar of which is noticeably longer. But for those who are familiar with the greatest of all painters, there is no need to see the signature. The study is dazzling with incomparable French genius. The perfectly visible date of 1847 indicates that this study was made two years before the one officially adopted for the definitive work.

I am convinced, Sir, that this will interest your readers and that you will graciously offer your hospitality to these lines which your faithful subscriber has hastily penned.
Sincerely,
Signed: A. Merrheim

Let us congratulate M. Merrheim on an acquisition that brings him so much satisfaction; but how much did he pay for it? That is a question of some importance in this little debate.

Fig. 422. Eugène Delacroix, *Study for "The Assassination of the Bishop of Liège,"* 1827. Graphite, 10⅞ × 14¾ in. (27.5 × 37.5 cm). Private collection. Collection Sale II: (hors catalogue)

Fig. 423. Eugène Delacroix, *Amédée Berny d'Ouville*, ca. 1830. Oil on canvas, 24 × 19¾ in. (61 × 50 cm). Fundação Medeiros e Almeida, Lisbon (FMA 225). Collection Sale I: 28

A. Damécourt, "Auction Chronicle" ("Chronique des ventes")
***Le Cousin Pons* 3, no. 53 (December 1, 1918), p. 423**
The month of November 1918 will remain celebrated throughout History, for it brought Peace to France; and the Victory was marked by a series of interesting sales, launching a season that is expected to be quite lively and filled with huge auctions.

On November 6, the sales of the Edgar Degas estate were resumed, and modern prints were sold for a total of 70,592 francs. The highest prices were paid for works by Manet, including *The Balloon* at 4,100 francs; *Lola de Valence* at 1,950 frs.; *The Guitar Player* at 1,250 francs; and *Olympia* at 1,250 francs.

A print by Daumier, *The Legislative Belly,* brought in 1,150 francs; Gavarni's *Les Lorettes* [figs. 418, 419], 777 francs; and a Japanese print by Kiyonaga, *Women Bathing,* 3,500 frs.

The sale of paintings and drawings [on November 15 and 16] yielded 69,175 frs.[36] There were contemporary things, many unsigned paintings sold under the title *Modern School.* Among these *unknowns,* a *Portrait of a Man and Two Children* went for 9,100 francs; *Manon Lescaut* for 3,105 francs; *Young Women at the Fountain* [now attributed

to Degas] for 2,100 francs; *Three Male Heads* for 2,000 frs.; *Man in a White Shirt* [now attributed to Degas; fig. 425] for 7,000 francs; *Bust of a Man* for 4,700 francs; and *Study of a Woman* for 4,350 francs.

Excellent prices were also paid for drawings by Delacroix, including *A Horse in a Stable,* 2,000 francs; *Arab and Jew* [*Seated Arab, Front View* and *Algerian Jewess,* sold together as lot no. 144], 2,300 francs; *Study for "Liberty"* [*Female Nude Brandishing a Staff*], 2,100 francs; and *Arab on Horseback,* 1,900 francs.

The drawings by Ingres went for between 400 and 1,500 francs, a drawing by Gavarni for 1,400 francs, and a *Portrait of Edgar Degas* by Legros for 3,000 francs. . . .

L. Dimier, "Arts Chronicle" ("Chronique des arts")
***L'Action française,* December 31, 1918**
A print dealer who bought Daumier's *Massacres of the rue Transnonain* at the Degas sale for 955 francs told me, "It's not expensive. *The Legislative Belly* went for 1,500 francs, and isn't worth much more than *Rue Transnonain.*"

Fig. 424. Ludovic-Napoléon Lepic (1839–1889), *Fish and Eels in a Basket, after Janin,* 1862. Etching, 14 × 20 in. (35.6 × 50.8 cm). Eric G. Carlson. Presumably Collection Print Sale: 214bis

Fig. 425. Edgar Degas, *Man in a White Shirt Seated at a Table and Smoking a Pipe,* ca. 1873–80. Oil on canvas, 9 × 13 in. (23 × 33 cm). L 337. Private collection. Sold as "Modern School," Collection Sale II: 59

It's true. One might wonder why the collectors pushed things that weren't so good higher than the better ones. . . .

Paul Lafond, *Degas* (Paris: H. Floury, 1918), pp. 117–21
On the walls of [Degas's] dining room hung several sketches and drawings by Ingres; various pencil sketches, pastels, and watercolors by friends, such as Bartholomé, Jeanniot, Forain, Napoléon Lepic [fig. 424], and Henri Rouart; lithographs by Daumier and Gavarni and etchings by Jeanniot. On the mantelpiece stood two eighteenth-century candlesticks that had been in his family. Not far away, one might notice the bust of the master of the house by his friend Paul Paulin. In a display case were various molds of Javanese women's hands, with long, tapering, twisted fingers. There were also albums of Outamaro and others, a plaster cast of Ingres's hand holding a pencil, and Neapolitan dolls. On top of the cabinet were a few bronzes by Barye and Bartholomé. Above a bookcase full of

books were boxes containing almost all the engraved work of Manet, lithographs by the two Devérias, Gavarni, and Daumier, whose prints he particularly admired, and of which he owned the principal ones in superb proofs. Other boxes, placed here and there, overflowed with drawings by Ingres and Delacroix. On a piece of furniture, one could see a child's toy, a large papier-mâché elephant that had appealed to him and that he had bought in a five-and-dime.

In the bedroom, facing the bed near the fireplace, were placed on one side the portrait of Degas's father listening to the guitar-player Pagans, painted by Degas himself, and a sketch for the *Battle of Nancy* by Eug. Delacroix. On the walls were a *Pear* by Manet, which Degas considered a masterpiece; two small *Views of Italy* by Corot; a small pastel portrait, by whom we do not know, of Degas in early childhood, etc. . . .

On a table in the middle of the living room, which was furnished in the style of the end of Louis-Philippe's reign, stacked issues of *Le Figaro* enfolded the weekly drawings by Forain that Degas particularly valued. On the walls hung various canvases: an *Auvergne Landscape* by Corot; a pastel portrait of *Mme Manet in a Blue Dress Resting on a Sofa,* by Manet; some *Studies of Hands* and two *Heads of Jupiter,* by Ingres. Other paintings were simply resting on furniture.

Everywhere the floors were covered with old oriental rugs for which Degas always had the taste and the attraction. For years he haunted the shops looking for them, and he found some remarkable ones.

Then it was one flight down, in a large, unfurnished room, to what he called his collection, shown on easels or against the walls: Two compositions by El Greco. By Ingres, the half-length portraits of *M. Leblanc,* the banker in Florence and correspondent to French artists, and *Mme Leblanc;* of the *Marquis de Pastoret,* which earned the painter 1,000 francs in 1827; and of *M. de Norvins,* the chief commissioner of police in Rome who later became Napoleon's historian; along with a reduction of *Angelica.* By Eug. Delacroix, the full-length portrait of his friend *Baron Schwiter* in a black suit, a painting that was rejected by the Salon of 1817 [actually the Salon of 1827]; oval bust portraits of two students from the Goubeaux Institute . . . one of which is of *Amédée Berny d'Ouville* [fig. 423] painted in 1830; an *Entombment; The Interior of Count de Mornay's Tent* [*sic*]. By Gustave Courbet, a good, solid *Portrait of a Man;* and by Thomas Couture, another *Portrait of a Man.* Various *Landscapes* by Corot; several canvases by Manet, including a full-length *Portrait of a Man* [*Monsieur Armand Brun*] as well as a part of *The Execution of Maximilian,* reconstituted from bits and pieces. A *Woman's Head* by Renoir; various works by Cézanne, Gauguin, Van Gogh, etc.

In the corners stood canes of all kinds and in all shapes, since on a whim Degas once developed a passion for canes. During that time he became a regular at the Verdier firm. He canvassed the Faubourg Saint-Denis in search of sheath makers, who possessed old handles. He even asked Gauguin to sculpt him a Tahitian walking stick. This fancy lasted about six months. . . .

"The Auctions: Some Prices for Modern Works During the War" ("Les Ventes: Quelques Prix d'oeuvres modernes pendant la guerre")
Art et décoration 36 (May–June 1919), p. 12
If the effect of the war, especially at the beginning, was to diminish the number of auctions, even in the most tragic hours there were some sensational bids—as will become apparent from reading the

figures given below: . . .

March 26 and 27, 1918.—Edg. Degas Collection: . . . Total proceeds: 1,966,220 [francs]. . . .

November 7, 1918.—Edgar Degas Collection (prints). Total proceeds: 74,592 [francs].

November 15 and 16, 1918.—Ed. Degas Collection (2nd auction). Paintings, drawings, watercolors, pastels. Total proceeds: 69,175 [francs]. . . .[37]

M. A. Frappart, "The Main Auctions of 1918" ("Les Principales Ventes de 1918")
Annuaire des ventes . . . , 1 (October 1918–July 1919), p. 19

DEGAS PRIVATE COLLECTION.—*Paintings,* March 26—Proceeds: 1,966,000 frs. *M. and Mme Leblanc,* by Ingres: 270,000 frs. The *Marquis de Pastoret,* by Ingres: 90,000 frs.; *Baron Schwiter,* by Delacroix: 80,000 frs. *Departure of the Folkestone Boat,* by Manet: 40,500 frs. *Portrait of Cézanne,* by himself: 30,500 frs.; *Saint Ildefonso,* by El Greco: 82,000 frs.; *Saint Dominic,* by El Greco: 52,500 frs.; *Portrait of Mme Manet on a Sofa,* by Manet: 62,000 frs., bought by the Louvre.

DEGAS COLLECTION.—*Modern Prints,* November 6 and 7.—Proceeds: 74,592 frs. *Lola de Valence,* by Manet: 1,950 frs.

DEGAS COLLECTION.—*Paintings. 2nd auction,* Nov. 15.—Proceeds: 137,941 frs. *Portrait of a Man [and Two Children]:* 9,100 frs. *Man in a White Shirt:* 7,000 frs. (two canvases of the Modern School). [The latter has been reattributed to Degas; the former may have been painted by Degas as well.]

Pinturrichio [Louis Vauxcelles], "Studio Diary: Cézanne, Delacroix, and the False Paintings" ("Le Carnet des ateliers: Cézanne, Delacroix et les faux tableaux")
Le Carnet de la semaine, February 9, 1919

It seems that a number of the drawings sold at the auction of the Degas collection under the name Eugène Delacroix are in fact by Pierre Andrieu. Andrieu, the Romantic master's favorite student, the one he called his "clerk," and who assisted him in his preparatory work for the Apollo Gallery (like other students of Delacroix's: notably Delestre, Léger Cherelle, and Lassalle-Bordes, who helped him paint the murals for the Chamber of Deputies library), no doubt drew very well. . . . All the same, if the late M. Degas took them for drawings by Delacroix, such an error must make our sworn experts feel rather humble.

"The Auctions" ("Les Ventes")
Art et décoration 36 (July–August 1919), pp. 11–12

Begun under the bombardment, [the Degas sales] ended in the joy of victory and reached the impressive figure of 10,827,826 frs. (The Doucet sale, the only one in France to have surpassed this record, produced 13,884,460 francs in 1913.) In the Degas sales, the studio alone brought in 8,649,573, and the collections, 2,178,253. . . .

Geo. London, "The Legacy of the Painter Degas: An Interesting Trial" ("L'Heritage du peintre Degas: Un Curieux Procès")
Le Journal, January 9, 1924, p. 1

The painter Degas died in 1917 leaving behind a treasure: his own canvases and his collection, in which shone, among other artistic gems, paintings by Ingres and Delacroix. His will provided for two legatees with equal authority: his brother, M. René Degas, and the daughter of his late sister. The Degas collection was put up for auction. The sale, of which every collector has retained an indelible memory, yielded 10 million francs. After the estate taxes were paid, René Degas found himself in possession of 4 million francs in assets. Four years later, he too died. . . .

1. The two Ingres portraits mentioned are *Madame de Senonnes,* 1814–16, Musée des Beaux-Arts, Nantes, and *Louis-François Bertin,* 1832, Musée du Louvre, Paris.

2. Paul-Jacques-Raymond Binsse, comte de Saint-Victor (1827–1881), the art critic and author, and Edmond About (1828–1885), a novelist, journalist, and art critic, who championed Courbet, Daumier, and Delacroix.

3. The art dealers Julien-François (known as Père) Tanguy (1825–1894) and Alphonse Portier (d. 1902) both began their careers selling painting supplies and befriended a number of artists, including Cézanne, Gauguin, and Van Gogh.

4. The Dreyfus affair was the twelve-year scandal surrounding the trial of Captain Alfred Dreyfus (1859–1935), who was convicted of passing military secrets to the Germans and was imprisoned; years later it was discovered that he had been framed and he was exonerated. The affair triggered alarming expressions of anti-Semitism and divided French society. For example, the long-standing friendship between Degas and Ludovic Halévy (1834–1908), the opera librettist and novelist, was ruptured due to differing opinions concerning Dreyfus's guilt.

5. Sir Joshua Reynolds (1723–1792), the influential British artist who served as the first president of the Royal Academy, assembled one of the largest collections of paintings, drawings, and sculpture in eighteenth-century Britain. His posthumous sales, held in 1792, 1795, and 1798, included more than six thousand old master drawings and more than four hundred paintings.

6. Louis-Émile-Edmond Duranty (1833–1880), a novelist and art critic, was a close friend of Degas. One of the artist's portraits of Duranty (1879), included in Degas's Atelier Sale I: 48, is now located in the Burrell Collection of the Glasgow Art Gallery and Museum. Comte Isaac de Camondo (1851–1911) was a prolific collector who owned numerous works by Degas as well as by Cézanne, Manet, Monet, Sisley, Toulouse-Lautrec, and others; he is not known to have owned either of Degas's portraits of Duranty (L 517, 518).

7. Durand-Ruel, on behalf of Degas, purchased the two portraits of the Leblancs on January 23, 1896, at the sale of Mme Jean-Henri Place, née Isaure Juliette Joséphine Leblanc (1846–1896), at the Hôtel Drouot, Paris, for a total of 11,000 francs.

8. At the time of the Degas sales, the Musée du Louvre's collection included more than twenty-five paintings by Delacroix, including his *Self-Portrait,* ca. 1837, and his *Portrait of Frédéric Chopin,* 1838.

9. Degas, *Dancers Practicing at the Barre,* 1876–77, The Metropolitan Museum of Art, New York. This painting was given by Degas to Henri Rouart and included in the latter's sale, Galerie Manzi-Joyant, Paris, December 9–11, 1912, as lot no. 177. Durand-Ruel purchased it for 478,000 francs on behalf of the New York collector Louisine Havemeyer.

10. *Foyer de la danse*: The "green room" behind the opera stage where the ballerinas received their male admirers.

11. Teodor de Wyzewa (1862–1917), *Nos Maîtres: Études et portraits littéraires* (Paris, 1895).

12. Twenty-one paintings were featured in a retrospective of El Greco's work at the Salon d'Automne, October 1–November 8, 1908. Four years later, four paintings by El Greco were included in the sale of Henri Rouart's collection on December 9–11, 1912, at the Galerie Manzi-Joyant, Paris (lot nos. 42–45). On June 17–18, 1913, the auction

of Marezell de Nemes of Budapest, also held at the Galerie Manzi-Joyant, Paris, included twelve paintings by El Greco (lot nos. 28–39).

13. The two Delacroix pictures referred to are the mural painting of 1843 in the church of Saint-Denis-du-Saint-Sacrement, Paris (Robaut 1885, no. 768), and the oil of 1848, now in the Museum of Fine Arts, Boston (Johnson 1981–89, vol. 3, no. 434). The latter work had been sold by the artist to Count Théodore de Geloës of the Netherlands in 1848.

14. Degas's *Portrait of Léon Bonnat*, 1862, Musée Bonnat, Bayonne, dates from the period when the two artists were close friends.

15. François Flameng (1856–1923) and Fernand-Marie-Eugène Legoût-Gérard (1856–1924) were both well-known artists, Flameng for his history, portrait, and decorative paintings, and Legoût-Gérard for his depictions of daily life in Brittany. "Master of Cagnes" is a reference to Renoir, who spent the last two decades of his life at Cagnes-sur-Mer on the French Riviera.

16. Although Delacroix submitted *Louis-Auguste Schwiter* to the Salon of 1827, the painting was refused by the Salon jury. See *Le Siècle*, March 29, 1918.

17. See note 16.

18. Wilhelm Peter Henning Hansen (1868–1936), the Danish businessman and art collector, who in 1915 decided to form a collection of French paintings and sculpture that would be left to his country. By 1918 Hansen had acquired so many paintings—largely from the collection sales of Alphonse Kann and Degas—that he added a wing to his home in Ordrupgaard in which to display them. Other of Hansen's purchases from the Degas collection sales (bid for on his behalf by Trotti) include Manet's *Departure of the Folkestone Boat* and *Monsieur Armand Brun* and Sisley's *Factory during the Flood*. In the early 1920s, when the Landmandsbank collapsed, Hansen was forced to sell approximately half his French paintings. He later resumed collecting and after his death and that of his wife, their home was turned into a museum, the Ordrupgaardsamlingen.

19. None of the Gauguins sold for £640. *Martinique [Martinique Landscape (Allées et Venues)]* sold for 8,000 francs (£320). *Tahiti* may refer to either *Bathers (Tahitian Landscape)*, sold for 14,010 francs (£560), or *Day of the God (Mahana no atua)*, sold for 12,600 francs (£504). All three paintings were purchased from the Degas collection sales by Jos. Hessel.

20. The auction of the collection of Dutch and Flemish paintings owned by Baron Oppenheim (1834–1912), originally scheduled for October 27, 1914, was postponed until March 28–29, 1918. The sale took place at Lepke's Auction Galleries in Berlin.

21. Corot, *Tivoli: The Gardens of the Villa d'Este*, 1843, Musée du Louvre, Paris. Henri Rouart owned this picture by 1895; it was included as lot no. 114 in his sale in December 1912.

22. The New York sale referred to is that of George Arnold Hearn, a merchant and benefactor of The Metropolitan Museum of Art and the Brooklyn Institute of Arts. The Hearn sales were held over seven days (February 25–28 and March 1, 2, and 4, 1918) at the Plaza Hotel and American Art Galleries, New York, and consisted of hundreds of lots of paintings, Asian art, European ivory carvings, and objets d'art.

23. Degas acquired *Saint Ildefonso* on April 25, 1894, at Mme Millet's sale, Paris (lot no. 261). *Saint Dominic* had been owned by J. F. Millet and M. LeFèvre, Paris, before Degas purchased it from Zacharie Astruc in September 1896.

24. Henri Gervex (1852–1929) was one of the artists who frequented the

café La Nouvelle-Athènes, along with Manet and Degas. The artist Scott is probably Henri-Louis Scott (ca. 1846–1884).

25. After the death of his wife, the painter Paul-Albert Bartholomé (1848–1920) was encouraged by Degas to take up sculpture. Bartholomé's most celebrated funerary sculpture is the *Monument to the Dead*, unveiled in 1899 in Père Lachaise cemetery, Paris.

26. Victor Chocquet (1821–1891), a customs official and devoted supporter of the Impressionists, commissioned a number of portraits of himself, his wife, and his daughter. Portraits of Victor Chocquet painted by Renoir in 1876 are located in the Oskar Reinhart Collection, Winterthur, and in the Fogg Art Museum, Cambridge, Mass.

27. The work in question, sold in the Degas Collection Sale I: 37 as *Portrait of a Man* by an eighteenth-century French artist, has since been reattributed to Degas as *Portrait of a Man, Copy after Quentin de La Tour*, 1868–70, Musée Cantonal des Beaux-Arts, Lausanne. Bernheim Jeune purchased the painting at the Degas sale for 1,600 francs.

28. The artist in question is probably Paul Cézanne, who died in 1906.

29. In 1877 Manet began a portrait of Albert Wolff (1835–1891), the German-born journalist and art critic, who, while working for *Le Figaro*, championed Barbizon painting and disparaged Impressionism. The portrait (now in a private collection, on loan to the Kunsthaus, Zurich) is unfinished, as Wolff refused to continue to pose for it. Manet also painted the portrait of Count Henri de Rochefort Luçay (1831–1913), the French author and polemicist. In 1873 Rochefort was deported for having supported the Paris Commune. He later escaped and returned to France. In addition to the portrait (1881; Hamburger Kunsthalle, Hamburg), Manet also painted two versions of Rochefort's escape.

30. Wilhelm von Bode (1845–1929), the German art historian and author who was director of the Altes Museum, Berlin, from 1905 to 1920.

31. Moritz August von Bethmann-Hollweg (1795–1877), the German author.

32. The works in question are Delacroix's mural painting for the ceiling of the Apollo Gallery in the Musée du Louvre and his *Entry of the Crusaders into Constantinople*, 1840 (Musée du Louvre, Paris). The latter work was heavily criticized for its dull coloring and awkward drawing when it was shown at the Salon of 1841 (Johnson 1981–89, vol. 3, no. 274).

33. Philippe Burty (1830–1890), an influential art critic and collector who championed original prints and helped make Japanese prints known in Europe. He owned a unique collection of Manet's prints, a number of which later were acquired by Degas.

34. Founded by Charles Philipon (1800–1862), the Association Mensuelle Lithographique sold prints by subscription in the years 1832–34 to deflect censorship fines incurred by the political caricatures in Philipon's journals *La Caricature* and *Le Charivari*. *The Legislative Belly* and *Rue Transnonain, April 15, 1834* were among the five lithographs Daumier contributed to the cause.

35. The work Merrheim purchased from the second Degas collection sale was probably lot no. 8, *The Chariot of Apollo*, listed in the catalogue as an oil painting by an unknown artist from the Modern School. Alfred Robaut's catalogue raisonné of Delacroix's work, *L'Oeuvre complet de Eugène Delacroix* (Paris, 1885), is illustrated with sketches after Delacroix's paintings; Robaut's sketch of the Apollo ceiling appears on p. 296 of the book.

36. This amount probably represents the proceeds of just one day of the two-day sale. The sale's total was 137,941 francs.

37. See note 36.

Bibliography

The short forms and complete bibliographical citations for the sale cata-logues of Degas's collection and atelier are as follows:

Collection Sale I
Catalogue des tableaux modernes et anciens: aquarelles, pastels, dessins . . . composant la collection Edgar Degas Paris: Galerie Georges Petit, March 26–27, 1918.

Collection Sale II
Catalogue des tableaux modernes: pastels, aquarelles, dessins, anciens et modernes . . . faisant partie de la collection Edgar Degas Paris: Hôtel Drouot, November 15–16, 1918.

Collection Print Sale
Catalogue des estampes anciennes et modernes . . . composant la collec-tion Edgar Degas Paris: Hôtel Drouot, November 6–7, 1918.

Atelier Sale I
Catalogue des tableaux, pastels et dessins par Edgar Degas et provenant de son atelier Paris: Galerie Georges Petit, May 6–8, 1918.

Atelier Sale II
Catalogue des tableaux, pastels et dessins par Edgar Degas et provenant de son atelier Paris: Galerie Georges Petit, December 11–13, 1918.

Atelier Sale III
Catalogue des tableaux, pastels et dessins par Edgar Degas et provenant de son atelier Paris: Galerie Georges Petit, April 7–9, 1919.

Atelier Sale IV
Catalogue des tableaux, pastels et dessins par Edgar Degas et provenant de son atelier Paris: Galerie Georges Petit, July 2–4, 1919.

Atelier Print Sale
Catalogue des eaux-fortes, vernis-mous, aqua-tintes, lithographies et monotypes par Edgar Degas et provenant de son atelier Paris: Galerie Manzi-Joyant, November 22–23, 1918.

Adhémar and Cachin 1973
Jean Adhémar and Françoise Cachin. *Edgar Degas, gravures et monotypes.* Paris, 1973.

Adhémar and Cachin 1974
Jean Adhémar and Françoise Cachin. *Degas: The Complete Etchings, Lithographs and Monotypes.* Trans. Jane Brenton. New York, 1974.

Adriani 1985
Götz Adriani. *Degas: Pastels, Oil Sketches, Drawings.* New York, 1985.

Aitken and Delafond 1983
Geneviève Aitken and Marianne Delafond. *La Collection d'estampes japonaises de Claude Monet à Giverny.* Paris, 1983.

Alexandre 1901
Arsène Alexandre. "Le Marché aux toiles." *Le Figaro,* October 12, 1901, p. 1.

Alexandre 1908
Arsène Alexandre. "Collection de M. le Compte Isaac de Camondo." *Les Arts,* no. 83 (November 1908), pp. 2–32.

Armstrong 1991
Carol M. Armstrong. *Odd Man Out: Readings of the Work and Reputation of Edgar Degas.* Chicago and London, 1991.

Atelier Sale I, Atelier Sale II, Atelier Sale III, Atelier Sale IV, Atelier Print Sale
See citations at head of Bibliography.

Bailly-Herzberg 1980–91
Janine Bailly-Herzberg, ed. *Correspondance de Camille Pissarro,* Vol. 1, *1865–1885,* Paris, 1980; Vol. 2, *1886–1890,* Paris, 1986; Vol. 3, *1891–1894,* Paris, 1988; Vol. 4, *1895–1898,* Paris, 1989; Vol. 5, *1899–1903,* Paris, 1991.

Bataille and Wildenstein 1961
M.-L. Bataille and Georges Wildenstein. *Berthe Morisot: Catalogue des peintures, pastels et aquarelles.* Paris, 1961.

Baudelaire 1965
Charles Baudelaire. *Critique d'art.* Ed. Claude Pichois. 2 vols. Paris, 1965.

Baudelaire 1975–76
Charles Baudelaire. *Oeuvres complètes.* Ed. Claude Pichois. 2 vols. Paris, 1975–76.

Berhaut 1978
Marie Berhaut. *Caillebotte, sa vie et son oeuvre: Catalogue raisonné des peintures et pastels.* Paris, 1978.

Blanche 1919 (1927)
Jacques-Émile Blanche. *Propos de peintre.* Vol. 1, *De David à Degas.* Paris, 1919 (1927).

Bodelsen 1968
Merete Bodelsen. "Early Impressionist Sales, 1874–94, in the light of some unpublished 'procès-verbaux.'" *Burlington Magazine* 110, no. 783 (June 1968), pp. 330–49.

Bodelsen 1970
Merete Bodelsen. "Gauguin, the Collector." *Burlington Magazine* 112, no. 810 (September 1970), pp. 590–615.

Boggs 1962
Jean Sutherland Boggs. *Portraits by Degas.* Berkeley and Los Angeles, 1962.

Boggs 1963
Jean Sutherland Boggs. "Edgar Degas and Naples." *Burlington Magazine* 105, no. 723 (June 1963), pp. 271–77.

Boime 1971
Albert Boime. *The Academy and French Painting in the Nineteenth Century.* London, 1971.

Boston, Philadelphia, London 1984–85
Sue Welch Reed and Barbara Stern Shapiro et al. *Edgar Degas: The Painter as Printmaker.* Exh. cat., Boston, Museum of Fine Arts; Philadelphia Museum of Art; London, Arts Council of Great Britain, Hayward Gallery. Boston, 1984.

BR
See Brame and Reff 1984.

Brame and Reff 1984
Philippe Brame and Theodore Reff, with the assistance of Arlene Reff. *Degas et son oeuvre: A Supplement.* New York, 1984.

Breeskin 1970
Adelyn Dohme Breeskin. *Mary Cassatt: A Catalogue Raisonné of the Oils, Pastels, Watercolors, and Drawings.* Washington, D.C., 1970.

Breeskin 1979
Adelyn Dohme Breeskin. *Mary Cassatt: A Catalogue Raisonné of the Graphic Work.* Washington, D.C., 1979.

Burroughs 1919
B. B. [Bryson Burroughs]. "Drawings by Degas." *Metropolitan Museum of Art Bulletin* 14, no. 5 (May 1919), pp. 115–17.

Cambridge, Mass. 1967
Ingres, Centennial Exhibition 1867–1967: Drawings, Watercolors and Oil Sketches from American Collections. Exh. cat., Cambridge, Mass., Fogg Art Museum, Harvard University. Cambridge, Mass., 1967.

Chappuis 1973
Adrien Chappuis. *The Drawings of Paul Cézanne: A Catalogue Raisonné.* 2 vols. Greenwich, Conn., 1973.

Chennevières 1890
Henry de Chennevières. "Silhouettes de collectionneurs—M. Eudoxe Marcille." *Gazette des Beaux-Arts* 4 (1890), pp. 217–35, 296–310.

Chicago 1984
Richard R. Brettell and Suzanne Folds McCullagh. *Degas in The Art Institute of Chicago.* Exh. cat., The Art Institute of Chicago. Chicago and New York, 1984.

Clarke 1991a
Michael Clarke. *Corot and the Art of Landscape.* London, 1991.

Clarke 1991b
Michael Clarke. "Degas and Corot: The Affinity Between Two Artists' Artists." *Apollo* 132 (July 1991), pp. 15–20.

Collection Sale I, Collection Sale II, Collection Print Sale
See citations at head of Bibliography.

Coquiot 1924
Gustave Coquiot. *Degas.* Paris, 1924.

Daulte 1959
François Daulte. *Alfred Sisley: Catalogue raisonné de l'oeuvre peint.* Lausanne, 1959.

Daulte 1971
François Daulte. *Auguste Renoir: Catalogue raisonné de l'oeuvre peint.* Vol. 1, *Figures, 1860–1890.* Lausanne, 1971.

Davies 1970
Martin Davies. *French School: Early 19th Century, Impressionists, Post-Impressionists etc.* Rev. ed. National Gallery Catalogues. London, 1970.

***Degas inédit* 1989**
Degas inédit. Actes du Colloque Degas, Musée d'Orsay 18–21 avril 1988. Paris, 1989.

Degas inv.
Edgar Degas. Unpublished notes, a partial inventory of his collection. Private collection.

Delaborde 1870
Henri Delaborde. *Ingres: Sa Vie, ses travaux, sa doctrine.* Paris, 1870.

Delacroix 1932
Eugène Delacroix. *Journal de Eugène Delacroix.* Ed. André Joubin. 3 vols. Paris, 1932.

Delteil 1923
Loys Delteil. *Jean-François Raffaëlli.* Le Peintre-graveur illustré, vol. 16. Paris, 1923.

Delteil 1925–26
Loys Delteil. *Honoré Daumier.* Le Peintre-graveur illustré, vols. 20–29. Paris, 1925–26.

Denis 1902
Maurice Denis. "Les Élèves d'Ingres." *L'Occident* 2, no. 9 (August 1902), pp. 77–94.

Distel 1989
Anne Distel. *Les Collectionneurs des Impressionnistes: Amateurs et marchands.* Paris, 1989.

Distel 1990
Anne Distel. *Impressionism: The First Collectors.* Trans. Barbara Perroud-Benson. New York, 1990.

Dumas 1981
Ann Dumas. "Degas as a Collector." Master's thesis, Courtauld Institute of Art, University of London, 1981.

Duranty 1876
Edmond Duranty. *La Nouvelle Peinture.* Paris, 1876.

Duranty 1878
Edmond Duranty. "Daumier." *Gazette des Beaux-Arts* 17 (May–June 1878), pp. 429–43, 528–44.

Duret 1902
Théodore Duret. *Histoire d'Édouard Manet et de son oeuvre.* Paris, 1902.

Edinburgh 1979
Ronald Pickvance. *Degas 1879: Paintings, pastels, drawings, prints and sculpture from around 100 years ago in the context of his earlier and later works.* Exh. cat., Edinburgh, National Gallery of Scotland. Edinburgh, 1979.

Emberton 1996
Anne Emberton. "Keynes and the Degas Sale." *History Today* 46, no. 1 (January 1996), pp. 22–28.

Escholier 1926–29
Raymond Escholier. *Delacroix, peintre, graveur, écrivain.* 3 vols. Paris, 1926–29.

Faille 1970
J.-B. de la Faille. *The Works of Vincent van Gogh: His Paintings and Drawings.* Rev. ed. Amsterdam, 1970.

Fernier 1977–78
Robert Fernier. *La Vie et l'oeuvre de Gustave Courbet: Catalogue raisonné.* 2 vols. Lausanne and Paris, 1977–78.

Fevre 1949
Jeanne Fevre. *Mon oncle Degas.* Ed. Pierre Borel. Geneva, 1949.

Field 1968
Richard S. Field. "Gauguin's Noa Noa Suite." *Burlington Magazine* 110, no. 786 (September 1968), pp. 500–511.

Frantz 1913
Henry Frantz. "The Rouart Collection." *The International Studio* 50, no. 199 (September 1913), pp. 184–93.

Fries 1964
Gerhard Fries. "Degas et les maîtres." *Art de France* 4 (1964), pp. 252–59.

Fry 1918
Roger Fry. "A Monthly Chronicle: The Sale of Degas's Collection." *Burlington Magazine* 32, no. 180 (March 1918), p. 118.

Galassi 1991
Peter Galassi. *Corot in Italy: Open-Air Painting and the Classical-Landscape Tradition.* New Haven and London, 1991.

Gauguin 1923
Paul Gauguin. *Avant et après.* Facsimile ed. Paris, 1923.

Gimpel 1966
René Gimpel. *Diary of an Art Dealer.* New York, 1966.

Gordon and Forge 1988
Robert Gordon and Andrew Forge. *Degas.* New York, 1988.

Green 1987
Nicholas Green. "Dealing in Temperaments: Economic Transformation of the Artistic Field in France during the Second Half of the Nineteenth Century." *Art History* 10, no. 1 (March 1987), pp. 59–78.

Green 1989
Nicholas Green. "Circuits of Production, Circuits of Consumption: The Case of Mid-Nineteenth-Century French Art Dealing." *Art Journal* 48, no. 1 (Spring 1989), pp. 29–34.

Guérin 1944
Marcel Guérin. *L'Oeuvre gravé de Manet.* Paris, 1944.

Halévy 1960
Daniel Halévy. *Degas parle* Paris, 1960.

Halévy 1964
Daniel Halévy. *My Friend Degas.* Trans. and ed. by Mina Curtiss. Middletown, Conn., 1964.

Harris 1990
Jean C. Harris. *Édouard Manet, The Graphic Work: A Catalogue Raisonné.* Rev. ed. San Francisco, 1990.

Haskell 1976
Francis Haskell. *Rediscoveries in Art: Some Aspects of Taste, Fashion, and Collecting in England and France.* Ithaca, N.Y., 1976.

Havemeyer 1993
Louisine W. Havemeyer. *Sixteen to Sixty: Memoirs of a Collector.* New York, 1993.

Holmes 1936
Charles John Holmes. *Self and Partners (Mostly Self).* London, 1936.

Huysmans 1883
Joris-Karl Huysmans. *L'Art moderne.* Paris, 1883.

Huysmans 1975
Joris-Karl Huysmans. *L'Art moderne.* Paris, 1975.

J
See Johnson 1981–89.

Jamot 1918
Paul Jamot. "Degas (1834–1917) [La Collection Camondo au Musée du Louvre: Les Peintures et les dessins, pt. 2]." *Gazette des Beaux-Arts* 14 (April–June 1918), pp. 123–66.

Jamot and Wildenstein 1932
Paul Jamot and Georges Wildenstein. *Manet.* 2 vols. Paris, 1932.

Janis 1968
Eugenia Parry Janis. *Degas Monotypes: Essay, Catalogue & Checklist.* Cambridge, Mass., 1968.

Jeanniot 1933
Georges Jeanniot. "Souvenirs sur Degas." *La Revue universelle* 55 (October 15, 1933), pp. 152–74; (November 1, 1933), pp. 280–304.

Johnson 1981–89
Lee Johnson. *The Paintings of Eugène Delacroix: A Critical Catalogue.* 6 vols. Oxford, 1981–89.

JW
See Jamot and Wildenstein 1932.

Kendall 1985
Richard Kendall, ed. *Degas, 1834–1984.* Manchester, 1985.

Kendall 1987
Richard Kendall, ed. *Degas by Himself: Drawings, Prints, Paintings, Writings.* London, 1987.

Kendall 1993
Richard Kendall. *Degas Landscapes.* New Haven and London, 1993.

Kendall and Pollock 1992
Richard Kendall and Griselda Pollock. *Dealing with Degas: Representations of Women and the Politics of Vision.* London, 1992.

L
See Lemoisne 1946–49.

Lafond 1918–19
Paul Lafond. *Degas.* 2 vols. Paris, 1918–19.

Lapauze 1911
Henry Lapauze. *Ingres, sa vie & son oeuvre.* Paris, 1911.

Lapauze 1918
Henry Lapauze. "Ingres chez Degas." *La Renaissance de l'art français* 1, no. 1 (March 1918), pp. 9–15.

Lemoisne 1946–49
Paul-André Lemoisne. *Degas et son oeuvre.* 4 vols. Paris, [1946–49]; reprint, New York and London, 1984.

Letters of Degas 1947
Marcel Guérin, ed. *Edgar Germain Hilaire Degas: Letters.* Trans. Marguerite Kay. Oxford, 1947.

Lettres de Degas 1945
Marcel Guérin, ed. *Lettres de Degas.* Paris, 1945.

Lipton 1986
Eunice Lipton. *Looking into Degas: Uneasy Images of Women and Modern Life.* Berkeley and Los Angeles, 1986.

London 1996
Ann Dumas. *Degas as a Collector.* Exh. cat., London, the National Gallery. London, 1996. Also published in *Apollo* 44, no. 415 (September 1996), pp. 3–72.

London, Chicago 1996–97
Richard Kendall. *Degas Beyond Impressionism.* Exh. cat., London, The National Gallery; The Art Institute of Chicago. London, 1996.

London, Paris, Boston 1980–81
Pissarro: Camille Pissarro 1830–1903. Exh. cat., London, Hayward Gallery; Paris, Grand Palais; Boston, Museum of Fine Arts. London and Boston, 1980.

London, Paris, Washington 1995
Richard Dorment and Margaret F. Macdonald. *James McNeill Whistler.* Exh. cat., London, Tate Gallery; Paris, Musée d'Orsay; Washington, D.C., National Gallery of Art. London, 1995.

Loyrette 1991
Henri Loyrette. *Degas.* Paris, 1991.

Maison 1968
K. E. Maison. *Honoré Daumier: Catalogue Raisonné of the Paintings, Watercolours and Drawings.* Vol. 1, *The Paintings.* Greenwich, Conn., 1968.

Manet 1987
Julie Manet. *Growing Up with the Impressionists: The Diary of Julie Manet.* Trans. and ed. by Rosalind de Boland Roberts and Jane Roberts. London, 1987.

Mathews 1984
Nancy Mowll Mathews, ed. *Cassatt and Her Circle: Selected Letters.* New York, 1984.

McMullen 1984
Roy McMullen. *Degas, His Life, Times, and Work.* Boston, 1984.

Melot 1974
Michel Melot, ed. *L'Estampe impressionniste.* Paris, 1974.

Merlhès 1984
Victor Merlhès. *Correspondance de Paul Gauguin: Documents Témoignages.* Paris, 1984.

Michel 1919
Alice Michel. "Degas et son modèle." *Mercure de France,* February 16, 1919, pp. 457–78, 623–39.

Millard 1976
Charles W. Millard. *The Sculpture of Edgar Degas.* Princeton, 1976.

Moore 1890
George Moore. "Degas: The Painter of Modern Life." *Magazine of Art* 13 (October 1890), pp. 416–25.

Moore 1913
George Moore. *Impressions and Opinions.* 2nd ed. London, 1913.

Moore 1918
George Moore. "Memories of Degas." *Burlington Magazine* 32, no. 178 (January 1918), pp. 22–29; no. 179 (February 1918), pp. 63–65.

Moreau-Nélaton 1931
Étienne Moreau-Nélaton. "Deux heures avec Degas: Interview posthume." *L'Amour de l'art* 12 (July 1931), pp. 267–70.

Morisot 1950
Berthe Morisot. *Correspondance de Berthe Morisot avec sa famille et ses amis.* Ed. Denis Rouart. Paris, 1950.

Naef 1977–80
Hans Naef. *Die Bildniszeichnungen von J.-A.-D. Ingres.* 5 vols. Bern, 1977–80.

New York 1993
Alice Cooney Frelinghuysen et al. *Splendid Legacy: The Havemeyer Collection.* Exh. cat., New York, The Metropolitan Museum of Art. New York, 1993.

Paris 1949
Jean Leymarie and René Huyghe. *Gauguin: Exposition de centenaire.* Exh. cat., Paris, Orangerie des Tuileries. Paris, 1949.

Paris 1978
Juliet Wilson. *Manet: Dessins, aquarelles, eaux-fortes, lithographies, correspondance.* Exh. cat., Paris, Huguette Berès. Paris, 1978.

Paris 1984–85
Maurice Guillaud, ed. *Degas: Form and Space.* Exh. cat., Paris, Centre Culturel du Marais. Paris, 1984.

Paris, New York 1983
Manet 1832–1883. Exh. cat., Paris, Galeries Nationales du Grand Palais; New York, The Metropolitan Museum of Art. Paris, 1983.

Paris, Ottawa, New York 1988–89a
Jean Sutherland Boggs et al. *Degas.* Exh. cat., Paris, Galeries Nationales du Grand Palais; Ottawa, National Gallery of Canada; New York, The Metropolitan Museum of Art. English ed. New York and Ottawa, 1988.

Paris, Ottawa, New York 1988–89b
Jean Sutherland Boggs et al. *Degas.* Exh. cat., Paris, Galeries Nationales du Grand Palais; Ottawa, National Gallery of Canada; New York, The Metropolitan Museum of Art. French ed. Paris, 1988.

Passeron 1974
Roger Passeron. *Impressionist Prints.* New York, 1974.

Philadelphia 1973
Richard S. Field. *Paul Gauguin: Monotypes.* Exh. cat., Philadelphia Museum of Art. Philadelphia, 1973.

Pingeot 1991
Anne Pingeot. *Degas Sculptures.* Paris, 1991.

C. Pissarro 1950
Camille Pissarro. *Camille Pissarro: Lettres à son fils Lucien.* Ed. John Rewald. Paris, 1950.

L. Pissarro and Venturi 1939
Ludovic Rodo Pissarro and Lionello Venturi. *Camille Pissarro, son art—son oeuvre.* 2 vols. Paris, 1939.

Pool 1963
Phoebe Pool. "Degas and Moreau." *Burlington Magazine* 105, no. 723 (June 1963), pp. 251–56.

PV
See L. Pissarro and Venturi 1939.

Reff 1963
Theodore Reff. "Degas's Copies of Older Art." *Burlington Magazine* 105, no. 723 (June 1963), pp. 241–51.

Reff 1964a
Theodore Reff. "New Light on Degas's Copies." *Burlington Magazine* 106, no. 735 (June 1964), pp. 250–59.

Reff 1964b
Theodore Reff. "Copyists in the Louvre, 1850–1870." *Art Bulletin* 46, no. 4 (December 1964), pp. 552–59.

Reff 1965
Theodore Reff. "Addenda on Degas's Copies." *Burlington Magazine* 107, no. 747 (June 1965), pp. 320–23.

Reff 1968a
Theodore Reff. "Some Unpublished Letters of Degas." *Art Bulletin* 50, no. 1 (March 1968), pp. 87–94.

Reff 1968b
Theodore Reff. "The Pictures within Degas's Pictures." *Metropolitan Museum Journal* 1 (1968), pp. 125–66.

Reff 1969
Theodore Reff. "More Unpublished Letters of Degas." *Art Bulletin* 51, no. 3 (September 1969), pp. 281–89.

Reff 1971
Theodore Reff. "Further Thoughts on Degas's Copies." *Burlington Magazine* 113, no. 822 (September 1971), pp. 534–43.

Reff 1976a
Theodore Reff. *Degas: The Artist's Mind.* New York, 1976.

Reff 1976b
Theodore Reff. *The Notebooks of Edgar Degas: A Catalogue of the Thirty-eight Notebooks in the Bibliothèque Nationale and Other Collections.* 2 vols. Oxford, 1976.

Reff 1985
Theodore Reff. *The Notebooks of Edgar Degas: A Catalogue of the Thirty-eight Notebooks in the Bibliothèque Nationale and Other Collections.* 2 vols. Rev. ed. New York, 1985.

Rewald 1958
John Rewald. *Gauguin Drawings.* New York and London, 1958.

Rewald 1996
John Rewald in collaboration with Walter Feilchenfeldt and Jayne Warman. *The Paintings of Paul Cézanne: A Catalogue Raisonné.* 2 vols. New York, 1996.

Robaut 1885
Alfred Robaut. *L'Oeuvre complèt d'Eugène Delacroix: Peintures, dessins, gravures, lithographies.* Paris, 1885.

Robaut and Moreau-Nélaton 1905
Alfred Robaut and Étienne Moreau-Nélaton. *L'Oeuvre de Corot: Catalogue raisonné et illustré.* 4 vols. Paris, 1905.

Rome 1984–85
Accademia di Francia a Roma. *Degas e l'Italia.* Exh. cat., Rome, Villa Medici. Rome, 1984.

Roquebert 1989
Anne Roquebert. "Degas collectionneur." In *Degas inédit* 1989, pp. 65–85.

Rosenblum 1967
Robert Rosenblum. *Jean-Auguste-Dominique Ingres.* New York, 1967.

Rothenstein 1931–39
William Rothenstein. *Men and Memories.* 3 vols. London, 1931–39.

D. Rouart 1945
Denis Rouart. *Degas à la recherche de sa technique.* Paris, 1945.

D. Rouart 1988
Denis Rouart. *Degas à la recherche de sa technique.* 2d ed. Paris, 1988.

D. Rouart and Wildenstein 1975
Denis Rouart and Daniel Wildenstein. *Édouard Manet: Catalogue raisonné.* 2 vols. Lausanne, 1975.

E. Rouart 1937
Ernest Rouart. "Degas." *Le Point: Revue artistique et littéraire* 2, no. 1 (February 1937), pp. 5–22.

Rouault 1927
Georges Rouault. *Souvenirs intimes: G. Moreau, Léon Bloy, Cézanne, Ch. Baudelaire, Renoir, Daumier, J.-K. Huysmans, Degas.* 2d ed. Paris, 1927.

RW
See D. Rouart and Wildenstein 1975.

Schmit 1973
Robert Schmit. *Eugène Boudin, 1824–1898.* 3 vols. Paris, 1973.

Sévin 1975
Françoise Sévin. "Degas à travers ses mots." *Gazette des Beaux-Arts* 86 (July–August 1975), pp. 17–46.

Shapiro 1992
Barbara Stern Shapiro. "Pissarro as Printmaker: Some Questions and Answers." *Apollo* 136 (November 1992), pp. 295–300.

Sickert 1917
Walter Sickert. "Degas." *Burlington Magazine* 31, no. 176 (November 1917), pp. 183–91.

Sickert 1947
Walter Sickert. *A Free House! Or, The Artist as Craftsman.* London, 1947.

Sutton and Adhémar 1987
Denys Sutton and Jean Adhémar. "Lettres inédites de Degas à Paul Lafond et autres documents." *Gazette des Beaux-Arts* 109 (April 1987), pp. 159–80.

Terrasse 1983
Antoine Terrasse. *Degas et la photographie.* Paris, 1983.

B. Thomson 1987
Belinda Thomson. *Gauguin.* New York and London, 1987.

R. Thomson 1987
Richard Thomson. *The Private Degas.* London, 1987.

R. Thomson 1988
Richard Thomson. *Degas: The Nudes.* London, 1988.

V
See Venturi 1936.

Valéry 1960
Paul Valéry. "Degas, Dance, Drawing," in *Degas, Manet, Morisot.* Trans. David Paul. New York, 1960, pp. 1–102.

Venturi 1936
Lionello Venturi. *Cézanne: Son art, son oeuvre.* 2 vols. Paris, 1936.

Vigne 1995
Georges Vigne. *Dessins d'Ingres: Catalogue raisonné des dessins du musée de Montauban.* Paris, 1995.

Vollard 1924
Ambroise Vollard. *Degas (1834–1917).* Paris, 1924.

Vollard 1936
Ambroise Vollard. *Recollections of a Picture Dealer.* Trans. Violet M. MacDonald. London, 1936.

Vollard 1937a
Ambroise Vollard. *Degas, An Intimate Portrait.* Trans. Randolf T. Weaver. New York, 1937.

Vollard 1937b
Ambroise Vollard. *Souvenirs d'un marchand de tableaux.* Paris, 1937.

W
See Wildenstein 1964.

Wagner 1974.
Anne M. Wagner. "Degas's Collection of Art: An Introductory Essay and Catalogue." Master's thesis, Brown University, 1974.

Washington, Boston, Williamstown, Mass. 1989–90
Nancy Mowll Mathews and Barbara Stern Shapiro. *Mary Cassatt: The Color Prints.* Exh. cat., Washington, D.C., National Gallery of Art; Boston, Museum of Fine Arts; Williamstown, Mass., Williams College Museum of Art. New York, 1989.

Washington, Chicago, Paris 1988–89
Richard Brettell et al. *The Art of Paul Gauguin.* Exh. cat., Washington, D.C., National Gallery of Art; The Art Institute of Chicago; Paris, Grand Palais. Boston, 1988.

Washington, San Francisco 1986
Charles S. Moffett et al. *The New Painting: Impressionism 1874–1886.* Exh. cat., Washington, D.C., National Gallery of Art; San Francisco, M. H. de Young Memorial Museum. San Francisco, 1986.

Wethey 1962
Harold E. Wethey. *El Greco and His School.* 2 vols. Princeton, N. J., 1962.

Wildenstein 1954
Georges Wildenstein. *Ingres.* New York, 1954.

Wildenstein 1964
Georges Wildenstein. *Gauguin.* Vol. 1, *Catalogue.* Paris, 1964.

Zurich, Tübingen 1994–95
Felix Baumann and Marianne Karabelnik, eds. *Degas Portraits.* Exh. cat., Zurich, Kunsthaus; Tübingen, Kunsthalle. London, 1994.

Index

Page references for illustrations are in *italics*. Degas's works are identified by Lemoisne number (e.g., L 5) where appropriate. Works included in the Degas sales are identified by sale number, with the abbreviations for the sales as follows: CS I, II—Collection Sales I, II; CPS—Collection Print Sale; AS I–IV—Atelier Sales I–IV; APS—Atelier Print Sale. See also the Note to the Reader, page xii.

Photograph Credits

Basel, Oeffentliche Kunstsammlung Basel, photograph by Martin Bühler: figs. 63, 101

Boston, Courtesy Museum of Fine Arts, Boston: figs. 275, 316

Cambridge, Mass., © President and Fellows, Harvard College, Harvard University Art Museums: figs. 24, 29, 170, 183–85, 192, 390

Chicago, © 1997, The Art Institute of Chicago, all rights reserved: figs. 12, 20, 66, 96, 108, 292, 325, 327, 328, 379

Cleveland, © The Cleveland Museum of Art, 1997, Gift of Ralph M. Coe, Twenty-fifth Anniversary Gift, 1941.316: fig. 65

Copenhagen, © Ole Woldbye: figs. 36, 160, 189, 397

Copenhagen, Ordrupgaard: fig. 380

Detroit, © The Detroit Institute of Arts: fig. 93

Glasgow, © Glasgow Museums: fig. 8

Hamburg, Fotowerkstatt Hamburger Kunsthalle, photograph © Elke Walford: fig. 256

London, © British Museum: figs. 33, 43, 45, 51, 72, 73, 115, 166, 191, 221, 338, 391, 393, 399, 418, 419

London, Courtesy of the Lefevre Gallery: fig. 85

Merion, Pa., © 1997 by The Barnes Foundation, all rights reserved: figs. 161, 285

Montauban, Cliché Roumagnac: fig. 188

New York, The Metropolitan Museum of Art, The Photograph Studio: figs. 21, 22, 78, 123, 128, 187, 202, 207, 228, 231, 235, 236, 267, 268, 291, 294, 295, 298, 300, 301, 312, 333, 335, 336, 343, 366–75, 396; new photography by Juan Trujillo with Patricia Mazza, Caitlin McCaffrey, Bruce Schwarz, Eileen Travell, and Karin Willis, figs. 68, 69, 70, 79, 119, 120, 125, 219, 224, 245, 250, 257, 259, 270, 299, 313, 314, 317, 318, 321, 330, 348–50, 357, 364, 376, 389, 401, 407, 420, 421

New York, © 1996 The Museum of Modern Art: fig. 304

Northampton, Mass., Smith College Museum of Art, Purchased, Drayton Hillyer Fund, 1933: fig. 199

Oslo, Nasjonalgalleriet, © NG 1997, photograph by J. Lathion: figs. 258, 271, 273, 416

Paris, Photographie Durand-Ruel: fig. 182

Paris, Giraudon: figs. 179, 206

Paris, Musée des Arts Décoratifs, photograph by L. Sully-Jaulmes: figs. 46, 139, 143

Paris, © Réunion des Musées Nationaux: figs. 16, 31, 38–40, 90, 101–7, 110, 116, 122, 133, 137, 146, 149, 150, 171, 215, 217, 218, 230, 244, 288, 339, 341, 358, 362, 414; Arnaudet, fig. 88; Michèle Bellot, figs. 48, 52, 147, 216, 252; J. G. Berizzi, fig. 408; Gérard Blot, figs. 138, 144, 148; G. Blot/J. Schor, fig. 4; Hervé Lewandowski, figs. 249, 303; R. G. Ojeda, figs. 47, 400; Jean Schormans, figs. 93, 242

Parma, Amoretti: fig. 55

Philadelphia, Philadelphia Museum of Art, photograph by Graydon Wood, 1994: fig. 100

Princeton, N.J., © 1997 Trustees of Princeton University: fig. 255

Richmond, Va., © 1991 Virginia Museum of Fine Arts, photograph by Grace Wen Hwa Ts'ao: fig. 62

San Francisco, © The Fine Arts Museums of San Francisco: fig. 59

Stockholm, Nationalmuseum, photograph by Hans Thorwid: fig. 417

Stockholm, Statens Konstmuseer: figs. 76, 241, 266; Erik Cornelius, fig. 27; © Fotograf Åsa Lundén, fig. 77

Vicenza, Diego Ferrini: fig. 54

Washington, D.C., © Board of Trustees, National Gallery of Art, Washington: figs. 1, 2, 3, 83, 97, 99, 309, 365, 412; Dean Beasom, figs. 81, 302

Williamstown, Mass., © Sterling and Francine Clark Art Institute: figs. 165, 213, 222, 322, 324, 342, 404

Worcester, Mass., © Worcester Art Museum: fig. 296

Zurich, © 1997 Kunsthaus Zurich, all rights reserved: fig. 198

© 1997 Artists Rights Society (ARS), New York / ADAGP, Paris: figs. 57, 127

Clem Fiori: fig. 278